'[An] exemplary, diligent biography' William Boyd, *New Statesman*

'Excellent ... Ursula Buchan has balanced her grandfather's public and literary achievements with his family life and internal tensions. He emerges as a thoroughly decent man and she as a brilliant biographer' Lawrence James, *Standpoint*

'Hugely impressive ... Magisterial ... Provides illuminating evidence of how often aspects of [Buchan's] own life fed into his fiction' Andrew Hook, *Scottish Review*

'[Ursula Buchan's] biography is thoroughly researched and elegantly written, and it proves beyond reasonable doubt that John Buchan was, if not one of the greatest, then certainly one of the most remarkable writers and public men of the early twentieth century' Kevin Jackson, *Literary Review*

'John Buchan was a writer of considerable significance but he was also a man who led a remarkable public life. This magnificent biography leads us through that life with great style and understanding' Alexander McCall Smith

'Ursula Buchan combines an intimate understanding of her grandfather with a scholarly reading of the immense mass of his papers in a hugely enjoyable and rewarding biography of a man of many parts and remarkable energy. A Buchan revival is certainly due' *History Today*

'Page-turning, buccaneering stuff ... The reader finishes this biography full of admiration' Laura Freeman, *The Times*

'The great strength of this book is to make Buchan not just the writer of "shockers", but a man whose influence helped change government policy ... An admirable piece of work ... This lays a line towards a reimagination of Buchan' Stuart Kelly, *Scotsman*

A Note on the Author

Ursula Buchan studied modern history at New Hall, Cambridge, and horticulture at the Royal Botanic Gardens, Kew. She is an award-winning journalist and author, having written eighteen books and contributed regularly to the *Spectator, Observer, Independent, Sunday Telegraph, Daily Telegraph* and *The Garden*. She is a daughter of John Buchan's second son, William.

BEYOND THE THIRTY-NINE STEPS

A Life of John Buchan

URSULA BUCHAN

BLOOMSBURY PUBLISHING

LONDON · OXFORD · NEW YORK · NEW DELHI · SYDNEY

BLOOMSBURY PUBLISHING
Bloomsbury Publishing Plc
50 Bedford Square, London, WC1B 3DP, UK

BLOOMSBURY, BLOOMSBURY PUBLISHING and the Diana logo are trademarks of
Bloomsbury Publishing Plc

First published in Great Britain 2019
This edition published 2020

A catalogue record for this book is available from the British Library

Library of Congress Cataloguing-in-Publication data has been applied for

ISBN: HB: 978-1-4088-7081-5; PB: 978-1-4088-7082-2; eBook: 978-1-4088-7083-9

2 4 6 8 10 9 7 5 3 1

MIX
Paper from
responsible sources
FSC® C020471

Typeset by Newgen KnowledgeWorks Pvt. Ltd., Chennai, India
Printed and bound in Great Britain by CPI Group (UK) Ltd, Croydon CR0 4YY

To find out more about our authors and books visit www.bloomsbury.com
and sign up for our newsletters

To the happy memory of my mother, Barbara Buchan (1924–1969), who came from similar stock to John Buchan and possessed the qualities he valued the most.

Contents

Introduction

'Better than the book' was John Buchan's verdict when he first saw Alfred Hitchcock's film, *The 39 Steps*, in 1935. This was not simply an example of his famous courtesy and good nature. Rightly, he reckoned his novel of 1915 to be a modest accomplishment in the context of his many other achievements. After all, he was just about to take up his appointment as Governor-General of Canada, earned after a hard slog in the House of Commons, with the title of Lord Tweedsmuir. However, it is that film which, more than anything else, has kept the book and its author in the public eye ever since.

John Buchan's career as a writer, one of the best-selling of his day, would have been remarkable, even in someone who had done nothing else. He wrote more than a hundred books, including twenty-seven novels, six substantial biographies, a monumental twenty-four-volume contemporary account of the First World War, three works of political thought and a legal textbook. There were also dozens of poems and short stories, and about a thousand articles for newspapers and periodicals. As well as a writer, he was a scholar and an antiquarian and, at various times, a barrister, colonial administrator, journal editor, publisher, director of wartime propaganda, Member of Parliament and imperial proconsul. He had been a skilled and intrepid mountaineer in his youth and was always a dedicated fisherman and a prodigious walker. And he did all this while suffering from debilitating illness for most of his adult life.

In his private life, John Buchan had a gift for friendship, with a breadth of sympathy and a willingness to see another's point of view

that endeared him to people, while inhibiting his political career. As a result of his upbringing and education, he was at ease all his life with shepherds and ambassadors, coal miners and prime ministers. This ability to transcend boundaries, even in stratified Edwardian England, found expression in his happy marriage to an aristocratic Grosvenor, brought up amongst the grandeur of Moor Park. Thanks to that improbable match, this account of his life contains, at its heart, an enduring love story.

There were shortcomings and failures, of course. For one generally so modest, he never could quite let go of certain vanities. Like most essentially honest men, he could be disingenuous. He was loyal to a fault. His political judgement was sometimes wayward. He closed down on new literary ideas rather early in life. Although he did not worship success, he could be too tolerant of those who succeeded. He did not make it into the Cabinet. Spreading himself so widely, he never wrote the great novel of which he was (probably) capable. Grandfilial loyalty has not prevented me from confronting his flaws and reverses with an historian's unblinking eye.

I never knew him, but certain rather random material things have come down to me: a run of nine Morocco-bound books written by his sister, Anna, each with his bookplate, a stylised sunflower flanked by the initials 'J' and 'B'; a gold 'plaid pin' brooch, comprising a finely wrought sunflower, encircled by the motto 'Non inferiora secutus', which means 'not following inferior things'; a battered, japanned barrister's wig box with 'John Buchan Esqre.' in faded gold letters on the front; a silver-gilt rose bowl, inscribed to 'Their Excellencies the Governor General and the Lady Tweedsmuir from W. L. Mackenzie King Christmas 1938'; and a photograph of the Thirty-Second President of the United States, on which Franklin D. Roosevelt has written in his own hand, 'For Lord Tweedsmuir with the regards of his sincere friend.' The significance of this serendipitous collection of items can only be properly understood in the context of the story that has been unfolding for me, in fits and starts, all my life.

At home, his books were on the shelves and we heard family stories about him, although research for this book has inevitably been accompanied by the crump of exploding myths. The first real intimation I had of the extent of his fame occurred when my twin sister and I were about ten years old and went to play Bingo in our village

Reading Room. We were fascinated by the way the caller gave an epithet to every number, such as 'clickety-click, 66', and astonished when he called out 'all the steps, 39'. Until that moment, we had thought that a book by our grandfather was something essentially to do with *our* family. We had no idea that *The Thirty-Nine Steps* was famous enough to be a Bingo call.

However, I have long been aware that much of this fame derived from the Hitchcock film. Furthermore, I have lost count of the times that people have said to me that they enjoyed John Buchan's exhilarating adventure stories when young, but 'of course' they had not read him since. My response has been to urge them to try again, and also extend their reading beyond the thrillers, especially to his short stories and biographies, because they might be surprised by the underlying seriousness of purpose and by how intensely his writing resonates with universal, very grown-up concerns.

Returning to the fiction I had read when young and reading much that I had never broached before (the poetry, some of the biographies, and political thought), I discovered, as many have before me, that John Buchan was far more than a spinner of improbable but appealing yarns. He wrote some of the most lambent prose I have ever read, and he did so with an easy grace and elegance, a wit, an erudition, which resulted from lightly worn scholarship, a deep humanity and a life lived to the full. I discovered that he had much to say to me – not as a descendant, but as someone trying to navigate a responsible and cheerful course through life.

This book is not a work of literary criticism; if it were, it would be double the length. In any event, if you are like me, you may prefer the satisfaction of working out what you feel about his craft for yourself. In truth, I am the 'ordinary' reader of John Buchan; once there were millions of us and there are still a great many, despite expert critics bending down from a great height to warn us against him. So, rather than reveal too much of the plots, or dissect his style and hunt down his references, I have thought it most useful simply to set the books, especially those such as *Greenmantle* that have a complex political genesis, in the context of his life and times, making clear what may have become cloudy in the decades since they were written. The writing of this book has involved painful decisions over selection, as well as the expression of judgements that may be idiosyncratic and are certainly

personal. This much I can promise you: if you stay the course, you will have gone far beyond *The 39 Steps*.

In referring to John Buchan and his wife, I have exercised one of the few privileges that belong to consanguinity and called them respectively 'JB' and 'Susie': JB is what John Buchan was called by his family and friends, and is the nickname his descendants use, while 'Susie' is what he called her.

Childhood and Youth, 1875–1895

The countryside of upper Tweeddale had experienced a fierce storm, so that the snow was piled high in drifts on the morning of the second day of December 1874, but that did not prevent family and neighbours from crowding into the parlour of Broughton Green, a square-fronted, whitewashed farmhouse standing on the main Edinburgh to Carlisle road. They had come to witness the marriage of the Reverend John Buchan to Helen Masterton, one of two daughters of the house. Afterwards, they sat down to a generous farmhouse luncheon of hare soup, roast meats, creams and trifles, and stayed on to drink cups of tea and eat cake and shortbread before braving the snow once more.

The bride was seventeen years old, slight of build and no more than five feet tall, with a strong face, blue eyes and a magnificent mane of golden hair, which she put up for the first time that day. She wore a white satin dress and white kid shoes with rosettes on the toes and blue silk laces, in sharp contrast to her new husband's sober clerical black. The Reverend John Buchan was ten years her senior, of above average height, strongly built, with blue eyes, a ruddy complexion and mutton-chop whiskers.

The couple had met in church the Christmas before, after Helen came home from boarding school in Peebles, the county town; at the time the young man was deputising for the sick resident minister of the Free Church of Scotland in Broughton. The year 1874 had seen a religious revival in Britain, generated in part by the arrival of the charismatic American missionaries and hymn writers, Dwight Moody and Ira Sankey, and Helen had already heard tell of this eloquent,

committed – and handsome – young preacher, who held outdoor prayer meetings in lonely glens. He was a notable topic of conversation in the Masterton circle, not surprisingly, since this family had shown both piety and independence when they provided the land, and helped to build the Free Kirk in Broughton, at the time of the 'Disruption' in 1843.*

The Reverend John Buchan later told his wife that he had fallen in love at once with the back of her head; in her turn, she was stirred by his youth and his religious ardour: 'As a young man he was like a sword-blade, pure and keen. And yet he was such a boy with it all, or I never would have dared to marry him.'[1]

Mr Buchan was the eldest son of John Buchan, a 'Writer' (solicitor) in Peebles, and his wife, Violet Henderson, who was of local farming stock.** The boy had been a good classical scholar in his youth, and was always a voracious reader, in particular loving Sir Walter Scott and Robert Burns. He also knew by heart a great deal of poetry, old Scottish stories and all the Border ballads, published or not, which he had learned at his mother's knee. She also taught him the names of the Lowland wild flowers. When young, he had tramped the hills around Peebles, fishing in the 'waters' that ran into the River Tweed, and rioting with local boys. His was quite a wild youth, which may explain the comparative latitude he gave his children.

When the wedding party was over, the couple took the train from Broughton via Edinburgh to Perth, to the little stone-built manse in York Place, close to the Knox Free Kirk, to which he had been 'called' after his temporary sojourn in Broughton. Mrs Buchan was, not surprisingly, daunted by having to run a household on a tight income, as well as playing her expected part in the life of the kirk. Moreover, almost immediately, she became pregnant, giving birth to a son on 26 August 1875. He was called, simply and unimaginatively, John. She was only just eighteen years old. Later, she told her children that there were many times in that first year when she had been sorely tempted to run away home.

*Some 450 ministers (approximately one-third of the total) left the Church of Scotland over an issue of principle concerning patronage and founded the Free Church of Scotland, usually known as 'the Free Kirk'.
**She came from Whim, near Lamancha in Peeblesshire.

It is possible that the Buchans' move from Perth to Pathhead on the Fife coast less than two years later was the result of a friendship that Mr Buchan had forged in his theological college days with Miss Helen Chalmers, the elderly daughter of the mighty Dr Thomas Chalmers, one of the leaders of the 'Disruption'. The two worked together amongst the poor of south Edinburgh and, when the Free Kirk in Pathhead (in which the Chalmers family had an interest) lost its minister, it is likely that Miss Chalmers recommended her young protégé to the Elders.

Whatever the truth of that, in November 1875, the Buchans found themselves 'flitting', with their baby son, to a manse in Smeaton Road, a quarter-mile up a steep hill from the harbour at Kirkcaldy and close to Nairn and Co's linoleum factory. Mrs Buchan's heart sank at the first sight of the manse and its environs:

> November is a poor time to go to a new place and Kirkcaldy certainly looked a most unattractive part of the world when we arrived on a cold wet afternoon. The 'queer-like smell' from the linoleum factories, the sea drearily grey and strange to my inland eyes, the drive through the narrow streets and up the steep 'Path', past great factories and mean houses, until we reached the road, knee-deep in mud, where the manse stood, combined to press me to the earth.[2]

In the 1870s, Pathhead was a large village, still more or less distinct from the town of Kirkcaldy to the south-west and the village of Dysart to the north-east. The area had long been a centre of textile-making, salt-panning and coal-mining, the products of which were trundled down to the ports for export abroad or for transport up and down the coast. The coming of the railway in 1847 had accelerated industrialisation and, in particular, the manufacture of linoleum. The square, stone-built manse stood in a big garden but, behind it, nearer the sea, was the coastal railway and Nairn's colossal factory, while, in front, across a very muddy by-road, there was a coal-pit, a rope-walk and a bleaching-works.

In fact, for all the shortcomings of locality, the manse itself suited the expanding family well. A number of babies were born there: Anna in 1877, William in 1880, (James) Walter in 1883 and Violet in 1888.

The household also included a young nursemaid called Helen Robertson (known as Ellie Robbie), who had accompanied the Buchans from Perth, as well as a cook called Marget from the Borders, but Mrs Buchan took pride in being able to keep her own house spotless. In particular, she enjoyed the annual spring cleaning, so necessary in towns where smuts from coal fires and industrial processes dulled the polish of furniture, smeared the windows and darkened the carpets and curtains. The house was surrounded by a flower and kitchen garden, tended by Mr Buchan, where the children all had their separate garden plots. The back of the house looked across the town below to the Firth of Forth, with a distant prospect of Edinburgh and the Pentlands and a view of the Inchkeith Lighthouse in the Firth.

When 'JB' was four or five years old, he was badly injured in an accident. He was travelling in a carriage, when he leant out to look at bluebells and the door gave way. The back wheel passed over the side of his head and broke his skull. In a panic, Mrs Buchan ran into the nearest cottage and started opening drawers to find something to bind the wound.* Mercifully, their doctor happened to be passing in a dogcart, and escorted them home and stayed all night. He held out little hope that the boy would survive or, if he did, would not be brain damaged. JB was operated on to relieve pressure on the brain and, when finally he regained consciousness, his mother asked him the name of their butcher, a particular favourite of his. When he gave the name at once, she wept with relief.

For much of a year, he lay in bed, not allowed to try to read or exert himself; when finally he was allowed up, he had to learn how to walk again. He went about with an enormous bandage on his head and one neighbour memorably remarked: 'It seems almost a pity he pulled through. I'm afraid he will never be anything but an object.'³ The only lasting sign of this accident was a prominent bump on the left side of his forehead, which very slightly dragged down his left eyelid.

Both Sir Walter Scott and Robert Louis Stevenson spent time as small children in bed or as invalids. Such an enforced state of idleness encourages the development of both patience and imagination in sensitive children.

*More than fifty years later, JB met a man in the west of Canada who remembered seeing him being carried down Thornton Road in Pathhead after the accident.

Once up and about again, JB's circumstances fostered those beginnings. The presence of so many different industrial activities within even a small child's walking distance could not but engender a sense of adventure and wonder. Smeaton Road may now be a post-industrial wasteland but, in 1880, it hummed continuously with life and noise: the clanking of the pithead wheel, the factory sirens and the comings and goings of workers. The children watched women twisting rope in the rope-walk and they were – astonishingly – tolerated by the miners, who would place them in trolleys underground and pull them about. They played in disused quarries and the wooded 'dens' or glens of the burns running down to the sea. When a little older, they discovered the beach below the ruined Ravenscraig Castle, famous for Scott's ballad of *Rosabelle*, where the oystercatchers poked about in the shallows, their piping mingling with the wash of the tide and the cries of the seagulls. Beyond was the harbour at Dysart, with a harbourmaster's house slant on, and a ship-building yard, and carts rumbling down the narrow wynds. Here sailors strolled about, and occasionally conducted the children around their ships, and told them colourful tales of foreign lands.

Inland, there were the Dunnikier woods, knotty with the roots of beech and oak, with hidden ponds, where they skated in winter, bluebells flowering in spring, and, just beyond, the rolling landscape of agricultural Fife. These places JB peopled with characters and incidents from the Bible and *The Pilgrim's Progress*. A pond he named the 'Slough of Despond' and there was more than one 'Hill Difficulty'.

The characters of the Buchan children were formed both by devoted, serious-minded parents and their environment, at a time when children were given what seems to us unimaginable freedom but where they had to create their own amusements. They had the time and encouragement to make deep friendships, undistracted and untroubled by what was happening in the outside world. They were taught to learn poetry and prose off by heart and, all his life, JB would depend heavily on the results of this early training – when writing letters, speeches and even his prose works. It's hard to imagine how he could have done as much as he did without being able to dip confidently into so capacious and reliable a memory. It rarely failed him.

As children, the young Buchans were markedly adventurous and full of pranks. JB belonged to a gang of boys, who fought with the children of local industrialists, including the enormous and fiercesome Robert

Key Hutchison, whom he later met in the Great War, by which time he was a Major-General but had somehow become ordinary-sized and very amiable.[*] The second Buchan boy, Willie, was a particularly ferocious user of his fists, since he had a quick temper, although at home he was gentle and forgiving. But it was JB who led them into the most mischief – for example, setting light to tar barrels and rolling them into a disused quarry. After a particularly egregious misdemeanour, the local policeman, who was an Elder of the Free Church, remarked that 'I'll hae to jail thae bairns and leave the kirk'.[4]

In such a free environment, there were plenty of opportunities for accidents and hurts, but the Buchan parents seem to have taken the 'Better to break a child's head than his spirit'. approach. Considering the anxiety caused by JB's accident, and his capacity for mischief, this seems little short of heroic.

The Pathhead Free Kirk had opened just a year after the Disruption, paid for by the congregation of factory workers, miners, retired seafarers, small manufacturers and independent-minded bonnet lairds. It was a large, ugly building, of unforgiving whinstone, standing a quarter-mile away from the manse down the hill towards the sea on the west side of St Clair Street. From the age of five, the children were expected to attend two services on Sunday, one in the morning and one in the afternoon, as well as a Sabbath School. Kindly parishioners eased the tedium of these services by slipping them toffees, but it's plain that, at least for part of the time, the children listened. JB could not have quoted the King James Bible, especially the Old Testament, so extensively in adult life if he had not.

At least the Sabbath meant bacon and eggs, rather than porridge, for breakfast, and sugar biscuits and cake for tea. Since the children were not allowed to indulge in any secular activities on Sundays, what time they had at home they spent acting out the more rumbustious of the Old Testament stories. They also read pious tracts and bloodthirsty accounts of martyrs. Most especially they read *The Pilgrim's Progress*.

This work, the greatest of all Christian allegories in English, was written when John Bunyan, a Puritan 'Independent', was imprisoned for unlicensed preaching, after the restoration of the monarchy in 1660. In the book, he describes the journey of one Christian to the Celestial City, through many difficulties – the Slough of Despond, a sojourn in

[*] JB's *The Free Fishers* is dedicated to Hutchison's brother, John.

Doubting Castle and the false delights of Vanity Fair – meeting divers people on the way who help or hinder him, such as Mr Standfast, Mr Valiant-for-Truth, Giant Despair and Mr Worldly Wiseman. The influence of this powerful narrative can be seen most obviously in JB's novel of 1919, *Mr Standfast*, when Richard Hannay and his confederates use it as a communication code, but the central idea of a hero setting out on a quest in an unfriendly, sometimes frightening, often desolate landscape, and needing friends to help him defeat the forces of evil, surfaces in all the spy stories, including *The Thirty-Nine Steps*.

As in his writing, so in his life. In 1939 he wrote:

> My delight in it [*The Pilgrim's Progress*] came partly from the rhythms of its prose … there are passages, such as the death of Mr. Valiant-for-Truth, which all my life have made music in my ear. But its spell was largely due to its plain narrative, its picture of life as a pilgrimage over hill and dale, where surprising adventures lurked by the wayside, a hard road with now and then long views to cheer the traveller and a great brightness at the end of it.[5]

The children were brought up to have a consciousness of sin, of the attractive wiles of the Devil, and of being always under the eye of the Almighty. But, thanks to the influence of Robert Burns (and unlike Robert Louis Stevenson) they did not grow up terrified of Hell and the Devil. They took seriously the consequences of the religion they were taught, and accepted that there were rather more duties than privileges to being children of the manse. There was the prospect of the Celestial City at the end of life but, in the meantime, there was a burden of obligations to their parents, to each other and to the congregation their parents served. JB's first published work, 'By a Scholar', appeared in a church magazine when he was only eleven years old. It is entitled 'New Year's Hymn 1887' and the first verse runs:

> To Thee, Our God and Friend,
> We raise our hymn today;
> Oh, guard and guide us from above
> Along life's troubled way.*

* It can be sung to the tune of 'Blessed are the pure in heart'.

At that age, JB saw the time spent in school in the week as an unwelcome interruption from home and outdoor play. The 'board school' that he attended after a short-lived stay at a dame school, where he learned to knit but was expelled for knocking a pot of soup off the fire, was just a few steps away at the end of Smeaton Road. At the age of eleven, he went to the Burgh School, later renamed Kirkcaldy High School, in the centre of the town, walking the three miles each way every day. Despite his protestations that he wasn't a good scholar, aged thirteen, he won the top prize in his class.[6]

He read avidly, including most of the works of Sir Walter Scott, so he later said, between the ages of eight and ten. It's unlikely he was quite as young as that, but he certainly grew up knowing them extremely well. They helped him develop stamina and patience, as well as teaching him how to read both fast and retentively, while embedding in his memory the rhythms of Lowland speech. He and his sister Anna, in particular, had a strong sense of what it meant to be Scots, with a ferocious pride in their country's bloody history, and an intense pity for anyone with the misfortune to be English. Reading Scott did little to diminish that.

The Buchans' orderly and disciplined life was tempered and enriched each summer when they took the train to the 'sunny Borders', the land of their forefathers, going first to Peebles to visit Mr Buchan's bachelor brother, William, and his unmarried sisters, Jane (Jean) and Kate, at the house with the red door on the corner of the High Street, known as Bank House. Their father, who had been born near Stirling, the son of an innkeeper and grocer,* had striven hard to escape his background, accepting a job in Peebles as a lawyer's clerk in 1835, and working his way up to become a respected 'Writer' and bank agent for the Commercial Bank from 1867, as well as Honorary Sheriff Substitute for Peeblesshire, and the owner of a small estate in Midlothian.** William Buchan joined him in the firm in 1876, and in 1880 was appointed town clerk and procurator fiscal. They moved to Bank House, which had both office and residential accommodation, in 1881. Old John Buchan died two years later, much borne down by having to fight, unsuccessfully, a

*His mother was Catherine Stewart, or Stuart, of Thornhill, Perthshire.
**Stellknowe, near Penicuik.

lawsuit, after the spectacular crash of the City of Glasgow Bank in 1878, and sell his property.*

From Peebles, it was a short train ride to Broughton, situated at the point where the River Tweed turns east, to stay with Mrs Buchan's parents and her sister, Agnes, at Broughton Green. Mrs Masterton, who was always said to be a cousin of William Ewart Gladstone and had apparently the same hooked nose and bright, commanding eyes, was fierce and stately; a woman who rarely praised, she was nevertheless both hospitable and tolerant of children, a favoured saying of hers being 'Never daunton youth'. The children's grandfather, who was rather frail and asthmatic in later life, was a man of consequence and means, much respected in the countryside around. The Mastertons had been sheep farmers in the district for at least two generations and Helen's father, as well as her brothers, John, James and the much younger Eben, were as hefted to the hills as their sheep.

If Pathhead was formative in binding JB to woods and sea, Broughton taught him to love even more the green, rounded hills and the sparkling waters of upper Tweeddale, not only for its quiet beauty and solitude, but for its clashing, stirring past. The countryside was full of the echoes from legend: Merlin, the sixth-century political leader (rather than the wizard), supposedly had been killed at Drumelzier near Broughton, and buried under a thorn tree at the mouth of the Powsail Burn, while the roughly contemporary Arthur may have fought a battle around Cademuir Hill, outside Peebles. In the late Middle Ages, the quarrelsome reiver clans of Tweedie and Veitch had fought and plundered. The Jacobite army had marched past the door of Broughton Green on the way from Edinburgh to Derby in 1745. For centuries, almost down to JB's day, hardy, hard-fighting men had driven cattle along the drove road from Falkirk to the English markets over the bridge at Peebles and across the lonely hills.

When very young, the children messed around in the farmyard, rode ponies, and learned to fish for small trout in the burns that run into the River Tweed. A favourite moorland playground, Broughton Hope ('hope' means a side valley), was reached by walking past the site of the House of Broughton (which had belonged to Sir John Murray, the

*The lawsuit was the result of a trusteeship he had taken on for a Peebles widow's estate, which had included shares in the bank.

most famous turncoat of the Jacobite rebellion) where a burn trickles down and the ground rises up to above 1,000 feet, with Trahenna Hill to the right and Hammer Head beyond it. Now, as then, the turf (or 'bent') is green and sheep-cropped, there is a patchwork of squares of burned heather, called 'moorburn', and distant prospects of rolling, rounded hills.

It is small wonder that the Buchan children little relished their return to Pathhead each September. When JB arrived at Oxford University in the autumn of 1895 he bought for Anna a specially bound Commonplace Book, in which he wrote a poem for her about their holidays:

> We were two children, you and I,
> Unkempt, unwatched, far-wandering, shy,
> Trudging from morn with easy load,
> While Faery lay adown the road.[7]

Their mother objected to the use of the word 'unkempt', saying she was surprised that the next word was not 'unwashed.'

As a result of these summer holidays, JB felt keenly all his life that, like his hero, Sir Walter Scott, 'he had that kindest bequest of the good fairies at his cradle, a tradition, bone of his bone, of ancient pastoral, of a free life lived among clear waters and green hills as in the innocency of the world'.[8]

In November 1888, Mr Buchan was 'called' to the John Knox Free Church in the Gorbals, on the south bank of the River Clyde, in Glasgow. His wife was now very sad to leave Pathhead, for the Kirk had flourished there, and they had seen 'a season of rich spiritual harvest'.[9]

The John Knox Kirk in Glasgow presented an altogether different challenge. It was a cavernous city church, dating from the Disruption, set in an urban slum, where recent waves of immigration, especially of Jews and Irish Catholics, had depleted the potential congregation, many of whom were now living in other parts of the city. The move for the family from Fife meant more than twice as much income – a stipend of £410 – but there was no manse, so the Buchans had to rent a house in Queen Mary Avenue in Crosshill, a rather more genteel location near the Queen's Park, about two miles away from the church. Since they set great store by visiting members of the congregation, this

often meant long walks or bus rides for the minister or his wife and daughter.

Florence Villa was a double-fronted, comfortable stone house, about the same size as the manse in Pathhead. It had certain obvious attractions for the Buchan children, with their highly developed interest in their country's past, since it was built close to the site of the Battle of Langside, where Mary, Queen of Scots, lost both her liberty and any hope of winning the crown of Scotland. They dug up a small cannonball in the garden, which they not unnaturally believed had been fired during that battle.

The garden[10] behind the house, flanked by high brick walls, was large enough to contain two tall elms, a 'thin grove' of scrubby ash and lime trees, and an untrimmed privet hedge, as well as flower borders filled with old-fashioned flowers – pinks, lilies, honeysuckle and roses (including the white 'Prince Charlie' rose, which plays a part in an early novel, *A Lost Lady of Old Years*). The charm of this garden lay in its dappled shade and well-kept lawn – since the flowers were soon flecked with soot – as well as its birdlife, which brought something of the country into the town. Flycatchers nested in the ivy, there were linnets, thrushes and starlings 'as thick as flies' on the grass and cuckoos called nearby.

JB was sent to Hutchesons' Grammar School, a half-hour walk away, Willie joining him there from Queen's Park Academy in due time, while Anna attended Hutchesons' Girls' Grammar School close by. Hutchesons' Grammar School was founded in 1641 for indigent boys and, although not as famous as Glasgow Academy or Glasgow High School, was well-regarded and, crucially, socially quite diverse. The buildings were in Crown Street in the Gorbals, two miles from Queen Mary Avenue. A prospectus dating from JB's day declared that Hutchesons' was 'essentially a Public School, intended to reproduce in its best form, the old Grammar School, where in former days a superior education was to be had at a moderate fee, where the children of country gentlemen, professional men, tradesmen and artisans, were educated side by side, and prepared either for University or commercial life'.[11] The curriculum consisted of English grammar and composition, History, Geography, Religious Knowledge, various forms of Mathematics, Drawing, Latin, French, Singing, Drill and Fencing.

Greek and Rifle Drill were added for second-year students. In JB's first year the fees were one guinea a quarter.

The lack of a conventional public-school boarding education, such as the majority of his contemporaries at Oxford University enjoyed, may well have been an advantage to JB. Because he stayed at home, he had the edge over his richer confrères in three respects: deep knowledge of his city environment and the boys it produced; close and continuing proximity to his lively, intelligent and warmly affectionate family; and no vitiating, unhelpful sense of entitlement. Because of all that, he does not seem to have lacked the qualities that team games – such as were almost a cult in late Victorian boarding schools – were supposed to engender, namely loyalty, subordination of self to a greater cause, self-control, determination, courage and fortitude.

He had plenty of time for books. His reading at this age ranged from the classic novelists, in particular Scott, Thackeray and Dickens, to playwrights, especially Shakespeare, and essayists such as Bacon and Hazlitt, Lamb and Addison. He read plenty of poetry, especially Milton and Wordsworth. He particularly enjoyed Matthew Arnold and learnt most of the oeuvre by heart. He even began to wrestle with Robert Browning. He maintained later that he did not have any desire to excel and 'sat far down' in his classes, and that his reading was 'only half-conscious and quite uncritical'.[12] It is hard to know how seriously to take this, especially since he won an open scholarship a year after he arrived, and the fees were waived. In his final year, he was taught by a remarkable teacher, James Caddell, who fired his enthusiasm for Latin and Greek, especially the former, and prepared him for the University of Glasgow – so well that he won a John Clark bursary of £30 a year.* In 1920, JB recalled Caddell as one of the shaping influences of his life:

> ... he had a large and generous understanding of classical literature, and there was something Roman in him which made the Latin culture a special favourite. The classics were to him the 'humanities' in the broadest sense, and he managed to indoctrinate his pupils

* The two men kept up their friendship by correspondence in later life, JB sending James Caddell a copy of his *Poems Scots and English* in 1917.

CHILDHOOD AND YOUTH, 1875–1895

with their intrinsic greatness and their profound significance for the modern world.[13]

The boy's walks to school took him into the heart of the Gorbals. In the 1880s and 1890s it was busy, noisy, grimy and, in places, absolutely poverty-stricken. As a result of the Irish Potato Famine of the late 1840s, people had fled Ireland for the west of Scotland, which had the virtue to them of already sustaining a substantial Catholic population. They settled in Glasgow districts such as the Gorbals, which were already overcrowded; the population was ever at risk of epidemics and sometimes even starvation. The extreme tenderness with which JB describes his band of six ragged children, who form themselves into the 'Gorbals Diehards' in *Huntingtower* (published in 1922), stems from the knowledge he had acquired of the plight of orphaned or just abandoned street children, who he encountered daily on his way to school in the 1890s. Some of the street children joined the Sunday School class that JB taught when a teenager, although possibly less for religious sustenance than for warmth in winter and the annual summer outing.

Even in a church denomination that valued teaching very highly, Mr Buchan was an exceptional preacher. One of his flock remarked: 'We cannot readily forget the eloquence, the fervour, the poetic fancy with which he presented his choice themes, expounded and enforced by all his fertility of genius and warmth of heart. But there was a deeper satisfaction in the very earnestness of his preaching. One can recollect an eager appeal, as if he would fain bear us all in his arms to the feet of Jesus.'[14] He had 'a voice of uncommon melody and a poetic style'[15] and 'looked you straight in the face'[16] rather than at his few notes.

To gain a clear picture of what Mr Buchan was like, and the influence he had on his children, especially his eldest son, it is important to look beyond the stereotype of a nineteenth-century Free Church minister and not to be misled by JB's references in his reminiscences, *Memory Hold-the-Door*, to the household being 'ruled by the old Calvinistic discipline'[17] and his father's theological conservatism. The account given by both JB and his sister Anna is of a notably happy childhood, with loving parents who allowed them an almost anarchic freedom. If JB was conscious of the omnipotent God's interest in him, he was unworried by the 'Calvinistic Devil' who he regarded 'as a rather humorous and

jovial figure'.[18] As Anna put it, 'Calvinism sat lightly on our shoulders. I think Father had too keen a sense of humour to be the stern Victorian parent.'[19]

The word 'Calvinistic' has come to be equated with joylessness, dreary Sabbath observance, harsh internal Church discipline, blind belief in the inerrancy of Scripture, intolerance and belief in 'double predestination' – that from the beginning of time, God has decreed that certain people (the 'elect') would be saved and all the rest would be damned. However, it seems that Mr Buchan, in the way he lived, conveyed a powerful sense of God's love and mercy. He was cheerful, devoted to simple pleasures, happy, and drove himself relentlessly in the care of his congregation. No children can have grown up with a clearer sense of duty to each other, their parents and to other people, nor a better understanding of the importance of making something of their lives.

Furthermore, Mr Buchan's theology, on examination, may not have been quite as unswervingly rigid as the stereotype would suggest. While there is much firm orthodoxy, there are also some tantalising suggestions of something softer, in a valedictory sermon he preached when leaving Pathhead in 1888[20] and in a privately printed collection of his writings and sermons.[21] His tireless pastoral concern for his congregation is apparent throughout. In his family life, he was no killjoy, and this is reflected in his writing and preaching of gladness in 'the glorious excellence of the message'. There is no reference to the application of internal Church discipline (harsh or otherwise). His reverence for Scripture is not unthinking; he is plainly aware of the liberal, especially German, strand of analysis and interpretation and is prepared to engage with it. In his Pathhead valedictory, he sought to explain that it was not due to 'natural harshness or desire to say unpleasant things' but because 'knowing the terrors of the Lord, I have spoken much of hell and the retribution that will overtake the careless'. In saying so, he demonstrated an ambiguity in relation to predestination. It would take considerable theological sophistication, even sophistry, to argue that retributive punishment could be both unavoidably predetermined by God and avoidable by taking care.

Although he could be explicit about the doctrine of election, it seems that he could not let go of the thought that the autonomous exercise of free will might play a part in salvation. He wrote of God rendering

'unto every man according to his deeds' (rather than 'according to God's predetermined decree').[22] He preached against letting 'the opportunity slip of saving the soul'.[23] How could that be if the soul was damned from the beginning of time? In a sermon entitled 'The Teaching of Paul – the Plan of Salvation', he admitted that he was unable to reconcile predestination and free will, 'they must be left where scripture leaves them – side by side'. However, intriguingly, he found in St Paul's teaching 'bright glimpses of a universality [i.e. that all might be saved] in the plan of salvation'.[24] JB much later regretted that his father had not lived to read the great Protestant theologian, Karl Barth, for he thought their views had much in common. While Barth's approach to Scripture may have been closer to Mr Buchan's than that of the German liberals, he had proposed a doctrine of predestination that could be characterised as 'universalist'. If JB believed that his father would agree, that would cast some light on the latter's theological openness.

JB as an adult was not sectarian, unlike many members of the Free Kirk. As in politics, he was always sympathetic to the validity of other sincerely held views. Nor was he a Bible literalist. In *The Kirk in Scotland* of 1930 he criticised the view of religion as something static, 'the forms of which have been established once and for all by a divine decree which admits of no fresh interpretation'.[25] He liked to quote the fourth-century Roman statesman, Symmachus, who believed that there was no single road to so great a mystery. He was both an ordained Elder in the Church of Scotland and an Anglican churchwarden. He attacked the cruelty of seventeenth-century Presbyterian church discipline and the dangers of antinomianism (by which those who believe themselves 'elect' feel free from any moral law) – most vividly, in *Witch Wood* – but his target was plainly contemporary as well as historical.

It would be mistaken to conclude that all this amounted to outright rejection of Calvinism. Unfortunately, it is difficult to extract from JB's many speeches and writings in which he touched on religion a consistent, systematic account of his theology. It is better, and easier, to look at how he lived. As the story unfolds, we shall see that, far from rejecting all of that for which his father stood, in a number of ways he exemplified and developed it in a manner that is distinctively (though far from uniquely) Calvinist. As JB himself said of his time at Oxford, 'the Calvinism of my boyhood was broadened, mellowed, and also confirmed'.[26] That word 'confirmed' is the key.

Following his father's example, JB's Christian faith was the foundation of his understanding of the cosmos and the motivation for his way of living. In a talk he gave to the Selkirk Public Service Association in December 1915, he described religion as meaning 'nothing less than the government of life according to spiritual discipline' – a view with which his father would have wholeheartedly agreed; both men lived their lives accordingly. In the same talk, JB characterised 'carelessness' (a favourite theme of his father's) as irreligion. Both had a lifelong wonder and delight in the natural world, which they understood to disclose God's glory. Both had a sense of the limitless sovereignty of God, resulting in gratitude, humility and obligation, but also an unmediated relationship with Him (the characteristic of all Protestantism). Both believed that each unforgiving minute must be filled with sixty seconds' worth of distance run, and that happiness is not to be sought, but might be hoped for as the result of achievement, following self-denial (the earthly road, as for Christian in *The Pilgrim's Progress*, being narrow and hard). And both father and son shared the apprehension of a cosmic battle between Good and Evil being played out in the world and the urgency with which that must be recognised and engaged. JB's life cannot properly be understood without grasping this.

As one Scottish minister of religion succinctly put it: 'Presbyterian Calvinism set great store on justification by grace through faith, but Old Testament legalism sometimes loomed large in practice – most obviously in Sabbatarianism.'[27] Certainly, as he grew to manhood, JB found Sabbath restrictions on his reading more irksome. In *Scholar Gipsies* he wrote of his grandfather, John Masterton, to whom this collection of essays is dedicated: 'One man of good character but no pretensions to piety made the writer's boyhood a burden by forbidding the reading of any secular book on the Saturday, Sabbath, or Monday. "For," said he, "though there's naething in the Bible about it, I hold that the Lord's day shall aye get plenty of room to steer in."'[28]

As a result of their ministry, JB's parents had a large and diverse acquaintanceship and were not above giving sedate soirées, where they could embarrass their children by their catholic taste in people. The children learned how to put a variety of people at their ease, finding

common ground and never showing that they were bored. Most importantly, they learned to look for the good in the most unpromising material and, by looking, often found it.

They made their own friends mainly amongst the children of Presbyterian ministers, who understood completely what it was to be born in the shadow of the pulpit. Charles Dick, JB's closest boyhood friend, was the son and grandson of Free Kirk ministers. Other friends, David Young Cameron and his sister, Katie, were the children of a Church of Scotland minister. The Camerons were both artists, and David later introduced JB to John Lane, who had founded the publishing company, The Bodley Head, as well as the voguish, short-lived periodical, *The Yellow Book*, which featured stories by well-known writers such as Edmund Gosse and Henry James, and drawings by Aubrey Beardsley, its first editor. Katie Cameron seems not to have cared much for JB as a teenager, finding him too short in stature, too little prepared to fall in with social events, too little impressed by Glasgow, too quick to give offence (which the gentle Willie Buchan had then to smooth over), too obviously ambitious and single-minded, and too little inclined, as was Anna also, to fall in love with anybody.[29]

He was certainly single-minded. In the school 'session', 1891–2, he took the Leaving Certificate Examination and passed with Honours in Higher English, Higher Latin, Higher Mathematics and Lower Greek. In October that year, aged seventeen, he enrolled at the University of Glasgow to study the general MA course, while living at home, as did most Scottish students at the time. The course consisted of seven subjects: Latin (called Humanity), Greek, History, Mathematics, Logic, Natural Philosophy (what we would call Natural Sciences) and Moral Philosophy.

The session ran from October to April,* and every morning I had to walk four miles to the eight o'clock class through every variety of the winter weather with which Glasgow fortifies her children. My road lay through the south side of the city, across the Clyde, and so to the slopes of Gilmorehill. Most of that road is as ugly as anything

*The reason why the 'session' only lasted half the year was because many students had to work for the rest of the time to earn the tuition fees.

you can find in Scotland, but to me in the retrospect it was all a changing panorama of romance. There was the weather – fog like soup, drenching rains, winds that swirled down the cavernous streets, mornings that dawned bright and clear over snow. There was the sight of humanity going to work and the signs of awakening industry. There was the bridge with the river starred with strange lights, the lit shipping at the Broomielaw, and odours which even at their worst spoke of the sea ... And at the end there were the gaunt walls of the college often seen in the glow of a West Highland sunrise.[30]

Those gaunt walls had been designed by George Gilbert Scott in the mature Gothic Revival style, and enfolded a double quadrangle, between which were cloisters, entered through the base of an enormously tall tower, topped off with pinnacles. The university had moved there from the kindlier, sootier and more confining Old College in the High Street in 1870. JB thought the buildings like 'the battlements of a celestial city', which might have pleased Scott had he known. Gilmorehill was close to Kelvingrove Park, designed by Joseph Paxton in the 1850s, which led down to the River Kelvin. The students were thus away from the crowded, dirty streets of central Glasgow and breathing fresh air.

When JB arrived, the reputation of the university was flying high, since Lord Kelvin (the great scientist of thermodynamics, after whom the Kelvin measure of temperature is named) was still, after many years, the Professor of Natural Philosophy, while other luminaries included Edward Caird, Professor of Moral Philosophy, who was succeeded by the even more eminent, and very lovable, Henry Jones in 1894. A. C. Bradley, the Shakespearean critic, was Regius Professor of English. From JB's point of view, the most important Chair turned out to be that of Greek, which was held by Gilbert Murray, the outstanding Oxford-educated classicist who had been elevated to the post in 1889 when only twenty-three, and who was to make such an impression on the young man – and he on Murray.

At the end of a lecture to his Middle Greek class, JB went up to ask what Murray considered a most unexpected question. The lad explained that he was editing Sir Francis Bacon's essays for a London publisher and wanted to know why Bacon quoted a phrase from the Greek philosopher Democritus in Latin and where would he have found the

translation? Murray thought the quotation was from Cicero, 'but such a pupil in the Middle Class was obviously a treasure, and we formed a friendship which lasted through life'.[31]

JB seems not to have been a 'figure' at Glasgow, indeed was practically anonymous in the first year. Although his friends from Hutchesons' who had gone on to university with him – Joe Menzies, Charlie Dick and John Edgar, in particular – thought him a 'genius' and told anyone who would listen, he kept his talents pretty well wrapped up, working in solitude on his studies, as well as writing essays, poetry, short stories and even a novel in his spare time.

A shadow fell over the family while JB was still in his first year at the University. His much-loved five-year-old youngest sister, Violet, was ill; indeed at the end of the session, in April 1893, he had to postpone a promised visit from Charlie Dick because of her sickness. 'She is much weaker since we came here [Peebles] and if we cannot get her strength up soon she will not recover.'[32]

Violet was a most singular little girl, who seems to have had a highly precocious moral sense. Her father wrote of her: 'To tell her that she was grieving Jesus was sure ere long to bring a penitent confession from her lips. There was in her character a deep substratum of serious thought.'[33] She also shared with her father a great interest in flowers, both wild and garden, forming thereby a close bond with him. Five years younger than Walter, she was very much the pet of the family, and a welcome companion in such a masculine environment for her older sister Anna.

When she was about three, Violet began to suffer from periodic and sometimes painful gastric troubles, which caused her to lose weight. A family photograph taken, probably, in the summer of 1892 shows Violet sitting on her mother's knee, looking like a wraith in comparison to her heartily healthy brothers and sister. But the family were not seriously alarmed until early the following year, when she began to decline quite fast. They took her to Broughton in April in the hope that the country air would do her good. 'In the furnace of affliction she was chosen. Her self-will was gone and a beautiful patience took its place,' wrote her father.[34] It is hard not to recoil at the idea of a little girl discussing her imminent demise with her family, but infant death was an ever-present fact of late Victorian life and the Buchan family were, of course, firm believers in the Hereafter.

She died on 16 June, apparently of tuberculosis of the mesenteric glands in the stomach. Who knows whether even the expensive Edinburgh doctor who was summoned to her bedside diagnosed her illness correctly? Whatever it was, he had no answer for it. She was buried in Broughton churchyard, next to her grandfather, John Masterton. Mr Buchan put together a privately published memorial volume, *A Violet Wreath*, which included poems that he had written about her, in both English and Scots. It is one long howl of pain for the family's loss – impossible to read without emotion – but at the same time there is a resigned submission to the will of God. 'The Lord has a right to the best, and we do not grudge her to Him and happiness,'[35] celestial happiness being of a completely different order from the earthly variety. JB was shaken out of his profound teenage self-absorption and wrote to Charlie Dick three weeks later: 'I must apologise for not writing to you sooner. My only excuse is that I hadn't the heart, I was so troubled at my sister's death. I had no idea a death in a family was such a painful thing ...'[36]

He wrote a lot to Dick that summer, sometimes in the arch and mannered style common amongst well-read, precocious teenagers in every age. In September, for example, he was (reluctantly) on holiday with his family on the Isle of Arran and Dick received this:

> I am coming up, perchance next week for more books, when, if the gods be propitious, I may see thy face once more. Yet, (as is likely) if I come not back any more at all, but leave my bones (os, ossis, a bone) on this desolate island, the following is my will (testamentum, saith Cicero)...[37]

Charlie Dick seems to have been JB's closest friend at Glasgow, their interests coinciding and their personalities complementary. (Katie Cameron called Charlie Dick 'vague'.) In the vacations, they bicycled to see each other in Tweeddale, since Dick's grandfather was a minister in Coldstream, and they walked long distances in Galloway. When in South Africa in 1902, JB wrote to Dick saying how 'deplorably sentimental' he was about 'those old madcap days of ours'.[38] Other friends at Glasgow included H. N. Brailsford, to whom Professor Murray gave a revolver when Brailsford said he wanted to fight for

the Greeks in the Greco-Turkish war of 1897, and who became a well-known left-wing journalist. There was also Robert (Bertie) Horne, later Chancellor of the Exchequer, as well as Alexander MacCallum Scott MP, who has left us a pen-portrait of JB at this time:

> He seemed to step into an inheritance. Everything he put his hand to prospered and people accepted him on every hand. He had an air of simple and convincing assurance. He believed in himself, not offensively, but with a quiet reserve. His whole manner inspired trust and confidence and respect. He could depend on himself and others felt that they could depend on him too. His judgment was sane and was therefore listened to. The fact was that he made himself indispensable to people. They knew him for a man who could order and systematise.[39]

Two days before Violet died, JB had finished editing Sir Francis Bacon's essays and apothegms that he had mentioned to Gilbert Murray in the first session. Almost certainly, he was introduced to Walter Scott (a publisher with both Newcastle and London offices) by D. Y. Cameron, who had illustrated several books for him, since there is no reason otherwise why the former should have picked out an unknown University of Glasgow student to edit one of the volumes of his popular series of classics, The Scott Library. But it shows a great deal of perspicacity on Scott's part.

The first paragraph of the Introduction, which contained biographical and critical notes, shows both JB's sure historical sense and his ability to tell a story:

> The two decades between 1550 and 1570 are marked, perhaps, more than any other in the history of our literature by the birth of famous men. In the Devonshire farmhouse Raleigh saw the light; Shakespeare in the home of the wool merchant of Stratford; Sidney in the manor-house of Penshurst; Spenser under the shadow of the Tower of London. Mary was dead, and her sister Elizabeth had mounted the throne; and by her wise and generous policy had given great hopes to her people of a peaceful and prosperous reign. The times seemed fit for the birth of a man who should be great alike in the worlds of politics and letters.[40]

For his own amusement, JB wrote poetry. There are, extant, a number of unpublished early poems dating from his late teens: they are, as can be expected, derivative, consciously archaic, conveying conventional sentiments. They are pale versions of his father's 'musings'. They are concerned with nature, the seasons, landscape, death, and some are classically inspired.

One example will suffice:

When the fairy-footed Spring,
Rising like a maiden,
Cometh swift on airy wing,
With her bounties laden;
When the dainty lips have kissed
Darkness from the hollow –
Clothed in mist of amethyst –
Rise and let us follow.[41]

His most successful poems were experiments with different verse forms, such as the kyrielle and triolet. In one poem, in trochaic tetrameter (like Longfellow's *Song of Hiawatha*), he manages very cleverly to rhyme 'boat is' and 'note is' with 'myosotis', the botanical name for forget-me-not:

Let us twain go where the boat is
Rocking by the riverside,
By the beds of myosotis
And the lilies open-eyed,
Where the little sedgebird's note is
Heard by men at eventide.[42]

Although JB worked extremely hard on his books in the vacations, he found time for fishing, as well as helping his Masterton relations on the farm. He felt the romance of their work and admired immoderately the shepherds that he met. He particularly enjoyed rising at dawn to 'look the hill':

delighting in the task, especially if the weather were wild. I attended every clipping, where shepherds came from ten miles round to lend a hand. I helped to drive sheep to the local market and sat, heavily

responsible, in a corner of the auction-ring. I became learned in the talk of the trade, and no bad judge of sheep stock. Those Border shepherds, the men of the long stride and the clear eye, were a great race – I have never known a greater ... My old friends, by whose side I used to quarter the hills, are long ago at rest in moorland kirkyards, and my salutation goes to them beyond the hills of death. I have never had better friends, and I have striven to acquire some tincture of their philosophy of life, a creed at once mirthful and grave, stalwart and merciful.[43]

Shepherds get the best press of any working people in the Bible, and a pretty good one in *The Pilgrim's Progress* as well, so it is hardly surprising that JB was so influenced by them. They are to be found everywhere in his early writings, fiction and non-fiction. His skill as a fisherman of hill burns, as well as his family connections with the well-respected Masterton brothers, gave him an almost unique access (for a Glasgow boy) to this breed of highly independent, observant, often devout and always hardy race. Much later, in the House of Commons in 1931, he told the no doubt bemused company that he would rather take the view of a Border shepherd on most questions than that of all the professors in Europe. He meant it.

His uncles would inevitably have been expert in divining changes in the weather. The success of their sheep-farming, even the security of shepherds' lives and those of their charges, might depend on them knowing when the heavy snows or the 'Lammas rains' were coming. One of the enduring fascinations of JB's novels is the way he uses weather as a protagonist, sometimes benign, more often malign, but always an influence on the action. At the same time, he learnt how the moon behaves, what happens at sunrise and sunset, and even probably how to guide his way by the stars, all of which knowledge informed his fiction, especially the adventure stories and historical novels.

The summer of 1893, after Violet's death, JB borrowed an old bicycle so that he could go further afield for his fishing expeditions and explore the hills surrounding the valleys of the rivers Clyde and Annan. There is a charming, joky triolet in the Commonplace Book he kept for a few years from 1890 about his brakes failing and him being laid up with a cut head.[44] At one point, he cycled all the way from Broughton to

Moffat, past the deeply creepy Devil's Beef Tub, where he saw the body of a man on the roadside, which frightened him considerably and from which he fled. And, since he always had a fascination for waterfalls, he cycled up the side of Moffat Water to see the Grey Mare's Tail, and into the hills above the lonely clachan of Tweedsmuir to Talla Linns.* The roads were grass-grown and empty, the motorcar unknown. The sound of the 'whaups' (curlews) and 'peesweeps' (lapwings) and the sight of wild flowers in the bent stayed with him all his life.

When not out on the hill or at the riverside, or concentrating on his books, he wrote essays, his first published and paid-for work being *Angling in Still Waters*, which came out in *The Gentleman's Magazine* in August 1893, just before his eighteenth birthday. In the essay he describes getting up before dawn to fish the River Tweed, noting the weather and landscape, the sounds and sights of peaceful Tweeddale, and the excitement of it all. He wrote to Charlie Dick: 'Sir James Naesmyth [of Dawyck] has read my article in the *Gentleman's* and told my uncle that he is going to prosecute me for poaching on his heronry and produce my essay for evidence. "The wicked have digged a pit etc."'[45] It is unsurprising that this essay should have been, ostensibly at least, about fishing, a sport that retained its appeal all his life. He had begun at the age of nine in the burns around Broughton; initially catching trout with worms, he was soon expert with the fly. Later he took to salmon fishing as well. He was undoubtedly encouraged, even perhaps taught, by his Uncle Willie, whose salmon rod he inherited in 1906. His technique was exemplary, as his eldest son recalled: 'My father, for all his slight figure, could throw a salmon fly thirty yards, and use a heavy greenheart rod all day. He was one of the finest salmon fishers that I have ever watched. The rod appeared to do his work for him. The perfect curve of his back cast seemed to follow forward with the fly drawing out the long, straight line ahead, independent of his agency. It is the hallmark of all experts that the instrument appears to do its own work.'[46]

More fishing articles followed: 'Rivuli Montani' in October 1894 described the mountain streams of the Borders, while 'The Muse of the Angle' in January 1895 explored those writers with a particular facility for writing about fishing. (He had a lifelong admiration for Izaak

*This was twelve years before the Talla Reservoir was completed.

Walton and *The Compleat Angler*.) He was paid 30 shillings per article: the money was very useful.

In the vacations, he would sometimes cycle or take the train from Broughton to Peebles, to stay with his uncle and two spinster aunts. The aunts were hospitable and notably God-fearing, but their piety may have trumped their familial feeling in the case of their bachelor brother Alexander, a lawyer who seems rarely, if ever, to have been mentioned in the family after he went to England as a young man. There was another unmarried brother, Tom, known as 'the black sheep of the family', who became a sailor and went to Australia, but they never lost touch with him.

JB and his uncle Willie became fast friends, since the latter, a cultured middle-aged bachelor, with a pale face, dark eyes, hooked nose and a neat black beard that made him look like a sparer version of Edward VII, was plainly a delightful man, and an unusual one, even for a Scottish provincial town that respected learning and bred the occasional scholar with a national reputation such as John Veitch, Professor of Logic at Glasgow. Willie was competent, organised and cheerful, with broad interests. He was a keen fisherman, a collector of antiquarian books, a great reader of poetry and French novels, and an inveterate European traveller. He encouraged JB to learn French, which was to prove very useful in later life, and introduced him to Flaubert, Maupassant, Dumas, Gautier and Daudet. He also gave him valuable books, including an Elsevier's version of the works of Tacitus from 1621, in very good condition, which his nephew had bound in leather.[47]

JB's letters to Charlie Dick are full of his reading. In April 1893, for example, he was deep into the autobiography of Lord Herbert of Cherbury, George Herbert's brother, a prominent English Deist. This, with the work on Bacon, shows the beginnings of a profound and lasting interest in the seventeenth century. Another book that he read but probably never finished, since he found it 'very smart but very tiresome after a little',[48] was Robert Hichens' *roman à clef* about Oscar Wilde and Lord Alfred Douglas, called *The Green Carnation*, which was published in 1894 but so scandalised the reading public that it was withdrawn the following year.

At this age, his principal inspirations in fiction were Robert Louis Stevenson and George Meredith. He read *Kidnapped* and *The Master of*

Ballantrae for 'the 4th or 5th time' that summer. His sailor uncle Tom, who was visiting Peebles, told him 'that he had lived for six months in Samoa and had often seen Robert Louis. He said that he is a sort of King there, but that he goes about with nothing on him except a blanket, worn toga-wise, and pinned at the shoulder with a Cairngorm brooch. Fancy! Sic a sicht for sair een! A decent, honest Scotsman come to that!'[49]

It is hardly surprising that Stevenson should be such an important early influence on JB and his generation, since he was at the height of his fame at this time (dying in 1894) and, most importantly, he was Scottish:

> He had the same antecedents that we had, and he thrilled as we did to those antecedents – the lights and glooms of Scottish history; the mixed heritage we drew from Covenanter and Cavalier; that strange compost of contradictions, the Scottish character; the bleakness and the beauty of the Scottish landscape ... He was at once Scottish and cosmopolitan, artist and adventurer, scholar and gipsy. Above all he was a true companion.[50]

Looking back to his youth in the late 1930s, JB had to admit that Stevenson's influence on him did not last and that he tired of his phrase-making, since 'I wanted robuster standards and more vital impulses'.[51] He thought his prose too fastidious, too self-conscious, with too much artifice about it. But in the late 1890s, Stevenson was almost the ideal mentor for a young Scot who already sensed that his future lay in the world of letters. As for George Meredith, JB was attracted to him as an optimist, 'who believes that the universe is on the side of man's moral strivings. He believes in the regeneration of the world by man, and in the high destiny of humanity.'[52]

Much of September that year he spent with his family on the Isle of Arran, and one senses he was beginning to feel confined by the family circle, and was happy to escape back to the Borders to stay with his grandmother and 'Antaggie' at Broughton Green, where in early October he was to be found working on an historical novel about seventeenth-century Tweeddale, which he called *John Burnet of Barns*.

In his second session at Glasgow, he moved up to Gilbert Murray's top class and the two men got to know each other better. Murray was much more than a simple scholar, he was an innovative and inspiring teacher, and his influence on JB can scarcely be overstated:

He was then a young man in his middle twenties and was known only by his Oxford reputation. To me his lectures were, in Wordsworth's phrase, like 'kindlings of the morning' (sic). Men are by nature Greeks or Romans, Hellenists or Latinists. Murray was essentially a Greek; my own predilection has always been for Rome; but I owe it to him that I was able to understand something of the Greek spirit and still more to come under the spell of the classic discipline in letters and life. I laboured hard to make myself a good 'pure' scholar; but I was not intended by Providence for a philologist; my slender attainments lay rather in classical literature, in history, and presently in philosophy. Always to direct me I had Murray's delicate critical sense, his imaginative insight into high matters, and his gentle and scrupulous humanism.[53]

Murray was a convinced Liberal, a social reformer and a champion of women's university education, as was his wife, Lady Mary (née Howard), an aristocratic Englishwoman of beauty, style, intelligence and high principles, but not much sense of humour. She had inherited Castle Howard, a great house in Yorkshire, but had given it to her brother. Her parents were interested in art and social reform, and numbered amongst their friends George Eliot, Edward Burne-Jones, William Morris and John Morley. Lady Mary was much admired – being both exotic and open-hearted – by the Glasgow students who came across her. Murray had brought with him from Oxford the tradition of pastoral care that the collegiate system fostered, and the Murrays were unusual in entertaining some of their students at their home, both in term time and in the vacations. In 1895, JB spent several days with them at Sheringham, on the Norfolk coast, where he and the Murrays read *Pendennis* by William Makepeace Thackeray aloud to each other in the evenings.

JB's *Essays and Apothegms of Francis, Lord Bacon* was published in the spring of 1894, and he rode over to Peebles to see the piles of copies of his book in Redpath's bookshop. In June, when he was nearly nineteen, he acquired another brother, Alastair Ebenezer, the healthy child of his

parents' middle age, and some consolation for the loss of Violet the year before.

The year 1894 was also when Henry Jones arrived at Glasgow, to take up the Chair of Moral Philosophy. Professor Veitch of Peebles had earlier introduced JB to Descartes, before ever he went to Glasgow and, although not especially attracted by Jones' 'semi-religious Hegelianism', he wrote in his reminiscences that 'a braver, wiser, kinder human being never lived'.[54] He was of the age to hero-worship his elders, especially those who saw the spark in him.

He was much influenced that year by Walter Pater, whose *Plato and Platonism* was published in 1893. JB was already keen on Plato as a poet, but Pater showed him the value of the influence of the Greek philosopher on seventeenth-century Calvinist divines, such as Ralph Cudworth and Henry More, the so-called Cambridge Platonists:

> ... I was born with the same temperament as the Platonists of the early seventeenth century, who had what Walter Pater has called 'a sensuous love of the unseen', or, to put it more exactly, who combined a passion for the unseen and the eternal with a delight in the seen and temporal.[55]

To JB, their Calvinism had been mellowed and warmed by the love of humanity and of all things true and beautiful.

For style, however, he was far less inclined to copy the over-ripe and prolix romanticism of Walter Pater, however good the matter of what he wrote, than that exhibited by John Henry Newman, the Catholic theologian, and T. H. Huxley, the scientist, 'whose one aim was to say clearly what they had to say and have done with it – a creed which would be regarded, I fear, as a sort of blacklegging by most men of letters'.[56] For JB clarity was of paramount importance.

In his third year at Glasgow, he contributed a few pieces to the university magazine, and gave papers to the Alexandrian and Philosophical societies. However, apart from some canvassing in the Rectorial election when he supported H. H. Asquith, which led to fisticuffs with Robert Horne,[*]

[*]When Horne, who was the son of a kirk minister, became a member of the Cabinet in 1919, his mother is supposed to have remarked: 'We always prayed that Robert would become a minister but maybe the Lord mistook our intention.'

he was not really visible. But he was working with such dedication and success that, in the autumn, he decided to try for a scholarship to Oxford University. Gilbert Murray almost certainly suggested this to him, but would have been pushing against an open door. JB's studies and the university life had inevitably widened his horizons, and Murray probably told him that study at Oxford would be the best route to an academic post in Scotland. He decided to apply to Brasenose College, rather than the more usual (for Scotsmen) Balliol College. Although Walter Pater had died several months before he applied, he wanted to go to a college that still felt his influence, and was full of his friends, such as the Principal, Dr Heberden, and the chaplain, Dr F.W. Bussell.

Life at home in Queen Mary Avenue was becoming increasingly stifling. His closeness to his mother was lifelong, but he was now also someone in whom she placed great hopes. In his book of reminiscences, late in life, he hinted at the difficulties, but was too guarded to explain them in a really illuminating way to his readers – a necessary obfuscation because his brother and sister, equally devoted to her, were still alive:

> ... in my adolescence we sometimes arrived at that point of complete comprehension known as a misunderstanding. We had no quarrels, for to each of us that would have been like quarrelling with oneself, but we had many arguments. Instinctively we seemed to grasp the undisclosed and hardly realised things which were at the back of the other's mind.[57]

His teenage rebellion was not generated by resentfulness at his relatively confined circumstances, nor exasperation that the family were not smarter or richer, but rather frustration that there was an exciting world to be explored, which he could only travel in his imagination. This frustration was fuelled by a strong intuition that his mother wanted him to stay nearby. She was as ambitious as he was and, for a minister's wife, surprisingly worldly, but that world was Glasgow or, at the widest, Scotland. She had discovered early in life that her husband was wedded to good, selfless work amongst his shabby congregation and, despite any endeavour of hers, would remain in relative obscurity. So her focus had switched to her bright and talented eldest boy; for her, or rather for him on her behalf, nothing short of Moderator of the Free Church would do.

It was at this precise moment, however, that her hopes were permanently dashed. In early January 1895, JB travelled to Oxford for the entrance examination, a visit that was little short of a revelation to him:

> It was, I remember, bitter winter weather. The Oxford streets, when I arrived late at night from the North, were deep in snow. My lodgings were in Exeter College, and I recall the blazing fires, a particularly succulent kind of sausage, and coffee such as I had never known in Scotland. I wrote my examination papers in Christ Church hall, that noblest of Tudor creations. I felt as if I had slipped through some chink in the veil of the past and become a mediaeval student. Most vividly I recollect walking in the late afternoon in Merton Street and Holywell and looking at snow-laden gables which had scarcely altered since the Middle Ages. In that hour Oxford claimed me, and her bonds have never been loosed.[58]

He achieved a Junior Hulme scholarship to Brasenose College, his tutor, Dr Fox, later recalling that his essay in the scholarship exam was just like a piece of Stevenson. He abandoned the University of Glasgow after three years, leaving without taking a degree.

At the same time he was working on a couple of short stories, 'The Herd of Standlan' (first published in *Black and White* magazine in 1896) and 'A Journey of Little Profit' (first published in *The Yellow Book* the same year), in which a drover comes up against the Devil. He was very anxious to get these projects finished before he went up to Oxford.

That year, 1895, his uncle Willie was granted, along with all his father's descendants, the right to bear heraldic arms. The crest on the escutcheon was a sunflower with the motto 'Non inferiora secutus'. The Buchans were entitled now to call themselves gentlefolk. JB was proud of this as doodles in a 'commonplace book' of the time show. He might be a hard-up Scottish provincial, but he was, in his own eyes at least, on a par with the men he would meet at Oxford, and not just intellectually.

Just before he left Glasgow, he wrote to Gilbert Murray, enclosing an advance copy of his first novel, *Sir Quixote of the Moors: Being Some Account of an Episode in the Life of the Sieur de Rohaine*. The dedication

read: 'To Gilbert Murray. Whatsoever in this book is not worthless is dedicated by his friend.' He wrote to him:

> Now that I read it in print I don't feel at all satisfied with it. Some of it I like, but in a good deal of it I think I have been quite unsuccessful. Of course you will understand that it is all written in character, and that this accounts for the frequently exaggerated sentiment and style. I only hope that you will not repent now of having given me permission to dedicate it to you. The binding of the book, I think the most awful conceivable – a livid nightmare.[59]

The lack of confidence, both in the dedication and the letter, is painfully obvious, as if he were already regretting it all.

He received a long reply a few days later from Murray, in which the latter had obviously mixed kindly praise with judicious criticism. JB wrote back to thank him: 'One of the worst faults of the book, I think, is the tendency to mere sentence-making. I think this is due partly to the excessive admiration which I have felt for some years for Stevenson, partly in the way the book was written.'[60] It had been written in small pieces at snatched moments towards the end of his time at Glasgow, and that showed. No doubt he felt he was a more mature writer now. But at least he was a published novelist, at the age of twenty.

The novel is set in the 'Killing Time', when 'Covenanters' – those Scottish Presbyterians who had signed the National Covenant of 1638 – were persecuted by Graham of Claverhouse, known popularly as 'Bonnie Dundee', in the 1680s. *Sir Quixote of the Moors* tells of a French soldier of fortune who finds himself in the position of having to protect a 'fair maiden' while her father and lover are hiding from Claverhouse on the Galloway moors. The book was, JB wrote, 'an effort to show what would be the course of a certain type of character in certain difficult circumstances, and in the second an attempt ... to trace the influence of scene and weather on the action and nature of man'.[61] These were Stevensonian preoccupations that would surface again and again in his early fiction. Young as he was, he had already learned the importance of writing an arresting first sentence:

> Before me stretched a black heath, over which the mist blew in gusts, and through whose midst the road crept like an adder.[62]

What was obvious, even this early, and despite some offputting archaisms, was not only his acute interest in, and observation of, the natural world, in all its kindness and malice, but that he knew from experience what it was like to be cold, wet, stormstayed and frightened, and could translate that with immediacy to the page.

Moreover, it is obvious that this twenty-year-old already knew what sexual longing was. The soldier rides away from the girl, because he cannot trust himself to behave honourably if he stays, and thinks his honour more important than her protection. We do not know, but can easily imagine, what he thought when the American publisher, Henry Holt and Company, insisted on an additional paragraph to give the story a happy ending, thereby entirely undermining the point of the book.

This unfortunate compromise appeared in the United States in October 1895, just as JB, his character forged and his literary career already under way, set his face southwards, like many an ambitious Scot before and since. Although he would never live permanently in Scotland again, his upbringing there had taught him how to be happy, and despite tragedies, misfortunes, failures, ill-health, successes and fame, that capacity for happiness never left him.

2

Oxford, 1895–1899

JB arrived at Brasenose College on the afternoon of 11 October 1895 to find that his rooms were on No. 1 staircase, in the corner of the sixteenth-century Old Quad. Brasenose College was part of a cluster of colleges close to 'The High', the main east/west thoroughfare through a city that was still small, compact and mainly medieval in character. At the end of the nineteenth century, the ordinary 'commoners' of Brasenose were often sons of country gentry from the north of England, while the 'scholars' tended to come from provincial grammar schools. The college, referred to by its members as BNC, was renowned for its sporting prowess, especially on the river and the rugby football field. (William Webb Ellis, the supposed inventor of Rugby Football, was an alumnus.) In retrospect, JB reckoned Brasenose taught him much about the English character.

Oxford in the mid-1890s still had an air of the monastery about it, since college dons had only finally been allowed to marry less than twenty years before. There was no great turmoil in the outer world to disturb the ancestral peace of the place, and young men (for they were nearly all men) had time to make elaborate friendships and read themselves into a proper, if arguably already rather old-fashioned education, based on the Classics.

JB quickly settled down to work all morning at his Classics (Homer's *Iliad*, Theocritus and Demosthenes), spent part of the afternoon in the Bodleian Library doing research for the 'Stanhope', the university history prize, then more Classics before and after supper, and finally what he called 'general work', meaning journalism. Within two weeks of arrival,

he had written a piece for *The Glasgow Herald* on his first impressions of Oxford and, in early November, another, on 'Nonconformity in Literature'. This was a doughty, if overwritten, attack on the so-called 'Kailyard' ('cabbage-patch') school of Scottish novelists, which included S. R. Crockett, a Free Church minister, whom he knew, Gabriel Setoun and Ian Maclaren. Of Crockett he wrote:

> Mr Crockett hates the sickly and the grimy with a perfect hatred. He is all for the wind and the sunshine, hills and heather, lilac and adventure, kisses and fresh-churned butter ... he is all for the great common things of the world – faith and love, heroism and patience. But it seems to us that in this also there is a danger; mere talking about fine things does not make fine literature, and Mr Crockett at his worst is only a boisterous talker. No man, however high his spirits and rich the life within him, can hope to be a great writer save by the restraint, the pains, the hard and bitter drudgery of his art.[1]

That last sentence gives a good idea of what the twenty-year-old thought of the art (and craft) of writing, but these harsh words prompted a howl of protest from Robertson Nicoll, the editor of *The British Weekly: A Journal of Social and Christian Progress*, a conservative and religious magazine very popular in Scottish kirk-minded homes. JB was rebelling against the parochial and Pollyanna-ish nature of Scottish fiction-writing at the turn of the century, which threatened to stifle him quite as much as Glasgow manse life, and from which he was equally determined to escape.

This wide-ranging article also dealt with other fashions in 1890s literature, notably 'decadence' and 'naturalism', and he showed his distaste for the exalting of vice into virtue by the 'decadents', and the incidental and insignificant in 'naturalism'.* He was not against novelty per se, but rather against the elevation of newness to something more than it deserved, at the expense of traditional literature. 'The besetting sin of the day is pride,'[2] announced the youngster. 'The decadents' distinguishing feature is a sort of disdain for the things which common

*In an essay on his High Victorian hero, George Meredith, published in *The Spectator* in May 1909, JB wrote '... he never fell into the blunder of those who think that a mass of undigested and unselected detail is fiction'.

men think great and good, and an affected seeking after esoteric beauties and virtues.' These writers were providing vices with a touch of paint and a coating of sugar, he thought. 'They claim to represent a new age, a new era, a new hedonism, a new Heaven knows what.'

The nub of his essentially conservative philosophy, which he never abandoned, was: 'The moral law has been accepted by saint and sinner for many hundred years, and has been the basis of all sound work, artistic or social, which has ever been done. And yet here we have so many presumptuous folk declaring that it is out of date, and setting in its place a substitute manufactured from their own evil desires.'[3]

In the early afternoons he went on the river, played golf, or took long walks, the Cumnor Hills and Bablock Hythe being popular destinations for him, in homage to Matthew Arnold. He found the countryside around Oxford enchanting with its lush greenery, hidden lanes, fine houses and churches, slow-flowing rivers and, best of all, its long and stirringly chequered history: 'From Roman centurion to Norman baron, from churchman to cavalier, much of the drama of England was staged here.'[4]

He had not been at Brasenose for more than a couple of days when his rooms were invaded by six drunken college men, who turned his furniture upside down and then demanded whisky, which JB could not provide. Nevertheless, they left him with profuse protestations of friendship. It is not surprising that, as he told Gilbert Murray, his first impression was that his contemporaries were a curious mixture of overgrown schoolboys and would-be men of the world, whom he thought he might tire of quite soon.

In his first term he helped to found a select Ibsen Society, to meet weekly to read the great man's plays. 'But after a few meetings the study of the works of that master so scandalised the members that they passed a vote of censure on me and turned the Society into a [dining] club called "Crocodiles", with a tie of green, grey and white (that, in the opinion of the members, being the colour of the crocodile).'[5] He rather ruefully consented to be its President.

Despite his scholarship of £80 a year, he could not initially afford to eat in hall more than four days a week. But the remedy was in his own hands, because, even in his first term, he had aroused the interest of London publishers and editors. Very soon after he arrived, T. Fisher Unwin

came down to talk about the imminent publication of *Sir Quixote of the Moors* (for which he paid £25)[6] as well as possible publication of a collection of short stories under the title *The Face of Proserpina*. In the end, Fisher Unwin havered so much that JB sent them instead to John Lane, who published them as *Grey Weather* in 1899.

Moreover, a couple of weeks after he arrived, he was summoned to breakfast in the Clarendon Hotel by John Lane,[7] who invited him to become a publisher's 'reader' (reading manuscripts and recommending whether they should be published or not), at a rate of three a week, earning £6 thereby. He had no hesitation in accepting, despite the substantial increase in his workload, since this would both enhance his reputation and help make ends meet. As importantly, it would also keep him abreast of what other fiction writers were doing. It was a time when novelists were experimenting with (comparatively) explicit sexual material, which frankly unsettled the prudish young man. These were some of his comments to Lane about Edgar Jepson's *The Passion for Romance*: 'It is very full of "sex", full of sickening descriptions of passion, and sugary paroxysms. In a word, it is thoroughly vulgar ... I do not think that it would do any good to your firm's reputation.'[8]

When he came home for his first vacation, his family laughed at his 'Varsity' accent, which he had swiftly acquired. In this vacation he walked long miles in the hills with his brother, Willie, and worked on his novel, *John Burnet of Barns*, as well as a bleak, compelling story about a reformed sinner, entitled 'A Captain of Salvation', which was published in *The Yellow Book* during the next term.[*]

He finished *John Burnet of Barns* in early March. It was 100,000 words in length and had been a substantial labour. The process had certainly taught him the courage to carry out a big project, but he thought, rightly, that, in places, it was cumbersome and ill put together.

[*]In 1937, John Betjeman teased his friend Alice Fairfax-Lucy (JB's daughter) in his poem 'The Arrest of Oscar Wilde at the Cadogan Hotel':

So you've brought me the latest Yellow Book:
And Buchan has got in it now:
Approval of what is approved of
Is as false as a well-kept vow.

John Betjeman, *Continual Dew*, John Murray, London, 1937, p. 1.

About the same time, he wrote an article for the University of Glasgow Magazine on 'Books and Places' to please Charlie Dick, who had become its editor. JB wrote to his friend '… I enjoyed your <u>Notes on a Western Isle</u> immensely. You are getting into an admirable and restrained English style.'[9] He had enthusiastically congratulated Dick the year before when his edition of Walton's *The Compleat Angler* appeared in The Scott Library. And so began an enduring tradition of warmly praising (unprompted) other labourers in the same vineyard, which must often have surprised writers unused to such magnanimity in their contemporaries.

In the Trinity (summer) Term, he failed to win the Stanhope prize, although this did not depress him unduly, for he reckoned that the subject chosen for the following year – 'Sir Walter Raleigh' – would suit him better. He told Dick that 'I have been alternating between hard work (I get about 10 hours done in the day) and lying on my back among trees at the riverside, or drinking cider in the Union Gardens. I have done a good deal of tennis, yachting, rowing, canoeing and punting lately.'[10] He was also reading three manuscripts a week and reporting on them to Lane.

All the while, he was fizzing intellectually. He continued to Dick: 'I am busy preparing a violent article for the Yellow Book on <u>Modern Criticism</u> in which I am having a drive at all my <u>bêtes-noires</u> from the <u>Kailyard School</u> to Socialism.' Sadly, since that would have been quite a trick to pull off, this was never published, because the quarterly ceased after the April 1897 number. His last story to appear in it was 'At the Article of Death' – a rather moving tale about a dying Border shepherd.

His health was not terribly good, as a result, he said, of too much work and excitement – in other words, burning the candle at both ends. However, although a heatwave in late May gave him asthma, the full beauty of the city of Oxford and the surrounding countryside was open to him that term. He told his mother that 'Oxford is a lovely sight, with its greenery and flowers, pretty frocks and pretty faces; speaking generally, the beauty and fashion of England are congregated here just now. When I turned up yesterday on the barge in boating clothes, I was horrified to find it filled with ladies, and opera glasses and parasols.'[11] It must have looked like a scene from the farce *Charley's Aunt*, which was running in London at the time. *Zuleika Dobson*, the cynical satire of

Oxford undergraduate life, which Max Beerbohm had begun in 1898, describes just such an occasion.

As well as the money for *Sir Quixote*, JB was also paid for a short story for Macmillan and two more articles for *The Glasgow Herald*, and there were regular and welcome increments in his second and third terms from John Lane. However, his earnings really began to take off just before he started his second year, when he received £100 for the serial rights for *John Burnet of Barns*. At the end of 1896 he had more than £190 in the bank. At the end of the following year, 1897, the balance was less than £130, despite reviewing for *The Academy*, reading for Lane, and receiving royalties from *Scholar Gipsies*. He had begun to spend more, and was gradually turning into the typical late Victorian undergraduate, although he was careful not to waste his money. He could afford vacation holidays, and to buy as many books as he liked. He would often lend money to his mother, who was punctilious about paying him back, as well as to his friends, who may not have been so careful, and he also gave to charity. He felt able to afford to join the Union Society and even a London gentleman's club, the Devonshire in St James'. Crucially, in the spring of 1897, he had enough money to pay £40 6s 8d to become a member of the Middle Temple. He had come to the conclusion that he was capable of earning sufficient from his pen to read for the Bar. The Bar, of course, was a sensible option for a man with an Oxford classical education who knew he must make his way in the world, as well as a writer who doubted whether, initially or indeed ever, he could make a living by his pen.

That summer he bought his sister Anna ('dear Pudge') a bicycle for £12 10s, which he had promised her if he received advantageous serial rights for *John Burnet of Barns*. He was determined to help her have as much freedom as was possible for a middle-class teenage girl in turn-of-the-century Glasgow.

JB, like many of his contemporaries, was very shy of girls, for they featured rarely in Oxford college society in the 1890s. Whenever he met one at a tea party, he seemed fated to be dressed unsuitably, having just come from the river or the library, which made his shyness worse. There were few women's halls (Somerville only became a college in 1894) and the female students were, in any event, heavily chaperoned. Most Oxford men lived an almost continuously masculine life, unless

they happened to meet someone's sister on a visit of his 'people'. There are a number of references in his letters to charming or pretty girls and he definitely admired Miss Lilian Collen, who played the female lead in a student production of *Romeo and Juliet* in February 1898. Although he was not, constitutionally, very susceptible, and does not seem to have seen young women as part of his landscape at Oxford, he was not entirely immune to their charms.

In early June 1896 he wrote to Anna, who was his discreet and faithful confidante, crossly turning down his parents' invitation that he become a deacon of the John Knox church – how far away that must have seemed to the urbane Oxford 'undergrad'! A week later he told her that he had been on the river nearly every afternoon. 'It is very pretty, for the water-lilies are all out and the lanes are simply masses of wild roses.' He went on to write: 'What in the world does Mother mean by telling me to take care of my health and my morals! She is a most uncomplimentary person.'[12]

After the end of term, he went to stay for a couple of days with John Lane in his set of rooms in Albany, Piccadilly, close to the offices of the Bodley Head. Lane took a fatherly interest in the young man and introduced him to a number of literary and would-be literary figures, such as Arnold Bennett, whose first novel JB had read for him and warmly recommended for publication, despite doubting whether it would be a striking success.* He was right about that. Bennett reckoned that, after the cost of typing was taken away, he made one sovereign out of *A Man from the North*; with it, he bought a new hat.

Arnold Bennett has left us with a pen-portrait of the twenty-year-old JB:

A very young, fair man, charmingly shy, 'Varsity' in every tone and gesture. He talks quietly in a feminine, exiguous voice, with the accent of Kensington tempered perhaps by a shadow of a shade of Scotch ... A most modest, retiring man, yet obviously sane and shrewd. Well-disposed, too, and anxious to be just, a man to compel respect, one who 'counts'.[13]

*Originally entitled *In the Shadow* but published as *A Man from the North* in 1898.

JB stayed three days in London and told his Brasenose friend Benjamin Boulter, known as 'Taffy', that he had 'met all sorts of people, from awful New Women, who drank whisky and soda and smoked cigars, to John Murray, the publisher, who is a sort of incarnation of respectability. I never was in so many theatres and restaurants in my life.'[14]

He was rather loath to go north at the end of the summer term to spend the first part of the vacation with his family, since his parents' idea of a holiday was to manse-swap with other ministers – first Innerleithen, east of Peebles, and then Gallatown, close to Pathhead. However, as it turned out, he enjoyed Innerleithen more than he thought he would, since Charlie Dick came to stay; after studying in the mornings, they would walk, play golf or fish every afternoon. At Gallatown in August, JB entertained John Edgar, another friend from Hutchesons' and the University of Glasgow, and they played a lot of golf, but he still managed to work on *Modern Criticism*, begin writing 'Sir Walter Ralegh' (*sic*) and his Newdigate Prize poem on Gibraltar, plan a new novel in twenty chapters to be called 'A Lost Lady of Old Years' (a quotation from Robert Browning's *Waring*), and read George Meredith's *Evan Harrington* for the second time. All this exhibited an unusual and, as it turned out, enduring capacity for breaking off from one subject to another, while retaining the same high level of concentration for each.

He wrote to Charlie Dick from Gallatown two days after his twenty-first birthday:

… my hair is completely white with Sir Walter Ralegh [sic], who seems to have ordered his life for the sole reason of perplexing biographers.

Even as I write, I observe from my turret chamber the Countess of Rosslyn and the beautiful Lady Dudley are driving past from Dysart House in a high dog-cart. I begin to wish I were she, and then, reflecting that her husband has lost all his money on the Turf, I am glad I am not. Still a high dog-cart makes up for many inequalities in life. In fact, now that I have been 21 years in this Valley of Humiliation, I begin to reflect that life what with over-work, being confined to bed, wind, rain, aristocrats and submerged reefs* is played out. But I am consoled by the thought of high dog-carts.[15]

*He had dived into a deep channel among rocks and cut himself badly.

After Gallatown, he went to Galloway to walk in the hills, most likely with his brother Willie, telling Charlie Dick that he had had one of the most enjoyable and adventurous holidays ever and got much fresh material. 'I slept one night in a shepherd's cottage, 9 miles from the nearest house and 25 miles from the nearest station. I took him two loaves and some tea, and he told me that he had not seen loaf-bread since the Spring and did not get his letters till a fortnight late.'[16]

Before he went up to Oxford for his second year, Lane told him that he was happy to publish a collection of his short stories, and they agreed upon the title *Grey Weather: Moorland Tales of My Own People*. These had already appeared in a variety of publications – *Chambers's Journal, The Yellow Book, Macmillan's Magazine* and *Black and White* – which showed how quickly he had learned the tricks of the freelancer. At the same time, in late September, *Scholar Gipsies*, a mix of essays and stories, with six exceptional drypoint etchings by D. Y. Cameron, was published. Within five months, Lane was forced to print a second edition.

From an early age, JB, in thrall to Matthew Arnold, had seen himself as a cerebral man of action, a man for the open road with a stick in his hand and a copy of Thucydides in his pocket. He had managed to persuade John Lane (unlike T. Fisher Unwin, who 'hummed and hawed') to publish this book of early writings in the autumn of 1896. That was no mean feat, since published essays are usually the product of a mature mind and ripe experience, not of a callow lad who had only just achieved his majority. Certainly, his readers must have imagined him to be much older. *Scholar Gipsies* was dedicated to the memory of his grandfather, John Masterton of Broughton Green, and comprised sixteen essays, containing, in his words, 'a few pictures of character and nature, pieces of sentiment torn from their setting, a fragment of criticism, some moralisings of little worth...'[17] The best chapters are those that draw on his experience of talking to shepherds in remote places, of fishing on the Tweed, or of thinking back to how he thought as a child, just as the shades of the prison house had effectively closed upon the grown boy.

'Men of the Uplands', for example, anatomises the particular characteristics of Tweed folk (of which he counted himself as one) and their interests – religion, politics, sport – and describes vividly a night-time poaching expedition, with local ne'er-do-wells, which has the ring of personal experience about it. He had been caught poaching salmon,

aged sixteen, and probably only escaped being hauled in front of the procurator fiscal – his uncle – because of his youth and his family's standing in Peebles:

> [Salmon-poaching in the close season] is hazardous in the extreme, for the waters are often swollen high, and men in the pursuit of sport have no care of their lives … 'Firing the water' as it is called, consists in flaring torches, made of pine-knots or old barrel-staves dipped in tar, over the surface of the river, and so attracting the fish. The *leister* with its barbed prongs is a deadly weapon in a skilful hand, but in the use of it a novice is apt to overbalance himself and flounder helplessly in the wintry stream. The glare of light on the faces of the men, the leaping fish, the swirl of the dark water, the black woods around, the turmoil of the spot in contrast with the deathly quietness of the hills, the sack with its glittering spoil, the fierce, muffled talk, are in the highest degree romantic.[18]

He had not yet rid himself of the tendency to some *de haut en bas* pontificating at times, as well as a self-consciously literary tone, but the fine writing is tempered by some good, yet comprehensible, Scots dialogue, for his ear was by now finely tuned, and some of the 'characters' described, particularly an old kirk minister, do leap from the page.

In his second year, JB was given rooms on Staircase 6 in Old Quad, which he found delightful and easy to work in. He was buoyed up by good reviews and sales of *Scholar Gipsies*, as well as the offer from Fisher Unwin to send him manuscripts to read, which 'will add to the hardships of my lot'[19] but for which he was paid handsomely.

He was beginning to become active in the Union Society, having, at the end of his first year, seconded a motion 'That motley's the only wear'. This was a strange proposal for such a dapper young man to endorse but proof that he was developing a lawyer's zest for arguing any point, however duff.

He spent the Christmas holidays mostly at Broughton, working all morning and then taking long walks in the afternoons. A 'magnificent walk' of fifteen miles took him to the foot of Caerdon, through the hill pass and down the Holmes Water. 'A snow storm was drifting up against the setting sun, and I have rarely seen anything finer than the lurid

crimson and yellow flaming behind the bald white domes of the hills.'[20]
As well as working on his Latin poetry he had nearly finished another
chapter of his Jacobite novel, *A Lost Lady of Old Years*. The lost lady was
the wife of 'Traitor' Murray of Broughton, the man who turned King's
evidence to save himself and betray Bonnie Prince Charlie. 'Here, not
five hundred yards from the place [the House of Broughton] which
once was her home, I seem to write better,' he told Charlie Dick.

In preparation for reading for the Bar, he started to 'eat dinners'*
in Middle Temple Hall in March 1897. That Lent term, he sat 'Mods'
and, after it, celebrated with friends in his rooms sufficiently well
that they were each fined £1 to pay for broken windows. Generally, in
comparison with most other Brasenose men, he was notably temperate,
but he could sometimes be reckless, in a way that would have caused
frowns and heart-burnings in Queen Mary Avenue, had the occupants
known of it.

However, when the exam results were posted in May, he was
disappointed to discover that he had narrowly missed a First. He had
ploughed Roman Poetry; although expected to get an alpha plus he
could only manage a beta minus. He told Gilbert Murray that it had
been foolish of him to spend so much time writing his essay on Sir
Walter Raleigh. However, at least he had won the Stanhope History Prize
and, as a result, had to read out part of it at the Encaenia,** held after
the end of the summer term. 'Sir Walter Ralegh' (sic) was published by
Blackwell's in July, when *The Oxford Magazine* enthused: 'The essay of
Mr J. Buchan on Sir Walter Raleigh seems to have thoroughly deserved
the success which it obtained ... the author is well up with his subject,
and writes in a pleasing and sometimes very epigrammatic style. His
estimate of the character of Raleigh is just, and his criticisms on his
literary productions are incisive.'[21]

That summer was spent partly at Broughton, mixing hard work (he
translated 360 pages of Plato's *Republic* from the Greek in a fortnight)
and violent exercise, including practising diving and swimming in
the Tweed. In July, with Taffy Boulter, he went on a walking tour in

*Eating twelve dinners in the Middle Temple Hall, where he would meet other barristers, was
one prerequisite of being called to the Bar.
**The name for the annual Oxford ceremony when honorary degrees are given out.

Galloway, north-east of Newton Stewart, basing themselves at a cottage in St John's Town of Dalry. He told Charlie Dick that the trip was 'the most soul-satisfying and adventurous I ever had'.

They walked in blinding heat the ten miles up the Ken and the Pulharrow Burn to the Forest of Buchan, climbed the Clints of Millfire (2,500 ft. high) and then plodded through bog to the Back Hill of the Bush. Here they found a shepherd making hay, who gave them tea, lent them each a blanket, and escorted them across the Silver Flow of Buchan. They then had a hard climb to the top of the Wolf's Slock, where they could look down on Loch Enoch:

> I shall never forget that sight as long as I live. The loch was one sheet of burnished silver with its wonderful milk-white sand, and islands glowing like jewels all athwart it ... All the other great lochs of the Dungeon were spread out at our feet – Neldricken, Arron, Valley, Macaterick, Trool etc. We went down to a promontory, had a long swim then I fished, but had very indifferent sport. About 8.30 we lit a large fire of heather and bog-oak and made supper. Then we rolled ourselves in our plaids, lit our pipes, and lay down before the fire and slept ... At 2.30 I got up and fished for a little. Then we went for a swim. Did you ever bathe before sunrise? It is a queer effect to be swimming in the blackest water, and see shafts of golden light cleaving ravines in front of you.[22]

The images that JB retained of Galloway, in particular its extreme remoteness, the pattern of its hills and lochs, even the position of railway stations 'in the bog', did not leave him, and he conjured them later, both as the background to the terrifying story he wrote while at Oxford about a remnant of Picts,* and, most famously, for Richard Hannay's flight across the moors in *The Thirty-Nine Steps*.

In his third year at Oxford, JB was happy to be given the set of rooms in which Reginald (later Bishop) Heber** had entertained Sir Walter

*'No Man's Land' appeared in *Blackwood's Magazine* in 1899, and was collected in *The Watcher by the Threshold*, published in 1902.
**Composer of that most patronising and tuneful of missionary hymns, 'From Greenland's icy mountains'.

Scott; they were pleasant and light, and looked over the Exeter College gardens.* The Michaelmas term was the usual mixture of hard Classics studies and reading novel manuscripts; at one moment he had twelve of these 'in my coal-hole mixed up with my coal and faggots. When I want one I light a candle, say my prayers, get the coal hammer and begin to burrow.'[23] The following term, he achieved a Senior Hulme scholarship, the examiners acknowledging that the paper would have gained him a First in Greats. The scholarship was worth £130 a year and added substantially to his financial security. Even by the standards of the privileged young men of the time, he was now a rich undergraduate.

His attractiveness to publishers, together with his ambition to succeed in as many fields as possible, ensured that he was often almost overwhelmed with extracurricular work. At one time he was revising *John Burnet of Barns* for publication ('It is dreary work for I have entirely lost the sentiment I wrote it in,'[24] he told Gilbert Murray), reviewing books for *The Academy*, getting up a speech on foreign policy for the Union, and learning about Celtic and Norse poetry to deliver a paper to the Ingoldsby, the Brasenose literary society. He learned some Icelandic for the purpose and read a good deal of Icelandic poetry, he told Charlie Dick, 'and I am altogether rather intoxicated just now with things like the <u>Mabinogion</u> in Celtic poetry and the <u>Helgi</u> songs in Norse. I am trying to make my paper as thorough and original a piece of work as possible.'[25]

He was also writing *A History of Brasenose College*, a task given to him by the Principal, Dr Heberden, and a signal honour for an undergraduate. The title was to appear in a series of Oxford College histories, written by Fellows and published by F. E. Robinson. It was not an easy book to write, but the college was pleased with the result. It showed JB's growing capacity for writing for a particular audience in a way that did not come naturally to him; he was frankly not very interested in the college's sporting achievements, yet he gave them their proper place. As one reviewer, obviously not a Brasenose man, commented in *The Spectator*: 'Mr Buchan is a clever young Scotsman who, with the intellectual precocity of his race, has produced several volumes while still an undergraduate. He can scarcely be accounted a

*Later, his brother Willie was to occupy the same rooms.

typical product of his College, but he has done his business of chronicling very thoroughly. The subject forbade his making an interesting book, for Brasenose, except on the river and (in the days of Mr. Ottaway) at Lords, has never been conspicuous ... For the outside public Brasenose will chiefly be of interest as the curiously inappropriate setting for Mr. Pater's delicate qualities of mind.'[26]

He continued to spend time in London at the beginning and end of every term, meeting publishers and editors and enjoying himself with friends, away from his family. Now that he was a member of the Devonshire Club, he no longer needed to depend on his elderly uncle and aunt in Clapham for lodging, with all the constraints that that imposed.

During the Easter vacation in 1898 he went north with John Edgar to walk in the Highlands, and encountered difficulties that could have stopped this narrative in its tracks. The pair left the train at the Bridge of Orchy in Perthshire and walked through the Black Mount deer forest until they reached the King's House in Glencoe.* 'The next morning the Spirit of Evil tempted me and I fell,' he told Dick. The two young men decided to climb up Buachaille Etive Mhor (Gaelic for the Great Shepherd of Etive), despite the fact that contemporary guidebooks called it 'inaccessible' and members of the Scottish Mountaineering Club had only succeeded in climbing it the summer before, using ropes and ice-axes. It was a piece of the utmost foolhardiness, for they had no proper equipment and, moreover, were encumbered with waterproofs. It was not long before they became separated, since JB was a more audacious mountaineer, and in his excitement forgot all about Edgar. The going was very hard, for he had to pull himself up, hand over hand, on rocks encrusted with ice, and then cross crevasses of snow:

> Once I thought I was done for. I was crossing a snow-filled gorge when I began to slide. I got on my face and kicked, but I couldn't stop, so before ever I knew I had shot down a chasm away below a great snowdrift of about 20 feet in depth. I thought I should slip to the foot of the drift and be suffocated, but luckily my foot caught a rock and I stopped. The place was pitch dark; only the hole I had fallen through shone like a little patch of light away above me. I was lying flat in the bed of a stream and the icy water was trickling up

*Where part of Alfred Hitchcock's *The 39 Steps* was filmed.

my arms and down my neck. I should think I must have taken an hour to crawl out, inch by inch, and when I reached the open and lay down on a rock, I felt as weak as water and my teeth were chattering with fright.[27]

He managed to get to the summit and, on the way down, he met Edgar, who had had his own difficulties, having lost the nail of a finger when he made an involuntary glissade down a snow-field and fell amongst rocks. Even if one takes account of a youthful over-dramatisation of the incident for the benefit of his rather less adventurous friend (he never went climbing with Charlie Dick), the young men were extremely lucky to survive without much injury.

JB took full advantage of the many opportunities for enjoying what a university town can offer in the third year of a four-year course, despite his punishing and very carefully organised work schedule. Although he never played games for either college or university, he took plenty of exercise and was sufficiently well thought of to be elected a member of Vincent's Club, more usually the preserve of those who played sport for the university.

He also made some enduring close friendships outside Brasenose, in particular with Tommy Nelson, from University College, whom he probably met through Stair Gillon (known as 'Sandy') of New College, since they both came from Edinburgh. Sandy Gillon was a Scot educated at an English public school, who had a big booming voice, a thatch of fair hair, a loyal nature and a very kind heart. He had the capacity to oxygenate the air around him by good humour and sheer high spirits. Tommy Nelson, scion of the Edinburgh publishing house Thomas Nelson and Sons, was a most popular undergraduate and supremely gifted sportsman; he played Rugby Union for Oxford, and gained an international cap, playing outside centre for Scotland in 1898. Almost certainly JB saw him play rugby for Oxford against Cambridge in the Varsity Matches of 1897 and 1898. (There is a gripping account of an international rugby match at the beginning of JB's 1930 novel *Castle Gay*.) Tommy was President of Vincent's when JB was elected, admired for his sanity, warmth of personality and his balance. He also had a pronounced social conscience, which JB – sensitive to these things – divined early on.

Other friends of the sociable Sandy Gillon, to whom he introduced JB, included Harold Baker, Alec Maitland and Hugh Wyndham. And John Edgar, who had arrived that year after finishing at the University of Glasgow, introduced him to an even more distinguished circle of earnest, clever, amusing and very sporting men in Balliol. These were either Scotsmen or English public schoolboys, and a number became lasting friends of JB's, including Raymond Asquith, Cuthbert Medd, 'the cleverest man I ever knew', Reginald Farrer, Aubrey Herbert and his cousin, Auberon, as well as Johnnie Jameson, son of a Scottish judge, Lord Ardwall, a Gallovidian from the edge of the Solway. The 'brain-grey wall'[28] of Balliol sheltered some of the most talented undergraduates in Oxford, since the spirit of the meritocratic, thrusting Dr Benjamin Jowett, who had died in 1893, was still potent there. With the exception of the Herberts, they were not aristocratic, but came mostly from the comfortably-off, well-connected professional classes. None had had such a striving start in life as JB.

There is, in the Buchan archive at Queen's University, Kingston, Ontario, in Canada, a finely wrought book, entitled *Epistolae praecursorum* (*Precious Letters*). Bound in red leather, tooled with gold, it was the work of the famous bookbinder Katharine Adams. As well as letters from, for example, his father and his brother, Willie, there are sixteen letters to JB from Raymond Asquith, the first dating from early 1898. That was not long after Asquith had come up to Balliol from Winchester College, then, as now, one of the most academically demanding of the major English public schools. The keeping of these letters by one who cavalierly threw so many away suggests how much they meant to JB. Certainly Raymond was a remarkable correspondent, even if many of his sprightly jokes and aphorisms have lost their meaning over time. Some might find his subjugation of sense or honestly held belief to a ringing phrase, preferably a paradoxical one, a bit wearisome, but that was the taste of the time amongst young men.

The stories about this good-looking Wykehamist, the centre of this Balliol group, are many and various: for example, that the Professor of Latin tipped his hat to him in the street and asked his father, H. H. Asquith, then a barrister and rising MP, whether he was related to *the* Mr Asquith. According to JB, the good fairies at his cradle 'gave him great beauty of person; the gift of winning speech; a mind that mastered readily whatever it cared to master; poetry and the love of

all beautiful things; a magic to draw friends to him; a heart as tender as it was brave…'[29] Raymond Asquith swept all before him at Oxford, winning the Derby, Craven and Ireland scholarships, achieving a First in both Mods and Greats and, after all that, an All Souls fellowship. Yet he never seemed to do any work; it was apparently effortless. As JB put it, 'An air of infinite leisure hung about him'.[30]

Raymond Asquith was also a very fine speaker at the Union, with a mellifluous voice and a talent for biting satire. What the good fairies withheld from him – apart from a long life – was the gift of a right, respectable ambition. He did not care in the way his friend cared. JB loved him, but could see why he did not appeal to everyone. 'He was immensely admired, but did not lay himself out to acquire popularity, and in the ordinary man he inspired awe rather than liking. His courtesy was without warmth, he was apt to be intolerant of mediocrity, and he had no desire for facile acquaintanceships.'[31] JB was teased mercilessly by Asquith for his Calvinism, his love of wild weather and scenery and his crude, as the other saw it, passion for romance. But what Asquith saw was a brain as acute as his, a learning more ardently striven for, an attachment to the earth that in his Olympian way he did not feel, but could not but admire.

This Balliol circle, of which JB was a cherished honorary member, disliked what they called 'heygates', Oxford men who were old beyond their years and already and obviously mapping out a career for worldly success. (JB kept his heygatism well closeted during his Oxford years.) His set put a premium on levity:

Again, while affectionate and rather gentle with each other, we wore a swashbuckling manner to the outer world. It was our business to be regardless of consequences, to be always looking for preposterous adventures and planning crazy feats, and to be ready for a brush with constituted authority. 'Booms' were a great fashion … It was a 'boom' to canoe an incredible distance between a winter's dawn and dusk; to set to walk to London at a moment's notice;* to get horses, choose a meeting-place, mark down compass-courses and ride them out, though the way lay through back gardens and flooded rivers; to sleep out of doors in any weather; to scramble at midnight over

*Both his son, Johnnie, and his great-grandson, Tommy Wide, achieved this feat, although possibly not at a moment's notice.

Oxford roofs; and to devise all manner of fantastic practical jokes ...
The peculiar features of our circle were that this physical exuberance
was found among men of remarkable intellectual power, and that it
implied no corresponding abandon in their intellectual life. In the
world of action we were ripe for any adventure; in the things of the
mind we were critical, decorous, chary of enthusiasm – revenants
from the Augustan age.[32]

It was no wonder that four of these superheroes – Asquith, Buchan,
Medd and Baker – should have accepted invitations from Arnold
Ward* in March 1898 to join a literary society called The Horace
Club. Members included the dons Dr Bussell of Brasenose and the
Reverend A. G. Butler of Oriel, graduates such as Hilaire Belloc, and
undergraduates such as A. E. Zimmern of New College and Aubrey
Herbert of Balliol. There were honorary members from Cambridge,
including Maurice Baring and Owen Seaman. An Arbiter was chosen
for each occasion, and when it was JB's turn, he invited all members
to the President's Garden in Magdalen to read poems and bring fruit
'after Horatian precedent'. He also allowed the members to bring ladies
as guests, although it is not known how many women took up the
invitation to spend an evening of recited verse that was as likely to
be in classical Greek or Latin as in English. This rarefied gathering of
poets spurred JB to write some of his best early poems: 'Ballad of Grey
Weather', 'From the Pentlands Looking North and South' and 'The
Soldier of Fortune'.

Benjamin** Henry Blackwell, the bookseller in Broad Street close to
Balliol College, was Keeper of the Records; after each meeting, he would
paste the handwritten and signed poems into two handsome Kelmscott
folios.[33] In 1901 he published a limited edition of the best of the poems,
including some of JB's, which earned a mention in *The Times*.[34] The
Horace Club folded after three years, when that particularly brilliant
group of undergraduates left Oxford.

A photograph of JB exists from 1899, which shows, despite the bump
on his forehead and the drooping eyelid, a good-looking young man
in a three-piece suit, high collar and neat tie. He looks a little austere,

*Matthew Arnold's great-nephew and son of the very popular novelist, Mrs Humphry Ward.
**Not Basil as is often, erroneously, reported.

on account of his thin, but not mean, lips and his long, wedge-shaped nose ('questing and sagacious as a terrier's',[35] in Catherine Carswell's memorable phrase), yet his is undoubtedly a very intelligent face. The year before, he had achieved an entry in *Who's Who*, in which his occupation was given as 'undergraduate', and which included his publications to date and his recreations: 'golf, cycling, climbing, angling and most field sports'.[36] Small wonder he was popular. Cuthbert Medd of Balliol addressed him as 'you would-be outspoken pragmatical, puritanical Scotty you'.[37] He was mercilessly teased for his Jacobite sympathies, but his friends were generally respectful of his keenness, drive and maturity, and they found him excellent company. He made something of a thing of his Scottishness, the respectability of which was helped by his friendship with such swells as Tommy Nelson, Johnnie Jameson and Sandy Gillon. He even chaired a Burns dinner: 'It was magnificent, but what an orgy!'[38]

Roger Merriman, an American who became a history professor at Harvard, remembered long afterwards how JB had once come adeptly to his rescue. Merriman had attended a boozy rowing dinner and fetched up at Brasenose 'looking for more fun'. In the Old Quad, someone put a Roman candle down his 'Oxford bags'. A mixture of drink and shock caused him to pass out. 'When I came to, I heard loud voices shouting for John Buchan. "He's the only sober man in B.N.C.!" In a minute a charming young Scot appeared in front of me...' JB carried Merriman off to Balliol, getting past the porter somehow (for it was past 11 o'clock), and put him to bed, even bothering to come the next day to enquire after him. 'From that moment on I adored him,'[39] wrote Merriman.

In one of his periodic drawings-up of plans for the future, on his twenty-first birthday, JB mapped out the next four years under four columns – literary, academic, practical and likely income. Standing for the Union committee was one of his immediate aims. He had been a member for most of his time at Oxford, had seconded a motion as early as the summer of 1896 and, in December 1897, he proposed the motion condemning the Kailyard School. In this, he was almost talking to himself: explaining his desire to shake free of those aspects of Scottish provincial life that he knew could hold him back. His supporters in the debate were two Scottish friends, Robert Rait* and Johnnie Jameson.

*Later Professor of History at the University of Glasgow.

The Oxford Magazine reported, 'His delivery is much improved, though still somewhat indistinct…', and that the types of character of the Kailyard school that he mocked 'were ridiculous, especially its young man of impossible genius from the countryside, and its theologically-minded peasants'.[40] Jameson 'closed the debate in a racy speech in which he spoke of porridge as an English drink'.[41] The motion was carried – just. Not long after, JB was well vindicated in his attitude to the Kailyard School by the publication of George Douglas Brown's famous *The House with the Green Shutters*, which used Kailyard clichés to subvert the genre, by showing the effect of external social change on the supposedly timeless Scottish countryside.* In March 1898 he was elected Librarian, being proposed by the President, E. C. Bentley, who is best known to history as the inventor of the clerihew.

At the end of that summer term, JB attended the New College Ball, at the invitation of Sandy Gillon, in a party that included Johnnie Jameson and Tommy Nelson, as well as two Dumfriesshire cousins of Sandy's, called Caroline and Olive Johnston-Douglas. After breakfast in his room, they went down to the riverside and danced reels barefoot on the grass. The Johnston-Douglas girls** remembered JB many years later as 'very quiet and a bit shy'[42] in comparison to his more boisterous confrères.

Before he left Oxford that summer, he was again invited to the Encaenia; this time to recite part of *The Pilgrim Fathers*, the poem that had gained him – finally – the Newdigate Prize for poetry and, with it, 21 guineas and a place in a distinguished pantheon that included John Ruskin, Matthew Arnold, Julian Huxley and Oscar Wilde. 'Commemoration went off very well and I managed to recite my Newdigate better than I expected ever to be able to spout my own nonsense.'[43] The student paper *Isis* thought it 'more readable than the average Newdigate and – what is of more importance – seems to show greater power of promise'.[44]

This was also the moment when *John Burnet of Barns* ('my big story') was finally published in book form by The Bodley Head. Although

*However, by the time that Anna Buchan began to write novels, which have elements of the Kailyard in them, after the Great War, JB no longer seemed to wish to do battle over it.

**Caroline, later Lady Kinross, became a lifelong friend of JB's. A third sister, Nina, married Sandy Gillon after the Great War.

finished two years earlier, it had only appeared in serial form in *Chambers's Journal* between December 1897 and the following July. JB had originally intended to dedicate it to Lady Mary Murray, but in the end (perhaps under familial pressure?) he dedicated it to his sister Violet's memory, with a Greek epigraphic inscription from Plato, which translates as:

> You used to shine, as the morning star among the rising dawns,
> And now – in death – you shine as the evening star among the
> shades.

Although the novel had been a very great labour to him, he managed to create a believable tale of the 'Killing Time', towards the end of the seventeenth century, and a Borderer, John Burnet, from Barns near Peebles, who is a descendant of desperate reivers, yet has the education of a scholar. This book contains a terrific fight between John Burnet and his wicked cousin, Gilbert, a stirring description of a flash flood on the Tweed, and some rather too long and detailed, but entirely accurate, descriptions of wanderings in Tweeddale and Clydesdale, much influenced by Robert Louis Stevenson's *Kidnapped*. By this time he had lost much of his tendency to overwrite. According to Professor David Daniell, the great Buchan literary analyst, it is in *John Burnet of Barns* that he shows that he has now become a fully conscious craftsman. 'It is not simply that he has learned from classical literature "the virtue of a clean bare style, of simplicity, of a hard substance and an austere pattern".[45] The drastic reduction of epithets ... shows a literary intelligence which has grasped the secret of getting more colour by using less.'[46]

In its review, *The Times* specifically absolved the book from any taint of the Kailyard. 'Mr Buchan's work shows signs of thoughtful elaboration but, nevertheless, it is brightened and relieved by flashes of the sacred fire.'[47] Robertson Nicoll of the *British Weekly*, on the other hand, had a score to settle with the young man:

> Mr Buchan is understood to be a miracle of precocity. There is little that he has not attempted, and more or less succeeded in, during the brief period of his existence, but he has not succeeded in this story ... What his book wants is life ... Mr Buchan may, and I trust will,

do great things; but there is no sign that he will ever do much in fiction.[48]

As JB told Charlie Dick: '*John Burnet* is out, and has been well reviewed by some papers, critically and sensibly by some others, and roundly abused by some of the baser sort (e.g. our dear friend Robertson Nicoll in the B.[ritish] W.[eekly]).'[49] It must be said that it did not sell at all well until after *The Thirty-Nine Steps* was published.

After the end of term, he went north to Ardwall, a small estate close to Gatehouse of Fleet in Galloway, to join a cheerful party of undergraduates that consisted of his host, Johnnie Jameson, together with Sandy Gillon and John Edgar. He found himself in quite a different Scottish atmosphere from that which he knew best, since he was staying in a comfortable country house, solely amongst men of his own age. They galloped ponies along the sands by the Solway Firth, sailed, fished, chased hares with greyhounds, and made an expedition into the remote hills, to the Dungeon of Buchan, where they lunched off pâté de foie gras and drank Burgundy. Since few experiences were ever entirely lost to him, there is a description of the Solway Firth in 'Streams of Water in the South', one of the most accomplished and moving of his early short stories, published in *Grey Weather* in 1899. The Solway also plays a part in *Castle Gay*. During the same vacation, he sought refuge at Broughton for the peace and quiet (for there was a noisy infant brother at home in Glasgow), rather more often than his family would either have liked or expected.

His fourth year at Oxford was spent out of college, at No. 141, The High [Street], opposite 'Schools' (where students still take their university examinations), sharing digs with Taffy Boulter and his old Hutchesons' and Glasgow friend John Edgar. During the previous summer, he had acquired a black collie dog called Dhonuill Dubh ('Donald the Black'), which accompanied him to Oxford. This was a mark of some eccentricity, and required an understanding landlady, not to mention friends, especially as the dog had a habit of disappearing and arriving back in the middle of the night. The rooms were reasonably spacious, and quite in the right place for friends to drop by. Hilaire Belloc, who could not stay away from Oxford, even though he had graduated two

years before, was once heard to call up from the street: 'Buchan, have you any beer up there? Very well, I'll come up.'[50]

JB was gearing up to take his final exams ('Greats') the following Trinity term. He had not much cared for Mods work, with its concentration on close textual translation and analysis; he was happier with philosophy and ancient history. He was taught by highly capable Brasenose dons, in particular the chaplain, Dr Bussell, Pater's old friend. His speciality was Byzantine history and under his tutelage JB became interested in pre-Christian cults, something that helped him later when writing the short story 'The Wind in the Portico' and the novel *The Dancing Floor*. Francis Wylie, his tutor that year, was a philosophy don and an inspired teacher, who found JB 'a brilliant, and already mature mind', perhaps partly because he had been taught so well in Greek philosophy by Professor Jones at Glasgow. He attended university lectures given by such luminaries as Edward Caird of Balliol (who had come from the University of Glasgow) on the moral philosophy of Aristotle, and F. H. Bradley of Merton on Hegel. He was also reading contemporary philosophers, including William James, Henry James' brother, one of the originators of Pragmatism.

He finally achieved his ambition of becoming President of the Union in November 1898 for the Hilary Term (January to March) of 1899, with Johnnie Jameson elected Secretary and Raymond Asquith Librarian. Raymond and 'Cubby' Medd wrote to congratulate him in a characteristic letter dated 2 a.m. 'We are both very drunk ... but that does not prevent us from tendering to you our very heartiest congratulations on our own behalf and on that of all right-thinking men in this University (and the world) upon your election. I wonder if you are as drunk as we are?'[51]

When JB became President of the Union, the university magazine, *Isis*, ran a profile of him under the heading, '*Isis* Idol', and it is worth repeating since it shows how he struck his contemporaries. There was a caricature by Taffy Boulter, one of his most consistent and loyal friends, showing him dressed in a kilt, armed with a sgian-dubh (short-bladed knife) and basket claymore (sword), and brandishing a club, with a background of mountains and a foreground of empty whisky and wine bottles, a libel on one of the more temperate members of Brasenose. The eulogy ran:

In 1895, our Idol descended upon Oxford and began to carry all before him that he cared to trouble himself with – one of the finest things about him is that he has a very good idea of what is worthwhile and what is not.

It is no disrespect to Glasgow to say that he now became really great; it is simply that he developed. Here his powers ripened, his tastes matured, his knowledge of men and things increased...

His powers of work are remarkable, and inspire awe in his friends; he confesses to a deep-seated loathing for what is called leisure. Yet there exists no keener lover of action in the open than he, and no sounder authority upon all branches of Scottish sport...

Our Idol is a very good business-man, and publishers world-famous for robbery have wagged their heads over him, owning they have met their match! ... He has found out something good in everybody. All the same he can be angry when called upon in a right cause. This is established by recent experience.

In politics he is a Tory-Democrat-Jacobite. Legitimacy is his ruling passion ... He collects etchings. He dislikes dancing, and hates ladies. He has no high opinion of the literature of today, on the principle, doubtless, of 'we makes it'. He does not like to hear about his own books; he refuses to be classified as a literary man. His works have a large circulation in the United States, where the newspapers have portraits of him as a tall, melancholy man with unkempt hair and beard...

We know of no one who has had more success, or deserved it better. He is as popular with men as he is with Fortune. We hate eulogy; but we are helpless.[52]

The remark about him being angry in a good cause refers to a contretemps in the college late in 1898. College 'rowdies' caused a rumpus one Sunday night in Hall, accusing the Principal, C. B. Heberden, a cerebral elderly bachelor, of being unsympathetic to their interests and trying to turn Brasenose into an intellectual college. JB spoke up for the Principal (whom he rather liked) in Hall and then, when a fight broke out outside, he berated the sportsmen, saying, amongst other things, that it was time they grew up. According to Janet Adam Smith, 'the baiting stopped, and the chief rowdy was sent down, but Buchan paid for this outburst of righteous anger by a series

of sleepless nights'.[53] Although far from lacking in courage, he disliked conflict and it took its toll on him.

By this time, he was ready to invite his mother and sister to visit him in Oxford, something that apparently required money, self-confidence and the good-humoured help of friends. The two women arrived in February and were put up by JB in a respectable hotel, The Mitre, in The High, close to his digs. He whisked them round the colleges at a very brisk pace, gave a dinner party for them, and took them to an Oxford University Drama Society production of *A Midsummer Night's Dream*. This left a lasting impression on Anna since, despite knowing the play off by heart, she had never been to the theatre before. This was the beginning of her lifelong passion for watching Shakespeare's plays, which would take her to Stratford each spring, and was later to create a strong bond between her and JB's equally stage-struck daughter, Alice.

March 1899 saw the publication of *Grey Weather* by The Bodley Head. The fifteen stories are hymns of love and praise to the loneliest parts of Tweeddale and the people he knew who inhabited it, and are fragrant with the scent of heather and bog myrtle on hot summer days, when they are not chilling from the nightmarish terror experienced by a benighted traveller in the hills.

These stories show how much he had absorbed of his environment in his youth. He confessed to be what the Greeks called a 'nympholept', under the spell of running waters. In his last, unfinished work, *Pilgrim's Rest*,* he had learned to describe everything from a deep salmon pool to a raging torrent or a dripping mossy stone.

Despite all his other activities, he did achieve a First Class degree in Greats (the best of his year) that summer, which was a source of great satisfaction to him. But he scarcely broke step before starting on the study of law 'and the dryer sods of history' that vacation, variously in Tweeddale and Galloway, and when on holiday with his family in Arran in August. This was because his tutors had persuaded him to stay on for the Michaelmas term to try for an All Souls Fellowship, worth a handsome £200, and with enormous academic kudos attached to it. September was spent shooting grouse or partridge on the estates of

*Two chapters of which appear at the end of his reminiscences, *Memory Hold-the-Door*.

various friends, indicative of the smarter, richer world to which Oxford had introduced him.

His Jacobite historical novel, *A Lost Lady of Old Years*, was published that month by The Bodley Head, having first been lucratively serialised in fifteen parts in *Today*. In the dedication to his Scots friend, Duncan Grant Warrand, whose ancestor, the Lord President at the time of Culloden, plays a small cameo in the book, JB wrote that 'it is the story of the bleak side of the Forty-five, of goodness without wisdom, of wisdom first cousin to vice, of those who, like a certain Lord [Lovat], had no virtue but an undeniable greatness'. It is an interesting, if historically inaccurate, tale of 'Traitor Murray' of Broughton and his beautiful wife, whom JB turns into a noble character, which she almost certainly was not. He also experiments for the first time with an unlikeable, angry but redeemable 'hero', Francis Birkenshaw, who is of a gentle family that has fallen on evil days and who, from time to time, lets his gentility down badly. *The Times* thought the book in tone, style and method very influenced by Stevenson's *Weir of Hermiston*[*] but was not critical except about the amount of time given over to Birkenshaw's early life. JB wrote to Charlie Dick that he felt the only real merit in the book, apart from the depiction of Lord Lovat, was the atmosphere of those moorland wars fought in the mists and rain.

By now he was working on yet another novel, his first with a contemporary setting, entitled *The Half-Hearted*, published in September 1900 by Isbister. It was brought out a little later by Houghton Mifflin in the United States; this was his first connection with that publishing company, which would continue until his death. The book was dedicated to his friends, Raymond Asquith, Harold Baker and Cuthbert Medd. Its hero, Lewis Haystoun, a young Scottish laird, the 'half-hearted' of the title, was probably largely based on Raymond, whose post-Oxford letters to JB show him to have been without obvious ambition. However, the book developed from many conversations with his friends about what kind of life they should pursue and how they could develop the will and power to act, when so much had been given to them – brains, classical education, security, personal gifts – without them really trying.

After much navel-gazing by the hero, whose unwillingness decisively to act loses him the girl to a stupider, less conflicted man, the action

[*] Others, such as Professor David Daniell, saw the influence of Stevenson's *Catriona*.

moves to the North-West Frontier of British India, a region providing much anxiety at the turn of the century, because of the expansionist (as the British saw it) tendencies of the Russians. No doubt *Kim* was at the back of his mind: in *Memory Hold-the-Door* he called Kipling an early influence 'more because of his matter than his manner'.[54] This is an uneven book, which lingers too long initially but reaches a stirring, if incredible climax. If the writing of it taught him anything it was that the dual sides of his nature – the romantic and the realist – *could* be harnessed in the cause of creativity, and in later novels he would do this more successfully. However, he told Lady Mary Murray that it was a 'stupid book', written at a time of 'violent prejudice' (whatever that meant) at Oxford. He told her husband, 'I am glad you think I am better at love-making! I hate the stuff. I sit and blush with disgust when I am writing it.'[55]

That October he went to live at 105, The High Street, with Sandy Gillon. A fifth year at university is rarely so good as the others, since most friends have gone down and, in the end, he did not achieve an All Souls Fellowship either. This was, undoubtedly, a great disappointment and one that JB contemplated with a certain, though short-lived, bitterness, since he was considered by many to be a very strong candidate and he thought himself superior to his friend, Dougal Malcolm, who beat him to the History Fellowship.* The letters of indignation and consolation poured in afterwards, including one from his tutor, Francis Wylie, who said that All Souls would be sorry one day that JB's distinctions were not part of the college's record. Dr A. G. Butler, the dean and chaplain of Oriel, wrote to console him: 'Without however underrating the advantages of such a position, still I think it is often good for a man to be cut adrift from Oxford. There is little or no career here; and yet it is so pleasant, that people stay on here and lose their thews of action.'[56] Butler also said in his letter that he was happy to introduce JB to John St Loe Strachey, editor of *The Spectator*, and by that he did the younger man a very great favour.

JB told Gilbert Murray that he hated not to do the things he was expected to, and he was even more forthright to his mother: '... the general opinion in Oxford is that the election is preposterous. I am of course bitterly disappointed, but I will recover. Many thanks for the

* They nevertheless remained friends for life.

many kind letters you have written to me during the last weeks ... I am chiefly sorry that I did not get it for your sake and Father's ... I must cut my coat according to my cloth and take humbler lodgings in town than I intended.'[57] When she wrote bemoaning the fact he would have unpleasant quarters in London, he replied that they wouldn't be nasty, only unfashionable, and that he would have between £200 and £250 for the next two and a half years, while he was training, and that would be enough to live comfortably in a quiet way.

His father was moved to write one of his very rare letters to his son, who thanked him and said that the following year he would try for a Junior Fellowship at Oxford, but 'I will not go in for All Souls again for worlds ... Sandy Gillon has taken All Souls much more to heart than I have. He is inconsolable.'[58] Not for the last time, Sandy would take JB's reverses harder than he took them himself.

JB was not one to brood and, in any event, he had cause to be cheerful that winter when his brother Willie sat the Oxford examinations and achieved a Junior Hulme Scholarship to Brasenose. It was a source of great satisfaction to JB that his clever, ambitious, politically sophisticated, athletic brother (he was a very good soccer player) should go to the same college and experience the same formative and intensely pleasurable four years that he had enjoyed.

Sir Walter Scott told his son Charles that, although some people might scramble into distinction without a classical education, 'it is always with the greatest difficulty, like climbing over a wall instead of giving your ticket at the door'.[59] Oxford had given John Buchan that ticket, as well as the opportunity to discover what talents he had and what he might want to do with his life. He could have stayed on to teach philosophy as a Junior Fellow, but Butler's words had gone deep. In later life he recalled that he 'wanted to explore the wider stages of life'.[60]

The Bar, Journalism and South Africa,
1900–1903

On a windowpane in the parlour of 34 Queen Mary Avenue, Glasgow, is etched a quotation from *Kenilworth*: 'Fain would I climb, but that I fear to fall.' Sir Walter Scott put this phrase into the mouth of Sir Walter Raleigh, a man who, as we have seen, had early captured JB's attention. It is safe to assume that the engraver was JB, rather than any other occupant before or since, most likely at the time when he was thinking hard about what he should do after Oxford.[1]

He arrived in London right at the start of the new century, and found lodgings in The Temple, sharing them with Richard Denman, a would-be City banker whom he had known at Oxford. 'My first rooms were in [4] Brick Court, the ugliest part of the Temple; they were small and new, reached by a staircase of lavatory bricks, and with no prospect but chimney-pots.' He missed Oxford and he missed home. London, which he had enjoyed visiting from Oxford, now seemed to him dull, dingy and inhospitable. Fortunately, his homesickness lasted no more than a month, before he was caught up in the excitement of learning a profession in a cosmopolitan but still fairly small and contained city:

London at the turn of the century had not yet lost her Georgian air. Her ruling society was aristocratic till Queen Victoria's death and preserved the modes and rites of an aristocracy. Her great houses had not disappeared or become blocks of flats. In the summer she was a true city of pleasure, every window-box gay with flowers, her streets

full of splendid equipages, the Park a showground for fine horses and handsome men and women. The ritual went far down, for frock-coats and top-hats were the common wear not only for the West End, but about the Law Courts and in the City.[2]

As was common a hundred years ago, JB had fixed up for himself a few months' training in a solicitor's office – Rowcliffes, Rawle and Co – at 1 Bedford Row, as a precursor to being taken on as a barrister's pupil in a set of Chambers. He had sought advice from a friend's father, a London solicitor, who told him he would be wise to practise commercial law, presumably because it was, then as now, one of the best paid of legal specialisms. Rawle was an influential lawyer – later President of the Law Society – and the firm acted as a prominent London agent for provincial solicitors.[3] But JB had to pay for this privilege. He wrote to his sister, Anna, that month: 'I am liking my office work very much. I get all sort of queer jobs to do, such as rummaging among wills in the Bank of England, and interviewing defaulting Motor Car Companies.'[4]

In the same letter he told her that he had been asked to join a 'special yeomanry corps' for gentlemen who could ride and shoot, to go out to fight in South Africa, three months after the start of the Second Boer War. This war, between the British Empire and two Boer Republics, the South African Republic (Transvaal) and Orange Free State, had begun the previous October. Smouldering political and economic resentments between Boers and 'uitlanders' – immigrants who were mostly of British origin – in the Transvaal, had flared up into a fierce and, as it turned out, lengthy conflagration. JB felt, on advice, that he could not 'play tricks' with his profession. But he told Charlie Dick in late January, 'I have been leading a curious life lately, very busy and keen on my law, very gay, and at the same time tormented with proposals to go to the front, which unhappily fall in with my desires. These last I have now finally conquered, and I can now watch my friends go off without special bitterness.' The truth was that he was in the first flush of fascination with his new profession. 'I am acquiring an enormous craze for the law. Nothing has ever impressed me more with a sense of profound intellectual force than the decisions and pleadings of some of our great lawyers.'[5]

Moreover, there had recently been a severe military reverse in South Africa when, as a result of poor preliminary reconnaissance, the lives

of many in the Highland Brigade, including its commanding officer, General Wauchope, had been sacrificed at the Battle of Magersfontein. Although JB could not bring himself to say it out loud, he was not inclined at this juncture to risk his neck for a cause about which he did not care very strongly.

His office hours were a comparatively gentle 10 a.m. until 5 p.m., five days a week, which gave him the necessary leisure for fee-earning journalism, as well as the writing of books and the reading of manuscripts for John Lane. It was quite natural that he should turn for his freelance work to *The Spectator*, a popular weekly periodical, which was conservative, but generally Liberal Unionist, in politics. Founded in 1828,* the chief proprietor and editor for the previous twelve years had been the clever, Liberal-inclining commentator, John St Loe Strachey, a cousin of Lytton Strachey, and it was to him that the well-disposed Dr Butler wrote a letter of introduction.

JB's first article appeared on 20 January 1900 and was entitled 'The Russian Imperial Ideal', a subject about which he can have had only a limited knowledge before he knuckled down to research it, but which he was exploring in his novel, *The Half-Hearted*. Other articles that appeared that year included one on the decline of the memoir, a review of a book of poems by W. E. Henley, and an editorial on the politics of Roman Catholicism in Italy and France. His ambit was wide: he wrote on the law, philosophy, economics, history, literature, religion, and even angling and mountaineering. It was both an excellent training in getting up a subject quickly (much the same as the law in fact), and a necessary one, if he were to develop further an easy, attractive, popular literary style.

Since *The Spectator* was run on a shoestring, yet had an influential, cultured and educated readership, he had often to work at great speed and to delve into areas with which he was unfamiliar. His articles on South Africa, before he arrived there in October 1901, for example, reveal his youthful leanings and prejudices, uninhibited by much real appreciation of the situation on the ground. But he proved himself to be a quick learner, and the imperatives of producing copy more or less every week loosened his writing style. He began to display both

*It should not be confused with *The Spectator*, founded by Joseph Addison, which flourished for a short while in the early eighteenth century.

authority and a distinctive tone, especially where literary criticism was concerned.

His voracious early reading of established authors, his broad education, as well as his introduction to unpublished manuscripts – good, bad and indifferent – by contemporary authors, had taught him to discern not just what might sell but also what might be of lasting quality, and this made him an increasingly accomplished critic. He followed Sir Walter Scott's example of being a kindly and courteous one as well. Many an author, known and unknown, had their day cheered by a sympathetic review, where praise was always judicious and criticism never captious or self-regarding.

He very soon began to spend part of each week in the offices at 1 Wellington Street in Covent Garden, writing his articles there as well as helping with much of the nitty-gritty of putting a weekly magazine together. He did not tell his legal seniors that he was doing this – something made easy by the fact that articles in *The Spectator* were anonymous. This was the common practice at the time, although it also had the advantage of disguising how few people actually wrote for the paper. He even deputised for St Loe Strachey for short periods at various times in 1900 and 1901, for example when the latter attended Queen Victoria's funeral.

The offices in Wellington Street were situated in a tall, narrow building. As JB wrote, at the time of the centenary of *The Spectator*'s foundation: 'On the first floor St Loe Strachey sat, surrounded by new books, writing articles on foolscap paper in his large, illegible hand, breaking off to stride about the floor and think aloud for the benefit of the visitor, overflowing with gossip and quotations, so full of notions that it seemed as if no weekly journal could contain one half of them.'[6]

On the floor above worked Strachey's predecessor as editor and proprietor, the venerable and once great leader writer, Meredith Townsend, by then in his early seventies, who had bought *The Spectator* in 1861 and edited it for more than thirty years, and to whom Strachey obviously felt a great loyalty:

> On the next floor ... Charles Graves [the deputy editor and nephew of Sir Edward Grey, the Foreign Secretary] had his dwelling and I my modest chair. It was our business to see to the base mechanical details of editing, to correct proofs, and above all, to keep the great men

below us straight. For Townsend had sometimes a noble disregard of current news, and Strachey rarely got a classical quotation quite right. Charles Graves and I were supposed to represent the critical and unsympathetic outer world ... It was a merry place, as I remember it ... Among the little group of us there was complete confidence and liking. I know I benefited enormously. The kindly admonitions of Charles Graves suppled the joints of my style, which was rapidly becoming a dreadful compost of legal and philosophical jargon; and, under Strachey's influence, one who at Oxford had been a stern and unbending Tory was in danger of becoming something very like a Whig.[7]

What JB did not say about Graves was that he had a kind of genius for cultured comic verse, which had its full flowering when he wrote for *Punch* before and during the First World War. We are fortunate to have a poetic portrait of JB written by Graves, recalling his time at *The Spectator*, which appeared in a collection of his poems published in 1912.[8] It merits reproducing in part, since it contains some very perceptive insights:

TO JOHN BUCHAN
... Ev'ry Tuesday morn, careering
Up the stairs with flying feet,
You would burst upon us, cheering
Wellington's funereal street,
Fresh as paint, though you'd been 'railing'
Up from Scotland all the night,
Or had just returned from scaling
Some appalling Dolomite.

Did we want a sprightly middle
On the humour of the Kirk?
Or a reading of the riddle
Set in Bergson's* latest work?
Did we want to show that Paley's**

*The French philosopher, whose works fascinated JB at the time.
**Presumably William Paley, the eighteenth-century Christian philosopher.

Views were based on *iravra pel*?*
Or to prove that capercaillies
Nested in the Isle of Skye?...

Pundit, publicist and jurist;
Statistician and divine;
Mystic, mountaineer and purist
In the high financial line;
Prince of journalistic sprinters –
Swiftest that I ever knew –
Never did you keep the printers
Longer than an hour or two.

Then, too, when the final stages
Of our weekly task drew nigh,
You would come and pass the pages,
With a magisterial eye:
Seldom pausing, save to smoke a
Cigarette at half-past one,
When you quaffed a cup of Mocha
And devoured a penny bun...

In this verse, Graves managed to nail a number of facets of JB's personality, in particular his modesty, fizzing vitality, impressive intellect and mild ascetiscm, as well as the speed at which he worked and the variety of his occupations and preoccupations.

Added to all this excitement, JB was in some demand socially. He had already been marked out as an interesting and coming man before he left Oxford, since many of the university's alumni were in the higher reaches of politics and society. He had not been in London a fortnight before he was dining with Lady Arthur Russell** in South Audley Street, in company that included the Home Secretary, the party then going on to see *She Stoops to Conquer* at the Haymarket Theatre. On another

*The theory, proposed first by Heraclitus, that the world is in a state of 'unceasing flux'.
**The widowed Lady Arthur Russell was known for the quality of the talk at her table.

occasion, he told his sister: 'We went to the Hippodrome pantomime. I wish that Mhor [his little brother Alastair's nickname, a Gaelic word meaning 'the Great One'] could have seen it. It is really a fine spectacle and the performing seals are immense!'[9]

The elder statesmen R. B. Haldane and Arthur Balfour, as well as senior judges such as Lord Halsbury, began to take an interest in the young man and he dined almost every week with Canon Ainger, the humane, godly and witty Master of the Temple Church.* 'I frankly enjoyed dining out. For a minnow like myself there was the chance of meeting new and agreeable minnows, and the pleasure of gazing with awe up the table where at the hostess's side was some veritable triton.'[10] When no invitation was in the offing, he would go to one of his clubs, the Devonshire, the Cocoa Tree (mentioned by his beloved Thackeray) or the Piccadilly, all in St James', where he could depend on meeting Oxford friends or being introduced to some 'figure' in politics or business. He began to spend weekends at houses in the country, such as the one belonging to the Gilbert Murrays, at Churt in Surrey.

During his lifetime, and indeed afterwards, JB was sometimes accused of being 'on the make' or, even more damning, 'a Scotsman on the make'. While he lived, this charge almost certainly came from men either in receipt or expectation of inherited wealth, who had little sympathy or understanding for those not born with their advantages and without the desire or facility to dissemble. Later, the accusation came from those who saw how far he had managed to go, and suspected that it could only have been possible through sheer ambition, which excluded everything else, in particular the wants of family and friends.

By the time that he arrived at Oxford, JB knew that he and his brothers would have to support their parents, certainly in old age but possibly long before that, as well as their unmarried sister, Anna, who was not expected to earn money for herself. Only dutiful sons could prevent an impecunious old age for a church minister who, when working, had been entirely dependent on the generosity of his congregation. If JB had been truly 'on the make' he would have gone into the City, like his flatmate, Richard Denman,** where he might well earn a fortune,

*The minister of the church of the Middle and Inner Temple Inns of Court.
**Who, once his financial position was secure, became first a Liberal, then a Labour politician.

rather than embracing the much more precarious professions of the Bar and quality journalism. JB's obvious ambition may not have been very attractive to rich men who could afford to be more languid, but it is entirely understandable. And, as we shall see, there were times when he worked against his own financial self-interest; for example, by going into public service rather than business in South Africa, as well as writing memorial volumes after the First World War, instead of thrillers, which his wartime successes suggested would be a great deal more profitable. JB's well-wishers must sometimes have despaired at how much time he was always willing to give to unremunerative or unremunerated projects.

After a few months as planned, JB left Rowcliffes' to become a pupil in a set of Chambers in Harcourt Buildings, his 'pupil master' being John Andrew Hamilton, later Lord Sumner, a Lord Justice of Appeal. 'That was a privilege for which I shall always be grateful, for it gave me the friendship of a great lawyer, who, in the evenings when the Courts had risen, would discourse cynically and most brilliantly on men and affairs.'[11] What Hamilton would also have told him, however, from bitter early experience, was that barristers lived a rackety life; even the really good ones were often 'briefless', and therefore impecunious, for long periods.[12]

He studied hard to make himself a good lawyer, reading the law reports assiduously, but also the lives of lawyers, which most people would find very dull. He analysed every one of Lord Mansfield's judicial decisions, and decided to write his *Life* in three volumes, a project he began but never finished.* He thought the position of a judge the most honourable, dignified and independent of all, and one to which he aspired in the fullness of time. Progressive traditionalist that he was, he loved the rituals of the Inns of Court – 'the sense that here was the hoar-ancient intimately linked to modern uses'.[13] He also thought that the very exactitude of the law was an important corrective for people like him who were principally educated in the humanities and, he might have added, temperamentally inclined to juggle a number of balls in the air at one time.

*The Earl of Mansfield, the eighteenth-century Scottish judge who became Lord Chief Justice.

Despite having protested vehemently that he never would do such a thing, he did in fact sit once more for an All Souls Fellowship that autumn. Again he failed, but this time the failure seems to have had much less effect on him, since he had moved on to other things. He wrote to his brother, Willie, now at Brasenose, 'I felt annoyed at the time but have forgotten it now. It seems to have been a very close thing, and I had heaps of letters from different All Souls fellows saying how disappointed they were.'[14] He had come to realise that leaving Oxford had been, in many ways, a lucky escape. In December he felt sufficiently financially secure to leave dreary Brick Court for much nicer quarters at 3 Temple Gardens, which he shared with Richard Denman, Harold Baker and Cuthbert Medd, and from where he could see the river and hear the calls of wild birds as they flew upstream in winter.

So busy was he pursuing his own study of the law, in particular his biography of Lord Mansfield, that he failed to prepare properly for his Bar Finals exams and ploughed them in January 1901. At the same time, Hamilton 'took Silk' (was appointed a King's Counsel), so JB moved on to Sidney Rowlatt's Chambers. Rowlatt was junior counsel to the Inland Revenue, so JB had the chance to learn more than the rudiments of tax law and legal practice: 'From Rowlatt I learned many lessons, chief of which was that scholarship was as valuable in law as in other things … Moreover, he stripped the subject of pedantry and dullness; he had the same boyish zest in tracking out a legal conundrum as in sailing his little yacht in the gusty Channel.'[15] JB also did work for the Attorney-General, Robert Finlay, to whom Rowlatt recommended him.

He wrote copiously for both *The Spectator* and *Blackwood's Magazine*, and the family felt the benefit. That spring he sent Anna a fur coat ('I thought I might as well get a good one, for it will wear better…') and a book of theological essays to his father, although he rather doubted – unfairly – that his father would read them, 'such is his invincible distaste for theology…'[16]

At Whitsun 1901 he was invited by Auberon Herbert's uncle, Lord Cowper, to stay at Panshanger in Hertfordshire. Cowper was known for hosting house parties of thirty guests or more, so this was an important step in JB's progress into both political and aristocratic circles, since these intersected. The guest list included Lady Curzon, Arthur Balfour and several members of the Cecil family. This may have been when

he first met Lord Robert Cecil, who became a lifelong friend and political ally.

When he was not invited away for a weekend, he would travel into Hertfordshire for a day's fishing on the dry fly, accompanied by Andrew Lang, the prolific and talented writer of fiction, poetry and literary criticism, best known now for his books of fairy tales and folklore. He was an old friend of JB's from the Borders, and the man to whom *Musa Piscatrix* was dedicated. Lang would tease him about losing his Scottish ways, although coming from Lang, who lived in London for half his life, that was a bit rich.

In June, having passed his Bar Finals at last, he was 'called to the Bar', and joined the Northern Circuit. Then, as now, it was possible to have tenancy in Chambers in London but with your principal work coming from elsewhere. He was kept busy with work for Rowlatt – a Parliamentary Bill – and had to dash between the offices of *The Spectator*, the House of Commons and Chambers, since he was deputising for Strachey again, but also helping to prepare the case for the Crown in the infamous Earl Russell appeal before the House of Lords. (Lord Russell had been convicted of bigamy at the Old Bailey, and the conviction was upheld by the House of Lords. He went to prison for three months.)

In early July, Richard Denman left the bachelor lodgings in Temple Gardens and those left – JB, Harold Baker and Cuthbert Medd – acquired a comically lugubrious manservant called Mole: 'ex-artillery man, a profoundly meditative and serious person, very respectable, a little slow', who made very good porridge, but had a habit of boiling eggs 'to the consistency of a Mauser bullet. He is very good at folding clothes and all kinds of valet work.'[17] (Paddock, in *The Thirty-Nine Steps*, bears a close resemblance to Mole.) With so much 'gaiety', JB required a Jeeves to keep his dress clothes pressed, and enough shirts folded for his 'Saturday-to-Monday's in the country. Because it was the Season, he was going out in the evening a great deal, however much he protested that he hated dancing.

He told his sister in early June: 'I dined with Lady Arthur on Wednesday – Paul Phipps, Miss Florence Wolseley (an heiress, begorrah!),* the Lindleys and Lady Mary Morrison. Then we went

*In those days, every young bachelor would be told who the heiresses were. It must have been acutely uncomfortable for the women involved.

to Lady Sligo's dance, which was very crowded. The Duchess of Northumberland had the most amazing diamonds I have ever seen. Then I went on to Lady Tweedmouth's which was horribly packed. I danced once with Lady Grizel Cochrane, and then I got away early.'[18] One wonders how early 'early' was. He told Charlie Dick, in one of his now rare letters to his old friend: 'I think I have at last found my feet in London – that is, I can enjoy life and at the same time get through a great deal of work. Last year I was rather experimenting, gay and serious by turns, but now things have got relegated to their proper places.'[19]

Into this settled, busy, but mildly precarious life came a crashing thunderbolt. One day in early August, JB was summoned to the Colonial Office to meet Lord Milner, High Commissioner of South Africa, who was in England for a holiday and to recruit staff for the reconstruction of the occupied Boer republics of the South African Republic and the Orange Free State now, or shortly to be, under British control. 'He was convinced that for so novel and strenuous an undertaking he needed both youthful energy and unconventional minds,'[20] wrote Leo Amery, who was one of the young men he wanted on his staff. However, as Amery was working for *The Times* on its *History of the War in South Africa* and did not feel he could let the newspaper down, he suggested instead that Milner approach JB, whom he had known at Oxford.

Besides Amery's recommendation, Milner had also discovered from Joseph Chamberlain, Secretary of State for the Colonies, that JB had been the author of an article on South Africa that had recently appeared in *The Spectator*. In it, he had written that the task of reconstruction after the war was comparable to that after the American Civil War and that it would mean 'years of work before us, only to be undertaken by responsible and serious men'.[21]

On the spot, Milner offered the young man the chance to go out to South Africa as one of his private secretaries, writing a few days later from RMS *Saxon*, on his way back to South Africa: 'A certain sum has been put at my disposal to enable me to provide myself with extra secretarial assistance during the exceptionally heavy work immediately before me. Any men, whose service I may secure, will not be <u>salaried officials</u>, or members of the official hierarchy, but will be, individually, working exclusively for me and directly under me. As between themselves they will have no rank or seniority, and I am making an independent

arrangement with each of them, the terms of which I should prefer not to be divulged.' He was prepared to pay JB £1,200, for a year's contract initially, but renewable. 'I cannot foresee the shape of the new administration, and you will have to find out what you think of the country and its prospects. The whole thing, as I told you, is a "gamble" for you. But personally I think it is a good chance.'[22]

A very good chance for JB, certainly, but Milner was taking a big chance with him, since the young man had no practical administrative experience of any kind and might very well turn out to be damagingly naïve, dangerously maverick or both. He wanted JB to write reports for him, help with despatches to London and, as JB told Richard Denman, 'do certain pieces of special confidential work'.[23] Without a doubt, this Liberal politician also wanted JB to act as a conduit to St Loe Strachey at *The Spectator*, for South African administrators and policy-makers needed friends cheering them on back home. Indeed, while he was in South Africa, JB wrote every fortnight to Strachey as well as (anonymous) articles for *The Spectator* and elsewhere.

Milner had told Sir Percy Fitzpatrick, the South African businessman and politician: '... I mean to have young men. There will be a regular rumpus and a lot of talk about boys and Oxford and jobs and all that ... Well I value brains and character more than experience. First-class men of experience are not to be got. Nothing one could offer would tempt them to give up what they have ... I shall not be here for very long but when I go I mean to leave behind me young men with plenty of work in them...'[24]

JB was flattered, intrigued and excited by Lord Milner's offer, but he consulted widely amongst his legal sponsors as well as Strachey to see what effect, if any, a two-year* sojourn in South Africa would have upon his future career. They were reassuring, the Attorney-General telling him that it would not hurt him, quite the reverse, and that having been a private secretary to Milner would secure him a lot of South African 'appeals'. Strachey promised to give him first refusal of Townsend's place at *The Spectator* if it fell vacant while he was away, and that his old place would always be available for him when he returned.

*Lord Milner in his letter only offered one year, in the first instance; however in conversation they had talked of how it might be two.

JB chose to be reassured, telling a friend that he would return: 'with a knowledge of S. Africa unique among English lawyers, and chances of Colonial appeals. My inclination was all for coming, for I love seeing the world and I much prefer politics to law.'[25] It is hard to know if this is disingenuous, or just a conflicted state of mind. But at least, as he told Denman, by deciding to return to the Bar after only staying two years, he would be burning 'very little ship's timber in his wake'.[26]

He told his mother, who was not happy about the prospect, that he was free to come back when he wanted, that he would probably get back to Britain once or twice in two years (which proved illusory) and he would be able to save half of the £1,200 a year (some of which she knew would end up in her purse). He also told her that the Attorney-General had said it was like going on a legal mission such as the Venezuelan Arbitration.[*] 'I would be going to live in comfort in one of the healthiest places in the world ... Also it will be an adventure...' But 'I am not going if it is to hurt you badly.' Nevertheless, he thought it 'a great chance, an interposition of Providence',[27] which he knew was usually a winning argument with his mother.

Shortly afterwards, he wrote to Lady Mary Murray, to whom, in the absence of a mother who could be rational about such matters, he turned for advice. He told her it was a great honour to be associated with Milner, whom he admired, in 'so serious and difficult a business'.[28]

He cancelled a proposed trip to Norway with A. C. Gathorne-Hardy (an old Oxford friend) and, instead, went up to Scotland in late August to say goodbye to his family, bringing Anna down south with him to help pack up belongings for home and to wave him goodbye. He hosted a convivial farewell dinner for his friends; they included Cubby Medd, who came all the way from Northumberland for it, and Hugh ('Algy') Wyndham, who had also decided to go out to work for Milner. Anna was sent home with a gold bracelet for his mother. 'My bonnie old mother, I hope you are being brave and not moping. Two years will go past before you know.'[29]

[*] The Venezuelan Arbitration of 1895 concerned the resolution of a boundary dispute between Venezuela and the United Kingdom over a portion of British Guiana. In *The Power-House*, Edward Leithen is very bound up with the Chilean Arbitration at the time when the arch-villain, Andrew Lumley, dies.

He sailed for South Africa from Southampton, aboard the RMS *Briton*, on 14 September 1901. After such a sober, tiring, sometimes professionally dull time in London, when, as he said, he had 'slipped into a sort of spiritual middle-age', he felt youth coming back to him like a spring tide:

> As soon as we had passed the Bay of Biscay I seemed to be in a new world, with new scents, new sounds, new sights. I was intoxicated with novelties of which hitherto I had only had glimpses in books. The blue days in tropical waters were a revelation of bodily and mental ease. I recovered the same exhilaration which long ago, as a boy on the Fife coast, I had got from the summer sea.[30]

'As far as weather and seas we might be on the road to Colonsay,' he told Anna. 'It is only at night when we have gigantic castles of crimson clouds in the West and dolphins and flying-fish playing round the vessel, that one realises that one is in a very different bit from Quothquan', a reference to a picturesquely named village close to Biggar.[31] While on the ship he read the proofs of his five *Blackwood's* stories, which were to be published as the collection *The Watcher by the Threshold*, and wrote the dedication to Sandy Gillon, who was now reading for the Scottish Bar: '… It is of the back-world of Scotland that I write, the land behind the mist and over the seven bens, a place hard of access for the foot-passenger but easy for the maker of stories …"

He also made sure he had some idea of the background to British policy in South Africa by reading a number of the 'Blue Books'; these were British government publications containing reports from the colonies, on which policies were based. Contributing to these Blue Books was one of the tasks that Milner would ask of him. He had thought rather more about the British Empire than many men of his age, although that might not have been saying very much, and the subject certainly touched his idealism. To begin with, he was a Scot, which made him, in 1900, in some ways a 'colonial', certainly a man

*Dedication to *The Watcher by the Threshold*. An edition of *The Compleat Angler* by Izaak Walton, with introduction and notes by JB, was published by Methuen in November. It was dedicated to Sir Edward Grey, politician and passionate fly-fisherman.

from the periphery. He also had the young Scotsman's urge for wider skies and broader horizons. And he had a high regard for what he saw as the merits of Western civilisation, which had creatively enfolded both the Hellenistic and Roman, and was underpinned by Christianity. To him, as to many others educated in the same way, the British Empire project was a civilising mission amongst peoples who had not had such advantages, but could slowly be drawn to benefit from them.

JB also saw Empire as providing opportunities for adventurous spirits to test themselves to the limit in challenging environments – Lewis Haystoun loses his life but finds his soul on the Indian frontier in *The Half-Hearted*. And, as he wrote many years later and, it must be said, with the benefit of hindsight, he saw 'in the Empire a means of giving to the congested masses at home open country instead of a blind alley … Our creed was not based on antagonism to any other people. It was humanitarian and international; we believed that we were laying the basis of a federation of the world.'[32]

After a fortnight at sea, he landed at Cape Town, where he did not tarry, leaving soon after by train, amidst crowds of refugees fleeing from the sporadic guerrilla warfare. He was bound for Johannesburg, where Milner was based. The train passed through the Karoo, where he saw 'huge stony hills, absolutely desert, except for clumps of heath and prickly pears and cactuses. The air was marvellously fine and clear, and sunrise was a thing to remember. We breakfasted at Matjesfontein [sic], and I had time to have a look at [General] Wauchope's grave.'[33] Once he had crossed the Orange River into the Orange River Colony, newly if fragilely under British administration, the country became flatter and more pastoral. Here soldiers came out of their trackside barracks, their bayonets fixed. 'Soldiers began to come in at wayside stations – officers going up to Bloemfontein, so dirty and ragged that only their white teeth and clean nails distinguished them from tramps.'[34] Near the border with the Transvaal, he encountered a young lieutenant-colonel, Douglas Haig. JB arrived in Johannesburg on 4 October, having travelled, he reckoned, about 8,000 miles in twenty-one days. 'It was pleasant to get clean again and get between sheets, and I went to bed and slept like a graven image.'[35] He reported to the Office of the High Commissioner the next morning, and was allocated an office to himself.

Never much liking hotel life, he almost immediately set up house in Parktown, an easy horse ride north of the very new and raw city of Johannesburg, with other young Britons working in the administration: Gerard Craig Sellar, Hugh Wyndham and Lord Basil Blackwood. The last arrived with seven lurchers, forty walking sticks and an Indian servant.[36] JB was to write of this charming man as he knew him in South Africa: 'His air was full always of a quiet cheerfulness, with a suggestion of devilment in the background, as if he were only playing at decorum. His interest in life was unquenchable, and he found endless amusements in that somewhat dull environment.'[37] The house, wooden in construction with a wide verandah, was set on the edge of a wood, but looked out towards the Magaliesberg forty miles away, 'a great range of jagged blue mountains which might be the Coolins [Cuillins of Skye]',[38] he told Stair Gillon. It had a flower and vegetable garden, an orchard and good stabling. Craig Sellar imported his English housekeeper, butler and maid, while a number of local men looked after the horses, the cow, the two dozen chickens and the maize ('mealie') patch, so this bachelor establishment was well cared for.

Except for JB, these men came from aristocratic families and, apart from Blackwood, they were all rich. However, they were not so spoiled that they would not roll up their sleeves and dig the vegetable garden. JB was detailed to look after the flowerbeds and took pains to pull up the indigenous South African species in order to sow European flowers. In that regard he could not be said to be ahead of his time. He told his sister, 'My father would rejoice at the sight of hot-house plants like heaths and begonias springing out of the dust.'[39] Although these young men gardened, they still dressed for dinner, as if they were in England.

The group chosen by Milner to be his private secretaries, or allocated specific tasks in the post-war reconstruction, shifted in personnel over the years until his departure in 1905, but it was always about a dozen strong. It included Hugh ('Algy') Wyndham, a son of Lord Leconfield; Robert Brand, a son of Lord Hampden, Governor of New South Wales; Lionel Hichens, who had fought in the Boer War and would one day be Chairman of Cammell Laird, the shipbuilders; Lionel Curtis, who had also fought in the Boer War and who became

an important imperialist thinker; Patrick Duncan, the clever son of a Scottish crofter who became Governor-General of South Africa in 1937; Geoffrey Robinson, later called Dawson when he was the influential Editor of *The Times*; Dougal Malcolm, a classics scholar who had beaten JB to the All Souls Fellowship; Lord Basil Blackwood, a younger son of the Marquess of Dufferin and Ava, who illustrated Hilaire Belloc's *Cautionary Tales*; and Philip Kerr, later the Marquess of Lothian, who was Lloyd George's private secretary in the last two years of the Great War and helped draft the Treaty of Versailles. (Gerard Craig Sellar was a friend, but not a member, of Milner's staff, having been sent out by Joseph Chamberlain from the Colonial Office to be Clerk to the Legislative Assembly.)

They were Oxford graduates, bright, enquiring, hard-working, self-confident, liberal-minded by the standards of the time, although inclined to a patrician sense of superiority, and by no means free of the pervasive paternalism with which Britons viewed the constituent parts of the Empire. They were conspicuously loyal to Milner. They were nicknamed 'The Kindergarten' by a barrister in Johannesburg who disliked Milner, and they adopted the name as a badge of pride. JB maintained later that he had been a member of the forerunner to the Kindergarten proper, what he called 'The Crèche'. Most of the Kindergarten later became members of the Round Table, an organisation that advocated imperial federation, with ever closer political and economic unity of the various parts and even, ideally, in the future a world government. Significantly, JB was never a member of the Round Table since his ideas on the way the British Empire should develop began to diverge from those of Milner and his young administrators before he left South Africa.

Soon after JB arrived in Johannesburg, he joined the mounted battalion of a territorial outfit called the Rand Rifles. The main function of this unit was to defend Johannesburg and the army posts surrounding it from attack by Boer guerrillas. In fact, JB lasted as a trooper only until April 1902, because his urgent work for Lord Milner precluded him from turning out much, if at all. He told his son Johnnie that he had been shot at by Jan Smuts five times as he and two other troopers galloped away from an ambush, an exciting tale of derring-do almost certainly

with no basis in fact.* He seems, however, to have been awarded the
Queen's South African Campaign Medal,[40] so the story may not be
complete nonsense.

JB struck up a swift rapport with Lord Milner, whom he found
kind, approachable, helpful and extraordinarily hard-working, if
rather emotional and not always level-headed. He was to feel a deep
and enduring loyalty to him – and vice versa. Although they had met
just once in England, Milner's reputation was well known in Oxford,
for he had been a mighty scholar. Benjamin Jowett, the Master of
Balliol, considered him the ablest student of his time. Twenty years
older than JB, Milner had put away his scholarship on a high shelf
and become a dedicated senior public servant, both in England and in
Egypt, before going out to South Africa in 1897, where his reputation
became extremely mixed; he was applauded by some as the strong man
in a crisis, but criticised by others for bearing some responsibility for
the war, because of his intransigence. Certainly, he didn't think a great
deal of Boers and he could never see eye to eye with President Kruger
of the South African Republic. When JB arrived in the autumn of
1901, the British were finally winning what ha.d been a surprisingly
difficult and protracted campaign, and thoughts had turned to post-
war reconstruction, where Milner's talents as a courageous, pragmatic,
if autocratic administrator, who understood finance, began to reveal
themselves.

JB's tasks, initially, were to draft despatches and prepare reports on
various subjects for 'His Exc – very much the sort of work an industrious
"devil" at the Bar does for his leader.'[41] He worked long hours, as did all
the administrators, but felt marvellously invigorated nevertheless.

For Milner, and thus for JB, two of the main problems facing South
Africa towards the end of the Second Boer War were, firstly, how to make
the country districts prosperous and peaceful again as soon as possible
after such a terrible ravaging and, secondly, how to get the Transvaal
mines going once more, since on these the economic prosperity of
the country depended, at least in the short term. The first concerned
the Afrikaners, the second the Uitlanders, who were non-Boer white
expatriates who had come to South Africa in the nineteenth century
to work in the mines and elsewhere. JB wrote to Dougal Malcolm's

*Jan Smuts being nowhere near Johannesburg at the material time.

wife, Angela: 'There is uncommon latent wealth, both mineral and agricultural, and when we have quiet, well-governed industrial towns and the country districts leavened with English settlers and made prosperous by a scientific irrigation system, the land will be on the road to genuine prosperity. Meanwhile, of course, things are still in embryo, and the martial law régime retards our civil reconstruction.'[42]

While settling in to his new life, he had also to deal with his parents' decision to come out to South Africa, after his father received an invitation to act as a locum minister in Port Elizabeth for six months. His wife thought that the change of scene would be a holiday for him. Despite ever more desperately discouraging letters from JB, his parents arrived in South Africa in December 1901, bringing with them Alastair, aged seven.

JB's disapproval of the scheme no doubt had more than a tinge of 'am I ever going to get away from my parents?' irritation – his letters to his sister at the time have a decidedly ironic tone – but it was prompted by very real concerns as to how restricted their movements would be, since martial law obtained at the ports, and they would be vulnerable to illness in the unhealthy climate of south-east Africa. He offered to help pay for a holiday for them in Madeira or Egypt, but to no avail. They would not be told.

In the end, the six months passed off reasonably well, even JB having to concede that, since everyone was very kind to them, it would do them good. His brother Alastair acquired a mongoose which, in that bookish family, was inevitably called Rikki.* However, by the end of April they had had enough: '[Father] makes a good traveller, but a bad colonist',[43] JB told his sister. He was certainly rather shocked by how thin his family were when he went to visit them in Port Elizabeth in the second half of May 1902. Soon after, they left to go back to England, much to everybody's relief.

JB was detailed by Milner to work on two major projects, which were to take him all over southern Africa, from the Cape to the Limpopo River, engendering a deep, long-lasting love of the country as a result. They were, firstly, the improvement of conditions in the 'concentration

*Rikki-Tikki-Tavi is the brave mongoose hero of a short story in Rudyard Kipling's *The Jungle Book*, published in 1896.

camps' – the first time that this phrase, made so hideous by the Nazis in
the Second World War, was used – and, secondly, the business of land
settlement after the war. These were highly sensitive issues.

The refugee camps had been set up during the war by the British
Army to accommodate the many people, especially, but not exclusively,
Boer women and children, who had been displaced by General Lord
Kitchener's 'scorched earth' policy, whereby Boer farms were laid waste,
to prevent the guerrilla commandos from getting supplies from their
own kin. However, the conditions in these tented camps had become a
scandal, with disease and malnutrition rife as a result of overcrowding,
while the education of the children was abysmal or non-existent. JB had
written in *The Spectator* shortly before he left for South Africa about the
inmates of the refugee camps: '… we have to remember that our charges,
while they are the relatives of our enemies, are also the stock of our future
citizens. We have to preserve good temper, patience and humanity,
knowing that every misfortune will be only too readily interpreted as a
crime.'[44] He was horrified when he first visited the camps.

The terrible conditions there had caused a furore in Britain, fired by a
courageous activist, Emily Hobhouse, who had toured many of the camps
in the summer of 1901. The outcry her report engendered prompted the
government to set up the all-women Fawcett Commission, chaired by
the Liberal Unionist and prominent suffragist Millicent Fawcett; they
visited the camps and recommended sending out many more nurses
and teachers from home or other colonies, increasing food rations and
achieving much higher levels of hygiene.

Joseph Chamberlain, Colonial Secretary and, by the by, father of
Neville, bowed to pressure from both sides of the House of Commons
and instructed Milner to override military control of the camps in order
to bring the death rate down. The situation was not easy, however,
since, as JB told his brother Willie, the military was not only 'damnably
incompetent' but also obstructive. In December 1901 he wrote to
Richard Denman: 'I have been worrying [Lord Kitchener] lately to get
supplies for my camps and he has nearly taken my head off.'[45]

It was JB's task, with others, to decide questions concerning water
supply, sanitation, catering, hospital and financial management – a
challenge for a young man of twenty-six without, as yet, much grasp of
the Boer language, known as the 'taal'. He found it expedient to invent
a wife and children in order for his words to carry any authority at all

with the Boer mothers. However, by mid-January 1902, he could write to Charlie Dick, 'Thank Heaven, now things are better, and I think Chamberlain may face Parliament confidently.'[46]

He wrote to a very concerned Lady Mary Murray at the same time: 'The Refugee Camps have made my hair grey. When we took them over they were terrible – partly owing to the preoccupation of the Military with other things, partly to causes inherent in any concentration of people accustomed to live in the sparsely peopled veldt. I shall never forget going through the hospitals a month ago, where the children were dying like flies. We have now revolutionised the whole system, and the death rate is down to something nearly normal now.'[47] Not only were the physical conditions greatly improved but so also was education for the Boer children, provided by teachers who came from across the British Empire, and who often stayed to settle permanently.

With the end of the war in sight, there was pressing urgency to resettle the rural Boers back on their farms. In 1939, JB recalled that:

> ... we [meaning the whole of Milner's team] had to prepare for the repatriation of the Boer inhabitants from the commandos, the concentration camps, and the prisoner-of-war camps overseas. This was a heavy business, and it had to be done at racing speed. Since so much of the land was devastated, huts and tents and building material had to be provided in vast quantities; transport, too; horses and mules and cattle; seeds and every kind of agricultural implement; as well as rations for many months. We had the help of people with an intimate knowledge of the country, and the task was duly accomplished, though at a high cost owing to the necessity for speed. I have always considered repatriation a really creditable achievement. We had no luck, for the first year of peace saw a serious drought. Nevertheless, within a year from the treaty of Vereeniging [31 May 1902] burgher families to the extent of nearly a quarter of a million souls had been settled on their farms and equipped with the means of livelihood.[48]

The other pressing problem was to find land for the demobbed soldiers – both British and from the Empire – who fancied staying on to farm. This resettlement had a political as well as economic imperative for Milner, since he was thoroughly committed to a policy of increasing

the numbers of English-speakers at least to parity with the Boers. His hope was partly that, if the Transvaal became more anglicised, it would be possible to control any disloyal Afrikaner element in a parliament of a federated South Africa, when that moment came, as it surely would. But he also wanted, more positively and idealistically, to bridge the gap between the Afrikaner rural and British urban communities, in order to foster a common South African identity. In the end, however, land resettlement was not very successful, and what achievements there were came about by the use of questionable tactics, with Milner cutting constitutional corners, and requiring JB to be his 'fixer'.[49]

Although a Land Settlement Board existed in Pretoria, Milner decided to form a Land Settlement Department, putting JB in charge, until a permanent Commissioner of Lands could be appointed. Its primary task was to place new settlers on the land, and it faced major challenges in relation to the acquisition of suitable land. Milner, who, according to Emily Hobhouse, had the 'soul of a spy',[50] charged JB with the secret recruitment of agents, to pose as private land dealers and go into the refugee camps to try to buy land from Boers, who were both isolated and frightened that the British were going to confiscate what they owned. Milner understandably feared that, if it became known that the British administration was interested in buying land, there would be a property boom and, anyway, the disgruntled Boers would not sell to it. But this stratagem left a sour taste in the mouths of senior officials overseeing the camps. Milner also wanted the Colonial Office to grant him powers of compulsory purchase and, to that end, anonymous articles, written or instigated by JB, appeared in *The Spectator* and elsewhere approving the High Commissioner's land policies. Ever the optimist, JB told his uncle in February 1902 that 'My Land Settlement schemes are, I am glad to say, going very well.'[51] However, looking back, years later, JB wrote that their hopes for land settlement had been disappointed.[52]

His work took him to remote districts (often on a horse called Alan Breck) where he met what he thought were the last of the professional Boer hunters, 'whose lives were spent far beyond the edge of civilisation and to whom the War signified nothing'.[53] Peter Pienaar, hero of *Greenmantle* and *Mr Standfast*, was a well-realised character based on these self-reliant, but sometimes highly dubious, individuals. JB was not blind to the fact that these hunters had greatly helped to deplete the numbers of large animals in parts of South Africa, and there is an

eloquent appeal in his 1903 book, *The African Colony*, for the need to conserve big-game populations by the founding of game reserves in South Africa.

He recalled later that he had had to be a jack-of-all-trades – transport-rider, seedsman, stockman, horsecoper, merchant, lawyer, diplomat – especially at the beginning, before proper civil departments were established. It was fortunate, perhaps, that he had, unusually amongst the British, some understanding and liking for the country Boer, as a result of his own partly rural and fully Presbyterian background. It is true that he thoroughly disliked their brand of Calvinism but he understood it better than many. He deprecated the way 'it was used to buttress his [the Boer's] self-sufficiency and mastery over weaker neighbours ... [In his religion,] God made men of two colours, white and black, the former to rule the latter till the end of time ...'[54] Despite that, he generally got on well with them, staying often with Boer farmers in far-flung homesteads.

His upbringing had inclined him to the conclusion that the countryside was inherently healthier, morally and physically, than the city, and he saw Nature as a beneficent force in life, vital for refreshment, invigoration and even sanity. In the words of the historian Peter Henshaw, 'In common with a wide range of Victorian thinkers, most famously Matthew Arnold and John Ruskin, Buchan thought that without an ongoing and energetic engagement with the countryside and the wilderness, Britain and the empire would slip into irretrievable moral and material decline.'[55] He also grew to believe that a country's natural landscape gave a nation a powerful and valuable unifying identity, a belief that he would carry to Canada in the 1930s.

In April 1902, *The Watcher by the Threshold* was published, attracting favourable reviews and good sales; Blackwood's brought out a second edition just two months later. His brother Walter thought that it had a horrible cover and JB replied, 'If I wrote a book of hymns, it would be published as a yellow-back,'[56] the name given to cheap books with colourful, pictorial covers.

These three stories and two novellas are all set in Scotland, but they show the influence of Oxford, both on JB's experience and his reading, especially concerning the possible survival of the Picts. The title novella had been expanded and improved from a rather unsatisfactory short

story, which had first appeared in *Blackwood's Magazine* in 1900. This collection also reveals for the first time his preoccupation with the supernatural – in 'The Far Islands' and 'The Outgoing of the Tide' – which can be found later, in more accomplished form, in stories such as 'The Wind in the Portico' and 'The Grove of Ashtaroth', as well as the novel, *The Gap in the Curtain*. Nevertheless, these unsettling stories are remarkably assured for someone still in his early twenties.

In late May 1902 the peace treaty of Vereeniging was finally signed in Pretoria. Both sides had negotiated skilfully, and there was sufficient magnanimity displayed by the British to prevent the Boers feeling humiliated. (Jan Smuts and Louis Botha, two of the Boer leaders, supported Britain in the Great War.) By this time, JB was acquainted with a young British artillery officer, who spoke fluently a number of languages, in particular Cape Dutch. Lieutenant Edmund Ironside was an excellent soldier with a taste for intelligence work, who acted as an interpreter in the negotiations with Jan Smuts over peace terms. According to the present Lord Ironside, whose biography of his father is based on the latter's diaries, JB (presumably on Milner's orders) employed Ironside to listen in to the Boer deliberations, using Marconi recording equipment installed in their tents. 'Effectively, the proceedings had been bugged, and Buchan needed someone by his side who was more than just an interpreter, when he was in discussion with Smuts and his associates.' According to Lord Ironside, 'My father fitted the bill perfectly and his insights aided Buchan's negotiations by enabling the latter to foster an atmosphere of trust between the negotiating parties...'[57] Nowhere else can I find evidence that JB was directly involved in the peace negotiations, but the fact that this information comes from Ironside's contemporaneous diary is, at the very least, suggestive.

After the war was over, Lieutenant Ironside went undercover, seeking out intransigent Boers who would not swear allegiance to the Crown, before spying for the British in Hereroland and German South West Africa (now Namibia), in the guise of an ox-wagon driver working for the German Army. These exploits proved him to be brave, resourceful, a talented linguist and capable of taking on disguise. These were all qualities that were later to distinguish Richard Hannay, the character whom JB always maintained was partly based on Ironside.

In June 1902, Milner made JB Acting Secretary of the Department of Lands. He was effectively the head of it, with a hundred officials under him, some of whom worked on the development of a department of scientific agriculture. JB, not unnaturally considering his upbringing, was extremely interested in agricultural methods, and their modernisation, even writing a memorandum[58] on the virtues of the steam plough for tilling new ground, at a time when draught animals were scarce. 'I have at last got my Crown Lands Disposal Act passed, and the whole department organised,' he told his mother, who had recently arrived home from South Africa. 'The thing is my own creation from top to bottom and I am quite proud of it...'[59] He also told her that, although he would have earned much more as a civil servant, rather than as an independent directly employed by Milner, he was determined to maintain both his close links to Milner and his freedom of manoeuvre.

In fulfilment of the peace treaty, £3 million was set aside by the British government for resettlement and reconstruction work,* and part of that was put at JB's disposal. He had little of the caricature carefulness of the Scot with money, or public money at least. Farming experts needed to be recruited from abroad, but luring them to South Africa meant promising high salaries and he was criticised, from time to time, for profligacy by Johannesburg newspapers. Moreover, the department's policy of threatening to cancel leases held with the previous governments, if the rent had been very low or the land not developed, was opposed by the Attorney-General in the Transvaal Administration, who thought it illegal.

Word of some of his difficulties reached his parents: 'The papers last week were full of attacks on me for reckless expenditure,' he told his mother in December 1902, 'engineered by a man to whom I refused employment. I was able to show, however, that the paper was ludicrously wrong and that there was actually a balance to our credit in the transactions where I had been accused of wild extravagance. I don't think after my experience here I shall ever be afraid of responsibility again.'[60]

He did have some stout defenders. As *The Times* put it in early January 1903: 'Mr Buchan ... at once brought to bear upon his work not only an intelligent interest in, and some practical knowledge of

*Later Lord Milner negotiated a loan of £35 million.

matters agricultural, but an aptitude for rapid decision and for taking responsibility.'[61] *The Times* correspondent (probably Leo Amery, who had recently returned from Johannesburg) could not share in the 'wholesale condemnation' of the department and, in particular, he praised the Settlers' Ordinance. Nevertheless, there is no doubt that some unsuitable land was bought, expensively, and the blame for that had to be laid at JB's door, since it was his department. In the context of all the difficulties in communication, dislocation, destruction, and with an unhappy, beaten people to deal with, it is hard to see how criticism could have been avoided. That said, in the words of the historian Michael Redley, JB 'came to epitomize the inexperience and naivety of the young assistants ... whom Milner had set over the permanent civil servants in South Africa'.[62]

Like many Britons in South Africa at the time, JB suffered periodic bouts of ill-health, especially when travelling. Late in 1901 and again in early 1902 he contracted dysentery from drinking 'bad water' and sleeping out of doors. He took opiates for the dysentery, and for a number of days he was quite ill and was left very weak for some time afterwards. On these trips, he had often to carry on regardless, his discomfiture made worse by sunburn and saddle sores. He occasionally also suffered from non-specific fever, possibly malaria, and recalled later: 'Every one who has ridden through the African bush with fever on him knows the misery of the experience – the blinding headache, the unbearable thirst, the shivering fits which make it difficult to keep in the saddle.'[63]

Generally speaking, however, he found the climate and life suited him marvellously well. And he was young. Indeed, the happiest times for him in South Africa were spent travelling in the 'backveld', since the rural environment had a profound attraction for him. In August 1902 he went off for a ten-day tour with two cape carts, a spring wagon, eight mules, two riding horses, as well as a guide, two servants and a cook. He travelled west of Johannesburg to Klerksdorp, Lichtenberg, Korannafontein, Malmani Oog, Zeerust, Elands River, Rustenberg, Crocodile Poort, ending up in Pretoria.

He never forgot it. Nearly forty years later, he wrote in *Memory Hold-the-Door*:

I bathed in one of the Malmani pools – and icy cold it was – and then basked in the early sunshine while breakfast was cooking. The water made a pleasant music, and near by was a covert of willows filled with singing birds. Then and there came on me the hour of revelation ... Scents, sights and sounds blended into a harmony so perfect that it transcended human expression, even human thought. It was like a glimpse of the peace of eternity ... The world was a place of inexhaustible beauty, but still more it was the husk of something infinite, ineffable and immortal, in very truth the garment of God.[64]

That autumn, Willie sat the Indian Civil Service exams and came a creditable twenty-fourth. JB was delighted for him, but there were predictable difficulties with his mother. He told Anna: 'Do try to keep Mother from fretting about Willie going to India. It is a perfectly healthy and safe life [which was disingenuous of him, since he had read Kipling] and he will get ample holidays. Ask her whether she does not think that she keeps her sons far nearer her by letting them go abroad in honourable professions, than if she had them married and living in the next street ... It is not distance that alienates – just the other way.'[65]

In late November, Cubby Medd, who had contracted typhoid on a tour of Albania and Italy, died in London. JB was very shocked and saddened, but also rather guilt-ridden. Medd had been badgering him since the summer to help him get a job working for Lord Milner, and he had not yet achieved it:

... and I cannot forgive myself that I did not hurry on the matter and the whole thing might have been saved. He was one of my dearest friends, and though I have a great many so-called friends, I haven't very many real ones – Cubby and Raymond, John Edgar and Boulter, Sandy and John Jameson make up the list. [He missed out Charlie Dick, but that was surely accidental?] It seems such a stupid causeless thing for a man so brilliant and courageous to die of a thing like fever in a place like London ... Out here one gets accustomed to death – accustomed to dining with a man one week and hearing that he has got a bullet through his heart the next: but death out here is a different and simpler thing. When I think of the old walking-tours and escapades I nearly cry.[66]

He continued to attract criticism that winter. He told his mother that one Johannesburg paper had said he was the most headstrong and unreasonable person in the country. The criticisms did not surprise him, he told her, since he had to do some unpopular and arbitrary things in land settlement. Curiously, despite the press criticism, he was offered the editorship of the influential, and sometimes inflammatory, Johannesburg daily, *The Transvaal Leader*, at a munificent £3,000 a year, but he had few qualms in turning the offer down, despite the fact that he would have made 'a modest fortune'. He told Anna, 'I think if one does a thing purely to make money one is apt to make a mess of it.'[67]

After Christmas 1902 he went on a week's trip, with a fellow Kindergartener, Robert Brand, to the Wood Bush, an elevated plateau in the Zoutspansberg in the eastern Transvaal. He told Anna that the climate was like Scotland and the countryside like Glenholm, a glen near Broughton. This remote place was to haunt him all his life as a *temenos*, the Greek word he used for a sacred, consecrated place, and it appears not only in *Prester John* but also in the short stories, 'The Grove of Ashtaroth' and 'The Green Wildebeest':

> You climb to it through bare foothills where the only vegetation is the wait-a-bit thorn, and then suddenly you cross a ridge and enter a garden. The woods of big timber trees are as shapely as the copses in a park laid out by a landscape-gardener. The land between them is rich meadow, with, instead of buttercups and daisies, the white arum lily and the tall blue agapanthus. In each cup is a stream of clear grey-blue water, swirling in pools and rapids like a Highland salmon river ... Here is a true lodge in the wilderness, with on the one side the stony Pietersburg [now Polokwane] uplands, and on the other the malarial bushveld. The contrast makes a profound impression, since the Wood Bush itself is the extreme of richness and beauty. The winds blow as clean as in mid-ocean, soil and vegetation are as wholesome as an English down ... I resolved to go back in my old age, build a dwelling, and leave my bones there.[68]

He told Anna about it: 'I have an idea of buying a little farm on the ridge of the plateau, and having it as a kind of African country house, where you could grow every known flower and fruit. I only wish my

old father could have seen the place. He would have realised where the garden of Eden really was situated.'[69] He wanted to build a long, low, whitewashed, thatched house, which he would call 'Buchansdorp', on the edge of the plateau looking down 4,000 feet onto the fever plains below, 60 miles of mountainous terrain from the nearest train station.[*]

JB had gone out to South Africa with a number of preconceptions, most of which did not stand up to scrutiny once he had been there for a while. In particular, he began to see that a new, distinctive and positive national identity could, and should, develop in the Dominions, drawing its power from the landscape and heritage of their peoples, rather than simply some anaemic copy of British identity. As a Scot, he knew well that the Scottish nation was racially, linguistically and religiously mixed (including Catholic Highlanders speaking Gaelic and Presbyterian Lowlanders speaking English or 'Lallans'), and this made him temperamentally and intellectually unsuited to approve a crude policy of 'assimilation' of the Boers by the British, which was advocated by many imperialists, including Milner, after the war was won. JB considered it not only possible but also highly desirable for people to hold, sincerely, a number of concentric loyalties simultaneously – to locality, nation and empire. This attitude was confirmed in South Africa, where he discovered Scots people who had lived in the country for generations, yet retained aspects of their old Scottish culture, and he felt they were the better for it. JB understood the Afrikaners (who had both Dutch and French Huguenot origins) better than most because of his background and he wrote in 1902, 'We cannot fuse the races by destroying the sacred places of one of them, but only by giving to the future generations some common heritage.'[70] (The ultimate failure of that ideal led directly to the triumph of Afrikaner nationalism in 1948, and all the evil that flowed from that.)

Early in 1902 he felt impelled (and was encouraged by Milner) to write an extended essay about South Africa, which was published in 1903 as *The African Colony: Studies in the Reconstruction*. (He had wanted to call it *African Studies*, which would have better described it.) 'I could not help it,' he told Gilbert Murray. 'I am so much in love with

[*]There is an impressive memorial to John Buchan in the Wood Bush near Haenertsberg, north-eastern Transvaal. It was unveiled by JB's son, Johnnie, on 22 November 1987.

this country, and have so many things to say which I think ought to be said … I want to talk about the beauty and mystery of the landscape, the curious history, the intricacies of the Boer character, and the racial and economic questions ahead. A funny hotch-potch but I think it will have a certain unity.'[71] The history was certainly curious, in fact in places inaccurate, and his attitude to the attributes of the native Africans was very much of his time. But, for a Briton, he was unusually open to the qualities and rights of the Boers, and he was thinking hard about reconstruction. 'Ideals are all very well in their way, but they are apt to become very dim lamps unless often replenished from the world of facts and trimmed and adjusted by wholesale criticism.'[72] These days, the interest in the book lies principally in the accounts of the four long, exhilarating journeys he made into the wilds, his 'celestial Scotland'.

JB was often in Pretoria in early 1903 and, sick of hotels, at one point he stayed for a while with General Sir Neville Lyttelton, commander-in-chief of the British military forces in South Africa, and his family. However, after a few days of breakfasting with Lady Lyttelton and her three daughters, he went back to hotel life, for 'I have lost the art of talking to womenfolk and they bore me to death.'[73] The erstwhile President of the Brasenose Ibsen Society told Anna: 'Miss [Lucy] Lyttelton will talk about Dante and Ibsen, and it is no good pretending ignorance and asking if they were horses.'[74] In a letter to his mother, JB mentioned two couples of their acquaintance marrying. 'Nocht but marryin' and givin' in marriage. It's a comfort there's nane o' that in the next warld.'[75] JB was writing to his mother and sister what he knew they wanted to hear: that he was heart-whole and not in danger of falling for any pretty, aristocratic girl whom they had never met.

Perhaps fortunately, in February 1903, a permanent Commissioner of Lands was appointed, which meant that JB could go back to being simply a private secretary, helping to prepare the Budget for the new Federal Council. He felt much less hustled as a result. In March he had planned to conquer the unclimbed north-eastern buttress of the Mont aux Sources, a 10,000-foot mountain in the Drakensberg, with Sandy Gillon, but the latter failed his Bar exams and had to stay at home. Instead JB travelled into Swaziland with Robert Brand to see the country and shoot game. He was beginning to think hard about

what to do next – whether to return to the Bar and *The Spectator* or to carry on with administrative work. As early as April 1902 he and Milner had talked of his future plans, since he had always intended to leave after two years. Milner considered that he had 'administrative talents of the highest order', and that if he continued he had a great career ahead of him. However, JB also thought, briefly, of going into the City, on the basis that doing so might provide the financial independence necessary to fulfil his ambition to be 'a free and honest and effective politician'.[76]

His Glasgow and Oxford friend, John Edgar, had come out to Cape Town in March to take up an appointment as Professor of History at the university. However, within a couple of months, he had to take a rest cure because of what was then called 'neurasthenia', the first intimations of the periodic bouts of profound depression he was to suffer, and which were to be a source of concern for many years to the triumvirate of Johnnie Jameson, Sandy Gillon and JB. The latter wrote to Anna, 'Thank goodness my nerves are sound, as though I get overworked I never need rest-cures. It is a great thing to have a sound constitution.'[77]

In July, just before sailing for home, he wrote to his mother that he had had 'a very fine time, a great deal of pleasure, too, but the chief advantage is that I have come on so much, learned so much, know so much better what I can do and what I can't do. I wouldn't have missed the experience for worlds, and nothing can make me regret that I came out here two years ago.'[78] That said, he had bumped up against the realities of what was possible in public life, and they had sobered him. He had also acquired a creed.

Looking back in 1939, he thought that South Africa had taught him:

... that there was a fine practical wisdom which owed nothing to books and academies ... Above all I ceased to be an individualist and became a citizen. I acquired a political faith. Those were the days when a vision of what the Empire might be made dawned upon certain minds with almost the force of a revelation. Today the word is sadly tarnished. Its mislikers have managed to identify it with uglinesses like corrugated-iron roofs and raw townships, or, worse still, with a callous racial arrogance. Its dreams, once so bright, have been so pawed by unctuous hands that their glory has departed ... Milner,

like most imperialists of that day, believed in imperial federation. So did I at the start; but before I left South Africa I had come to distrust any large scheme of formal organisation. I had begun to accept the doctrine which Sir Wilfrid Laurier was later to expound; that the Dominions were not ready for such a union and must be allowed full freedom to follow their own destinies.[79]

This was an important difference between him and some of the other Kindergarteners, who cleaved to the idea of a federated British Empire, and is the reason why JB never joined the Round Table movement. His vision was of a collection of self-governing entities bound together loosely but securely by ties of a common legal system and allegiance to the British Crown.

Both his work on land settlement, and the process of writing *The African Colony*, had forced JB to think how this could be achieved, and it led him into ways that were, perhaps surprisingly, progressive for their time. Unlike many white people in South Africa, he firmly advocated the use of 'economic equalisation', in other words white men working in unskilled jobs, such as those in the mines, rejecting the idea that indigenous Africans should be left to do all the awful jobs.

Against prevailing white opinion (especially, but by no means exclusively, Afrikaner), JB believed also in the gradual integration of the black peoples into the body politic. 'I thoroughly agree with you,' he told St Loe Strachey, 'that we must do nothing to endanger the chance of the native progressing to equal political rights, as at present he enjoys equal legal rights.' JB advocated a programme of education to this end. In early 1906, in the context of an uprising of Christian black Africans in Natal, JB wrote an article in *The Spectator* expressing his belief in the duty owed by white towards black South Africans and the dangers of inadequate integration. His attitudes read now as paternalistic and condescending, and he used popular expressions that are unacceptable today, but he was in some ways enlightened for his time. The son of the Reverend John Buchan had at least a commitment to the common humanity of members of all races.

He experienced widespread prejudice amongst white people as a result of his views. The antagonism he encountered may be one of the

reasons why he was happy to go home in the summer of 1903, before the two years were quite up.

Late on in his career in South Africa he was made Secretary of the Inter-Colonial Council, whose purpose was to align policy in the two former Boer republics. His last Council meeting was on 8 July, when he had to supply Lord Milner with the figures needed as he addressed the Council. At the end, Milner made a gracious speech about him, saying he could not have done without his industry and ability. Before catching his ship home, JB spent a few days staying with the Governor of Cape Colony, as he wanted to see something both of Cape Town and his distressed friend, John Edgar. He sailed on the SS *Dunvegan Castle* on 19 August, taking with him a host of curios given him by African chiefs he had met on his travels.

His two years in South Africa had changed his perspective substantially: his rather arrogant 'Britain trumps all' mentality had been swiftly converted to a more humble acceptance that politics, especially the politics of reconstruction after war, are very complicated and, moreover, that other races – of whatever colour – had aspirations that needed to be respected and advanced, if gradually. His pre-South Africa sentiments, which were based on theory alone, could not survive close contact with the country and its inhabitants, including those Dominion 'irregulars' who had fought for the British. They were often country boys, and he conceived a real admiration for them, which would be reinforced by seeing them in battle during the First World War. 'I had regarded the Dominions patronisingly as distant settlements of our people who were making a creditable effort under difficulties to carry on the British traditions. Now I realised that Britain had at least as much to learn from them as they had from Britain ... I began to see that the Empire, which had hitherto been only a phrase to me, might be a potent and beneficent force in the world.'[80] Perhaps he could not write anything else, since he was Governor-General of Canada at the time, but it chimes with much he said in earlier days.

The fiendishly difficult post-war situation, coupled with JB's adamantine loyalty to Lord Milner, despite their differences in temperament and outlook, had required him to do some morally questionable things in pursuit of what they considered the general good in South Africa. He

had been given awesome responsibility for one so young and, while he had had some successes, he had also suffered embarrassing failures. In the process, he had lost something of his youthful, pleased-with-himself breeziness and he returned to England a wiser man.

4

London, Courtship and Marriage, 1903–1907

On his return to England from the expanses and excitements of South Africa, JB experienced a dispiriting ennui. 'A sedentary London life with clubs and parties and books ... seems to me now rather in the nature of the husks which the swine do eat,' he told his sister,[1] while to his mother he reported that 'I feel rather strange and my law is pretty rusty. It is a foolish point of view, I know: but after the last two years I cannot help feeling that the law is all rather a pother about trifles ... I fell in with Gerard Craig Sellar the other day, profoundly depressed and bemoaning the littleness of civilised life. Even a million and a half sterling [he had inherited a great deal of money] are no consolation to him ... Raymond Asquith looks ill and old. Everybody marvels at my healthy appearance and youth.'[2]

For a time, South Africa completely unsettled him:

I did not want to make money or a reputation at home; I wanted a particular kind of work which was denied me. I had lost my former catholicity of interests. I had no longer any impulse to write. I was distressed by British politics, for it seemed to me that both the great parties were blind to the true meaning of empire. London had ceased to have its old glamour. The eighteenth-century flavour, which entranced me on coming down from Oxford, had wholly departed, leaving a dull mercantile modern place ... The historic etiquette was breaking down; in every walk money seemed to count for more; there was a vulgar display of wealth, and a *rastaquouère* craze for

luxury. I began to have an ugly fear that the Empire might decay at the heart.[3]

It is likely that JB had changed more than London. If South Africa had taught him anything, and it had taught him a great deal, it was that, like Longfellow's young man, he must be up and doing, with a heart for any fate. So he set about pursuing his objective of working in Egypt for the Earl of Cromer, an administrator of Lord Milner's stamp and stature. Cromer was officially the adviser to the Khedive but, as British Agent and Consul-General, he was de facto ruler of Egypt and had a staff of British administrators to help him. JB told his sister in a private letter that Cromer was anxious to engage him but that no opportunity to do so had yet occurred.

Meanwhile, Willie, having joined the Indian Civil Service, left for India in November 1903. The ICS, which attracted the brightest young men, was called 'heaven-born' because of the incorruptibility of its employees. Five years younger than JB, Willie had a similar desire for public service rather than private money-making. He had not been a very diligent scholar at Hutchesons' Grammar School until his sister Violet died in 1893, when he seems to have grown up quickly and begun to study hard. While at the University of Glasgow, he made up his mind that he would join the Indian Civil Service and never deviated from that, following his brother to Brasenose College, where he read Classics and History, his fees partly paid for by his Uncle Willie[4] and partly by winning a scholarship. The handsomest and tallest of the Buchan boys, he had intensely blue, myopic eyes, and wore a monocle. He was a good footballer, a better and more enthusiastic 'shot' than JB and, like all the male Buchans, a more than competent angler. He was popular at Oxford, because he was a good sportsman, witty, had a ready laugh, was exceptionally hard-working, devout in an unostentatious way, and he loved the place as much as his older brother had done. He was a prominent member of the Canning Club, the foremost University Tory political society.

His departure for India left a substantial gap in the family circle, which even JB felt in London, and which gave his mother rich opportunities for complaint. 'Why, why will you weary about Willie? You cannot abridge time and space to suit your convenience?'[5] JB wrote to her, having been goaded beyond endurance. And Willie was a most

affectionate and assiduous correspondent to his family, even more patient than JB with the megrims and vagaries of his mother.

JB was still finding London a petty, muggy place, 'not to be mentioned in the same breath as Buchansdorp'[6] after which he still hankered. The feeling was not helped by having to spend most of the Christmas holiday in London, since Strachey needed him to manage *The Spectator* for him. But it was not all drear, for he spent weekends away in country houses, meeting influential people such as the Earl of Selborne, who succeeded Lord Milner as High Commissioner, not to mention the powerful Alfred Harmsworth, owner of the *Daily Mail* and later Viscount Northcliffe, with whom he spent a winter's Sunday in Surrey 'rushing about a frost-bound country … in a magnificent motorcar'.[7]

In June 1904, JB was approached by the Chairman of the South Edinburgh Unionist Association, who was looking for a candidate to stand at the next general election, but he refused, for he saw that this was premature, while he struggled to get back his practice at the Bar. Members of Parliament were not paid until 1911; he simply could not afford to stand.

His holidays he spent climbing mountains. A real passion for mountaineering began when he was only seventeen and climbed a sheer rock face on Ben Alder; it was promoted by trips to the Alps with Anna and some climbing in the Drakensberg in South Africa. This was the perfect antidote to his sedentary London life. He had both the personality and the physique for it. He was spare, wiry, very strong, and had excellent balance. He claimed he had the opposite of vertigo, for he gained comfort from looking down from a great height. He was brave, indeed sometimes foolhardy. In September 1904 he climbed Ben Nevis with Walter and Sandy Gillon, himself a very accomplished climber, who successfully proposed him for the Scottish Mountaineering Club.* After JB's death, Sandy wrote in the Club's journal:

He never served an apprenticeship. He just went at it by the light of nature. When I knew him his methods were original, unconventional, individualistic, but his movements were sure, decided, purposeful, and invariably he finished his climb. His assets were strong fingers and arms, rather short legs of enormous lifting power, an enviable

*JB was also elected to the prestigious Alpine Club in 1906.

poise ... and a body that had limpet qualities ... I never saw him tired. Mentally he had purpose indomitable, patience, courage, calm, self-control and nerve.[8]

In his fiction, JB wrote some heart-stopping descriptions of terrifying climbs and descents, notably the desperate crossing of the Colle delle Rondini in *Mr Standfast* and the cat-and-mouse chase with Dominick Medina in *The Three Hostages*. In *The Last Secrets*, his book on exploration, he described some real-life attempted ascents on Mounts McKinley [Denali] and Everest.

In November 1903, *The African Colony: Studies in the Reconstruction* was published, dedicated to Hugh Wyndham 'in memory of our African housekeeping'. It was an immediate success, no doubt helped by the fact that a number of London newspapers carried two-column reviews of it on the day of publication. Although JB only went back to South Africa once more, he kept in touch with Lord Milner and the Kindergarten, sending them copies of the book, and continued writing about South Africa in *The Spectator* and elsewhere. Lord Cromer wrote a twelve-page letter in his own hand, praising *The African Colony*, remarking on how many analogies there were between Egypt and South Africa. However, by February 1905, it had become apparent that JB would not be offered a job in Egypt. Late in life, he chose to believe that it was the home authorities who declined to ratify Cromer's choice, on the grounds of his youth and inexperience. Whatever the reason, he was mightily disappointed.

Restless, stifled, and short of interesting legal work, JB sat down to write his least-known, least-read, book, *The Law Relating to the Taxation of Foreign Income*,[9] a guide to the law in this area for the benefit of both lawyers and laymen. Richard Haldane KC, MP,* suggested that he write it, and agreed to contribute a preface. Published in 1905, it was sufficiently readable to prompt a later commentator to exclaim: 'There are few other books on tax law which can be read in bed.'[10]

He kept up his South African contacts as best he could, joining a dining club that Leo Amery had founded, called the Compatriots, whose president was Lord Milner and which numbered amongst its

*Haldane was a great Liberal swell, a barrister, philosopher and politician who, as Secretary of State for War, instigated important army reforms before the First World War.

members F(rederick). S. Oliver, a most unusual and engaging man – he was a Director of the department store, Debenham and Freebody, and author of a well-regarded biography of Alexander Hamilton – who was to become a close friend of JB's. Other new friends included Violet Markham, a financially independent, Liberal social reformer from a Derbyshire coal-mining family, who was a granddaughter of Sir Joseph Paxton, the designer of the Crystal Palace. She was a force of nature, who was deeply involved and active in social and educational projects, and would later become a town councillor, then mayor, of her native Chesterfield.* She also gained a reputation as a political fixer.

JB continued to provide financial support to his family. Early in 1905, when Mrs Buchan had made herself ill over worry about Willie in India and keeping up the house, JB advised a holiday and offered to pay all her medical bills. His mother could make money go a long way, but there were limits even to her ingenuity. And the Buchans would have felt it a great deprivation if they had been too poor to give money away liberally to charity. On one occasion in 1905, JB sent money for his mother to buy a dress and stressed to Anna that it should not go to foreign missions or 'that bottomless sink, the Sustentation Fund',[11] which supplemented the stipends of Free Church ministers.

In June, after JB returned from Cape Town, where he had conducted an appeal for the Transvaal Chamber of Mines, he tried to address the problem of Anna's lack of interesting occupation and pressing need to get away from Glasgow from time to time. He was too busy to be able to spend much time in Scotland, but he could make her more independent of her parents. He wrote to his mother: 'I am very sorry for you all but especially for my old Nan [Anna]. She is suffering what anyone must suffer who has an extended horizon and a limited opportunity. It is a complaint common to most young women nowadays. Had I been a minister in Glesca [Glasgow] and William a doctor in Strathbungo, and had we all lived together there would have been no horizon and therefore no complaints.' His solution was to open a bank account for Anna, and pay £100 into it yearly. 'That will give her pocket-money for clothes and any travelling she wants to do. I look to you all to see that she spends it on herself or at any rate by herself.'[12] Anna wrote in her memoirs, *Unforgettable, Unforgotten*: 'I

*She was an unsuccessful Liberal candidate in the 1918 general election.

thought then, and I think now, that it was a remarkable thing for a young man to do. But it gave him pleasure, I believe, and it made all the difference in the world to me; to have a cheque-book of my own made me feel like a millionaire. Even when I no longer needed it he could hardly be persuaded to give it up.'[13]

That summer JB wrote to Anna, referring to his mother as 'the old obstructionist' because she wouldn't take a holiday. Mrs Buchan was at risk of relapsing into a debilitating state of anxiety, and for someone normally so decisive, she was finding it difficult to settle anything. JB told his sister that she needed to be 'removed by force' and made to have a holiday in August, probably in St Abbs, and he got his way. Urged on by their sons, the Glasgow Buchans also finally moved to a smaller house at 35 Maxwell Drive, Pollokshields.

Mrs Buchan could be a severe trial to her children, especially when they began to go out in the world. Yet they retained their deep affection for her, a testament to how important she had been to them in childhood and how seriously they took the Fifth Commandment. Both JB and Willie had cause to be stern with her from time to time, but from exasperation rather than ill-feeling. Willie, so far away in India, looked forward to letters, even if they took three weeks to arrive by sea, and was often prey to anxiety about his mother, which he could only suppress by very hard work.

Meanwhile, there was just a hint from JB to his sister that he had been courting an American woman, for he told her that the girl had sailed for New York in July 'leaving me broken-hearted. Though I bear it with manly fortitude, life can never be the same to me again, as story-books say.'[14] Since there is no other mention of this woman in any letters, we must assume the tone was ironic. Certainly, he was getting out a great deal, going to dinner parties and even, although usually under protest, dances. But he was thirty years of age that summer and was now looked upon, both by his family and his contemporaries, as a confirmed bachelor.

It was well-nigh inevitable that, sooner or later, JB would meet Susan Grosvenor. By 1905 he was acquainted with Richard Haldane, Sir Edward Grey and Arthur Balfour, all of whom were well known to her mother. And he had met Susie's cousin and best friend, Hilda Lyttelton, when staying with her parents in Pretoria.

The couple's first meeting took place some time in the spring of 1905, when JB was taken to dinner at her home, 30 Upper Grosvenor Street in Mayfair, by a mutual friend. The custom was to call to thank the following week and, when he did so, JB found Susie alone in the drawing room; she gave him tea and they pursued a rather stilted conversation. When they recalled that meeting later, JB told her that he thought her haughty, while she thought him conceited and difficult to talk to. 'Why we should have belied our real characters in this way I cannot imagine.'[15] I think we all can.

When they met, Susie was twenty-three years old, shy and unassertive amongst strangers, but with a well-developed sense of humour and, in particular, a finely tuned appreciation of the absurd, which would too often cause her to collapse in helpless giggles. As a girl, she had had to leave the Opera House in Bayreuth during a production of Wagner's *Parsifal*, helpless with mirth when the dove descended from the heavens upside down. She was kind, very gentle, and a tender support to her sometimes ailing, and always hypochondriacal, widowed mother, Caroline (née Stuart-Wortley), known to her as 'Baba', towards whom she felt a great protectiveness.

She was of medium height, slim, with a good figure, graceful in movement and with an erect carriage. She had particularly fine, long-fingered hands, as well as masses of pale blonde hair, which she piled on top of her head, with a fashionable, if faintly ridiculous, 'teapot handle' to it. She was good-looking rather than classically beautiful, having not entirely escaped the heritage of the Stuart-Wortley undershot jaw. Dora Carrington, the artist, who met her in 1916, thought her face was 'Johnesque' (like an Augustus John drawing). She was an attractive, agile and responsive dancer,[16] although she endured the Season without much enjoyment. She was not at all keen on country sports or games, much preferring to spend her time reading.

Her origins were markedly different from JB's. On her father's side she came from an English aristocratic family that could trace its lineage directly back to Gilbert Grosvenor, 'le gros veneur' ('the fat hunter'), nephew of Hugh Lupus, himself nephew of William the Conqueror. Her father, Norman Grosvenor, who died when she was only sixteen, had been the fifth of five sons and two daughters of Robert, 1st Lord Ebury. Ebury, a Whig, was a younger son of the Marquess of Westminster, and uncle of the first Duke of Westminster. Norman's mother, Charlotte

Wellesley, was a niece of the 'Great Duke' of Wellington. Norman's connections and upbringing were, therefore, very grand indeed, even if, as a younger son, he could never have expected more than a modest patrimony, since the laws of primogeniture exerted such an iron grip.

His wife's family, the Stuart-Wortleys, had made their money out of coal-mining in Yorkshire, her grandfather having been raised to the barony as the 1st Lord Wharncliffe. The Stuart-Wortleys could trace their descent directly back both to the Earl of Bute and Lady Mary Wortley Montagu (letter writer and poet), and were connected to Lady Louisa Stuart, the confidante of Sir Walter Scott. Caroline Grosvenor's father, James, a younger son, had been Recorder of London and Solicitor-General, but a riding accident finished his career and put him in a wheelchair, and there was never much money. Caroline's mother, Jane, was a well-known philanthropist and her four sisters were notable for their good looks, artistic propensities and unworldliness.

Norman Grosvenor had been a particular friend of Edward Burne-Jones, as well as W. S. Gilbert, Leslie Stephen (father of Virginia Woolf), and the social reformers, William Morris and Charles Booth. His politics were Radical, or what we might term progressive Liberal. According to his daughter Susie, he was regarded by many of his stuffy relations as a traitor to his class, the more so because he declared himself, most daringly, to be an agnostic in religion. This caused great hurt to his gentle mother, as well as his enthusiastically Evangelical father* (who had spent years trying to make the Church of England more Protestant by advocating the revision of the Book of Common Prayer), not to mention his two devout maiden sisters. But as Susie wrote later of her godly Grosvenor relations: 'They were all, except his mother, a little blind to the fact that he [Norman] practised the Christian virtues of charity and loving kindness to an extent which they rarely attained.'[17]

In his ample spare time, Norman had been a very accomplished amateur pianist and composer. His works were praised by critics but never published, since he did not think them good enough. This gentle, cerebral, charming man was no seeker after fame nor, sadly for his immediate family, fortune. He had been a short-lived Liberal MP for

*As Lord Robert Grosvenor M.P., he had served in a number of Whig administrations and had supported factory working hours' reform. Late in life, when Lord Ebury, he opposed William Ewart Gladstone on Irish Home Rule.

Chester, and then gone into business, becoming the Managing Director of the Sun Fire and Life Insurance Company. He helped to found, in 1878, the People's Concert Society, which provided classical music for people in the East End and for a number of years he served as its president.

Caroline gave Norman two daughters – Susan Charlotte, born in 1882, and Margaret Sophie Katherine, known as Marnie, born in 1887. For the first few years of their married life, the Norman Grosvenors lived mainly at Moor Park, the Palladian country house near Rickmansworth, owned by his father. Moor Park was then one of the great houses of England, a neo-classical palace in a Lancelot Brown-designed park. It had been, two hundred years before, when still Jacobean in outline, the home of Sir William Temple, whose 'Moor Park' apricot received a favourable mention from Mrs Norris in *Mansfield Park*. In Susie's childhood there were fourteen indoor servants, including three footmen. It was a veritable Downton Abbey.

Thanks to Lord Ebury, the style of life there was markedly old-fashioned. Not only did Susie, her sister and her parents live there, but all Norman's brothers, with their wives and children, nursemaids and governesses, along with the unmarried sisters. Lord Ebury treated them all almost like children, standing in the hall to give each their bedroom candle before everyone was sent to bed. He introduced a cheap harmonium to the splendid hall for Sunday evening hymn-singing and directed conversation at the interminable meals. The grown-up sons, in particular, took to playing elaborate games and indulging in wordplay to avoid the potentially explosive topics of religion and politics. The older female Grosvenors busied themselves in visiting the poor on the estate and in Rickmansworth, in an endless round of small benevolent works.

After eleven years, Caroline had had enough of such an airless life and she, Norman and the two girls went to live in London, in houses on the Westminster Estate, first in Green Street and then, most happily, at 30 Upper Grosvenor Street. They were plainly very contented together, and provided a secure and affectionate environment for their daughters, and rather more indulgence than was vouchsafed by other adults who, Susie remembered, were inclined to squash children at every turn.

A governess taught the girls at home. Susie read incessantly and very widely, including Dante in the original, with a crib, and she even attempted Hegel. Norman gave her a 'most unVictorian' run of his

library. But she found it impossible to learn anything by heart. Her formal education was so sketchy that it was forever an impediment to her. Her governess had been chosen for her moral standing rather than her skill as a teacher and, although Susie learnt some English and history, her knowledge of geography and mathematics was lamentable. She wrote many years later: 'I still mourn the fact that I was never taught to concentrate or to have exactness of mind when I was a child, and that I was never told of their vital importance in later life ... We drew profiles [doodles] on our copy books and showed up sloppy and inaccurate work. We were scolded for this, but I don't think we were as much to blame as our elders, who should have seen that all was not well with our education.'[18]

In 1898, aged fifty-three, Norman died of cancer after a long illness. He was buried in the family plot in the churchyard of Holy Trinity, Northwood, and his wife spent years making a plaster headstone of an angel with outspread wings battering on a door, which was then cast in bronze. Apparently, being an agnostic didn't prevent her believing in angels.

Caroline was forty years old when her husband died, and his death was most likely the genesis of a periodic melancholic pessimism (what her sisters referred to as 'Kyo's disillusionment') which at times undermined her daughters' resolve. The girls, aged sixteen and eleven, also felt the loss very keenly. Caroline continued to live in society, but there was not a great deal of ready money, and she was at least partly beholden to the Duke of Westminster. When the estate sold the top end of Upper Grosvenor Street in the late 1920s, so that the Grosvenor Hotel could be built, she had to move across the road to the smaller, narrower No. 2.

Her relative impecuniousness, as well as her restlessness and intellectual curiosity, prompted her to spend much of the year abroad, taking her two girls to stay in hotels in cities or spas in Germany, France and Italy in particular, as well as spending two winters in Cairo. The beneficent effect of all this travelling was that the girls spoke European languages proficiently, especially German and French, and were exposed to the architecture and art of Dresden, Cologne, Paris and Florence. They were cultured far beyond what was usual for girls of their class. Moreover, in Cairo, Susie had her first opportunity to get to know men

of her own age in a more relaxed environment than at home, for the place was swarming with underemployed army officers.

Although far from free from the ingrained sense of entitlement of her class, Susie understood the duties, as well as privileges, of her position. And, since her mother never considered university for her, she had to find some other way of immersing herself in something useful while waiting to meet potential husbands. When not staying in a variety of country houses (where she was often accompanied by her grey parrot), she worked as a volunteer for the novelist Mrs Humphry Ward at the Passmore Edwards Settlement in Tavistock Place, handing out meals to disabled children. She also worked several days a week at the Charity Organisation Society office in Baker Street.

She gave up working for the COS on her marriage, but never lost her interest in the problems of what were then called 'the less fortunate'. To a man like JB, who had spent his own childhood and youth rubbing shoulders with the poor, and had compassion for but no illusions about them, Susie's philanthropic instincts were very appealing.

Her upbringing instilled in Susie what she later called 'an instinct to please', a very useful social accomplishment. But, when she met JB, she was in need of rescuing, for such a bookish, unworldly girl, without a father, was in constant danger of accepting a proposal from the wrong man.

JB went to South Africa for a law case in May 1905 but, on his return the following month, the couple began to meet quite frequently. They both attended Lucy Lyttelton's twenty-first birthday party in July, and went on with a party to Earl's Court, probably to see Buffalo Bill's Wild West Show, which was a great hit there at the time. JB ever so casually told his mother who his companions were: 'It was a very pleasant friendly party.'[19]

That summer, Susie spent much time at Crabbet Park near Crawley in Sussex, a house owned by Wilfrid Scawen Blunt, the writer and traveller, but leased to the very hospitable Sir Edward Ridley and his wife, who had been connections of Cubby Medd, and who liked to surround themselves with young people. JB was invited down several times that August, when he was deputising for Strachey at *The Spectator*: 'I am going down to Crabbet every evening this week,' he wrote to his sister

on the magazine's writing paper. 'It is very pleasant after a dusty day in town to get down to that lovely old house* and nice people.'[20]

A tantalisingly undated letter written by Susie to her cousin, Hilda Lyttelton, from Crabbet Park, must derive from that summer, and is typical of her rather breathless style at the time:

> ... we are very happy here. We have had Mr. Buchan and Mr. [Harold] Baker here for Sunday. What dears they are especially Mr Buchan – We had great fun as we all ragged each other hard – and a Crabbet Magazine was instituted in which we all wrote things. Parodies chiefly. They were awfully good some of them. Mr Baker's parody of Walt Whitman took the biscuit I think! ... I am reading Morris' *Life*** which is awfully interesting. I spend my time reading here – and doing a very little drawing and a minus quantity of embroidery.[21]

JB told his brother in India about his trips to Crabbet, to which Willie replied, 'you seemed to be having a frivolous time at Crabbet Park in your [indecipherable] party of unchaperoned youth'.[22] Years later, Susie recalled those days:

> There were many pleasant things to do at Crabbet – walks through the woods, lazy hours to be spent in boats on the lake over which the wild duck flighted at night. I remember ... John lying under some trees outside the drawing-room window making notes for a review in the *Spectator* of a book on philosophy. He remarked at intervals 'this man really shouldn't write about philosophy when he knows so little about it'.
>
> We started by having an amusing friendship discussing life and literature at great length and writing long letters to each other. We soon found that life had brightened for us both. He had never really settled down in London after his time of hard work and high

*Not that old. Crabbet Park was only built in 1873, but in the Queen Anne style, which is what foxed him.

**A biography of William Morris, probably one of the two volumes of J. W. Mackail's *The Life of William Morris*, published in 1899 and 1901, respectively.

adventure in South Africa, and I was suffering from a feeling of aimlessness.[23]

In mid-September, JB intended to go climbing with his brother Walter in the Cuillins of Skye, which he loved above all other mountain ranges. However, before he went, he received a letter from his mother begging him not to go, as it was too dangerous, particularly since Sandy Gillon wasn't going with him, and he wasn't going to Glasgow first. This nonsense prompted one of the angriest letters he ever wrote to her, in which he made it clear that he resented her lack of confidence in him, that he was a very safe climber, and that he never went anywhere without a professional guide. (He had conveniently forgotten his escapade with John Edgar.) 'The Bird [Walter] will tell you I am one of the safest of climbers, more especially as I have him in my charge.'[24] It must be said that Walter found his brother 'exhilarating and terrifying' as a climbing companion. In the end, she couldn't stop him and he heard no more about it.

That October, JB wrote to Susie, enclosing a copy of *The Watcher by the Threshold*: 'I'm afraid all the stories are rather crude – they were written at Oxford: but I still have "kind feelings" for the last one ['Fountainblue'], which indeed is more or less the subject of the novel at which I am being vanquished by an impossible "ingénue". I am going to make her half-Polish and half-Spanish, speaking no language but Basque, so that I may not be compelled to give specimens of her conversation.'[25]

Why he considered these stories suitable reading matter for a very sheltered young woman, it is hard to imagine. In particular, 'No Man's Land' is a very scary story about a relict population of Picts in Scotland who, apart from killing lonely shepherds, from time to time kidnap Scots girls to widen their gene pool.

However, it *is* easy to imagine how flattering it was for a twenty-three-year-old *ingénue* to be sent someone's published work, so it is not surprising that she wrote back so enthusiastically: 'I have just finished *devouring* it and I must tell you how awfully good I think the stories. They are so well sustained and interesting. The characters are so well drawn and clear ... I hope we are going to see you again soon. If you would come in for tea or later any day you would always find us.'[26] Susie's letters were sweetly naïve, rather unsuccessful attempts at

worldliness, and full of innocent gossip. 'You write just as you speak,' he was often to tell her. In November 1905, JB told Charlie Dick: 'I am pretty busy with Board of Trade work at the Bar, and a good deal of the <u>Spectator</u> falls on my shoulders in these days [since Strachey was away pursuing his parliamentary candidature]. Also the world is too much with me late and soon ... I mean <u>le beau monde</u>. I dine out or go to plays very nearly every night, and I am being dragged back to balls again.'[27] This was the influence of Susie.

It was a time of frenetic politics, and JB now knew many of the protagonists. The general election in early 1906 brought a crushing defeat for the Tories, and the victory of the 'Little Englander' faction in the triumphant Liberal Party. For a Free-Trader who, though he called himself a Tory was truly a Liberal Unionist, and one who believed in the Empire, this was not good news. In his spare time he had been writing *The Mountain*, a contemporary novel about a young Northumbrian, much like him, who wants to go out to east Africa; it relied heavily on memories of a trip to Northumberland with Charlie Dick when they were at the University of Glasgow. He ran out of steam after five chapters.

In 'A Reputation', a short story published in *Macmillan's Magazine* in 1898,[*] JB seems to be describing the sort of multifaceted career that he was later to have. There was obviously a debate going on in his head about whether the pursuit of public reputation was a worthy ambition, for in this tale he suggests that it may not do a man any good. Arnold Layden is not an attractive figure. An eminent lawyer says of him, 'Layden has chosen a damned hard profession. I never cared much for the fellow, but I admit he can work. Why, add my work to that of a first-class journalist, and you have an idea of what the man gets through every day of his life. And then think of the amount he does merely for show: the magazine articles, the lecturing, the occasional political speaking. All that has got to be kept up as well as his reputation in society. It would kill me in a week, and, mark my words, he can't live long at that pitch.' But that was exactly what JB was doing up until January 1906.

[*]Included in the collection *Grey Weather*, John Lane, London, 1898.

However, in that month, Strachey offered him the job of assistant editor at *The Spectator* alongside Charles Graves, since the ageing Meredith Townsend had by now practically retired. It would mean a handsome £800 a year, conditional on him leaving the Bar, although he would be allowed to write books and magazine articles, as well as do any legal writing in his spare time. He would be expected to write a review, a leader and seven 'notes' a week, as well as help with the general editorial work. Strachey magnanimously told him that, although he himself would risk all his prosperity to resist Protectionism, he didn't expect JB to do so. In reality he knew they were not far apart generally, and certainly not on the matter of Free Trade. If JB continued at the Bar there could be no retainer, but Strachey would guarantee him £150 of work a year. JB accepted the original offer, conditional on being allowed six weeks' leave a year and with the proviso that when Townsend died, or retired, his salary would go up to £1,000. They also agreed that when Strachey was away, Graves would be editor and JB his assistant.

He lost his work for the Attorney-General in any event, when the Conservatives left office in December 1905, but he also gave up going into court and being available to take on cases. However, he did continue to write legal opinions, as Strachey had said he might. And the new regime gave him a certain amount of leisure, which allowed him both to pursue a love affair and to finish a work of political thought on empire, which he called *A Lodge in the Wilderness*.

Because of the iron rules concerning chaperonage of upper-class girls, courtships had to be pursued under the eyes both of observant, but mostly favourably disposed, contemporaries and also the rather more critical and cynical older generation. Fortunately for this couple, that generation was reasonably benign and, in Susie's mother, JB found an active supporter.

During tea parties held at Temple Gardens, and dinner parties at Upper Grosvenor Street, Mrs Grosvenor had the opportunity of sizing him up, and the two quickly established a rapport. He called her 'Gerald', a mystifying nickname but one which suggests that she was happy to be teased, and she undoubtedly enjoyed exchanging choice political and literary gossip with him. For JB, liking soon turned to a real affection, since Mrs Grosvenor was not only kindly, sympathetic,

intelligent and socially concerned,* but she held an honoured position in a civilised and artistic circle, whose members simply required of him that he be amusing and interesting. He soon grew to value her opinion. Although she mostly spent her time painting, he encouraged her to write a novel, *The Bands of Orion*, and helped to get it published by Heinemann in 1906.

In her turn, she introduced him to important political and intellectual figures or promoted burgeoning friendships. For example, through her he met Moritz Bonn, the clever young German-Jewish economist who had studied and later taught at the London School of Economics, and who was to become a lifelong friend of the family.

In February 1906, JB's Uncle Willie died, after a long illness. JB went north for his funeral, which was attended by 800 people 'for he was a well-known and much beloved man in all the countryside'.[28] His death was a grief to JB, since his uncle had been very kind to him and had widened his horizons as no one else in his family had thought to do. Willie Buchan's death meant a change of the guard in Peebles, but that turned out to be a peculiarly smooth transition. His nephew, Walter, the twenty-three-year-old advocate, was appointed the agent (manager) of the Commercial Bank as well as town clerk and procurator fiscal in his uncle's place. He moved to Bank House.

At this point, Willie's two sisters decided to go to live in Guernsey, no doubt to warm their elderly bones, so Walter asked Anna to leave home in Glasgow in order to keep house for him in Peebles. This arrangement suited Walter, but, more importantly, he knew it would save her from the risk of gradually settling into a confined, spinsterish middle age looking after her ageing parents.

It was from early 1906 that JB began to nickname Susie 'Miss Clara', which almost certainly derives from the name of the girl in 'Fountainblue', the last of the stories in *The Watcher by the Threshold*. She is a shadowy figure who falls in love with the nice, ineffectual man, rather than the great but difficult man who saves her life.

His courtship of Susie continued slowly and circumspectly. By early April, however, they had established a firm correspondence, itself a mark

*She helped found both the Colonial Intelligence League for Educated Women, and the Women's Farm and Garden Association. The latter continues to this day. She was appointed CBE in 1920.

of regard, for it required her permission (and possibly Mrs Grosvenor's as well). He wrote, 'It is so kind of you to allow me to write you this scrawl', and signed it 'JB'. In that letter, sent from Kildonan, where he was staying with Gerard Craig Sellar and fishing for salmon on the River Helmsdale, he demanded to know who the villain was who had said he was 'a ladies' man', a piece of gossip that she had sent him. 'A smoking pistol or a bloodstained sword will alone wipe out the insult. I don't suppose any charge – except that of being a Liberal – could be more shamefully untrue, and if Gerald believes it, it will really be too much for me to bear.'[29] Susie had also passed on Violet Asquith's remarks about the Balliol set (including her brother Raymond) as being dirty, blasphemous and woman-hating. He rejected it, saying he was not dirty, nor conspicuously blasphemous, nor woman-hating, but prepared to accept that he was the opposite of 'susceptible'. Her rallying reply was, 'I was very much amused indeed at your remarks about the Balliol set, especially the extreme "hauteur" with which you speak of the "woman-hating" accusation. To quote you, "the true members of the set never troubled themselves sufficiently about the subject to form any opinion". I feel thoroughly put in my place along with the rest of my sex. I shall never err on the side of thinking that we are important again.'[30]

When sending her two books of French poetry for her twenty-fourth birthday on 20 April, 'because you said I might',[31] he was still not quite sure if he had presumed too much. A few days later he wrote that he was going to a dance, rather on sufferance, but was glad there was a chance she might be there. 'I hope you will spare a few minutes from your Guardsmen to talk to me. I promise not to relapse into any barbarous exclamation like "Heck".'[32] Her teasing him about his use of Scots expressions prompted him to try to teach her some. In early April he wrote asking her how she was getting on with her studies in the Scottish language and defying her to translate 'How mony nievefu's of stoor mak' a gowpen of glaur?'*

At a time when the couple were still pursuing a diffident correspondence, her family were already speculating as to whether they would make a match of it. Her aunt Katharine Lyttelton wrote to a relation on 13 April: 'I never know quite what to think about Susie

*'How many fistfuls of dust make a double handful of mud?' If this is a Scottish saying, I can find no Scot who has ever heard of it. It may have been already redundant by the early twentieth century. JB to Susie Grosvenor, 3 April 1906, NLS, Acc. 11627/1.

was dull, 'but there is nothing to write about when your mind has the perfect contentment of a Buddhist lama and your body the weariness of St Laurence after a long day on the gridiron'. He hoped to meet her at Rounton in Yorkshire, and sent white heather from the 'Glen of the Fairies so it might be lucky'.[35]

Susie, staying with her mother in Schlangenbad in Germany, told him she thought this letter 'very characteristic and couldn't have been written by anyone else – you sound very happy and contented in your favourite strenuous way. You are to repeat every Scrap of Gossip that you hear ... Gerald and I will discuss it quietly and gravely over our meals instead of talking about Snakes or the Pathway to Reality which are at present her favourite subjects. They tell us that there are gold and silver ones – (snakes not Pathways) in the woods here...'[36]

He replied, 'You are a great angel to write me such a long delightful letter ... You must come to Rounton* ... Please do, like a Christian and a lady ... I am so glad that she [Gerald] is getting on with the Pathway to Reality. She mustn't mind if she comes to great snags ... The book I thought she ought to read next was Wallace's Prolegomena to Hegel [sic] but on second thoughts I think Plato would be better.'[37] It is amusing to think of these stately Edwardian ladies, sitting in a plush hotel in a spa town in Germany, without a word of the Classics between them, struggling with Hegelian philosophy to please an enthusiastic and attractive young man.

After the trip to Skye, JB wrote to Susie from Cloan in Auchterarder, home of R. B. (Richard) Haldane, Secretary of State for War and author of the famous *Pathway to Reality*: 'It is very nice of you to think me like Charles James Fox; but alas and alack! I am not. I wish I was never idle and never bored. I am incorrigibly idle at present, and I have been comprehensively bored ever since you left these shores.'[38]

It was about this time that JB finally decided to put his resolution to the test and ask Susie to marry him. The timing was probably prompted by the projected publication of *A Lodge in the Wilderness* on 14 November. Although the first edition was published anonymously, for reasons

*Rounton Grange was owned by Sir Hugh Bell, the steel founder (and father of Gertrude Bell). Caroline Grosvenor was a long-time friend of the family but JB also knew them.

unknown, JB's friends almost certainly would guess it was from his pen and he knew that, buried not very deep in this symposium, was a paean of love for Susie. (He is Hugh Somerville in the book, and she Lady Flora Brune – fictional names never were his strong suit.) There are even expressions from their letters in it: at one point Lady Flora says to Hugh, 'If I were not such a Christian and such a lady…'[39]

Before he proposed, however, he had first to secure his future. He could not expect much, if anything, in the way of a marriage settlement. He was naturally uncertain that journalism and the odd legal opinion together would give him a sufficiently substantial and reliable income for a London household, which would have to include several servants, rather than simply a gentleman's gentleman who lived out.

He decided to accept an invitation from Tommy Nelson to become a partner in the family publishing company, Thomas Nelson and Sons, as an editor and literary adviser, to be based mainly at the London office at 35/36 Paternoster Row, in the shadow of St Paul's Cathedral. He travelled up to Edinburgh in early November to meet Tommy at Nelson's headquarters in the Parkside Works in Newington and ten days later wrote to his mother: 'I have investigated the business carefully, and have taken all sorts of advice, and I am satisfied they are continuing successful and capable of enormous development. They offer me a share in the profits and guarantee me a large minimum income … It would give me work I should be deeply interested in. I should live in London still and I should be able to go into Parliament within a reasonable time. Altogether I agree with Milner [whose name carried great weight with his mother, since his South African days] that it is the chance I have been looking for.'[40]

The benefit was mutual. This was not a question of giving a job to an old chum simply for the sake of 'auld lang syne'. JB had been reading manuscripts for publishers since his Oxford days; he was a published author, an assiduous reviewer of books and, perhaps most importantly, he had excellent literary connections in London, while not having entirely forgotten his Scottish roots. The firm, which had agencies also in Dublin, Leeds and New York, was on the cusp of a major expansion, and Tommy's request came at an apposite moment. (Offices were opened in Leipzig and Paris in 1910 and Toronto in 1914.)

The agreement with Nelson's, initially for two years, was that he should work full time for them, as a partner until the firm became a

limited company, and then as a director, for £1,000 a year. Once the partnership was incorporated, he would be given enough ordinary shares to yield £500 in a normal year; before that, Nelson's guaranteed him an income of not less than £1,500 a year.

When he got back to London, he wrote to his sister: 'Everyone in London just now has a cold and is in a bad temper, except Strachey and Miss S.G. The latter has taken to learning Greek, has become a strong supporter of woman-suffrage, has invented a familiar spirit called "Sir Joseph" whose conversation is ridiculous, and is opening a church-bazaar next month.'[41] He was at the stage of finding everything about her delightful.

He proposed finally on 10 November, very likely in the drawing room at 30 Upper Grosvenor Street, Mrs Grosvenor and Marnie having made themselves scarce. Susie turned him down.

Four days later, he wrote to his mother:

> I asked Susie Grosvenor to marry me, and it is a marvel to myself that I have been able to defer the question so long. We have been intimate friends for years [well, eighteen months at most] and I know her as well as I know myself. She has not accepted me yet for she is in a great state of doubt as to whether she might not spoil my life. No really nice woman ever wants to be married; they have all to be coerced into it. I have given her a week, and I think she will accept me. But you may imagine the kind of state of worry I live in just now.
>
> My dearest Mother, I want you to be kind to me about this and not make it harder for me. I know you will. [He knew nothing of the sort.] Burn this letter and keep what I have told you private for the meantime.[42]

There are a number of puzzling aspects to this letter, most of them not amenable to rational explanation so long after the event. What exactly did Susie mean when she said she was worried she would spoil his life? Did she fear that she couldn't keep up with the man her family persisted in calling a 'genius', for she certainly undervalued her own abilities, or was it that she worried about her periodic debilitating melancholy, which we may now identify as depression? And why did he tell his mother, knowing for sure that it would give her ammunition against

a young woman she was bound to dislike, at least initially? Even more astonishing is the statement that no really nice woman wanted to marry. Was he trying to placate his mother by giving her the impression that all the running had been made by him? He didn't succeed, if that was the case. Moreover, Mrs Buchan did not burn the letter. One thing is certain; this letter reveals his high state of anxiety, which had spurred this usually keenly rational being into writing irrational things. He thought he had made a mess of it.

Susie had not, however, turned him down flatly, and it is likely that her mother had stern words to say to her. For on 14 November, in response to an invitation to dine at Upper Grosvenor Street, he wrote a letter that any young woman would like to receive:

> I will come to dinner tonight as you suggest. I quite understand your wanting to take time to decide and I love you for it, for you are very wise and I should not expect you to make [up] your mind easily. I am afraid I was very stupid and nervous on Saturday and did not say half what I meant. You see I have had no experience and I am always apt to understate my feelings. [He had obviously talked too much about his ambitions and excellent prospects and not enough about how he couldn't live without her.] What I wanted to say to you – and what I shall keep on saying – is that you have come to mean far more to me than anything else in the world. I used to think only of my ambitions, but now everything seems foolish and worthless without you. I think I have always been in love with you since I first saw you, but last Christmas I began to realise how much you had come to mean to me. And then for a long time I was quite hopeless, for I did not think I could ever make you care for me in that way or give you the kind of things you wanted in life. Of late – quite unreasonably perhaps – I have begun to hope, and during the last month I felt that I had to put matters to the test as soon as possible.
>
> Of course that is only my side of the case. I am miserably conscious how unworthy I am of you, for I think the whole world must be in love with your grace and kindness. And I have not very much to offer except chances. But I think I could make you happy, and one thing I can give you, the most complete devotion and loyalty. You

are the only woman I have ever been in love with, and ever shall be in love with.

I don't want you to decide hastily, and above all I don't want you to let any kindliness or pity for a friend influence [you], if you are not quite sure. (I oughtn't to write this, for you are so candid and wise and honourable that I know you would never say what you didn't really and truly mean...) But, oh my dear dear child,* if you can care for me, you will make me so gloriously happy, and I think we should both be happy people in life.

I won't write any more for I shall see you soon. Brighton was very pleasant. I was very restless and <u>distrait</u> and must have been a great nuisance to Harold [Baker, his old Oxford friend], but it made me feel very well. Yours ever JB.[43]

Not surprisingly this did the trick.

Even after their engagement, the only intimation that their relationship was physical comes in teasing comments about her golden hair becoming thoroughly disordered when they meet. The habit then of reticence about such matters (at a time when anyone might pick up a letter lying around) was too strong to break, on paper at least. Nevertheless, this was a true love match, and – as is obvious from all the extant letters to each other up to the last time they were separated in the autumn of 1938 – it was one that lasted.

Sundry writers have surmised over the years that there was a strong element of calculation in JB's wish to marry Susie; that she provided an *entrée* into the heart of the British establishment that a Scottish parvenu required if he was to 'get on'. The evidence simply does not bear this out. To begin with, he was already very well set up in her milieu before he met her. From his youth, he was known to a number of well-connected Scots, such as Andrew Lang, Augustine Birrell and the Marquess of Tullibardine, since class barriers were never so adamantine in Scotland as in England. At Oxford, he made a number of friends, whose parents would have dined with Susie's mother. What is more, the Grosvenors were most notable for their wealth rather than distinction or fame in any other field, and Susie's immediate family

*A common expression in those days, which Susie would not have considered patronising.

were not capable of advancing JB's career in any particularly useful or material way. A more calculating man would instead have courted the likes of Miss Florence Wolseley, the heiress, or Lady Grizel Cochrane, the daughter of a Scottish earl.

If he had not discovered that he loved Susie and felt impelled to ask her to share his life, he might well have remained a bachelor. There was no stigma attached to it, as there was to spinsterhood; there were plenty of opportunities for social life and companionship amongst men, in particular, in London, and he could afford to pay staff to cook and clean for him. Moreover, there was no pressure from his family for him to marry, quite the reverse, since his father had been the only one of six children to marry, while his mother had two bachelor brothers and, despite herself being happily married, was inclined to think JB's marriage would break up the closeness of the family. If he had not fallen in love, he might still have married in the end but it would have been in order to have children, and the joy that he knew, from his own experience with a much younger brother, that they could bring. His most complex and best-realised fictional character, Edward Leithen, never marries, which suggests that JB had no prejudice against bachelordom.

A few days after the successful proposal, Anna wrote a generous, if not entirely frank, letter to Susie:

> I have thought of you such a lot since John wrote me his great news last Friday. John has been all the world to me since I can remember anything and I don't really think there ever was a kinder and more considerate brother. I used to wonder what I should do when John married but now that John has found the one woman in the world, I find I don't grudge him to you in the least and can only rejoice with him in his great joy.
>
> He is so blissfully happy and he says such lovely things about you. When I meet you, he declares, I shall be sure to fall in love with you too. I am prepared to be very proud if you will let me be very fond of John's wife. I am looking forward so much to meeting you. You will try to like me, won't you, for John's sake?[44]

The letter from Mrs Buchan to Susie was not so effusive. It is plain where she thought the balance of benefit lay:

My dear Miss Grosvenor,

I have just heard from John of his engagement to you and am writing to assure you of a very friendly welcome into our family – which has always been a most happy one. I think you are to be congratulated, for if John is as good to his wife as he has been to his Mother you ought to be a very happy woman. It is my earnest prayer that this may be the beginning of a most happy and useful life for both of you. I shall be very grateful to you if you make a happy home for my dear boy. My son Walter, with whom I am living at present, joins with me in every fond wish. We shall look forward to making your acquaintance when it suits you to pay us a visit.

With love and again hoping for you all that is best.

Yrs v. sincerely

Helen Buchan[45]

However, in private, the complaints about JB's engagement were long and bitter, and made Mrs Buchan 'depressed'. Despite her assurances to Susie, Anna was not happy either. Fortunately, JB had a stout ally in Willie in India. Once the news reached him, he wrote to his mother: 'I am altogether delighted and feel sure that John has done a very wise thing, though it does take a little time to adjust one's point of view from John the Confirmed Bachelor to John the Engaged … I have written to Susie expressing my approval of her as a sister in law!'[46]

His mother didn't agree, for Willie was moved to write to her again on Christmas Day: 'I don't think you are taking John's engagement in the proper spirit. It isn't true to say that John is selfish when you know what a good son and brother he has been. In a matter like this John is the best judge, and how much happier you would be if you would only realise that. This whole thing is perfectly natural and inevitable and desirable, and in his own best interests. Of course it isn't pleasant for you, as that sort of thing never can be to a Mother, but you want to take a much broader view of life, old body. I know that your mournfulness is chiefly due to your not being very well and Father being seedy. I am very sorry indeed to hear it, and I do hope you are both all right now, and will write me more cheerful letters.'[47]

Mrs Buchan cannot be entirely blamed for her attitude. She had never met Susie, who came from a world she knew nothing about, being English *and* Anglican, nor had she watched the courtship unfold. It is highly likely that Willie, as well as Anna, had taken care not to tell their mother what was afoot. Consequently, JB's letter announcing his engagement must have come as a thunderbolt out of a clear blue sky.

A Lodge in the Wilderness, a fictional political symposium published by Blackwood's,* was dedicated to 'G.C.S.' (Gerard Craig Sellar). The action takes place in a country house, Musuru, which resembles the fantasy house that JB wanted to build at 'Buchansdorp', but set on a high plateau in east Africa. The high-minded, well-heeled characters, nine men and nine women, from the upper and professional classes, are all there at the invitation of Francis Carey, a thinly fictionalised portrait of the late Cecil Rhodes. The fictional characters approximate to a number of real people, including Lord Rosebery, Lord Milner, the Canadian statesman Sir Wilfrid Laurier, the Rand magnate Alfred Beit, Lady Leconfield, and Susie's aunt, Katharine Lyttelton, as well as a big-game hunter, a soldier and a journalist. The women talk sense, and are taken seriously by the men, which in itself may have been refreshing. The protagonists, who display a number of different viewpoints – there are free traders and protectionists, Tories and Liberals – debate what Empire means and how it should best be developed. 'Hugh Somerville', JB himself, says: 'What we are going to talk about is the whole scheme of life which a new horizon and a new civic ideal bring with them. It affects the graces as closely as the business of life, art and literature as well as business and administration.'[48] There is a specific rejection of 'Jingoism' by Lord Appin (Lord Rosebery): – '[Jingoism] means that we regard our empire as a mere possession, as the vulgar rich regard their bank accounts – a matter to boast of, and not an added duty … [Jingoism] belongs to the school of thought which thinks of the Empire as England, with a train of dependencies and colonies to enhance her insular prestige; but it has no kinship with the ideal of an empire moving with one impulse towards a richer destiny.'[49] The measured and reflective, if over-idealistic, tone of the book ensured a positive reception at the time and, a century

*Nelson's brought out an edition in 1917.

later, the *Dictionary of National Biography* averred that 'it remains one of the clearest and fairest analyses of British imperial endeavours'.[50] As a guide to JB's attitudes and interests, it is instructive that the portrayals of the Jewish financier and the Canadian politician are favourable. But the modern reader inevitably catches a strong whiff of paternalism.

Thanks mostly to Mrs Buchan's attitude, the engagement did not progress along a primrose path. Willie wrote early in the New Year that he was sorry JB had had a 'slight breakdown', by which he meant that he had been ill, since he was not suffering from a nervous collapse in December. (Either that, or it is a euphemism of his mother's for the effect of a row with her.) Relations between him and his mother were plainly very strained. He was not much in evidence that Christmas, avoiding the kirk service on the Sunday before, so that he could go for a long walk with Walter. He left home on Christmas Day in the afternoon to eat a solitary dinner in Edinburgh and catch the night train, in order to arrive at Crabbet Park on Boxing Day, and spend the holiday with Susie and her family and friends. With what relief must he have settled into post-Christmas festivities with the woman he loved and amongst courteous, kindly, agreeable, uncensorious English people.

Devoted to his mother as he was, JB had chosen a bride who was almost the antithesis of her. With the exception of the golden hair, conspicuous family loyalty, proneness to low moods and pronounced social conscience, there were no shared characteristics. Susie was much taller, and more languid, lacking Mrs Buchan's almost daemonic energy (Susie had breakfast in bed all her life), not at all interested in household matters, religious only in a muted and restrained Anglican way, chronically indecisive, absent-minded, always mislaying her possessions, and, crucially, coming from a markedly privileged and thoroughly entitled background. She might have to put up with possessing few dresses, but she could indulge her love of the contemporary theatre and spend time amongst friends in some of the grandest country houses of England. She was related to almost all the great, in the sense of historically prominent, families in England, whose traced lineage went back close to a thousand years, a fact that at the time would have impressed many a fond mother. Susie's interest in politics and intellectual matters, and the fact that she was gentle, feminine, a very good listener, discreet, unselfish, without pretentiousness, and that she

plainly adored him, were all virtues that would recommend her to JB, of course, and they would eventually win Mrs Buchan round. But it was tough going at first.

It is customary for a large, close-knit family to feel that anyone marrying into it has most of the luck and privilege on their side. Even so, it still seems odd that the Buchans – especially JB's mother but Anna as well – did not consider that Susie was good enough for their John. What makes the irony even more piquant is that the aristocratic families that crowded around Susie, who it might be assumed would have been snobbish about a Scottish son of the manse, without title or inherited money, seem to have appreciated his qualities from a very early stage and were (mainly) delighted with the connection. As a relation said, when congratulating Susie on her engagement: 'So you aren't going to be a fat Duchess after all. I had always looked forward to being given one finger to shake at an omnium gatherum garden-party by your Grace, and now you're going to marry something like a genius instead.'[51] Susie's mother wrote to one of her sisters: 'I love him dearly. I don't think you could help loving him. He is so manly and simple and *so* intelligent.'[52]

True, there were one or two English people whom Susie didn't please much more than she pleased Mrs Buchan. Virginia Woolf, to whom the Norman Grosvenors had been conspicuously kind when she was a girl, repeated the opinion of her brother-in-law, Jack Hills:[*] 'Susie Grosvenor is engaged to John Buchan and the wise – that is Jack – predict tragedy. How is she to live with a clever man all the days of her life? She is pretty and flaxen and brainless (that is Jack's voice) and must have a man to hold her handkerchief – but her heart is excellent – He has a brain, edits *The Spectator* and thinks of politics.'[53]

Much as JB liked her family, he couldn't resist teasing Susie about some of her more reprehensible ancestors. In *Midwinter*, his historical novel set at the time of the '45 Jacobite rising, he has General Oglethorpe remark about Sir Robert Grosvenor, a Cheshire baronet in the mid-eighteenth century: 'Now Sir Robert's mother [née Mary Davies] was an heiress and all the faubourgs of London between St. James' and Kensington village were her fortune. Whence came that fortune,

[*] J. W. Hills was the widowed husband of Virginia Woolf's half-sister, Stella Duckworth.

think you, to enrich the honest knights of Cheshire? 'Twas the fortune of an ancient scrivener [notary] who bought up forfeited lands from Cromwell's Government, bought cheap, and sold most profitably at his leisure…'[54] In other words, a direct ancestor of Susie's had become rich from the downfall of other, better men.

In January 1907, Mrs Buchan and Anna travelled to London to meet Susie, and to attend the couple's engagement party. The first meeting took place at Brown's Hotel in Piccadilly and it was a sticky occasion. They enjoyed more the engagement party in the mansion in Park Lane, belonging to JB's South African friends, the Hermann Ecksteins, despite it being a ridiculously lavish affair in their eyes, with white heather, menus printed on silver bells, and silver slippers containing sweets. 'One almost expected the footmen to be got up as cupids,'[55] observed Anna drily.

Having heard an account of this trip, Willie wrote to his mother: 'What a lot of interesting people you and Nan met in London. Isn't that one of the pros of John's engagement? I am sorry you didn't take to Susie, poor girl: but I hope you will come round. It is certainly your bounden duty to try.'[56] And to his sister: 'I am glad you liked Susie, but astonished that you thought so little of her intelligence and looks … I never claimed for Susie ravishing loveliness, but my recollection of her is certainly one of smartness and cleverness, and I'm certain it wasn't due to my freshness from the jungle. The prospect of matrimony may not be conducive to light conversation. It certainly would tongue-tie me.'[57] Willie, so much more worldly, would have met girls who looked and sounded like Susie at balls given by the Lieutenant-Governor of Bengal.

Once JB decided to join Nelson's, he knew he must resign from his position at *The Spectator*. Although he gave nothing like a year's notice, Strachey wrote very kindly to him, saying that he was glad that JB had not shut the office door for the last time and that he wanted many 'serious and sober' reviews from his pen.[58] At least initially, these tended to be long round-up reviews of poetry, as well as articles on exploration, mountaineering and fishing.

In February a second edition of *A Lodge in the Wilderness* was published, with JB's name attached, putting an end to all the speculation surrounding the author. At the same time, JB went to work

in Edinburgh, having promised Tommy Nelson that he would spend two or three months there at once in order to learn about the publishing and printing trade at the Parkside Works.

The firm had been founded as a second-hand bookshop in West Bow in Edinburgh in 1798 by Thomas Nelson, a canny entrepreneur who could see that there was a market for cheap editions of out-of-copyright classics. In 1850 his son, also Thomas (who together with William had joined the firm some years before), perfected 'the rotary press', which revolutionised mass printing, since it could print on both sides of the paper, and very fast too. The range of books offered by the firm expanded to include 'moral books' (which became very popular as Sunday School prizes), educational and travel works, as well as adventure stories. In 1880, after a fire, the works moved to Parkside, near Arthur's Seat, and the innovations continued, with upgraded presses that could produce standardised sizes of books. In 1900 these included the New Century Library of classic fiction and, from 1903, the Sixpenny Classics, reprints of books out of copyright. These were in a standard size of 6 ½ by 4 ½ inches, for ease of production – the right size for knapsack, pocket, 'and especially suitable for railway reading'.[59]

When JB arrived at Parkside in early February, the company was well positioned to cater for the mass market in cheap good books, especially as Nelson's were building an extension to the factory, a printing and binding plant with a production capability of 200,000 books a week. The other partners were the brothers Tommy and Ian Nelson, together with their capable and hard-working Canadian cousin, George Brown, who had imported an up-to-date ('very complex and scientific') accounting system from the United States. Nelson's were notably good employers for the time: there were extensive sports facilities and a cultural institute for the employees, and women were well treated.

In May, three months after JB arrived, Nelson's introduced the first titles in the Sevenpenny Library. These differed from the thin-paper Sixpenny Classics in that they were reprints of works still in copyright, so of modern rather than classic fiction, and they were handsomely bound in red and gold cloth bindings. JB sent the very first copy off the presses – *The Marriage of William Ashe* by Mrs Humphry Ward – to Susie, and four titles appeared in bookshops in May, with new ones added every fortnight. JB began to use his contacts amongst London literary agents to bring in works by Joseph Conrad, H. G. Wells (whom

JB described as 'quite the most disgusting person')[60] and his friend Henry James. Nelson's technological efficiency and vertical integration ensured that the Nelson 'Sevenpennies' revolutionised the habits of the book-buying public;[61] certainly their competitors were quickly forced to follow suit.

JB was in the thick of these new developments, even if he didn't initiate them. As well as literary advice and the minutiae of book production, he found himself dealing with sales personnel, literary agents and general administration, including the sourcing of paper. While working at Parkside in early 1907, he stayed with Tommy Nelson and his wife, Margaret, at a large neo-Gothic house built by Tommy's father, called 'St Leonard's', very close to the Works. (It is now part of the Pollock Halls of Edinburgh University.) In March, however, he went to lodge in Hanover Street with Sandy Gillon, now practising at the Scottish Bar. At weekends he travelled to Glasgow to see his parents, for his mother was ailing, or to Peebles, so that he could walk the hills with Walter.

He was extremely busy learning the business. He wrote to Susie: 'Today I have spent almost entirely in machine shops in the company of old and [indecipherable] Scotch engineers. They know their business uncommonly well and explain details to me with an Olympian superiority. Great engines always fascinate me, and I enjoy the work very much. But there is a great deal of detail besides which has not the interest of novelty.'[62]

JB also took over responsibility for *The Scottish Review*, a weekly penny journal issued by Nelson's, which he wanted to make into a Scottish version of *The Spectator* and was his particular concern from the time he first arrived at Parkside until it folded at the very end of 1908. The editor was a Scottish writer called W.[illiam] Forbes Gray, but it was JB who wrote a great deal of the copy, contributing a number of columns, including book reviews, a survey of politics and a 'London letter'. *The Scottish Review* had grown out of a rather churchy periodical called *The Christian Leader*, which Nelson's acquired in 1905. JB at once set about making it less parochial and more secular, with good-quality serial fiction and book reviews, stories and political articles by distinguished writers, from the Scottish novelist Neil Munro to R. B. Haldane. He also toned down its Radical and ultra-nationalist stance.

He gradually introduced columns on art, music and the academic world, as well as one for women.

Gray increasingly worried that it went over the heads of the buying public. As he wrote, a little sniffily, in the Introduction to *Comments and Characters*, an anthology of pieces from *The Scottish Review*, published after JB's death: 'Buchan, I soon realized, was not enamoured of popular journalism, nor was he in entire accord with Scottish sentiment ... Residence in England and South Africa, together with an Oxford education, had influenced his point of view, probably unconsciously, and interposed a barrier ... between him and his countrymen...'[63]

Gray freely admitted that JB was a delightful person to work with, since he appreciated good work and praised it. Interestingly, even by 1907, Buchan had taken on a veneer of Anglicanism that Gray thought was the reason why he did not view the Scottish Church very warmly, believing that, at that time in Scotland, there was 'a kind of restless interest in church affairs which is no more a spiritual thing than an interest in party politics'.[64] (That criticism could certainly be laid at his mother's door.)

Circulation and advertising both diminished under this regime so the plug was reluctantly pulled at the end of 1908. JB wrote to Gray, 'It has been a gallant and worthy little paper, of which none of us have any cause to be ashamed.'[65] Its end was regretted by intellectuals, academics and literary novelists, but probably not that much by ordinary church-minded Scots.

Despite his extreme busyness, he found time to write to Susie (using her mystifying nickname Moufflée) every morning after breakfast. Since they were mostly apart, they had to express their love and suppressed longing for each other almost entirely through their letters. ('O Mouffs, I am so sick of not seeing you. You have poisoned my life, for you are so much nicer than anything else that all my modest pleasures have paled in comparison.')[66] JB missed her much more acutely than he had expected but could take the anodyne of hard work, while Susie found it almost impossible to distract herself, even by dealing with the torrent of presents that poured into 30 Upper Grosvenor Street. These included several silver inkstands from Asprey's, a fleet of silver sauce boats, and an enviable set of lustre plates from William de Morgan himself. In

those six months the couple only managed a few days together towards the end of March at Highcliffe in Hampshire, as well as a short trip to Peebles.

Willie in India had no doubt that Mrs Buchan's hostile attitude to the forthcoming marriage was affecting her health, which deteriorated materially in February and March. 'You are needlessly fretting yourself unwell,'[67] he wrote that April. In *Ann and her Mother*, Anna's extremely thinly veiled biography of her mother, published some years later, 'Mrs Douglas' says: 'Mark's [JB's] engagement gave me a great shock. It came as a complete surprise, and we knew nothing about Charlotte [Susie], and it seemed to me that it must break up everything, and that I must lose my boy.'[68]

Anna herself, though she tried to make the best of things, was not entirely happy either, privately dreading the loosening of ties and caught in a tangle of illogicality. 'To him I owed so much the pleasure and interest in my life that I very earnestly wished him well.'[69]

It was little surprise that Susie suffered an acute crisis of nerves when finally she travelled up to Peebles to stay with the Buchans in late May, JB having had to go from Edinburgh to London to collect her, since there was no room in Bank House for her lady's maid. As she wrote to her mother when she arrived at Bank House: 'I had a horrid moment of homesickness before I got to Peebles. John told me his brother [Walter] was going to be there and my heart went into my boots – and I even went so far just before we arrived at Peebles station as to ask John to let me go home to my woolly one [one of her mother's nicknames]. I really really meant it – I would have given all I possessed not to go on. However I pulled myself together and saw Walter on the platform. He is very short and has a much longer, narrower face than John. Then a small boy [Alastair] in a kilt and a cap with streamers was lifted into the carriage murmuring "Very glad to see you." '[70]

A few days later she wrote: 'Yesterday we had a tea party of the rank and fashion of Peebles. They all arrived punctually at 4 o'clock – I was an object of great interest as they had all read John's books and regard him as a celebrity. We made conversation steadily for about an hour and a quarter. Peter [a terrier] was a great help as whenever topics flagged we patted him and stuffed him with cakes, with the result that he was very sick that evening!!!'[71]

Nothing in her life ever became Susie better than the way she approached the Buchan family. It was much more than simply a matter of good manners, but a serious attempt to please JB's 'people'. She studied beforehand to make sure she had topics of conversation for them all: flowers for the Reverend John Buchan, 'the poor' for his wife, poetry for Walter, novels for Anna, and she brought butterscotch for Alastair. She seems to have seen their worth at once, even if she had never come across anyone quite like them in her twenty-five years:

> I was charmed by Bank House with its polished brass door-handle and its little hall, and the sitting-room with a glowing fire and books everywhere. I felt strange and a little alien to my new family, but we soon found that the same things made us laugh, and no bond is stronger. I was fascinated by my mother-in-law's ability, and by the rapidity with which she worked. I can see her now writing long letters with her pince-nez perched on the end of her nose, or putting a lightning patch on her husband's or sons' underclothes, or making spills out of newspapers.
>
> Her powers of work were amazing. She would get up at five in the morning and tackle the day's tasks from then onwards with a pace and … concentration which would have exhausted most strong men. She radiated an incessant activity and had apparently solved the problem of perpetual motion. Her husband and children adored her.[72]

Considering how much Mrs Buchan sighed over the engagement, this seems remarkably gracious.

Of Mr Buchan, Susie wrote to her mother:

> John's father is such a gog [delight]. He has the most heavenly good-tempered way with him – and laughs and is laughed at by his family all the time. He plays the penny whistle delightfully – and Peter [the terrier] simply <u>howls</u> at it!!!
>
> There is something very keen and strenuous about the atmosphere here; to begin with one feels very fit. They all talk awfully well – so intelligently and keenly and the amount of poetry quoted is amazing. One feels very alive and invigorated.[73]

What impressed Susie particularly was the way the family practised economy as far as their own wants were concerned, while exhibiting open-hearted generosity to others:

> I had known extravagant people who spent money on their own pleasures and had nothing left to give to others. I had also met many kind and generous people, but I had never before come in contact with any one family who economised so much on themselves and gave away money so unsparingly.[74]

Thanks to Anna's generosity of spirit, as well as their mutual weakness for collapsing into giggles at the same absurdities, she and Susie struck up a close and lasting friendship. One of the reasons they got on so well together was that they were bred to the same predicament: as bright as educated men but knowing that most avenues of worldly endeavour would never be open to them.

Susie had particular reason to be grateful to the twelve-year-old Alastair during this time, since he was unaffectedly delighted to make her acquaintance and was prepared to bake her cakes as tokens of his esteem. Being so much younger than his brothers and sisters, he had been a good deal petted in childhood by them, especially by Anna, who took charge to a great extent in bringing him up, since Mrs Buchan was deeply involved in kirk matters. Even disregarding the exaggerations prompted by family affection, he was plainly a delightful boy: funny, cheerful, idiosyncratic, a great dreamer, and much attached to his family. He was a voracious reader of poetry and prose and, when inspired by something he read, would march up and down the room, declaiming. He was particularly keen on *Cyrano de Bergerac* and would stand on the sofa, waving a home-made sword, and leap off, shouting 'Cadets of Gascony are we', as if he were 'behind the walls of Arras'.

During her stay, Susie was taken to the farm at Bamflat, near Biggar and listened respectfully to the Masterton uncles, John and James, even though she could scarcely understand a word they said. They visited Helen's sister, 'Antaggie', and her blind husband, Willie Robb, at Gala Lodge in Broughton: 'Mrs Robb is very fat and cheerful and was dressed in a shiny thick silk dress and Mr Robb told us Scotch stories and played the pianola. We sat consuming scones in the little drawing room and listening to talk about the various ministers.'[75] Fortunately, at times JB managed to

contrive to get his fiancée alone to breathe some fresh air walking in the hills round Peebles, or by the River Tweed as far as Neidpath Castle or Manor Water. By the end of the fortnight, Susie had won over most of the family; it was only Mrs Buchan who refused to unbend.

After the Whitsun holiday, JB settled down to working daily at Paternoster Row in London. He acquired immediately as his secretary an eighteen-year-old girl straight out of secretarial college, called Lilian Alcock (after 1916, Lilian Killick), with whom he was to have a close working relationship for the rest of his life. She was efficient, reliable, literate, intensely loyal and dependably discreet, and she became a dear and respected friend of the Buchans, despite never dreaming of calling them by their first names. Decades later she remembered her first day working for JB at Nelson's in London, when he dictated forty letters at high speed, in a high-pitched voice that could blur the vowels, so that she once wrote down 'Countess of Ayr' when he was writing a letter to the County Surveyor.[76] He could dictate at 160 words a minute, never hesitating when dealing with letters or speeches. 'I would not say that he was a business man in the ordinary sense of the word,' she wrote much later, 'but he *was* business-like and methodical to a degree.'[77]

There is much truth in that, for, although JB was very interested in most processes of the business of Thomas Nelson and Sons Ltd, and had an excellent relationship with the workforce, he seems to have had something of a blind spot about the firm's finances, and often recommended books to George Brown on gut instinct rather than an informed, costed assessment as to whether they would make Nelson's money or not. Brown, and even more the long-suffering production manager, George Graham, had sometimes to rein in his enthusiasm.

The last weeks before the marriage were made extremely fraught because Mrs Buchan was so unwell. Thin, weak and downcast as she was, JB began to think that there was no chance that she would make the wedding and that it might even have to be postponed. He told Susie that 'I am very distressed about her, and Anna, for once, seems at her wits' end. The truth is that she has no desire to get better, and won't be persuaded to do anything.'[78] As a result of these anxieties, even JB's generally equable nerves became strained. A fortnight before they were married, he wrote to Susie: 'Darling mine, I was a hideous cross old bear with a sore head last night and you were a kind little angel, and

I don't deserve to have such an angel, and I am very sorry, and I won't do it again and that's all.'[79]

Despite worrying about his own mother, he had space to be anxious about Susie's. Just before they married, he wrote to his fiancée: 'The person I can't get out of my thoughts is our poor Gerald. You see my gain is the measure of her loss, and as the one is so enormous the other must be very bad. I am very sorry for her. She is a great angel.'[80]

In the end, all the Buchans were well enough to attend the wedding and the sun shone brightly on the afternoon of Monday, 15 July 1907, as the bride arrived at St George's, Hanover Square. (How JB, who loved Thackeray, must have smiled at the thought of being married in the church of *Vanity Fair*.) Susie had been conveyed – rather queasily – the half mile from Upper Grosvenor Street in the Duke of Westminster's* carriage, which had been lent for the occasion. She was met by her uncle, Lord Ebury, at the door and they walked up the aisle to the strains of the Allegro in C from the *Serenade for Chamber Orchestra*, composed by her father, and played by his friend, Dr Walford Davies, the organist of the Temple Church.

The square eighteenth-century church, with its wide nave, box pews, gallery, and chancel floor of black and white marble, was filled with what the newspapers called 'a fashionable crowd', although it also included the Grosvenor Square road sweeper, a long-time friend of the bride's. St George's had seen many society, and in fact Grosvenor, weddings, but this occasion was a little different. Instead of the customary sober, white and green mixture of lilies and trailing smilax vine, the flowers on the screen erected across the chancel steps were colourful sweet peas, red rambler roses and mauve wisteria. These struck one commentator as being 'rather suggestive of a maypole'.

The bride, who was described as 'extremely comely', wore an ivory-white stiff satin gown, with a fichu bodice and kimono sleeves of silver-embroidered chiffon, made for her by the voguish dressmaker, Madame Kate Reilly of Dover Street. Her veil was of ultra-fine Brussels lace and trailed to her feet. She carried a sheaf of white lilies. The young page, who carried her long train, was Ivor Guest, the son of a cousin, and the very image of little Lord Fauntleroy in his pink and silver brocade court

*The Westminsters no doubt remembered JB as one of their hosts in the house in Parktown outside Johannesburg in 1902.

suit, with lace ruffles and paste shoe buckles. Susie was accompanied by seven bridesmaids, including her sister, Marnie, and JB's sister, Anna. They wore plain long skirts and fichu bodices of pale pink *ninon de soie*, embroidered with silver 'passementerie', over white glacé silk. On their heads they wore wreaths of pink roses, and they carried little baskets of sweet peas. These dresses were intended to show off the slenderness of their waists and were modest in the extreme.

Mrs Grosvenor gave away her daughter, while Hugh Wyndham,* a friend from South Africa days, was best man. Dr Cosmo Lang officiated. He had been born in a Church of Scotland manse, but was now the Anglican Bishop of Stepney, resplendent in purple. JB would not permit an address on the grounds that you never knew what a Bishop might say. Hugh Wyndham reported that Mrs Buchan glowered at Lang. If she did so, it was perfectly understandable, since not only would she have considered him a traitor, but she was bitterly hurt that her husband had not been invited to take part in the ceremony. Certainly such a snub looks, at this distance, to be a piece of reprehensible Anglican bad manners, but the Reverend John Buchan, though disappointed, was resigned. He knew his church history too well.

While the Register was being signed, the congregation sang 'O Perfect Love', a hymn specifically written for weddings; this was followed by Mendelssohn's anthem, 'Lift thine eyes to the mountains, whence cometh help', which we can safely assume was the bridegroom's choice.

The public prints had a field day. There were descriptions, not all very accurate, in many national and provincial newspapers and periodicals. *Queen* even carried a fashion plate to show Miss Grosvenor's wedding dress and 'going-away' outfit, as well as the bridesmaids' dresses.

Although the outfits of some of the most aristocratic guests were described (Mrs Ivor Guest must have looked wonderful in corn-coloured painted chiffon), little was said in the English newspapers about any of the Buchans, except the groom. He was 'clever and popular', 'the well-known novelist and literary critic', and 'in his way, a very remarkable man'.

There were no photographs taken of the couple after the ceremony, since Susie's mother did not want the guests to be made to hang around – photography in 1907 being still a laborious business. This

*Later the 4th Lord Leconfield.

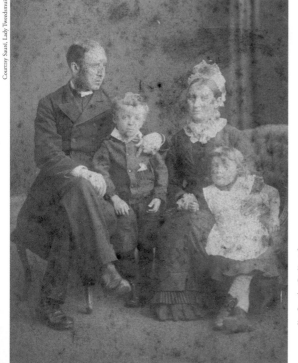

Broughton Green in Broughton, upper Tweeddale, on the Edinburgh–Carlisle road, where John Buchan's mother, Helen Masterton, was born, and the Buchan family spent their childhood summer holidays.

The Reverend John Buchan, a minister of the Free Church of Scotland, with his wife Helen and two eldest children, John (born 1875) and Anna (born 1877).

Hutchesons' Grammar School masters and pupils in 1891. JB, aged fifteen, is second from right, back row, and James Cadell, his inspirational Classics master, is second from right, middle row.

The Buchan family in the summer of 1892 or spring 1893. Back row (left to right): Anna, JB and the Reverend John Buchan; front row: Walter, Mrs Buchan with Violet on her lap, looking like a wraith, and Willie.

The Oxford Union Society Committee, 1898. JB is second left, middle row, with his hands on Johnnie Jameson's shoulders. The inventor of the clerihew, E.C. Bentley, is furthest on the right.

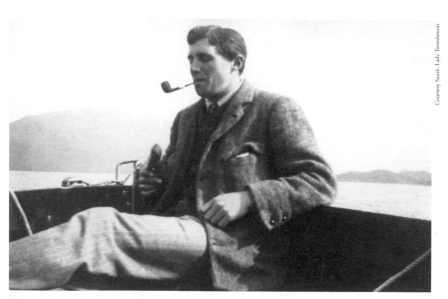

Tommy Nelson, who met JB first at Oxford, asked him to join his family publishing company in 1906. He owned an estate, Achnacloich, on the shore of Loch Etive in Argyllshire, which is probably where this photograph was taken.

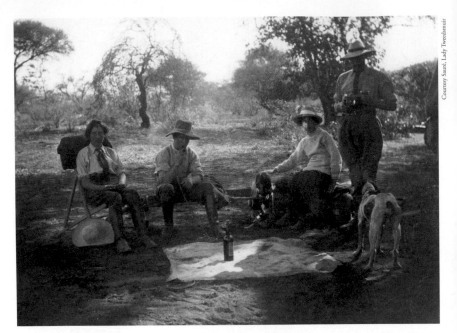

JB is sitting second left in a camp in the South African veldt. 'No words can tell the tale of a veldt sunset.' (*The African Colony*).

Lord (Alfred) Milner, High Commissioner of South Africa and JB's immediate boss, on an old nag close to the Parliament House in Cape Town, circa 1901. Note the cows wandering about.

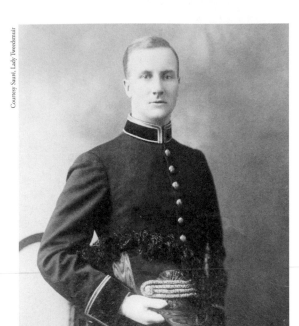

William (Willie) Buchan, born 1880, the handsomest of the Buchan brothers, in Indian Civil Service uniform. He worked in Bengal and Bihar from 1903 until shortly before his death in 1912. He is the 'Fratri Dilectissimo' of JB's most famous poem.

JB – barrister, journalist and dapper man about London – just after *The African Colony* was published, and about the time he was writing *The Law Relating to the Taxation of Foreign Income*, by a distance his least-read book.

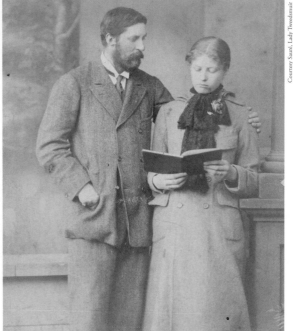

Norman Grosvenor, youngest
son of the 1st Baron Ebury, with
his wife, Caroline (neé Stuart-
Wortley), parents of Susan and
Margaret Grosvenor. An amateur
but accomplished pianist and
composer, Norman died aged
only fifty-six, when Susie was
sixteen and Margaret (Marnie)
eleven. Caroline was an artist
and later also a published novelist.

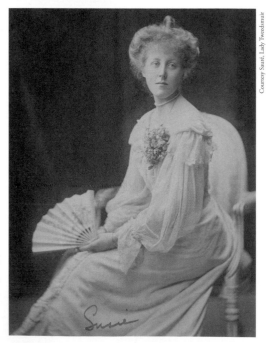

Susie before her marriage, with
a fashionable 'teapot-handle'
hairstyle and just a hint of the
Stuart-Wortley undershot jaw.

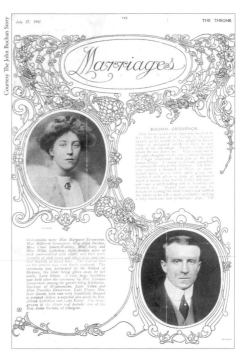

Marriages

BUCHAN - GROSVENOR

Miss Susan Grosvenor, who was married to Mr. John Buchan at St. George's, Hanover Square, on St. Swithin's Day, ought to have a return or unexpected shower of days for any truth in the old adage. There, to be sure, where the sun shone on their union. She is the elder daughter of the late Norman de Ville Grosvenor, third son of the first Baron Ebury. I heard of friends who came to admire the very pretty wedding. The bride who carried a hundred or more of closely looked heels in one white satin gown embroidered with silver in June of uttermost much in favour with Society belles this year and wore a satin-clinging veil of beautiful old Brussels lace. Rather love's said was the honour of having the bride's trousseau and fulfilling the duties of his office most creditable, making every handsome and picturesque pages. The bridesmaids were Miss Margaret Grosvenor, Miss Mildred Grosvenor, Miss Alice Buchan, Miss Clare Stuart-Wortley, Miss Lucy and Miss Hilda Lyttelton; their dresses were of pink embroidered with silver, and they wore wreaths of pink roses and silver tulle, and carried baskets of floral lace. So musical part of the service was very fully rendered. The ceremony was performed by the Bishop of Stepney, the bride being given away by her uncle, Lord Ebury. A very large reception was held after the ceremony by Mrs. Norman Grosvenor, among the guests being Katharine, Duchess of Westminster, Lady Nellen and Miss Dorothy Grosvenor, Lady Ebury, Mrs. Hoe Grant, who was very beautifully dressed in painted chiffon, a material also worn by Mrs. Alfred Lyttelton and Lady Kerry. The bridegroom is the clever and popular son of the Rev. John Buchan, of Glasgow.

Announcement of the marriage of Susan Grosvenor to John Buchan in St George's, Hanover Square, London in *The Throne*, July 1907.

A fashion plate from *Queen* magazine showing the dresses worn by (from left) the bridesmaids and the bride, as well as Susie's 'going away' outfit.

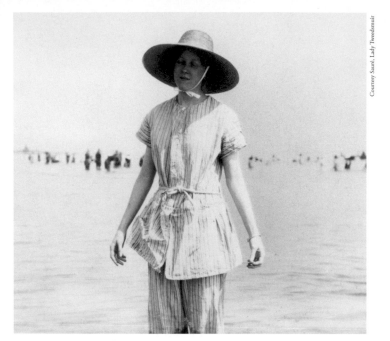

Susie and JB at the Lido in Venice in August 1907, during their honeymoon. As Susie wrote to her mother: 'Mine was a sort of Norfolk jacket and knickerbockers all in one, and striped pink … Anything more killing than we both looked would be hard to imagine.'

'We reluctantly gave up the hats and plunged into the sea which was Prussian blue and hot and gogglie to the last degree … It was the most delicious experience I have ever had.'

was later a source of regret to the family, although presumably not to Master Ivor Guest, the elaborately dressed page boy, who grew up to be a dignified politician called the 2nd Viscount Wimborne.

The reception was held at Upper Grosvenor Street, and the papers were keen to stress that the dowager Duchess of Westminster had favoured it with her presence. If any of the grand guests, such as the Countess of Kerry or Adeliza, Countess of Clancarty (names reminiscent of *Vanity Fair*), later remembered this wedding as different from any other that they had attended at the fag end of the Season, it might well have been because of the fond farewell they witnessed between Susie and her parrot, Aglavaine. This parrot 'had a commanding upper beak and a mass of wrinkled grey skin round a pair of bright dark eyes. In spite of his formidable appearance, he was a gentle and affectionate bird who had no objection to being kissed.'[81] He was wrapped in a towel so as not to spoil the bride's pale blue *crepe de chine* 'going away' dress, but fought noisily to get out and clamber onto his mistress.

Willie Buchan, far away in India, wrote in fine fraternal style to his sister: 'I saw portraits of the misguided couple in several of the papers … I perceive you were dressed in *ninon-de-soie*. Never heard of it. But John said you looked beautiful. Surely that wasn't possible … What a gay gallivantin' family you are! And my elderly respectable father kissing his daughter-in-law and jaunting over to Paris! He'll be losing his job one of these days…'[82] Since Free Church people were absolutely not given to social kissing, this gesture, by the man who had taken so little part in the fractious debates over JB's marriage, mutely but eloquently signalled the acceptance of Susie into the Buchan family – to the whole world, but most particularly to his wife, Helen.

The first week of the honeymoon was spent at Tylney Hall in Hampshire, a house owned by Sir Lionel Phillips, the Rand magnate. It was luxurious to a point: pink, scented water flowed from the bath taps. From Hampshire the couple travelled to Achensee* in the Tirol, staying on the north side of the lake at the Hotel Scholastika, which backed up against steep mountains covered in fir trees. They went for walks in the woods and rowed on the lake and JB did some work on a

*Franklin Scudder mentions the Achensee in *The Thirty-Nine Steps*.

novel, possibly *Prester John*, although he told her mother that Susie was 'a dire distraction'.[83]

They moved on to Cortina d'Ampezzo in the Italian Dolomites, where JB intended to introduce his wife to the joys of mountaineering, as he had succeeded in doing with his sister Anna. An alarmed Willie, who had all too vivid memories of his brother's rock-climbing exploits, wrote to Anna that he trusted JB hadn't succeeded in making Susie a widow or an angel in the Dolomites.

JB did not kill either himself or Susie but he tested her good nature and courage sorely. He persuaded her to climb Monte Cristallo, the mountain that looms up to a height of 10,000 feet north-east of Cortina, and offers glaciers, screes and some stiff rock climbing. Baedeker's guide to the Eastern Alps[84] considered it only suitable for 'adepts'. They slept the night before the climb in a little hotel at the top of the Tre Croci* pass, rose at 3 a.m. ('oh so horrid'),[85] dressed by candlelight, and started out long before dawn. Susie would have been walking in a long skirt and uncomfortable, stiff, hobnailed boots. 'We went over 2 snow slopes and then up in to the rocks – somehow or other I was pushed up by John and Pierre Blanc [their guide]. We breakfasted on the top about 9.30 having taken all that time from about 4.30 am to get there.'[86] What she didn't tell her mother was that she developed an acute attack of vertigo on the way up, when Blanc advised her at one point to put her foot 'into the void'.

JB was decidedly more upbeat about the expedition in his letter to 'Gerald': 'We took it very easily, and we had splendid guides, one of whom Susie used largely as a pack mule. She had some vertigo going up, but Pierre and I performed wonders of [indecipherable] so that we were always on each side of her. But at the top she recovered, and came down quite easily ... She must have far more physical strength than any of us imagined. Of her pluck there could never be any question. I am very glad she has done a little climbing, and she is glad herself ... Cortina has been a great success.'[87] (In 1937, however, he told Janet Adam Smith, a keen mountaineer, that 'if I had not had the two best guides in Europe we should not have got down'.)[88] Despite his brave words to Mrs Grosvenor, JB had learned the first stern lesson of marriage, which

*The name he gives to the inn in 'The Company of the Marjolaine'.

is to give up that which really does not suit your spouse. He hardly mountaineered seriously again.

In mid-August the couple boarded a train to Venice, where they stayed on the Grand Canal at a fifteenth-century Gothic palazzo, the Hotel Europa. It was directly opposite the Dogana di Mare and the church of Santa Maria della Salute and was full of cultural ghosts, since Verdi, Turner and Proust had all stayed there. The Buchans visited St Mark's, which they found 'rich and glowing', as well as the Accademia, were serenaded in a gondola, visited Torcello and Burano in an orange-sailed felucca, and even took a small steamer to the fishing village on the sandbar in the Venetian Lagoon where the Lido had been established in the 1850s and which was in the process of becoming an upmarket resort.* Here they were given bathing clothes – Susie's was 'a sort of Norfolk jacket and knickerbockers all in one, and striped pink ... We obtained also two bright-yellow straw hats shaped rather like cornucopias and tied under one's chin with damp white strings and then walked some way down to the sea. Anything more killing than we both looked would be hard to imagine. We reluctantly gave up the hats and plunged into the sea which was Prussian blue and <u>hot</u> and gogglie [delightful] to the last degree ... It was the most delicious experience I have ever had.'[89] In late August they returned home by train after what Susie called a 'heavenly' honeymoon. She cried when they arrived at Paris. They had been away a leisurely six weeks.

In *Memory Hold-the-Door*, JB wrote briefly about his engagement and marriage:

> I had no longer any craving for a solitary life at some extremity of the Empire, for England was once more for me an enchanted land, and London a magical city ... I had been suffering from loneliness, since my family were four hundred miles away. Now I acquired a vast new relationship – Grosvenors, Wellesleys, Stuart-Wortleys, Lytteltons, Talbots – and above all I found the perfect comrade. I have been happy in many things, but all my other good fortune has been as dust in the balance compared with the blessing of an incomparable wife.[90]

*Five years later, Thomas Mann set *Death in Venice* there.

5

London and Edinburgh, 1907–1914

Two days after the wedding, Willie Buchan wrote to his mother: 'Well, John's marriage is a thing of the past. Don't you think now that the best thing for a wise and intelligent and sensible old body like yourself to do is to accept it and to pluck up your spirits and your health again? … Surely you must have discovered by now that John's having a wife makes no difference to his affection for his mother.'[1]

It was by no means certain that she was prepared to discover that just yet but, fortunately, she was distracted by the imminent departure of Anna to stay with Willie in India. The brother and sister were deeply attached to each other, and this trip was long planned, and vigorously promoted by JB, who paid for it, to prevent Anna from feeling too lonely after the wedding. (It must have been very galling to have his mother complain that his marriage would mean he would rescind the offer.)

Willie was based partly in west Bengal and partly in the neighbouring state of Bihar. He began as Assistant Magistrate and Collector in Chapra, meting out justice in familial disputes and minor criminal cases. Later he oversaw the building of agricultural colleges. In 1907 he was for a time an Under-Secretary to the Governor of Bengal. The work was hard and the hours very long, with many protracted and arduous journeys into the countryside, on a bicycle or pony.

Willie managed to show Anna rather more of India than was common for young British women to see. He even took her 'up country', and they camped in tents or in government-owned 'dak bungalows'. The diary she kept and the letters she sent home were to become the basis for her

first, very autobiographical, novel, *Olivia in India*, the foundation stone of her literary fame. She arrived home in early April 1908. 'It's a great mistake for a family to be too affectionate; partings are too upsetting,' wrote Willie to his mother after she had left. 'It was a wretched business saying goodbye.'[2]

In January 1908, Willie had been appointed Registrar of Agricultural Banks in West Bengal. This scheme, set up four years earlier, aimed to deliver debt-ridden village farmers ('ryots') out of the hands of rapacious money-lenders, the idea being to provide a network of cooperative banks even in extremely remote areas. This work required even more travelling in country districts than before, and risked his health. By 1910 there were 650 cooperative credit societies in Bengal. (What began in 1904 continues to this day, in the work of the West Bengal Department of Cooperation.)

JB and Susie spent a month after their honeymoon at St Leonard's in Edinburgh, with weekends at Ardtornish, a house on the edge of the Morvern peninsula, which could only be reached by boat, as the guests of Gerard Craig Sellar, as well as at Achnacloich on Loch Etive with Tommy and Margaret Nelson. On their return to London in October they took up residence at 40 Hyde Park Square, just a stiff walk through Hyde Park from Upper Grosvenor Street, although not nearly such a smart address. Theirs was a tall, slightly gaunt house with a steep staircase, a disadvantage for Susie since she was now pregnant. The house was inconvenient to look after, but pleasant enough, and it had a conservatory built out from the stairs where Susie made her first essays in gardening.

In June 1908 she gave birth to a girl, Alice Caroline Helen, at home. With those names the younger Buchans satisfied not only their own inclination, but saw to it that neither mother would feel left out. It was the arrival of Alice that finally broke down the barrier erected by Mrs Buchan against Susie, since the latter was only too willing for her mother-in-law to revel in the joy and pride of a first grandchild. In September, she was even prepared to send the baby, and the nursemaid of course, to spend a weekend with the family in Peebles, while she and JB holidayed at Achnacloich.

The couple were sincerely happy and easy together. When Lucy Lyttelton, Susie's cousin, became engaged to the Liberal politician,

Charles Masterman, in 1908, JB wrote to her: 'As Susie and I beat you by a year, out of the depth of my experience I am bound to "testify" as we say in Scotland. And my testimony is that most human joys are a little overrated when you come to try them yourself, but about true love nobody has ever been able to say half enough. You feel that just now, of course, but believe me you will always feel it.'[3]

On his marriage to Susie, he acquired an extensive network of agreeable connections. These included most particularly the Stuart-Wortleys, since Susie's mother, being a widow, was rather out of the Grosvenor orbit (and her family were much more fun). JB, as we have seen, was notably 'clannish' and he delighted in the idiosyncrasies and undoubted charm of these relations, listening respectfully to their complaints and lengthy descriptions of ailments. In return they enjoyed his wit and intellect, and the opportunity they now had, shamelessly, to trouble a man of such energy and good nature. They were not the only ones, although they probably felt they had the most legitimate claim on him; other *grandes dames* who, from time to time, felt entitled to bother him to do things for them included Lady Desborough, the Countess of Minto, Lady Cynthia Asquith and the Marchioness of Londonderry.

A rich example of the way he was put upon was when he (together with Henry James) was asked in 1909 by Susie's aunt Mamie, the Countess of Lovelace, to read through a lot of correspondence and adjudicate upon the obsession of her late husband, Ralph, concerning the slurs on the reputation of his grandmother, Lady Byron, and the conviction he had that Lord Byron had had an incestuous relationship with his half-sister, Augusta Leigh. The two men agreed that the Earl of Lovelace had been justified: '… Henry James and I waded through masses of ancient indecency, and duly wrote an opinion. The thing nearly made me sick, but my colleague never turned a hair. His only words for some special vileness were "singular" – "most curious" – "nauseating, perhaps, but how quite inexpressibly significant."'[4]

In November 1908, *Some Eighteenth Century Byways and Other Essays* was published by Blackwood's. Dedicated to JB's mother, the book encompassed articles that first appeared in a variety of periodicals, but chiefly *The Spectator*, in the ten years between 1898 and 1908. These tended to be historical – on Bonnie Prince Charlie, Lady Louisa Stuart, Charles II, the Victorian Chancellors and Castlereagh – but there was

also an important exposition of his views on fighting wars, 'Count Tolstoi and the Idealism of War', and a reflection on John Bunyan.

In May 1909, Willie finally arrived home from India for his longed-for six months' leave, some of it spent at Harehope in the Meldon Hills, not far from Peebles. This was a cherished and long-remembered summer holiday, when the family fished, walked and went rough shooting on the Tweeddale heights. When sailing back to India through the Red Sea, Willie pined for the 'winds and the rain and the mist and the hills and that ever white road over the moor'.[5]

The brothers had taken the opportunity, when together at Harehope, to discuss how they would fund their father's retirement. The imminence of this had begun to press upon them, after Anna came back from India and noticed that her father was slower and less inclined to climb to the top of tall tenements. As a result of pressure from his children in the matter, Mr Buchan broached the subject with his Session and Presbytery that November. His retirement was given added urgency when, in the spring of 1910, he and his wife, together with Anna, Walter and Alastair, set off for a trip to Zermatt in Switzerland but only got as far as London, before he had a heart attack. The doctors were adamant that Mr Buchan must live a very quiet life from then on, so at this point he retired from the ministry.

Almost immediately, he and his wife moved to Peebles, to a house called 'Woodlands', not far from Bank House, bought for them by their sons. The three boys also insisted that they supplement their father's very modest annual pension of £120. When Mrs Buchan fell ill again, in the autumn of 1910, the brothers vied with each other as to who paid the medical expenses.

In 1910, JB and Susie moved to a rather more spacious rented house at 13 Bryanston Street, just a few minutes' walk from her mother. In April they accepted an invitation from Gerard Craig Sellar to join his steam yacht, *Rannoch*, at Constantinople, for a six-week 'spring tour', leaving the toddler Alice to cheer up her ailing grandmother in Peebles. They travelled in extreme comfort the entire way to Constantinople on the Orient Express train, spending enough time in the city to inhale something of its exotic atmosphere.

JB wrote to Gilbert Murray from the boat: 'I had a very interesting time in Constantinople for I saw many of the Turks, both "young" and "old" and had interminable political discussions ... It is Cromwellian

England over again with a dash of Venice. This would not matter so much if the Committee [of Union] was sympathetic to the average Turk. But they are mostly quaint Positivist intellectuals, whose one strong interest is military...' He also told him he was worried there would soon be another outbreak of anti-Armenian feeling.[6]

They cruised in the *Rannoch* to the foot of Mount Olympus and to Troy, which they surveyed under the eyes of a guard of Turkish soldiers. Years before, JB and Charlie Dick had had the idea of writing a romance about the Ionian Migrations. So, after they had steamed round Lemnos, Imbros and Samothrace, JB went ashore near Thermopylae, to walk in the hills and find the place, Kallidromo, where the Phocians had guarded the goat path that the Persians needed to take if they were to outflank the Greeks at the pass of Thermopylae. 'It is a most glorious country, and the scenery is pure Theocritus,' he told Dick.[7] They then sailed down the coast of Euboea to Athens, passing the Petali islands on the way, where they were intrigued by a shuttered and impenetrable house, standing back from the shore in a walled garden.

They spent a week in Athens sightseeing, as well as travelling to the Straits of Salamis to see the site of the naval battle between the Greeks and Persians in 480 BC, then sailed off into the Gulf of Corinth and on to Delphi. 'What a place! It is set far up in a gorge of Parnassus, and even from the ruin one can judge what a place it must have been ... Early next morning, I climbed the crags and got well up Parnassus. These Greek mountains look bleak and rocky from below, but when you climb them, you find little green meadows and thickets and the most amazing flowers I have ever seen.'[8] They then cruised round the Ionian islands, going past Ithaca, and came off the boat at Corfu, where they witnessed the celebration of Easter and the killing of the Paschal Lamb.

This leisurely tour proved important, both because JB's wanderings around Thermopylae inspired one of his very best short stories, 'The Lemnian', and its associated poem, 'Atta's Song', both published the following year,* and because the 'shuttered and impenetrable' house would appear first in another supernatural short story, 'The Basilissa'.[9] This tale is about a highly sensitive young man who dreams every April of

*First in *Blackwood's Magazine* in January 1911 and then in *The Moon Endureth*, a collection of 'tales and fancies' published by Blackwood's in April 1912.

a series of rooms, dreading the last one, containing 'a terrible Something', which comes closer by one room every year. More than ten years later, he worked up this short story into the novel, *The Dancing Floor*.

It was now a decade since JB had published a proper work of fiction, although he had been working on one, on and off, since 1907. *Prester John*,* a story aimed at schoolchildren, finally came out in August 1910. It was the fruit of a maturing attitude about how to put a novel together and it turned out to be a much less laborious task than *John Burnet of Barns* or *The Half-Hearted* had been.

He dedicated it, in verse form, to Lionel Phillips. An American edition, with the title *The Great Diamond Pipe*, came out that October from Dodd, Mead and Co. *Prester John* was more of a success than any of his earlier novels, and it lasted the course better. It tells the story of a young lad, Davie Crawfurd, who goes to South Africa to become a shopkeeper, and helps thwart a potentially dangerous but brave native rising by a black ordained minister, the Reverend John Laputa, whom he first sees dance on the sands of the Fife coast. (JB had occasionally met African ministers in his childhood, when they were invited to preach in his father's church.) The charismatic Laputa claims to be the successor of the legendary Prester John, who some said was a Christian king of Ethiopia in the Middle Ages, in order to unify scattered African tribes. It is obvious, from his portrayal of Jim Arcoll, the intelligence officer who is keeping tabs on Laputa, that JB knew quite a lot about secret-service intelligence; he had gained this knowledge from his acquaintanceship in South Africa with men such as Lieutenant Edmund Ironside and Lieutenant-Colonel David Henderson, Director of British Military Intelligence during the Boer War. (The latter – head of the Royal Flying Corps in the Great War – was a Scotsman who had been to the University of Glasgow, and who JB referred to as 'beloved', his warmest term of affection, reserved for only a very few friends.)

Despite being a very exciting tale, containing wonderful descriptions of South African landscapes, and with a noble, if flawed, African protagonist, *Prester John* is well-nigh unreadable now, since the language used by some of the characters for the indigenous Africans – 'savages' in particular – is unacceptable to the modern reader. It makes uncomfortable reading, notwithstanding that such expressions were

*Called 'The Black General' when serialised beforehand in *The Captain* magazine.

commonplace in 1910, do not appear to have been loaded with such negative connotations and attracted no discernible adverse criticisms at the time or for many years after.

It was in 1910 that JB began seriously to think about a parliamentary career, now that he was well established in publishing, and earning a reasonable living, yet had time to spare. He encountered no opposition from his partners at Nelson's. His parents were periodically ill, sometimes separately, sometimes together, and that may well have decided him to seek a Border constituency to fight in the Unionist interest. In October, for example, he spent much time at Peebles, toing and froing from Parkside, as his mother was very ill, in great pain and very weak. She would periodically 'go off in a swoon' and JB was very worried that one of these attacks would kill her. 'She is absolutely resigned to dying, which is a bad sign,' he told his wife. 'I am torn between anxiety for Mother and my longing for you.'[10] At this moment of crisis, Walter found a tenant for 'Woodlands' so that his parents could move into Bank House, where they could be looked after by Anna and himself, as well as by kindly servants. They would stay there until their deaths.

Mrs Buchan staggered on into 1911, sometimes suffering extremely high temperatures, which made her delirious. Finally, in March, JB persuaded her to come to London to be examined by Sir Almroth Wright, a terrifyingly eminent and expensive doctor with a name out of Trollope and a specialism in bacteriology. He diagnosed her condition as pernicious anaemia and she stayed three months in London to be treated by him. By May, Wright thought he had scotched 'the microbe' using 'vaccinations'.

Meanwhile, Susie was suffering from one of the periodic bouts of depression, which descended on her from time to time throughout her married life – what JB referred to, guardedly, in letters to her as 'le chien noir'. These episodes brought out the most protective instincts in JB, for whom such an affliction was almost unknown. 'Never fear about your nerves, my little Moufflée, you and I together will put them all right,'[11] he wrote to her in February 1911.

That spring he was adopted as the Conservative and Unionist candidate for the constituency of Peebles and Selkirk, a (usually) Liberal seat whose incumbent at that time was the well-respected Donald

Maclean.* In June the Buchans accepted an invitation from Moritz Bonn and his wife, Theresa, to stay with them at a house they had rented by a small lake called Rosensee outside Partenkirchen in the Bavarian Wettersteingebirge. (It is a piquant irony that, in February 1917, Bonn was working as a propagandist for the German government, endeavouring to encourage the Americans to stay out of the war, while his friend, JB, was doing the exact opposite.)

JB was never so completely happy as when he was amongst mountains and, while staying with the Bonns, he set out one morning before dawn to climb the Alpspitze, accompanied only by a young forester called Sebastian. They duly reached the top but, on the walk down to the valley, something happened that he never forgot:

> It was a brilliant summer day with a promise of great heat, but our road lay through pleasant shady pinewoods and flowery meadows. I noticed that my companion had fallen silent, and, glancing at him, was amazed to see that his face was dead-white, that sweat stood in beads on his forehead, and that his eyes were staring ahead as if he were in an agony of fear...

Sebastian began to run heedlessly down the hillside and JB caught his terror and ran, too:

> ... like demented bacchanals, tearing down the glades, leaping rocks, bursting through thickets, colliding with trees, sometimes colliding with each other, and all the time we never uttered a sound.

JB thought, on reflection, that what had seized them with panic was that Sebastian 'had seen the goat-foot god...'[12]

Something similar had happened to JB as a boy, when he found himself utterly alone on a Peeblesshire hill, out of sight of sheep or sound of birds. An imagination that can break the bounds of reason is an uncomfortable thing to possess, but this acute sensitivity to atmosphere is, at the same time, a great benefit to a writer, and something of these sensations found their way into his supernatural fiction.

*

*His son, also Donald, spied for the Soviet Union, and defected in 1951.

After their trip to Bavaria, the Buchans joined the family once more at Harehope, staying for a couple of months while JB visited many parts of the constituency. That year JB and Willie (in India) competed with each other as to who was to buy a car and hire a chauffeur, so that their mother could get some restorative fresh air, and so JB could visit his far-flung potential constituents. JB won.

Susie's mother also came north to keep them company. 'I am hugely enjoying being with Susie and John,' she told a sister. 'They have got a motor and we go huge long expeditions in which John pays visits to all sorts of houses and cottages and nurses the constituency in the most approved manner. Susie is looking wonderfully well considering all things [she was pregnant again] ... I'm beginning to feel quite fit again in this splendid air with very little to do except talk myself hoarse to Susie and John. It is a heavenly little place high up in the hills. Very simple but quite comfortable enough.'[13] It must have been quite spacious, for Mrs Grosvenor never went anywhere without enormous domed trunks for her clothes, masses of painting equipment and a lady's maid. Meanwhile, during that summer, JB's parents pottered about Broughton and the retired minister worked on a history of Peeblesshire poets.

In local halls all over the constituency, JB drew good crowds, who were often appreciative, but they could be deadly hecklers, especially as he was standing as a Tory. JB came from a mainly Liberal family, and from a country where the Liberal party's dogmas 'were so completely taken for granted that their presentation partook less of argument than of a tribal incantation. Mr. Gladstone had given it [the Liberal Party] an aura of earnest morality, so that its platforms were also pulpits and its harangues had the weight of sermons. Its members seemed to assume that their opponents must be lacking either in morals or mind.'[14] Something of the flavour of those political meetings at which JB spoke can be gleaned from his novels. In *John Macnab* he describes graphically how nervous Sir Archie Roylance is before his first public speech, and in *The Thirty-Nine Steps* he makes a joke at the expense of the Liberals, especially those who denied the menace of Germany, by having the young, callow Radical candidate, Sir Harry, speak what seems to Hannay to be naïve nonsense at his political meeting:

He was all for reducing our Navy as a proof of our good faith, and then sending Germany an ultimatum telling her to do the same or we

would knock her into a cocked hat. He said that, but for the Tories, Germany and Britain would be fellow-workers in peace and reform. I thought of the little black book in my pocket! [which contained the notes Scudder made about the German Black Stone gang]. A giddy lot Scudder's friends cared for peace and reform.[15]

In the autumn Nelson's published *Sir Walter Raleigh*, an expansion of JB's Stanhope prize essay, which was aimed at teenagers. He dedicated it to 'My dear Ted', the young son of George Brown, from 'Your affectionate friend, J.B.' The same month his brother Alastair started his studies at the University of Glasgow. At the same time, his brother Willie, with two friends, made an epic journey through Sikkim to the Talung Glacier, from where Mount Kanchenjunga rears up sheer, with Everest showing behind it. No European traveller had ever got so close to Kanchenjunga and the men did useful surveying work. Willie described the trip in detail in an article published in *Blackwood's Magazine* in April 1912 (the same edition that contained JB's bleak short story of Border reivers [raiders], 'The Riding of Ninemileburn'). William Blackwood wrote to Willie: 'I read your article ... with intense interest and admiration, being struck by the power possessed by two brothers of such vivid, descriptive writing.'[16] 'It is very nice to find myself cheek by jowl with your fine story, though hardly fair to my article!'[17] Willie wrote to his brother.

At the end of October 1911, Mrs Buchan became very ill once more and her husband was sufficiently alarmed to write to JB twice about her. She was so weak that he doubted she would survive till Willie came home the following summer. But it was he, not his wife, who died, suddenly and painlessly, one Sunday afternoon in November at Bank House. Willie in India was distraught when he received the telegram and also 'desperately afraid that the blow will be too much for Mother's strength and I live in daily fear of another cable'.[18]

However, like many people who are apt to make 'a pother about trifles', Mrs Buchan faced real grief and loss with courage and few complaints. When JB dashed up to Peebles, he found her 'really wonderful, reading letters of sympathy, and better in health to my eyes than she has been for long. I took my last look of my beloved old Father. He was lying most majestic in death, like a great statue ... The people of Peebles have all been exceedingly kind. The clannishness of a little county town shows its good side on these occasions.'[19]

He wrote to his wife's aunt, Lady (Katharine) Lyttelton: 'He had the sunniest and most contented disposition I have ever known. He spent all his life working hard in a Glasgow slum parish, and he died of his wounds got there, for when he retired 1 ½ years ago he was a broken man. But I never remember seeing him cast down for one moment. His presence was a perpetual benediction. What a thing a strong faith is, which drives out every small care and selfishness!' In the same letter he told her that a week later Susie had given birth in the house in Bryanston Street to a son, John Norman Stuart. 'He is like me, but (at present) still more like the late lamented Leopold, King of the Belgians.'[20] It was for JB a very strange fortnight of condolence and congratulation, people reacting most favourably to the birth of a son and heir.

In the spring of 1912 a collection of his short stories and poems was published under the title *The Moon Endureth*. The book was dedicated 'To the Happy Memory of My Father' and followed by the strangely Catholic invocation: *Requiem aeternam dona ei, Domine, Et lux perpetua luceat ei*. It contained also his best poetry to date: 'Avignon, 1759', a desperately sad lament by an exiled Jacobite, who has lost family and home; 'Atta's Song', which accompanies 'The Lemnian'; 'Wood Magic', which harks back to the panic JB felt in Bavaria and complements 'The Grove of Ashtaroth'; 'Plain Folk', which follows 'The Riding of Ninemileburn'; and the powerful 'The Wise Years' about a hermit who experiences perfect peace, even though he is waiting to be burned as a heretic, because God has told him that 'He findeth God who finds the earth He made'.

The stories show his growing maturity as a writer. 'Space' introduces the barrister, Edward Leithen, in a role he was often to assume, that of listener and lawyerly confidant, and it combines JB's interest in Alpine mountaineering with that of the theories of the French philosopher/mathematicians, Henri Bergson and Henri Poincaré. 'The Grove of Ashtaroth' is a powerful supernatural tale about a sympathetically portrayed Jewish settler in South Africa, dabbling in pagan magic to his detriment. There are deeply affecting stories about ordinary people, such as 'Streams of Water in the South' about a Border shepherd close to death, while 'The Company of the Marjolaine' describes, unblinkingly, Scottish royalty gone to seed.

Sir Arthur Quiller-Couch ('Q') wrote that 'The Company' was a story 'which any man in my generation might be proud to sign',[21] while Sir Arthur Conan Doyle admired both 'The Lemnian' and 'The Company'. 'I don't think the 18th century was ever better caught...'[22] he said about the latter. Later that year, JB was the subject of a profile in *The Bookman*, when the influence of Robert Louis Stevenson on him was noted but the writer remarked that JB was beginning to develop his own style: 'He has breathed a new life into the moribund art of the novel; he has made the short story what a cameo might be when it is cut by the hand of a master, and he has even contrived to make the light essay and occasional article an entertaining and scholarly production.'[23]

Even short stories gave JB the opportunity to indulge one of his favourite devices when writing historical fiction, that of building up, layer by layer, a false but compelling provenance for his tales, relying on his capacious memory as well as his antiquarian bent to invent credible but completely fictional scenarios. 'The Company of the Marjolaine' is a clear example and got him into trouble with at least one irate reader, who felt he had been duped.

The story, which was published initially in *Blackwood's Magazine* in 1909, concerns the visit of four members of the Philadelphia Assembly – including 'a lawyer of New York' – to a small town in Italy where an aged and drunken Bonnie Prince Charlie is staying with his daughter, who looks after him. The Americans are monarchists and are on a mission to invite the Chevalier to be their King, but go sorrowfully away when they realise it's all far too late.

According to a note at the beginning, the tale supposedly came from letters amongst the unpublished papers of the Manorwater family, sent by Charles Hervey-Townshend ('afterwards our Ambassador at the Hague') to his aunt, the Countess of Manorwater, from Italy in the 1780s. The use of the name of a prominent Whig family, the Townshends, caused a New York railroad magnate and banker called Stuyvesant Fish to write a long letter to JB. In it, he asked to see the letters from Hervey-Townshend, since he thought that his grandfather, 'a lawyer of New York' in the 1770s, might be the man mentioned in the story, although the family had no records of him going to Europe. (He plainly wanted to absolve his ancestor of any monarchist leanings.) Fish had researched the histories of politicians called Galloway and Sylvester

(the other names that JB used), the details of which he sent to the author. At the end of the letter is a note of Susie's, written many years later: 'Mr Fish was extremely displeased with JB when he wrote to him to say that the Company of the Marjolaine was pure fiction.'[24]

Sadly, neither JB's letter of apology nor Fish's reply to it have survived, but it is not hard to imagine the latter, since no Wall Street banker would ever like to be taken for a mug. The exquisite embarrassment of this episode did not stop JB from continuing to provide elaborate false provenances for his historical fiction, the novel *Midwinter* being a particularly notable example.

The Buchans were in agreement about suffragism and, in the years before the First World War, JB gave a number of public talks on the subject. In May 1912 he delivered the keynote speech at a Conservative women suffragists' dinner in London and, in October the following year, his speeches to this kind of meeting were published as a pamphlet for the Conservative and Unionist Women's Franchise Association (of which Susie was a member). The pamphlet was entitled *Women's Suffrage: A Logical Outcome of the Conservative Faith*, and in it he outlined his reasons for believing that women should have the vote, a view hardly universal amongst his acquaintance.

He wrote that the franchise depended on citizenship, and he defined that as the bearing of certain civic burdens, so the gender of the citizen was immaterial. To deny the franchise to half the country's citizenship was 'an impossible position for a reasonable Conservative to maintain; for if the vote be denied to an educated and capable woman, who is a real asset to the State and takes a share in its burdens, not because she is not a citizen, but because, unfortunately, she is not a man, you are on the edge of a very dangerous doctrine'.[25] He went on to mock that hoary old chestnut, 'the thin end of the wedge'. He believed this to be the most foolish argument, for the British Constitution 'is stuck full like a pin cushion of thin ends of wedges, and so is every other successful human fabric, political, or social, or commercial'.[26]

In 1912, JB secured the end of a lease on a handsome Robert Adam house at 76 Portland Place in Marylebone. It was, according to Susie, 'a Georgian house with mahogany doors and a graceful staircase with shallow steps which wound its ways towards the nursery floor...'[27] It must have been large for it had two drawing rooms and a library.

In 1913, Anna's *Olivia in India* was published, under the pseudonym O.[livia] Douglas (since Anna refused to ride on her brother's coat tails), by the ultra-respectable firm of Hodder and Stoughton. It had first received the blue-pencil treatment from JB. One review averred that it was impossible to overpraise such a delightful book.

Anna depended heavily on JB (and Susie) for encouragement and advice, even when she was a well-established author of novels about Scottish provincial life, with a large, and growing, fan base. For example, Hodder sent the bound typescript of a later novel, *Penny Plain*, to Mrs Buchan as a gift, and Anna was amused by the blue pencil marks from JB, crossing out the indiscriminate 'quotes' to which she was addicted and commenting that passages were 'incorrigibly noble'.[28]

What is plain from the beginning of Anna's long and successful literary career is that her eldest brother had not the slightest intention of encouraging her to write in the way that he did. And the same was true of his wife when she took to writing both history and fiction. Many years of reading a wide variety of fiction – good and bad – for Nelson's had made him a most tolerant critic, while love for his sister and wife precluded him from bullying them. He must have had to bite his tongue at times, knowing how influenced they both were by his most airily expressed opinion.

In 1912 his health began to give increasing cause for concern. He complained periodically of painful stomach trouble, or what he called 'seediness', which was obviously more than indigestion. The travelling, hurried meals before speaking engagements, and the stress of projecting his thoughts and personality to a sometimes hostile audience, seem to have been contributory factors. For a long time, no one knew quite what the trouble was; in fact it was probably not until 1914 that he received a clear diagnosis that he had developed a duodenal ulcer.

That summer, Willie came home to Peebles for a much longed-for leave, projected to last more than a year. But he had scarcely arrived in Scotland before he began to complain of back pain, which his doctor initially thought was rheumatism. In August, JB and Susie took a house at a place called Broadmeadows near Selkirk, so that JB could tour that part of the constituency. The family shot and fished as they had done in 1909 but there was plainly something not right with Willie

and, in October, he developed pleurisy and was admitted to a Glasgow nursing home. Blood tests were taken and sent to Sir Almroth Wright in London. He pronounced that Willie was suffering from blood poisoning, due to a streptococcal infection picked up in India, and he sent a 'vaccination' to Scotland. JB, fretting impotently in London, wrote daily both to Willie and Mrs Buchan. 'Will you see that the news is sent to me every day for I am miserably anxious? ... Our kind beloved old William! But he will get all right, bonny body, and laugh at this job.'[29] He hurried up to Glasgow every weekend to visit his brother as the miserable, exhausting weeks went by.

The family maintained a vigil at his bedside, but it eventually became evident that there was no hope of recovery. On the afternoon of 11 November the doctors decided to operate, and Willie died under the anaesthetic. 'Mother is bearing up wonderfully,' JB wrote to Susie, but 'what are we to do without the dear, canny [gentle], brave laddie!'[30]

According to the lights of the day, Willie had been an exemplary imperial servant. He was undoubtedly a deft and dedicated administrator, with a feeling for India and its peoples, who might have gone far if death had not claimed him at the age of thirty-two. He was much mourned by the people who had worked with him. The Governor of Bengal, Lord Carmichael, wrote to JB: 'He was generally looked on as quite one of the best officers in Bengal, and everyone prophesied success for him.'[31]

JB's most anthologised and best-known poem, 'Fratri Dilectissimo' ('most beloved brother'), was written soon after Willie's death. It memorialises their childhood games and friendship:

When we were little wandering boys,
And every hill was blue and high,
On ballad ways and martial joys
We fed our fancies, you and I.
With Bruce we crouched in bracken shade,
With Douglas charged the Paynim foes;
And oft in moorland noons I played
Colkitto* to your grave Montrose...
Dear heart, in that serener air,

*Alasdair Macdonald, Montrose's confederate.

If blessed souls may backward gaze,
Some slender nook of memory spare
For our old happy moorland days.
I sit alone and musing fills
My breast with pain that shall not die,
Till once again o'er greener hills
We ride together, you and I.[32]

This poem forms the preface to a privately printed book, entitled *W.H.B*, compiled by Anna. In it is reproduced the *Blackwood's* article on Willie's journey in Sikkim as well as a tribute by Isla Macpherson, the daughter of an Indian Civil Service colleague, to whom Willie had proposed in 1910. Had she accepted (and her letter to Anna after his death is filled with regret), she would have found no such opposition from his mother as Susie had to endure, since Isla's ancestor, Macpherson of Cluny, was a prominent supporter of Prince Charlie in the '45. JB erected a tablet to Willie's memory in the antechapel at Brasenose College with an epitaph, which he adapted from Walter Savage Landor: *Patriae quaesivit gloriam videt Dei*. It translates as 'He sought the glory of his country, and now sees God.'

Willie's death sent JB to bed with stomach pain, not surprisingly, although he managed to contrive to do some work there, including writing part of his (first) biography of the Marquis of Montrose. This capacity to write, when otherwise *hors de combat*, was to prove invaluable to him for the rest of his life. When, a month later, he had recovered, there were more political speeches to make: this was a difficult time, politically, both because of the war between Balkan states and the Ottoman Empire, and the unresolved issue of Irish Home Rule.

JB gave a speech at Innerleithen on 18 December 1912, which he reckoned was one of the best he had given to date. He had it printed as a pamphlet, entitled *What the Home Rule Bill means*. It is a closely argued attack on the Home Rule Bill on a number of grounds – constitutional, legal and economic – but there was one simple political point, namely, that Ulster Protestants would not sign up to it. Although he was not against devolution on local issues (and would speak up for that in the House of Commons in the late 1920s), he thought that union was strength, and a more progressive force than narrow nationalism. That said, his view was tinged by his dislike of Irish nationalists, especially

those who forever harked back to ancient wrongs, and his even greater dislike of the coercion, rather than persuasion, as he saw it, of 1,500,000 Ulstermen by the majority.

After Willie died, Mrs Buchan spent several months with her son and daughter-in-law in London, allowing Walter space to get on with his book on the Duke of Wellington's military campaigns, which was published in 1914. (Walter's most substantial contribution to history, however, was as editor of the three-volume *A History of Peeblesshire* published in 1925, with a chapter by his eldest brother on the literature of the county.) When Helen went home in mid-February her daughter arrived to stay. Anna was very fond of Alice and young John, taking them on outings and happily allowing herself to be drawn into their world. She was by this time thirty-six, and set fair for spinsterhood. She was slim, with fair hair and piercing, intelligent eyes, as well as a long nose and slightly undershot jaw. She was striking-looking rather than handsome. Nevertheless, according to JB, she looked very pretty in her new evening gown at a dinner party the Buchans hosted for Willie's soldier/explorer friend, Cecil Rawling. Rawling and JB hatched a plot to attempt climbing Mount Everest, reconnoitring the north side one year, and climbing it the next. JB thought that their expedition had a good chance of being sanctioned by the India Office, although in the event the war intervened to prevent it.

In early 1913, JB wrote to his friend the writer Hugh Walpole, in reply to an invitation, that 'Susie and I think of taking a long cruise to the Azores and, if so, I shall amuse myself writing a real shocker – a tribute at the shrine of my master in fiction – E. Phillips Oppenheim – the greatest Jewish writer since Isaiah.' Some commentators have chosen to take exception to this remark, reminding us, rather ponderously, that there have been many greater Jewish writers than E. Phillips Oppenheim. It is hard to see why they bother, since this was so plainly a joke.

He went on: 'Alas, I hope to be abroad on the date of the Literary Fund dinner. Besides, Hugh dear, I really can't go to these beanfeasts. I love writers individually, but assembled in bulk they affect me with overpowering repugnance, like a gathering of clerics!'[33] This attitude must have made it rather easier for some highbrow writers to persuade themselves that his talents were meagre and his fiction lightweight.

In May the Buchans did indeed go on the cruise to the Azores, taking Mrs Buchan and Anna with them. It was not such a success as the tour

of the Mediterranean with Gerard Craig Sellar, because Susie had a bad cough and Mrs Buchan was not a relaxed traveller, but JB did manage to write much of *The Power-House*. This is a book that, in many ways, foreshadows *The Thirty-Nine Steps* and introduces to his long-form fiction the bachelor barrister, Edward Leithen, fighting desperate evil on the familiar streets of London. *The Power-House* was serialised by *Blackwood's Magazine* in 1913, and by *Living Age* in the United States in 1914, but not published in hardback until 1916, by which time its author was a great deal better known.

That summer, at the family's request, he wrote a private memoir of Lord Ardwall, Johnnie Jameson's recently deceased father. When he sent the monograph to Jameson at the end of July, the latter was wildly enthusiastic and grateful (like Sandy Gillon, he was always warmly appreciative of anything JB ever wrote), and urged him to consider giving it a wider currency than the Ardwall circle. JB complied and it was published by Blackwood's that November. *Andrew Jameson, Lord Ardwall* painted a vivid word picture of a larger-than-life, witty, rumbustious, sometimes alarming character, who had been an Edinburgh advocate and became a well-known judge.

In September Nelson's published *The Marquis of Montrose*, JB's first attempt at a serious biography. He had long thought to try to rehabilitate, from a low base, the reputation of 'the Presbyterian cavalier', King Charles I's Captain-General in Scotland. The dedication was to his brother, 'W.H.B.', and included the poem 'Fratri Dilectissimo'. The book dealt mainly with Montrose's campaigns, but JB had not yet learned to be objective enough about his hero and the result was not universally popular with the critics. *The British Weekly*, whose editor, Robertson Nicoll, never missed an opportunity to take a potshot at him, said that it was biased and careless. *The Scottish Historical Review* observed that there was 'an asperity of tone and an unguardedness of statement, which suggests the brilliant litterateur rather than the cautious historian'.[34]

The historian G. M. Trevelyan, who had by this time become a friend of JB's, wrote to say that there was not a dull page in it and that it was perfectly fair. Later historians, however, have been more critical, considering that JB was too admiring of Montrose and dismissive of his great adversary and head of Clan Campbell, the Earl of Argyle. But it did bring an important but – outside Scotland – forgotten figure

back into the light. JB was still feeling his way in the genre. The book's equivocal reception was salutary to him and he was to have another more successful crack at the subject fifteen years later.

With his first two biographies published close together, we might take a moment to consider JB's approach to the writing of history. In early 1914 he addressed an audience of the Workers' Education Association on 'The Muse of History':

By history I mean the attempt to write in detail the story of a substantial fragment of the past, so that its life is re-created for us, its moods and forms of thought reconstructed, and its figures strongly represented against a background painted in authentic colours ... As in a novel of Scott or a play of Shakespeare, a great piece of life must be taken, the threads of it distinguished, the motives and causes diagnosed, and the movement of it represented with something of the drama of the original. Some will concern themselves chiefly with the evidence, for unlike fiction, history must produce its credentials; some will prefer to dwell on the evolution of ideas and the birth of movements and the contribution of the period to the world's stock of thought; while others will see only the bright colours and the sounding deeds. Each half-view will claim to be the whole, and will label history accordingly as a science, as a philosophy, or as an art. But the truth is, that no more than a drama or a novel can history afford to be only one of these things. It must have science in its structure, and philosophy in its spirit, and art in its presentation.[35]

He went on to say that history must have the swiftness and cohesion of good narrative:

It must have drama, so that the sequence of events is shown as issuing in some great moment, and, contrariwise, the great moment appears not as an isolated crisis, but as linked to a long chain of causes and inspired by the characters of the protagonists. These protagonists must be made to live again with something of the vigour of reality, and psychology must lend its aid to make them credible human beings. The past must be no design in snow and ink, after the fashion of the minor moralist, but a picture with all the shades and half-tones of life.[36]

In 1929 he gave the Rede Lecture at Cambridge. 'The Causal and the Casual in History' was published afterwards as a pamphlet. It must have seriously irritated the Cambridge historians who heard it, for there was a strong tide running by then against JB's view that it was sometimes small incidents, rather than enormous social and economic forces, which shaped events.* JB, unfashionably, agreed with George Canning: 'Away with the cant of Measures, not men! – the idle supposition that it is the harness, and not the horses that draw the chariot along.'** This attitude informed the six biographies on which he hoped his long-term reputation would rest, and made them a pleasure for the general reader.

Alastair Buchan was not such a scholar as JB and Willie, but he had acquitted himself sufficiently to gain a place at the University of Glasgow, where he studied Classics, joined the Fabian Society to his brothers' amusement, wrote for the university magazine, and passed all his exams. A friend wrote later: 'There was no one in his year in College so generally beloved as Alastair ... in six years of university life I have never met anyone more honourable, more careless of spending himself for others, more fearless of fighting any injustice than he was.'[37] After he left, in the spring of 1914, he began to train as an accountant with the firm of Bringloe and Maxtone Graham in Edinburgh.

After Christmas, the Buchans went to Littlehampton by the sea, for the health of the children, as well as Susie, who had a troublesome, longstanding cough. JB would go for walks with Alice, 'the Wozer', now aged five, whom he found to be 'a splendid little companion'.[38] Although he had been, from the start, a fond father and a far from distant one, he was rather nervous of babies – and was shielded from them by brisk, no-nonsense nursemaids, in any event. Yet, once they were through the mad toddler stage, he found great pleasure in walking and talking with them. Early on, the children acquired a variety of extravagant nicknames, but collectively they were always referred to by their parents as 'the Blessings'.

*The work of recent historians seems to suggest that JB's view may be enjoying greater popularity these days: for example, Margaret MacMillan's *History's People: Personalities and the Past*.
**Speech in the House of Commons by George Canning against the Addington Ministry, 1801.

In the summer of 1914, on top of all his other obligations, JB became involved with a matter that made considerable demands on his time and emotional energy and affected his health adversely. Five years earlier, Susie's cousin and best friend Hilda Lyttelton had married Arthur Grenfell, a man of ebullient charm and charisma as well as apparent wealth. The Grenfells lived in an enormous house at Roehampton, the scene of lavish entertaining. In June, Arthur went spectacularly bankrupt, with personal debts of about £1 million, a vast sum for the time. The consequences were devastating, not least for the creditors.

Two of the people ruined by this disaster were Arthur's twin brothers, Francis and Riversdale Grenfell. Both were to be killed in the Great War, Francis winning the Victoria Cross. In 1920, Nelson's published a tribute to them, written by JB and originally intended only for private circulation.[39] In it, he described Arthur's business as having had 'a career of meteoric brilliance ... [which] ... had naturally aroused much jealousy among others who had entered for the same stakes'.[40] He went on to attribute the failure to a riding accident Arthur suffered in 1912, which had kept him from the business that had been riding 'high speculative tides', which required 'the hand of a skilled helmsman' and after which 'it seemed to many of his friends that he was not the man he had been'.[41] Additionally, according to JB, efforts by him and others to resolve matters were thwarted by 'a mysterious current moving through the world's finance' and 'by the middle of July [i.e. a month before the outbreak of war] it was clear that nothing could be done ...'.[42]

Others saw things differently.[43]

Arthur Grenfell, whose business career was already chequered (with particular crises in 1902 and 1907),[44] was the driving force in a web of interconnected enterprises concerned with British investment in Canada, at the core of which was the Canadian Agency. One of the first directors was his brother-in-law, Guy St Aubyn, of whom Arthur wrote, 'he is extremely good at detail, rather precise, & easily frightened and as [sic] I am entirely lacking in these qualities (so necessary for a business man)'.[45] St Aubyn resigned in 1909, having complained earlier that 'Arthur suffers from a sort of financial megalomania', pursuing ideas 'because they are big rather than because they are sound', and expressed his concern at his reckless speculation and improper loans.[46] St Aubyn's fears seem to have been well-founded. After the Canadian Agency's collapse, the Official Receiver's Report showed that Arthur

Grenfell had taken loans from the company of more than £1 million, which had grown, in part, due to the use of company cheques drawn in favour of his brokers. The other directors (including Riversdale) were criticised both for taking no action to restrain these loans and for their efforts to conceal them.

There were other irregularities, the most serious of which was the misuse of £125,000 from the Natomas Syndicate trust account. According to the solicitor Herbert Smith, who had been engaged to help the Grenfells (and whose name is still incorporated in that of the firm he founded), 'as and when the [Canadian] Agency was in need of cash, Arthur and Nonus [Riversdale] Grenfell as Directors of the Agency took this cash on resolution of their own, converting the Trust Fund into a regular deposit with the Agency...'[47] Smith told Lady Wantage (who was part of the salvage effort), 'The affairs in connection with the Agency are very far from satisfactory, and it is impossible for me to assure you that Mr. Arthur Grenfell can be regarded as free from the danger of prosecution. If the Natomas debt remains undealt with, I think it is practically certain that he will be prosecuted. On the other hand, if it is dealt with, he is by no means out of the wood, but his prospect of escape is fraught with materially less danger.'[48] The Natomas Syndicate was squared and, as Smith hoped, Grenfell was not prosecuted, but other creditors persisted and the Agency was wound up in July 1914.

JB was involved with the recovery attempt, particularly with trying to drum up financial support for the Grenfell family, earning fulsome thanks from family members, who seem to have had no idea of the reasons for the catastrophe. JB had uncharacteristically harsh words for those who were critical of Grenfell. Writing to Susie in late June, he said, 'Arthur and I are seeing [the solicitor, Sir Frank] Crisp at 1.30. I have just flung Bosanquet and his friends out of my office. They had the cheek to say that Arthur had little financial ability. I told them he was high up in the City when they were being spanked at school.'[49] It is apparent that, even by 1920, when he wrote the tribute to the Grenfell twins, JB also had little real understanding of the matter with which he had become involved. He should have delved more deeply, not least by acquainting himself with the conclusions of the Official Receiver.

Two aspects of JB's character are here revealed: his loyalty, come what may, and his clannishness. These virtues can, in some circumstances, become defects and this episode reveals that JB's sense of family duty could badly cloud his judgement. He found it hard to discuss money with friends and family, let alone challenge them. One of his sons was later to say that talking about money gave his father the creeps. There was something naïve about him. It seems he was not the *homme d'affaires* that others, and indeed he himself, thought he was.

At the same time as this disaster, Alice endured a serious operation for the potentially fatal infection mastoiditis, after a long spell of acute earache, which racked both her parents. Moreover, war had begun to look inevitable. JB was not suitable for front-line duty, because of his poor health. Although they were at the upper end of the age limit for volunteering, a number of his friends did join up, amongst them Raymond Asquith, Lord Basil Blackwood, 'Bron' Herbert (now Lord Lucas), Aubrey Herbert, Jack Stuart-Wortley and Tommy Nelson. There were younger friends, such as the Grenfell twins, ready now to ride through the gates of death, and there was also Willie's great friend Lieutenant-Colonel [later Brigadier-General] Cecil Rawling, a regular soldier who commanded a battalion of the Somerset Light Infantry. On the other hand, Reginald Farrer, an old Balliol friend, who had made a name as an extraordinarily accomplished plant hunter and gardening writer, capable of the lushest prose about plants, was travelling in remotest Tibet in 1914 and was scarcely aware of what was happening in Europe until he arrived home in 1916.

Alastair Buchan was only too aware. When war broke out, he abandoned his accountancy training and, with many of his contemporaries from the University of Glasgow, took the King's shilling and joined the Cameron Highlanders. He later transferred to the Royal Scots Fusiliers, a Borders regiment with a ringing Stuart motto – *Nemo me impune lacessit* or 'No one can harm me with impunity'. Walter was unable to join up because of his important civic duties in Peebles.

The day war was declared, 4 August 1914, JB and his family were staying in Broadstairs, on the coast of Kent, in order that Alice might recuperate out of London from the operation performed six weeks earlier, and for

JB to try to get fit after his own bout of illness, which was becoming increasingly serious and disabling.

The Buchans stayed in a guest house, St Ronan's, in Stone Road, quite close to St Cuby, which Hilda Grenfell had taken at the same time. St Cuby was on the North Foreland and the house's occupiers had the key to a gate, which led to a wooden staircase in a tunnel down to a private beach. Confined to bed and having exhausted his supply of suitable thrillers to read, JB started to write his own. Susie recalled: 'His mind had been turning for some time towards the writing of detective fiction. He read a few thrillers and said to me one day before the war, "I should like to write a story of this sort and take real pains with it. Most detective story-writers don't take half enough trouble with their characters, and no-one cares what becomes of either corpse or murderer." '50

JB's working title was *The Kennels of War* but, in the end, he called it *The Thirty-Nine Steps*. There are a number of plausible reasons for the change, one being that Alice, aged six, counted those wooden steps to the beach for her father. She certainly recalled this (according to her son Edmund)51 and, when the steps were removed some time after the Second World War, one tread was kept and sent to the family with a plaque that read: 'The Thirty-Ninth Step'. (It is now in the John Buchan Story Museum in Peebles.) A legend persists in Scotland that there were thirty-nine steps down to the beach at Pathhead. There are actually rather more, but generations of Fife schoolchildren have grown up with this notion. A more mundane, but possible, explanation is that, because JB celebrated his thirty-ninth birthday on 26 August 1914, the number was in his head. He himself never explained why he picked that number, almost certainly because he had quite forgotten the reason.* He started the book in Broadstairs, but finished it after he had been ordered to bed again at the end of October and stayed for six weeks with Susie's mother (always a sympathetic listener to tales of illness and woe and blessed with excellent domestic staff) in Upper Grosvenor Street.

*There are also, of course, Thirty-Nine Articles of Religion, to which the Church of England adheres, and St Paul submitted to thirty-nine lashes (2 Corinthians, chapter 11, v. 24). Thirty-nine is a very suggestive number.

The outbreak of war had an immediate impact on Nelson's, the publishers. Tommy Nelson joined his Territorial unit, the Lothians and Border Horse, the day after war broke out, while his brother, Ian, joined the 4th Cameron Highlanders a few weeks later. The business would now be in the hands of just two partners, JB and George Brown. On the day war broke out, JB wrote to Brown an anxious letter from Broadstairs: 'We shall have to make arrangements for a bad slump in our business. I earnestly hope it will be possible to keep going at half power so as not to throw too many of our people out of work. Our continental business will go by the board but will it not be possible to do something to fill the gap? Special war publications, for example, or a concentration upon American and South American business.'[52]

Brown wrote back immediately saying they would try to keep the 'Sevenpennies' going, and suggesting that Nelson's produce a weekly war magazine. JB was enthusiastic: 'My notion is a sort of budget of war news, articles and illustrations, sold at some price like 3d … If you like I will edit it. It might succeed and be the basis for future magazine work. In any case, I think it would pay its way and help to keep our staff going.'[53]

On 7 August, George Brown was gloomy about prospects generally but suggested that Nelson's publish a 'part work', which would follow the course of the war – an idea that his partner seized upon. They first asked Sir Arthur Conan Doyle but he wouldn't do it, and another possibility, Hilaire Belloc, was unavailable for the next six months, since he had a contract with *Land and Water*. This was probably a relief in view of Belloc's cavalier attitude to deadlines. In the end, JB made up his mind that he would have to write it himself. By mid-September, when he and his wife were staying at Ardtornish, he had already begun work on the first volume. They decided that *Nelson's History of the War* would be published in bi-monthly parts, of 50,000 words each, and JB would instruct a military historian, A. Hilliard Atteridge, to check facts and draw the maps. Other histories were being assembled at the same time by newspapers such as *The Times*, but they were 'patchwork compilations' rather than the work of one man.

On 9 October, JB wrote to Lord Rosebery, asking whether he would write a short preface to the first volume. The letter shows what was in his mind:

We are making a great effort to keep all our people in employment, which is not easy, as all our foreign business has ceased. About 170 are with the colours [i.e. have joined up], and we are trying to keep the remainder on full time and also, of course,* to pay wages to the families of those who have enlisted … I have undertaken, as my contribution to this work, to write a <u>History of the War</u> in monthly parts, the first part of which will appear at the beginning of November. [In fact the first one did not appear until early February 1915, at least partly because of JB's illness.] Military history on these terms is, of course, rather ridiculous, but as I shall always be three months behind the fighting I shall be able to know more or less correctly the general lines of what has happened, and I have various ways and means of getting information. We propose to devote any profits from this, as from the rest of our war publications, first of all to our own employees and, if there is any surplus, to general relief purposes…[54]

In the end, the idea of giving a 'surplus' to charity was abandoned, possibly because it was impractical to hypothecate the profits from the *History*, but certainly the wives and widows of serving Nelson's men were supported during the war, as letters of thanks from them attest.[55]

JB's decision, taken in a hurry, was to have momentous consequences, for he felt honour-bound to write the *History* throughout the entire war, even when he was frantically busy elsewhere; the strain on him, especially in the summer of 1917, would have crushed most people. By July 1919, there were twenty-four volumes on the shelves, amounting to over two million words, only a fifth less than Edward Gibbon's *Decline and Fall of the Roman Empire*, but written in four years rather than twelve.

JB had only had limited direct military experience in South Africa, but he was well versed in conventional military strategy and tactics, both from his wide reading and from conversations with the young, ambitious army officers he had met there, notably Julian Byng and Douglas Haig.

*That was the decent thing for a company to do, although it is unlikely that all did so since servicemen were paid a wage, in the case of the private soldier usually a minimum of 1s 2d a day.

Ian Nelson, who was more commercially astute than either his brother Tommy or JB, questioned how easy it would be to find the accurate details in wartime. JB acknowledged the anxiety but told George Brown: 'It is very curious how things clear up as they go along. A month ago it seemed impossible to be definite about the Belgian fighting; today we know pretty well what happened. The same with the retreat to the Marne.' He thought he would know much more about the Aisne fighting by the time he came to write that part. But this was mobile war; it was to prove far more difficult once the two sides dug in for a long attritional struggle. He told Brown: 'My chief sources of information are (1) a careful recension of all newspaper reports, which I am having made. It is curious how near you can get by the method of elimination. (2) The French papers, which often contain inspired articles and have very full quotations from the Russian papers, which know more than any other press. (3) Information from returned officers whom I am always seeing. (4) Reports from friends in France and Petrograd. I have also got a good deal of information about Belgian fighting from Belgian refugees. You see our scale is such a small one that we only need to tell the story on its main lines. Details like actual losses, exact numbers of men engaged, and the allocation of different regiments will, generally speaking, be impossible till the war is over; but, then, we do not want these for our scheme.' He also told Brown that he was following the principle not to say that any regiment in any Allied army misbehaved, since Nelson's would only get into trouble, 'and these incriminations had better be left till after the war'.[56]

That autumn and winter were, not surprisingly, difficult for the firm. The over-ambitious *The War* weekly sold less well than was hoped, and was discontinued early in 1915, because of distribution and advertising difficulties. Moreover, the firm could no longer obtain parts for their German machines and the commercial relationship with Tauchnitz in Germany came to an abrupt halt 'for the duration'. Then JB was finally diagnosed by Sir Bertrand Dawson with a duodenal ulcer and advised to have absolute rest in bed for six weeks, which would delay the publication of the *History*, since he knew he must proofread it carefully and he was forbidden from writing in bed. Despite that, he kept up with his correspondence, Lilian Alcock visiting him daily to

take dictation at his bedside. It was agreed that the *History* would be best placed in Nelson's 'Shilling Library', since that would give much-needed work to the 'New Factory' (the one built in 1907), and would not clash with the much more expensive war history (*A General Sketch of the European War, First Phase*) that Hilaire Belloc had agreed to write.

The stresses imposed on him were substantial and almost certainly made his delicate digestion worse. The symptoms that he suffered were stomach pain, especially in the mornings, as well as before and after meals, together with nausea and bouts of gastritis, especially when under pressure. There must have been times when he felt absolutely wretched and certainly exhausted, both because vitamins and minerals were not properly absorbed but also because abdominal pain probably disturbed his sleep.

In 1915, when writing *Greenmantle*, he gave duodenal trouble to his American businessman turned spy, John S. Blenkiron. It is possible to learn something of JB's diet in the early years of his affliction from the pages of that novel. Blenkiron offers Richard Hannay luncheon on their first meeting but says he cannot enjoy the food, since he suffers from duodenal dyspepsia. 'It gets me two hours after a meal and gives me hell just below the breastbone. So I am obliged to adopt a diet. My nourishment is fish, sir, and boiled milk and a little dry toast.'[57] This was to be JB's regime for much of the rest of his life.

6

The Great War, 1914–1918

The first volume of *Nelson's History of the War* was well received. *The Spectator*, for example, pointed out that, importantly, unlike other similar works, it was the work of one man.[1] The books were 'crown octavo' size, bound in red cloth, with the spine details picked out in gold leaf – until the autumn of 1917, when gold leaf became too expensive. The original price was 1 shilling, although the increasing scarcity of paper meant that in 1916 a volume cost 1s 3d, and by the end of the war 2s 6d. *Nelson's History* was not government-sponsored, indeed JB categorically did not want it to be. However, after June 1916, he did have the tacit support of the Foreign Office and also, grudgingly, GHQ in France.

The geographical ground that JB covered was vast: as well as the main theatres of the Western Front, the Eastern Front and the Ottoman territories, he also included fighting in the European powers' colonies, for example writing of skirmishes in south-west Africa, German losses in the Pacific and a sea battle near the Falkland Islands.

During the war *Nelson's History* sold more than 700,000 copies. And, although it was not published separately in the United States, it had a wide circulation there and JB later maintained the series had 'a far reaching influence' in America. It was praised for its range and lack of bias by the opinion-formers' newspaper, the *New York Times*, and at least one historian believes that the *History* shaped positive perceptions of Britain's role in the war in neutral states, including the United States.[2]

Modern assessment of *Nelson's History of the War* has to be approached with care. As with all JB's writing during the war, he did not pretend to

be a neutral observer and was transparently dedicated to Allied victory. Plainly, it could not be considered 'history' as the word is understood in the context of academic study, years after the events, when analysis is possible of all the available material, from the full range of participants. It was, in fact, well-informed reportage, a first draft, as it were, of history. JB likened his task to that of Thucydides, chronicling, as well as taking part in, the Peloponnesian War.

The *History* was sharply criticised in the 1930s by David Lloyd George, a man who could nurse a grudge as if it were a dear relation. Although JB wrote many admiring things about him, Lloyd George seems to have picked up only on criticisms and he strongly objected to JB's description[3] of his enthusiastic reaction to the plan of the French commander-in-chief, Robert Nivelle, in January 1917, to break through on the Western Front – a plan that failed miserably. He also disliked JB's criticism of journalists and politicians at the time of Passchendaele.

In his *War Memoirs*, published fifteen years after the end of the war, Lloyd George wrote that JB had lapsed into his fictional mode in the *History*: 'When a brilliant novelist assumes the unaccustomed role of a historian it is inevitable that he should now and again forget that he is no longer writing fiction, but that he is engaged on a literary enterprise where narration is limited in its scope by the rigid bounds of fact...'[4] When Lloyd George was admonished by Captain Basil Liddell Hart, the journalist and military historian, for rubbing JB's nose in the dust, he replied that he was 'a pagan. I like fighting, and love to flatten out my assailants.'[5]

More recently, JB has been accused of 'falsifying the whole military situation on the Western Front', of 'covering up for failures of the military leaders',[6] and, more generally, of 'jingoism'.[7] These accusations require examination.

There is, today, a pervasive narrative of the First World War as a futile, bloody hecatomb, during which millions were sent to their deaths by incompetent, callous, upper-class dolts who were unwilling or unable to learn from their lethal mistakes. JB's wartime writing has been viewed through this lens. So stubbornly persistent is this idea that it is hard to keep in mind how recently it took hold and became almost universal; only since the 1960s in fact.[8] The stereotype encourages the idea that the generally steadfast public opinion during the war can be explained by the population being actively deceived by JB, among others.

However, the scale of death and injury could scarcely be concealed. The newspapers published frequent casualty lists. The crutches and empty sleeves of those too severely wounded to return to the front were there to be seen. The grief of families and friends was shared in those times of general community solidarity. Not all servicemen or nurses returning home on leave found it impossible to discuss their experiences. In September 1916, during the Battle of the Somme, the artist C. R. W. Nevinson held a highly successful exhibition, at the Leicester Galleries in London, of drawings and paintings he had made on the Western Front, when a private in the Royal Army Medical Corps. The work was harshly Futuristic* in style and included *La Mitrailleuse*, a bleak depiction of a brutalised machine-gun crew, impassively sharing a trench with a dead comrade. Nevinson became an official war artist in 1917, in a process encouraged by JB, by then Director of Information. Furthermore, the now (and rightly) celebrated 'War Poets' were not entirely representative of their comrades. There were other poets who did not shrink from describing the horrors of the trenches but nonetheless believed the cause was just – for example, the poet, composer and crack shot Ivor Gurney, whose *Severn and Somme* was published in November 1917.[9] No collection of Wilfred Owen's poems was published until 1920. Between then and 1929 fewer than 1,430 copies were sold. In the same period, the comparable figure for the collected works of Rupert Brooke was about 300,000.[10]

Of course, the war and its conduct were the subject of serious, reasoned criticism from the outset. But the conflict and its prosecution was always contested. This was especially the case while so many who had directly experienced the war were still alive to contribute to the controversy.** The development of public perception has been the subject of close scholarly research.[11] However, the 'lions-led-

*Influenced by Italian Futurism, a pre-war avant-garde movement that emphasised the speed and energy of modern life, and often depicted machinery and technology.

**Hew Strachan, when making the Channel 4 television series *The First World War*, was determined that 'As far as possible this series should convey the realities of war in phrases uttered at the time, not in the memories of surviving veterans, however powerful. Mediated by the intervening events of the twentieth century, such testimony can create not an immediacy but a distance between us and the First World War.' Hew Strachan, *The First World War*, Simon & Schuster, London, 2014, p. 334. JB's own views were not immune. In *Memory Hold-the-Door*, written in 1938–9, p. 167, he wrote of the war's 'boredom and futility' in terms that were significantly different from what he said and wrote at the time.

by-donkeys-in-a-completely-pointless-war' stereotype has proved, in the public eye, remarkably impervious to the work of a number of modern military historians, such as Professor Sir Hew Strachan and Professor Gary Sheffield. It is not necessary, here, to arbitrate between competing experts, merely to point out that JB's wartime writing should be read with a lively sense of the existence of a wide range of expert, nuanced opinion, which is at odds with simplistic popular myth.

A fair assessment of *Nelson's History of the War* has been made by, for example, Professor William Philpott, who has written that JB 'would strike a judicious balance between morale-boosting and vérité reportage, telling the story of the war in a romantic, adventurous spirit but not glossing over the horrors of the modern battlefield'.[12] Similar support comes from Professor Keith Grieves, when considering JB's four-volume revision of the *History*, published in 1921 and 1922: 'Buchan was writing a highly engaged form of history which was utterly clear and steadfast in its judgements. The conclusions which first emerged in 1915, were still intact in 1921, and were clearly not specifically designed to respond to state policy.'[13]

It cannot be denied that, to the modern mind, JB's language can seem almost absurdly florid. To take one example, he wrote of the Battle of Jutland, 'it may confidently be said that not even at Trafalgar did the spirit of [Britain's] seamen shine more brightly'.[14] His euphemisms can jar badly: of the first day of the Somme, 1 July 1916, he wrote, 'minute by minute the ordered lines melted away under the deluge of high-explosive, shrapnel, rifle, and machine-gun fire'.[15] However, he also wrote, bluntly, that the British attack north of Albert that day failed,[16] nor did he leave the reader in any doubt about the scale of the battle, the grim nature of the fighting, and the colossal number of casualties.

He did not believe that all Germans were evil; indeed, he repeatedly went out of his way in the *History* to praise the German serviceman (though not his commanders and never his cause). The charge of jingoism is hardly consistent with the final words of this massive, multi-volume endeavour:

The world had suffered a purgation by pity and terror. It had made solemn sacrifice, and the sacrifice was mainly of the innocent and the young. This was true of every side. Most men who fell died for

honourable things. Perversities of national policy were changed in the case of the rank and file, both of the Allies and their opponents, into the eternal sanctities – love of country and home, comradeship, loyalty to manly virtues, the indomitable questing of youth. Against such a spirit the gates of death cannot prevail. Innocence does not perish in vain. We may dare to hope that the seed sown in sacrifice and pain will yet quicken and bear fruit to the amelioration of the world, and in this confidence await the decrees of that Omnipotence to whom a thousand years are as one day.[17]

War conditions meant that JB's constituency work was in abeyance, but the *History* brought him to the attention of the government and, in the spring of 1915, he was asked to give a set of three public lectures, to raise money for war charities. He accepted, both because it was war work and because he thought it would help sales of the *History*. The first lecture, on 22 March, in the Bechstein Hall on Wigmore Street, was chaired by the Foreign Secretary, Sir Edward Grey.

JB spoke about official control of information concerning the war and the problems this caused to journalists: 'Newspaper reports are only accurate by accident; it could hardly be otherwise when they have no accredited correspondents at the front; and our Press Bureau has views which are all its own about what constitutes desirable information for the public. The result is that great events have happened of which we knew nothing till many weeks after.'[18]

His comments chimed with the thinking of both the owner of *The Times*, Lord Northcliffe, and its editor Geoffrey Robinson (later Dawson), and the following month he was asked to go out to France for a few weeks as a special correspondent for the newspaper to cover what became known as the Second Battle of Ypres. Journalists had initially been banned from the battlefields, but that diktat was relaxed in April 1915 to allow five accredited journalists to operate on the Western Front, provided that they submitted to having their copy reviewed by the censors at General Headquarters. JB eagerly accepted the invitation, since not only was it a challenge that he relished, but to see the battlefields for himself would make his *History* more credible to the general public.

He travelled out to the British Expeditionary Force's General Headquarters at St Omer in mid-May. He was given a car and a driver and allowed to go almost anywhere he liked. His first *Times* despatch,

'On a Flemish Hill', was published on 17 May. It was full of typical Buchan tropes: the linking with military history (from Caesar through to Marlborough), the descriptions of landscape and topography, then the rural nature of the scene, followed by the contrast close to the fighting: 'Brown scars, which are not heather or bracken, line the woods, zig-zag across the meadows, and stand out red and raw on the further slopes. A neat château shows in a gap of forest, but the glass reveals it as a riddled husk.'[19]

Five days later he described the destruction of the town of Ypres: 'The [main] street lies white and empty in the sun, and over all reigns a deathly stillness. There is not a human being to be seen in all its length, and the houses which contain it are skeletons.'[20] He recounted what a shock it was to see the graves of men whom he had known in the pride of youth and strength. He also told the probably mythical story of the soldier who, being left behind by his comrades the November before because he was asleep, restored order to a lawless Ypres for a week and became known as 'le Roi d'Ypres'. Although based on a false premise, that the Allies had abandoned Ypres, this tale was too good for a fiction writer to miss and he turned it into a short story about a Scots soldier, called 'The King of Ypres', which was published in December 1915 in the *Illustrated London News*.

He was given remarkable access to senior generals – French, Plumer, Allenby, Haig and Byng – as well as Henderson of the Flying Corps, and also heads of the railway and transport departments. In *The Times* he described the Battle of Festubert, in which his partner at Nelson's, Ian Nelson, had distinguished himself with the 4th Cameron Highlanders. This was a desperate struggle over streams and flooded ditches and he turned it into a stirring story, even telling his readers that the men, mainly drawn from Skye and the Highlands, reminded him of 'their seventeenth-century forbears, slipping on a moonlight night through the Lochaber Passes'.[21]

After JB arrived home, he went back to Paternoster Row when he could, Nelson's being so hard-pressed. (The firm was converted into a Company in December that year, with the partners becoming directors, 'because of the special circumstances'.) At about the same time a valued political friend and his son's godfather, Lord Robert Cecil, MP for Hitchin and third son of the Victorian Prime Minister, Lord Salisbury, became Parliamentary Under-Secretary at the Foreign Office,

responsible for propaganda. Most likely it was he who invited JB to join him there. By the end of the year, JB had become a senior member of staff in the News Department of the Foreign Office.

One of his tasks was to work on suitable propaganda for the United States; this endeavour was considered vitally important but thorny in the extreme. He set about getting to know the London correspondents of American newspapers, using his charm and tact to gain their respect and trust, and transmitting, through them, news stories to counteract the vigorous propaganda coming out of Germany. His time was now roughly divided between the Foreign Office, Paternoster Row and trips to the front.

'I have never been so hustled in my life,' he told Gilbert Murray that July: 'Two of my partners and 67% of our male employees are with the colours. My remaining partner, most of our managers and some more of our men are with the Munitions Department. So I have the whole business on my hands, besides a lot of Foreign Office work ... Still it is a good thing to be very busy at a time like this, when most of one's friends have fallen. It prevents brooding.'[22] By July 1915, Francis and Riversdale Grenfell were both dead, as were their cousins Billy and Julian, the poet, as well as Gilbert Talbot, a connection of Susie's. JB was prone to exaggeration in his correspondence; death had by no means finished with his friends.

His adventure story about seventeenth-century Virginia, *Salute to Adventurers*, was published by Nelson's that month. It was dedicated to Susie's uncle by marriage, Major-General Sir Reginald Talbot, who had been in the column that arrived too late to save General Gordon at Khartoum in 1885. As a young man he had been temporarily attached to the staff of General Sheridan of the Union during the American Civil War, so JB thought it fitting to dedicate a book about the early days of settlement in Virginia to this well-liked, retired regular soldier.

The tale, set in the 1680s, concerns an upright Edinburgh merchant, Andrew Garvald,* and his adventures both in Scotland and Virginia. Although written before the Hannay novels, its publication confirmed that JB was already keen, in this case subtly but unmistakably, to point up the long association between Britain and its former New World

*One of several Border place-names that JB used for surnames in his novels.

colonies, as well as the common ancestry of many of their people. He dealt confidently with themes that were to recur over and over again in his books: the potency of the frontier, both actual and as an idea; what really constitutes civilisation; and what hell can be let loose in the world when religious fervour turns to self-centred fanaticism, a theme that reappeared, with greater force, in *Witch Wood*.

In September he was sent out to the Western Front again, this time by the War Office, to observe and report on what became known as the Battle of Loos. He sent back dispatches to *The Times* at the same time, again making good use of his privileged access for gathering information to write the *History*. 'I have written two very scruffy things for the <u>Times</u>, but it is impossible to publish details yet,' he told his wife.[23] The battle made him rage privately against the shortcomings of the senior military, especially Sir John French, Commander-in-Chief of the British Expeditionary Force, who, he thought, had sent men into battle without proper back-up and reserves.

He wrote in the *History*: 'Mistakes were no doubt made, of which the future historian will have much to say. In such a work as this, criticism would be premature and improper.'[24] However, in the revised version, published in 1921,[25] he was more forthright: 'Yet the exhilaration of victory, the sense that at last we were advancing, was tempered by a profound disappointment. We had had a great chance of which we had failed to take full advantage. Most of the results of surprise and of initial impetus had been lost during that tragic interregnum from Saturday at midday till noon on Monday, when a few weary and broken brigades clung heroically to an impossible front. There had been somewhere a colossal blundering.'[26] In *Greenmantle* both Sandy Arbuthnot and Richard Hannay are wounded at Loos. During the battle, he himself came under German machine-gun fire when striving to 'foregather' (as he called it) with Cecil Rawling.

Once home again, he continued to work for the Foreign Office in public relations, for example conducting a delegation of Russian politicians (including Vladimir Nabokov's father) to view the British Fleet at Scapa Flow in the Orkney Islands.* From time to time he

*Sir Walter Bullivant, in chapter XI of *Mr Standfast*, wonders whether the genius German villain, 'Moxon Ivery', might have visited 'the Grand Fleet as a distinguished neutral'.

showed high-profile civilians around the battlefields. And always there was work to do on the *History*, which he would mainly write at weekends when he joined his family, who spent much of their time in rented houses in rural Kent.

On 19 October 1915 the 'shocker', which he had spent the dreary six weeks in bed in 1914 writing, was published by Blackwood's, under his own name, having been serialised in three parts in *Blackwood's Magazine* under the pseudonym 'H. de V.' This may have referred to a friend, a Brasenose rowing Blue called H. C. de J. du Vallon, as a, now unrecoverable, joke.

JB defined the 'shocker' in his dedication to Tommy Nelson as 'the romance where the incidents defy the probabilities, and march just inside the borders of the possible'. He dedicated it 'in memory of our long friendship, in these days when the wildest fictions are so much less improbable than the truth'.

For nearly twenty years before the outbreak of war, there had been a naval arms race between Germany and England, and novelists such as Erskine Childers,* William le Queux and E. Phillips Oppenheim had plugged into a widespread anxiety about possible invasion from the sea by Germany. It is scarcely surprising, therefore, that the plot of *The Thirty-Nine Steps* should be informed by those fears, and be conceived by a patriotic man trying to come to terms with being a non-combatant, and understandably anxious to find other ways of playing his part.

The book introduces Richard Hannay, the comfortably-off but unsophisticated mining engineer, of Scottish blood but reared in Rhodesia, alone and bored in London. Bored, that is, until the murder in his flat of a new acquaintance – a freelance secret agent – by a gang of German spies (the Black Stone) intent on smuggling the current dispositions of the British Fleet out of the country, sends him on the run. Hannay is chased by them for the knowledge they think he has acquired, as well as by the police, who suspect he is a murderer.

If *Prester John* was an encomium to the beauty of rural South Africa, then *The Thirty-Nine Steps* performed the same duty for the Scottish Lowlands. Hannay would have found it much easier to hide in plain sight in London, but decides to take a train to Scotland and disappears

** The Riddle of the Sands came out in 1903, and was much admired by JB.*

into the wilds (and they are wild) of Galloway, that same landscape where JB had slept out with Taffy Boulter in the summer of 1897, and which he also knew from his riotous sojourns at Ardwall. Harried by the Black Stone gang, Hannay moves eastwards and ends up in JB's beloved upper Tweed valley.

JB maintained that Hannay was modelled on Edmund Ironside, later hero of Vimy Ridge and Archangel, whom JB had met when he was a young regular officer in South Africa, doing intelligence work. He was brave, resourceful and instinctive, as Hannay is, but there are substantial differences. Hannay is, in some ways, the ordinary man (which Ironside emphatically was not), conscious of his limitations but determined to do his best, and is thus someone with whom readers can readily identify. Hannay is far from cerebral, unreconstructed in his views and forthright and slangy in his speech – 'of my own totem'; 'a sportsman called Nietzsche' – which is why it is so odd that anyone should ever mistake him for his creator.

The tense, fast-paced, first-person narrative, exciting chases by car and aeroplane of the fugitive hero, and deft descriptions of landscape and weather, made an impact on fiction readers in all strata of society. JB received many letters from men in the trenches: 'It is just the kind of fiction for here,' wrote one officer. 'One wants something to engross the attention without tiring the mind. The story is greatly appreciated in the midst of mud and rain and shells.'[27] Indeed, it has been said that the reason why there are so few first-edition copies of the book with their dust jackets still intact is because they were lost in the mud of the Western Front. Sandy Gillon, who was with the King's Own Scottish Borderers at Gallipoli that winter, wrote to say that he had enjoyed it, even if it was 'glaringly improbable'.[28] In reply to Gilbert Murray's congratulations, JB wrote, 'I am very glad you like my "shocker". It is the most restful and delightful thing in the world to write that stuff.'[29]

The book was reviewed favourably but not widely. *The Spectator* said that it had 'just that quality of literary amenity which the average "shocker" conspicuously lacks; it lifts the book out of the ruck without being so pronounced as to repel the unlettered reader.'[30] It was an immediate success, selling 25,000 copies by the end of 1915. It made JB known as a fiction writer to a degree that *Prester John* had not achieved. When giving his war lectures, he began to be referred to as 'the famous novelist and war correspondent'.[31]

It is not hard to see why the book was so immediately popular: you could happily give it to anyone as a present, since without a female love interest there could be no troubling undercurrent of sex. Hannay is honourable, dutiful and patriotic, yet deliciously transgresses conventional behaviour by running away from the police, stealing cars and occasionally hitting people. (But this is emphatically not 'snobbery with violence', that appealing but, in the case of JB's novels, misleading phrase of Alan Bennett's.)* The prose is clean and spare, which was the hallmark of all his novel-writing, with occasional 'parallelism' derived from the Psalms: 'The free moorlands were prison walls, and the keen hill air was the breath of a dungeon.'³² That could have been a sentence from one of his father's sermons.

According to one academic, LeRoy L. Panek, 'Buchan took the spy novel out of the hands of innocuous romancers like Oppenheim and gave it sinew and meaning.'³³ That is some claim for a book that ran to just 245 pages of text in its first edition. Certainly, *The Thirty-Nine Steps*, and the other spy novels JB wrote, were to have an influence on other thriller writers. According to Panek: 'If John Buchan had not existed he would have had to have been invented. The modern novel of espionage simply would not have developed along the same lines without him.'³⁴ It has also been said of JB that he 'gave a model of form and an inner spirit to the spy story, giving it through his vision of the world a capacity to express in terms of contemporary international politics and intrigue the yearning for a lost world of fullness and heroism'.³⁵ Raymond Chandler remarked that the dedication to Tommy Nelson at the beginning of *The Thirty-Nine Steps* was a pretty good formula for the thriller of any kind. Graham Greene and Ian Fleming both acknowledged their debt to him. To take just one example, we would call the Black Stone's use of powerful cars and aeroplanes to pursue the hero in the novel 'pure James Bond', if JB hadn't got there first. Pursuit and escape, omnipresent danger, often from more than one side, and the hero not knowing who to trust and prey to paranoia, are all important elements of twentieth-century British spy fiction.

*Alan Bennett, *Forty Years On*, Faber, London, 1969. Act 2: 'Sapper, Buchan, Dornford Yates, practitioners in that school of Snobbery with Violence that runs like a thread of good-class tweed through twentieth-century literature.'

Interestingly, there is a direct homage to JB (more likely than John Bunyan) in John le Carré's *The Honourable Schoolboy* when George Smiley is asked his name and he replies 'Mr Standfast'.

The Thirty-Nine Steps is not JB's best novel; there are several that are better plotted, with subtler characterisation. It is an obvious piece of British war propaganda. However, it will always be the book with which JB is associated and remembered. It is solemnly debated by academics, in sometimes mystifying but always sincerely earnest terms. It has never been out of print in more than one hundred years; precious few novels survive so long. It is therefore a 'classic', according to Leslie Stephen's definition: 'It takes a very powerful voice and a very clear utterance to make a man audible to the fourth generation.'[36] By 1960, it had sold 355,000 hardback copies, only slightly outdone by *Greenmantle* and, when the book went into Penguin and Pan paperback in the 1950s, it sold twice as many copies as it had done in hardback. By the time Janet Adam Smith's biography, *John Buchan*, was published in 1965, *The Thirty-Nine Steps* had sold about 1.5 million copies in English, and there were translations into a number of languages, including Persian and Arabic. JB's works are now out of copyright, and editions of the book are published frequently, both in print and as digital downloads. There is no possibility of keeping track of its sales.

His most famous creation, Richard Hannay, has become, truly, an iconic figure. His name just has to be mentioned, without comment, and a whole world of meaning opens up to the reader or listener. Even now. Take just one of countless examples: in a 2007 biography of the cerebral poet, R. S. Thomas, the author, Byron Rogers, mentions a war hero, General Pugh, who came to live in Thomas' remote Welsh parish: 'He was Richard Hannay.'[37] No more was, or needed to be, said.

Scarcely a book review of a new spy thriller is complete without John Buchan's name being mentioned as a result of *The Thirty-Nine Steps*. These books are sifted by reviewers into categories – as exciting as Buchan, with Buchan characteristics, not as good as Buchan and so on. As for those thirty-nine steps, they turn up in company reports on how to grow a business, in travel-writing, in advice to teenagers about how to live their lives[38] and in innocent games. As I learned very young, they are a Bingo call: '39, all the steps'. *The Thirty-Nine Steps* has so penetrated our consciousness that we do not puzzle at its mention, whatever the context. Writers continue to write books that they are

proud to admit are strongly influenced by it.[39] In 2003, *The Thirty-Nine Steps* came 44th in *The Observer* list of the 100 greatest novels of all time, one above *Ulysses* and two above *Mrs Dalloway*, which would have afforded JB a wry smile.

The Thirty-Nine Steps changed his life, both because he now realised he could make very useful money out of writing fiction and because people began to view him in a different way. For better or worse, he was now pigeon-holed as a writer of exciting thrillers, a reputation which was augmented by the publication of *The Power-House* and *Greenmantle* the following year.

Despite the hustle of the war, JB continued, from time to time, to amuse, distract or console himself by writing poetry. He produced, for example, a privately printed, pseudo-heroic 'eclogue',* *Ordeal by Marriage*, a poetical discussion on the subject of marriage, supposedly by seven old friends of his, who were both bachelors and Knights Bachelor. Susie later wrote that it was 'a private joke written for a group of friends and quite incomprehensible to anyone else'.** And he continued to write for newspapers and periodicals: *The Times, The Times Literary Supplement, Land and Water*, and even the *Chicago Daily News*, to which he cabled a succession of weekly pieces in 1916.

Meanwhile, Susie was far from idle. Despite being pregnant again (William, their third child and second son, was born in January 1916), she helped Lady Wolmer found and run a nursery for children in Gospel Oak, a poorish area of north London. Gospel Oak caught JB's fancy and the name and area appear in his 1924 novel, *The Three Hostages*. She also did part-time work for the Voluntary Aid Detachment, which provided auxiliary help by the genteel to trained nurses. Her mother and sister, Marnie, had been doing much the same thing in Paris in 1915.***

In May 1916, hard on the heels of the success of *The Thirty-Nine Steps*, Blackwood's brought out a hardback edition of *The Power-House*, which they had serialised in their magazine in 1913. This story stretches

*Strictly speaking, a pastoral poem, which this is not.

**The friends were Sir Lionel Curtis, Sir Philip Kerr (later Marquess of Lothian), Sir Alfred Zimmern, Sir Robert Brand, Sir George Craik, Sir Lionel Hichens and Sir Edward Grigg.

***Marnie had trained to be a singer, and went out to Australia to stay with her aunt and uncle when the latter, Major-General Sir Reginald Talbot, became Governor of Victoria in 1904. While in Australia she acted as secretary to the famous singer Dame Nellie Melba. She met her future husband, Jeremy Peyton-Jones, an Australian, in Paris and they married in 1916.

the suspension of disbelief beyond breaking point; there are just too many coincidences and it contains a most uncharacteristic, if necessary, blunder by the clever lawyer, Edward Leithen. It is best remembered for the most famous short passage in the entire Buchan canon, the description of civilisation by the arch-villain, Andrew Lumley: 'You think that a wall as solid as the earth separates civilisation from barbarism. I tell you the division is a thread, a sheet of glass. A touch here, a push there, and you bring back the reign of Saturn."* For once, a Buchan character can safely be assumed to be expressing the views of his creator. As far back as 1901, in the short story 'Fountainblue', he wrote much the same: 'There is a very narrow line between the warm room and the savage out-of-doors ... You call it miles of rampart; I call the division a line, a thread, a sheet of glass.'[40]

There is no ducking the fact that JB was stimulated by the work in France, despite the depressing or terrifying nature of many of the sights. Nor is it so surprising. For one thing, he admired the ordinary British soldier, and for another he was as close to the action as he could be for a patriotic non-combatant, convinced of the rightness of the Allied cause. He was also popular at GHQ. Howard Spring, a clerk there and later a well-known novelist, recalled: 'I remember John Buchan, a cavalier if ever there was one, always commanding our respect but never forgetting how to unbend.'[41]

Journalist that he was, he enjoyed producing despatches from the front for *The Times*, even when his copy was sometimes censored unnecessarily or he feared that indiscreet comments by its military correspondent, Colonel Repington, might redound badly on him. He told his wife on 23 May: 'That fool Repington, who was out here last week as Sir John French's guest, went home and wrote a thing which gave away one of our front positions. The result was that the place was shelled next day and a lot of men killed. The 1st Army are furious, and a lot of people who don't know me think I am responsible. The result is that

The Power-House, chapter III, William Blackwood, Edinburgh, 1916. Something of the same feeling is expressed by Kipling in 'In the House of Suddhoo':

> A stone's throw out on either hand
> From that well-ordered road we tread
> And all the world is wild and strange.

no visitors are allowed in that part of the line.' He had been going to spend the night in the trenches with the Scots Guards but the visit had been cancelled. 'The truth will be known very shortly but meanwhile it is very annoying.'[42]

JB's brother Alastair went out to France in 1915. In the early part of 1916 the 6th Battalion, the Royal Scots Fusiliers, was commanded by Lieutenant-Colonel Winston Churchill, who found a temporary berth there when he left the Cabinet after the disaster of Gallipoli, and Alastair served under him for a short while. The lad sustained a shrapnel wound to the right thigh in February and was sent back to Scotland to recuperate. He was based that summer at North Queensferry, on the north bank of the Forth, and managed to get home to Peebles at weekends. Anna remembered him as a kindly uncle to Alice and Johnnie, playing mock trench-warfare games with them by the banks of the River Tweed.

In June 1916, Lord Newton, JB's boss at the Foreign Office News Department, visited GHQ in France to speak to General Charteris (Head of Intelligence) about the press and propaganda, especially the need for morale-boosting stories. Charteris made it clear that he would help, provided 'the boosters confine themselves to boosting what has happened and not what they hope may happen'.[43] Charteris 'told him [Newton] what we were already doing in the way of facilities and offered to improve them in any way he could suggest, subject only to censorship requirements. He suggested a free-lance man from his own department to which I agreed.'[44] The man chosen by Newton was JB. At the Foreign Office, he had been very keen (pushing against War Office reluctance) that trained reporters be employed to move freely behind the lines, to provide accurate, unsensational information that could be given to the public. That is why Newton recommended him to GHQ.

Charteris wrote in his diary on 27 June 1916: 'Newton's emissary, John Buchan, arrived this morning. I have sent him on, meantime, with the Press people, but have told him he can do exactly as he wishes, and go where he pleases. I have written to ask for him to be given a commission at once. He has not got uniform at present, and runs some risk of being arrested and suffering some measure of inconvenience if he leaves the Press.'[45] JB was immediately commissioned a Second Lieutenant in the Intelligence Corps.

The Foreign Office permitted him to continue the *History*, since they considered it useful propaganda, but GHQ had misgivings, since they didn't want it to appear to have the army's official *imprimatur*. Charteris argued that 'critical words should not come from anyone who has access to such papers as we propose to show Buchan'.[46] In the end, Charteris gave in, provided that the Western Front chapters were submitted first to the Chief of the General Staff and not published until at least five months after the events described. This JB considered 'exceedingly nice and reasonable',[47] since he knew it was the *quid pro quo* for the extraordinary amount of access that he had been given. No one seems to have worried much about all the other theatres of war covered in *Nelson's History*.

He arrived at GHQ, which by now had moved to the École Militaire at Montreuil, in time to witness the beginning of the Battle of the Somme on 1 July, from a hilltop above Albert. His life resolved into a pattern of several days spent in France every three weeks, escorting journalists, press barons or politicians, gathering material for official summaries, communiqués and press releases to go to the War Office, the press or the clandestine propagandists at Wellington House. His duodenal ulcer gave him periodic problems, which was not unexpected, considering the irregular, unsuitable meals, jolting drives over terrible roads and uncomfortable quarters. Alfred Noyes, the poet, who worked in the Foreign Office News Department in 1916 recalled: 'He [JB] would turn up in uniform at the FO, looking tired and grey after some mysterious expedition to the front, in which I could picture him playing the part of Richard Hannay. [That is precisely what he couldn't do.] He was one of the sincerest men I ever knew, and there was something in his bearing which made one think of the young Caesar ... Buchan realised more fully than most of his contemporaries the gravity of the world situation, in which the war was merely an irruptional symptom of a far wider and deeper disorder.'[48]

When in London, he continued to make speeches for the government or war charities, and organised tours for neutral journalists and dignitaries. He did work for Nelson's, whenever he could, while Lilian Killick deputised heroically when he was away, checking Atteridge's maps and even sometimes reading manuscripts.

In September, concern about the quality and tone of official communiqués issued from GHQ in France prompted Generals Haig and Charteris to ask him to take over the task until the end of 1916. JB needed little persuasion, though it meant he had to be in France almost full-time. He found himself warming to Haig, a fellow Borderer, alumnus of Brasenose College and devout Presbyterian. He admired him for his professionalism, moral courage, fortitude, patience, sobriety and what he called 'balance of temper'. In his opinion, Haig was not a visionary, and was slow to learn lessons, but he did learn in the end.*

JB spent his time visiting Army, Corps and Division headquarters – 'a life of most inglorious security'[49] – but managed also to work most days on his *History*, now running about six months behind the events described. He provided reports for the propagandists working for Charles Masterman at Wellington House and also wrote a separate account of the Battle of the Somme, gleaned mainly from the Army War Diaries, which was translated into foreign languages for propaganda abroad and, as an afterthought, came out in Britain in two volumes in November 1916 and May 1917 respectively. These were published by Nelson's, and printed on the big rotary presses, for speed, and sold at 1 shilling.[50] He told George Brown that 'It looks as if the Govt. was going to make a mess of my Battle of the Somme. It is a pity, for it might have been a nice little book.'[51] He may be referring to the fact that the maps, prepared by 'a Government Department',[52] were inaccurate or else that the information the book contained was ham-fistedly censored.** (Curiously, *The Battle of the Somme* exists in miniature form in Queen Mary's Dolls' House at Windsor Castle.)

In October 1916, *Greenmantle*,*** which JB had written between February and June that year, was published in hardcover by Hodder and Stoughton (in a print run of 37,000, selling at 5 shillings), having been serialised first in *Land and Water*.**** In the dedication to his

*As far as JB was concerned (and indeed a number of modern historians agree), the success of the push in the late summer in 1918, which ended the war quicker than had been expected, was quite as much Haig's success as Foch's.

**What JB considered a fuller and more accurate account of the two stages of the Somme battle came out as volume XVI of *Nelson's History* the following year.

***The title of the book echoes Sir Walter Scott, who named a character in *Redgauntlet* 'Green Mantle'.

****JB was paid £750 as an advance.

mother-in-law, Mrs Grosvenor, he wrote that it had amused him to write it and he forestalled criticisms of his use of coincidence, which were made about *The Thirty-Nine Steps* and would continue to be made about his other adventure novels:

> Coincidence, like some new Briarcus, stretches a hundred long arms hourly across the earth.[53]

It is salutary in this connection to recall the account by his son Johnnie[54] of a day in August 1939 spent fishing with his father on the remote Lake Maligne in the Jasper National Park in Alberta. They saw, but did not meet, a trail rider who brought his pony down to the edge to drink. Eight months later, this same man, Tommy Waitt, arrived with Canadian forces at Aldershot in England and was detailed to be Johnnie's batman. Three years later, he saved Johnnie's life in Sicily, when the latter was badly wounded by a mortar bomb, carrying him out of danger in the face of sustained German machine-gun fire. Even JB might have had qualms about inventing such a far-fetched and – importantly – meaningful wartime coincidence. Had he lived to know it, he would have called it the work of Providence.

In *Greenmantle*, Hannay is hauled out of the line by Sir Walter Bullivant of the Foreign Office (where of course JB was working at this time), to do some special secret work. Unlike *The Thirty-Nine Steps*, where he is alone for much of the book, Hannay acquires associates, who are as appealing, but certainly very different: Sandy Arbuthnot, scion of a noble Scottish house but a wild dreamer, master of disguise and 'blood-brother to every kind of Albanian bandit';[55] John S. Blenkiron, the canny and rich American engineer/businessman/spy, who speaks in scriptural metaphors and shares JB's digestive problems and love of the card game, Patience; and the Boer tracker and hunter, Peter Pienaar. JB said that Sandy Arbuthnot was based on his Oxford friend, the charismatic Aubrey Herbert, who had travelled widely, spoke a number of languages, and had taken up the cause of an independent Albania, but turned down the offer of its throne in 1914. He had escaped from German captivity after the Battle of Mons in August that year. John S. Blenkiron was introduced to interest Americans in the book, which was published in the United States in November 1916,

five months before the country entered the war. Blenkiron makes it clear that Americans are not interested in saving the British Empire, but some individuals are doing clandestine work for the Allies because 'there's a skunk been let loose in the world ... we've got to take a hand in disinfecting the planet'.[56]

In *Greenmantle*, very ingeniously, JB integrated fictional happenings into a factual context, the Russian advance in eastern Turkey in early 1916. Richard Hannay's task is to investigate and, if possible, foil the potential threat of a Muslim jihad against the Allies, under the leadership of a holy man known as 'Greenmantle'. Passions are being stirred up by the Germans, allied with Enver Pasha and the Young Turks, to use for their own advantage – particularly against the Russians, who are on the Allied side – as well as to promote German influence generally in the Near and Middle East. Indeed, something of the kind was happening, with a rumour abounding that the Kaiser had actually been converted to Islam. Wilhelm II certainly fomented trouble by supporting the jihad in Syria in 1915 and the Senussi, a Sufi sect, against the British in Egypt in 1916 and 1917. JB did not know as much about this as T. E. Lawrence, say, and probably no more than anyone who read the newspapers carefully, but he knew enough to harness it plausibly to his fiction. Lawrence told Robert Graves that '*Greenmantle* has more than a flavour of truth'.[57]

The dénouement of *Greenmantle* is the capture of Erzerum in eastern Anatolia by the Russians in February 1916, in which Lawrence may have had a hand. The factual underpinning of this account comes straight from *Nelson's History*.[58] Scarcely had the city fallen than JB started to write *Greenmantle*, which helps to explain its immediacy and furious narrative pace. It is tempting to speculate that, if Gallipoli had been an Allied success, the ending might have taken place in Constantinople, since that would have made a much greater impact on the war, and involved British and Empire troops, rather than the Imperial Russian Army.

JB relied for colour and verisimilitude in the book on his visit to Constantinople in 1910, which he had very much enjoyed. He had written then to Charlie Dick: 'My experiences varied from lunching in state with the Sultan's brother and dining at Embassies to chaffering with Kurds for carpets in a sort of underground Bazaar. I don't know any place where one feels history more vividly.'[59]

The reaction to the book was immediate and very positive. JB was pleased and flattered to be compared, in one review, to Sir Walter Scott. His friends wrote to congratulate him, although Arthur Balfour questioned 'How you can find time and strength to interpolate these parerga into the middle of your other labours I cannot imagine.'[60] But the truth was that he saw *Greenmantle* as part of his war work, just as much as those elegantly phrased communiqués or *Nelson's History*.

JB wanted to write a thrilling story for the 'war-torn man in his dirty dug-out at the front'[61] but one with a subliminal message. *Greenmantle* is notable – counterintuitively – both for the good press given to the Turks, who were 'victims simultaneously of forty years of British neglect and German aggression',[62] in the words of one historian, Professor David S. Katz, as well as for its sympathetic portraits of two Germans; one an engineer called Gaudian, who turns up again in 1936 to help Hannay in *The Island of Sheep*, and the other, more startling in the context of the time, the Kaiser. As Professor Katz puts it, *Greenmantle* was 'a novel about historical events only nine months in the past, which not only entertained but also helped educate its readers through the most subtle form of propaganda, novelized instant history'.[63] JB was 'transforming shockers into shock troops'.[64] Lloyd George was completely wrong: JB was not a novelist trying to write history but an historian writing fiction when it suited his purposes.

The readership for *Greenmantle* was surprisingly far-flung for wartime. In 1917, JB's publishers received a letter from the Grand Duchess Olga, daughter of Tsar Nicholas II, in exile at Tobolsk in the Urals, saying that she and her sisters and father had been greatly cheered and comforted by *Greenmantle*. 'It is an odd fate for me to cheer the prison of the Tsar,' JB told his mother.[65]

During October in France, JB kept to a strict diet, but still his insides gave him trouble. He wrote to his wife: 'In my present condition I am a nuisance to others and a misery to myself ... I shall write a denunciatory ode on my duodenum. I don't think Blenkiron's was as troublesome, do you?'[66] That day he collapsed, in his otherwise empty billet, suffering acute agony, and it took him hours to crawl to call a sentry for help. He was taken to a casualty clearing station, where he spent three days until he recovered, resisting the efforts of the doctors to send him to hospital or home to England. 'I hope you haven't been worrying. It is

an experience that I wouldn't have missed for a great deal,' he told Susie.
He wrote of the company, even of the seriously wounded, being 'such
jolly, plucky chaps'.[67] He managed to get back to GHQ, existing mainly
on Benger's liquid food until he could go home.

Nothing like the full story of his difficulties appeared until the
publication of *Memory Hold-the-Door* in 1940. He fully acknowledged
that he 'had but a small share in the dangers of campaigning' (although
he did occasionally come under German machine-gun fire or shelling),[68]
but that he had a full measure of its discomforts, for he was almost
continuously unwell. He wrote that he was reduced 'to such a state of
physical wretchedness that even today a kind of nausea seizes me when
some smell recalls the festering odour of the front line, made up of
incinerators, latrines and mud'.[69]

One thing that work at GHQ afforded him was the opportunity
and privilege – denied to almost all British servicemen outside their
own units – of being able to foregather with friends. At one point
he caught up with Tommy Nelson, and they snatched the chance to
talk business. Tommy told him he loathed the war and wanted to join
the Royal Flying Corps, but JB succeeded in dissuading him and he
joined the Tank Corps instead. 'It was very nice seeing the beloved old
fellow.'[70] The following day he told Susie that he would be escorting
Arthur Balfour round the battlefield. 'I won't take him within a mile
of a shell; he is too precious. Had it been certain other politicians we
wot of, I should have had them at the Schwaben Redoubt and given
Providence a chance.'[71]

Alastair, recovered from his wound, was back out in France in October
1916, serving with the 6th and 7th Royal Scots Fusiliers, and billeted
quite close to GHQ. 'A and B Coys are together in a hut,' he wrote to
his family. 'At present we are trying to light a fire, a difficult operation
as the fuel is damp. Perhaps it won't go because we are using *The British
Weekly** as paper. Browning suggests something inflammatory like *John
Bull*,** and someone else says *Greenmantle!*'[72] The brothers met each
other one November afternoon, when JB went to the village where he
knew the battalion was resting, having just come out of the line, and

*Robertson Nicoll's staid, churchy periodical.
**Founded by the rabble-rouser Horatio Bottomley.

again on New Year's Day 1917, when JB and Sandy Gillon managed
to find him, and they all dined together in the mess on turkey, haggis,
plum pudding and Mackie's cakes to the sound of the bagpipes. The
battalion had just come out of the trenches after a very bad time, but
Alastair's rosy face and broad smile struck Sandy as being about the
cheeriest sight he'd seen at the front.

Shortly after this, JB's diverse attempts at promoting the public
image of Britain at war coalesced, when he was appointed Director of
Information, in charge of the nation's propaganda efforts. Propaganda is
a word that has become freighted with such negative meaning that it is
hard to clear our minds and imagine a time, a hundred years ago, when
it was considered to be information put out mainly by organisations or
individuals rather than by government, and was not necessarily more
than simple truthful communication or bland advertising. In other
words, it was certainly intended to affect opinion, but not to brainwash
a nation for evil purposes as in Nazi Germany or Stalinist Russia in
the 1930s. At the beginning of the First World War information of all
kinds was communicated mainly by (usually) high-minded books,
pamphlets and public lectures or, for immediacy, newspapers and
periodicals, which were not so high-minded, although they would
seem so in modern terms. Few people had a radio set at home, there
were no televisions, even the telephone was only something the middle
and upper classes owned. Any attempt to influence public opinion was
ad hoc, disorganised and small-scale, mainly carried out by patriotic
organisations such as Fight for Right, founded by the explorer, Francis
Younghusband, and of which JB and other writers like Thomas Hardy
were members.* As the war progressed, matters changed radically: the
main techniques and avenues by which propaganda was propagated
were established, the ethics of it debated, and the government had
finally taken charge, with all the constitutional challenges that that
implied.

In 1914 the Cabinet was made aware that the Germans were
concertedly spreading misleading, even mendacious, information in a
number of neutral countries, including the United States, and that this
was damaging to the Allies and needed to be speedily and energetically
countered. As early as the end of August 1914, David Lloyd George, the

*Its slogan was 'To Fight for Right till Right be Won'.

Chancellor of the Exchequer, 'urged the importance of setting on foot an organisation to inform and influence public opinion abroad and to confute German mis-statements and sophistries'.[73]

Lloyd George turned to his friend, Charles Masterman, a brilliant, idealistic, intensely loyal, melancholic, Liberal politician and journalist, who was chairman of the National Health Insurance Commission, with offices in Wellington House near Buckingham Palace. The mission of Masterman's War Propaganda Bureau, as it came to be called (although not, it seems, by those who worked in it), envisioned by the Cabinet, was to direct propaganda specifically at Allied and neutral countries, but not at either the enemy or the Home Front. Its task was to provide publications of every sort, which Masterman's associates would write, translate if necessary, publish and distribute. (The News Department of the Foreign Office, where JB was working, supplied news – after censorship – to the newspapers.)

From the start, Masterman and his colleagues, operating behind the front of the National Health Insurance Commission, were convinced that their work must remain secret, since information would be less persuasive, or even counter-productive, if it were known to derive from an 'official' source. Moreover, they believed, at least initially, that propaganda should be aimed principally at opinion-formers. So successful was 'Wellington House' in keeping its activities under wraps that most politicians, outside the inner circle, did not know the War Propaganda Bureau existed.

Masterman would countenance no fabrications or outright lies, although he was not against the selective use of facts that showed Britain in a good light.[74] He did not, for example, give credence to some of the wilder stories of German atrocities in Belgium, or the disgraceful report that appeared in *The Times* in May 1917 that the Germans were boiling down their own dead soldiers to make fertiliser and glycerine – and nor did JB.

Masterman was able to draw on some notable talent for the organisation, which of course was outside the ambit of the civil service: Ernest Gowers (later the author of *Plain Words*); Anthony Hope Hawkins, of *The Prisoner of Zenda* fame; A. S. Watt, the literary agent; Sir Gilbert Parker, a Canadian who was both a writer and a Member of Parliament; and the historian Arnold Toynbee, who was Gilbert Murray's son-in-law. A number of well-known writers, such as John

Masefield, Arnold Bennett, Gilbert Murray, G. M. Trevelyan and H. G. Wells, helped write the 'literature'.

As time went on, there was more and more emphasis laid on pictorial information. War artists, stills photographers and, crucially, cinematographers were engaged to leaven the diet of factual pamphlets. The first Wellington House-sponsored war artist, Muirhead Bone, went out to France in 1916, while at the end of 1915, the first film, *Britain Prepared*, was premiered in both neutral countries and in Britain. It was followed by *The Battle of the Somme*, an hour-long film chronicling the preparations for the battle and the battle itself, which appeared less than two months after the offensive began. This had a substantial emotional impact on audiences, since it scarcely pulled its punches; for the first time on cinema screens, civilians saw scenes of dead British soldiers.

H. H. Asquith was removed as Prime Minister in December 1916 by a coup of his mostly Liberal enemies, and was replaced by David Lloyd George. He insisted on immediate changes in the propaganda operation, having always taken a more robust line on the subject than the fastidious and rather Olympian Asquith and Balfour, who held fast to the nineteenth-century view that the role of the State should be strictly limited, and who thought that the rightness of the Allied cause was, in any event, self-evident.

Lloyd George had hardly got his feet under the table of his new, small War Cabinet (consisting of Lord Curzon, Andrew Bonar Law, Lord Milner, Arthur Henderson and himself) when he persuaded his colleagues that the whole business of propaganda needed to be rationalised, with duplications stripped out, and deficiencies remedied. In this he was encouraged by the War Office, which was both keen on a centralised propaganda authority and jealous of the Foreign Office's influence. The immediate cause was the adverse propaganda that had appeared in Italy about Eleftherios Venizelos, the pro-Allies Prime Minister of Greece – the model for Karolides in *The Thirty-Nine Steps*. But the deeper reason was the fear of post-Somme war-weariness amongst the Allies. What is more, although the Americans were on the cusp of coming into the war, there was a solid core of isolationism, especially in the Midwest, that needed to be addressed.

Lloyd George asked a number of departments, notably the War Office and the Foreign Office, as well as the General Staff, to prepare

memoranda. He also turned to his old friend, Robert Donald, editor of the *Daily Chronicle*, who, as a newspaperman, had very strong views on propaganda, and asked him to provide recommendations on policy as well as personnel. However, in January 1917, without waiting for the departmental reports to come in, Lloyd George and the War Cabinet decided in principle to set up a separate Department to draw most of the propaganda strings together. A Cabinet minute reads '… what was required was not so much an attempt to convert neutrals by pamphlets as an effective system for the speedy distribution of sound news in this country, the Allied countries, and among neutrals. Attention was drawn to our failure to make any impression on the American West and Middle West, and to the extent to which the Germans, by bold and skilful contracts for advertising matter, were closing a large area of the American newspaper and publishing world to British propaganda … The first step is to select the head of the new organisation and invite him to report on the whole question with the view to the establishment of a good home organisation as a preliminary.'[75]

Several members of Parliament were approached to head this Department, although none could be persuaded to take on the task. Donald suggested three names for Deputy Director: John Buchan, T. L. Gilmour (an able and experienced journalist and administrator favoured by Donald) and Roderick Jones (Managing Director of the Reuters press agency). Donald admitted that JB had excellent qualifications, would be a popular choice with the war ministries, and 'knows what is wanted in the way of propaganda and how it should be presented'.[76]

Lloyd George seems to have been reluctant to choose JB as Director, partly because of his close links to the Foreign Office, which Lloyd George (unfairly, in this instance) mistrusted, and partly because of JB's connection with Field-Marshal Haig, against whom the Prime Minister consistently schemed. Lord Milner had to come to the aid of his long-time protégé,* writing to the Prime Minister in mid-January: 'Don't think I am too insistent! I wish you would not "turn down" John Buchan, without seeing him yourself. If you had a talk to him, and were not favourably impressed, I should have nothing more to say. But I am not satisfied to have him rejected on <u>hear-say</u>, and ill-informed hear-say

*A number of other Kindergarten members found senior administrative posts in wartime, among them Leo Amery and Philip Kerr.

at that!'[77] Certainly newspapermen would have had an instinctive prejudice against a man who was both more highbrow than them and, as they saw it, not a 'real' journalist.

Lord Curzon and Leo Amery also weighed in on JB's behalf and so, despite Lloyd George's misgivings, he was offered the job, his title being Director of the Department of Information, at a salary of £1,000 per annum and the rank of temporary (unpaid) Lieutenant-Colonel. Although he had jumped several military ranks, the lack of real seniority was to prove a great disadvantage, especially in his dealings with the War Office.

Before taking up the post, JB produced a report recommending that the Department be directly answerable only to the War Cabinet, and have two main functions: propaganda, by which he meant the putting of the Allied case in neutral countries and the explanation of the British effort in Allied countries 'with the object of ensuring a wholesome state of public opinion'; and also addressing British opinion where it was needed: 'It is not suggested that there should be any attempt to spoon-feed the British press ... But the War Cabinet may desire to give a lead to British opinion, either by the confidential disclosure beforehand to responsible editors of some line of policy or coming event, or by the publication of some statement or other.'[78] This was a significant departure from the nineteenth-century consensus concerning the State's limited role.

On JB's recommendation the new Department of Information was split into four. There were two Production sections: Wellington House handled books, pamphlets, photographs and art, while T. L. Gilmour's department dealt with cables and wireless, films and press articles sent abroad. The Administrative section, under the very experienced Hubert Montgomery, was fashioned out of the old Foreign Office News Department, and was concerned with propaganda abroad; it was divided into branches corresponding to the ten geographical regions, with a specialist in charge of each one. This section was housed in the Foreign Office, where JB chose to locate his office (although he toured the other sections frequently). The Department of Information, inevitably, remained very reliant on the Foreign Office, especially for the distribution of material abroad and because of the expertise developed by the News Department. Lastly, there was an intelligence branch, which provided reports upon political and civilian matters in

foreign countries. At Nelson's before the war, JB had been involved with the company's international business, providing printed matter for countries as far away as South America; this experience proved valuable. According to the Buchan scholar Michael Redley: 'The model on which he built the Department of Information was Nelson's reprint publishing, in which the publisher identifies popular demand and seeks out the supply to satisfy it.'[79]

JB took up his new position on 20 February 1917. It is clear that he understood the complexities of the task, although he probably overestimated the capacity of other people to understand his vision, and underestimated the capacity of politicians and journalists to make trouble, even at a time of national emergency. Moreover, this was a Department, not a Ministry, and lacked the prestige necessary to safeguard its interests and enforce its requirements. It was not staffed by experienced civil servants and many of his colleagues were unpaid, often part-time, and emboldened at times to take their own line.

All the virtues of the administrator that JB had learned young in South Africa – approachability, having an open-door policy, being slow to chide and quick to bless, prodigiously hard-working, and with the courage to back his own judgement – he brought to this job. However, as it turned out, those qualities could be negated by his inability to second-guess, and therefore counter, those who intrigued against him, and a certain reluctance to conduct difficult interviews. Nor was he as careful with public money as was desirable, considering that there were many politicians, even in 1917, who thought propaganda an unnecessary evil. To these people £750,000 a year (which rose to £1,200,000 when the Department became a Ministry in 1918) was a staggering, unjustifiable drain on the Exchequer.

JB was also unlucky. A week after taking up the post, he had to submit to long-planned surgery on his digestive tract. This procedure, a gastroenterostomy, was conducted by a well-known surgeon, John Lockhart-Mummery, at home in Portland Place. Although JB intended to recuperate carefully, by going to stay, together with his family, at the house belonging to their friends, Fred (F. S.) and Katie Oliver at Checkendon in Oxfordshire, the intense pressures of his new job did not allow enough time off for the operation to be perfectly successful. Roderick Jones, a colleague at the Department of Information, later recalled: 'It was a dangerous proceeding and called for care and rest

in convalescence. Yet disregarding all prudent advice Buchan insisted upon papers being sent to him from the Department, which he studied, annotated, and fixed judgement upon, and, in general, directed the Department from his bed ... But his unquenchable spirit and energy drove him forward, then and at many another time, and I cannot help feeling that he paid dearly for it in the end.'[80]

The number of people involved with the Department rose to 485. Roderick Jones of Reuters worked on telegraphy and wireless communication, while Hugh Walpole, the novelist, studied Russia, Arnold Bennett, another novelist, ran the French section, and Hugh Seton-Watson, the historian, dealt with enemy propaganda in the Austro-Hungarian Empire. Even the Test cricketer, 'Plum' Warner, became involved. JB's Oxford friend, Reginald Farrer, roved about the battlefields, sending back reports, which he put into a book called *The Void of War*, and dedicated to JB, 'the onlie begetter'.[81] Sandy Gillon, who had fought at Gallipoli and on the Somme, and been wounded, was pleased to become, for a time, JB's personal assistant, although this caused trouble with the War Office, who wanted him back at the front. The ever-loyal and efficient Lilian Killick also worked in JB's office, only going to Nelson's in Paternoster Row to pick up the post.

JB might have been disliked by some politicians and newspapermen but he commanded the warm loyalty of those who worked under him. Jones wrote later about his capacity for winning support and cooperation from those about him: 'For he was tireless and swift. We others strove to imitate him, perhaps not always with success, but certainly with more effect than if we had had a less sympathetic and vitalising leader.'[82]

As far as JB was concerned, opinion in the United States was of the first importance, especially as there were many Americans under the misapprehension that the French and the Canadians were the main protagonists amongst the Allies. JB sent a man called Geoffrey Butler to New York to run what turned out to be a successful British Bureau of Information, responsible to the American section of the Department. Academics and poets, such as Gilbert Murray and John Masefield, crossed the Atlantic to speak on what they liked, the single proviso being that they did not mention Ireland – the US having a large population of people of Irish descent, who tended to support Home Rule. JB, who

had always been keen on neutrals seeing what was really going on, ensured that a château at Radinghem in northern France was available to provide hospitality to visiting American opinion-formers.

A British press bureau, Maison de la Presse, was also opened in Paris. Additionally, JB found some money for Lina Waterfield, one of the Anglo-Italian scholars who had recently founded the British Institute in Florence, to increase its activities; this was an attempt to combat the widespread anti-British feeling in Italy, which existed even though the country had joined the Allies in May 1915.

JB encouraged Masterman and Arnold Bennett to employ more battlefield photographers* and also those war artists who had seen action. These included Richard Nevinson, William Orpen, Henry Lamb, Wyndham Lewis and Stanley Spencer. JB visited an exhibition of drawings by Paul Nash of the Ypres Salient on the Western Front in July 1917 at the Goupil Gallery in London; although the pictures did not appeal to him personally, he arranged for Nash (who was within hours of being sent out to Egypt) to meet Masterman, with the result that he was appointed an official war artist based at GHQ in France. Nash told his wife, 'I hope to hear from Buchan shortly; would you like to ring him up and worship over the phone – he deserves it.'[83] On his return to England, Nash was nervous that Masterman would not care for the startling, uncompromising pictures he painted, but the latter was enthusiastic and arranged for them to be exhibited at the Leicester Galleries in May 1918. The fruits of all these endeavours were some of the greatest war paintings of the first part of the twentieth century: Nevinson's *Harvest of Battle*, Orpen's *Zonnebeke* and Nash's *The Menin Road* and *We are Making a New World*.

There is no doubt that propaganda acquired a harder edge** under JB than it had in the days of Masterman at Wellington House. This was partly because, by 1917, the conflict was no longer prosecuted by relatively small, professional armies obeying age-old conventions, but had become an all-out struggle for the nation's survival. However, it had

*In October 1918 the Ministry of Information opened a Photographic Bureau, which sold war photographs to the public.
**The sanctioning of the dissemination in the United States of Louis Raemakers' vicious (and influential) cartoons against German militarism, for example.

also to do with JB's ever-present fear that Evil could prevail over Good. To win that battle, most weapons were permissible.

While JB was building up the Department of Information, his brother Alastair was writing encouraging, cheerful letters to his fearful family from France, telling them that the past two years had been the happiest of his life. 'There are two corporals in my company that I love. They are called Dobson and Hamilton and have been friends from the beginning. They are both wonderful and don't know what fear is – a thing which a timid man like myself marvels at. Also they have a marvellous sense of direction, and are kindly disposed towards the weaker sex (that's me again). They form my bodyguard and every time I fall into a shell-hole or dodge a crump you can hear them shout *"Are ye hurt, Mr Buchan?"* They both wear the Military Medal.'[84]

In March 1917 his battalion moved up to Arras, in preparation for the coming spring battle. He attended 'an English church service [i.e. Anglican] which was nice and quiet and simple. We read a most appropriate psalm about the terrors by night, etc … Things may be happening soon, but don't worry about me. I was just thinking last night what a good time I have had all round and what a lot of happiness I have had. Even the sad parts are a comfort now.'[85]

At dawn on Easter Monday, 9 April, Alastair led his platoon 'over the top' – like his hero Cyrano de Bergerac 'behind the walls of Arras'. They managed to reach the second line of German trenches before he was badly wounded by shrapnel. When JB visited the casualty clearing station the following week they told him that Alastair had been practically pulseless when he was brought in, and had died within an hour. The nurse, Beatrice Reid, who had cared for Alastair and another dying officer, wrote to Mrs Buchan, telling her that 'when she had washed the battle-grime from their faces and smoothed their flaxen hair, they looked mere children, and, knowing that somewhere over the Channel hearts would break for these bright heads, before they were laid in the earth she kissed them for their mothers'.[86]

The telegram arrived at Portland Place two days later. Susie jumped into a taxi but, when she arrived at the Foreign Office, she had to wander along anonymous corridors, waiting until JB came out of a meeting, trying to compose the right words to say. When finally she was ushered in to see him, he rose from his desk, smiling, and all she

could do was hold out the telegram, saying simply 'Alastair'. When the couple arrived back at Portland Place, another telegram was waiting, this time to announce that Tommy Nelson was dead. The two men had died within half a mile of each other, Tommy being killed instantly by a shell as he stood in a trench near the railway station in Arras.*

Sandy Gillon, veteran of a number of battles, wrote to Anna of Alastair: '... he was a splendid, attractive lad – the happy warrior if ever there was one ... I suppose he was doing the very best work possible for one of his years – the capable and gallant leading of men in battle, and watching and caring for them behind the front. I could see at a glance that he was the right man in the right place, and I know what his Colonel thought of him – the very highest possible. He was just what one would like to see grow out of the little boy in the kilt sitting next to me at John's wedding, and the shy, bright-eyed schoolboy who came to Broadmeadows with Willie; which reminds me of another loss. But what better lives have been led than these two? Willie and Alastair were lovely and pleasant in their lives** and the good they did by work and example will never die.'[87] Amongst other condolence letters was one from Alastair's erstwhile commanding officer, Winston Churchill.

On 18 April, in a hand that was not steady, JB wrote to his sister about having a picture of Alastair painted, he hoped by William Orpen, who was working for him: 'Don't worry about me, old Nan. I am wonderfully well, and to be desperately busy is a great comfort in these times. I am a lucky man, for I am working directly for the same cause for which our dear laddie fell.'[88]

JB travelled to Arras the following week and visited his brother's grave. He met Alastair's fellow officers and the two corporals who had taken such care of him. It can be no coincidence that the sturdy, pugnacious, lovable Jock who looks after General Hannay in France in *Mr Standfast* is called Geordie Hamilton. JB met William Orpen at a hotel in Arras and the painter agreed to take on the commission himself, for which he would take no payment – although he did not finish it for ten years.

*Edward Thomas, the poet, also lost his life that day.
**A quotation from 2 Samuel, chapter 1, v. 23: 'Saul and Jonathan were lovely and pleasant in their lives and in their death they were not divided: they were swifter than eagles, they were stronger than lions.'

*

JB readily acknowledged that he faced nothing like the dangers and hardships of the trenches, but he was, nevertheless, under great pressure throughout the summer of 1917. Like almost everyone else, he had to deal with the continual news of the death or wounding of friends. He had to meet the prodigious demands of *Nelson's History*. His mother expected a daily letter and he had to make time to read the manuscript of Anna's novel, *The Setons*, which was published that November and enjoyed substantial commercial success. On top of all of this, he was still often dealing with the minutiae of Nelson's business.

His propaganda work was grievously difficult. At the beginning of his Directorship, he had acceded, most unwillingly, to Lloyd George's demand that he consult an advisory committee, made up of four senior newspapermen, a recommendation that came from Robert Donald of the *Daily Chronicle*. This was to prove an enduring headache, since the men chosen all thought they could do the job far better than he. They were the ever-duplicitous Donald, C. P. Scott of the *Manchester Guardian*, Lord Burnham of the *Daily Telegraph*, and Lord Northcliffe, proprietor of both *The Times* and the *Daily Mail* who, when he went to the United States, was replaced by Lord Beaverbrook (of the *Express* newspapers).

JB divined that Lloyd George thought that membership of this committee would neutralise their public criticisms of government policy, but he could all too clearly see the dangers of populist-minded newspapermen running the propaganda operation, since they were far less scrupulous over facts and impressions than he or Masterman. For the first four months of his tenure, he did not convene the committee once, the ostensible reason being that the Prime Minister had not yet set the terms of reference. This was, in retrospect, a serious mistake, for in early June the committee members complained bitterly to Lloyd George. JB was summoned to Downing Street and carpeted by the Prime Minister, who told him that there must be weekly meetings, with an agenda, and that this committee should be his 'Cabinet', discussing all matters of policy. JB had to bow to this pressure and promise that matters that did not have to be 'decided in a violent hurry' would be discussed at these meetings.

Regular meetings did not entirely solve the problem, however, and the rows rumbled on, from time to time, throughout the summer, to

the point where JB several times contemplated resignation. He wrote to his mother on 19 July: 'I am having a controversy with my Committee of Editors (an idiotic business which the P.M. forced upon me owing to his fear of the Press). I don't intend to give way, so if the P.M. doesn't support me, I shall resign on the spot. So I may have a little leisure after all. I have discovered that in this world it is very easy to be strong, but very difficult to be urbane at the same time. It is my business to avoid friction, but at the same time there is a limit.'[89]

The next day he wrote to Anna: 'I faced all my Committee of Editors … telling them that either they must resign or me. The funny thing is that I kept my temper and we parted in perfect amity. I hate talking about resignation, which is mainly a cheap and rather cowardly trick, but in this case I had no choice. The P.M. is in such a funk about the Press that he probably won't let them resign, so I may get a holiday after all. I am very much ennuied with the whole business.'[90] Three days later he had still not heard from Lloyd George, so he didn't know whether to resign or not. 'I will slave to every extent in the public service, but I must have a free hand. I am not a hack politician, who is miserable out of office.'[91]

Lord Burnham met the Prime Minister at the end of July, when the latter told him that Buchan wasn't the right man for the job, 'in which we all agree'.[92] This was perfidious of the Prime Minister, since if he had really thought that, he should have sacked him long ago; instead, he repeatedly refused to meet him. Eventually, Milner felt moved to intervene, and JB was left to carry on. He was later to compare popular newspapers, and by inference their proprietors and editors, during the war to an eighteenth-century mob who, when things went wrong, hunted perseveringly for scapegoats. Moreover, 'They underestimated the complexity of government and hugely overrated their own infallibility…'[93] Small wonder he didn't get on with this committee.

Late in August he went to France, to inspect a château commandeered by his Department to provide facilities for American journalists and other visitors. He took the opportunity to try to find out exactly what had happened to Alastair. He didn't succeed, since Alastair's battalion were in the middle of a battle elsewhere. Nevertheless, in a sentimental journey, he motored to all the places where he had seen his brother, then visited the spot where he died (now deathly quiet), and put roses and dahlias out of the GHQ château's garden on his grave at Duisans.

Appropriately for JB in this elegiac mood, his *Poems Scots and English* were published that summer by the Nelson subsidiary, T. C. and E. C. Jack. There are fewer than one hundred extant poems of his, of which about two-thirds were published in his lifetime or soon afterwards. They encompass a number of different verse forms, they are influenced by a wide range of other poets, and several, such as 'Fisher Jamie' and 'Fratri Dilectissimo', have been anthologised a number of times. The dedications to some of his best-known novels are in poetic form. Yet, curiously, he did not choose to mention his poetry in *Memory Hold-the-Door*, and only recently have scholars developed an interest in this side of his literary output.

His poems show that he was as happy, if not happier, writing in what he called 'guid Scots' when he felt strongly about something or wished to convey the thoughts and feelings of ordinary Scots people. This is particularly true of his First World War poetry. In the preface, he wrote that Scots had never been a book-tongue for him. 'I could always speak it more easily than I could write it; and I dare to hope that the faults of my verses, great as they are, are not those of an antiquarian exercise.'[94] Not surprisingly, the poems reveal the private man rather more clearly than can be discerned in the fiction. As importantly, they challenge the criticism sometimes made of him that he had sympathy for his fellow men, but lacked the capacity to get inside their heads.

There are seven war poems that can be positively attributed to him, since all but one appear in *Poems Scots and English*,* and the seventh is 'A.E.B.', his poem about Alastair. He wrote in the first person, as if he were a private soldier from the Borders, and the homely Scots cadences were so bred in his bone that these poems are strangely convincing, in places wryly amusing and often moving. 'On Leave', for example, is about a soldier coming home to the Borders to discover a child has just died while he's been away, and he has to climb up into the hills in order to make his peace with God.

He shows in 'Sweet Argos' what sympathy he had for the ordinary British Tommy:

For sax weeks hunkerin' in a hole
We'd kenned the warst a man can thole –

*Expanded and published by Nelson's in 1936.

Nae skirlin' dash frae goal to goal
Yellin' like wud,
But the lang stell that wechts the soul
And tooms the bluid.*

The most touching poem is 'Home Thoughts from Abroad' in which
a soldier, having read in the newspapers that soldiers won't be able to
settle happily at home after the war, disputes it, looking forward to a
comfortable and pleasant life as a shopkeeper once more, with 'cracks'
with his friend Davie. Except that Davie is dead.

The fact that he wrote these poems in Scots dialect suggests strongly
that he was more concerned with relieving his own feelings than having
an eye on his reputation. *Poems Scots and English* is dedicated to the
memory of Alastair with a quotation from *The Pilgrim's Progress*: 'I am
come from him whom thou hast loved and followed; and my message
is to tell thee that he expects thee at his table to sup with him in his
kingdom the next day after Easter.' Alastair had died on Easter Monday.

Almost the most remarkable feature of that hectic summer of 1917
was that JB found time to begin his third Hannay story, *Mr Standfast*.
Although he always maintained that he thought out the plots of his
novels before committing them to paper, this book's climax concerns
General Ludendorff's all-out, but ultimately failed, offensive in late
March 1918. We shall never know what ending he had first envisaged.

Mr Standfast was more than a welcome relaxation in a hustled life; it
was another part of his war effort. *The Thirty-Nine Steps* and *Greenmantle*
had been conspicuous successes, both in the trenches and at home,
and JB saw the next novel as a way of influencing home opinion, in
particular, which was becoming shaky in the summer of 1917 and all
the way through the 3rd Battle of Ypres (Passchendaele) that autumn.
Civilians were understandably tired and frightened; the casualty lists
continued to appal; food was becoming short as the German U-boat
blockade intensified; the revolution in Russia, after the abdication of the
Tsar in March, had destabilised industrial relations; and London and
other cities were subject to attack by Zeppelins and Gotha bombers.
(Indeed, in May, JB had finally come round to Donald's view, and

*'Sweet Argos' (1916) from *Poems Scots and English*.

suggested to Lloyd George that 'direct propaganda' be aimed at Britain itself, to help fend off the real threat of war-weariness; the result was the all-party National War Aims Committee, which organised patriotic meetings and film shows throughout the country. JB sat on its executive committee but it was separate from the Department.)

It is only necessary to list the 'subjects' dealt with in the episodic *Mr Standfast* to gauge JB's purpose: war aims (which, unhelpfully, were not explicitly laid out by Lloyd George until January 1918) and the growing influence of the peace party; the naiveté and spiritual pride of secular conscientious objectors, in danger of being exploited by German spies;* political agitation and attendant labour strife in the large industrial cities, but the essential patriotism of most working-class Socialists; the beastliness of the German High Command and the right-headedness and courage of the Americans and the French; the qualities of Field-Marshal Haig; the invincible humour and endurance of ordinary soldiers, their lack of hatred for their German counterparts, and their amazing courage during the orderly retreat towards Amiens.

JB believed that Germany had become 'de-civilised', which was one reason why it was necessary to prosecute the war to defend civilisation, but he saw the risk that Britain and the Empire might themselves become de-civilised in the process. In the light of that, it is instructive that Richard Hannay refuses to shoot the evil German genius, von Schwabing, when he has the opportunity, because the man has his back to him.

Mr Standfast had to be written at odd moments, usually at weekends and sometimes during air raids. It took about a year to finish – far longer than usual. It was published in serial form before the end of the war in *The British Weekly* (also published by Hodder and Stoughton), but it did not come out as a book until May 1919. However, even in peacetime it still had a role to play in reassuring the British public, civilian and military, that their sacrifices had been worthwhile and their fears understood. There is no doubt that JB used his wartime novels to say things that simply could not find a place in *Nelson's History* or *The Times*. In particular, one of the most interesting and

*There is a persistent, if vague, rumour that JB visited Letchworth Garden City, hotbed of pacifism, to stay with a Captain Stewart at a house like the one in 'Biggleswick' described in *Mr Standfast*.

well-realised characters in *Mr Standfast* is a conscientious objector. He also describes sympathetically the sufferings of a shell-shock victim.

Events were unfolding as he wrote *Mr Standfast*, beginning with the capture of the Messines ridge in early June, which Hannay mentions very early on. JB made good use of knowledge acquired from his work, such as the description of the filming, for propaganda purposes, of a mock-battle on a Yorkshire moor, to which Hannay brings total confusion.* But he also fictionalised an incident that affected Susie. On Saturday, 7 July 1917 the Germans bombed London for the first time in daylight. Gotha bombers arrived 'like a flock of birds' and JB went to an upper window in the Foreign Office building to watch their leisurely, and initially unhindered, progress over the city. He was gravely anxious when it looked as if they might drop a bomb on Portland Place, but discovered later that Susie had been on a bus in the Brompton Road when they came over, and had hurriedly left it for the safety of an Underground station. She was badly frightened and the incident found its way into *Mr Standfast*. Hannay discovers Moxon Ivery (a.k.a. the Graf von Schwabing) sheltering in a Tube station, and realises that this supremely competent and impressive evil mastermind has a weakness; he is a physical coward.

Mr Standfast sold well, but not as well as the two earlier Hannay books. JB received a generous 25 per cent royalty for it (he had got 30 per cent for *Greenmantle*), something he was never to achieve again.

One major problem for the Department of Information was that, because most of its work was of necessity secret, there was no informed debate about the ethics, parameters or methods of propaganda, either inside the Houses of Parliament or elsewhere. The War Cabinet of five men set policy, which the Department of Information tried to carry out, but the ignorance of almost everyone else about it was profound.

A leader, which appeared in *The Times* in early August 1917, pointed up some of the problems with which JB had to contend. After first inveighing against the muddle and delay of censorship, and the multifarious nature of 'publicity' across several departments, it went on to say that there were too many government departments concerned with publicity but no central authority with full responsibility. *The Times*

*This occurs near 'Bradfield', generally thought to be Sheffield. On the moors close to Sheffield can still be found the remains of Great War training trenches, almost certainly known to JB.

had had high hopes of JB, apparently, but thought he was virtually a subordinate of the Foreign Office, and his rank of Lieutenant-Colonel made him a comparatively humble member of the military hierarchy. 'His work, we are sure, is of the greatest national importance. The point is that it is merely that of an addition to the existing "publicity" departments, not that of a supreme co-ordinating agency.'[95] JB put a brave face on things for his mother: 'There is a very good leader in the "Times" today, setting out the disadvantages I labour under. The original idea of the Department of Information has never been carried out, owing to the [indecipherable but undoubtedly uncomplimentary] of a small gang of London editors and the jealousy of minor officials in the War Office.'[96]

He had become convinced that he needed a champion in the War Cabinet and he spoke about that on a number of occasions to his old friends, Lord Robert Cecil and Lord Milner. As a result, Sir Edward Carson, an Ulster Protestant barrister and politician (famous for destroying Oscar Wilde's reputation during a libel trial), who had recently joined the Cabinet, was detailed first to supervise home propaganda by heading the National War Aims Committee and then to be de facto head of the Department of Information as well. JB was mightily relieved that at last someone would speak up for it in Cabinet, and to whom he had immediate access. Carson had told him that he could trust him to fight his battles. JB told Susie, 'I have now got a chief who will defend me through thick and thin. I am going to give the W. Cabinet a weekly report.'[97]

He spoke much too soon. Although he admired Carson and enjoyed his company, he soon discovered that, in this regard, the man was a broken reed. He did not fight his battles, except over money; indeed he seemed scarcely able to keep his mind on the job when there was such ferment in Ireland. As late as 1 December, JB presented a memorandum to him to explain exactly the lines of command in the Department, and also what he (JB) meant by the word 'propaganda'. He also took this opportunity to explain why British propaganda had failed to have much effect in Russia, which was racked again by revolution that November:

In the first place it [propaganda] is a matter of infinite small details, and involves an hour-to-hour study of foreign opinion ... It

resembles an election campaign, where seed must be sown broadcast, regardless of the fact that much must fall on unsuitable ground ... In the second place the Department must work to a large extent secretly, and as far as possible through unofficial channels. Camouflage of the right kind is a vital necessity. <u>It can advertise its wares, but it dare not advertise the vendor.</u> [My underlining] Popular opinion in every country is so delicate an instrument that attempts to play upon it in the name of a foreign Government are certain to be resented, and not only lose their value, but become positively injurious to our cause ... We frequently receive complaints that the Government is doing nothing, and our attention is called to publications, exhibitions, &c., with the comment that it is shameful that such matters should be left to private enterprise. In nearly every case the things referred to have been the work of the Department.

... Finally, propaganda cannot work miracles. <u>Its aim is to state honestly and fully the different aspects of Britain's achievement in the war, to inculcate in the popular mind the main principles of the Allied policy and its justification, and to inform the world accurately of the atrocities and claims of our opponents.</u> [JB's underlining] But it is a perpetual struggle. We have to break down in neutral countries the prejudice against Britain caused by their economic sufferings. In Allied countries we have often to contend with a stubborn and jealous particularism. And always we have to fight against the lavish German effort which has had a start of forty years. The most active propaganda cannot undo the effect of an enemy victory or explain away an Allied check. No propaganda of ours can really counteract Socialist and pacifist appeals in a country where the Government itself makes no attempt to counteract or suppress them. If the powerful war parties in Italy and Russia failed to stem the tide of anti-war propaganda it is hard to see how the efforts of a foreign Government could have succeeded.[98]

This was meant to give Carson ammunition in the War Cabinet, after the Prime Minister asked Donald to look into the workings of the Department in late October, since criticisms concerning duplication, lack of coordination and centralisation would not go away. (Although it is hard to see how explaining a nation's cause, both to other nations and

its own citizens, could ever be confined to one department.) However, the instructions Lloyd George gave to Donald were guaranteed to offend the Director and members of the Department: he had full authority to call for documents and reports and examine officials, to ask for a list of all officials employed, their remuneration and conditions of service, as well as the volunteers, and to analyse the expenditure. Pembroke Wicks, Assistant Secretary to the War Cabinet, wrote to Carson: 'The trouble is, I think, that B.[uchan] despises Donald and the feeling is reciprocated … the P.M. is "delivering him into the hands of his enemy", and all the other men of the Department have a poor opinion of Donald. If B. goes, I think we shall be landed, because he has everything at his fingers' end and it is not like an ordinary Department where you have the permanent officials to carry on, and in addition, I expect he is popular in the Department and I should not be surprised if others resign out of loyalty, though he has not suggested anything of this to me.'[99]

Wicks was right about the attitude of JB's colleagues. When Hubert Montgomery learned what was afoot, he fired off an incandescent letter to JB (which JB passed on to Carson), doubting the suitability of Donald, for 'he is known to have a <u>parti pris</u> against the Department', and saying that, if JB resigned as a result of his recommendations, 'the whole system set up with so much care and carried out with much success in many foreign countries, and notably by Mr [Geoffrey] Butler in America, will be disorganized'. He questioned, too, why there should be another inquiry as there had been one at the beginning of the year when no fault had been found with the actual work. 'Since then [when JB was appointed] no criticism with any substance in it has been made against the Department by any person with any knowledge of the subject: on the contrary we have evidence from many countries that its work is most effective.'[100]

Donald reported in six weeks, having scarcely interviewed a single official or read a document. However, worse than the ignorant report was Donald's behaviour: he seemed incapable of keeping his mouth shut. He showed his confidential report to friends and published some of its criticisms in his newspaper, the *Daily Chronicle*. This JB found very hard to forgive. Robert Donald was not, as Leo Amery called him, a 'ruffian'[101] – he was a scoundrel.

Years later, Sir Roderick Jones wrote: 'Robert Donald must have behaved more destructively than I ever suspected at No. 10, where he had the ear of the Prime Minister, for John always alluded to him afterwards with an unmeasured bitterness wholly foreign to him and reserved for Donald alone. Towards his fellows generally Buchan was, in my experience, one of the kindest of men; to decry others or to harbour enmity was repugnant to him.'[102]

JB recognised perfectly well that improvements could be made, and the episode convinced him that he needed a boss with both a real interest in propaganda and clout in Cabinet. He finally got it in early March 1918, after Carson had resigned on a matter to do with Ireland. Lord Beaverbrook, well known already for his skill and energy as a propagandist for the Canadian war effort, was the final choice. He became Minister of Information, while Lord Northcliffe became Director of Propaganda in enemy countries,* based at Crewe House, quite separate from the Ministry. This was a device for neutralising the perpetually jealous and critical Northcliffe. Robert Donald was made Director of Propaganda in neutral countries, a position in which he did not shine; he resigned after six weeks due to poor health. Home propaganda remained with the National War Aims Committee.

Lord Beaverbrook was a rich and canny Canadian-born businessman and newspaper magnate, who had been a Unionist MP, but was ennobled by Lloyd George as a reward for helping to oust Asquith from the premiership in December 1916. He had a controlling interest in the *Daily Express* newspaper, although at this point he resigned from the *Express* board. When Beaverbrook became Minister of Information, JB was made head of a Department of Intelligence under him; its task was to deal with the acquisition of intelligence (from Foreign Office telegrams and the like) and supply it to those writing the propaganda to be supplied to Allied and neutral countries.

JB had suffered a demotion but it was not one that seems to have affected his *amour-propre*. At last, in a Ministry, he was protected from the time-wasting attacks, since the arrows now had to bounce off Beaverbrook's broad back.

*Except Turkey, and the Near and Middle East, which remained the responsibility of the Ministry of Information.

JB liked working with 'Max'. He wrote to his mother in May: 'I am very busy, but finding my work much more satisfying. Beaverbrook has an extraordinarily candid mind and is so willing to learn.'[103] He was also an experienced propagandist who understood, as JB did, the power of film and pictorial images. The benefit was mutual: Beaverbrook found JB very hard-working, intelligent, and a safe pair of hands, who would not make blunders like the brilliant but maverick Masterman. However, he did not think him good at fighting his own corner. In an article in his newspaper, the *Sunday Express*, published in 1919, Beaverbrook paid tribute to JB and Masterman, saying that he (Beaverbrook) had simply taken over and developed a department which, although often attacked by the press, was praised by the German General Ludendorff. He was right: Ludendorff had admitted that German propaganda failed, especially in neutral countries, because of the strength of the Allied kind – a 'moral blockade'[104] he called it.

JB was certainly freer to do what he was good at. An assistant, Hugh (later Lord) Macmillan, remembered his Department as the 'power house'[105] of the Ministry and considered that JB held the key position within it. His work included visits to Buckingham Palace to discuss public opinion in foreign nations with King George V. However, contrary to frequent speculation, JB was no spymaster, even if he did sometimes meet British agents to receive information and, for their sakes, in strange and covert places. What use he made of the information gleaned we will never know. No one who has read *A Prince of the Captivity*, his 1933 novel, or his short story, 'Dr Lartius', can be in any doubt that he knew how spies operated behind enemy lines during the Great War.

As with the Department of Information, one of the most important functions of the Ministry was to provide facilities for foreign pressmen and influential travellers to see the British war effort, both civilian and military. A conspicuous success with this 'personal propaganda' came after JB arranged for the famous American journalist, Lowell Thomas, to meet General Allenby in Palestine in February 1918. In the office of the Military Governor in Jerusalem, Thomas met T. E. Lawrence and, after the war, he toured both the United States and Britain, giving lectures on his dealings with Allenby and Lawrence. In the process he invented 'Lawrence of Arabia'.

In March, JB was elected to The Club, the most desirable of dining clubs for a cerebral yet sociable man, since it had been founded by

Samuel Johnson and Sir Joshua Reynolds in the mid-eighteenth century, and had boasted as members many important figures from the worlds of politics and letters: Charles James Fox, Adam Smith, Sir Walter Scott, Edmund Burke, Matthew Arnold and William Ewart Gladstone. In 1918 the members included Lord Curzon, Arthur Balfour, Sir Henry Newbolt, Sir Edward Grey, Rudyard Kipling and Lord Stamfordham, the King's Private Secretary. There could be no clearer indication that JB was valued for his conversation, and that his modest origins were, for some distinguished figures at least, no bar to his popularity.

There is nothing in a life more difficult to recreate than conversation. It is as evanescent as a cloud shadow. JB's facial features, his voice, the way he walked, all these can be recovered in photographs or on film, but how he talked with his wife, his friends, his children, his employees, his neighbours, his fans, seems lost to us irretrievably. In the eighteenth century letter-writers often set down, apparently faithfully, what people said, but by the twentieth century this attention to detail had gone out of fashion. What is more, conversation is as much about the raised eyebrow, the sparkle in the eye, the expressive hand gesture, and these can almost never be reproduced.

However, one or two of his friends valued his conversation so highly that they have left a sense of it in their memoirs, and we can also glean something of the breadth of his talk amongst his contemporaries from the set of stories called *The Runagates Club*. We know that he had a generous fund of Scottish tales, and with little or no prompting would break out into broad Scots, sometimes to the mystification of his hearers. We also know that he would talk literature, philosophy and history, but only 'argued about' politics and religion 'professionally',[106] and that discussing money and sex embarrassed him and he rarely if ever mentioned them. His old friend F. S. Oliver, another sparkling conversationalist* as well as letter-writer, encouraged him to be sedately bawdy, but he rarely if ever swore (except about the 'bloody' or 'damned' war) and never in front of women.

Walter Elliot, a friend from the Borders, recalled after his death: 'He would stand and face you and discuss endlessly – wedge-nosed, his head forward and to one side, his lips parted, eager to speak, eager to listen. I do

*He was called 'another Voltaire' by Mario Praz in *La Stampa*, 15 June 1934.

not remember that he ever broke off a conversation. John Buchan wrote as he spoke, and for the same reasons. He liked to meet people; he liked to talk to people; he loved to hear their adventures. When he couldn't meet people he invented them.'[107] If, as Elliot says, he wrote as he spoke, then we can capture the pleasure of his company by reading his books.

Here is his son, William: 'When he was in the company of tall people my father would have to stretch and crane a little to converse with them, and they would stoop to listen to him. But ... I never knew him fail to dominate his surroundings. This was done ... not by aggression but by a kind of collectedness, poise, concentration coupled with his unique appearance, the bright blue flash of his eyes, a look of expectant eagerness...'[108]

Stanley Baldwin wrote after his death:

In friends indeed he was a millionaire ... What a joy was his conversation! The enthusiasm of a boy, the broad humanity with its comprehension of all classes and kinds of men, the generosity, the knowledge, deep and wide, of our own literature: if I had ever by chance come upon some phrase, some paragraph, some lines, which I felt I must show him, ten to one he would know it, quote the context before you had completed it, tell you where you had found it and give you details of the author's life which had never been published in mortal book.[109]

A friend of Mrs Grosvenor's told her that she loved talking with JB, because he made her feel clever and at her very best. In Canada, later in his life, when he was Governor-General, people were surprised (and flattered) at his capacity to listen patiently and courteously to them – be they a mining engineer in the Northwest Territories, a farm hand in Manitoba, or a French Canadian Roman Catholic priest. And not only listen, but retain what he heard.

JB snatched a few days' holiday in Scotland that June, spending it in Peebles and walking with his mother and sister around their old haunts. On his return to London he discovered that Beaverbrook was very sick and having to lie on a sofa all day, but life was still more orderly now that he was no longer the boss of the whole enterprise. He spent his weekends with his family in Kent, 'prowling' in the countryside and climbing haystacks with his children as well as telling stories to them.

The Magic Walking Stick, published in 1932, grew out of tales he told on country walks to his children, and later also to his nephew and nieces.

Meanwhile, though work at the Ministry of Information was more congenial, there was a great deal of opposition from outside it, since Beaverbrook was a businessman who owned a newspaper, and an obvious target for criticism. Members of Parliament were distinctly queasy about Beaverbrook's access to confidential information, which he might use for his own interests in the future, if not at present. The other Ministries, especially the Foreign Office and War Office, were extremely suspicious of its wide remit. There were both general anxieties about a Ministry that had not been created by Parliament and about whose work the MPs knew very little, and specific criticisms of waste and extravagance, after a recent Select Committee report – even though the Committee's anger was mainly directed at the Treasury for not keeping a closer grip on the accounting system. But there were also reminders of an embarrassing incident when a member of the Ministry organised the entertainment of foreign journalists in Dublin, and the cost came to an exorbitant £31 with £5 for cigars, a fact that was reported in all the newspapers at the time.

These matters were debated in the House of Commons on 5 August 1918. JB wrote to his mother that day in anticipation: 'My own conscience is void of offence, but Lord B has so many enemies that I will get some of the mud intended for him.'[110] The subsequent report of the debate in *The Times* prompted a letter from Mrs Buchan, which caused a now very rare outburst of anger from her son. We don't have her letter, but we do have his reply: 'I never thought you would distrust me. They were blunders of subordinates – the kind of thing that occurs daily in a government department.' She must have ranged widely for he continued, 'I had a Herculean task, for I could get no assistance from the Prime Minister and had to build up a department as best I could. I insisted on sticking by various unpopular men like Masterman and I had a pack of journalists on my heels. I believe I did good work in spite of difficulties. I stuck by Beaverbrook, and I think I have prevented him making many blunders, but of course he has many enemies and I get a share of them.' In the debate, the Ministry had its spirited defenders, most notably Stanley Baldwin, who drew attention to comments in the German press that the British propaganda effort was superior to their own, despite far less being spent on it.

Mrs Buchan was stricken with remorse, for he replied to her next letter: 'However did you get so wrong about the row we have had?

There was never the slightest charge against me personally. The point of
the Select Committee was to blame the Treasury for not accepting and
putting into place the system of accounts I suggested, and so preventing
a better accounting check. The story of the Irish trip was a blunder by
a subordinate whom I sacked for it. The dinner they objected to was
given under a direct instruction from the War Cabinet. The stories of
waste of paper were lies, as were admitted in the House.'[111]

Lord Beaverbrook decided at this point that it would be wise to
shrug off the secrecy and present a short paper to Parliament on 'The
Organisation and Functions of the Ministry of Information'. Much of
the report must have come as a complete surprise to the politicians who
read it. The terms in which it is couched give its author away:

> Propaganda is the task of creating and directing public opinion. In
> other wars this work has not been a function of the Government,
> but has been left to the enterprise of the private citizen, since it is
> the traditional British plan to do nothing by official channels which
> can possibly be done outside them. But it was soon evident that in
> a struggle which was one not of armies but of nations, and which
> tended to affect every people on the globe, this aloofness could not
> be maintained. Since strength for the purposes of war was the total
> strength of each belligerent nation, public opinion was as significant
> as fleets and armies...'[112]

On 9 September, Susie gave birth to another boy. JB wrote: 'He is a very
fine fellow – weight between 9 and 10 lbs and a regular fair-haired, blue-
eyed, square-headed Buchan type. He was perfectly hideous when he
was born and very like Haldane; and now he has become rather good-
looking. He is to be called Alastair Francis, after Alastair [Buchan] and
Francis Grenfell. I wish my dear Father was alive to baptise him. On
Sunday night I read a lot of old letters – Father's, Willie's, Raymond's,
Cubby's and Bron's, and it was like opening graves. The birth of a new
child makes one realise the great and good people who are dead.'[113]

On 26 October, Beaverbrook underwent an operation for a throat
abscess, and resigned as Minister a couple of days later. On 11 November,
the day of the Armistice, JB visited all the Ministry's departments,
shaking everyone by the hand, then went home to bed, without
bothering to join the public celebrations. But he heard news from the
front, which he put into *The King's Grace* in 1935:

> In the fog and chill of Monday morning, November 11th, the minutes
> passed slowly along the front ... Officers had their watches in their
> hands, and the troops waited with the same grave composure with which
> they had fought ... Suddenly, as the watch hands touched eleven, there
> came a second of expectant silence, and then a curious rippling sound,
> which observers far behind the front likened to the noise of a light wind.
> It was the sound of men cheering from the Vosges to the sea.[114]

Two days after the Armistice, the War Cabinet ordered the liquidation
of the Ministry of Information. JB was asked to wind up most of
its activities, and transfer those that were to survive elsewhere, with
Sir Campbell Stuart doing the same for 'Crewe House'. JB, helped
by a number of volunteers, set to with a will, cancelling all schemes,
terminating contracts and giving notice to his officials, both at home
and abroad. Publications, stills photography and film-making ceased
at once, as did entertainment for American troops in Britain. But
the work of a number of sections, especially those to do with foreign
countries (including entertaining foreign visitors), wireless and cables
and the library, were sensibly transferred to the Foreign Office, to form
the basis of a propaganda department to continue at least until the
peace negotiations were completed. The photographs and paintings
were handed over to the fledgling Imperial War Museum, providing
a unique and invaluable visual resource accessible to the public to this
day. Five tons of documents were destroyed. The whole process was
completed in just over a month, by 18 December.*

In July 1918, JB had written to Donald Maclean, the Liberal sitting
member for Peebles and Selkirk, telling him that he would not be
standing against him in the forthcoming election, whenever that was
to be held. This was a principled decision, reached partly because of his
conviction that, in attitudes towards post-war reconstruction, the two
men were *ad idem*, and partly because he thought there had been an
undemocratic banding together of Conservatives and Liberals, with the
government granting 'coupons' to malleable Conservatives. Despite the
efforts of Beaverbrook and others to get him to reconsider, he had come
to hate the whole business of politics at that moment and would have
nothing to do with it.

*Announced in *The Times*, 18 December 1918.

It is entirely understandable that he should wish to go somewhere quiet at the end of the war to recover his strength and mourn his brother and his friends, rather than immediately plunge into a hurried, frantic and ill-tempered general election, at a substantial distance from London. The 'Make Germany Pay – Hang the Kaiser' election was held in December 1918, while he was busy liquidating the Ministry. However, he showed in his 1935 book, *The King's Grace*,[115] how well he understood the difficulties of the post-war world, and how much he deprecated the vengeful tone of British politicians, which helped result in such a controversial settlement at Versailles. This was not *ex post facto* reasoning; his attitudes immediately post-war were equally moderate. His temperate, reasonable voice would have stood out in such a febrile, unforgiving place as the House of Commons in 1919. As for his personal political career, the decision was against his interest. He had turned forty-three in 1918, and was still young enough to make his mark. That was far less certain by the time he eventually reached Parliament in 1927, when he himself admitted that he was too old to begin to try for Cabinet office.

There is little about his wartime work in his book of reminiscences, *Memory Hold-the-Door* (1940), but that was much more likely the result of discretion than from any residual feelings of disappointment. He never wavered from his belief that evil was alive in the world and had to be fought with almost every weapon at a country's disposal; at the same time he recognised that such a fight could take a toll on those who thought themselves on the side of the angels. In his novel *The Three Hostages*, published in 1924, he has Macgillivray, the Irish policeman from Scotland Yard, say to Hannay: 'Dick, have you ever considered what a diabolical weapon that [propaganda] can be – using all the channels of modern publicity to poison and warp men's minds? It is the most dangerous thing on earth. You can use it cleanly – as I think on the whole we did in the War – but you can also use it to establish the most damnable lies. Happily in the long run it defeats itself, but only after it has sown the world with mischief.'[116]

At the end of the war JB summarised the results of German propaganda in neutral countries: eight had declared war on Germany, nine more had severed relations, while in most of the others public opinion had turned against her, according to the Germans themselves. 'This is not a result of which any propaganda department need be

ashamed."* Adolf Hitler bitterly complained in 1925, in *Mein Kampf*, of the shortcomings of German propaganda, averring instead that enemy propaganda had been deployed with amazing skill and brilliant calculation. He claimed that he learned a great deal from how the Allies did it.[117] In 1935 the American historian James Duane Squires wrote: 'British propaganda was a real force in winning the World War. It kept the home masses docilely patriotic. It gained, or mightily helped to gain, powerful allies. It was of prime importance in bringing about the disintegration of civilian and military morale in Germany.'[118] Although modern historians take a more nuanced view, the central facts hold true, and JB contributed to that success.

By 1922, the post-war European landscape was already beginning to look quite bleak, thanks to deep divisions over the League of Nations and the distinct unease that honourable people felt about the apparently draconian clauses of the Treaty of Versailles. As JB put it: 'I realised that we were at the point of contact of a world vanishing and a world arriving, and that such a situation was apt to crush those who had to meet it.'[119] It was in this atmosphere that he worked on the revision of *Nelson's History*. On their publication, the four volumes of *A History of the Great War* were widely praised (by, amongst others, King George V, Field Marshal Sir William Robertson and General Sir Ian Hamilton), but there were reservations from some historians, who thought that JB had taken too little account of early post-war historical scholarship, especially as far as naval operations were concerned.

He concluded the final volume with a romantic peroration that drew letters of commendation from serving men and civilians alike.

The war was a vindication of the essential greatness of our common nature, for victory was won less by genius in the few than by faithfulness in the many. Every class had its share, and the plain man, born in these latter days of doubt and divided purpose, marched to heights of the heroic unsurpassed in simpler ages. In this revelation democracy found its final justification, and civilisation its truest hope. Mankind may console itself in its hour of depression and failure, and steel itself to new labours with the knowledge that once it has been great...

*Quoted in Michael Redley, *The John Buchan Journal*, no. 47, p. 22. Redley goes on to say: 'His success in quietly burying nearly all traces of the vast special effort made by the British State was the last, but not the least, of his many contributions to the Allied effort in the Great War.'

The world is poor indeed without them [those who had died], for they were the flower of their race, the straightest of limb, the keenest of brain, the most eager of spirit. In such a mourning each man thinks first of his friends; for each of us has seen his crowded circle become like the stalls of an unpopular play; each has suddenly found the world of time strangely empty and eternity strangely thronged ... The youth which died almost before it had gazed on the world, the poets with their songs unsung, the makers and the doers who left their tasks unfinished, found immortal achievement in their death. Their memory will abide so long as men are found to set honour before ease and a nation lives not for its ledgers alone but for some purpose of virtue. They have become, in the fancy of Henry Vaughan, the shining spires of that City to which we travel.*

These days we recoil from the notion of youth finding its apotheosis in death, but JB was articulating what many people – combatant as well as civilian – believed, or wanted to believe, a century ago. And he was vindicated to the extent that the memory of that youth is still cherished a hundred years on.

*A near quotation from 'Joy of my life while left me here!', a poem by the seventeenth-century religious poet Henry Vaughan; the image is that of the saints as beacons, guiding others to Heaven. John Buchan, *A History of the Great War*, vol. IV, pp. 443–4.

Elsfield, 1919–1927

With the war over, the Ministry wound up, and after a short, badly needed rest over Christmas, JB set about tackling some unfinished business from the war. An immediately pressing public issue was the matter of the imprisoned conscientious objectors. This was a cause close to the hearts of the Gilbert Murrays, who enlisted JB's help in organising a petition to present to the Prime Minister. The Murrays were shocked that, six weeks after the Armistice, there were still 1,500 conscientious objectors in prison, and 700 of those had served more than the maximum of two years. It was a glaring scandal and JB was happy to put his name prominently to a memorandum, which was delivered to Downing Street on the first day of 1919.*

JB and his colleagues believed that most of the conscientious objectors genuinely acted under the demands of conscience. 'We urge that men in prison under these conditions should not be kept there during a period of national rejoicing, and that our country should not show itself slow at such a time to carry through an act of just mercy.'[1] This memorandum did not on its own do the trick, but it gave ammunition to high-minded politicians, who kept up the campaign in the House of Commons, while the newspapers also carried appeals. Most conscientious objectors were released during the spring.

JB did not suffer from the post-war debilitating malaise that afflicted some of his friends, although he was certainly no stranger to sorrow and

*The memorandum contained representative names from writers, clergy of every stripe, trade unionists, journalists and editors, politicians, intellectual Socialists and Liberal aristocrats.

regret. If he felt something of the guilt that very often assails those who have survived some great trauma, he saw it for what it was and, within a few months, had regained much of his optimism and drive. He began to see the war in the same way as Henry James, as a 'great interruption':

> I felt like a man recovering from a fever, or like the medieval poet who, going into the fields after his frozen winter's vigil, abased himself before the miracle of spring.

He found it strange but comforting that he had found something of the exhilaration of youth. 'I was forty-three, but I seemed to have "found again my twentieth year".'[2] He could not imagine why, since there was precious little cause for optimism. This rediscovered youth prompted an outpouring of writings, but a number of these were of a memorial nature, which strongly indicates that, despite his later protestations, he was by no means recovered from his grief:

> When the future is uncertain the mind turns naturally to the certainties of the past, and finds comfort in what is beyond the peril of change ... I wanted the sense of continuity, the assurance that our contemporary blunders were endemic in human nature, that our new fads were very ancient heresies, that beloved things which were threatened had rocked not less heavily in the past.[3]

He was thoroughly put off by what he called 'the clerisy', the interpreting classes who influenced opinion and, as far as JB was concerned, ran round their cages in pursuit of their tails. These people, whom he thought arrogant, yet devoid of any creed, had depended on their belief in the steady march of science and reason and the perfectibility of man, which had been thoroughly exploded by the Great War. As a result, 'they plumed themselves wearily on being hollow men living in a waste land.'[4]

After JB's death, his son Alastair wrote that his father had developed to a high degree what the Greeks called *Sophrosyné*, an inner harmony which engendered spiritual restraint. From this 'sprang a force so warm and positive that it charged the air around him. This lack of jealousy and anger, springing not from indifference but conviction, so pervaded the climate of his mind and of his conversation, that in his company one forgot the cheap jibe and the vindictive comment.'[5]

Sophrosyné had not been a conspicuous characteristic of the rather conceited imperial administrator in South Africa, nor yet the too loyal member of the pre-Great War ruling class. It was the cataclysm of the war and its aftermath that embedded in him a wise moderation in the face of a brutalised, atomised, inward-looking and fearful world. It is one reason why he refused to join the ranks of the disillusioned intelligentsia after the war, for one of his signal characteristics was his optimism – not a vague Micawberish hope that 'something will turn up', but optimism solidly based on his close study of the history of his people, and his experience of enduring happiness. It is true that this optimism led him quite often to underestimate difficulties and overestimate people, especially politicians. But despite the horrible personal setbacks he suffered during the war, and the desolation he saw all around, he continued to believe in the progress of civilisation and the essential greatness of humanity, if only that greatness could be drawn out. The inevitable corollary of such a belief was the dedication of his life to public service. The ivory tower could be no permanent refuge.

Soon after the war, he wrote a slim volume, entitled *These for Remembrance*, which contained six short, heartfelt, biographical sketches of some of his closest fallen friends: Tommy Nelson, Cecil Rawling, Basil Blackwood, Jack Stuart-Wortley (Susie's cousin), Raymond Asquith and Bron Lucas. The latter, Lord Lucas, had been known as Auberon Herbert at Oxford, was a Liberal minister before the war and, despite having only half of one leg, joined the Royal Flying Corps as a pilot and was shot down in late 1916.* In the words of JB's grandson Toby Tweedsmuir, 'These are not hagiographies, but like the epitaphs of the classical Greek poets, they bring a recollection and a curious sense of peace to the hollowest of losses.'[6] The Chiswick Press printed forty copies of this book, at JB's expense, in the summer of 1919. It was a beautiful production, hand-bound in full calfskin blocked with gold, and was dedicated to his children, whom he addressed in the Preface:

> Every generation, I know, has the same prejudice; but I am convinced that few men have ever had more lovable, more brilliant, more generous, more gallant friends ... I do not want you to be always thinking about the war, for the eyes of youth should be turned

*Cf. Peter Pienaar and his fate in *Mr Standfast*.

forward. But neither do I want you to forget it, since it is a thing for everlasting remembrance and eternal pride … [His friends] propped up the falling heavens and saved the world for you. But most of them died of it. I hope that will never befall you which has befallen me – to look around and find a great emptiness…[7]

These for Remembrance initiated a cascade of sorrowful but thankful letters from mothers, wives and friends. He told his mother, 'I can scarcely re-read it, it makes me so sad … I am well repaid if it gives pleasure to relatives. I am paying for it out of what I got for my little article in the *Herald* last December. I thought it wise to have it finely printed.'[8]

In the spring of 1919, JB also wrote an account of the South African forces in France. He had been asked to write the book by Jan Smuts and the South African government as early as 1916, but it was impossible to attempt it until the war was over, by which time Smuts and Louis Botha had decided that South Africa could not pay for it. So it became 'a labour of love', probably because JB thought the South African actions at Delville Wood in July 1916, during the Battle of the Somme, and Marrières Wood, held by South African soldiers as the Allies retreated in March 1918, were two of the bravest and most stirring of the war, worthy of immortality. *The History of the South African Forces in France* was published in 1920 and became a school textbook in South Africa.

He began to take his own advice about looking forward as well as back and, that summer, he published the second of his fictionalised political symposia. This time he collaborated with his wife Susie, and the book, *The Island of Sheep*, was published by Hodder and Stoughton, under the pseudonyms of 'Cadmus and Harmonia', in a small softback edition. Cadmus was the first King of Thebes and was married to Harmonia, the goddess of harmony and concord, a gracious compliment to Susie, which will have passed most people by.

The Island of Sheep, which must not be confused with JB's novel of the same name of 1936, is not unlike *A Lodge in the Wilderness* in that it features a variety of people of both sexes and most political standpoints, who find themselves in a country house, this time soberly discussing difficulties in the post-war world. Although JB claimed that the book was mostly written by his wife, we can discount that, if only because

Susie had recently had a baby. This book contains many of JB's post-war preoccupations – the need for a League of Nations to abolish further wars born of external aggression and national jealousy, and to ensure that the dead had not died in vain,* the importance of the participation of all classes in the democratic process, and the collapse of Liberalism. It is interesting to note that the humane, socially conscious, anti-authoritarian Toryism, which he espoused, and which came to be known in the 1920s and 1930s as Baldwinism, is represented by a character in the book called George Stanbury Maldwin.

He was intensely aware that this was an important moment for democracy, now that the suffrage had been granted to women over thirty and men over twenty-one. JB had been an enthusiastic supporter of women's suffrage, but he could see that mass participation in the democratic process was not without its dangers; in particular it was necessary to provide a clear, attractive path between Left and Right. Moreover, the individual must never be lost sight of; JB thoroughly disliked abstractions such as 'the masses'.

The Island of Sheep (1919) is not a book to read for pleasure a hundred years on; it is too earnest, and the preoccupations are sometimes opaque. But there are some gems as, for example, when the leader of the Labour Party says about a Liberal newspaper: 'I've got tired of a paper that's shaken in every column by a passion of sobs.'[9]

The Island of Sheep foreshadows much of his writings in the next two decades, which become more insistent with the rise of authoritarianism and the hijacking of democratic levers for anti-democratic ends. According to the historian J. P. Parry, for JB 'the counter-attack must proceed along two lines: the private battle within each soul, and the public one to safeguard the marriage of law and self-government which protected it. In one way or another, these struggles were the stuff of most of Buchan's novels.'[10]

*

*He told the Provost of Peebles that he believed whole-heartedly in a League of Nations, not because he was a dreamer, idealist or humanitarian but because he was a practical man. 'I want us not only to have won the war but to bank our winnings and I can see no other way but this.' JB to the Provost of Peebles, 1 January 1919, Queen's University Archives, John Buchan fonds, locator 2110, box 3.

There was one piece of business left over from the war, which JB was reluctant to let go: petitioning for an honour for his work during the Great War. Here the modern reader bumps up against one of those practices that seem now both inexplicable and frankly demeaning, although it was the accepted way of doing things in the past.* As early as 1916, R. B. Haldane had petitioned Sir Edward Grey for a KCMG (Knight of the Order of St Michael and St George) for JB, but Grey left office so nothing transpired. Putting the idea of a KCMG rather than the much more commonplace Knight Bachelor into JB's head, and in particular his mother's, was a mistake for, in December 1918, he and Lord Beaverbrook discussed how he might get a KCMG for his multifarious efforts, paid and unpaid, during the war. Beaverbrook approached Arthur Balfour, who told him that only the Foreign Office or the Colonial Office could recommend a KCMG, so there was no use applying to the Prime Minister for one for JB.

Balfour went on: '… we only have a very small store and it would really not be fair to rob men who look forward to this Honour after many years under the Foreign Office in order to reward services, however meritorious, rendered to other Departments'. This ignored the fact that JB had worked for the Foreign Office during much of the war. In a postscript he added, 'Personally I have the greatest possible regard for Col. Buchan, and hold his abilities in very high estimation.'¹¹ JB's name did not appear in the Honours List of January 1919.

It is a mystery why JB was not prepared to settle for a plain knighthood, which he would undoubtedly have got** (and which he turned down in 1921), but held out for the more prestigious KCMG or KCB (Knight Commander of the Order of the Bath, in the Prime Minister's gift). Part of the answer must have to do with his mother's persistent badgering of him and partly with the fact that KCMG and KCB are orders of chivalry, which the KB is not. But most people, even then, would hardly have known the difference, and Knights Bachelor

*When Walter Scott wanted to be a Baron of Exchequer, he wrote to the Duke of Buccleuch: '… a man may, without condemnation, endeavour at any period of his life to obtain as much honour and ease as he may handsomely come by'. Quoted in John Buchan, *Sir Walter Scott*, Cassell, London, 1932, p. 167.

**A great many were given out after the war for acts of public service. For example, William Jury, head of the Film Department in the Ministry of Information and junior to JB, received one.

were often 'upgraded' in future years, so he could just have bided his time, his wife would have been Lady Buchan and his mother would have been content.

That was not the end of it, however. In February 1922, JB revived his request, writing to tell Beaverbrook that he was pretty well restored to health and would probably take up politics again, and would like to have a memento of his war service. (It would certainly help his status when he stood for Parliament.) He admitted that his mother was 'desperately anxious for something of the kind…'[12]

In May, Beaverbrook asked him to send a draft of what he should forward to Lloyd George. This embarrassing document, written, as JB said, 'with a scarlet face' and which he begged 'Max' to destroy (which Beaverbrook obviously didn't), itemises his public achievements in the war; it included *Nelson's History*, which had by far the largest circulation of any war publication, 'and which by its sanity, breadth of view and reasoned optimism, did much to balance and inform the public mind and had, notably in America, a far-reaching influence'.[13] He also said that the recognition of his services would be welcomed by the very large public to whom his name had become a household word.

All this was probably true, if embarrassing to read in cold print. However, despite the petition that Beaverbrook sent to Winston Churchill, Colonial Secretary, on 2 June, signed by Sir Robert Horne and Lord Birkenhead as well as himself, and with the words 'We set forth many reasons why you should make him a K.C.M.G. For God's sake, do it!',[14] Churchill did not. Nor was Lloyd George any more inclined to grant him a KCB. JB could not have chosen two people less likely to do him a favour, or even play fair by him. Either he had no choice, since his ill-wishers were still in the ascendant, or he did not fully understand how grown men could nurse resentments for years on end. It may have been clearer to him, when Lloyd George published his war memoirs in the mid-1930s, that for the former Prime Minister a grudge was a grudge that could not be forgiven or forgotten.

All through JB's adult life he struggled with, and never entirely overcame, a propensity for small acts of vanity. He knew the dangers better than most, but could not quite cure himself of it. No one born to privilege, as so many of his friends were, could truly understand the enduring sense that self-made men have of the road along which their own efforts have brought them. As he thought back, as he surely did,

to his childhood amongst shabby people, living next to a muddy lane and close to a coalpit, he would scarcely have been human if he had not wondered why his success and acts of public service had not brought more obvious worldly rewards.

Two honours that he did get, and without angling for them, were an Italian decoration, the Order of the Crown of Italy in 1918, as well as the Freedom of Peebles, which he was very pleased about. In June 1919 he accepted an honorary LLD from the University of Glasgow 'in recognition of your eminent services to the country and to letters'.[15] At the same time he founded a poetry prize in memory of his brother Alastair at the university, which is still awarded annually.

In 1919, JB was also determined to gather his strength once more. He weighed only ten stone, and his ulcer was giving him periodic trouble. He had such a painful episode in May 1919 that he carried laudanum around with him, in case of a sudden acute attack. The first step to better health, not just for him but his wife and children, seemed to be to find a house in which to live in the country.

His children had thrived best when staying in the countryside during the war, falling ill with minor complaints on their returns to London, while Susie had been told by her doctor that she should spend more time in the country 'for her nerves' sake'. JB's leisure occupations had always been rural. Walking, fishing, bird-watching and gardening were hard to do from a house in Portland Place, and he always felt better for them. Moreover, the happiest days of his life had been spent in the countryside and, at a very fraught moment in September 1917, he and Susie had managed to get away for a few days to the Cotswolds in Gloucestershire where the very pretty limestone villages and the rolling, wooded hills and green watered vales enchanted them. At the beginning of *Mr Standfast*, the rugged colonial Richard Hannay describes this peaceful countryside and attributes to it the reason why he is fighting:

Below were dusky woods around what I took to be Fosse Manor, for the great Roman Fosse Way, straight as an arrow, passed over the hills to the south and skirted its grounds. I could see the stream slipping among its water-meadows and could hear the plash of the weir. A tiny village settled in the crook of the hill, and its church tower sounded seven with a curiously sweet chime. Otherwise there

was no noise but the twitter of small birds and the night wind in the tops of the beeches.

In that moment I had a kind of revelation. I had a vision of what I had been fighting for, what we all were fighting for. It was peace, deep and holy and ancient, peace older than the oldest wars, peace which would endure when all our swords were hammered into ploughshares.[16]

Gloucestershire, the Buchans knew, was too far from London to be convenient if JB were to continue working for Nelson's, so they started to look in a small circle around Oxford, which not only had a good train service to Paddington and contained a number of their friends, but was a place that held such happy, prelapsarian memories for JB.

That May, they finally settled on a house, Elsfield Manor, a partly Jacobean, partly Georgian, partly Victorian house in a small, straggling village on the top of the ridge just outside and to the east of Oxford, at the very eastern end of the Cotswolds. He wrote to his mother soon after the deal was done: 'It was looking ravishing yesterday, and I fell desperately in love with it. I walked all round the borders of the land we are taking.'[17] There had probably been a dwelling on the site since Anglo-Saxon times and certainly the land surrounding it appears in the Domesday Book. The present house, however, dated from the seventeenth century, with additions in the following century made by Francis Wise, a scholar and antiquarian, who was the Librarian of the Radcliffe Library in Oxford, and a friend of Dr Samuel Johnson, who visited him there in the summer of 1763. This event is imagined in JB's historical novel, *Midwinter*.

Since 1886 Elsfield Manor had been in the possession of an Oxford banking family called Parsons, who had added a large and very ugly 'Oxford Gothic' extension on the north side of the house, with precipitous back stairs and cavernous kitchen quarters in the basement. In 1919 they had sold the village houses and farms they owned to Christ Church but, since the college was not interested in the Manor, the Parsons* sold it on to JB with twenty acres of ground, consisting of a large garden, a small, broad-leaved wood and a couple of meadows.

*The elderly Miss Parsons moved to another house in the village and became a friend as well as an important ally in Susie's attempts to interest an evasive female population in the benefits of belonging to the Women's Institute that she founded in the early 1920s.

The house, built of the soft grey-yellow Cotswold limestone with stone roof tiles, had the quality of a Border keep in the way it rose, cliff-like, from the village street. It was much like Fosse Manor, where Richard Hannay settles into married life, but a far cry from Weald Manor, the elegant Georgian country house at Bampton in Oxfordshire that JB had been unable to secure, almost certainly because he could not afford it. Weald Manor influenced the house imagined in his short story 'Fullcircle', published in *Blackwood's Magazine* in 1920. To console himself for his disappointment, or to warn himself of the dangers of smug vegetating in the country, JB made the house, Fullcircle, take over the lives of the supposedly fortunate couple who had inherited it, turning them from progressive, atheistic, active do-gooders into complacent Roman Catholic idlers.

In buying Elsfield Manor, JB was part of a vanguard of professional people who moved out from the cities after the Great War. They bought houses that once belonged to the hoar-ancient squirearchy and, in places, helped to revivify country life.

In June 1919 the Buchans took their seven-year-old Johnnie to visit Moor Park, just before it was sold by Susie's first cousin, Lord Ebury, to Lord Leverhulme. 'It was looking perfectly lovely, but that great kind of house is no use to anybody now except profiteers...'[18] Lord Leverhulme would not have liked to have been called a profiteer, but he certainly destroyed the integrity of the Capability Brown landscape by laying out a golf course, which survives to this day.* Also that month, the horse that Waldorf Astor had bred and named 'John Buchan' was just beaten into second place in the Derby at Epsom. JB told his mother: 'He would have won if the jockey had not tried to pass the winner on the wrong side.'[19] (It did, however, win the Eclipse Stakes at Sandown Park in 1919 and 1920, and sired some great horses, with witty names such as Short Story and Book Law.)

The Buchans' last day in the old home in Portland Place was 24 June 1919. However, since Elsfield Manor needed a good deal of modernising, especially the installation of new lavatories and bathrooms as well as extensive bookshelves in the library/study, so necessary for JB's work and comfort, they rented a house in Headington, the suburb of Oxford nearest to Elsfield. They moved into the Manor on 7 January 1920.

*The house became the grandest of golf clubhouses.

JB told visitors that Axylos, the son of Teuthras, in the sixth book of the *Iliad*, had built his dwelling by the roadside and entertained every wayfarer.[20] I imagine that he used the example of Axylos to excuse the shortcomings of his house rather than buying it on Homer's recommendation. As ever, he made the best of things. And the Buchans were certainly kind to wayfarers, in this case, tramps, of whom there were many on the roads after the Great War.

JB described the village in his book of reminiscences:

Elsfield stood on the edge of the long ridge which intervenes between the Chilterns and Cotswold, a ridge muffled in great woods, and dropping in the north to the fen of Otmoor; so our people were half-uplanders and half-woodlanders, and therefore dissociated both from the shepherd-folk of the high Cotswold and the valley-folk along Thames and Cherwell. They had their own ways, their own speech, their own pride of descent, for you will find the same names to-day in the villages as in mediaeval abbey-rolls, and they gripped like a vice on the past. From my lawn I looked over some thirty miles of woods and meadows to the dim ridges about Stow-on-the-Wold, and, except in the bareness of winter, there was not a house to be seen. That view was a symbol of our detachment.[21]

Certainly, it was far more remote before cars became commonplace and the roads were tarmacked, but it was probably a slight exaggeration to say that, less than four miles from Oxford, it was 'as set in its ancient ways as an isle of the Hebrides'.[22] However, it is true to say that both the Manor and the surrounding countryside were as full of historical echoes as Tweeddale: not only was there the Johnsonian connection but Oliver Cromwell's troops had used the stable yard as a gun park before the siege of Oxford. The great Elizabethan botanist, John Gerard, author of the *Herball*, had looked for rare wild flowers in nearby Stowood. At the crossroads where the London to Worcester road bisected that from Elsfield to Beckley stood an old elm from which hung a rusty chain; this was the tree on which Haynes the highwayman was hanged, after he shot dead a coachman of the Worcester Mail. Below Beckley lay Otmoor, once marshland surrounded by the seven 'towns', whose inhabitants had risen up against the drainage of the marshes

for enclosures in 1829 and 1830, in the so-called 'Otmoor Riots'. The people who lived in those villages were strange to the ridge-dwellers and known as 'web-footers'. At one end of Beckley Common were the remains of a Roman camp. All this naturally resonated with such a finely tuned historical sensibility as JB's and he used the surrounding countryside as the setting for two historical novels, *Midwinter* and *The Blanket of the Dark*.

The visitor to the Manor entered by a door off the village street into a stone-flagged hall, the walls covered in white panelling which reflected light, and showed off the undistinguished paintings as well as could be. There was also the head of a 'Royal" stag, which JB had shot at Glen Etive in 1912. Beyond an arch, a Georgian staircase curled right-handed to the upper floors. The back hall opened into a morning room and, next to this, a drawing room, also panelled, with tall, deep-set windows. According to a *Homes and Gardens* article of 1932, hanging on the walls of the drawing room were a painting by Melchior d'Hondecoeter, which I can believe, and one by Poussin, which I cannot. JB bought pictures for their subject matter or associations, not for intrinsic artistic merit, and even in the 1920s a Poussin would surely have been beyond his grasp.

The Victorian extension tacked onto the north of the Jacobean house contained the dining room and library. Above the marble fireplace in the library hung a picture of one of JB's heroes, Sir Walter Raleigh, after Federigo Zucchero. But what struck the journalist from *Homes and Gardens* most were the books in shelves that extended from floor to ceiling: he gushed that there was 'a splendid collection, including many rare editions. And with a writing desk of generous dimensions, easy chairs and miscellaneous personal items to keep them company, the room imparts a most delightful feeling of intimacy...'[23] Both the drawing room and library were certainly very comfortable, with mahogany furniture, chintzes on the sofas, plenty of cut flowers from the garden and bright log fires. (They needed them, for there was no central heating.)

A few years later, the Buchans vastly improved the appearance of the Georgian part of the garden front by removing the flat roof and building another storey with a pitched roof to match the existing one.

*A 'Royal' has antlers with fourteen points. It is now in the John Buchan Museum in Peebles.

This provided, above the drawing room, a large upstairs study, with a writing table by each of the three windows, so that JB, Susie and Anna (when she was staying) could all write there. These windows provided the best views from the house.

The garden consisted of a broad terrace, facing due west, below which was a stiffish slope of lawn, bordered by the elms of Crow Wood, a pond and a 'druidic' temple summer house. Beyond was Manor Meadow, and to the side Pond Close, another meadow which concealed a venerable well. To get to Pond Close meant passing through an archway of elms, which framed the magical view of the spires and domes of Oxford, captured by E. H. New when he drew a bookplate for JB in 1926, and which the latter's son, William, called 'as serene and heart-catching as a celestial city in the background of an Italian primitive'.[24]

On the south side of the Manor was a rose garden, much loved by Susie, together with cottages for staff and a walled garden, complete with glasshouses. On the other side of the house was the stable yard and the chauffeur's cottage, as well as a large, sloping orchard, a second kitchen garden and a very broad herbaceous border. JB himself would go to the 'cutting garden' in the morning to select a button hole before he left for London, and often at weekends he would pick and arrange the flowers for the house; skilfully, as well, much to the exasperation of his wife and daughter.

Elsfield Manor was certainly a country house, with many of the same accoutrements as those that the Buchans had known in their youth, but there were no broad acres to sustain it, nor did JB want them. He styled himself 'a minor country gentleman with a taste for letters'; either he could not, or would not, become a farmer as well. The Manor's upkeep and staffing entirely depended on him working at a great pace at business and writing. There was always something going on, for it was not so grand an establishment that the machinery of living could be hidden away from the sight of its inhabitants. There was bustle, but it was orderly, thought-out and energised by JB.

A number of local families were dependent on the Buchans for employment. Amos Webb, who became a great friend, was of an Elsfield family and drove his employer's Wolseley, the only car in the village. Mrs Charlett, a most good-humoured and unflappable middle-aged widow ('decency personified'[25] according to JB), was the cook, and her two daughters and son worked at the Manor. Mrs Charlett and

Elsie, her daughter, the children's nanny, were crucial to the smooth running of the house and stayed many years, Mrs Charlett sleeping in a room at the top of the steep back stairs, which must have been hard on her legs. The butler slept beyond the kitchen. Until James Cast was engaged in 1932, butlers changed fairly frequently at Elsfield, and their dismal quarters may have had something to do with that. Annie Cox, who had started working life as a maid at Moor Park before the turn of the century, was the housekeeper and Susie's lady's maid, and there were parlourmaids as well.

The outdoor staff consisted of Mr Martin and two undergardeners, as well as Jack Allam, the gamekeeper, from whom JB and the boys, in particular, learned a great deal about the ways of wild birds and animals. Although JB bought the forty-five-acre Noke Wood, and Susie (with a small legacy) the forty-acre Beckley Common, both nearby, he gave up shooting game early on in their time at Elsfield, so Allam became more a companion and mentor to the boys. He taught them to fish for chub in the Cherwell, find birds' nests in Noke Wood, and shoot snipe on Otmoor. Perhaps because he could scarcely read, and so most of his knowledge came from observation, Allam seemed to JB to embody the virtues of 'old England'. Although romanticised and given almost supernatural powers for fictional effect, the 'dwellers of Old England' in *The Blanket of the Dark* and *Midwinter* had some basis in the local men who worked for JB. The happiness of these arrangements can be glimpsed at the beginning of *The Three Hostages*.

In the country houses that the Buchans had frequented before the Great War, servants often ensured that the family did nothing more taxing than outdoor sports and indoor games, as well as relentless entertaining on a substantial scale. But at Elsfield, as at Portland Place, staff gave JB the freedom and time for concerted public endeavour and paid work, as well as congenial socialising. Staff allowed Susie, for whom housekeeping was not an absorbing interest, to follow her own literary, philanthropic and gardening pursuits, zealously protect her husband from unwanted interruptions, and provide comfortable relaxation by organising the entertainment of friends at weekend parties.

She founded a Women's Institute in the village, despite some initial opposition. The Women's Institute movement, which had begun in a remote area of Ontario in 1897, crossed the Atlantic during the Great

War; in the 1920s, Women's Institutes were being founded in villages all over England, often by educated, socially assured women such as Susie. She was later to write that the Women's Institute was the work that in all her life she loved the most,[26] and she certainly put much of her energy into organising programmes and chairing meetings, both in the village and for the Oxfordshire Federation of Women's Institutes. Along with her friend, the writer Elizabeth Bowen, she was also active at Oxford House, an organisation that carried out educational and social work in Risca in the Welsh valleys during the Depression.

She began to write books, sitting on the other side of a 'partner's desk' from her husband in the library. There were works of history, such as *The Sword of State: Wellington after Waterloo* (Hodder and Stoughton, 1928); *Lady Louisa Stuart*, dedicated to her husband, and published by Hodder in 1932; and *Funeral March of a Marionette*, the story of Charlotte, Duchess of Albany, Bonnie Prince Charlie's ill-fated daughter, which was published by the Hogarth Press in 1935, with a dust jacket designed by Vanessa Bell. These were works of solid research: *Funeral March* was based on a collection of letters in the Bodleian Library, written in French by Charlotte to her mother, Clementina Walkinshaw. The books were generally well received by critics; they reveal a capacity to marshal facts as well as sympathy for, and knowledge of, earlier times and contain, at times, wit and pungent comment: 'Intrigue was certainly in her blood and it is a quality which, like bad spelling, is apt to run in families.'[27] She also wrote children's stories, such as *Jim and the Dragon*, *The Freedom of the Garden* and *Arabella Takes Charge*.

Life at Elsfield Manor revolved largely around the schedule of its owner. It had to be so, if JB were to achieve everything that he needed to pay for such an expensive establishment. He had always valued punctuality,[*] but he also had the capacity to turn from one thing to another and then back again, without loss of concentration. Hilda Grenfell once wrote to him: 'How do you manage to be so imaginative and so punctual? … I don't understand how you command your actions in two worlds so completely and distinctly as you do and have time to be the best Pal in the world besides.'[28]

[*] The gold watch given to him by the John Knox congregation when he went to Oxford shone brightly from constant use.

In the spring and summer, at weekends, he would ride out in the early morning but be back for family prayers before breakfast. All his life he conducted, or heard, short prayers read every day: they were, for him, in George Herbert's words, 'the soul in paraphrase, heart in pilgrimage'.[29] On Saturdays, he started writing punctually at nine o'clock and worked steadily until lunchtime. He did not mind his children playing round him, provided that they were reasonably quiet. He did not work in the afternoons – that was the time for walking, playing with the children or energetic gardening – but he would go back to his desk after tea for a couple of hours. After dinner, he would read either to himself or out loud to the family (sometimes from a book on which he was at that moment engaged) or they played games. Only when working laboriously on the proofs of *A History of the Great War* in the early 1920s did he work after dinner. On Sundays after church, if no one was staying, he would go for a very long walk, wearing his oldest tweeds. A thirty-mile round trip via Brill was not unusual. He had always found walking spurred his imagination, and it was on these expeditions that he developed his plots.

Each morning during the week, Amos Webb drove him to the station in Oxford so that he could take the train to London. There used to be a number of people who would swear they had seen him write his novels on the Oxford train, but in fact he never did.[30] He spent the time reading or thinking. He would arrive back at Elsfield in the early evening.

He had early developed that capacity that he admired in Raymond Asquith, of appearing to have infinite leisure whilst working immensely hard. He seemed to have time for everyone. And, although most of this came from his own orderly habits and capacity to work very quickly, he was greatly helped by Susie, who saw it as her life's work mainly to promote his. By the time they moved to Elsfield, JB was sufficiently famous to be an object of curiosity and interest, not only for neighbours but for others with a weakness for lionising literary figures. Susie worked hard to shield him from people who arrived unannounced at the door, to catch a glimpse of the man whom they thought they knew so well from his books. It was not unknown for Susie to keep them talking at the front door while JB slipped out the back.

Although he disliked those interruptions, he seemed infinitely tolerant of being asked favours by aspiring writers; indeed, from 1915 on, when he wrote a preface to Violet Jacob's *Songs of Angus*, he acceded to many

requests to read manuscripts, give his opinion and, if the books found a publisher, write a preface, foreword or introduction. He wrote more than forty of these, including an introduction to Mary Webb's *Gone to Earth*, as well as, bizarrely for a man who never learned to drive, a preface to a volume entitled *Motoring To-Day and To-Morrow* by the Earl of Cottenham. He also contributed stories, poems and essays to a variety of charitable publications.

He made a habit of writing to his friends on the publication of their books. G. M. Trevelyan wrote to him, after *History of England* was published: 'That's the way to write to your friends, if you have a heart of gold.'[31] But many an unknown, aspiring writer will have been astonished to receive an unsolicited letter of praise and encouragement from the great man. The warmth of heart that prompted this also caused him to praise politicians for good speeches, leaving himself open to the charge of 'toadyism'. However, it was not done for personal advantage, but sprang from a ready appreciation of the importance of encouraging others. This was something that he learned from his parents.

This activity was only a tithe of the support he gave to others, freely, both in time and in financial help. He almost certainly helped pay his nephew's school fees, as well as providing the cost of teacher training for the daughter of a school friend who had emigrated to Canada, and had fallen on hard times. He acquired a number of honorary godchildren. One of these, John Carswell, he put through school and university, after he became friendly with the boy's parents, Donald and Catherine Carswell, who were hard-up writers.* When Lilian Killick's husband was unemployed after the Great War, JB paid their mortgage and rates, until he got a job.

In 1926 his uncle, Tom Buchan, a merchant seaman who periodically drank far too much, came back for a holiday from Australia, where he worked for a kindly clergyman, to see his sisters in Guernsey. They sent him away as he was drunk, and he was rescued by JB and Walter when he found himself down and out in London's docklands. (He later took the Pledge.) They paid for his passage back to New South Wales, and gave him money and books for the voyage. Indeed, JB, and, most

*Catherine Carswell, a novelist who had also published books on Robert Burns and D. H. Lawrence, helped Susie to put together two books, *The Clearing House* and *John Buchan by his Wife and Friends*, after the Second World War.

likely, Walter as well, continued to send Uncle Tom money from time to time.[32]

JB could also be relied upon to do what he could to give young people a leg-up as far as employment was concerned, often providing letters of introduction. Willard Connely, an American, whom the Buchans entertained when he was studying at Oxford in the mid-1920s, scarcely recognised himself in the glowing picture painted by JB in his letter to a Fleet Street editor, to get him a job.[*]

One small but typical act of graceful kindness concerned the twelve-year-old son of a Reuters man, who encountered JB at a garden party hosted by his father. As a result of a serious operation, the lad could not stand for long, but found himself engaged in conversation by one of his father's colleagues. Two days later, *Salute to Adventurers* and *Greenmantle* arrived in the post, with the injunction that they should be read sitting 'very quietly' in a chair.[33]

JB and Susie made friends with local people, such as Robert and Nancy Graves who lived at nearby Islip, Vernon Watney (of the brewing family) at Cornbury Park near Charlbury,[**] Percy and Clotilde Feilding at Beckley Park and, of course, the Gilbert Murrays and the John Masefields the other side of Oxford on Boar's Hill. Susie's sister, Marnie, who had been left a widow with three young children when her husband, Jeremy, died suddenly of pneumonia in 1930, lived not so far away at Wendover Dean in the Chilterns. In 1932, JB dedicated his children's book, *The Magic Walking Stick*, to her children, Jeremy, Carola and Margaret.

The Buchans tried very hard to reproduce their own carefree childhood for their children at Elsfield, even though JB was perforce often away from home. And they largely succeeded. The children were free to roam around Elsfield and the surrounding district, birds' nesting and playing imaginative games, and only coming home for meals, when summoned by a police whistle. Their father walked with them, listened to them, took their preoccupations seriously, especially if these concerned history, literature and nature. Although they were aware from an early age that he was rather different from other fathers, they

[*]He was later a literary critic, biographer and public lecturer in the United States.
[**]The house plays a part in *Midwinter*.

were great difficulties associated with the supply of paper. The company had been shaken by Tommy's death, and no one more so than JB; moreover, Tommy's share of the capital was in trust for his children. The enormous works at Parkside imposed a massive burden of fixed costs. In August 1920 the Board was discussing how to deal with an overdraft of £38,000.[35] The business was in much the same situation as Walter Scott's publisher, Constable, had been in the 1820s, 'like a drunken man, who can avoid a fall only so long as he keeps running'.[36] The dominant personality in the firm, after Tommy Nelson's death, was his brother Ian, who set about attempting to inject greater professionalism into its direction and was not intimidated by JB's reputation. George Brown, JB's fellow director and closest colleague in the firm, resigned in 1921.

It was imperative in the early 1920s to find other ways of making money than through libraries of cheap reprints, and JB encouraged his fellow directors to contemplate expanding the company's existing presence in the school textbook market. Here he was helped by the friendship he had forged with Sir Henry Newbolt. The latter had chaired a committee set up in 1919 by H. A. L. Fisher, President of the Board of Education, to investigate how to improve the teaching of English in schools. This committee reported in 1922, and JB asked Newbolt to help in editing a series of books based on its recommendations. The series was entitled 'The Teaching of English' and the books became standard texts in schools for many years. They followed this with 'The Teaching of History', the eleven volumes of which were written by well-known historians such as Robert Rait, an old Oxford friend of JB's.*

This was a high-minded as well as commercial venture. JB and Newbolt were determined to better the lot of future citizens of all classes, by providing attractively written textbooks that would open to them a world of good literature, both contemporary and traditional, and connect them with their cultural and historical roots. When Newbolt told Fisher of the plan, he replied: 'I think it is the greatest service you could do for the country…'[37]

Henry Newbolt, the son of an evangelical Anglican vicar, was becoming one of JB's closest friends. Although Newbolt was thirteen years older,

*Professor Rait was a popular Principal of the University of Glasgow from 1929 to 1936.

they often lunched together at the Athenaeum or The Club. They had worked together briefly at the Ministry of Information. They were both very involved with the Workers' Educational Association just after the war, when it was expanding rapidly to try to fulfil the needs of returning servicemen; for JB, adult education was a vital component of the struggle to cleave a *via media* between Left and Right, by educating the public so that they did not fall for false abstractions or too simple solutions. Both men were interested in social amelioration but averse to abstract theorising about it. Small wonder that Newbolt was so enthusiastic about Nelson's offer, although he did insist on a contract lasting ten years with a retainer, so that he could work undistracted on the project.

Newbolt had a thin, ascetic, eagle-like profile, much like JB's, and they had much the same approach to conversation, ideas and literature. JB viewed Newbolt as much more than the writer of the 'Frankenstein's monster' (as Newbolt called it) of *Vitaï Lampada*. Newbolt admired JB for both his scholarship and his practical sense. Perceptively, he wrote to his wife: 'I wish I were as free as John Buchan from the fatal scholar's habit of trying to know all about a subject before you write on it – he always seems able to call his Secretary and dictate an article on anything at a moment's notice. Exhilarating for him, and much better suited to public taste ... JB *is* a scholar, but he doesn't take thought to prove it – he knows it and can bear a slip or two.'[38] Henry and Susie were also firm friends, as was Margaret, his wife; they were the first guests at Elsfield, after the Buchans settled in. Henry liked children and was especially kind to the shy, bookish Alice. (Of his irregular *ménage à trois*, with his wife's cousin who lived with them, the shockable Buchans can have had no idea.)

JB himself wrote a couple of the 'Teaching of English' books – *A Book of Escapes and Hurried Journeys* (1922) and *The Last Secrets* (1923). He had always been fascinated by journeys carried out under stress and pressure: 'In the great romances of literature they [hurried journeys] provide many of the chief dramatic moments, and, since the theme is common to Homer and the penny reciter, it must appeal to a very ancient instinct in human nature ... We live our lives under the twin categories of time and space, and when the two come into conflict we get the great moment. Whether failure or success is the result, life is sharpened, intensified, idealized.'[39] The stories include the escape of Bonnie Prince Charlie after Culloden, the springing of the Earl of

correspondence is full of expressions of disappointment that they don't meet more often, he tried hard to see them. He would shape his visits to Nelson's Parkside Works around weekends that could be spent in Peebles, staying at Broughton for at least part of the summer holidays and, as often, leaving the children there with their nanny, especially before they were old enough to enjoy the rigours of an August spent at a remote fishing lodge in the Highlands. He was encouraged in this by Susie, who was sincerely attached to Anna and Walter, as they were to her, and extremely dutiful to Mrs Buchan, who must sometimes have made her grind her teeth but about whom she was steadfastly loyal.

The 'English' Buchans settled easily into Bank House or Gala Lodge at Broughton when they were in Scotland, walked with Walter, shopped in Edinburgh with Anna, attended tea parties with Mrs Buchan, looked out for them in the audience when JB gave lectures in Glasgow or speeches to rural communities in the Borders, and sometimes played a prominent part in the annual Beltane celebration in Peebles. Anna relied heavily on JB for literary advice and encouragement. Walter looked to JB to provide political gossip, book talk and glimpses into a less confined, more urbane world, while he depended on Walter to act as his banker, and informal adviser on tax matters. As JB wrote to Walter soon after he arrived in Canada in 1935, 'You are by far my greatest friend.' The converse seems also to have been true.

The children, when young, revelled in an atmosphere of fond adult family attention, Alice and Anna finding a mutual interest in amateur dramatics, Shakespeare and reading, while the boys found Walter a kindly, indulgent uncle in whom they could confide. The childhood naughtiness of Billy gained him the unhelpful soubriquet of 'Bad Bill' from the childless Anna, but it also earned him £25, since she put an affectionate portrait of him into her novel, *Pink Sugar*, and promised him a farthing* for every copy of the first edition that sold. The dedication reads 'To John and Susan Buchan because of Bill.'

Thomas Nelson's had emerged from the war in poor shape. More than eighty men did not return, including Tommy Nelson himself. Foreign markets had gone. The home market had changed (causing the company's staple of 'Sevenpennies' reprints to be abandoned). There

*A quarter of an old penny. The first print run must have been an impressive 24,000.

might well have replied, as Sir Walter Scott's son did, when asked why people made such a fuss about his father: 'It's commonly *him* that sees the hare sitting.'[34]

The Buchans took avidly to country life, and particularly the opportunities it afforded for keeping animals. JB would ride his hunter, Alan Breck, on whom he rarely if ever hunted foxes, and the children rode ponies, Alastair becoming the keenest and most skilful horseman. The family lavished attention on a succession of tyrannical and mischievous terriers, of which the best loved and worst behaved was Spider, part Sealyham, part wire-haired terrier, who was given to Alice as a puppy in 1927. He appears in *Castle Gay* as the disreputable but endearing and useful 'Woolworth'. He was joined by an equally independent-minded, wholly black terrier called Black Douglas, known as 'Duggie'.

On Sundays the family attended service in the small, stone-built church of St Thomas of Canterbury, dating from the thirteenth century and in the Early English style. JB preferred to worship in the village where he lived rather than go to Presbyterian services in Oxford. Only when his mother arrived each April would he escort her to the services of the Presbyterian Chaplaincy, for she disapproved of this early example of ecumenism, referring to it as 'bowing down in the house of Rimmon',* a remark that never failed to irritate her grandchildren. JB told her that none of them were or ever would be Episcopalian, which was only in a very strict sense true.** But the regime at Elsfield was very different from that of Pathhead: the boys encountered a milk-and-water, highly ritualised Anglicanism at school, and the children grew up knowing less about the religion they professed than their parents, and without seeming to understand their father's.

From 1920 onwards, Anna Buchan came every April to Elsfield, and was followed a week later by Mrs Buchan and Walter. These were happy times, something of the flavour of which was captured in family group photographs taken by Walter. Although JB could never spend as much time in adult life with his Scots family as he would have liked, and his

*Rimmon was a Syrian god, mentioned in 2 Kings, chapter 5. Naaman, the Syrian commander, although cured of his leprosy by the prophet Elisha, still feels he must support his king physically, by bowing down when he did in Rimmon's temple. What Helen Buchan seems to have missed, but JB would not have done, was that Naaman did it only out of loyalty.
**They were baptised into the Church of Scotland.

Nithsdale from the Tower by his resourceful wife after the '15, and
Winston Churchill getting away from a Boer prisoner-of-war camp.*

The Last Secrets: The Final Mysteries of Exploration also concerned an
enduring fascination of JB's, namely, exploration, at a time when people
began to fear there were few fascinating geographical unknowns still to
discover. The book was dedicated to the memory of Cecil Rawling, 'An
intrepid explorer, a gallant soldier and the best of friends'. This book
describes pre-war exploits, including Younghusband's expedition to
Lhasa, Scott's epic failure to get first to the South Pole, Rawling's own
exploration of New Guinea and his discovery of a pygmy people, as well
as the 1922 Everest expedition.

The move to Elsfield had changed JB's circumstances. He had been
working for Nelson's on a basis that had been agreed in 1907, at the time
of his marriage. By early 1923 the cost of setting up and maintaining
the elaborate establishment at Elsfield and the arrival of four children
had put real pressure on his financial affairs. During the war he had
been the government's appointee on the Reuters Board and in 1919, at
the invitation of Sir Roderick Jones, had supplemented his income by
resuming his directorship. He was now looking to increase both what
Nelson's paid him and his involvement with Reuters, after Jones had
asked him to become Deputy Chairman, at a handsome salary.

JB could not face discussing Reuters' offer with Ian Nelson, but asked
another director, John Kemp, to tell him instead. In an apologetic letter
to Ian, he later explained, all too truthfully, that this was because 'I am
desperately shy about speaking money matters with friends.'⁴⁰ Nelson
responded, '[I am] aware that you have not got very much out of the
business in the past. This has been due to the fact that, as conducted
during the last 20 years or so, the business has been extremely unsuccessful
and for this result we must all take some share of responsibility. Had the
business been moderately successful your share of the surplus profits on
ordinary dividends (whichever you like to call them) would have been very
considerable. As things are today the Co. is in such a critical condition
that I am afraid as a director I could not at present support an alteration
in anyone's agreement which would involve the guaranteeing of more

*This book was still being given out as a reader when I first arrived at grammar school in the
mid-1960s.

cash year by year and that quite independent of results.'[41] JB's response was to the effect that he realised Nelson's could not afford to pay him a large salary – his value to the firm being in developments that would not be immediately profitable. He added that he had not decided whether to accept Reuters' offer, which would depend on the advice of his doctor and Reuters' agreement to his continuing to work for Nelson's.[42]

There was an issue about the remuneration JB had received and, in that connection, JB was provided with a statement, which caused him to write, for him, a strongly worded letter complaining that he had been paid £6,300 less than was shown and asserting flatly that 'the figures are certainly wrong'.[43] In reality (as an equally stern letter from Ian Nelson and a further financial statement proved),[44] the statement was right and it was the author of *The Law Relating to the Taxation of Foreign Income* who had forgotten to take into account tax paid by the company on his behalf to the Inland Revenue. Such an elementary error, in relation to such an enormous sum of money, is, to say the least, surprising. It resulted in a humiliating climb-down.[45]

In July, Ian Nelson wrote to JB to say that, after the latter had said in January that he had not made up his mind about Reuters, 'From that day to this, I have heard nothing from you directly, but it seems obvious from your very close association with Reuters, and from what has appeared in the Press, that your position there now is very different to that of an ordinary director.' He wanted to know exactly what was going on.[46] After the two men met that month, JB explained his failure to discuss the matter earlier: 'I had avoided raising the question before, for I did not like to worry you when you had so much to think about.' He went on to summarise (as Nelson had asked him to do) the terms they had discussed.[47] Nelson, in reply, pointed out that JB had omitted from his account what Nelson's might expect from him in return for the proposed remuneration. Lilian Killick's observation about JB being businesslike but not a businessman was uncomfortably close to the truth. He undoubtedly suffered from having had no mercantile upbringing. Gradually, however, matters progressed and the terms on which JB could work for both Reuters and Nelson's were agreed that November. The agreement was to last another six years.

In late 1920, JB suggested to his old friend the Earl of Rosebery that he might edit a collection of the latter's speeches and essays, since 'it is

really not old friendship which makes me think they are the purest and finest prose of our time'.[48] Rosebery, extremely grudgingly, agreed, and Hodder and Stoughton published, in two volumes, *Miscellanies; Literary and Historical*, in September 1921. In an act of singular generosity the old man gave the royalties to JB and he spent them partly on renovating the dilapidated temple near the pond in the garden at Elsfield, and partly on helping 'some of the honest men I am always coming across who have been knocked out by the War and those beastly times'.[49] In the end he received more than £1,500.

Meanwhile, the printing presses continued to turn on his account, with Nelson's producing *The Long Road to Victory* as well as *Days to Remember: The British Empire in the Great War*, while *The Nations of Today: A New History of the World* was published in nine volumes by Hodder and Stoughton in late 1923 and early 1924 with JB providing the General Introduction to each one.

He wrote, or co-wrote, three regimental histories, without taking a royalty for them, in the early 1920s: *The History of the South African Forces in France* (Nelson's, 1920); *The History of the Royal Scots Fusiliers* (Nelson's, 1925); and *The Fifteenth (Scottish) Division*, in which he collaborated with a Lieutenant-Colonel J. Stewart, DSO (Blackwood's, 1926). A note in this last book announced that his contribution 'was a labour of love in memory of his gallant brother Alastair, who fell in action at Arras, 1917, while serving with the Division in the 6/7th Royal Scots Fusiliers'. With that book completed, JB had finally discharged his duty to the dead. It was more than time to move on.

In 1921 he went back to fiction with the publication of *The Path of the King*, which chronicles the varying fortunes of descendants of a Viking king, the physical link being a gold ring. He had the help of Susie in this and the dedication reads 'To My Wife I dedicate these chapters first read by a Cotswold fire'. This was an ambitious attempt to trace royal blood over a dozen centuries, starting with a Viking boy descended from Charlemagne and finishing with Abraham Lincoln, 'the last of the Kings', thereby implicitly connecting Britain with America in a shared heritage, as well as underscoring his belief that greatness could, and often did, come from humble origins. JB was fascinated by how certain characteristics in a family surfaced from time to time in later generations.

The times he chose included the thirteenth-century with the Crusades, the sixteenth century at the time of the St Bartholomew's Day massacre in Paris, and the seventeenth century at the time of Charles I's execution. One of the best stories is set in twelfth-century Bruges. 'The Wife of Flanders' was later dramatised by Susie, as was the chapter about Joan of Arc, which she called 'The Vision at the Inn'.

G. M. Trevelyan, a close friend and, by now, a famous British historian, well known for the quality and readability of his own prose, declared that it was the best of JB's books and that 'The historical vignettes are full of the spirit of each passing age, psychologically interesting and yet with a "moral uplift" which "done me a lot of good", and a unity to the whole book given by the entrancing mystery of heredity ... The idea and execution of the seedy rascals is also capital ... And for the imaginative use of real historical knowledge and sound thought on historical happenings it delights me to the heart.'[50]

During the early Elsfield years the family spent six weeks every August and early September in Scotland, partly staying at Peebles or Broughton, and partly with friends in the Highlands, where they would fish for brown trout, sea trout or salmon, and JB would stalk red or roe deer. The favoured locations were Ardtornish, where the ever-hospitable Gerard Craig Sellar lived with his mother until his untimely death in 1929; Letterewe, a house on Loch Maree taken by Alec Maitland, an Edinburgh barrister, and his wife Rosalind, who was Craig Sellar's sister; Glen Etive in Argyll, owned by Ian Nelson; and Kinlochbervie in Sutherland, home to General Stronach, the moving spirit behind Road Rails, a short-lived company providing transport in difficult terrain in developing countries, with which JB and Lord Milner were involved in the early 1920s.

JB's eye for topography, first sharpened when walking with his friends from Oxford in Galloway or climbing in Skye, developed during his tours of battlefields, and writing accounts of battles during the Great War, served him well when he began to receive stalking invitations from friends. For this reason he must have earned the respect of the ghillies, whose provinces these 'forests' were, and with whom he often made friends. He was no 'head hunter' but, like his hosts, keen to remove the older stags who were 'going back', to keep the herd strong. He would also sometimes refrain

from shooting a deer that was in his rifle-sights, since it was the 'stalk' not the kill that appealed to him more and more as he grew older.

All his love of wild landscape, strenuous exercise, thrill in the chase, the intellectual challenge involved in out-thinking an animal in its element, together with his conservationist instincts, came together in those August days. Susie seems also to have enjoyed these holidays (which cannot have been true of all wives in these circumstances), for she was content to read, walk, fish or sit in the garden, and there would be good, if sleepy, talk at night over dinner. JB usually felt very well on these holidays. It is no accident that he wrote a hymn to the joys of good fellowship and stalking, the novel *John Macnab*. And, because all experience could be grist to his mill, the fact that he once found himself with a deer in his sights but the wrong cartridges in his pocket[51] became a crucial plot development in *The Three Hostages*. As the children grew older, and were thought to be able to cope with being cold, wet and bitten by midges, they began to accompany their parents on these strenuous holidays.

It was in the early 1920s that JB began a tradition of each spring writing a book that could be published in time for his readers' summer holidays. *Huntingtower*, a contemporary novel of adventure, was published by Hodder and Stoughton in August 1922. It was dedicated, at length, to an old Glaswegian friend of an earlier generation, W. P. Ker, the Professor of Poetry at Oxford. In the dedication he gives the 'history' of the descent of his hero, Dickson McCunn, from Baillie Nicol Jarvie,* a playful nod to Sir Walter Scott that Ker would have enjoyed. Moreover, Ker would not have missed the strong resemblance of Huntingtower to the house on the edge of the cliffs in *Guy Mannering*.**

The plot revolves around the threat to an exiled Russian princess by ruthless Bolsheviks, who chase her to a castle in south-west Scotland. Those who come to her rescue consist of a most motley crowd of unlikely heroes and heroines: a recently retired, profoundly respectable, eminently practical but secretly romantic Glasgow grocer; a gang of Glasgow street urchins, whom the grocer is supporting, let loose in the countryside; a young Modernist poet, who is 'turned' by Dickson

*Baillie Nicol Jarvie is an important figure in *Rob Roy*.
**Scott scholars will no doubt find other associations in the book.

McCunn so that, in the end, he burns his poems to keep warm and goes back to reading Tennyson; an elderly, respectable village Scotswoman who both bakes delicious scones and intrepidly takes on a disguise; the boyishly charming and game, if sometimes naïve, Sir Archie Roylance;* and a Russian prince on a motorbike.

The story is ridiculous but fast-paced and witty (the Socialist Sunday School songs in Scots are delicious). But it is still preoccupied with the problem of evil, in this instance represented by totalitarianism that breeds brutal degenerates, an evil that in this case is defeated by a small, disadvantaged, inner-city boy.

JB's knowledge of feral street children in Glasgow in the late nineteenth century comes through in this comic book. It is, of course, a fantasy of how resourceful poor children would behave, but it exhibits a deep sympathy for them, as well as a general belief that Man has a capacity for greatness, however humble or unpromising his beginnings. As he was later to say: 'The task of leadership is not to put greatness into humanity, but to elicit it, for the greatness is already there.'[52] That explains why he had such an enduring interest in the Scout movement, from its early days under Sir Robert Baden-Powell, and took his Chief Scout duties so seriously once he became Governor-General of Canada.

Late on in the book, Dickson McCunn muses about the Gorbals Die-Hards:

> As he looks at the ancient tents, the humble equipment, the ring of small shockheads, a great tenderness comes over him. The Die-Hards are so tiny, so poor, so pitifully handicapped, and yet so bold in their meagreness. Not one of them has had anything that might be called a chance. Their few years have been spent in kennels and closes, always hungry and hunted, with none to care for them; their childish ears have been habituated to every coarseness, their small minds filled with the desperate shifts of living ... And yet, what a heavenly spark was in them![53]

*First encountered as a brave but insubordinate RFC pilot in *Mr Standfast*, Sir Archie Roylance – airman, ornithologist and Scots laird – was one of JB's favourite creations, appearing in six novels, and referred to in two more.

At least two of the Gorbals Die-Hards appear in *Castle Gay* and *The House of the Four Winds*, having benefited from McCunn's generous patronage.

Huntingtower sold, in hardback, 230,000 copies, as many as *Mr Standfast* and two-thirds as many as *The Thirty-Nine Steps* and *Greenmantle*. None of his other contemporary novels would do as well. Gainsborough Pictures made the book into a 'comic' film five years later. It starred Sir Harry Lauder, the Scots comedian and singer, as Dickson McCunn, the castle scenes being filmed at Bamburgh Castle in Northumberland.*

Nothing shows his indifference to literary coteries better than JB's persistent interest in the Borders ('Lallans') dialect, in pursuit of which he brought out a careful selection of poetry, *The Northern Muse: An Anthology of Scots Vernacular Poetry* (Nelson's, August 1924). It was dedicated to Lord Rosebery but was also a homage to his father. 'I have made this little [it's 547 pages long] anthology with no other purpose than to please myself,' he wrote in the Introduction, and confined his choice to poems, which he considered to be literature 'from a bottle song just redeemed from doggerel by some quaintness of fancy to the high flights of Burns and Dunbar'.⁵⁴ The book did include some modern poetry, but by fellow Scots language enthusiasts, such as the vernacular poets Charles Murray** and Violet Jacob, the latter best known for her novel, *Flemington*, and her 1915 collection of poetry, *Songs of Angus*.

In this Introduction he put the case for the Scots vernacular and its literature, but he was clear-eyed enough to see that the particularities of the Scots written language were dying out. The problems with it, from which he excepted the poetry of Robert Burns, were a certain provincialism and sentimentality. 'Instead of Burns's "stalk of carle hemp" there seems to be in such writers a stalk of coarse barley sugar.'⁵⁵ Besides Burns and Stevenson, as well as Murray and Jacob, the Scottish

*Sadly, because it was filmed on nitrate film stock, which was highly flammable and also degraded over time, there is no extant version of this film. Since then, there have also been two radio and two television dramatisations.

**Best known for a collection called *Hamewith* (1900).

poet who gets the best coverage is the medieval chronicler, William Dunbar.

In the Commentary he describes a medieval winter in such vivid terms that we can almost smell the thawing offal in the streets. 'Winter was a pall which lay black on a man's spirit, and made him think, like Dunbar, of his latter end. Then, like a recovery from sickness, came the Spring and the world awoke. Men went out of their dark dwellings, bemused with sunlight, drunken with bird song and greenery, marvelling at the common flowers as if they were celestial visitants. Of such sudden awakenings poetry is born.'[56]

Despite so many years spent in England, Scotland was, and always would remain, at the back of JB's head. The choice of 'Lallans' to express how he felt about the soldiers' war in 1916 and 1917 drew him to those Scottish poets, such as Violet Jacob and Christopher M. Grieve, a Lowlander, who were attempting to use the Scots vernacular in poetry as a means of expressing their country's particular identity.

On the face of it, the friendship that JB struck up with Grieve (who by the early 1920s was calling himself Hugh MacDiarmid) after the Great War was an unlikely one, since the latter was first a supporter of fascism, then communism, a Scottish Nationalist who was influenced by Modernism, and extremely inclined to fall out with people. However, JB had tried to help him get a job in journalism after he was demobbed, by writing to the owner of *The Scotsman*, and he was in sympathy with what was already called the Scottish Renaissance Group, headed by MacDiarmid, which was set on reviving and protecting the Scots language as a vehicle for a distinctive nationalist, though not nationalistic, literature. MacDiarmid included three poems of JB's[*] in the 1920 first edition of his anthology of contemporary Scottish poets, entitled *Northern Numbers*, and three more the following year: 'The Gipsy's Song to the Lady Cassilis', 'The Wise Years' and 'Wood Magic'. It is interesting that these poems, essentially traditional, should appeal to MacDiarmid. Professor Alan Riach believes that the reason why he had such high praise for JB, initially at least, was perhaps because, 'like Conrad, Buchan displays rather than endorses unlikeable or even despicable characteristics, and usually leaves them open for question. He knows what is at stake and what it costs to maintain what he values.'[57]

[*]'Fratri Dilectissimo', 'Fisher Jamie' and 'From the Pentlands Looking North and South'.

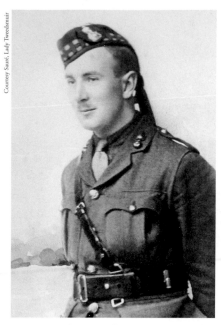

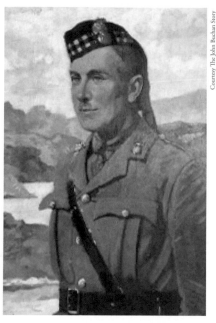

Lieutenant Alastair Buchan (1894–1917) in the uniform of the Royal Scots Fusiliers.

An oil painting of Alastair Buchan by Sir William Orpen from the photograph opposite. Orpen did not charge a fee.

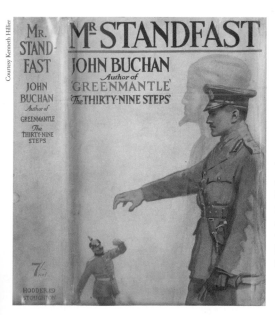

The dust jacket of the first edition of *Mr Standfast*, published in 1919. It is mystifying until one realises that it harks back to the cover of *Greenmantle*, published three years earlier by Hodder and Stoughton, and JB's bestselling novel at that point.

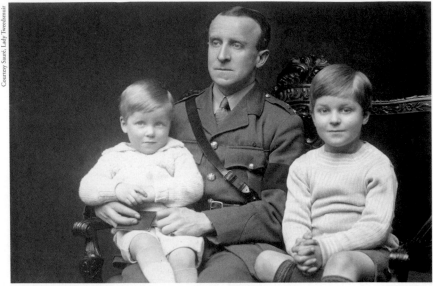

JB in the uniform of a Lieutenant-Colonel, with William on the left and Johnnie on the right, in 1918.

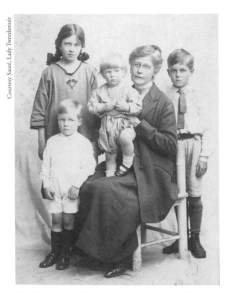

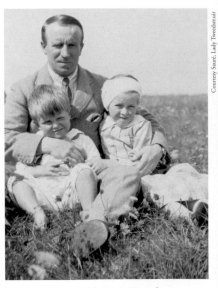

The Buchan children in late 1919 or early 1920 with their grandmother, Caroline Grosvenor, known to them as 'Tin'. Alice and Johnnie stand behind with William in front and Alastair on Mrs Grosvenor's knee.

JB with Alice and Johnnie in Broadstairs, Kent, on the August 1914 holiday when he began to write *The Thirty-Nine Steps*. He was suffering badly from a duodenal ulcer and Alice was recovering from a mastoid operation.

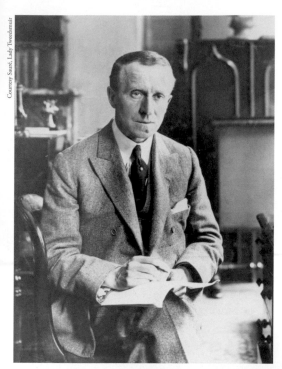

JB after he had been appointed Deputy-Chairman of Reuters in 1923. According to Johnnie, photographs of his father were misleading, since they 'gave him a look of frozen gloom, a travesty of his good-humoured self'.

A photograph of the family in the garden at Elsfield Manor taken by Walter Buchan, probably April 1934. Standing are Johnnie, with his beloved goshawk, Jezebel, on his fist, together with William and Alice. Sitting are JB holding on to an invisible dog, Mrs Buchan, Susie and Anna Buchan (the novelist, O. Douglas).

The stone-built, architecturally mixed Elsfield Manor from the road in the 1920s, after another storey, containing JB's writing room, had been built on the garden side.

JB, Susie and the Reverend Charlie Dick leave the Palace of Holyroodhouse in an open landau on their way to the General Assembly of the Church of Scotland, to which JB was Lord High Commissioner, in May 1934. The landau was accompanied by a mounted escort of the Royal Scots Greys.

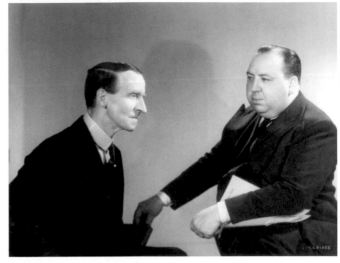

JB with Alfred Hitchcock in 1935. The way the picture is lit suggests the photographer had a sense of humour.

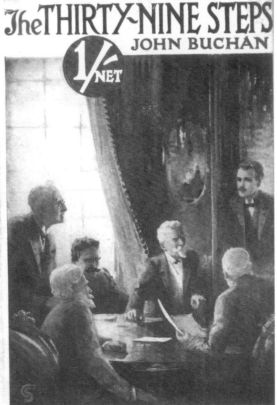

The dustjacket of the first edition of *The Thirty-Nine Steps*, which was published by Blackwood's in October 1915. It shows Richard Hannay bursting in, unannounced, on an emergency high-level meeting, after he divines that a German spy has impersonated the First Sea Lord.

JB's coat of arms when he was made 1st Baron Tweedsmuir of Elsfield in 1935. The motto translates as 'Not following inferior things'. Why the sunflower's leaves should be wilting is an irrecoverable mystery.

JB's bookplate after he bought Elsfield Manor. It was designed by E.H. New in 1926, and shows the view from JB's study towards Oxford.

A formal group photograph taken in early 1937 in Government House, Ottawa. From left: Colonel Eric Mackenzie, Comptroller of the Household (far left); Shuldham Redfern, Private Secretary (fourth from left); Ruth Redfern, (sixth from left); Lieutenant Gordon Rivers-Smith, R.N. (ADC); William Buchan; Johnnie Buchan; Beatrice Spencer-Smith (lady-in-waiting); Colonel H. Willis-O'Connor (permanent ADC) (fourth from right); Lilian Killick (third from right); Frederick Pereira, Assistant Secretary (second from right); Captain John Boyle (ADC) (far right). Seated: JB and Susie (aka Their Excellencies, the Governor-General and Lady Tweedsmuir).

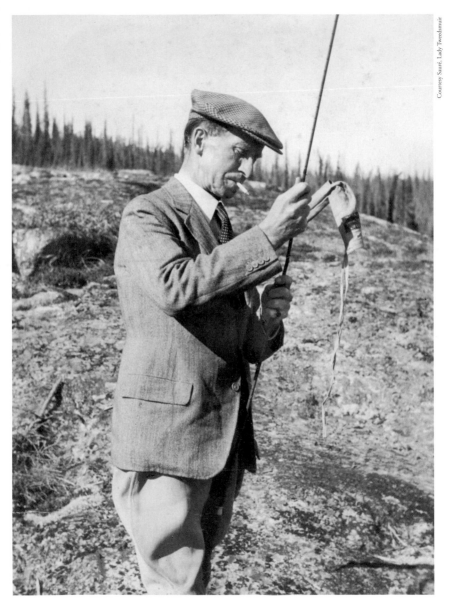

JB fishing on the Cascapedia River in Quebec, probably in early June 1939, while the Royal party toured the west of Canada. This was JB's favourite leisure pastime but, as things turned out, they were there a week too early for the salmon run.

JB with his mother on the garden steps of Rideau Hall (Government House) in Ottawa, June 1936. Only when he became Governor-General did Mrs Buchan feel that her son was properly appreciated for his talents.

In 1923, MacDiarmid dedicated his first book, *Annals of the Five Senses*, to JB 'for the encouragement and help he has given to a young and unknown writer'. JB continued to do so, anthologising one of MacDiarmid's poems in *The Northern Muse*. In 1925, JB wrote the preface to MacDiarmid's *Sangschaw*. MacDiarmid called him 'The Dean of the Faculty of Contemporary Scottish Letters'.

However, in 1976, in the introduction to a new edition of *Contemporary Scottish Studies*, MacDiarmid displayed a curious lack of gratitude to JB in quoting, critically, from an article in the *Morning Post* about 1920s Fascist Italy, which JB had written forty-seven years earlier (see p. 279). The difference between JB and MacDiarmid was that the former was, in fact, a Baldwinite, one-nation Tory, whereas MacDiarmid was a Communist long after the true nature of Communism had become glaringly apparent, standing for Parliament under that banner eight years after Soviet tanks crushed the Hungarian Uprising in 1956.

Another contribution that JB made to the Scottish literary renaissance was his active support of the project to make a national library for Scotland out of the old Advocates' Library in Edinburgh. In 1919, Hugh Macmillan, back at the Bar in Edinburgh, formed a committee with the intention of transferring the collections to the nation, if possible. He found JB deeply interested in the project and ready to help. He used his contacts in London and Scotland to involve many influential Scots, most particularly the Earl of Rosebery. He was at least partly instrumental in interesting Ramsay MacDonald, the Earl of Crawford and Balcarres, and Arthur (later the Earl of) Balfour as well.

The problem was money. The government promised a yearly grant of £2,000, which was welcome but not sufficient. An Endowment Trust was established, with Macmillan as Honorary Secretary, and an appeal for donations was devised, with JB adding an eloquent and characteristic last sentence: 'It must not be said that a nation, which above others is tenacious of tradition and historic possession, permitted one of the chief of its heritages to decay, or that a race which has carried the light of learning throughout the globe suffered the lamp in its own citadel to grow dim.'[58]

Once the appeal was made public, Macmillan received an invitation to visit the McVitie and Price biscuit factory to meet Alexander Grant, the quiet, unassuming businessman who was head of the firm. Grant

told Macmillan that he had invested £100,000 in the War Loan during the Great War and now wanted to put it to good use, to give people the advantages of learning that he himself had not enjoyed. He asked whether £100,000 would be enough and Macmillan, computing the interest earned on it in his head, thought that it would. On 28 June 1923 the government's acceptance of the transfer of the Advocates' Library was announced in the House of Commons.* When, in 1925, the National Library of Scotland Act was passed, JB was co-opted by the Trustees to be a member of the Board; he became a full Trustee in 1928 and served until he left for Canada in 1935.** In 1928, when it was obvious that the National Library required larger premises, Grant, now Sir Alexander Grant in public recognition of his generosity, gave another £100,000, which was matched pound for pound by the government.

As a result of these developments, JB and Sir Alexander became fast friends. JB dedicated *Castle Gay* to him in 1930 'in gratitude and affection', while Grant did JB a number of very good turns thereafter (about which more later).

Perhaps because he was a publisher, and could do so without too great a financial penalty, JB sent many of his books as presents to his friends and to those acquaintances, such as King George V, whom he knew enjoyed them. Aware as he was that there is nothing better than 'word of mouth' in the sales of a book, the effort would not have been wasted. The personal inscriptions were often highly valued by the recipients, and these days presentation copies fetch good prices at book auctions.

Although JB never allowed himself to become part of a literary circle, he did cultivate the friendship of individual writers, one of them being Thomas Hardy, whom he asked out to GHQ in July 1917 (the great man couldn't face it), and with whom he exchanged books after the war. JB sent him volumes of his revised 'History' and Hardy wrote in reply: 'What a number of events have passed under your eye since the fateful day in 1914. You must be still a walking kinema of them: though

*Other important donations included £5,000 from Lord Rosebery to establish a Department of Manuscripts. Rosebery, a most avid reader and discriminating bibliophile, also gave many important volumes from his enormous libraries.
**JB left all the books that he had gathered on Montrose to the National Library of Scotland on his death. Many of his personal papers, as well as those of his wife, brother, sister and eldest son are also held there.

putting them down in a book does in a way get rid of them for a time.'[59]
In 1922 he sent JB a book of poems, *Late Lyrics and Earlier with many other Verses*. The latter replied with one of his gracious, literary aperçus:

> I love the flute notes especially, and they seem to become sweeter
> with every volume; but in the present one you have got at the very
> heart of seventeenth-century melody.[60]

In 1923, JB published *Midwinter*, a historical novel concerning the attempts by a Scottish soldier to rouse the English and Welsh Jacobites to join the cause, at the moment when Prince Charlie and his Highlanders are marching south towards London in 1745. It was dedicated, in verse, to Vernon Watney, who lived at Cornbury Park in Wychwood, where part of the action takes place. One of the subsidiary characters, and the most attractive, is a youngish, penniless, boy's private tutor, Samuel Johnson. His inclusion was homage to a man whom JB so much admired, and who had a close connection with his already beloved Elsfield Manor. He cleverly interposed well-known Johnsonian sayings into the dialogue.

In the book's preface, which is another of JB's historical conceits, papers about the Jacobite adventure – found at the back of a solicitor's office cupboard – purport to be written by James Boswell, and refer to a visit that they made to Francis Wise at Elsfield, when Johnson is forcibly reminded of some terrible events of his earlier life, about which he had always remained silent to Boswell. JB wrote:

> I had always felt keenly the romance of the Jacobite venture,
> but less in its familiar Scottish episodes than in the dreary ebb
> of the march to Derby, so I took that period for my attempt in
> *Midwinter* to catch the spell of the great midland forests and the
> Old England which lay everywhere just beyond the highroads and
> the ploughlands.[61]

In the inaugural issue of *The Listener* in 1929 he mused about the historical novel:

> I am told that the historical novel is a little out of favour to-day. It is
> suspected of dullness by those simple souls who like their fiction to

be an elaborated form of what they can read in their evening paper; it is accused of shallowness by those subtler spirits who believe that the word 'modern' denotes not a period in time, but a stage in values. This is to be beaten on both sides of the head. For the complaint against the historical novel used to be that it found its romance too cheaply, that it was apt to be a sword-and-cloak affair, a raw chronicle of adventure. It is hard that the popular taste should shy at it because it is believed to be high-brow, and the high-brow condemn it on the ground that it is popular.[62]

He went on to write that the historical novelist had imaginatively to reconstruct modes of life and thought with which he was not familiar (and past modes of thought are harder to realise than modes of living). The historical novelist had to think himself into an alien world before he could expound its humanity. JB believed that an historical novel had to demand the same scrupulous gift of selection, and the same austerity of conscience, as a biography required. 'It is easy to play tricks, and to startle with false colour and meretricious invention.'[63]

It seemed, however, that historical novels were for the Buchan connoisseur. Elsewhere he wrote that 'These were serious books, and they must have puzzled many of the readers who were eager to follow the doings of Richard Hannay or Dickson McCunn. That is the trouble with an author who only writes to please himself; his product is not standardized, and the purchaser is often disappointed.'[64]

They have never been nearly as commercially successful as his adventure and spy novels, but they provide some of the most satisfying reads in the canon and, moreover, they have dated less. Interestingly, he told Alice late in life that, on re-reading them, he had been surprised by the historical learning which they exhibited. 'It was not bogus, but thoroughly documentary!!'[65]

It is the lot of all successful published writers that they become, in one sense, public property. Certainly if a book absorbs the reader, he or she will often feel the urge to connect in some way with the writer, either to say how much they enjoyed or conversely disliked the book, or to put them right about some error in it. In JB's case, letters that he received were generally laudatory, but sometimes readers couldn't resist bringing up something that displeased them.

Because of the power, allure and range of his writing, he was probably more subject to this sort of thing than most. The letter-writers ranged from an outraged woman who wrote to scold him for allowing his hero to kick a greyhound in *Midwinter* when he stumbled over it at a moment of great danger and tension, to Arthur Balfour complaining – wrongly in fact – of a misprint in *The Moon Endureth*.[66] The most tiresome example was from a barrister who wrote to the publishers about *Mr Standfast*: 'In view of the likelihood of such an admirable book going into further editions I hope you won't think me very pernickety if I point out that Assistant Provost Marshals on Home Service do not wear the red staff marks, they wear blue.'[67]

Continuing with his mission to provide his readers with a book a year, JB produced another thriller in 1924, *The Three Hostages*. The dedication to 'a young gentleman of Eton College' merits quoting almost in full:

> HONOURED SIR, On your last birthday a well-meaning godfather presented you with a volume of mine, since you had been heard on occasion to express approval of my works. The book dealt with a somewhat arid branch of historical research, and it did not please you. You wrote to me, I remember, complaining that I had 'let you down', and summoning me, as I valued your respect, to 'pull myself together'. In particular you demanded to hear more of the doings of Richard Hannay, a gentleman for whom you professed a liking … [Hannay] was so good as to tell me the tale of an unpleasant business in which he had recently been engaged, and to give me permission to re-tell it for your benefit. Sir Richard took a modest pride in the affair, because from first to last it had been a pure contest of wits, without recourse to those more obvious methods of strife with which he is familiar. So I herewith present it to you, in the hope that in the eyes of you and your friends it may atone for certain other writings of mine with which you have been afflicted by those in authority.[68]

Close to the beginning of *The Three Hostages*, Sir Richard Hannay, now married and settled down in the Cotswolds with Mary Lamington (whom he met in *Mr Standfast*) and their son, Peter John, entertains a

254 BEYOND THE THIRTY-NINE STEPS

friend, Dr Greenslade. This man berates his friend for wasting time on detective novels:

> 'These shockers are too easy, Dick. You could invent better ones for yourself.'
> 'Not I. I call that a dashed ingenious yarn. I can't think how the fellow does it.'
> 'Quite simple. The author writes the story inductively, and the reader follows it deductively.'[69]

Greenslade goes on to say that the writer takes three things that have no apparent connection with each other, weaves a story around them, and the reader is satisfied because he or she doesn't realise that the author fixes on the solution first and then invents a problem to suit it. This was almost certainly the way that JB wrote his thrillers, but his success depended as much on the manner in which the story unfolds as the mystifying nature of the dénouement.

The Three Hostages has similarities to *Greenmantle* in that there is a riddle to solve, but this time the action takes place only in England and Scotland, often in ill-favoured London suburbs, and concerns the kidnapping of two young people and a boy by one of those evil geniuses with whom Buchan readers were by now thoroughly familiar. This time he is a deracinated Irishman, devilish clever and an inspired hypnotist. Hannay wins out in a frantic race against time, but in the end it is Mary who sees more clearly the way than her occasionally blockheaded husband.

JB liked and rated women, even if he was the opposite of 'a lady's man'. He sought out the company of intelligent, independent-minded women, such as Violet Markham (Mrs James Carruthers), Lady Mary Murray, Margaret Newbolt, Angela Thirkell, Enid Bagnold and Dorothy Gaskell, not to mention his sister Anna. And, although he saw the division of labour and function in marriage in those days as convenient and efficient, it is obvious from his strong support of women's suffrage, and his encouragement of female university undergraduates, that he was committed to the progress of women, both politically and educationally. He was certain that a woman should be her own person, rather than just an adjunct to her spouse.

As his fellow Scot Catherine Carswell recalled about a meeting with him in 1932:

> Most completely happy (his own words) in his marriage, his liking and sympathy went out to women of all sorts and ages. His approach was without effusion, as without shyness or suspicion. A traditionalist in so many respects, he was yet a champion of the modern girl, delighting in her independences, even in her defiances, frowning neither upon her sometimes extravagant make-up nor upon her occasions for wearing trousers. As among the goddesses, his preference was for Artemis.[70]

It *is* true, however, that his portrayal of women in his novels is a little tongue-tied and occasionally rather ridiculous. He confessed to Anna that she was far better at portraying women in fiction than him – which she was. In this respect he was no Sir Walter Scott. There are lively, intelligent, courageous, attractive heroines in the novels – Mary Lamington, Janet Raden, Jacqueline Warmestre, Koré Arabin, Alison Westwater and Anna Haraldsen, in particular – and there is one terrific villainess, Hilda von Einem, but his male characters mostly get the best lines. And, by making Mary Lamington just eighteen years old in *Mr Standfast*, he not only ensures that she is a most unlikely seasoned spy, but also makes her relationship with the much older Richard Hannay look a little creepy. Interestingly, although Susie steadfastly denied the fact, most of JB's fictional women have something of her about them. As Violet Markham put it, and she should have known, '… it is Susie, as I first knew her, who appears again and again in the high-spirited and attractive young women of the adventure stories'.[71] However, since JB, along with a great many of his male contemporaries, put his womenfolk 'on a pedestal' (in the words of his son-in-law),[72] it is not surprising if his female characters do not always entirely convince.

From his Elsfield vantage point, JB still looked north to Scotland but now also west across the Atlantic. His interest in North America was long-standing, the result of his admiration for an enormous country that, through its federal system, balanced its central and local authorities, and could thus be seen as a model for the evolving British Empire. In 1906, his friend F. S. Oliver had produced a well-received biography of Alexander Hamilton, the eighteenth-century

Scottish-bred revolutionary credited with a key role in drawing the fissiparous American colonies into a federation. As the years went by, JB increasingly saw the shared interest in democracy, the shared culture and heritage, as well as cooperation during the Great War, as comprising a potential force for good on a global scale. At least since 1917, probably as a result of the Russian Revolution, JB had become convinced that the alliance of the United States and Great Britain would be the 'greatest safeguard for the peaceful ordering of the world',[73] a theme to which he often returned.

Moreover, he had admired the writings of Walt Whitman and Henry Thoreau as a young man. In *Salute to Adventurers* he had extolled the richness and variety of North American 'nature'. On a personal level, he got on very well with many Americans and Canadians, having met countless journalists, soldiers and politicians during the Great War.

In September 1924, partly as a result of an invitation to give a lecture, partly because he had Reuters business to transact, and partly because they had friends clamouring to see them, the Buchans took off for their first visit to Canada and the United States. They left on 30 August on RMS *Empress of France* and docked at Quebec in early September. After a fishing holiday with friends, Robert and Elsie Reford at Grand Métis, they went to stay with William Lyon Mackenzie King, the Canadian Prime Minister, at Laurier House in Ottawa.* The Buchans had first met Mackenzie King through Violet Markham in May 1919, when they were still living in Portland Place.

King, who kept a daily, voluminous, often self-serving and misleading, but as often illuminating, diary, recorded his initial thoughts: 'I was much impressed with Mr Buchan's personality. He is a young man [he was forty-four, less than a year younger than Mackenzie King] of scholarly appearance, and a delightful quiet English manner.'[74] The two men kept in touch from time to time, corresponding on Canadian politics in particular. Mackenzie King, who had a disconcerting tendency to idolise people whom he had just met, only to undergo a process of disillusionment as they steadily refused to live up to his over-inflated expectations, wrote in his diary, after he had shown the Buchans around Laurier House, 'He is a charming man, a man I love with my whole heart.'[75] When they arrived in Ottawa, JB gave Mackenzie King a copy of

*The house in Ottawa that he had inherited from his predecessor, Sir Wilfrid Laurier.

his soon-to-be-published biography of Lord Minto, and had to endure a gush of sentimental flattery as a result. (Some people found this kind of thing intolerable: the wife of the British High Commissioner, Lady Floud, for example, declared that it was like being licked all over by the family cat and made her want to have a bath.)[76]

The next day was a Sunday and they were taken for a walk near Mackenzie King's country estate at Kingsmere in the Gatineau Hills. They set off up a hill but, before they got all the way, their host blindfolded them – surely an excruciatingly embarrassing experience for the reticent Susie – and led them to the top, where he removed the blindfolds so that they could enjoy the panoramic view of the Ottawa River valley. JB rose to the occasion gallantly by commenting that it was 'a real Pisgah's heights', a reference to Pisgah on the top of Mount Nebo, from where God showed Moses the Promised Land. He probably wondered whether he had gone too far but Mackenzie King, for whom there was no such thing as too much flattery, was thrilled by the association. He wrote about JB in his diary: 'I know no man I would rather have as a friend, a beautiful, noble soul, kindly and generous in thought and word and act, informed as few men in this world have ever been, modest, humble, true, a man after God's own heart.'[77] This weekend spent in each other's company was to have far-reaching consequences for them both.

From Ottawa, the Buchans travelled by train to Boston, to meet Ferris Greenslet, the literary advisor and director of Houghton Mifflin, JB's American publishers. Greenslet and JB had struck up a deep friendship, at least partly because of their shared fascination both with fishing and the American Civil War, and Ferris had promised to conduct the Buchans around some of the battlefields of Virginia.

The two men, who were the same age, had first met when, in early 1915, Greenslet had crossed the Atlantic to visit Charles Masterman at Wellington House and find publications that might tell Americans something about the European situation. Greenslet returned to England in January 1917 and spent time with JB, just about to become Director of Information, when they discovered a mutual love of fishing and 'we spoke the same language – largely Latin, after dinner. My rather Shandean sense of humor was matched by Buchan's mildly Rabelaisian turn.'[78]

The Buchans and Greenslet travelled together from Boston to Washington D.C., where JB's reputation, as a result of his war work, was

very high, amongst both soldiers and journalists. As he told his brother Walter: 'I went to the War Office where the Secretary for War [John W. Weeks] welcomed me, and called in all the Generals and we had a good pow-wow. Then I had half an hour with the President [Calvin Coolidge] – very good of him in the middle of his election.'[79] Greenslet, who sat in the outer office while this was going on, wrote: 'He came out after an hour, twice his allotted time, flushed and smiling. Asked what they had been talking about, he replied, "Latin poetry".'[80]

They then took off in a large, open-topped car, accompanied by the historian Professor Sam Morrison, for a ten-day tour of the Virginia battlefields, driving through Maryland to Antietam and Harper's Ferry, and then up the Shenandoah Valley. Equipped with Confederate battle maps, they followed the trail of Stonewall Jackson and his men. At Port Republic, they came upon the house marked on the map 'Lewis House', and found an elderly Miss Lewis sitting on the porch where she had sat on a June day in 1862, and watched General Taylor's Louisiana Brigade 'burst from the woods back of the house to capture a Massachusetts battery on its front'.[81] According to Greenslet, JB could tell his American companions the names of the Blue Ridge and Massanutten mountains without looking at the map.

It was a thrilling ten days for JB, especially as he had long had in mind writing a biography of General Robert E. Lee, the Confederate leader for whose generalship he had the greatest admiration. But when, at Richmond, he met the journalist and historian Douglas Southall Freeman, who guided them over the country of the so-called 'Seven Days Battles', from the Chikahominy River to Malvern Hill, he backed off, because Freeman had already begun his magisterial four-volume study of General Lee.

One idea that may have germinated from conversations with Greenslet on this trip was that of an historical novel concerning the hounding of 'witches' in seventeenth-century Scotland. Ferris Greenslet was a direct descendant of a woman hanged as a witch in Salem in 1692* and, not surprisingly, he felt very strongly about the matter. It is possible that the 'witch pricking' incident in *Witch Wood* developed from informed discussions between the two men about what Greenslet called 'Puritanism gone mad'.

*She was exonerated by the Massachusetts General Court in 1957.

The party went north to New York, where JB completed some business for Reuters, met old friends from the Associated Press, and was conducted around the Pierpont Morgan Library, 'an amazing treasure-house'. They then travelled up to the White Mountains of New Hampshire, to stay at Greenslet's country home. The next day the two men walked up Mount Chocorua, all 3,500 feet of it. Greenslet had climbed it before with G. M. Trevelyan, who, like JB, was a member of the Alpine Club, but this was altogether more taxing. 'Talking continuously, even on the steepest stretches, he accomplished the ascent in fifty minutes. Foaming at the mouth, but trying to look pleasant, I just managed to keep within sound of the one-sided conversation.'[82]

They then travelled to Milton Academy in Massachusetts, so that JB could deliver the War Memorial Foundation's* annual lecture.** His brief was to address 'the responsibilities and opportunities attaching to leadership in a democracy'[83] and he was invited on the strength of the final paragraphs of volume IV of *The History of the Great War* (quoted in Chapter 6); these had impressed the headmaster, since they so exactly expressed the spirit in which the War Memorial had been founded. JB had been pleased to oblige, because he thought it an imaginative way to commemorate the dead.***

He began by saying that the Great War had made them all for a time one household and went on that his object was to illustrate the continuity of history; he talked of what the British military learned from the American Civil War, since 'all the main strategic and tactical developments of the Great War were foreshadowed'.[84] He described the reasons why the North had won the Civil War, showing a knowledge of it that must have astonished the staff of the school. He discussed the greatness of Abraham Lincoln: 'Lincoln fought to prevent Democracy making a fool of itself, and if that noble but most brittle type of polity is to be preserved to the world, we have not done with the fight.'[85] This was his most important point: that democracies had sometimes to battle to preserve that 'brittle type of polity'. Greenslet recalled in his memoirs: 'I was astounded and charmed when the quiet, swift voice to

*Funded by money raised in memory of the twenty-two alumni who had died in the Great War.
**16 October 1924.
***He was in fact invited to give the inaugural lecture the year before, but was too tied up at Nelson's to contemplate a trip in 1923.

which I was accustomed deepened its pitch and increased its volume, taking on old cadences of the Kirk of Scotland, and an eloquence I had not heard since the brief church-going period of my own youth.'[86]

The Buchans then travelled back to Canada to stay with Viscount Byng of Vimy, Governor-General of Canada, at Government House in Ottawa. JB had first met Julian Byng in South Africa in 1902, when he was sitting on his haversack on a deserted station platform, wondering where he might next eat and sleep. 'Bungo' Byng had arrived at the head of a mounted column of men and given him supper, so beginning a lifelong, affectionate friendship. JB found him a most attractive personality, funny, intelligent, kindly and honourable, who, like Sir Walter Scott, talked to anyone he met as if they were a blood relation. A few weeks after he was sworn in as Governor-General in 1921, Byng wrote to JB: 'We have settled down – myself as governor general, i.e., a governor who doesn't govern and a general who cannot generalize and my better half as governess general.'[87]

He was much loved by the Canadian army veterans for, with the support of Lieutenant-Colonel Edmund Ironside, amongst others, he had led them to a profoundly important victory at Vimy Ridge in April 1917. Byng had a very excitable and unusual half-Greek wife called Evelyn, an enthusiastic gardener, who made a rock garden in the grounds of Rideau Hall (Government House) that survives to this day. She could not stand the Prime Minister, Mackenzie King, at any price, even before the so-called 'King-Byng thing'.

'The King-Byng Affair' was the constitutional crisis that blew up in 1926, when Mackenzie King wanted the Canadian Parliament dissolved for partisan political advantage, as Byng thought, and he would not agree to it. Constitutionalists argue to this day as to who was in the right, but no one argues about the political consequences: at the Imperial Conference in 1926 in London, Mackenzie King pressed for, and got, agreement that the Governor-General's role should be altered, and this agreement was enshrined in the Statute of Westminster in 1931. No longer was the Governor-General to be in any way the representative or agent of the British government in the Dominions; he would not be chosen by the British government but by the King, on the advice of the relevant Dominion government, and his effective power was all but extinguished. As JB put it in 1935, '[The Statute of Westminster] removed, with a few small exceptions, every shackle from a Dominion's sovereign power.'[88]

While staying with the Byngs, JB gave a number of public speeches and one in particular, which he delivered to the Empire Club of Canada in Toronto on 23 October, caused a great deal of interest. He spoke on 'Some new elements in British politics', referring to the earthquake that had shaken the political establishment, both in Britain and in the Empire, in 1923, when the Labour Party became the largest party in the House of Commons, shored up by the Liberals, with Ramsay MacDonald as Prime Minister. To have a Socialist government, albeit a minority one, in power in Britain, only six years after the convulsions in Russia that led to the Russian Revolution, was for many people, not just conservatives, alarming. Nine months later, and less than a fortnight before JB rose to speak in Canada, Ramsay MacDonald's government had fallen on a vote of censure, so JB felt it was time to tell Canada what was going on. What he said showed how percipient he could be about politics, and also that he paid much more than lip-service to the idea of democracy.

He pointed out the advantages of a new party, in bringing in new blood. For '… no country can afford to limit its election of rulers to one small social circle'. He also stated that British socialism was different from the Continental variety, its proposers being much more pragmatic: 'They cannot give up in a moment the fake creed they have preached on a thousand platforms, but they are practical men and Englishmen and they can recognize compelling facts. If they cannot formally discard their theories, they can neglect them. [Laughter].'[89]

Earlier that month, the Byngs had entertained the Prince of Wales (later King Edward VIII) on his way back to England from visiting his ranch in Alberta. Despite being warned by the Governor-General not to go to a private house, he had done so in the company of a married woman late at night after a dance. A furious Byng, anxious that such a story might get out and adversely affect Canadian opinion of the future monarch, told the Prince very firmly that he should not come back to Canada while Byng was Governor-General. He knew he had to tell the King what had happened, but was reluctant to put the news in a letter; instead, he gave JB the unenviable task of calling on the King with this tale on his return in November.*

*Sadly, but not surprisingly, there is no record of what JB said to King George V, or vice versa.

JB had been energised and diverted by his trip. His Atlanticism had been confirmed and, perhaps most crucially, he was now looking firmly to the future.

He once wrote that there was daftness in the blood of all Scots; certainly he was not free of such a thing. The older he grew and the more domestic and business responsibilities he acquired, the more hectic and irresponsible were the activities of his heroes in the fiction he wrote at the same time. It seems it was absolutely necessary for him to escape into a world of 'romance', as a counterweight to all the worthy enterprises in which he was engaged. There is a subversive strand in most of his novels, but nowhere more so than in *John Macnab*.

Initially serialised in *Chambers' Journal* between December 1924 and July 1925, and then published that July by Hodder and Stoughton, it was dedicated to Gerard Craig Sellar's sister, Rosalind Maitland. It is highly likely that some of the novel was written while he was on holiday at Letterewe with the Maitlands, as well as with General Stronach at Kinlochbervie. JB had heard about the exploits of a rather colourful soldier, Captain James Brander Dunbar, who, in the last years of the nineteenth century, had sent a gentleman's challenge to Lord Abinger at Inverlochy, telling him he intended to poach a deer from his estate. He succeeded, winning a wager of £20 in the process. When *John Macnab* appeared, Captain Dunbar wrote to its author, sending him pictures of both the 'head' of the stag he had poached and the cheque.

John Macnab should really be subtitled 'Eminent Men Behaving Badly' since it tells the story of how three friends – a senior banker (John Palliser-Yeates), a former Attorney-General (Sir Edward Leithen) and a Cabinet minister (the Earl of Lamancha) – discover that they are all suffering from a period of paralysing ennui and, remembering the exploits of 'Jim Tarras', they decide to write to three landowners in the Scottish Highlands, proposing to poach two stag and a salmon from them over a certain period, and signing the letters 'John Macnab'. This venture will require skill, guile, hard exercise and even danger, since the reputations of such prominent people will be placed in dire jeopardy if they are apprehended. They are aided and abetted by Hannay's old friend, Sir Archie Roylance, who, rather unbelievably, is a Unionist parliamentary candidate, and has to deliver his first speech at a political

meeting. This is a set-piece in the book, much as it had been in *The Thirty-Nine Steps*.

Although the three men prove themselves to be brave and skilful poachers – and it is pleasing to see the ultra-respectable Leithen, in particular, take on disguise and lie like a trooper – the real heroes of this book are the clever, outdoorsy girl, Janet Raden (referred to by the smitten Sir Archie as 'clean-run', as if she were a salmon!), the brash journalist, Crossby, and the clever 'tinkler' boy, Fish Benjie. The latter was based on an itinerant juvenile fish-seller who JB encountered when staying with Stronach in Sutherland.

John Macnab exhibits the love JB had come to feel for the Highlands, but it is a challenge to read for anyone who does not understand 'the lie of the land' as JB did, and must have mystified many a city-dweller who had never been near Scotland. There is an elegiac strain in it, ostensibly for the old life of a sparsely populated, impoverished area of the British Isles, but with a wider application. This elegy is spoken by Janet Raden, the daughter of a laird, and it may point to the way that JB's thinking was tending in the years after the war:

> The old life of the Highlands is going, and people like us must go with it … Nobody in the world to-day has a right to anything which he can't justify. That's not politics, it's the way nature works. Whatever you've got – rank or power or fame or money – you've got to justify it, and keep on justifying it, or go under. No law on earth can buttress up a thing which nature means to decay … People should realise that whatever they've got they hold under a perpetual challenge, and they are bound to meet that challenge … Papa and the rest of our class want to treat politics like another kind of property in which they have a vested interest. But it won't do – not in the world we live in today.[90]

Perpetual challenge is the key, both for people and nations. JB was describing not just the predicament of old-fashioned lairds in the Highlands, but the aristocrats of post-war Britain as well, who were thoroughly in retreat – paralysed by grief for the loss of their sons and circumvented by a new class of politicians who were keener to meet the multifarious challenges of the 1920s.

*

In early 1926, Violet Markham relayed to JB a message from the Canadian Prime Minister, Mackenzie King, in which he said that he would like him to be the next Governor-General of Canada and suggested that he get his friends to approach Stanley Baldwin, the British prime minister, about the matter. Although this was a decision that would still be made by the British government, Mackenzie King was determined to have a substantial say in it. JB, not surprisingly, told Violet Markham that he would not do anything to put himself forward and, in the end, the job was given to Viscount Willingdon, who had experience of being Governor of Bombay and then Madras, and would subsequently be Viceroy of India. Susie, in particular, felt that they had been marched up a hill, only to be marched down again, and this may have been the origin of her dislike of Mackenzie King, although it was not really his fault.

While sailing for home from Canada in early November 1924, JB had started to write *The Dancing Floor*, one of his most inventive and close-textured stories, influenced by Sir James Frazer's *The Golden Bough*. This is a more complex tale than *John Macnab*, for example, drawing, as it did, on JB's enduring interest in the survival of pre-Christian cults, which dated from his Oxford days under Dr Bussell's tutelage, and his memory of the house that he and Susie saw when cruising with Gerard Craig Sellar in the Aegean in 1910. The central character with the terrifying vernal nightmares, Vernon Milburne, survives into the novel from the earlier short story, 'Basilissa', but he is joined in the novel by Sir Edward Leithen and a girl who they both come to love, Koré Arabin, whose house is on a Greek island, where the climax of the action takes place. The plot revolves round the islanders, during a period of great hardship, abandoning Christianity for ancient pagan rituals, and turning against Koré as against a witch, because of her late father's depravities. She is saved by the courage of Milburne, the rationality of Leithen and the power of Christianity, the climax coming at the time of the Greek Orthodox Easter. The novel is carefully plotted; the only problem readers will have had was that the map in the first edition was orientated 180 degrees in the wrong direction. The book frightened Enid Bagnold, the author of *National Velvet* and wife of Sir Roderick

Jones, so much, that she had to fetch her Sealyham terrier in from the stable to keep her company while she read it.

The summer of the following year, 1927, was spent partly on the mountainous coast of the Isle of Mull. The house the family took was close to the River Lussa, where it entered the sea-loch, Loch Spelvie, so they caught sea-trout, watched eagles and otters, and did their best to avoid the many adders that made their home in the heather. JB, as was his custom, worked on a novel in the morning (*The Courts of the Morning*), fished for an hour until lunch, then walked or bird-watched with the children in the afternoons. On Sundays, when they were not allowed to fish, they would go on expeditions, for example to see the salmon jumping up the waterfall at Tor Ness. It was one of their happiest holidays. His son Johnnie recalled it:

> During our third week at Ardura the worst school report that I have ever had … arrived by the somewhat erratic post. My father was horrified by it. It was a close thundery day when the post arrived. Then the clouds broke and the whole valley was a smoking deluge of thundery rain. Within fifteen minutes it was reported that the river was rising.
>
> My father was a fisherman first. We grabbed our rods and all four of us tumbled down to the sea pool … When we came back – soaked to the skin – we were carrying a heavy basket up the steep slope to the house. Practically nothing was said about my report after that. It was talked over briefly, but without rancour, as one might discuss an unpleasant happening, reported in the newspapers, in some part of the world where Britain had no responsibilities.[91]

While on Mull, JB received a John Macnab-style challenge from three sporting Clydeside Labour MPs, but to his great regret he could not accept it as they were just about to leave the island.

Many Buchan fans will have taken a copy of the recently published *Witch Wood* with them on holiday that summer. Dedicated to his brother Walter, this book was born of the researches he had done over the years on the Marquis of Montrose, which had led first to his 1913 biography and would lead to a revised version, published in 1928. *Witch Wood* is the product of the keenest of historical sensibilities, and it lacks the obviousness of *John Burnet of Barns*, since by the 1920s

JB was vastly more at home with the speech patterns and thinking of seventeenth-century Scots. And he really minded about the subject. In a number of the historical novels he tried to explain the hideous perversion of religion represented by seventeenth-century Covenanting Protestantism, and the harm it did to Scotland, but nowhere was his hand surer than in *Witch Wood*.

He himself wrote of his novels that 'The best, I think, is *Witch Wood*, in which I wrote of the Tweedside parish of my youth at the time when the old Wood of Caledon had not wholly disappeared, and when the rigours of the new Calvinism were contending with the ancient secret rites of Diana. I believe that my picture is historically true, and I could have documented almost every sentence from my researches on Montrose.'[92]

In the novel, the Marquis of Montrose plays a crucial, if mostly offstage part, winning over the earnest, ardent and scholarly young Kirk minister, David Sempill, who has the cure of souls in a benighted parish in Tweeddale, called Woodilee and based on Broughton. Some of the self-righteous members of his congregation are in fact practising witchcraft in the Wood of Caledon; David determines to root it out, with the help of Katrine Yester, an idealised young gentlewoman straight out of a Border ballad, with whom he falls in love, as well as a few villagers of generally ill-repute. In the process he uncovers hypocrisy and licentiousness on a grand scale, but he brings down the wrath of his blinkered Kirk superiors, haters of the 'malignant' Montrose, lovers of 'church discipline', and deeply suspicious of Sempill's emphasis on Christian charity to all.

JB took more care over this book, particularly the psychology and the characterisation, than over his rollicking adventure stories, and devised some memorable characters, such as David's friend, Mark Riddel, Montrose's captain, whose denunciation of fundamentalist Bible literalism is a tour de force. In this story JB tackled antinomianism – as he did in *Salute to Adventurers*. Even more than sexual perversion, which he addressed in *The Dancing Floor*, JB detested religious perversion.

David Sempill is one of his most cherished character types: the scholar called to action (compare *The Free Fishers*). He is also one of the most complex. His character, without doubt, is based on the Reverend John Buchan. This is a book of light and shade, of paradisaical contentment and stark tragedy. Much of the dialogue is

in Borders dialect, already in rapid retreat by the 1920s. But the idiom (which is not difficult to pick up, and there are online dictionaries to help) adds mightily to the power of the language – as does the author's sure use of Biblical texts.

Witch Wood is the only example of JB writing a novel as a result of research for a biography. His revised and expanded *Montrose* was published the following year. As in 1913, the book was dedicated to the memory of his brother Willie. He had started to collect more material, in particular seventeenth-century pamphlets and contemporary accounts, as soon as the first book had been published, and began to write it during the General Strike of 1926, finishing it in March 1928.

He made a much better fist of the task second time round. It was 100 pages longer and much more nuanced in tone and fact. He said his aim was to 'present a great figure in its appropriate setting', making this an excellent guide for anyone confused about the precise nature of Scottish seventeenth-century religious struggles, part of what we now call the War of the Three Kingdoms. This book may one day be superseded in scholarship but it is unlikely ever to be bettered for readability. It won the James Tait Black Prize – the only literary award that JB ever achieved. Clarity of thought, brevity of expression, acute historical imagination, breadth of learning and courage of conviction were the hallmarks of his biographies, and *Montrose* exhibits all these qualities.

The strengths of *Montrose* are the ones you would expect: the vivid descriptions of weather and landscape, the understanding of military tactics, religious profundities and political wranglings, and the portrayal of a man of (usually) honour and integrity, a romantic hero born well ahead of his time. Montrose was committed to religious toleration, at a time when that was widely considered the Devil's work in Scotland. That, for JB, was his crowning glory. He told friends that this book contained much of his own philosophy of life. *Montrose* and *Witch Wood* are compelling expositions of the disastrous consequences of religious fanaticism – destructive both to society and to the faith it perverts.

One of the most thoughtful of all the congratulatory letters that JB received came from T. E. Lawrence in Waziristan, where he was stationed in 1928. He was reading *Montrose* 'inch by inch' – keeping it in the Wireless Cabin where he had to collect signals several times a day, and taking ten minutes off each time to read it:

I had not suspected, from my desultory reading of the Civil War, that such a man existed. The <u>style</u> of his last words on the gallows! And those profound memoranda on political science ... He has been unlucky in waiting three hundred years for a real biographer: but he must be warmly happy, now, if anything of his personality can still feel. You unwrap him so skilfully, without ever getting yourself in our way. The long careful setting of the scene – first-rate history, incidentally, and tingling with life, as if you'd seen it – and on top of that the swift and beautifully-balanced course of action. Oh, it's a very fine thing ... Too long, this letter. But I couldn't help telling you of the rare pleasure your book has given me. Its dignity, its exceeding gracefulness, its care for exactness and the punctilio of your manners, fits its subject and period like a glove. You've put a very great man on a pedestal. I like it streets better than anything else of yours.[93]

Elsfield and London, 1927–1935

JB's political ambitions had been slow to revive after the war. He resigned the Conservative and Unionist candidacy for the Peebles and Selkirk constituency (by this time Peebles and Southern Midlothian) in 1918 and turned down the offer of Central Glasgow, in succession to Andrew Bonar Law, in 1922. That did not mean that he was not thinking about politics or meeting politicians. In particular, he had grown to know and admire Stanley Baldwin, the mild-mannered, shrewd, politically conservative but socially progressive, rather lethargic ex-businessman, the would-be classical scholar who also loved the works of Sir Walter Scott. As for Baldwin, he had been a fan of JB's fiction ever since a day in 1902 when he had bought a second-hand copy of *The Watcher by the Threshold* at Paddington Station, and he responded positively to the younger man's keen intellect and lack of partisanship when he met him. From 1924, they began to collaborate on plans to expand Conservative education.

In 1927, on the death of Sir Henry Craik, JB was invited to stand as one of the three Members of Parliament for the Scottish Universities in the resulting by-election. He scarcely hesitated before accepting, since this constituency had the virtue, for a man in indifferent health, of not requiring him to do any of the wearing electioneering or speech-making that had been necessary when he was the candidate for Peebles and Selkirk. He had merely to write one election address, to be sent out by post to all the eligible voters, who were the graduates of the Scottish Universities.* He achieved 88 per cent of the vote.

*Plural voting, where graduates had two votes, one in their home constituency and one in their old university, was not abolished until 1948.

When he had first stood as a political candidate in 1911, there were friends uncertain as to which party he would espouse. In 1927 there was no such uncertainty, but he let it be known that, although he sat as a Conservative, since he was a firm believer in party government, he was an MP for the Universities and he would not be single-mindedly partisan. After he arrived in the House of Commons, he was apt to call members of other parties 'My Honourable Friend' if he knew and liked them, when the convention was (and still is) to do that only to those on your own side. As he wrote in a short story of 1910: 'Every man has a creed, but in his soul he knows that that creed has another side, possibly not less logical, which it does not suit him to produce. Our most honest convictions are not the children of pure reason, but of temperament, environment, necessity and interest. Most of us take sides in life and forget the one we reject."

As it happened, 1927 was a difficult year for the Conservatives. Large majorities cause their own problems, especially for newer members who want to get on, and the party had also been thoroughly shaken by the General Strike of 1926. The first major debate of the new session concerned the Trade Disputes and Trade Unions Bill, designed to outlaw secondary industrial action and ensure that there could not be another General Strike. Labour members thought the measure vindictive and were also fearful that funds from unions would decrease, since this Act required trade union members to contract *in* rather than *out* of the 'political levy'. All in all, the Bill had rather soured the atmosphere in the House.

Nevertheless, this was an exciting time for JB. Here was something he had dreamed of doing – if intermittently – ever since he was a young man, and he always enjoyed feeling that he was in the centre of the action. He had plenty of ready-made friends in the House of Commons: Lord Hugh Cecil, who was MP for Oxford University; Philip Snowden; Walter Elliot from the Borders; and Leo Amery, the imperialist thinker from South African days. He soon made more friends, such as Oliver Stanley, W. S. (Shakes) Morrison, Robert Boothby and Harold Macmillan. Members of Parliament were genuinely fascinated

*John Buchan, 'A Lucid Interval', collected in *The Moon Endureth*, William Blackwood, Edinburgh, 1912.

to meet him, since he was a celebrity.* And he developed a broader acquaintance than most, for he was on good terms with many in the Labour Party, and seemed able to draw out the best from even that dry old stick, Clement Attlee.** The latter thought him a most delightful man and a very broad-minded one – 'a romantic Tory, who thought Toryism was better than it was'.¹ Even the wilder Glasgow members, such as James Maxton, a 'Hutchie bug' like JB, Tom Johnston and David Kirkwood, did not scare him, despite Maxton having been imprisoned for a year during the Great War for promoting strife in the shipyards. These men found JB friendly, sympathetic and non-partisan, and he liked their humour and egalitarianism. However, his propensity for speaking kindly of most people meant that he was open to the charge of insincerity and even, occasionally, toadyism.

Life changed substantially for JB when he became an MP. Instead of commuting daily to London, he left Elsfield on a Monday morning and came back on Friday afternoon. Susie travelled up to London sometimes to join him, particularly if they had accepted a dinner invitation, but she was happy to stay mainly in the country. He would lodge with his mother-in-law in Upper Grosvenor Street or (more conveniently for the House) with her hospitable sister, Blanche Firebrace, in Buckingham Palace Gardens; but more often he slept at St Stephen's Club, a haven for Conservative MPs, close to his office in St Stephen's House and across the road from the Houses of Parliament. If not invited to dine out, he would eat mainly in the House of Commons or in one of his clubs. He wrote to Susie every day, the letters a mixture of concern for her, the children and their doings, a list of the people he had dined with, and political gossip – a distillation of the day's events, fleshed out no doubt over dinner on Friday. Mercifully for Susie, his letters were often typed by Lilian Killick, for they were practically illegible when he wrote them on his knee while listening to a debate in the House.

*Ellen Wilkinson, the Labour MP for Middlesbrough, was introduced to JB by Lady Astor, when he was showing the famous American aviator, Charles Lindbergh, round the House of Commons. 'Lindbergh was an interesting and charming youth, but I confess that at that moment I was more concerned in taking stock of the Scotchman's rugged, unusual face. Buchan is delightful to meet.' 'Men in the Commons', *Evening News*, 8 May 1928.

**Clement Attlee, later 1st Earl Attlee, was Labour Prime Minister between 1945 and 1951.

Private letters, especially those to his family, did not often bring out the best in JB as a writer. Once his youth was past, he saw letters as a means of keeping in touch, rather than – except on rare occasions – displaying his feelings or his personality and interests. He wrote so many, particularly to his mother and his wife, that they have a rather deadening sameness to them. They were the early twentieth-century equivalent of the nightly telephone call to reassure the recipient that they are loved and all is well. Only at times of triumph or disaster did he expand in his letters to his mother. Those to Susie were not very different, except that he would ask for her advice, especially on family matters, and he rarely, if ever, failed to tell her how much he missed her. His letters to his children, as they grew, were affectionate, perceptive and engaged. Any criticism was lightly done, while praise was heaped on honest effort in any field.

He spent his mornings either at Paternoster Row or at Reuters' headquarters in Carmelite Street. He would lunch with political colleagues in the House, pass the afternoons sitting on Parliamentary Committees or charitable trusts and, after dinner, would spend the rest of the evening in the House, listening to debates or waiting to vote. It was a pleasant, orderly, thoroughly masculine existence.

Although he took his seat in May 1927, he bided his time before delivering his maiden speech. The occasion he chose was the vote of censure moved by the opposition leader, Ramsay MacDonald, on 6 July against the government's proposals for reform of the Parliament Act, on the grounds that these were unconstitutional. These proposals, which had been developed by, amongst others, the Lord Chancellor, Lord Cave and Lord Birkenhead (F. E. Smith), were designed to restore some of the powers to the House of Lords that had been ceded in 1911. By 1927, however, attitudes had altered, and these proposals were causing disquiet even in die-hard Tory circles, especially as the House was at that moment embroiled with the contentious Trade Disputes Bill.

The censure debate began with a speech by MacDonald. He was followed by the Prime Minister, who defended his noble colleagues' plan but made it pretty plain that his heart was not in it. JB, knowing that he had 150 of the more progressive Tory members at his back, then rose to his feet and criticised the Labour leadership for wanting to censure the plans but also the Tory government for supporting such backward-looking proposals. His thesis was that the Parliament Act had

turned out surprisingly well and that, although the British constitution had many anomalies, it nevertheless appeared to work. He went on to say that the argument used for Cave's scheme was fear of some revolutionary intention on the part of a future Government. There was no worse cant talked in public life, he averred, than the cant about revolution:

> ... whether it is used by those who hanker after it or by those who fear it ... I am as credulous and as imaginative as most men, but my imagination and my credulity cannot rise to these apocalyptic heights. But suppose there was any such danger of revolution, how could any paper barrier prevent it? There will be no revolution, no constitutional revolution, in Britain until the great bulk of the British people resolutely desire it, and if that desire is ever present, what Statute can bar the way?[2]

In his speech he also quoted Edmund Burke:

> The old building stands well enough, though part Gothic, part Grecian, part Chinese, till an attempt be made to square it into uniformity. Then, indeed, it may come down upon our heads altogether in much uniformity of ruin.[3]

It was a nimble and witty speech, with graceful allusions to seventeenth- and eighteenth-century precedents, and it was endorsed by both David Lloyd George, who called it a brilliant, wise and eloquent maiden speech, as well as by Winston Churchill, both men who he might not have expected to back him. One Liberal MP, Lieutenant-Commander Kenworthy, said his speech could not have been made more damaging if it had been delivered from the Liberal benches.

JB told his mother the next day, in a long letter euphoric from relief: 'I never started anything in such poor form. I was feeling very tired and not very well, and it was horrid, hot, muggy weather. To make things more difficult "The Times" announced that I was going to speak, and the whole stage was set as if I had been a Cabinet Minister ... Besides, I was going to attack the [Tory] Government and try to get them to drop this foolish House of Lords scheme, which would split the party, and that is not an easy job for a new Member, especially when

the Prime Minister is an intimate friend.' Matters were not helped by
Stanley Baldwin not saying exactly what JB was expecting him to say,
so he had rapidly to recast his speech. He rose to his feet at about
5.30 p.m., 'with a very empty House, in which interest was absolutely
dead. You know I am not often nervous, but my legs knocked together
and my mouth was as dry as a stick!' He spoke labouredly at first, but
as the word went round that a maiden speech was in progress and the
House filled up, he began to enjoy himself. He spoke for more than
twenty minutes and was cheered to the echo, so that Lloyd George
had to wait several minutes before he could begin. 'I had a ludicrous
amount of congratulations, which I must store up against the day
when I shall make a fool of myself.'[4] He particularly enjoyed telling his
mother how pleased the Clydeside Labour Members had been, coming
up as a group to congratulate him. Maxton told him, 'Man, we were
terrible nervous when you began, for we thought you weren't going to
get away with it, and we were awful happy when you got started!'[5] To
Henry Newbolt, JB wrote: 'I got on surprisingly well, but my goodness!
I was in a funk at the start. There is no doubt that the thing that pays
in life is audacity. We have killed this foolish scheme, and Baldwin told
me privately that I had done him a great service.'[6]

James Johnston, a political commentator, wrote that he had heard
many maiden speeches, but none that made such an impression on
him and the House. He thought the voice sometimes had something
of the 'Free Kirk whine' about it, but was generally a pleasant blend of
Scotland and Oxford. However, it did not match the golden quality
of the words. He thought the speech statesmanlike in the noblest
sense 'for it exhibited a mind which does not live on catchwords and
stratagems but on great fructifying ideas'.[7] *The Spectator* stated: 'The
wide knowledge of a student of history, the grave enthusiasm of an
ardent patriot, the pawky commonsense and shrewd realism of a
Lowland Scot, the deep sympathy and understanding underlying the
whole, and the impressive eloquence of the final passages, combined
to give this speech an unusual distinction, and to place it upon a
plane far above the level of ordinary Parliamentary debate.'[8] JB gave
an equally accomplished speech a few weeks later on the history of
the Union with Scotland, and the benefits it had brought, which
may have surprised MPs by its mixture of wit and erudition. All this
augured very well.

Later that year, a measure came before the House that thoroughly engaged his interest. It concerned changes to the liturgy of the Book of Common Prayer, which had been accepted by the ecclesiastical authorities but which had to come before the House of Commons, since the Church of England is established and subject to statute. The Book of Common Prayer dates from 1662, but is close to that devised by Archbishop Cranmer during the previous century. The language was already archaic by the seventeenth century and, by the early years of the twentieth, was causing disquiet to Anglican clergy – although not their congregations, who generally were keen to keep to the old ways. The modifications that the Church of England advocated were not substantial, but they were unacceptable both to Low Churchmen, who thought them too Romish and, to a lesser extent, to High Church Anglicans, who thought they were too Calvinist.

This debate produced a great deal more heat than light, since MPs, especially Evangelicals, seemed to wish to fight the Reformation all over again, and it needed the cool intelligence of a man bred in another tradition to try to bring them back to some sense of the point of the debate, namely the constitutional rather than liturgical implications of a measure that the Church of England hierarchy was impatient to implement. Although raised in a different Church, JB knew a great deal more than most of his colleagues about the history and content of the prayer book that they clung to. He attended a Book of Common Prayer service every Sunday in Elsfield, and was well versed in church history.

In an elegant speech he tried to tear the debate away from the metaphysical and back to the pragmatic. He likened MPs to Milton's fallen angels 'in wandering mazes lost'. He owned that there was a fear that the measure was a denial of Reformation principles and a departure from the Reformation heritage, but maintained that, since England was a Protestant country, he regarded the Reformation settlement as an implied part of the Constitution. It was masterly because it was so clear.

> [The Reformation] was a re-birth of the spirit of man. Its essence was simplification. The great organism of the mediaeval church, with all its intricate accretions of fifteen centuries was exchanged for a single revelation, the voice of the Almighty speaking through His word to the individual heart and judgement ... Liberty was its keynote,

liberty as against enforced obedience. It involved in a reformed Church a certain degree of self-government and that involved the right to change ... But what I would press upon the House is that this liberty to change, with all its imperfections – this liberty to change with popular approval – is the very opposite of the authoritarianism against which the Reformation was directed.

He went on: 'The Promised Land remains the same; its direction is the same; but there are various routes to it across the desert.'[9]

The Evangelicals were not having it and the vote was narrowly lost. The following summer, the measure came again to the House, and again the vote was narrowly lost. This time JB did not speak. Some parishes adopted the 1928 Prayer Book, illegally, but it took until the 1970s before the Church of England felt able to have another crack at modernising church liturgy, and this time it succeeded.

Besides the Constitution and religious practices, JB concentrated, as most backbenchers did, on a ragbag of worthy concerns, in his case tending mostly towards safeguarding and improving the lot of the general population: Scotland, including whether there should be a Scottish Parliament;[10] education, both of children and adults, including attempts to raise the school leaving age to fifteen; protecting workers' rights; the Empire and free trade; the countryside and its protection; the media, including films, and their use for education and entertainment; and the cause of a national homeland for Jews. He spoke on a variety of subjects, from unemployment to greyhound racing (he tried unsuccessfully to get a Bill through Parliament to regulate it), to the importance of air power in any future conflict. He managed to get a Bill through Parliament to outlaw the capture and caging of British wild birds in 1933. (The more substantial Protection of Birds Act of 1954 was piloted through the Commons by his daughter-in-law Priscilla Tweedsmuir, MP for Aberdeen South, while his son Johnnie saw it through the Lords.)

In the summer of 1929, Ashridge House in Hertfordshire opened as a residential college, training lecturers and providing public lectures and discussions, and in effect promoting the development of a corps of educated young Tory thinkers. JB was made chairman of the executive committee. Those trained at Ashridge College of Citizenship went out to influence opinion in the universities, under the auspices of the Federation

of University Conservative and Unionist Associations, founded in 1931, with JB as its first President. (He chaired and spoke at every annual conference of the Federation until he left for Canada in 1935, exhibiting his keen interest in developing political consciousness in the youthful.) The infusion of 'one-nation' Conservative values and ideas promoted by Ashridge and the Federation galvanised the intellectual wing of the Conservative Party in the years before and after the Second World War.

In 1928, JB joined the Central Council for Broadcast Adult Education, which was set up by the British Institute of Adult Education (BIAE, formed 1921) and the BBC. The following year the BIAE collaborated on a widely consulting commission, looking at educational and cultural films. The report, 'The Film in National Life', published in 1932, provided the intellectual underpinning for the foundation of the British Film Institute (BFI) in 1933. In May 1932, JB had suggested, during a debate on the Sunday Entertainments Bill, that 5 per cent of Sunday cinema takings should go to the assistance and development of British films:

> What those who are interested in the matter desire to see is something positive, a constructive effort to help in the development of this great medium of instruction and entertainment … The idea is ultimately the creation of a film institute, not a Government Department but a private body with a charter under the aegis and support of the Government.[11]

The purposes of a film institute, as he saw it, would be: to act as a school for the study of technique and interchange of ideas; to improve public taste; to provide advice to teachers about the educational possibilities of film as well as government departments on the use of film; and to secure the development of the assets for film production that the country and Empire possessed. His idea of a levy was accepted, the Institute was set up by Royal Charter, and JB became one of the nine founding Governors, and Chairman of the Advisory Council.

His interest in the BBC (as with the BFI) stemmed from his post-war preoccupation with the importance of informing and educating the general public, if it were not to fall prey to the kind of demaguery that had seduced the masses in Russia in 1917, and was affecting Germany and Italy. He was a supporter of it against its early critics in Parliament, although not a completely uncritical one: 'We have not had many

pieces of good fortune as a nation since the War, but I think that one of them has been the Broadcasting Corporation.'

He went on to say, in a passage arguing against censorship:

> I see no reason why a Communist should not be allowed to broadcast his beliefs and the reason for them. Incidentally, I cannot imagine anything more damaging to Communism ... Truth ... comes from an honest clash of opinion and not from the suppression of it. Controversy, honest, straightforward, well-regulated controversy is the only salt which will save a most valuable side of broadcasting from going rotten. After all, we can trust our people. The British Broadcasting Corporation, as it has grown up today, is a peculiarly British product, and, like all our true indigenous products, it is based upon a trust in the ordinary man.[12]

As a result of his interest in the issue, JB joined a cross-party consultative committee to advise on controversial political talks.

In November 1929 he took the trouble to articulate his political creed in an article in *The Spectator* entitled 'Conservatism and Progress'. He began by writing that he disliked the word 'Conservatism' since it seemed to connote the duty of preserving always, at any cost, when the real duty may be that of ruthless destruction. 'It suggests an antagonism to rational change.' He preferred to be called a 'Tory' since it originally meant an Irish robber and he thought a bandit had a more hopeful attitude to life than 'he who cherishes relics which should long ago have been buried or burned'.

His was a humane doctrine, rejecting the idea that society could be fully comprised by any set of categories. '[The conservative] is inclined to be suspicious of mere logic and highly suspicious of all abstractions. He dislikes undue simplifications and anything that savours of mechanism ... The problem in all politics is how to give to actual human beings the chance of a worthy life.' In his view, conservatives (with a small 'c') had no passion for change for change's sake but, when the case for change was clear, they would act boldly, for they set no sentimental value on a tradition which had lost the stuff of life:

> The two great problems of today in the widest sense are, I take it, the business of reaching a true democracy, where everyone shall be

given a chance not only of a livelihood, but of a worthy life, and the business of building up some kind of world-wide regime which shall ensure peace and co-operation between the nations.[13]

Some of JB's critics have accused him of Fascist sympathies on the basis of an article that he wrote for *The Morning Post*, published on the last day of 1929. It looks dashed off, probably on Boxing Day, and is a not very interesting overview of global politics in the preceding decade, in which he noted the decline in parliamentary institutions and the rise of dictatorships in a number of countries. He praised the new kind of imperial unity (since 1926) based 'on the completest liberty of the constituent parts' and went on to write that but for that, and 'the bold experiment of Fascism',[14] the decade had not been fruitful in constructive statesmanship. However, in his opinion, the post-war recovery of European countries such as Italy and Germany had much less to do with a creed or a man than with ordinary people working hard. His true and considered political views are clear from his many other expressions of support for democracy, moderation and pluralism; it is indicative that a little more than a year after the *Morning Post* article, he began the contemporary novel, *A Prince of the Captivity*, in which he describes a sinister and murderous German political brotherhood, plainly based on the Nazi Brownshirts.

In 1928, Hodder and Stoughton brought out a collection of his short stories, *The Runagates Club*. The genesis of these tales was various, some of them having already appeared in *The Pall Mall Magazine*, but JB gave them unity by declaring them stories told after dinner at the fictional Thursday Club. The fifteen members of the club include a number of Buchan stalwarts – Hannay, Arbuthnot, Leithen, Lamancha, Palliser-Yeates, Sir Arthur Warcliff – but others, such as Major Oliver Pugh, are introduced for the first and only time. Most have had exciting, sometimes secret, jobs in wartime. (Dominick Medina, suave villain of *The Three Hostages*, is a member of the club until his demise.) JB reproduces the Clubland atmosphere that he enjoyed, although it must have been rare in real life to hear such a collection of cracking tales, however distinguished the company. Like JB, these men are not your average club buffer but classically educated men with a taste for the apposite Biblical quotation. In the Preface he writes of the storytellers

and the varied lives they have led – 'the ornithologist had watched more perilous things than birds; the politician had handled a rougher humanity than an English electorate.'[15]

One feature of these stories, especially those written in the 1920s when JB was a thoroughly assimilated Establishment figure – and on the surface a very conventional one, climbing his way, hand over hand, up the pole to worldly success – was how unconventional they can be. A number of tales in *The Runagates Club* run counter to the world's expectations and expose the fears in every secure person's breast.

In 1932 life imitated art when JB met Rudyard Kipling at a luncheon of The Club, and the talk turned to the rhythms and assonances of the King James Bible and how it was that such a wonderful style was the product of compilers who were theologians and linguists, not writers. JB raised the intriguing possibility that they might have consulted William Shakespeare or Ben Jonson, and Kipling leant across the table and asked JB whether he could use the idea 'much as he might have asked for his fellow-member's portion of gooseberry fool, should Buchan not happen to want it himself'.[16] The result was one of Kipling's last short stories, 'Proofs of Holy Writ'.

JB's next full-length novel, *The Courts of the Morning*, came out in 1929 and was dedicated to Ferris Greenslet, with a poem about the similar delights of fishing on each side of the Atlantic. Hannay has only a walk-on part in this novel, while Leithen appears not at all. This is Sandy's show, the man who grew more and more like T. E. Lawrence as the books went on; the guerrilla insurrection that he leads in a fictional South American republic, called Olifa, might well have appealed to Lawrence. As James Buchan has pointed out, Olifa is the Arabic word for 'friendship', the working title for the book was *Far Arabia*, and the landscape of desert and coast looks like the northern Hijaz, the scene of some of Lawrence's military exploits during the Great War. *The Courts of the Morning* is a complex tale about loyalties, intervention, mercenaries, moral equivocation and unlikely redemption and, pleasingly, the women – Barbara Dasent, who eventually marries Sandy Arbuthnot, and Janet Raden, now Lady Roylance – have just as much courage and mental strength as the men.

This story doesn't really work, the topography as well as the politics and military tactics* being too complicated and long-winded to be truly engaging, although there are some memorable scenes in it, such as the description of the Poisonous Valley into which the hapless Archie Roylance crash-lands his aeroplane.

The year 1929 turned out to be a difficult one for JB. A general election was held at the end of May, under the shadow of rapidly increasing unemployment, and the Conservatives, who campaigned on the slogan 'Safety First' – which JB thoroughly disliked – lost more than 150 seats and had to give way to Ramsay MacDonald's Labour Party, in a hung parliament. JB kept his seat but lost 10,000 votes. He also lost a number of Parliamentary colleagues, in particular Harold Macmillan, although he got back in two years later.

Although JB had no electioneering of his own to do, he spoke for others, travelling long miles, especially in Scotland, during the election campaign. The upshot was that he had to take to his bed for much of the summer and autumn, only going out publicly once to give an address on Mary, Queen of Scots, in Peterborough Cathedral in late July. He scarcely appeared in the House of Commons at all that year and, when his contract with Thomas Nelson and Sons ran out in November, he did not renew it, thus breaking a connection that had lasted for nearly twenty-three years.

Thanks to his capacity to write when ill, however, he spent his time at Elsfield composing a contemporary 'comedy', which appeared the following summer. This was *Castle Gay*, a title that only became ambiguous long after his death.

In this comedic, tongue-in-cheek thriller, Dickson McCunn has a minor role, for he is outshone by two of the Gorbals Die-Hards, Jaikie Galt and Dougal Crombie, whom he had more or less adopted, and who are now young men. They have done him proud; indeed, the book begins with a stirring account of Jaikie scoring a try for Scotland in a rugby international. This is a tale about an unctuous newspaper proprietor, Thomas Carlyle Craw – a mixture, JB said, of Lord Rothermere and Robertson Nicoll – who, despite a keenness to

*Basil Liddell Hart put it on the reading list in his book, *The Future of Infantry*.

ruin other people's privacy, obsessively guards his own. He is kidnapped by students for a rag and, during a week of enforced tramping in the Lowlands and an encounter with disreputable Central European republicans, he learns something about himself and humanity. It is salutary to note that this book (as with the short story, 'The Last Crusade', included in *The Runagates Club* collection) shows that JB perfectly understood the concept of 'fake news'. This novel also contains the beginnings of a touching love story between a scion of a played-out Highland aristocratic family and Jaikie, one of the most appealing and well-realised of JB's creations, which continues in *The House of the Four Winds*. This is a liaison that a 1920s readership may not have been expecting, but it is true to JB's beliefs in the efficacy of private charity and the inherent greatness of all humanity.

To make up the shortfall in income, when he left Nelson's, JB began to write well-paid celebrity columns for *The Graphic* (not unlike those for *The Spectator* in tone and range), as well as the rather more down-to-earth *Daily Express*. He also wrote the *Atticus* political gossip column in *The Sunday Times*, where he could utilise his knowledge as a House of Commons insider. In the early 1930s he achieved an income of about £9,000 a year.

By the turn of the decade his children had grown up to be the not unusual mixture of anxiety and pride to their parents. Alice was taught well by governesses at home, before being sent, aged about sixteen, to a small, cosy 'finishing school' in a suburb of Paris, to learn some domestic practicalities as well as French culture. On her return, she submitted to more than one London Season, when her parents took a house in Westminster for six weeks in the early summer, so that they could play host at parties, and escort her to dances. After that, she petitioned her parents to allow her to train to be an actress and, despite her Scottish grandmother's forthright protestations (in some quarters, acting for women was thought to be almost tantamount to prostitution), and the disapproval of the stout phalanx of Stuart-Wortley aunts, she got her way. Alice wrote years later: 'My mother with sublime moral courage faced the drawn-down upper lips and raised eyebrows of her relations ... found me respectable lodgings in London ... and paid my first term's fees at the Royal Academy of Dramatic Art.'[17] Although JB never much enjoyed the theatre, claiming that plays sent him to

sleep, he was punctilious in attending her performances, and thought her a very gifted speaker of Shakespearean verse. She also published a novel in 1931, and wrote a short play about Guy Fawkes, which won first prize in the Oxford Drama Festival and was produced at Elsfield, with JB acting the part of Sir Thomas Tresham and Alice the Countess of Hatfield. She won a national poetry recitation prize. However, she suffered, periodically, from a similar aimlessness to that which had beset her mother in youth.

Meanwhile, Eton was turning out to be a mixed blessing for the boys. They had been happy enough at the Dragon School in Oxford but the move, aged thirteen, to the most famous public school in England proved a challenge for them. Johnnie was always happier at home, fishing or flying his falcons – although he was consoled by being allowed to keep a kestrel in the school laboratory – but he generally behaved himself. He gained a place at Brasenose College, and 'went up' in the autumn of 1930. He spent much of his time there rowing for his college. While at Oxford he flew peregrine falcons and then acquired a goshawk, called Jezebel, who was, according to his father, his soul's delight. He spent one summer vacation on a scientific expedition to the recently evacuated (and now permanently uninhabited) island of St Kilda beyond the Outer Hebrides and another working as a deckhand on a Hull fishing trawler.

Alastair and William were even less enamoured of Eton than Johnnie and had a habit of bumping up against authority, and were beaten for it. Alastair was, in adolescence, a rebel, while William became unhappy and stopped studying. Their tribulations prompted expressions of affectionate exasperation from their father, but whether he really saw their predicament clearly is uncertain, since his imagination, strange to say, occasionally failed him. Three of his four children were at times wayward and awkward, not entirely impressed by Border and Presbyterian values and, with the exception of Alastair, less capable of the swift and hard work that came so easily to JB, nor the sturdy self-discipline that made it possible. But a source of their difficulties (if that is not too strong a word) was JB's own celebrity. A man whose most ordinary goings out and comings in were frequently cause for a column inch or two in *The Times* was not like other fathers. So the intense pride that his children felt in him was sometimes overlaid by acute frustration. William, in particular, squinted in the glare of

his father's magnificence, since he wanted to be a writer, the pre-eminent field in which his father laboured. In fact, his father always encouraged him to write, praised his poetry and was later to tell Alice that he thought the boy 'the literary genius of the family'.[18] William often felt the lack of his father's presence. He wrote later about the difficult or remote fathers of his schoolfriends: 'By comparison my own father seemed a different kind of being: cleverer, swifter-moving, more humorous, and infinitely more approachable – when, that is, he was there to approach.'[19]

Things improved for William in his last year at school, when he found the energy to produce, with a friend, an ephemeral magazine entitled *Masquerade*, in the process of which he learned something about publicity, marketing and publishing, which served him well in adult life. Even here, his father was hovering, anxious to help him, in this case unhelpfully. JB produced a short story for *Masquerade*, which he later expanded into the novel *The Island of Sheep*, but he asked his contemporaries to write pieces as well. These included J. M. Barrie, Henry Newbolt, Father Ronald Knox, Harold Nicolson and Noël Coward; with the exception of the last named, what a collection of embarrassing dinosaurs they must have seemed to a couple of eighteen-year-olds.

In Oxford University term time, the Buchans reserved Sunday afternoons for entertaining undergraduates to tea. These young people were friends of Johnnie's, or the offspring of their friends, or students whom JB had met in one of the undergraduate societies of which he was a patron or president, such as the Oxford Exploration Club. Wilfred Thesiger was one of these. Janet Adam Smith, the daughter of the Principal of Aberdeen University, George Adam Smith,[*] first met JB, whose biography she would one day write, at one of these tea parties:

This was perhaps the characteristic Elsfield occasion, and to the Buchans an unpredictable one, for anything from one to thirty might

[*] JB collaborated with the Reverend George Adam Smith in writing *The Kirk in Scotland: 1560–1929*, Hodder and Stoughton, London, 1930.

turn up – 'the Amalekites'* the family called these invaders. There
would probably be guests staying at the Manor – Violet Markham, or
the Amerys, or the Robert Cecils – who would give the undergraduates
a fresher view of the world of politics or government than would be
found in the North Oxford drawing-rooms they visited. Not that
there was any talking-down by the seniors: in the conversation round
the large tea-table, which was often general, everyone was encouraged
to talk (as in the Buchan home in Glasgow) and everyone was listened
to – at least by the host, if not by his own contemporaries. It was not
quite the talk of Oxford; cleverness cut less ice here, speakers had to
be ready to back up their views with facts.[20]

It sounds rather alarming, but the hosts were so kindly that many a
shy 'undergrad' retained for their entire lives a happy picture of Elsfield
Manor and its occupants in the 1920s and early 1930s.

Susie enjoyed these afternoons greatly, since she could talk (or, more
happily, listen) about books, politics or genealogies with a small group
of clever, polite young people, who did not hide their admiration for
her husband. JB recalled in his reminiscences that 'there was a legend
in the family that wherever one went on the globe one would meet
somebody who had been to Elsfield. These guests were of every type –
Blues, hunting men, scholars, Union orators, economists, poets – and
of every creed from Jacobitism to communism.'[21]

A. L. Rowse, a Socialist, found a calm welcome at Elsfield. He
reminisced rather sadly after JB's death about the latter's 'extraordinary
catholicism of sympathy ... In fact, I believe it was a special
recommendation with him that one was on the other side ... With one
young neophyte of the Left, ardent, impatient, fanatical, touchy, he was
patience and courtesy itself.'[22] The Buchans retained their interest in,
and affection for, Rowse, looking in on his Labour Party headquarters
at Falmouth, while holidaying in Cornwall, to wish him luck during his
election campaign in 1931.

The story of the friendship between T. E. Lawrence and JB, which
developed in the Elsfield years, bears retelling, since this maverick

*A nomadic tribe who persecuted the Israelites – rather an unkind family joke.

figure – romantic, quixotic, tortured, sensitive, prickly, conflicted, masochistic, brilliant – was very important to JB. He said about Lawrence, uniquely, that he could have followed him over the edge of the world. JB had succeeded in reconciling the antithetical sides of his own nature, but he understood and could not condemn the fissure in Lawrence's: the 'eternal war between what might be called the Desert and the Sown – on the one side art and books and friends and leisure and a modest cosiness; on the other action, leadership, the austerity of space'.[23] He was perfectly aware that Lawrence was 'an agonist, a self-tormentor, who ran to meet suffering halfway. This was due, I think, partly to a twist of puritanism, partly to the fact that, as he often confessed, pain stimulated his mind; but it was abnormal and unwholesome.'[24]

The two men met about half a dozen times a year when the Buchans were at Elsfield; Lawrence would arrive, usually unannounced and often on a Brough Superior motorbicycle, and disappear as quickly as he came. Conversation with him was an intense pleasure to JB, since they had much in common, talking about anything from the works of C. E. Doughty to *The Odyssey* to ideas on Empire. Lawrence knew more about the history and technique of war than any general JB had ever met:

> If you were once admitted to his intimacy you became one of his family, and he of yours; he used you and expected to be used by you; he gave of himself with the liberality of a good child. There was always much of the child in him. He spoke and wrote to children as a coeval. He had a delightful impishness. Even when he was miserable and suffering he could rejoice in a comic situation, and he found many in the ranks of the R.A.F. and the Tank Corps. What better comedy than for a fine scholar to be examined as to his literacy by the ordinary education officer?[25]

JB reckoned that T. E. Lawrence wrote the best letters of anyone he had known, apart from Raymond Asquith, but he also said that Lawrence was a great writer who never quite wrote a great book. He considered *The Seven Pillars of Wisdom* to be 'a shapeless book [that] lacks the compulsion of the best narrative',[26] something, of course, about which he knew a great deal.

In May 1925, Lawrence had asked JB, on the spur of the moment when they met in the street, if he could help get him back into the RAF, since

he didn't care so much about the Army. (He had had a six months' stint in the Air Force in 1922 under the pseudonym of Aircraftsman Ross, but his true identity had been discovered and the resulting publicity had not pleased his superiors.) He told JB in a follow-up letter, which he signed 'T E Shaw', 'The difference between Army and Air is that between earth and air: no less.' He wanted to be in the ranks, rather than be an officer, 'for I'm afraid of being loose or independent. The rails and rules and necessary subordination are so many comforts.' He ended the letter by apologising for the bother to JB, 'but the business is vital to me: if you can help straighten it out, the profit to me will far outweigh, in my eyes, any inconvenience to which you put yourself.'[27]

JB, whose friends knew he could be relied upon, swiftly and without parade, to do what he could to help, wrote a long and eloquent letter to Stanley Baldwin; he, in turn, petitioned Sir Hugh Trenchard, Chief of the Air Staff. In early July, Trenchard performed a volte-face, sending for Lawrence and telling him that he was suitable as an RAF recruit. This prompted a heartfelt letter of thanks from Lawrence to JB: 'The immediate effect of this news was to put me lazily and smoothly asleep, and asleep I've been ever since. It's like a sudden port, after a voyage out of all reckoning.' He had been hoping for it for so many years 'as the only way of getting across middle age'. Lawrence finished by asking JB to tell his children 'that the bike (Boanerges is his name) did 108 m[iles] an hour with me on Wednesday afternoon. [I] think the news of my transfer had gone to its heads: (cylinder heads, of course).'[28]

In 1928 he wrote from Waziristan to say that he had managed to extend his service in the RAF for another seven years until 1935. 'I wanted you to know that I am making the best use I can of the gift you let Mr Baldwin into giving me in 1925.'[29]

Back in England in 1931, Lawrence wrote in answer to JB's suggestion that he write a life of Alexander the Great, that he thought it unlikely he would ever write anything of his own again. 'You have in me a contented being, and no literature rises out of contentment.' But he knew he must leave the service in 1935, 'and after that I shall feel very lost'.[30] The next month he wrote to acknowledge JB's request that he might dedicate *Julius Caesar* to him.* 'A kindness, you call it! What you should have written is ... I was wondering whether to do you a

*'To my friend Aircraftman T. E. Shaw'.

great honour? I might perhaps dedicate my little monograph on Julius Caesar to you, and wonder if you are worth it?"

In July 1931, Hodder and Stoughton published another of JB's historical novels, *The Blanket of the Dark*," set at the time of the Dissolution of the Monasteries. It is a tale about an Oseney Abbey clerk who discovers he is the son of the executed Duke of Buckingham, and bids fair to lead a challenge to the throne of Henry VIII. It is one of JB's very best novels, showing starkly the power of his historical imagination. One of the most compelling examples of that is the description of where the London–Worcester road is crossed by that from Elsfield to Beckley, as it would have looked in 1533. JB knew the place well, since it was less than a mile from his house, and anyone who knows it can only marvel at his ability to cast his mind back four hundred years and convincingly people that road – then 'a mere ribbon of rutted turf, with on each side the statutory bowshot of cleared ground between it and the forest fringes'[31] – with mendicant Franciscan friars returning from begging money on Otmoor, a wool convoy, a troop of gypsies, and a cavalcade of King's Commissioners, on their way to enquire into the state of the religious house at Eynsham. He describes their clothes, their animals, their accoutrements, their behaviour, and we can almost hear the clink of harness and the slap of a monkish sandal, and smell the matted coat of a gypsy donkey. Moreover, anyone who thinks that JB never wrote about sex, or sexual temptation at least, should read in this book his account of the hero facing the agonising dilemma between bedding the beautiful, worldly girl or saving his monkish soul.

The seeds of why JB could not quite keep up the same impetus as a politician after that first year in the House of Commons were, paradoxically, sown at the time of his maiden speech. His intellectual, highly reasonable but sometimes rather Olympian approach to problems and difficulties, with all those quotations from historical precedent rather than contemporary allusions, did not particularly appeal to the stupider and more emotional of his colleagues, of which there were

*T. E. Lawrence to JB, 25 September 1931, NLS, Acc. 11627/51. *Julius Caesar* was a short book published in March 1931 by Peter Davies, one of J. M. Barrie's informally adopted children, after whom Peter Pan was named, and a man much encouraged by JB.

"The phrase comes from a soliloquy by Lady Macbeth in *Macbeth*, Act One, Scene V.

many. The admittedly clever Lord Birkenhead, whose plan for reform of the Parliament Act JB had criticised so successfully in his maiden speech, said of him, 'there was a suggestion of the lecturer, a hint of the dominie, and a whiff of some by-gone Calvinism in his speeches which was alien to the House of Commons'.[32] According to Lord Stewartby, who was a Conservative minister as well as JB's grandson-in-law, his lucid, beautifully composed, lofty, outward-looking, historically literate, romantic speeches 'were profoundly different from most of the speeches which were made by his contemporaries or indeed by his successors in Parliament'.[33]

What is more, those who had had a hard graft in unwinnable constituencies before ever they arrived in the House of Commons were not inclined to admire someone who seemed to have had an altogether easier ascent, and who demonstrably had irons in other fires. Nearly all members of Parliament had other occupations at that time, but few were so famous in such a very different field. How could you take a man entirely seriously if he talked in Ciceronian periods, yet your children were snatching his latest thriller out of your hand as you came through the door? And, although university MPs have sometimes made a great impact – A. P. Herbert with his Divorce Bill being a good example – some Members of Parliament from grittier constituencies had an instinctive prejudice against them.

Moreover, JB did not enjoy the really knotty committee work, when hours might be taken poring over a word in an amendment, the grinding dullness (and often fatuity) of so much of Parliamentary business, which was bread and butter to less gifted but more tenacious men. He skewers such a politician in his contemporary novel, *The Gap in the Curtain*, published in 1932. Any MP who read that will not have been well disposed towards its author.

The greatest impact he made, while in Parliament, was as friend and confidant to both his party leader, Stanley Baldwin, when Prime Minister, and then the Socialist Ramsay MacDonald, once the National Government was formed in 1931 and he became premier. At least once each week, when the House was sitting, Baldwin and JB would breakfast together and then walk around St James' Park afterwards. Baldwin valued these occasions. After JB's death, he wrote: '... looking back through many difficult years, I never failed to find in him complete understanding and sympathy, and his approval of any

particular course of action was a greater source of strength than he could ever have known'.[34] The *Sunday News* was of the opinion that 'it would be difficult to overestimate the influence of the quiet Scotsman and novelist M.P., Mr John Buchan. He is the closest friend of Stanley Baldwin, his advisor as regards all his more important speeches, and his confidant on all occasions.'[35]

Lord Davidson, Chairman of the Conservative Party, remembered that he and Baldwin would often be joined by JB in the Smoking Room of the House of Commons and they would immediately settle down to talk politics as ideas, rather than the usual fare of ways and means to manipulate people and votes. JB would develop some thought process and it was likely that it would end up in a Baldwin speech a few days later. In Davidson's words, JB was 'a fertilising influence'.[36]

The big foreign-policy issue at the time was India, and how it could progress in time and in an orderly fashion to become a self-governing Dominion. JB had swung behind the idea of self-government for India rather earlier than many. Maturity, and the lessons of the war years and after, seem to have tempered his youthful enthusiasm for ordering other peoples about: 'Self-government is the ideal for every unit: with many it has been realized; with some it may take generations before the ground is duly prepared; but the same goal is at the end of every road.'[37] To this end, he had a hand in drafting the 1934 joint select committee report on Indian constitutional reform.

In 1931, when the National Government's Cabinet was in the process of formation, JB's name came up as a potential Secretary of State for Scotland or, failing that, President of the Board of Education. But the first job went to the Liberal Sir Archibald Sinclair, while JB's old Peebles adversary Sir Donald Maclean got 'Education'.

There were misgivings about JB, arising partly from anxiety over his chronic illness, which had kept him away from London for most of the second half of 1929 and about which his colleagues knew nothing that was not alarming. There were those who saw clearly his virtues, but they tended to be outside Parliament. For example, in the summer of 1932, after Maclean's death caused a vacancy at the Board of Education, the Buchans' old friend Violet Markham was moved to write to Tom Jones, Deputy Secretary to the Cabinet, to plead JB's cause with Stanley Baldwin:

I think it is a real misfortune in the national interest that he [John Buchan] is not in the National Government. I also think he would make an admirable President of the Board of Education. Is there no chance of this being considered? It would be a thousand pities if that appointment is made on the rigid lines of party spoils, [for] John has vision and imagination ... He would bring vigour and enthusiasm to that dreary department and I believe might make a great success of the post. It never seems to me that his services and very real abilities have received adequate recognition so far. He never pushes or clamours and so he seems to get left aside – greatly so I think to the public detriment ... There are so many mediocrities in the Cabinet. John would reinforce the very moderate values of distinction not prominent at this moment.[38]

Jones passed the message on to Baldwin who told him that 'John Buchan would be no use in the Cabinet. Ramsay has written to me saying he must keep up the numbers of the Samuelites [Herbert Samuel was temporary leader of the Liberal Party] and proposing [the Marquess of] Lothian.'[39] In the end, the job went to Lord Irwin, who became the Earl of Halifax.

Later that year, when the Samuelites and Simonites ('Liberal Nationals' who followed Sir John Simon) in the Cabinet resigned over some aspects of the 1932 Ottawa Agreement, the post of Secretary of State for Scotland was given to another Liberal, Sir Godfrey Collins. JB wrote to Baldwin about his lack of preferment and one senses the words were squeezed painfully out of him:

I feel that somehow I have managed to acquire the wrong kind of political atmosphere. Most of my friends seem to think that I am a busy man whose life is completely filled with non-political interests. But that is not the case. I gave up business three years ago in order to devote myself to politics. I do not speak overmuch in the House – there is no need for it – but I do a great deal of speaking up and down the country, especially in Scotland, where I think I have a good deal of influence. Politics have always been my chief interest and I have had a good deal of administrative experience ... I am a free man and really anxious for definite work.[40]

It was not to be and the key is probably to be found in a letter that JB
wrote from Canada to Leo Amery in 1936 about Baldwin:

> It is wrong to say that S.B. has no capacity for friendship. The truth
> is almost the opposite! I had a most emotional parting from him last
> October. What is true is that he intensely dislikes the political game,
> and he has schooled himself to a kind of hard objectivity about his
> colleagues in it, and has tried to sink all personal feeling. He is a bad
> party leader so far as persons are concerned. The personal relationships
> in a party need careful cultivation, and S.B.'s curious moods of apathy
> and idleness prevent him from doing this most needful work. Only a
> perfectly first-class private secretary could have saved him. The result
> is that he has constantly been, apparently, guilty of harshnesses and
> disloyalties of which he was completely unconscious.[41]

Who knows if JB would have got further if he had been a man more
assiduously looking out for his own advantage? It is not necessary to
be one of those to achieve high office, but it certainly helps. JB never
formed a group of supporters round him, and therefore did not need to
be appeased by office. As Violet Markham made clear in her letter, he
was not a squeaky wheel.

Needless to say, Baldwin's refusal to give him preferment made no
difference to their friendship; they worked happily together until JB's
translation to Canada in 1935, and remained friends thereafter.

He performed something of the same service of companion and sounding
board for Ramsay MacDonald as he had done for Baldwin, after October
1931, when the National Government was formed. MacDonald was Prime
Minister of a coalition comprising mainly Conservatives (many of them
graduates of Ashridge College, incidentally), having been disowned by the
members of the Labour Party, which he had helped to found. MacDonald
was a long-widowed, lonely, difficult, humourless man, whose mental
and physical powers were slowly on the wane, but JB's kindly feeling
for any fellow human being in a fix, as well as his conviction that the
Labour Party was a more natural opposition to the Conservatives than
the Liberal Party, made a bond that crossed party lines. They had met first
in 1925, and found common ground in discussions of Scots poetry and

history. So in 1931, JB took to meeting and talking to him about his day-to-day commitments, suggesting points for his speeches, even sometimes drafting them, and giving his opinion on people and policies.

Generally, amongst the Conservatives he led in the coalition government, MacDonald was not well liked, being thought to be vain, conceited and snobbish, thrilled by the pageantry that so disgusted his left-wing colleagues, yet finding it difficult to find common ground with people who were not of his ilk. He was also often very hard to cheer up. JB's kindness was often tested sorely in the early-morning walks around St James' Park, before breakfasts at No. 10, but he stuck by him, aided by Baldwin, another kindly man, living next door at No. 11. MacDonald had qualities that JB admired; for all his faults, he was courageous, courteous and decisive. But he admitted that MacDonald lacked the 'kindly affection for the commonplace, which may be called benevolence, or, better still, loving-kindness, the quality of Shakespeare and Walter Scott … He was too ready to despise. He loved plain folk, but they must be his own kind of plain folk with his own background.' Nevertheless, JB thought his alleged vanity to be largely sensitiveness, the result of his difficult early struggles. 'The whole man was a romance, almost an anachronism. To understand him one had to understand the Scottish Celt, with his ferocious pride, his love of pageantry and poetry, his sentiment about the past, his odd contradictory loyalties.'[42] No wonder he clung to JB as to a solid spar in a stormy sea. MacDonald considered making him a minister without portfolio in the Cabinet in early 1934 but, although that never came off, in effect he did the job informally for about eighteen months, until Baldwin became Prime Minister once more in May 1935.

MacDonald's isolation made him vulnerable to pushy, confident individuals such as the Marchioness of Londonderry, the society hostess, who called herself 'Circe'. A Tory, she entertained at Londonderry House, at the south end of Park Lane, on a scale that would have seemed lavish before the Great War, and must have seemed positively obscene to some in the lean years of mass unemployment. She took up Ramsay MacDonald, and he became part of her inner circle, known as 'the Ark'. JB accepted invitations from her, at least partly to keep an eye on MacDonald, but he was never so drawn in as the latter, probably because Susie didn't care for her.

*

JB finally found his name on the New Year's Honours List in 1932, as a Companion of Honour. This Order was established by King George V in 1917; there are only ever sixty-five Companions at one time, plus the Sovereign. JB told Lord Beaverbrook in reply to congratulations on this highly prestigious honour, that he preferred a suffix to a prefix.[43] Whether Beaverbrook believed him is another question.

In 1932 there was agitation in some quarters in Scotland for Home Rule and, in the debate on the King's Speech on 24 November the issue of a Scottish parliament was raised. In a speech that contemporary Scottish Nationalists, who want independence from the rest of the United Kingdom, have fallen upon with glee, JB said:

> I believe that every Scotsman should be a Scottish Nationalist. If it could be proved that a separate Scottish Parliament were desirable, that is to say that the merits were greater than the disadvantages and dangers, Scotsmen should support it.

However, he went on to say that, although a certain measure of devolution was desirable, and the Scottish Office really should be in Scotland, a parliament in Edinburgh was a 'top-heavy structure [which] would not cure Scotland's ills; it would intensify them. It would create artificial differences, hinder co-operation, and engender friction if we attempted to split up services which Scotland has had in common with England for 200 years ... I believe as firmly as ever that a sane nationalism is necessary for all true peace and prosperity, but I am equally clear ... that an artificial nationalism, which manifests itself in a barren separatism and in the manufacture of artificial difference, makes for neither peace nor prosperity.'[44] There is no support for the SNP there.

The truth was that he was a 'unionist nationalist', with concentric, not warring, loyalties. As he wrote in his dedication to Vernon Watney at the beginning of *Midwinter*:

> We two confess twin loyalties –
> Wychwood beneath the April skies
> Is yours, and many a scented road
> That winds in June by Evenlode.

Not less when autumn fires the brake,
Yours the deep heath by Fannich's lake,
The corries where the dun deer roar
And eagles wheel above Sgùrr Mòr.
So I, who love with equal mind
The southern sun, the northern wind,
The lilied lowland water-mead
And the grey hills that cradle Tweed,
Bring you this tale which haply tries
To intertwine our loyalties.

He was well aware of the potential for comedy in politics, particularly in constituency speech-making, and a number of his novels and short stories deal with the subject in a decidedly amused way. The Radical (Liberal) candidate he encountered a lot in Scotland before the war finds his way memorably into *The Thirty-Nine Steps*, while in *The Three Hostages*, Sandy Arbuthnot recalls a speech that he had made on Irish Home Rule:

> Has it ever struck you, Dick, that ecclesiastical language has a most sinister sound? I knew some of the words, though not their meaning, but I knew that my audience would be just as ignorant. So I had a magnificent peroration. 'Will you men of Kilclavers' I asked 'endure to see a chasuble set up in your market place? Will you have your daughters sold into simony? Will you have celibacy practised in the public streets?' Gad, I had them all on their feet bellowing 'Never!'.[45]

Since no one wanted to give him a government post, JB spent his time in ferocious literary activity. In 1932 he published a major biography, a novel and a children's story.* First there was *Sir Walter Scott* (Cassell, March 1932), dedicated to 'two friends, lovers of Sir Walter, Stanley Baldwin and George Macaulay Trevelyan'. It was the sole literary biography he ever wrote, but he told friends he was bound one day to do it, for he had been born and bred under the shadow of Scott's great tradition. The book reveals much about himself, his own writing method and attitudes and, for many people, it is his finest biography.

* *The Magic Walking Stick*, Hodder and Stoughton, 1932.

Sir Walter Scott shows what a very good literary critic he was: careful, judicious, with a close ear for the music of words, and an educated eye for their texture. Here he is on the subject of Scott's poetry, for example:

> He adapted the old ballad form so as to fit it for a long and often complex narrative. Scott's octosyllables embrace, if carefully studied, surprising varieties of manner, and they are far more artful than they appear ... They can gallop and they can jig, they can move placidly in some piece of argument, and now and then they can sing themselves into a lyrical exaltation.[46]

This book is one of the very best guides to Scott's novels, those great but now, with the passing of time, sometimes problematic works of fiction. JB encouraged the reader to think them worth the effort of learning some of the Scots language, and ploughing on through the tedious scene-setting at the beginning of, for example, *Rob Roy*.

There was so much that he knew of Scott's Borders and also of Edinburgh, and he used his knowledge and imagination to describe 'Auld Reekie' in 1771 (the year Scott was born), which can hardly be bettered:

> Scotland had recovered her confidence. But in the process she was shutting the door upon her past. There were two strains in her history – the aristocratic and Cavalier; the Covenanting and democratic; and both were so overlaid by novelties that they were in danger of being choked and forgotten. The first, having suffered downfall with Jacobitism, survived only as a dim sentiment, the inspiration of songs when the claret went round, a thing of brocades and lace and twilit windows. The second had lost itself in formalism or eccentricity, and its stubborn democratic tradition was half forgotten. There was a danger lest the land, setting out confidently on new paths, might condemn as provincial and antiquated what was the very core and essence of her being. She was in the van of the new enlightenment: was her progress to be that of the rocket which shoots from earth into high places and then falls, or like the slow growth of a tree, deep-rooted by ancient waters?
>
> In 1771 Scotland stood at the parting of the ways. That she chose rightly was due to two children who were then alive on her soil.[47] [Burns and Scott].

JB also experienced, and could empathise closely with, many of Scott's difficulties, especially indifferent health. He could have been writing of himself in 1932: 'The reaction of a man to the ebbing of bodily strength in middle age is a certain proof of character, and Scott revealed that tough stoicism which can laugh even when the mouth is wry with pain.'[48]

He could also have said of himself what he said of Scott:

> He had mingled intimately with every class and condition of men; he had enough education to broaden his outlook but not enough to dim it; he was familiar alike with city and moorland, with the sown and the desert, and he escaped the pedantry of both the class-room and the drawing-room...[49]

Trevelyan, the dedicatee, called it 'the best one-volumed biography in the language'.[50]

In the summer *The Gap in the Curtain* was published, the only full-length supernatural novel he ever wrote. (Most of his tales of the uncanny are short stories.) Sir Edward Leithen is the narrator/onlooker and the gap in the curtain of the title refers to a moment when members of a Whitsun house party catch a glimpse of a page of *The Times* one year hence. How five of them deal with the foreknowledge forms the basis of the story. This novel contains, in the account of one of those who catch that glimpse, a brilliant, lengthy and disillusioned description of British politics at that time. It may well indicate how disappointed the high-minded JB had become with the manoeuvrings of contemporary politicians. Baldwin and MacDonald are, however, exempted; there are sympathetic portraits of them both.

A typical couple of days for JB in London, as he told his wife, included entertaining 'some University professors to lunch, and then ... successively Edward Irwin's education meeting, the Ashridge Governors, and a very long meeting of Scottish Members on Scottish Home Rule, where I had to speak at length ... Today I have to lunch with the English Review Club, and then have meetings of the Film Institute people and the British Philosophers, and finish with a long meeting at the House on the Everest flying scheme.'[51] The only aspects of

his public life not crammed into those two days were the Pilgrim Trust and his local involvement in the Council for the Preservation of Rural England, the Oxford University Chest and the Oxford Preservation Trust. These worthy and various projects gave him satisfaction and, in the case of the daring (and successful) Houston Mount Everest Flying Expedition, which he helped to promote, some intense, if vicarious, excitement.

Excitement of another kind came in May 1932. He wrote to his wife from London:

> Now, here is something important which I want you and Alice to talk over before I come back on Friday. They are going to separate Burma from India, and make it a separate Dominion under a Governor-General, and, since the Burmese are a reasonable and docile people, they believe that if self-government succeeds there, it will be a model to India. I was sent for last night, and they asked me to be the first Governor-General. I have been whistling 'Mandalay'* whilst shaving for some weeks, and that seems to have been an omen. What do you think about the old 'Moulmein Pagoda'? This would not be like Canada, a quasi-royal affair, but a piece of solid and difficult work. There is no hurry about a decision, for I have only been sounded, but I wish you would turn it over in your mind. Are we too old for a final frisk?[52]

It is interesting that, at fifty-six, he thought himself towards the end of his useful public life and that being Governor-General of Burma would be a more taxing task than Governor-General of Canada. The question came to nothing in the end, since the idea of creating a separate country fizzled out for the time being, but it resurrected thoughts JB had had about representing the King overseas, ever since Mackenzie King's abortive proposal that he should be Governor-General of Canada in 1926.

One of the most pressing issues that concerned JB in and out of Parliament in the early 1930s was the plight of European Jews, and the development of Palestine as a homeland for the persecuted. And in the

*A song of 1907, 'On the Road to Mandalay', from a poem by Rudyard Kipling.

light of the work he did in this field, we must consider the charge of anti-Semitism, which surfaces from time to time, mainly as a result of about a dozen unfavourable comments by fictional characters, mostly to be found in the Hannay books.

If the question is whether JB was, himself, anti-Semitic, it is important to avoid anachronism. Racial and national stereotyping, favourable and unfavourable, was commonplace throughout all society during his entire lifetime. It is hardly surprising that characters in JB's novels should engage in it, in ways that both commend and criticise. As it happens, there are favourable depictions of individual Jews in the short story, 'The Grove of Ashtaroth', in *A Lodge in the Wilderness* and, in particular, *A Prince of the Captivity*. In any event, great care should be taken to avoid attributing to an author the views of his fictional creations. For example, in *The Thirty-Nine Steps*, the anti-Semitic comments of the freelance American spy, Scudder, are explicitly denounced by Sir Walter Bullivant, as well as Hannay (who thought them 'eyewash'); both of them, of course, are also products of JB's imagination. (Scudder believes in a conspiracy of Jews seeking war for profit and to get back at Russia for the pogroms, which turns out to be completely wrong; the enemies in the book are in fact Prussian-led.) In any event, the case can be made that distinctions expressed by his characters and those made by JB outside his novels were really to do with nationality and culture, rather than genetics. JB was no cultural relativist. If he was not personally anti-Semitic, it would be hard to argue that he intended to be so in his writing. If anti-Semitism were found in his work, that would be the result of the reader's perception and not JB's intention.

The evidence of his close personal relationships with Jews and his support for the Jewish people – at a time when Tory politicians were thought to damage their chances of preferment by such support[53] – suggests that, if anything, JB was a philo-Semite. How could it be otherwise for a man deeply imbued in the Hebrew Bible (Old Testament) and in Jewish historical culture? As Allan Massie puts it, 'I think it well nigh impossible for a Presbyterian Scot to be hostile to the Jews and Israel.'[54] It is no surprise, therefore, that one of his most long-standing friends was the Jewish economist Moritz Bonn, who fled from Germany in 1933. Hermann Eckstein, a Rand magnate and banker, threw JB's engagement party. He dedicated *Prester John* to the Jewish financier Sir Lionel Phillips, in whose house he and Susie spent the first week of their

honeymoon. He and Dr Chaim Weizmann, later the first President of Israel, were good friends. All of which at the very least suggests that there were prominent Jews who did not consider JB anti-Semitic. He supported the Balfour Declaration, which endorsed a 'national home for the Jewish people' in Palestine. *A Prince of the Captivity* has been called 'almost certainly the first major anti-Nazi popular novel'.⁵⁵ In 1933, as Chairman of the Parliamentary Pro-Palestine Committee, JB received a deputation from 'the leaders of the synagogue' concerned with the persecution of German Jews; sitting at dinner that evening next to 'my beloved Mrs. Jimmy' (de Rothschild) he was so moved by singing the Hymn of Exile 'that I made a really good speech'.⁵⁶ On 5 April 1933, less than three months after Hitler came to power, JB was one of only fifty MPs who signed an Early Day Motion deploring the treatment of Jews in Germany. In the spring of 1934 he spoke at a rally in Shoreditch organised by the National Jewish Fund, describing Zionism as 'a great act of justice. It was reparation for the centuries of cruelty and wrong, which had stained the record of nearly every Gentile people.'⁵⁷ His name was inscribed in the *Golden Book* of the Jewish National Fund of Israel. It also appeared in a Nazi publication, *Who's Who in Britain* (Frankfurt, 1938), the entry reading: 'Tweedsmuir, Lord: Pro-Jewish activity.'⁵⁸

In 1933, Ramsay MacDonald invited JB to fulfil the role of Lord High Commissioner to the General Assembly of the Church of Scotland (with which the Free Church had merged in 1929). Ever since the sixteenth century, this body had met every year in the spring to discuss church matters. The Lord High Commissioner was the King's representative – 'a kind of stage sovereign'⁵⁹ as Robert Louis Stevenson put it – so the royal standard waved from the roof of the Palace of Holyroodhouse while he was in residence, and the whole procedure was hedged around with the conventions of (almost) kingship.

There would be much entertaining of worthies, grandees and friends of the Buchans at levées, receptions, luncheons, dinners and a large garden party. (On being told, Susie immediately began to worry about what she would wear.) However, the allowance for entertainment was not munificent, and initially JB told MacDonald that he would only accept the invitation if they could agree on how much, or rather how little, entertaining he was expected to pay for. Fortunately, before this

became an impasse, Sir Alexander Grant came to his rescue by offering to help out financially, if need be, so JB agreed to do it.

His acceptance of the invitation was, at least in part, a homage to his father as well as an obvious fillip for his mother. Moreover, he had loved heraldry, ancient arcane Scottish chivalry and, by extension, formal ceremony ever since he was a boy, and he had always enjoyed dressing up. He often quoted Dr Johnson: 'Life is barren enough surely with all her trappings; let us therefore be cautious how we strip her.' He knew that Susie would rise to the occasion as a hostess, that it would mean they could see and entertain a number of their Scottish friends, and that Alice, aged twenty-four, an aspiring novelist and sometimes underemployed actress, would enjoy being a lady-in-waiting.

The task of the Lord High Commissioner, addressed as 'Your Grace', was to open and close the Assembly, and attend some of its deliberations, although, since the Kirk was not established (as the Church of England is), he could not speak or vote, the proceedings being presided over by the Moderator. He also had to report on the events afterwards to King George V. The ceremonies had all the panoply of a medieval pageant: military guards of honour; a Purse-bearer; the Lord Lyon King of Arms, together with his heralds and pursuivants; the Royal Company of Archers in their dark green tunics; the Holyrood High Constables in blue and silver. JB, who was already a Deputy Lieutenant of Oxfordshire, was swiftly appointed one for Peeblesshire as well, so that he could wear a scarlet uniform and a plumed hat. He told a friend that he looked like a blend of General Moltke and 'Lord' George Sanger, the circus owner.

The ceremonies began on the evening of 22 May, when the Lord Provost of Edinburgh solemnly handed over to JB the keys to the city, as the symbol of the city's allegiance to the Crown. He settled into Holyrood Palace with his wife, mother, mother-in-law, sister and daughter, and they were attended by aides-de-camp, who included the Marquess of Clydesdale, fresh from flying over Everest, and Captain Brian Fairfax-Lucy of the Cameron Highlanders. The Lord High Commissioner requires a chaplain, so Charlie Dick was invited down from his Shetland fastness to say daily morning prayers and stand by his friend's side.

The following day, the Buchans hosted a levée of judges, members of the armed forces, the town council and church leaders in the Throne

Room, and then inspected the guard of honour of Argyll and Sutherland Highlanders in the courtyard. There was much blowing of trumpets and playing of band tunes, which mingled with the jingling of the harness of the mounted escort, and the barked commands of their officers. They then drove, in an open landau, accompanied by a mounted escort of the 9th Queen's Royal Lancers, to St Giles' (Presbyterian) Cathedral, through streets pressing with people, to the accompaniment of a twenty-one-gun salute from the Castle. After the service in the Cathedral, they removed to the packed Assembly Hall on the Castle Mound where, after a message from the King, JB addressed the Assembly: 'I come before you to-day with a full heart, for I am one of yourselves. I have in my bones the traditions of Scottish Presbyterianism.'[60] He paid tribute to the men of the Kirk whose memory was still a living thing to him, including his father. 'From their teaching and their lives I learned the meaning of the beauty of holiness and the grandeur of Christ's Kirk in Scotland.'

During the many receptions the ADCs would bring people up and introduce them to Their Graces, just as if they were the King and Queen; the stately Caroline Grosvenor, used to Court life at the end of the nineteenth century, was not too grand to confess she was mightily impressed. She told her daughter, Marnie: 'The whole thing has a sort of fairy-tale touch about it ... When I see people being led up to Susie and curtseying nervously to her, and when I have to curtsey myself I feel as if I must wake up and find it a dream ... I must say I am very proud of John and Susie. They both do it with much dignity and simplicity.'[61]

Most of the Scottish aristocracy, together with every senior civic officer, serviceman and legal luminary, found themselves at Holyrood Palace at some point over the ten days.* Among the personal guests were the Baldwins, Sir Alexander Grant and his family, and the Gillons. Not surprisingly, Mrs Buchan was in her element. She had been attending the Free Kirk assemblies for many years, and the Church of Scotland ones since Unification in 1929, listening intently to debates, knitting needles in her hand. She had a broad acquaintance amongst church people and an excellent memory for ecclesiastical disputes, so she was very helpful to JB.

*This annual Assembly, with its associated pageantry and entertainment at the Palace of Holyroodhouse, survives to this day.

Violet Markham, who was invited to stay at Holyrood (and gave a long account of the visit to Mackenzie King), remembered that JB, with his considerable entourage, made a point, after opening the Assembly, of visiting the other assembly, that of the Free Kirk, known as the 'Wee Frees', the numerically small sect that had stood out against all amalgamations:

> As our party clattered in, we seemed to fill up half the space of a thinly peopled hall. This was a gathering which might have been a persecuted remnant, meeting in the catacombs, mostly ageing men and women with here and there a child who looked on wide-eyed at this sudden influx of pomp and colour – soldiers in their brilliant uniforms, ladies in their gay frocks, and officials in dignified garb. [The Moderator told him that they had never before been visited by the King's Representative. JB talked to him of the great Protestant theologian, Karl Barth, whom he admired] with a fluency and knowledge above the heads of his guests. Then with mutual expressions of courtesy and good will, we clattered out again to engage in the festivities and the ceremonies of the day. But I remember I was very near to tears.[62]

At the end of the ten days, JB handed back the keys to the Lord Provost and the family climbed into a first-class carriage at Edinburgh Waverley, changing at Paddington Station into a third-class carriage to travel back to Oxford. It had all been a howling success, with the added bonus that Alice and one of the ADCs, Brian Fairfax-Lucy, had fallen in love. The Buchans were pleased, JB calling him 'the best of good fellows'. By the end of the following month the couple were engaged, and they married in St Columba's Church in Knightsbridge on 29 July.

After the Assembly, Sir Alexander Grant sent JB a cheque to help defray the substantial expenses; in strictly utilitarian terms – which this was not – a very generous return for a novel dedication. JB replied: 'I wish there were any words in the English language in which I could express how much I feel about your kindness.'[63] Grant also insisted on providing Alice's wedding cake, which must have been a magnificent confection.

The following spring, JB was asked again to be Lord High Commissioner. This time he did not hesitate. It took the same pattern

of ceremonial, large-scale entertaining, and a great deal of visiting of worthy institutions. The weather was again sufficiently clement for the Buchans to be driven to St Giles' Cathedral and the Assembly Hall in an open carriage, this time escorted by men of the Royal Scots Greys on their bright white horses. JB told the General Assembly that the Kirk had always laid emphasis on the freedom and responsibility of the individual soul and that in the difficult times they were passing through there was a danger of revolt against freedom from a failure of nerve. 'To oppose to-day a weak craving for servitude is as sacred a duty for this Church of free men and free women as any that it has faced in its stormy history.'[64] It is not difficult to see where his thoughts were tending, with the disquieting rise of the Dictators in Europe. The newspapers picked up on the theme and Gilbert Murray, who had by this time been awarded the Order of Merit, wrote to JB to thank him and to tell him that what he said needed saying. What JB had proved, not for the last time, was that he could make something meaningful and worthwhile out of an occasion that might otherwise have been not much more than flummery.

The year 1934 saw the publication of a novel and two biographies. *The Free Fishers*, his last historical novel, took him back to 'the windy shores of Fife at a time when smuggling and vagabondage were still rife'.[65] It is a rollicking, exuberant story, set in Regency times, and concerns a scholar/gipsy of St Andrews and some dubious old friends, who find themselves caught up in a bid to thwart a plot to assassinate the Prime Minister, Spencer Perceval. JB seemed to be able to evoke the early nineteenth century almost as well as the seventeenth, being at home, crucially, with the apparatus that attached horses to a coach. It is meant as a high compliment to say that this is a Georgette Heyer novel, but written by a man.

That summer, Johnnie Buchan successfully applied to be an Assistant District Officer in Uganda, and left for Africa in July. In the autumn, *Oliver Cromwell* was published on the anniversary of the Lord Protector's death, 3 September, having been first serialised in *The Sunday Times*. *Montrose* had concentrated JB's mind on the War of the Three Kingdoms from the point of view of the King's party, and it was now time to look at the story from the other side. This time he depended more heavily on secondary sources; it was a piece of reinterpretation

rather than original research, Cromwell having attracted much more interest from historians than Montrose.

The story of how Oliver Cromwell went from fenland country squire and Member of Parliament to military commander and regicide is told with lucidity and great sympathy for Cromwell, a man whose reputation will ever divide people but who, like Montrose, was ahead of his time. JB was by this stage so steeped in the language of the seventeenth century, and at home with both the politics and the religious struggles of the period, that the story flows smoothly and the tale unfolds with all the inevitability – taking into account the character of the main protagonists – of a Greek tragedy. And the characterisation is perceptive and written in pellucid prose. This is JB on Charles I:

> His gentleness and charm might attach his friends to him, but his public conduct had been in the highest degree fantastic, disingenuous, and uncertain. He had no gift of resolute purpose or single-hearted action; the prominent velvet eyes under the heavy lids were the eyes of an emotional intriguer. They were the eyes, too, of a fanatic, who would find in the last resort some curious knuckle of principle on which he would hear no argument ... The old monarchy could only survive if its representative had those qualities of plain dealing and sturdy resolution which were dear to Englishmen; and it was the irony of fate that this king should be part woman, part priest, and part the bewildered delicate boy who had never quite grown up.[66]

And on Cromwell:

> Paradox is in the fibre of his character and career ... a devotee of law, he was forced to be often lawless; a civilian to the core, he had to maintain himself by the sword; with a passion to construct, his task was chiefly to destroy; the most scrupulous of men, he had to ride roughshod over his own scruples and those of others; the tenderest, he had continually to harden his heart; the most English of our greater figures, he spent his life in opposition to the majority of Englishmen; a realist, he was condemned to build that which could not last.[67]

And is there a shorter or clearer exposition of the constitutional dilemma inherent in the Protectorate than this? 'He was to be a prince, but a prince who must remain standing, since he had no throne.'[68]

In November 1934 the Buchans sailed to New York, where JB had been invited to open the Harkness Library at Columbia University. He spoke to a large audience, and the speech was broadcast. While in New York, he was to meet the President, Franklin D. Roosevelt, for the first time, Ramsay MacDonald having 'entrusted me with some very confidential things to say to the President of the USA'.[69] Unfortunately, Roosevelt was detained in Georgia, so the two men did not meet until eighteen months later.

The Buchans came home after ten days, enduring an extremely rough voyage on RMS *Berengaria*. Also on the ship were Hugh Walpole, J. B. Priestley and Beverley Nichols. Walpole was ill in bed, and his fellow writers kept him company, Walpole remarking to JB: 'Do you realise that if this ship goes down tonight four of Britain's best-selling writers will be lost, and that all the non-best-selling writers will probably have a party to celebrate the event?'[70]

In January 1935 the family went to Lime Grove Studios in Shepherd's Bush to watch *The 39 Steps* being filmed. 'They have altered the story in parts, but very cleverly, and they have got a first-class man for Hannay,' JB told Johnnie.[71] That first-class man was Robert Donat, the handsome English actor with the beautiful voice who had come to prominence the year before in the Hollywood film *The Count of Monte Cristo*.

In 1934, Gaumont-British had bought a seven-year option to film *The Thirty-Nine Steps* for a very modest £800 and it was directed by Alfred Hitchcock, at a cost of £60,000. Hitchcock owned copies of all JB's novels and told François Truffaut that he had been 'a strong influence [for] a long time'.[72] (Hitchcock had originally thought of filming *Greenmantle* but concluded that *The Thirty-Nine Steps* would be easier, as it was on a smaller scale and usefully episodic.) The screenplay was mainly written by Charles Bennett, who thought the book 'awful'.

The 39 Steps (replacing words with numbers must have made things easier for the poster artist) was one of the first 'man-on-the-run' thrillers ever filmed and it made Alfred Hitchcock famous in America for the first time, breaking box-office records there. Much of the plot was changed to reflect the different international situation, twenty years on from 1915, as

well as the fact that the book's plot turned on the clever disguise of the Black Stone gang, something very difficult to film successfully back then. Hitchcock retained the suspense produced by the twin pressures of pursuit by both police and foriegn agents, but played up the comedy, especially at the political meeting. And he famously introduced a love interest. In the film, the nationality of the international spies is not specified – since the Foreign Office had told film-makers in the mid-1930s not to be beastly about the Germans. So 'The 39 Steps' becomes a foreign organisation trying to steal the details of an aircraft's production. Richard Hannay, now a Canadian, acquires a reluctant female companion, Pamela, played by the beautiful Madeleine Carroll; she initially tries to deliver him into the hands of the police but comes to believe his story. The scene when they have to share a room in a Scottish inn and she removes her stocking, while handcuffed to him, still gives off an erotic spark, and is one of the most famous romantic scenes in pre-war British cinema.

In early 1935, JB finished *The King's Grace 1910–1935*, telling Johnnie in Uganda that 'It was a most ticklish piece of work, but I could not get out of it.'[73] In 1934, Hodder and Stoughton had asked him to write a book to celebrate the Silver Jubilee of King George V, due the following year. JB did not feel he could refuse (he was also to write the House of Commons welcome speech for the King in 1935), but the task had to be done at high speed.

Although King George V is not a completely remote figure in the book, and something of the affection that JB felt for him comes through, *The King's Grace* is really a potted history of the preceding quarter-century. It is also a digest of his war books, and it gave him the opportunity to revise some of his judgements from *A History of the Great War*. For example, he was more magnanimous to David Lloyd George than the latter had been to him the year before, reserving some mildly waspish comments about him for his reminiscences, *Memory Hold-the-Door*.

He had had time to reflect, in tranquillity, on what the Great War had been, and what it had led to, and his sympathy encompassed much of the world:

Little farms in Touraine, in the Scottish Highlands, in the Apennines, were untilled because there were no men; Armenia had lost half her

people; the folk of North Syria were dying of famine; Indian villages and African tribes had been blotted out by plague; whole countries had ceased for the moment to exist, except as geographical terms. Such were but a few of the consequences of the kindling of war in a world grown too expert in destruction, a world where all nations were part one of another.[74]

The book was rushed through production, appearing on 4 April. At the Elsfield Silver Jubilee party, held in the Manor gardens that June, every child in the village was given a copy as a souvenir of this historic occasion.

One day in March 1935, JB wrote to Johnnie in Uganda:

I am in the throes of a great decision, and I won't be able to wait for your views. I was sent for to Buckingham Palace to-day and given a private letter from the King. Both Bennett, the Prime Minister of Canada, and Mackenzie King, his probable successor, have asked for me as the new Governor-General, and the King adds that it would give him very great pleasure if I would accept...

I told the Court people* that I would much prefer either the Washington Embassy or South Africa. About the latter there is the difficulty that they may very likely want a South African,** and about the former that the Foreign Office will fight for a recognised diplomat. Anyhow, I can scarcely refuse Canada on the chance of these other things.[75]

The year before, discussions had begun in exalted circles in Canada as to who should follow the Earl of Bessborough as Governor-General. That July the President of the University of Toronto, Dr Cody, had told JB at a dinner in London that everybody in Canada was hoping he would succeed Bessborough, prompting JB to tell his wife 'Not for me!'[76]

As a result of the constitutional changes brought about by the Statute of Westminster of 1931, the choice of Governor-General was now made, not

*Much to the surprise of the King's Private Secretary, Sir Clive Wigram.
**Patrick Duncan, one of Milner's Kindergarten, who had settled in South Africa, was chosen in 1937.

by the British government but by the Canadian Prime Minister, having consulted widely, with the King informed of the conclusions, which he would then 'rubber stamp'. In 1934 the Prime Minister was R. B. Bennett, leader of the Conservative Party, but he was tired and sometimes ill and, after sustaining a series of by-election losses, was almost certain to lose his majority at the next election that autumn and be replaced by the Liberal Party, with Mackenzie King becoming Prime Minister. Mackenzie King ideally wanted the decision to wait until after the election but, since Bessborough was anxious to be gone, he and Bennett put their heads together. A number of candidates were canvassed but they agreed finally on JB. His name was put forward to the King and accepted.

The offer of Governor-General made more sense than it had nine years before. JB now had experience in politics, he appeared frequently in the newspapers, had been a model Lord High Commissioner, was now a Companion of Honour, and had been given a number of honorary degrees (an LLD, Doctor of Laws, from St Andrews in 1930 and the DCL, Doctor of Civil Law, from Oxford in 1934, to go with the LLD from Glasgow). He was known to be an excellent public speaker, as well as hard-working and discreet, and both he and his wife spoke French, important because of the presence in Canada of the substantial minority of French Canadians, mainly in Quebec. He had a reputation for solid, although not spectacular, public work, and there had never been a whiff of scandal attached either to his private or financial life. King George V had known him since the Great War, enjoyed reading his fiction, and called him by his first name.

He was by no stretch of the imagination aristocratic, as most earlier incumbents – the Duke of Devonshire, the Earl Grey, the Marquess of Lansdowne, the Duke of Connaught and so on – had been. His appointment would be a real departure. However, JB knew rather more about Canadians than most British politicians and, what is more, was not tempted to patronise them. As a young man in South Africa, he had bothered to read the Durham Report on Canada, and as early as 1901 had written that 'Canada is essentially a country of the larger air, where men can face the old primeval forces of Nature and be braced into vigour, and withal so beautiful that it can readily inspire that romantic patriotism which is one of the most priceless assets of a people.'[77] In 1908 he had helped raise money for the Montcalm/Wolfe memorial in Quebec City and later wrote a biography of Lord Minto, who was

Governor-General at the turn of the century. He had both friends and relations in Canada.

Although it was no longer the British government's decision, Stanley Baldwin had already come to the conclusion that JB's future did not lie in Parliament (which is why he told a colleague that he was not going to give him a Ministry because he was 'saving him for Canada').[78] He watched him closely at Holyrood, when JB was Lord High Commissioner, in 1933, and remarked that his face was 'fine-drawn, sensitive to every emotion, full of pride in his own country and his own people, and happy that the lot had fallen to him to be the King's representative in his own home...' He had, according to Baldwin, 'the face of one who has heard the Word on the hillside'.[79] No doubt Baldwin communicated his conclusions to Bennett.

The day of his visit to Buckingham Palace, JB wrote to his wife:

Let me put the Canadian problem in writing.
　Against –
　1. Too easy a job for a comparatively young man.
　2. A week further away from Mother.
　3. A country and a people without much glamour.
　For –
　1. A very easy life for J.B.
　2. The possibility of doing good work – redressing Bessborough's mistakes [unspecified] – closer contact with Washington – the fact that I have been paid the enormous honour by both Bennett and M.K.
　3. Only five days from England, so that the boys [meaning William and Alastair] could come out for all their holidays.
　4. The right to return when we wanted, so that we could be in England when Johnnie was there. We could also bring him out to Canada and give him a hunting trip.
　5. Apart from special clothes and uniforms, we could do it on our salary, and the rest of my income would mount up.
　An immediate peerage might revive Mother. All the same, my heart is in my boots. I hate having to make these decisions.[80]

One important aspect missing from the minus side was his health and that of his wife. The list does not address the problems likely to occur as

a result of a life led in public, when so often in pain or discomfort: giving speeches to large audiences, travelling long distances, the general stress and strain of office, being pressured into eating both enormous formal banquets in Ottawa or Quebec City and homely tray-bakes in the Prairies.

True, in the past, he had had quite long periods of remission, which can be a feature of digestive illnesses. There were times when he felt quite well and capable of doing anything. Then something would happen – a period of overwork, a long journey or an ill-advised meal – that would cause the problem to flare up once more. This unpredictability made planning difficult. In Britain, he frequently accepted invitations to speak at school prize days, Burns Night dinners, conferences on the Empire or Conservative education, knowing that sometimes they might have to be cancelled. In Canada, where engagements were inked into diaries months in advance, and some of which – like the opening of Parliament every January – had an iron immutability to them, there would probably be moments of acute anxiety.

It is therefore permissible to ask what he thought he was doing, even considering taking on such a public role as the Governor-Generalship in such circumstances? Moreover, with Susie suffering occasional bouts of depression, doing his duty also risked jeopardising her well-being, when detached from the sheet anchor that was Elsfield. She would inevitably be miserable at the thought of leaving England, her mother, her children, and the most pleasant, useful life she enjoyed at home. The trip they had planned for that winter in Africa, visiting Johnnie in Uganda, would have to go by the board, as would Susie's work for Oxford House in Risca as well as the Women's Institute, both of which she valued greatly. '[Mummy] is in tremendous form and practically running Oxfordshire,'[81] JB had told Johnnie in February.

He was also quite unrealistic about the money. He would not be able to do any journalism, accept film deals or write books that had a political flavour to them, without bringing down the wrath of Buckingham Palace on his head. Just the month before, he had told Johnnie: 'I am besieged by film magnates just now. The purity crusade in America has driven them all to my books, which combine the decent with the dramatic! I ought to make a certain amount of money before I am done.'[82] Indeed, two days later he lunched with Alexander Korda, who was keen to film *Prester John* in Ruwenzori.

JB consulted with his wife and family, by telephone, as well as with Stanley Baldwin and Ramsay MacDonald, both of whom encouraged him. Badly hustled for an answer by the Palace, he accepted the job in just two days, knowing that his wife did not think it an unqualified good idea for him or, probably, for herself. That said, it is inconceivable that Susie would have stood in his way, however much her own comfort was compromised in the process. And, although he would have agreed with his creation, Sir Walter Bullivant, that Duty was 'a damned task-mistress',[83] there was probably not much doubt in his mind that She had to be obeyed.

At least his mother was thrilled, since finally her son was appreciated at what she considered his true worth. Characteristically, she wrote, 'I am sure you are right to go – you are not young and there may not be more chances. I am sure the King is fortunate to get you. Walter is afraid you do not mention a Peerage but surely the King cannot go back on that for this appointment ... I must say I would like to live to see you a Peer. I wonder at myself being so vain.'[84]

He took the job at least partly because of his growing disillusionment with British politics, and especially with the mediocrities that the National Government seemed to have fostered rather than avoided. This disillusionment can be traced from the early 1930s in his articles in *The Graphic*, his speeches and his novels; he was distressed that he could discern no great man to protect democracy at such a crucial moment, for it was hard at that moment for him (or in fact many people) to see the quality in Winston Churchill. *A Prince of the Captivity* (1933) is, in part, about the search for a leader who could see the way in the fog, without succumbing to the destructive egotism exhibited by the Dictators. JB needed a fresh start, somewhere where the air was, as he would put it, 'tonic', and where he might have a chance to make a difference.

Canada would bring together two of his main preoccupations in foreign affairs: the evolution of the imperial possessions into dominions, autonomous and equal in status to each other and Britain, but all under the sheltering umbrella of the British monarchy; and his conviction that the United States was, and would continue to be, the leader of the democratic world, with whom it was strikingly in the Commonwealth's interest to connect. If he were to situate himself just across the border from the United States, and with the advantage of speaking the same language, there might well be an important behind-the-scenes role

for him to play as a link between the British government and those in Washington and Ottawa. It is indicative that such a perspicacious politician as Lord Robert Cecil [now Viscount Cecil of Chelwood] should write to say that he thought the post would satisfy JB's long-standing 'hankering after Transatlantic work', and that Ottawa was 'a much more interesting and important job than Washington'.[85]

In the end JB agreed to take the job for a variety of reasons: a respect, bordering on devotion, for the idea of monarchy, together with a loyalty to, and friendship with, King George V that stretched back twenty years; his sense of public duty, which had ever spurred him on to expend his strength on worthy projects of many kinds; the fillip it would give to his flickering vanity; to cheer up his mother, who was now quite frail; and a recognition that he was not going 'all the way' in politics. His acceptance of the Governor-Generalship was certainly partly due to his inability completely to discount flattery, but as much because of an adventurous spirit and buccaneering optimism, which overestimated the rewards and underestimated the costs. He told his eldest son: 'Like you, I am a hopeless adventurer and cannot resist the challenge of a new thing.'[86]

He knew and liked, if he didn't entirely trust, the Prime Minister, William Lyon Mackenzie King. The Byngs, husband and wife, had separately left him in no doubt of the substantial difficulties the man had raised in 1926, but JB was an experienced politician, which Byng never was, and probably assumed – rightly as it turned out – that, although there might be turbulence at times, he and Mackenzie King could work together. He thought him an astute politician, a skilful diplomat and, perhaps most importantly, an adroit manager of his Liberal Party colleagues, not many of whom could match him for brains or drive.

One of JB's great virtues, as far as Mackenzie King and many other Canadians were concerned, was that he was a commoner, since the Canadian Prime Minister abominated the British obsession, as he considered it, with titles and honours, a position probably reinforced by the lofty stance taken by Willingdon and Bessborough. (Mackenzie King was mightily miffed the day that Bessborough placed him between his young daughter and her governess at lunch at Government House.) North Americans generally couldn't see the point of titles. *Time* magazine in the United States opined: 'Britain hoped King George V

would make his man a peer before John Buchan goes to Canada in the early autumn; Canadians fervently prayed he would not.'[87]

Sending a commoner to Canada would be setting a precedent and it was never an idea to appeal to King George V. Moreover, both Bessborough and Bennett respectfully suggested to the King that JB be given a peerage, for otherwise the people of Canada would wonder why a Canadian had not been chosen. The King invited the Buchans to stay the night at Windsor Castle after the announcement was made, when the subject was broached, and JB was in no position to gainsay him. In any event, a peerage inevitably appealed to JB's sense of being a Scotsman who had made good, and pointed up how far he had come by his own efforts from Smeaton Road, Pathhead.

Despite worries that no one would know who he was, once he lost the fine, simple and famous name of John Buchan, his family all joined in the discussion as to what the title should be. Lord Buchan was out, since there was already an (unrelated) Earl of Buchan. Lamancha and Manorwater were both candidates but, in the end, he settled on Tweedsmuir, after the village near the source of the Tweed where he had fished and walked as a boy. His uncles owned land at Fruid in Tweedsmuir parish, which he would inherit, so that he would own acres in his 'barony'.* A Covenanter, murdered nearby, was buried in Tweedsmuir churchyard, and the Crook Inn (owned by his uncles) had been an important staging inn, a place around which JB spun several short stories about Border reivers and benighted shepherds. All in all, he was happy to be gazetted 'The First Baron Tweedsmuir of Elsfield', which neatly pointed up his twin loyalties.

On 28 March 1935 he wrote to his wife:

> My leaving the House [of Commons] yesterday afternoon was a terribly melancholy affair. At three o'clock, when the official announcement came from the Palace, I ceased automatically to be a Member. I went in at ten minutes to three, and took my old seat behind Baldwin. The Speaker smiled at me and he and I kept our

*The land at Carterhope and Fruid did indeed pass to him on the death of one of his uncles in the late 1930s; it was compulsorily purchased in the early 1960s, so that it could be flooded to make Fruid Reservoir.

eyes on the clock. At one minute to three I got up, shook hands with Baldwin and Ramsay, bowed to the Speaker, and walked out. The debate suddenly stopped, and Members standing behind the Bar grasped my hand. I could not have spoken without breaking down.[88]

Telegrams and letters of congratulations poured in, photographers and journalists disturbed the peace of Elsfield; even Jimmy Maxton, who usually prided himself on not bowing to bourgeois convention by writing letters of congratulation, wrote to wish him a happy and useful time and told him to write a book or two while he was there. JB will have enjoyed the letter from the soon-to-be Governor-General of South Africa, Patrick Duncan: 'I congratulate you and Canada. It will be a new experience for them to get a change from the conventional run of aristocratic fainéants [do-nothings].'[89]

There was a lone dissenting voice. T. E. Lawrence wrote to him: 'I read yesterday in the paper that you have been chosen as next Governor of Canada. A high office, to which I grudge you immensely. It means that for three years you will be spent on public functions, doing them excellently, no doubt, but at the sacrifice of all your private virtue. Also I shall feel that something is missing, round Elsfield way. This is perhaps a queer way of congratulating you on breaking into another preserve of the Lords. Cromwell would approve it; but still I feel sorry. You are too good to become a figure.'[90] This was a douche of cold water after all the warm shower of congratulations that JB had received from the rest of his friends. But it was characteristic of Lawrence, who had once told JB that he thought public service was a shallow grave.

JB was glad to get away from all the fuss for a short walking tour with Alastair in west Wales, before beginning the task of extricating himself from the mountain of obligations he had piled up over the past few years: all those admirable duties, which had worn down his strength and limited the time he spent writing, undisturbed. He had been ill all winter, 'dragging his wing', and he embarked on a regime of no tobacco or alcohol, as he was determined to be well for Canada. Elsfield had never looked lovelier in his eyes that spring: 'It makes Mummie and me ache with homesickness to think we must leave it so soon,' he told Johnnie.[91]

Some time in early summer, Beverley Baxter, a Canadian-born journalist and a director of Gaumont-British, took JB to a private viewing of *The 39 Steps* and remarked that, whenever the plot deviated from the book, which was often, JB would say: 'First rate. Much better than my way.'[92] He told the projectionist that it was an immense improvement on the book, which electrified Baxter's fellow directors when he told them, since they had never heard an author say such a thing before. It was also a remark he made to the assembled company when, early in June, Baxter hosted a dinner at the Piccadilly Hotel before the premiere of *The 39 Steps*. Alfred Hitchcock and many of the cast, including Robert Donat and Madeleine Carroll, were present, as were Susie, William and family friends, although not Alastair, who was in the throes of his School Certificate exams.

The critics mainly agreed with JB that the film was better than the book, since what Hitchcock had done was new and very clever. One person who remained unimpressed, however, was Susie, who, to the end of her life, could not imagine why Hitchcock had felt the need to change the plot or import a female character.

While preparing for Canada, JB was substantially helped by Alan (Tommy) Lascelles, who was Private Secretary to the Earl of Bessborough. While in Ottawa, Lascelles had written a 'Green Book' – so-called because it had green leather covers – which was simply entitled *Government House Ottawa*. Although JB had some knowledge of how things operated at Buckingham Palace, and had stayed with the Byngs at Rideau Hall, this was nevertheless invaluable for all the tricky little pieces of organisation over appointment of staff, size of household, accommodation arrangements, invitations to levées, table plans, precedence, mayoral addresses, dress for particular occasions, the traditions that had grown up as to what functions 'Their Excellencies' did and didn't attend; as well as the more weighty aspects concerning the division of labour between Secretary, Comptroller and ADCs, and the protocol involved in ceremonial, entertaining and the conduct of tours. Studied conscientiously, as the book plainly was, would mean avoiding many opportunities for friction and muddle.

It also detailed the finance. JB's salary was $49,000 a year, but this would be augmented by an allowance for the salaries of the ADCs of $10,000, $19,000 for fuel and light, and $50,000 for travel. The average

annual expenditure on the household was $84,000 in Bessborough's time, so it was obvious that, with all the necessary initial outlay, this was not a money-making exercise for the Governor-General.

Almost as important as the 'Green Book', was the highly confidential fourteen-page addendum, which Lascelles called an 'Apocrypha', written for JB's eyes only, to help to ensure that he did not make the more obvious mistakes of his immediate predecessors. Open, yet never breaching the bounds of propriety, he usefully told JB that he didn't need to do things on the grand Bessborough scale ('... their standards in such matters as dress, food, wine, travel etc would appear fantastic in London, and do appear positively astronomical in Canada! Such standards are <u>not</u> necessary here; they are not even advisable').[93] The Comptroller of the Household, Colonel Eric Mackenzie,* 'by nature an extremely practical and economical Aberdonian!' reckoned, according to Lascelles, that 'a G.G. with no young family can reasonably expect to re-imburse himself out of his salary, by the end of 3 or 4 years, for the round sum he has to provide for initial expenditure'.[94] He ended the letter by assuring JB that Eric Mackenzie would help in every way to tone down the scale of living. All this will have been a substantial relief to JB, who was not a very rich man, and was still educating two children. He was also giving an allowance to the married Alice, whose husband Brian, having left the Army as a result of recurrent bouts of malaria, was having difficulty finding permanent employment. Furthermore, JB would need to pay back a £3,000 loan to help with initial costs, which he had accepted from the ever-generous Sir Alexander Grant. (Grant also gave him £1,000 as a present.)

Lascelles, who did not want to stay, also gave invaluable advice to JB about who to choose as a Private Secretary, warning against a really obviously military man, since this could go down badly, not only with civilian Members of Parliament but also small-town mayors and dignitaries – who 'must be treated as men and brothers, or one gets that dread label "high hat" which has damned so many Englishmen in this country'.[95]

JB scouted around for a suitable successor and found a youngish Colonial Service official, recently made Governor of the province of

*In 1928, Eric Mackenzie had written to JB, whom he did not then know, to correct him on an arcane piece of topography in *Montrose*.

Kassala in the Sudan, who, it turned out, was prepared to exchange the heat of equatorial Africa for the cold and snow of Ottawa. Arthur Shuldham Redfern, known always as Shuldham, was twenty years JB's junior, and had been educated at Winchester College and Cambridge. He was tall, thick-set, with a toothbrush moustache, and walked with a limp from a wound sustained as an RFC pilot during the Great War.

He turned out to be well-nigh ideal. He was hard-working and careful, perceptive, worldly, with a excellent sense of humour, distinctly subversive in private but never in public, and able by training and temperament to think on his feet. With his pretty, intelligent and stylish wife, Ruth, and young son, O'Donnell, he sailed to Canada in the autumn of 1935, and took up residence in Rideau Cottage (which was definitely a house) on the Rideau Hall estate. So began nearly five years of very cordial cooperation. JB found him very easy to get on with, responsive, keen to uphold the dignity of the Governor-General without being a blinkered, defensive courtier.

Much to the Buchans' sorrow, T. E. Lawrence was killed on 19 May 1935 in a motorcycle accident in Dorset. JB had last seen him in early March, when he had finally retired from the RAF and had travelled back to his home at Clouds Hill in Dorset from Bridlington in Yorkshire on a bicycle, and stopped off at Elsfield on the way. JB had described the visit to Johnnie: 'On Sunday morning Lawrence of Arabia arrived on a push bike. He has finished with the Air Force and is moving slowly down to his cottage in Dorset, a perfectly free man, and extraordinarily happy. We had him for the whole day, and he has become one of the most delightful people in the world. He has lost all his freakishness, and his girlish face has become extraordinarily wise and mature. He relies a good deal on my advice, but I don't know what can be done for him, for he won't ever touch public life again, and yet he is one of the few men of genius living.'[96]

Lawrence came back one more time to Elsfield. On 10 May he drove to Elsfield on his motorbicycle. JB was in London, but Lawrence was entertained by Susie and William, by then nineteen years old. The visit had a great impact on the young man; he recalled very clearly the visit many years later:

> I see him standing by the tall window in the library, facing me as we talked and giving me every strand of his attention. He was not

a tall man, indeed decidedly short ... Yet, like my father who was also short, he possessed the ability to dominate his surroundings by a combination of powerful controlled energy, poise and eager interest in what was being said. Then there were his fair good looks and, of course, his extraordinary eyes, eyes blue as the sky, brilliant, oddly innocent and yet penetrating ... He was full of an enthusiasm which was almost boyish, an excitement which clearly possessed him completely and gave him a youthful, a holiday air ... When that unforgettable visit was over, Lawrence mounted his fearsome machine and was off with a roar up the village street, leaving behind, for memory to lay hold of, the dying growl of a powerful motor and a whiff of castor oil.[97]

Not long after, William sat his first-year examinations at New College and failed them. He had enjoyed his year at Oxford, and made one or two good friends, but his activities had not extended to studying, and his parents had worried a lot as the exams approached. After the results were published in early July, JB went to see the Warden, his long-time friend H. A. L. Fisher, and the two men agreed that William should leave Oxford voluntarily, to avoid the embarrassment of being formally 'sent down'. It takes little imagination to divine how this divergence from his own experience of Oxford will have struck JB, nor that any exasperation with his son's idleness (for no one could doubt his brains) must have been tinged with self-reproach. But there was no use repining, for this undesirable turn of events meant that something interesting and worthwhile had to be found for him to do. He had evinced a keen interest in learning about film lighting, having been fascinated by the technicalities of *The 39 Steps* set, so JB used his influence with Beverley Baxter to get his son a job at Gaumont-British. He became an apprentice, paid 5 shillings a week. His parents did not wish him to be cast adrift and alone in London at such a tender age so they arranged for him to live in the house of their friends, the writer Elizabeth Bowen and her husband, Alan Cameron, with his grandmother keeping an eye on him. His Scottish grandmother was highly dubious, writing to JB: 'The atmosphere in the 39 Steps made me very unhappy. I think you would be miserable in Canada leaving him amongst people who are so entirely without religion.'[98]

The summer of 1935 was frenetic; it was filled with formal dress fittings, sittings for a bust by the Scottish sculptor Thomas Clapperton*, farewell dinners (Brasenose College gave him a royal send-off at Claridge's), and the hiring of staff, such as footmen, for Canada, as well as the letting of Elsfield Manor to Oxford friends called Askwith, who paid a peppercorn rent on the understanding that they keep on the outdoor staff. Mrs Charlett stayed at home,** but Lilian Killick agreed to accompany her employer to Canada as his correspondence secretary, James Cast as his valet, Annie Cox as Susie's lady's maid and Amos Webb as a chauffeur. It is not unremarkable that four of JB's Elsfield/London staff were so devoted to him (there is no other word for it) that they were prepared to leave hearth and home for five years in order to continue to serve him. Lilian Killick was a widow, James Cast and Annie Cox were unmarried, but Amos Webb left a wife behind in Elsfield.

One pressing task was the choice of a suitable coat of arms now JB was a peer. This required visits to Edinburgh to consult with the Lord Lyon. JB told Johnnie that they had 'settled the supporters for our arms – a stag out of compliment to me, and a falcon to you – both noble animals. The alternatives were Spider and Duggie.'[99] In early July he took his seat in the House of Lords, supported by the Lords Macmillan and Strathcona, and went to Buckingham Palace to 'kiss hands' and receive the GCMG from King George V.

July saw the publication of *The House of the Four Winds*, the last in the McCunn trilogy and probably JB's worst novel. The action has moved from Scotland to the fictional European Republic of Evallonia, which is Ruritania without the charm. It is notable, however, for the use of the word 'mole' to mean an undercover agent, forty years before John le Carré's *Tinker, Tailor, Soldier, Spy*. The book includes a masterly dissection of 1930s angst about the growing menace of authoritarian regimes, but that is unlikely to have appealed much to the general holiday reader.

He also made sure that he finished *The Island of Sheep*, the last of the Hannay novels, which was published in July 1936. It was dedicated to his eldest son 'who knows the Norlands and the ways of the wild

*Now in the Scottish National Portrait Gallery.
**Mrs Charlett came back to Elsfield Manor in 1940 and went through the Second World War and beyond as the cook.

geese', and it contains a child hero, Peter John, who bears a marked resemblance to Johnnie and who, with an equally resourceful girl companion, confounds a criminal gang, some of whom had not been dealt with completely in the earlier *The Courts of the Morning*.

That summer, Susie entertained Virginia Woolf to stay, so that they could visit the so-called 'Necromancer of Snowshill'* in the Cotswolds. This may have been a thank-you for the Hogarth Press publishing her *Funeral March of a Marionette*, although they had known each other a long time. Woolf's account of the visit is waspish. She wrote to her sister, Vanessa Bell:

> At first I thought it was going to be a complete frost – Susie awaited me in a typical shabby but large country house drawing room, alone, with a dog. She has grown very ample, and carries a faint flavour of Lushingtons. But by degrees we got warmer; and there was a dinner party – the Camerons, Isaiah Berlin, an Oxford undergraduate, a son, a daughter, and the daughter of Marnie – if you remember Marnie. Happily John was in London being given a dinner, or seeing the King, and it wasn't so bad. They're rather out of elbows, and have holes in the carpet and only one family W.C.

She twitted Susie about her grandeur, argued with Isaiah Berlin, and talked about films and modern poetry with William, 'who is a simple, and rather shaggy', a description of him that none of his family would have recognised.[100] William remembered the occasion as the only time he had ever seen Virginia Woolf roar with laughter – when he almost fell out of the car.

The departure from England was delayed by the Canadian election, which had been called for 14 October, so they did not sail before late October, almost the last moment to get to Quebec before the St Lawrence River froze for the winter. This delay made life harder for the Tweedsmuirs, who were suffering a severe bout of *Heimweh*, and it also gave Mrs Buchan the opportunity to write a number of rather lowering, if characteristic, letters: 'I wonder when exactly you leave for Canada. I must try to be brave. I don't know what life will be to me without you.'[101] 'I am afraid Walter is going to miss you terribly,

*Charles Paget Wade, an eccentric collector of treasures.

he doesn't make friends [which was plainly untrue, since he was both genial and open-hearted] and you are everything to him and Anna says it is just past words.'¹⁰² 'The longer I live I regret more and more my lost opportunities of being a good wife to the best of men and a good kind mother to wonderful children. Now I can only be a burden but none of you makes me feel my uselessness.'¹⁰³

On 18 October, JB wrote to her from Upper Grosvenor Street:

Leaving Elsfield was a sad business. It was a lovely autumn morning, but what between weeping maids and choking men I have never enjoyed anything less. Susie wept all the way to London, but recovered after that. Aunt Mamie [the Countess of Lovelace] came to luncheon to say goodbye [going off to govern a colony being something her family were accustomed to doing] and I had a most emotional farewell to Stanley Baldwin in the afternoon. He said he had no words to say what I had been to him in the last eight years. I feel rather solemn at leaving such a grave situation on this side.¹⁰⁴

9

Canada, 1935–1937

The substantial entourage that left for Canada on the *Duchess of Richmond* on 25 October 1935 consisted of the Tweedsmuirs, Alastair, aged seventeen, Beatrice Spencer-Smith, a schoolroom friend of Alice's, who had agreed to be Susie's lady-in-waiting, two aides-de-camp – one military and one naval, Captain John Boyle and Lieutenant Gordon Rivers-Smith – and the Elsfield staff. The ship was held up by fog in the Atlantic, and arrived more than eight hours late at Wolfe's Cove, Quebec City. In September 1759, General James Wolfe's army had rowed with muffled oars to shore and landed close by, before scrambling up the precipitous Heights of Abraham to fight the decisive battle against the French. This time, bells pealed and ship sirens boomed and the Citadel and Old Town were lit by a flaming red sunset.

The party was met on board by the Prime Minister, together with the Chief Justice, the Lieutenant-Governor of Quebec Province and the Premier of Quebec. They stepped ashore in the early evening, and JB, dressed in his heavy uniform of scarlet, blue and silver, with a helmet hat complete with white swan feathers, reviewed a guard of honour. The party was then driven in a cavalcade by torchlight to the white limestone Hôtel du Parlement in rue des Parlementaires, where he was sworn in by Mr Justice Rinfret, judge of the Supreme Court. JB replied to the many speeches in both English and French, much to the satisfaction of the Québécois, although opinions differed as to how good his accent was.

Their late arrival ensured there was no chance of their getting to Ottawa on Saturday and, since Canada was still in many places

Sabbatarian, it was not thought suitable to arrive in the capital city on a Sunday. They therefore slept the night in what was grandly called 'the Governor-General's Train', parked in a siding outside Quebec City and, on Sunday, went by motorcar to Cap Tournamente on the north side of the St Lawrence River. Here they watched the flocks of grazing Greater Snow Geese, 20,000 pure white birds, at the only place they halt on their autumn migration south from the Arctic to the Carolinas.

The 'Governor-General's Train' was, in fact, two luxuriously fitted-out carriages, in a brown and cream livery, attached to an ordinary scheduled train. The cars had been built in the mid-1920s for the use of senior executives of the Canadian Pacific Railway and contained bedrooms, bathrooms, sitting room and dining room. These cars were subject to the usual bumpiness, rattling and go-slows of Canadian trains at the time, but this was the only way that the Governor-General had any hope of crossing the vast distances in Canada,* and the Tweedsmuirs always travelled perfectly happily in them.

When they arrived at Ottawa next morning, an enormous crowd had assembled to meet them at the station, where JB reviewed yet more troops. They drove to Government House in an open landau, with outriders and a cavalry escort, the streets lined with people, calling out 'Good luck, John!'

'We are going to be a very happy and contented household, I think, and all the appurtenances of this house are the last word in comfort,' JB wrote to his mother. Alastair, after his 'dog-kennel at Eton' had a sitting room, bedroom and bathroom to himself, while, as was customary, Their Excellencies had their own separate bedrooms and sitting rooms.

Rideau Hall, in the smart suburb of Rockcliffe close to the Ottawa River, had been erected by Thomas Mackay, a timber magnate, but it had been the Governor-General's residence since 1867, the time of Confederation. It is a heavily built, grey limestone building with a rather portentous portico, but with well-proportioned and spacious rooms, large enough for enormous gatherings. James Cast, who was a most superior butler, said that it was something 'after the Windsor style'.[1] The house was very comfortable for its time, but not very up to date. Hilda Grenfell's daughter, Frances, stayed there for several months in 1938, and remembered the household, including 'Their Exes', standing around

*Ottawa to Vancouver took roughly five days by train.

the wireless set in the passage off the front hall, listening to the Grand National broadcast from Aintree. The house had no far prospects but it had (and has) substantial wooded grounds, where roamed enchanting coal-black squirrels. It also had pretty gardens, with extensive heated greenhouses and a kitchen garden, which provided flowers and produce for the house all year round – no easy matter in a climate where there is snow on the ground for a third of the year.

On the day that JB arrived in Ottawa he was photographed for an official portrait by Yousuf Karsh, a young man who had been a refugee from the Turkish oppression of Armenians in 1918, and had made his home in Ottawa. Karsh recalled in his 1946 book, *Faces of Destiny*, that 'although he [JB] wore a habitually grave expression, a gay sense of humor lay behind the mask, and he had the best and largest fund of Scotch stories of anyone I have ever known. On the first occasion, he greeted me with, "I hear you're quite an expert at this job. You'll need to be – to make me look the part." '[2] This was the start of many photographic sessions, and a close working friendship between the photographer and the Tweedsmuirs. Karsh took their photographs many times between November 1935 and January 1940, and very quickly became 'By Appointment' to them, as he had been to their predecessors, the Bessboroughs. Karsh also helped to shape the public's mental image of JB after his death, since his photographs were used for the back of Penguin paperbacks of JB's books after the Second World War.[*]

JB settled down quickly to a strict pattern of work. After breakfast, he would go to his study, where Shuldham Redfern would discuss with him the events of the day, show him the mail and any invitations, and give him papers to sign. JB was a good delegator and paid Redfern the compliment of never reading what he was signing, so the business was soon over.

If the Governor-General accepted a speaking engagement, he would call for Lilian Killick and dictate there and then what he was planning to say. The speech would be typed up, filed, and later given to the press

[*] The benefit was mutual: through JB, Karsh met Mackenzie King and, as a result, he was invited to take pictures after Winston Churchill spoke to the Canadian parliament in 1941. The famous 'bulldog Churchill' image came about because Karsh clicked the shutter a second after taking Churchill's cigar out of his mouth.

just before it was delivered, without notes, when it rarely altered much, if at all, from the printed script.

In his speeches, JB tried to keep a strict curb on his opinions, since he was not supposed to say anything not put in his mouth by a government minister, confining himself to what he called 'Governor-Generalities'. But even these had more heft, style and, most importantly, wit to them than Canadians were accustomed to. Mackenzie King was a very dull speaker and JB's predecessor, the Earl of Bessborough, had not been noted for his eloquence. JB could also adapt easily to his audience: light and witty for the Winter Fair in Toronto, scholarly and serious-minded for the universities.

He kept to his usual practice of not working after luncheon, going for a walk, a drive, skating on the skating rink in the park,* or even, in the early days, skiing, an occupation that the King had told him (through his Private Secretary since the monarch never communicated directly) was no sport for a middle-aged man. After tea, JB would entertain a guest for informal talks in his office – the Prime Minister sometimes walking in through the garden door about 5 p.m. – until dinner. If no one had been invited to dine, he would read with Susie in one of the sitting rooms. Dinners with invited guests were usually very formal: one evening in December 1935, for example, 'Their Exes' entertained eight premiers of provinces and their wives.

At least once a week, when Parliament was in session, he would go to the Governor-General's office in the East Block of the Parliament Buildings, where he was 'at home' to any Senator or Member of Parliament who wanted to talk to him. This was a tradition much valued by the politicians, especially the newer ones, since the Governor-General was of course above party politics, but could give sage advice from his experience if asked. The perspicacious Tommy Lascelles wrote in 1931 to a friend that there was plenty of rancour between the parties in Canada, but that they were all astonishingly patriotic: '... no nonsense about Monarchy, and the Monarch's representation, being a creed outworn. It is a red-hot article of faith.'[3]

Thanks to the strong Scottish heritage in Canada, almost everywhere they travelled they found a St Andrew's Church where they could attend Sunday service, and it was normal practice for JB to read the

*The footmen apparently made the best skaters.

lesson. In Ottawa, they generally worshipped at St Andrew's Church on Kent Street, which the Prime Minister also attended, and JB, when ordained an Elder, helped to serve Communion. In June 1937, JB spoke at the Fifteenth General Council of the Alliance of Presbyterian Reformed Churches, where the enormous audience must have been surprised at the depth of learning and commitment exhibited by a public figurehead. Instead of airy platitudes, he gave them a learned and humane commentary on the challenges facing Presbyterianism, the importance of changing in some particulars, if not in essentials, where necessary, and the benefits of working towards Christian unity: 'The task of religion is to spiritualize life, and in this task its foe is not science and the questioning powers of the mind, for science itself is a spiritual activity. The danger comes from the applications of science which have so marvellously elaborated the material apparatus of life and which may lead to an undue exaltation of mechanism. To counteract this peril there is need of a simpler and intenser evangel, freed from the lumber of a theology which itself can be a mechanical thing. The duty of re-statement is always with us…[4]

Prominent people, as well as personal friends travelling through, would stay at Rideau Hall. The Tweedsmuirs entertained 400 guests in three and a half years. Amongst the many were the film star Douglas Fairbanks Jnr, Prince and Princess Chichibu of Japan and a young German diplomat, Adam von Trott (later executed for his part in the July 1944 plot against Adolf Hitler). But JB also invited Canadian political leaders such as Henry Wise Wood, the populist agrarian politician from Alberta, and young people from organisations like the League for Social Reconstruction.

Although 'His Ex', as he was known by his staff, was occupied enough, there was very little for 'Her Ex' to do. The 'Green Book' advised that, in addition to the functions she would attend with her husband, she would fulfil a number of independent engagements, usually to do with women's and girls' organisations, but that she wouldn't be expected to say much, if anything. For an intelligent but shy woman, who thrived in small groups rather than great gatherings, such a prospect cannot have sounded at all alluring. For someone who had happily relaxed into the quietude of rural life in Oxfordshire, the constant comings and goings at Rideau Hall, the lack of privacy (she, like JB, couldn't even

go for a walk in the park without the accompaniment of an ADC), and the separation at night from JB, must have been sad burdens. She referred to herself as 'a Court card, with no back', observing action that scarcely concerned her, moved here and there in a stately round of small duties, which were apt to be stupefying. Her lady-in-waiting, Beatrice Spencer-Smith, was much too young to be a proper companion for her, and had all youth's lack of sympathy for the difficulties encountered by the middle-aged.

Furthermore, Tommy Lascelles had rightly warned the Tweedsmuirs against developing a Rideau Hall coterie, to avoid jealousies. They were only allowed to accept dinner invitations from those of ministerial or ambassadorial rank. This made it hard for Susie to meet potential friends.

Although 'Their Exes' turned out to be noticeably less formal than their predecessors, there were certain adamantine rules of protocol, set down in the 'Green Book', which JB could not ignore, but which tended to hide him behind a cloak of formality, and irritated his children in particular. He always entered a room before anyone else. Men walked backwards out of the room, with a bow. This custom was carefully upheld by Colonel Eric Mackenzie, the Comptroller of the Household, but not everyone appreciated the comical absurdity of it. Revealingly, JB gave up the practice of walking in front of his wife into a room, after he saw King George VI let Queen Elizabeth through when they stayed at Rideau Hall in 1939.

Long before JB arrived in Canada, he had worked out that the cardinal duty of the Governor-General was to get to know all kinds of Canadians, and to show them the different parts of Canada, to help foster unity in a collection of independent-minded provinces, different from each other in climate, topography, preoccupations and outlook. This would require tours of substantial length and complex organisation. After Christmas 1935, having visited Montreal and Toronto, he wrote to Walter to tell him of the trips he planned to make the following year: the country areas of northern Ontario to see the gold mines; Quebec City to stay in the Citadel; the Maritime Provinces in July; and a long tour of the drought-affected Prairies in late summer. He thought the last the most important, since the people were having such a terrible time and, moreover, there was the greatest preponderance of people of non-British descent. 'I propose to cut loose from my special train and, with

one A.D.C., to go touring the back parts, taking my own sleeping valise with me and picking up a lodging where I can. This has never been done before by a G-G, and I think it is the only way to get right down among the people ... There is not much I can do, but I can at any rate show that the King's representative is deeply interested in them.'⁵ This ambition was impracticable, not only because Mackenzie King would have thought it a derogation of his viceregal dignity, but also because of his unpredictable state of health. The optimistic side of JB never wanted to feel he was circumscribed, but he was. And it got worse.

The year 1936 began for the Tweedsmuirs with a sense of foreboding, since King George V was not well, and nor was Johnnie, who had to be invalided back to England from Uganda because of persistent amoebic dysentery. The King died on 20 January and JB was genuinely sorrowful, for, during the Great War, he had had the opportunity to see his best qualities. He wrote later: 'What struck me was his eager interest, his quick apprehension and his capacious memory ... I was not less impressed by his courage. He never lost heart, and his fortitude was not a dead, stolid thing, for there was always something about it of the buoyant and the debonair.'⁶ In a letter to Charlie Dick, he wrote: 'I feel his death like a personal bereavement, for he was an old and kind friend to me, as well as a beloved master.' He went on, insincerely, considering what he already knew about the Prince of Wales, 'But I think I shall be very happy with his successor.'⁷ The King's death caused an upsurge of genuine popular grief in Canada, as well as sympathy for Queen Mary, who had left a fragrant memory from her visit in 1901. Canada sincerely mourned the man who had been King during the travails of the Great War.

The first time JB opened Parliament, on 6 February, was thus a muted affair. The quiet at Government House rather suited JB, since his health was always better when he was not subjected to elaborate, drawn-out meals, and he could also settle into an organised pattern of working. But it was the worst time of the year for Susie, confined to overheated rooms (so different from Elsfield Manor, which was decidedly underheated), with the snow piling up outside, in a house draped on the outside with black crêpe. She also felt keenly the isolation, brought on by the rigid rules of Court mourning. It meant no dinner parties or levées for six months, only 'missionary teas'. She had to have her clothes dyed black.

The ADCs and Beatrice Spencer-Smith found it hard to find things to occupy her, and she was difficult to cheer up. She missed her children, over whom she constantly worried. She felt herself too old for skiing and violent exercise, so she couldn't enjoy much of what Ontario offered in winter. She was in her early fifties, detached by shyness from the crowds of strangers that so energised her husband on their visits away from Ottawa. She became withdrawn and uncommunicative and, not surprisingly, was viewed with an unsympathetic eye by some of the courtiers who surrounded her.

She missed her friends, as well as all those undergraduates with whom she had had such stimulating conversations around the fireside at Elsfield. She told her brother-in-law, Walter, four years later: 'The snow has descended upon us, which always makes me feel very queer and a little mad!'8 Her predisposition to depressive episodes seems to have been promoted by lack of daylight. If past experience was anything to go by, JB will have worried about her a great deal, but kept those anxieties away from the public gaze. There are, however, telling descriptions of the effects of depression on both the deracinated French Canadian, Galliard, and the sick Leithen, in JB's last novel, *Sick Heart River*.

The restrictions imposed by Court mourning ensured that JB had plenty of leisure to get on with his biography of Augustus. Writing a serious work of non-fiction so far from his books at Elsfield was less than ideal. Although he did borrow books from the Classical library at Université Laval, close to the Citadel in Quebec City, he also enlisted the help of an Oxford friend of Johnnie's, an Italian Renaissance scholar, Dr Roberto Weiss, as well as Professor Hugh Last of Brasenose, to answer points of scholarship by correspondence. It was a welcome recreation that first winter and spring, improving his rusty Latin so much that he declared he was almost thinking in the language.

In March 1936 the Tweedsmuirs made a tour of the Eastern Townships, a predominantly French-Canadian industrialised region on the east bank of the St Lawrence. In one week JB made thirty-two speeches in English and seventeen in French. 'I found myself,' he told his brother, 'at one moment driving in state in a sledge, accompanied by an old bishop in a tall fur hat, and at another rigged up in full miner's costume in the bowels of the earth among Nova-Scotian mine captains. I dined

with an eminent lumber magnate, and was given Coca-Cola to drink; while lunching at one convent, we had cocktails and an excellent dry champagne! The total impression was of immense warmth and friendliness.' He was happy in the company of French Canadians, attributing that, inaccurately but understandably, to his Scottish blood. In return they appreciated his interest and his catholic tastes: 'on lit Proust à Rideau Hall' was the surprised comment of the politician and scholar, Fernand Rinfret. He found the senior Catholics, such as Cardinal Villeneuve, cultured and wise. 'There is something great about a communion which gives such beautiful serene faces to the men and women who have spent their lives in its service.'[9] JB thought French Canadians, generally, were courteous and dignified, and the farmers never boorish. He was to pocket these experiences and transform them into something romantic in *Sick Heart River*.

It was on this trip that Shuldham Redfern discerned one particular and unexpected difficulty concerning the Governor-General, namely that his:

> ... musical sense is not on the same level as his literary ability. He is familiar with the tune of 'God Save The King', but there is another patriotic refrain called 'O Canada', which the Army authorities, in a misguided moment, decreed should be treated with almost the same respect as the National Anthem, and the Governor-General conforms as a matter of courtesy. At least that is his intention, but whether this melodious expression of patriotic sentiment is blared forth by a brass band and full supporting chorus, or by a piano, a violin and a flute, out of time with each other, and starting at different points ... it is the duty of someone on the Staff first of all to recognise it, and then to convey the information to His Excellency, by which time the flute may have passed the finishing post!'[10]

That month, Pelham Edgar, a Professor of English at Victoria College, Toronto, paid a visit to Rideau Hall on behalf of the Canadian Authors' Association, with an idea that had been germinating since they had first heard that the famous novelist had been appointed Governor-General. The CAA saw an opportunity to interest their Honorary President in helping to establish national literary awards. The valuable Prix du Québec (also known as the Prix David) for French-speaking writers

had been in existence since 1922, but there was nothing comparable for those who wrote in English. JB was enthusiastic about the idea, for he had been an early advocate of the development of distinctive national literatures in the British imperial possessions. How could it be otherwise with someone whose sense of Scottish identity was without doubt promoted by the strength and diversity of Scottish literature?

He would not or could not endow the prize, however. As William Deacon, the literary critic of the *Globe and Mail*, recalled to a friend in 1940: 'The deal we finally struck with him [Tweedsmuir] was simple. He gave us the name of his office to use in perpetuity. We bear all the cost and run it to suit ourselves.'[11]

Initially, there were just two Governor General's Awards categories – fiction and non-fiction – and all were Anglophone, since the French-Canadians were not inclined to get involved with another prize. Two bronze medals were awarded. In 1937, poetry and drama categories were added and, that year, the awards ceremony took place in the University of Toronto's Convocation Hall. JB delivered a peroration on the value of great poetry, entitled 'Return to Masterpieces', emphasising that 'Canada must make her own music.'[12]

In 1959 the administration of the 'G-Gs' was taken over by the Canada Council for the Arts and, at that point, French-language productions became eligible for prizes, and cash prizes were substituted for medals.[*] Writers who have won include Margaret Atwood, Rohinton Mistry, Stephen Leacock, Leonard Cohen, Alice Munro, Carol Shields and Mordecai Richler. In the words of Joanne Larocque-Poirier of the Canada Council: 'If today Canadian voices in literature are heard throughout Canada and around the world, it is in no small measure due to the support of these Awards and the legacy left by John Buchan.'[13] Intriguingly, the Canadian astronaut, Robert Thirsk, a distant connection of the Buchan family, took two 'G-Gs' prize novels into space in 2009.[14]

It is no wonder that JB was not keen to fund a literary prize. There was a great deal already that he had to pay for: staff wages, 'stores' (wines, gifts, including 30 cigarette boxes and 100 ashtrays), the car he bought from Lord Bessborough, as well as a new Buick and a 'bus'.

[*]In 2018 the prizes in fourteen categories, seven English and seven French, were worth $25,000 each.

Nothing – entertaining, travelling, clothes – could be done on the cheap. Susie's thrifty instinct for a bargain had to be headed off by the senior ADC, the Canadian Colonel H. Willis-O'Connor, for fear that if she spent too little on jewellery in an Ottawa shop, the fact would find its way into the newspapers. At the same time, although there were still substantial royalties from book sales, JB knew these would decline, since there would be no more novels, after *The Island of Sheep* in 1936, until he came home. He was also forbidden by Buckingham Palace from doing any journalism, or from signing any film deal, if the film was to be released while he was Governor-General.

During the period of Court mourning, JB could only see people unofficially, but he found that very helpful for getting to know the politicians individually. He told Sir Henry Newbolt in March that he liked the ones he met. 'I think they have the spirit which will solve all their problems – and these are big enough in all conscience.' (All nine provinces were running a substantial deficit as a result of the Depression.) 'The old trouble is the size of the land, which makes a common national feeling difficult, and inclines to provincialism.'[15]

At the same time he was getting to know the diplomats in the British High Commission, as well as those in the foreign embassies. Norman Armour, the head of the American Legation, was a highly civilised man with an aristocratic Russian wife, née Princess Myra Koudasheva, whom he had daringly smuggled out of Russia after the Revolution and then married. The Armours would become about the closest friends the Tweedsmuirs made in Canada. The strong mutual regard was useful, since JB was quietly working to effect a meeting with President Roosevelt that summer in Canada and then, if possible, accompany him back to the United States to stay a few days at his country house on the Hudson River.

Gradually, and much encouraged by JB, Susie began to get out and speak at meetings of, for example, the Society for the Overseas Settlement of British Women, a cause in which her mother was involved, as well as the many Women's Institutes in Ontario and further afield. The Women's Institutes provided cosy, small-scale gatherings of respectful, courteous women, who were eager to change their communities for the better; they provided a mutually beneficial environment in which Susie's best qualities were exhibited. In that milieu she gradually lost her shyness and became an accomplished impromptu speaker.

Canadian countrywomen had already started to put together local histories, but her support expanded the movement substantially and, after JB's death, they were named 'The Tweedsmuir Village History Books'. They survive to this day as 'Tweedsmuir Community History Books' and are a rich source of historical information for family genealogists, social historians and schoolchildren, as well as of pride for the communities to which they belong.

At the same time, Susie was encouraged by JB to write a novel, the first time she had attempted one for an adult readership. *The Scent of Water* drew heavily on her experiences doing voluntary work in the Welsh valleys, and was published the following year by Hodder and Stoughton.

In early April, Johnnie finally arrived in Canada, looking so thin and haggard that he had to introduce himself to his mother at Halifax. He was in desperate need of recuperation in a cooler climate, since he had very nearly died in Africa. At the end of that month, Mrs Buchan and Anna also arrived for their first visit, a stay of nearly three months, with Walter arriving later to enjoy some fishing with his brother, and then escort the women home. These Buchans were very popular at Government House since they were lively, accommodating, and stood on little ceremony. Guests were particularly charmed by the 'old lady', who would sit comfortably knitting in the drawing room, eager to talk to anyone who came up to her. One visiting British politician remembered that 'she showed a vivacity which many a young girl might envy ... She stayed up long after her son had gone to bed.'[16] She also stoutly refused to curtsey to her son, giving him instead 'a kindly nod'.

After their departure, Susie's mother arrived. She was also popular with the staff, despite being more stately than the Buchans. Beatrice Spencer-Smith, an amused spectator, wrote to her mother: 'Mrs G. is very nice to me – she is rather a melancholy companion – every sentence begins "Of course I can't help regretting such-and-such." '[17] The family spent a few days in June on a boat on the River Saguenay, but the cruise was rather spoiled by JB becoming 'very seedy'. It was something of a relief when they finally arrived in Quebec for their summer stay.

The Citadel, protected on the landward side by massive ramparts was, and is, the headquarters of the regular Royal 22ᵉ Régiment, known as

the Van Doos. The Governor-General's summer residence was (and is) at the east end of the officers' quarters, a grey building of the Regency period, perched right on the top edge of Cap Diamant, close to the Plains of Abraham, with truly remarkable views down the St Lawrence River, past the Île d'Orléans, away north to the Laurentian Mountains, and across the river towards Maine. The grounds were circumscribed on the landward side by the Regiment's parade square, but on the St Lawrence side the house had a glass-sided conservatory and a fine viewing terrace, like the deck of a ship.

JB liked to point out to his guests the view of the St Lawrence River bending away right-handed towards the sea and say, 'Ah, what must the French have felt every spring when the ice melted and they saw the spars of ships coming round the corner and wondered if it was the French fleet or the English...'[18]

Susie enjoyed their time at the Citadel best, since they were away from the heat and humidity of Ottawa, and the house, though smaller than Rideau Hall, had a very agreeable atmosphere. The landscape was more varied than around Ottawa, the drives they took out into *habitant* country were a novelty, and Susie always had a great liking for French Canadians, helped by the fact that she spoke excellent French. Moreover, friends from Britain were most likely to come out to stay in the summer. Charlie Dick, for example, visited in 1936 and preached a sermon 'by vice-regal command' at St Andrew's Church in the Upper Town.

Susie was sufficiently alarmed about her husband's health after Sagueney to ask the Professor of Medicine at McGill Medical School, Dr Jonathan Meakins, to come from Montreal to examine him. After JB endured another bad attack a few days later, Meakins sent him to hospital in Montreal for extensive tests. It was crucial at this point that he should recover quickly, since President Roosevelt's first visit to Canada was now fixed for 31 July. Meakins gave him a dietary regime from which he was not allowed to depart, but one which he considered tolerable. He was told, however, he must rest after meals, lying on his left side, something he did conscientiously for the rest of his life.

JB's illness meant the postponement of his trip to the Maritime Provinces (a tour that he made the following June) and it nearly scuppered the

visit by President Roosevelt as well. Despite last-minute anxieties,*
however, this did come off when the President, with his son James and
daughter-in-law Betsey, arrived at Wolfe's Cove, having sailed up the
coast from Campobello Island in New Brunswick, where the Roosevelts
had a summer home.

The President was accompanied by an entourage of such size and
complexity that it made the British courtiers boggle. There were four
ADCs, three private secretaries, the Chief of the Secret Service (a
Colonel Starling who said that, like John the Baptist, he was 'always
going before'), sixteen press men and photographers, and ten policemen,
toting pistols, a sawn-off shotgun and a Thompson machine gun.

The President was met at the station by JB in full dress uniform,
together with the Prime Minister and a host of Canadian dignitaries.
JB and Roosevelt, together with his constant attendant, Gus, were
installed in the first motorcar and, as they moved off, a contretemps
developed between the mounted cavalry escort of the Royal Canadian
Dragoons and an American policeman as to whether horses or their
motorcar should go just behind that of the Governor-General. A horse
kicked the police car, which then drove into it, prompting a 'G-man' to
draw a gun on the escort, whereupon he was 'pinked' in the arm by a
trooper with his drawn sabre. Presumably honour was satisfied, for the
incident ended there. Like the characters in an H. M. Bateman cartoon,
the Governor-General and President remained blissfully unaware of the
drama unfolding behind them and went on smiling and waving to the
crowds.

The party proceeded smoothly to the Wolfe-Montcalm memorial
near the Dufferin Terrace, overlooking the St Lawrence River, where
they were greeted by a twenty-one-gun salute, demanded by protocol
when a Head of State came to visit. The addresses of welcome were
broadcast across Canada, the United States and Britain. Once the party
arrived at the Citadel, they enjoyed a state luncheon, after which the
press took photographs of the President, his family, Mackenzie King
and the Tweedsmuirs on the Citadel terrace. Yousuf Karsh lingered in
the background, then asked whether he could take one more picture.

*Professor Jonathan Meakins was one of the guests at the state luncheon, which was mainly
composed of foreign diplomats, presumably to keep a wary eye on his patient from across
the table.

They agreed to stand in a formal grouping, and then relaxed, since Karsh pretended he had finished. While JB was telling the President one of his Scottish stories, Karsh got the characteristic picture he wanted.

The President and JB went out for a drive on their own and then, after tea, the party left once more for Wolfe's Cove. Roosevelt had been no more than eight hours in Canada, but in that time a mutually useful connection had been made and the Tweedsmuirs were invited to come to Washington the following year. As JB told the King, the President had specially wanted to talk to him about how, if he won the next election, he wanted to make a great push 'towards the pacification of Europe', possibly inviting the Great Powers' leaders to a conference. 'Such an appeal by the head of the United States could scarcely be disregarded, especially as the President is, with all his limitations, an extraordinarily dynamic and persuasive figure…'[19] Roosevelt had made it plain that he was no more interested than JB in keeping to the strict protocols governing what the Governor-General should or should not concern himself with.

The following week, the Tweedsmuirs motored to Lorette, a village of the Huron people on the Saint Charles River not far from Quebec City, where JB was made a Chief and given the name Hajaton, meaning 'The Scribe', and a headdress of feathers. It was to be the first of several. They then set off with Johnnie, Alastair, James Cast, Annie Cox and the ADCs to tour the Prairies, stopping off to see Professor Meakins in Montreal on the way, since JB was still not entirely fit and Susie was convinced that Meakins' reassurances had a beneficial psychological effect on her husband.

This tour, which included Winnipeg, Regina, Saskatoon, Edmonton and Vancouver, had many of the features of all the tours that the Governor-General was to make in his years in Canada: a reception at City Hall in the larger towns where they stopped, a drive around the area, taking in any particularly notable feature, a big dinner or a garden party at the provincial Government House, where he would be welcomed by the Lieutenant-Governor (his deputy in that province), and, on a Sunday, reading the lesson at a local Presbyterian church service. There was often a visit to a First Nations settlement. On this trip they visited the Plains Cree at Carlton, outside Saskatoon. Under their Chiefs Ahenekew, Dreaver and Swimmer – the latter wearing

a magnificent feathered headdress that reached to his ankles – they commemorated the signing of their treaty with Queen Victoria in 1876. JB was made a Chief and given a name, anglicised as Otataowkewimow ('Teller of Tales'), which he found impossible to pronounce. He was thrilled that it meant the same thing as the name the Samoans had given to Robert Louis Stevenson.

At Edmonton, he unveiled the memorial to the Great War dead and then boarded the train for Victoria, which stopped at Jasper so the party could admire the Rockies, and go for a drive to catch a sight of black, brown and cinnamon bears. When they arrived in Victoria, JB addressed the Canadian Club of Vancouver,* inspected a naval dockyard, and then went fishing for a week with his family, steaming up the coast of British Columbia on the yacht belonging to Lieutenant-Governor Hamber. This week on board saw Johnnie recover somewhat from the illness that was still dogging him; nothing could have been designed to cheer up such a passionate angler more effectively than fishing for salmon on the Campbell River. The size and nature of their catches were reported on the local wireless news each evening.

No doubt prompted by this knowledge, the magazine *Rod and Gun* asked for a message from the Governor-General for their December issue. JB made a plea for conservation that must have sounded advanced for the time:

> There is no question in Canada which interests me more than the conservation of Canadian wild life. [The first part of this sentence is one that he used often, in connection with a variety of Canadian preoccupations.] Canada should be the playground of North America, but in order to make this playground attractive it is most necessary to safeguard the assets which nature has given us, both in flora and fauna and scenic beauty. At present these assets are enormous; but it is only too true that the richest resources in the modern world will, unless they are safeguarded, disappear with tragic rapidity. I have seen in other countries carelessness in one generation destroy the wild life. I want to see facilities for sport open to every

*There were Canadian Clubs in all the big cities, founded to promote patriotism in such a diverse and enormous country, and concerned with the fostering of culture, business, science and so on.

sportsman, to whatever class he belongs. To make that possible we must preserve the wild game. We must have wise game laws and they must be strictly enforced, and this is not in the interests of any coterie, but of the nation at large.[20]

For the Canadian Club speech, JB chose to talk in theoretical terms about foreign policy. He spoke of the need for a revised League of Nations to ensure collective security, since the Empire, though powerful, was not strong enough to provide that security on its own, and its constituents would need to develop the proper machinery for cooperation. The headline in the Toronto *Globe* ran: 'Tweedsmuir Sees Common Defense as Unattainable; Empire as a whole cannot guarantee security in every part; he says Canada needs foreign policy.'[21] The press reaction prompted consternation in government circles. Then at Calgary on 3 September, JB made a speech to the Alberta Military Institute, which was to prove even more controversial, and to JB unexpectedly so, which seems slightly odd considering the newspapers' reaction to his Vancouver speech. In deference to the interests of the guests, he spoke about defence, pointing out that, with the disappointment that was the League of Nations, every nation had to think about their own defence: 'No country today is safe from danger. No country can be isolated. Canada had to think out a policy of defence and take steps to implement it.'[22] He said that his position as Commander-in-Chief made it his duty to take an interest in this.

Considering the shortcomings of the League of Nations, the European problems of 1936 (the Italians in Abyssinia, the German occupation of the Rhineland), and the fact that enemy aeroplanes now had the range to cross the North Atlantic, these seemed to him to be reasonable things to say, and not ones that would startle his audience. But he had not taken enough note of how much controversy Viscount Elibank, a British politician and supporter of Beaverbrook's United Empire Party, had already caused that August on his lecture tour across Canada, when he had several times criticised the Canadian government for its lack of military preparedness. JB's speech hit the headlines in newspapers across Canada. The Toronto *Globe*, in particular, used the speech as a stick to beat the Liberal Party and its leader, Mackenzie King.

The news reports disturbed ordinary Canadians, who were worried about how a possible increase in defence spending could be squared

with the provinces' attempts to bring down their budget deficits but, more seriously, it shocked both Ian Mackenzie, the Minister of Defence, and the Prime Minister. The latter had a dread of war even more acute than JB's, but there was for him the added complication of political dependence on the French-Canadian community, many of whom had been against Canada's involvement in the Great War. He was also hyper-sensitive to what he considered meddling by the King's representative in Canada, which went back to Byng's day in the mid-1920s.

Mackenzie King wrote at once to JB in strong terms, telling him that his words in Calgary would be misconstrued, would create controversy and put difficulties in the government's way. The same day he confided in his diary his belief that JB had hurt himself irreparably, would probably get ill and have to go home. 'I am afraid it is the Tory in him and "the tranquil consciousness of effortless superiority".'[23]

JB, realising he had gone too far, apologised, saying he had tried to be helpful, that criticising government policy was 'the very last thing I should dream of', and promised to be very careful. The row gradually blew over, particularly since both Mackenzie King and Mackenzie were only too aware that there were flaws in government policy on the matter, which really had to be addressed. Mackenzie King did, however, complain – confidentially – about JB's behaviour, both to Malcolm MacDonald MP, Ramsay's son, and the Earl of Halifax, when he stopped over in London the following month before he went to Geneva for the League of Nations conference.

Historians have spilled much ink attempting to understand the psychology of Mackenzie King. Certainly, as the result of a strange kink in his personality, the relationship that JB enjoyed with the Prime Minister was at times very fraught. He was of Scottish descent, with a grandfather, William Lyon Mackenzie, who had been a Mayor of Toronto and had led an unsuccessful revolt, the Upper Canada[*] Rebellion, against the British government in 1837, thirty years before Confederation – something which his grandson could never resist telling anyone that he met. Mackenzie King had studied law and social policy at Harvard, and was first a civil servant who subsequently entered politics as a Liberal in 1908 and was Minister of Labour from

[*]What is now Ontario.

1909 to 1911. During the Great War he had worked for the Rockefeller Foundation on industrial relations, in which he became an expert.

He had proved himself to be an astute, even Machiavellian politician, with the result that he served as Prime Minister for twenty-two years, on and off, from 1921 until 1948. He is generally considered, despite his personal idiosyncracies, to have been a successful leader, adeptly steering the country through the Second World War. He did it by a mixture of calculation – in particular not showing his hand unless he was forced to – luck and very hard work. (He was a terrible delegator.) He was also a platitudinous speaker, but had plenty of that Liberal 'unction' that JB had satirised years before in his short story, 'A Lucid Interval'.

Mackenzie King was a rather lonely bachelor, who made few lasting friendships, almost certainly because he was so quickly roused to jealousy. Lady Byng's lady-in-waiting was scandalised by having her thigh pinched twice by him, when dining at Rideau Hall in the 1920s, but he seems to have been most attached to his dead mother, to whom he erected an indoor shrine at the large house he inherited from his predecessor as leader of the Liberal Party, Sir Wilfrid Laurier. (Violet Markham called Laurier House 'that mausoleum of horrors'.) Mackenzie King was a strict Calvinist, who believed himself to be 'saved', and was temperamentally inclined to look to God to approve his decisions. Unbeknown to almost everyone until his voluminous diaries were published after his death, he pursued an interest in spiritualism, holding séances at his country residence, Kingsmere, in the Gatineau Hills outside Ottawa. He thought that he and JB had much in common and saw him as a potential friend, rather than simply a man in public life with whom he must have cordial dealings. Since JB had more than enough friends already, not to mention a confidante in his wife, and was rightly wary of Mackenzie King, the Prime Minister was destined to be, at times, thoroughly disappointed.

JB and Susie privately called him 'Mr Micawber' because he was short, round and bald, and reminded them of Phiz's depiction in the first edition of *David Copperfield*. Others might be put in mind of Mr Pooter, especially when in the presence of royalty, and even sometimes Bertie Wooster or his Aunt Dahlia, in his predilection for writing very long, explanatory telegrams.

*

At Edmonton, the family prepared to part. Susie and Alastair were returning to England – Susie to look after William, who had had a serious operation, while Alastair was due to take up a place at Christ Church, Oxford. Johnnie was still not well enough to stand the kind of long car journeys on which his father was about to embark. JB told his mother that there had been 8,000 people waiting for them at Edmonton Station and that 'Susie said she felt for the first time in her life like a film star. They are a most wonderfully welcoming people here ... It is rather melancholy, this breaking up of the household, for we have all been very happy together.'[24] The trip had been a substantial eye-opener, and not just about how careful JB was going to have to be in his public utterances. The party was struck by the warmth and friendliness but terrible poverty in the Prairies, which contrasted so very starkly with the lush growth, wonderful flowers, varied landscapes and relative prosperity of Vancouver and Victoria.

Susie recalled years later:

We first saw the southern Prairies in the tragic days when a long drought had made the land into a desert ... The whole countryside appeared to be blowing away and there were drifts of grey dust over everything. Huge thistles grew and maleficent little gophers peeped out of their holes. The only feature of the place that was not depressing was the fortitude and optimism of the people. I enquired of some of the women what I could do for them, and they asked me to send them books. With John's constant help and encouragement I started what was called the Lady Tweedsmuir Prairie Library Scheme, and with generous help from Canadians, from England and from the Carnegie Trustees in New York, I managed to send out forty thousand books from Government House.[25]

In a terse paragraph she described one of her most successful and long-lasting contributions to Canadian life. She secured $500 from the charitable Massey Foundation, via Vincent Massey, the Canadian High Commissioner in London, and also wrote to the President of the Carnegie Corporation of New York, whom she knew to have helped rural libraries in British Columbia. He could do nothing then, but

in November 1937, by which time the scheme was in full swing, the Carnegie Corporation did provide $1,500, as well as another $1,500 in early February 1940.

Here was a respectable and useful project that captured Susie's imagination and into which she could throw herself, escaping, thereby, the dreariness of a consort's life. JB encouraged her in this, partly because he could see the good it would do for very isolated communities in an age before television, but also because he knew how much she needed positive distraction. He provided books (he was sent a great many by hopeful authors) and gave her wise counsel about what would be suitable. Publicity about the scheme brought books from all over Canada, and also from Britain. There were many Nelson's 'Sevenpennies' among them, the print still clear and black and the spines unbroken. Susie herself oversaw the scheme from Rideau Hall, with Lilian Killick and Joan Pape (her lady-in-waiting from early 1937) in support. It gave purpose and structure to her daily life. The greatest demand was for children's books and the Bible, both of which secured Susie's approval, but she was careful to see that books about handicrafts – a subject about which she knew little and cared less – were also made available. She persuaded the Canadian railways to carry the books out west free of charge. When in England in 1937, she succeeded in interesting King George V's widow, Queen Mary, in the scheme. Enough books found their way westwards to stock dozens of small libraries.

After his family had left for Ottawa, JB travelled to Lethbridge in Alberta, accompanied by one of his ADCs, John Boyle, as well as Shuldham Redfern. They visited experimental agricultural stations, both there and also further east, where the drought was much worse, especially in areas on light soils. 'What should have been miles of waving corn, or a golden stubble,' he told his mother, 'is now as brown as Leadburn Moss.'[26]

The vice-regal party drove north from Medicine Hat to beyond the Saskatchewan border, through drifts of sand, to stay in an inn in a village called Alsask, so that JB could visit his old 'Hutchie' friend Alec Fraser. A Prairie farmer, Fraser had fallen on very hard times, since there had not been a harvest to speak of for seven years. The two men had a 'great talk', even though they hadn't seen each other for forty years, and the vice-regal party was most hospitably entertained. JB admired Fraser's

sons and daughters, one of whom, some years earlier, had trained as a teacher at his expense.[27]

The people who came to cheer him in the Prairies 'all bore the marks of toil and struggle, but I never met a finer or more courageous race', he told his mother.[28] Many were Scots, some even originating from Tweeddale. (He never failed to tell his mother of these encounters, even discovering an old lady, originally from Peebles, who had made her wedding dress.) He then went south-east to Swift Current, where he toured yet more government experimental farms, to see what drought protection measures they were developing. As he was to do many times while in Canada, he surprised the people he met with the depth of his understanding and knowledge about farming. He also visited the Niitsitapi (Blackfoot) nation at Kainaiwa reserve in southern Alberta, where Chief Shot-on-Both-Sides gave him the title 'Chief Eagle Head' – presumably impressed by his aquiline nose – and then visited the sole Mormon temple in Canada in Cardston, supported by Americans from Utah who had come north to farm. 'I tried to get a hang of the Mormon creed, but it is the most curious mixture of evangelical Christianity and primeval superstition.'[29]

At a Ukrainian settlement at Fraserwood in Manitoba, he told his audience that they would all be better Canadians for being also good Ukrainians.[30] He said that 'our Canadian culture cannot be a copy of any one old thing – it must be a new thing created by the contributions of all the elements that make up the nation'.[31] He went on to a settlement of Icelanders at Gimli, brushing up the Icelandic he had taught himself at Oxford, so that he could say a few words in his audience's own language, and praising them for not forgetting 'the traditions of your homeland. That is the way a strong people is made – by accepting willingly the duties and loyalties of your adopted country, but also by bringing your own native traditions as a contribution to the making of Canada.'[32]

The three men then went up into 'the bush country' north of Prince Albert, staying for three days at a cottage belonging to Mackenzie King (he was Member of Parliament for the constituency of Prince Albert) at Waskesiu, in the Prince Albert National Park. This cottage was close to Kingsmere Lake, which at that moment was 'in the full glory of its fall colours'.[33] An aeroplane had been put at their disposal, so they flew to a lake fifty miles away, where JB caught an enormous eight-pound trout. They then spent a long afternoon in the woods with the conservationist

Outside the White House in Washington at the beginning of the Tweedsmuirs' stay with the President, Franklin D. Roosevelt, and his wife, Eleanor, in April 1937. What was happening off-camera to cause such different reactions in the subjects?

On the terrace of the Citadel in Quebec City, overlooking the St Lawrence River, in July 1936. JB is telling a Scottish story to the President of the USA, who is supported by his son, James. 'Mr Micawber' – William Lyon Mackenzie King, Prime Minister of Canada – looks on.

© Yousuf Karsh

A group of American congressmen close-question JB on his visit to Washington in April 1937. Are they pressing for his considered view on Hitler or do they want to know what Richard Hannay will do next?

Courtesy Saurè, Lady Tweedsmuir

Shuldham Redfern's cartoon of Susie on her return to Ottawa in January 1937, painfully highlighting her predicament. Her dress has prison arrows, her earrings are keys and she wears a chain necklace and handcuff bracelet.

JB had a famous enough face to be portrayed on a cigarette card in 1937.

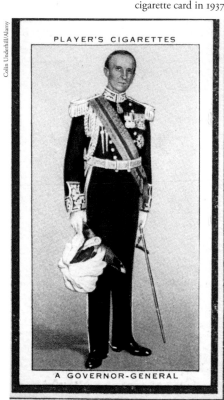

PLAYER'S CIGARETTES

A GOVERNOR-GENERAL

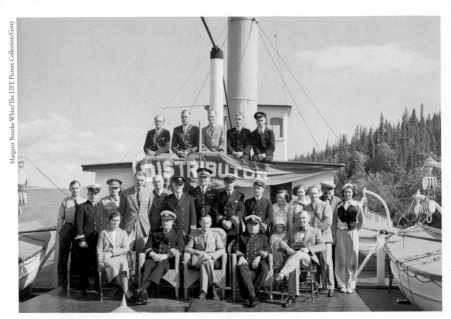

Voyagers down the Mackenzie River on the *SS Distributor* in July 1937, amongst them the Governor-General (centre, seated), Shuldham Redfern standing behind his seated wife, Ruth, and Gordon Rivers-Smith, JB's ADC, and Richard Bonnycastle of the Hudson's Bay Company, who organised the trip, on the top deck. The photographer, Margaret Bourke-White, who took this picture using a shutter timer delay, is standing, far right.

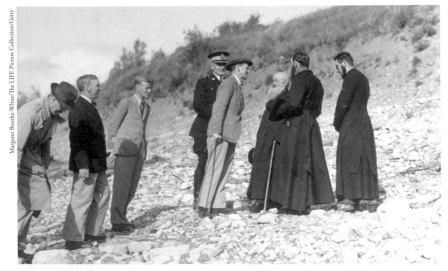

JB meets some Catholic missionaries of the Oblate Brotherhood at a small settlement on the edge of the Mackenzie River. They feature, in fictional form, in *Sick Heart River*.

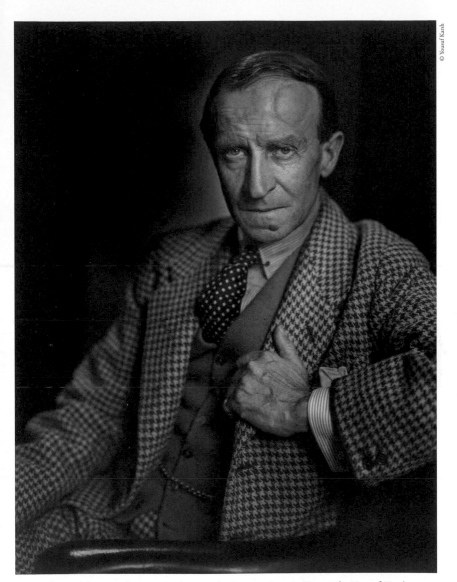

JB, neatly turned out as always, was photographed many times in Ottawa by Yousuf Karsh. This was his favourite picture.

JB dressed in the headdress and cloak of a First Nations people, most likely the Plains Cree that he met in 1936.

King George VI and Queen Elizabeth with the Tweedsmuirs in the garden of Rideau Hall in May 1939 during their four-week north American tour, a few short months before war broke out. This tour was instigated and orchestrated by JB. If for no other reason, the Queen's glamorous clothes by Norman Hartnell set her apart from everyone else.

JB's body lay in state in the Senate Chamber in the Centre Block of the Parliament Buildings in Ottawa for two days before his funeral in 1940. One of the soldiers who took turns to guard the coffin was his son Alastair.

Grey Owl, an Englishman from Hastings who pretended to have an Apache mother; JB wanted to meet him since he admired him as a naturalist and writer. Redfern took a picture of JB with one of Grey Owl's birds of prey on his fist. According to Boyle, 'Everything is tame, birds, beasts and beavers and we fed and handled all his pets. He.[Grey Owl] is a remarkable character, very well self-educated but a bit of a scoundrel I should say; with a strong penchant for the bottle.'[34] They were rewarded by the sight of beavers arriving to be fed.

While JB was in the west, he wrote – arguably beyond his remit – to Mackenzie King, who was in Geneva at the League of Nations conference:

> What Europe is witnessing at present is not a conflict of genuine principles so much as the wrangling of ambitious mob-leaders, who have behind them nations who have lost their nerve. In this wrangling we have no real interest, except as peace-makers. I do not believe that the British people, or the people of any Dominion, would be willing to participate in a war, except in the unlikely event of an attack on British territory, or upon the Low Countries, which are Britain's front door … The danger I fear is that we may be drawn insensibly into a diplomatic situation from which there is no retreat. You can do an immense amount to prevent that happening. Hammer into the British Cabinet's head that the most loyal people of Canada will refuse to return to the old eighteenth-century game in Europe. We have other things to think about.'[35]

It was clear that JB was now identifying himself strongly with Canada.

The following month saw the resounding re-election of Franklin Roosevelt, which naturally pleased JB as well as a number of his regular correspondents, such as the Earl of Crawford and Balcarres, known as 'Bal', who wrote: 'I look upon Roosevelt as the leading charlatan of history, but we want him to be re-elected. We think that if Europe misbehaves towards us Roosevelt is much more likely to use his friendly influence than [Alf] Landon [the Republican candidate].'[36]

Not everyone agreed with that analysis. Ramsay MacDonald, like a number of politicians in Britain, including Neville Chamberlain, had reservations about whether Roosevelt could be trusted to put his

money where his mouth was. He wrote to JB in early December: 'I was interested in what you said about the international development that the United States may now show. I do hope it is going to be a development in actual help and not in mere verbal or paper declarations.'[37]

Ten days later, JB wrote to Walter, his most trusted confidant, that Canada and the United States would be compelled more and more to think, and presumably act, together. 'This does not mean in any way a weakening of the imperial tie, but it does mean that Canada may be the motive power towards that closer understanding between the United States and the Empire, on which I believe the future of the world depends.'[38]

When JB returned to Ottawa he discovered that Johnnie's 'amoeba' was still preventing him from putting on weight, and the young man was forced to endure a course of severe 'inoculations'. So the Tweedsmuirs had worries about their children on both sides of the Atlantic. Susie confided to JB, when she arrived in England in October, that 'these eleven months of ceaseless anxiety have somehow worn down my morale and absolutely exhausted me – and I get stupidly jumpy'.[39] Not always able to make up her own mind, she intensely disliked being out of reach of the advice of her husband and eldest son. But at least she was back amongst her friends once more, and heartened by how pleased they were to see her after a year's absence.

JB was about to leave for another trip to the west when the problems between King Edward VIII and the British government over his love affair with the American divorcée, Mrs Simpson, came to a head. Wallis Simpson had finally been granted a decree nisi in her divorce proceedings and it was not thought that the British press would keep silent much longer in these circumstances, especially as the American press had no such scruples. The British government, under Stanley Baldwin, considered that it was not just unconstitutional and illegal for a British monarch to marry a divorced woman, but it would be deeply unpopular with all the Empire's peoples. Although Winston Churchill suggested that it would be possible if the marriage were morganatic, in other words the King's consort was not made Queen, this was a minority opinion. As far as the British government and most politicians were concerned (with a few exceptions, such as Lord Beaverbrook as

well as Churchill, both of whom disliked the Prime Minister), the King must choose between his throne and the woman he loved.

This was an issue that affected the Commonwealth very closely. In mid-October the King's Private Secretary, Sir Alexander Hardinge, wrote confidentially to JB, asking for his opinion of Canadian sentiment over Mrs Simpson. He wanted JB to write a letter that he could show to the King. The propriety of asking this of the King's representative was more than a little questionable, and we may wonder how Hardinge could have thought that JB was in a position to give a properly informed answer – given the discretion of the Canadian press, and the reticence of all around him. JB, embarrassed, did his best, replying most unwillingly, and only because Hardinge had asked him directly. The letter was typewritten, since he could assure Hardinge of Lilian Killick's discretion, and the gist of it was that Canada had come to believe the lurid stories circulating in the American newspapers, many of which were available in Canada, although the Canadian press was proving almost as stalwartly discreet as the British. He told Hardinge that he believed Canada to be the most sensitive part of the Empire about this matter, since it was still a church-going nation, where private life preserved 'the Victorian decencies' even if sometimes 'pedantically and pharisaically'.⁴⁰ He went on to say that the monarchy was considered in Canada a stable centre in an anarchic world and, moreover, Canadians idolised the charming, good-looking King, since he had made such an impression there on his visits in the 1920s. JB feared a reaction, especially among the young, if they discovered he had feet of clay.

To JB this was an intensely distasteful business, not simply because he cared neither for divorce nor for conflict ('this is a nice job for a quiet man,' he told his wife) but, more importantly, because he had been treated well by the King and was, in any event, by the nature of the position he held, loyal. Moreover, he knew how difficult his own position was. Hardinge should, properly, have gone to Sir Francis Floud, the British High Commissioner, who, frankly, would have found it easier to sound out Canadian opinion on such a delicate matter than could the Governor-General. News reached Mackenzie King that JB had communicated with Hardinge on this, which led him, once more, to criticise JB for interfering, although this time most unfairly. As the crisis deepened, Mackenzie King visited Government House a great deal and was, as JB put it, like 'a wet hen'.

In early November, JB received a confidential letter, along similar lines to Hardinge's, from the Prime Minister, Stanley Baldwin, to which he replied in much the same vein: that Canadians were both royalist and puritanical, and were infuriated by what they saw as the intolerable impertinence of the American press. 'In this most delicate matter I believe that Canadian opinion is an important card to play, for the King loves the country and the people, and I believe is jealous of her regard.'[41] He also pressed upon Baldwin that he should handle things alone, and keep the Archbishop of Canterbury (Cosmo Lang) and Ramsay MacDonald out of it. JB stressed that, as the King's representative, he should not be quoted and that any public expression of Canadian opinion should come from Mackenzie King. Susie was invited to lunch with Stanley Baldwin and his wife at Chequers the following week. Afterwards, she wrote to her husband: 'He said "John cannot write to me too often or too strongly", as we parted. You will understand.'[42]

Hardinge wrote to thank JB for his letter, which he had shown to the King and the Prime Minister. He asked rhetorically: 'A year ago would one have thought such degradation of the British Throne possible?'[43]

On 1 December, just a day before the crisis became public, Susie went to see Queen Mary, King George V's widow, about the Prairie Book Scheme. She wrote to her husband, 'I really enjoyed my half hour with her. She was looking tired and a little older but as upright and handsome as ever … My dear, what are we going to do if the King abdicates? Shall we return or what? I am dreadfully sorry for you … as I know in some ways Canada minds more than any one, although Australia appears to be absolutely on end. I feel a desperate sense of discomfort, misery and unhappiness, everything else is put into the background, nobody mentions the war or anything else.'[44]

The Abdication Crisis followed JB to the Prairies. He received daily cables from London which, as they were always in cypher, had to be decoded by the ADCs, and he was forced to make a number of transatlantic calls from remote Prairie telephone offices.

At times, however, he managed to set aside these anxieties to concentrate on the tour. He wrote to Susie from Winnipeg on 1 December: 'At Regina on Saturday afternoon I visited the community halls of the Germans, Poles, Hungarians, Rumanians, Ukrainians White and Red, and the Jews, and spoke in each. The Police didn't want me to go to the Red Ukrainians on the ground that they were

dangerous Communists, so of course I insisted on going, and was received deliriously in a hall smothered in Union Jacks, and they nearly lifted the roof off singing the National Anthem.'⁴⁵

JB arrived back in Ottawa on 6 December to be greeted by a very anxious Mackenzie King. He wrote to his mother: 'All yesterday and evening I was closeted with my Prime Minister. Today is the critical day. I am seeing eye-to-eye with my PM all through, and have been in daily correspondence with S.B. [Stanley Baldwin]. We have to take a major part in the whole business, and I have never had any doubt about the right line to take. It has been a terribly anxious and sad time.' The letter was continued the next day: 'No settlement yet! It cannot be much prolonged for the Australian Parliament is in special session waiting for news ... Baldwin's speech in the House yesterday seemed to me excellent. Winston [the romantic monarchist] is surely making a blazing fool of himself.'⁴⁶

King Edward VIII made up his mind to go and on 10 December he signed abdication papers at Fort Belvedere. The same day JB signed an Order in Council on behalf of Canada, approving the Abdication. He told Susie, 'It has been a miserable time, and for the last five days the Prime Minister and I have never been off the telephone.' He thought both Baldwin and Mackenzie King had been magnificent. 'It reveals an entirely new mechanism in the Empire. I am desperately sad about the whole business. I cannot bear to think of that poor little man with no purpose left in life except a shoddy kind of amusement. Canada is curiously bitter about the whole business. There is not a scrap of sentimental sympathy. That seems to be the feeling of the whole Empire.' He went on to hope that the new King and Queen would bring back the atmosphere of George V, 'and this horrible night-club, jazz, cocktail raffishness may go out of fashion'.⁴⁷ To his mother he recounted a witticism that was going the rounds: 'This is the first case of a British Admiral who has become third mate to an American tramp!'⁴⁸ By early February 1937, JB was writing to Baldwin: 'The recent Palace troubles are almost forgotten. Canadian opinion on the subject was curiously hard, harder, I think, than at home. There is never much mercy for an idol whose feet have proved to be of clay.'⁴⁹

Christmas 1936 at Government House was pleasant, now that the Royal crisis was past and the new dispensation in place. JB was in cheerful

mood and even prepared to join a game of Hide and Seek, during which the naval ADC, Gordon Rivers-Smith, caught him in a dark corridor, on hands and knees, as if he were stalking a deer. He also took the opportunity of a slack time to work hard on his biography of Augustus, which he finished the following summer. Much to his relief, Susie landed back at Halifax on New Year's Eve, accompanied by the convalescent William. Susie was still finding the Ottawa winter hard to bear and it is probably at this point that Shuldham Redfern drew a cartoon of her in a ball gown, decorated with prison arrows, with a chain around her neck, earrings in the shape of keys and bracelets that were handcuffs. The caption read: 'Her Excellency the Lady Tweedsmuir attended the ball of "The Return to Ottawa Life" in a most original toilette of sackcloth de soie embroidered in broad arrows of sequins...'⁵⁰

The long-awaited trip by the Governor-General to Washington, about which King George VI was content, since it was a visit to the President and not to the American government, took place in late March 1937. The Tweedsmuirs arrived in Washington just as spring was beginning and the tulip trees and golden forsythia were in flower. At Union Station the platform was lined with sailors, and a squadron of cavalry escorted their car down Pennsylvania Avenue to the White House, where the Roosevelts met them at the porch. JB was given Abraham Lincoln's study as his sitting room, which must have had a piquancy for the man who had written *The Path of the King*, displayed pictures of Lincoln in his study at Rideau Hall, and had talked of the great man at Milton Academy in 1924.

The next day he went to a press conference, made very cheerful by the presence of so many journalist friends from his Great War days. He was then driven to Arlington Cemetery, the destination for all visiting dignitaries, where he laid a wreath at the Tomb of the Unknown Soldier and at the monument to American soldiers who had fought in the Canadian Army during the Great War. After that he was shown round Arlington House, and 'It was thrilling to see the room where he [General Lee] walked all night making up his mind, when he was offered the commandership-in-chief of the Northern Army.'⁵¹

He lunched with the Secretary of State, Cordell Hull, with whom he had a long conversation 'on international questions'. In the afternoon he embarked on the presidential yacht. It sailed down the River Potomac to Mount Vernon, the home of George Washington, with the ship's

bell tolling and the flag at half-mast, as had been customary ever since Washington's death. In the evening, after a State dinner, JB and FDR continued to talk 'until far into the night'. He was not supposed to talk policy with the President, without the Canadian Prime Minister being present, but, as Roosevelt told the press, although there would be no official talks the two men could 'sit on a sofa and soliloquize, and each could not help overhearing the other'.[52]

The next morning he was driven to the picturesque town of Annapolis to visit the United States Naval Academy, after which he came back to lunch with the British ambassador, Sir Ronald Lindsay, at the Embassy. 'Then we went to Congress, and that, I think was one of the most difficult experiences of my life. I asked beforehand whether I was required to speak, and they said that I need only formally thank them for their greeting.' He was taken to the Senate. 'The Vice-President moved that the House adjourn, which was carried, and then to my horror he said, "His Excellency will now address you." I did my best, and happily what I said seemed to be well received, for they unanimously moved that it be recorded in the Minutes.'[53] He was the first Briton ever to address the US Congress.

He reminded the assembly that he had once been a free and independent politician like them; he had had an official character and a private one and he illustrated this with one of his hoary Scots stories about a minister who felt that, once a month, he had to deliver a sermon upon the terrors of Hell, but being a humane man would conclude 'Of course, my friends, ye understand that the Almighty is compelled to do things in his official capacity that he would scorn to do as a private individual.' Now he had only an official position, and had to be very careful what he said in public. Nevertheless, he expressed his belief that the future of civilisation lay principally in the hands of the English-speaking peoples. 'I want these great nations not only to speak the same language, but to think along the same lines. For that is the only true form of co-operation. ... [But] the strength of an alliance between two nations lies in the fact that they should be complementary to each other and each give to the other something new.'[54] Harry S. Truman wrote to his wife that day, in terms that would have amused JB: 'The governor was a real Limey. He made a very good speech, and then we all walked around and shook his hand.'[55] After that, JB went back to the White House for more talk, then dinner with the Canadian Legation, before boarding a train north once more.

Although he was to qualify his opinion of Franklin Roosevelt somewhat over time, discovering him not to be so straightforward as he was himself, JB had nothing but praise for the President after this visit. He wrote to Walter:

> The President, of course, stands by himself. His vitality oxygenates all his surroundings, and his kindliness diffuses a pleasant warmth about him wherever he goes. His reception out of doors was unbelievable. He is a real leader of the people. What impressed me most was his extraordinary mental activity. I have never met a mind more fecund in ideas. And these ideas are not mere generalities, for he has an astonishing gift of worming his way into a subject. His thought is not only spacious, but close-textured ... I was also profoundly impressed by Mrs Roosevelt, who is a very great lady. [She had looked after Susie while their husbands were occupied.] Her simplicity and her sincerity make her as widely popular as her husband.
>
> The Secretary of State, Cordell Hull, is a very remarkable man. There is a quiet patience and tenacity about him which makes him a very real force in his country's policy. He is without any kind of vanity or rhetoric, but he has an uncommon stock of practical wisdom...[56]

The talks between JB and Roosevelt concerned the American President's desire to call a conference of world leaders, to discuss the economic issues believed to be behind the unrest in Europe and the Far East, an idea to which JB was highly sympathetic. He wrote a private memorandum immediately on his return to Canada, entitled 'Note for the President', based on their discussion, in which he suggested that this was a propitious moment 'for some attempt to break the vicious circle of fear among the nations of the world. Recent events have, I think, disposed all the European dictators to reflect upon the future.' And he detailed these: British rearmament, the better position of the National Government in Spain, and the growing rapprochement between the great democracies – the United States, Britain and France. '[They] all point a moral which even the blindest cannot miss. A pause for reflection, and an attempt to obtain some settlement of the fundamental economic questions which are behind all the unrest, would do something to save the face of both Germany and Italy; and it is desirable to save their face,

for the situation would be in no way bettered by an internal breakdown in either country.'

He believed that only the President was in a position of sufficient detachment and authority to take the initiative. The first step was the most difficult – getting Italy, Germany and Japan to agree to join a conference of world leaders. If that were achieved, however, it was important to make clear that it was not called to provide answers but to take soundings of problems, with the aim of agreeing general principles, and that it would have nothing to do with the discredited League of Nations. He suggested Geneva as a suitable place to meet. He was most insistent that the President be present 'both for the sake of his personal influence and as an advertisement that America means serious business'.[57]

At the same time he wrote to the Prime Minister, Stanley Baldwin: 'It is very difficult for me to judge the effect of my visit, but Ronald Lindsay puts it very high, and it certainly has pleased Canada greatly. The President's last words to me were that he hoped it would show those rhetorical dictators in Europe how close England and America were!' Conscious of the delicacy of his position, he continued, 'I have, of course, no official standing in this matter, and I am only reporting to you as to a private friend. But I think you ought to know what the President feels.'[58] He went on, in relation to Roosevelt's idea for a conference: 'it does offer some kind of hope, and that it is very much in our interests to meet any proposals half-way'.[59] He had also said that he had impressed on the President the enormous psychological and economic benefits he saw in a trade agreement between Britain and America.

In absentia, JB was appointed a Privy Counsellor on 28 May. Responding to Ramsay MacDonald's congratulations, he told him that, along with the Royal Society, the Jockey Club and The Club, the Privy Council was one of the few reasonably select bodies left in the world. More importantly, that same day Stanley Baldwin relinquished office in favour of Neville Chamberlain.

JB was not just thinking about European politics. Canada had increasingly pressing constitutional difficulties, in particular the need to recalibrate the relationship between the federal government and the provinces. He believed that, without reform of the Constitution, it was

impossible to have Canada-wide financial, economic or social policies, which were all badly needed. He had a number of conversations with Mackenzie King about this and his influence can be seen in the appointment of the Rowell-Sirois Commission for this express purpose, in the late summer of 1937.

At the same time, he was aware that economic gripes would invite a reawakening of French nationalism, especially as business in Canada was largely in the hands of 'British Canadians'. He was beginning to think that the Governor-General was the only real *trait d'union* between the two groups, which was why he spent so much time in Quebec that summer in the company of French Canadians. He frequently met Cardinal Villeneuve and Fr Camille Roy (Rector of Université Laval), and spoke in French to 5,000 people gathered for the literary and cultural French Congress. He made a point of spending time with the Quebec Premier, Maurice Duplessis, who made what he thought a courageous speech against separatism during the Congress.

He also thought that all sections of the population could unite around an interest in the north of Canada, which he believed could be developed sensitively to benefit the whole country. So, during the winter of 1936, he and Redfern began planning their ambitious trip 'Down North' (meaning to the far North), travelling 1,300 miles down the Mackenzie River as far as the Arctic Ocean, as Lord Byng had done in 1925. The summer of the following year was the time to do it, when the river would be navigable. That would then be followed by a trip to the newly designated Tweedsmuir Park in British Columbia.

In early July 1937 the vice-regal party travelled to Alberta, first to visit the Frasers in Alsask and then on to Calgary to see the famous rodeo known as the Stampede. On 21 July they arrived at Waterways, where they left the train behind and took to a boat on the Clearwater, which soon joins the Athabasca River. They travelled on to Fort McMurray, where they were shown something of the Abasand Oils plant. It was there that the party was joined by the well-known American photographer Margaret Bourke-White, who landed on the Athabasca in a float-plane. Her editor at *Life* magazine had sent her in a hurry, when he discovered that JB was embarking on this epic journey. Young, pretty and dressed in tartan shirt and 'slacks', she provided a thoroughly unexpected aura

of glamour to the trip.[*] As she had been sent at short notice on this assignment, she brought with her ten chrysalises of the Mourning Cloak Butterfly,[**] the emergence of which she was watching for, to ensure she caught their entire life cycle on camera. It was at this point that Susie and Alastair left the group, going on to Vancouver and Victoria.

The party progressed north by an ancient wooden 'sternwheeler', by motorcar when circumventing the Slave River rapids, and then in a flat-bottomed wooden, wood-burning scow, the SS *Distributor*, which they boarded at Fort Smith. The *Distributor* made two extensive trips down to the Arctic every summer, carrying goods and people to be dropped off at little settlements on the way. Everywhere that they halted, JB would disembark with an aide, greet everyone who had turned out to meet them – indigenous people, missionaries, teachers, fur trappers, Hudson's Bay employees – and make a short speech.

Governor-Generals feel a responsibility to meet every kind of Canadian, of course, but it seems that JB took his duty to the First Nations particularly seriously, especially because there were usually treaty obligations between them and the British Crown. Many genuinely admired him as a result, the Chiefs treating him as an equal.[60] During this trip he met Chipewyans, Dogribs, Yellowknives, Slavey, Hares (North Slavey) and Gwich'in. He was concerned about their physical condition and the high incidence of tuberculosis amongst them. He thought this mostly due to under-nourishment, as a result of seasonal difficulties in hunting and trapping, made worse by 'the intrusion of the white trapper', who he considered not nearly so good a conservationist as the indigenous population. He became convinced that trapping reserves should not just be extended in the North but be made exclusive to the First Nations. He communicated his view to the Ottawa government in a memorandum entitled 'Down North', which he drew up on his return. He wrote later that, in a healthy democracy, the majority should 'respect a minority's sacred things'.[61] And, as the Canadian historian, Professor Hutchings, has written, 'Since Canada's First Peoples – who comprise a small minority of the nation's population – traditionally

[*] She was to become a famous war photographer, and something of a pin-up for the American troops during the Second World War.
[**] Known, when it occasionally appears in Britain, as the Camberwell Beauty. They hatched successfully, much to the fascination of the Governor-General and his staff.

considered the land itself to be sacred, Tweedsmuir's desire to limit the white man's access to indigenous hunting grounds may be seen as a sign of such respect.'⁶² (These ideas come through clearly in *Sick Heart River*.) JB also criticised the quality of some of the (white) Indian agents he met.

Generally, he found the trip very restful. He would sit reading in a deckchair on the barge being pushed along by the paddle steamer, or work on the index of *Augustus* on a trestle table set up for him in the boat's stern. Margaret Bourke-White memorably recalled that 'there he sat with the fluttering little white paper markers of his index all over the place. Our cargo almost swallowed him up.'⁶³

When they had crossed the Great Slave Lake, they arrived at the beginning of the Mackenzie River. At Fort Providence, JB had a 'pow-wow' with the Hare (North Slavey) tribe, and was impressed with the work of a French Catholic mission manned by Oblate Brothers, and with a particular missionary who had been wounded at Verdun in 1916. Redfern had to remonstrate with Bourke-White for suggesting to JB that she photograph him at the Roman Catholic church clasping the priest's hand against a background of pictures showing the torment of souls in Hell. He told her that this was too much for the dignity and prestige of the Crown, 'and although Maggie thought it was pretty fair drivel, as in fact it was, she took it in good part and philosophically remarked "Well you have your job and I have mine." Obviously I am not the first officious, pig-headed, unimaginative and obstructive functionary with whom Maggie has had dealings. The sad part is that nothing would have given me greater pleasure than to have seen Maggie's prospective masterpiece.'⁶⁴

At Fort Simpson, JB heard tell of the South Nahanni, a river that flowed into the Liard, a tributary of the Mackenzie, about a hundred miles above the settlement. No one had surveyed the South Nahanni valley, although it was rumoured to be rich in minerals, and the First Nations tribes avoided it. JB's interest was piqued by the fact that nine white men had disappeared in its interior during the previous twenty years. That mystery, as well as portraits both of Oblate Brothers and Hare Indians, would find their way into *Sick Heart River*, which he began eighteen months later.

It is hard to overstate the utter remoteness of the settlements in the Northwest Territories in the 1930s, consisting as they did of little clusters

of people living on the edge of lakes or along riverbanks, usually around Hudson's Bay trading posts, dependent on the fledgling aeroplane service for mail, and to take the sick and injured to hospital. JB was, predictably, enchanted by the sturdy self-reliance, neighbourliness and ingenuity of the people he met along the river.

When the party arrived at Fort Norman, the boilers of the boat had to be cleaned of the clinging grit that entered them from the river water. While this was happening, JB suggested that the party climb Bear Rock, which rose up a sheer 1,300 feet above the bank of the Mackenzie River. He behaved like an old hunter that pricks up its ears at the sound of a horn and gallops to the paddock gate. He decided to climb the face, which had never been climbed before, and some of the party followed him. Although JB reached the top, the rest became stranded on a crag and had to be helped down off their precarious perch by local guides with ropes. Thanks to Guy Rhoades, the journalist on the trip, the whole incident was reported in sensational terms in British Columbian newspapers, and Susie, who read the account while staying in Government House in Victoria, wrote to JB. 'What possessed you to do a foolish thing like that? I have so often heard you inveigh against the people who climb not roped [and] without proper guides. It isn't really sane for you to risk your life that way.'[65] Perhaps not, but how tempting it must have been. Before he received this stern missive, JB made light of the incident to his mother, saying that it was 'not bad for 62!'

On the evening of 1 August they finally crossed the Mackenzie delta and reached Aklavik, five days ahead of schedule. Aklavik was a great disappointment to JB, since he found the delta the 'most sinister place I have ever seen'.[66] It was an enormous quagmire – what he called a 'muskeg on a colossal scale', coarsely lush and very unhealthy. They were met by the entire population of the place, led by 'Archibald the Arctic', the Bishop of the region, a Scottish-born, Inuit-speaking missionary called Fleming. A party was held on board, and then the Governor-General opened the new Anglican hospital, complete with X-ray machine, iron lung and operating theatre, built with money that had come from Christian groups around the world. After that, he inspected the new school and church, driving a final nail into the central step of the chancel. While they were together, Archibald the Arctic tried to express his admiration for JB to him: 'He looked at me

solemnly for a moment and then a flicker of a smile passed over his face
as he said somewhat sadly, "Bishop, there is one thing I covet more than
success and that you seem to possess – good health." '67

The company stayed in the hospital for a couple of nights, the
Governor-General's flag fluttering over the building, as it did wherever
he went. They were thwarted by a north-east wind from taking a trip
to Herschel Island, to see the rich wildlife, so instead they went to
Tuktoyaktuk on the Arctic shore and the furthest northern post on the
mainland. JB told Beverley Baxter: 'When you follow the North Star
until you come to pack ice, then there is such a sense of infinite peace
and lonely, shimmering beauty that it is hard to persuade the soul to
come away.'68 Here he met Inuit from Bank's Land and Victoria Land,
and then they flew up to the edge of the Polar ice pack to visit more at
Coronation Gulf. He was charmed by the Inuit he met, admiring their
independence, practical skills, ready smiles, and the way they looked
him steadily in the eye.

After the Arctic trip, JB, the Redferns and Rivers-Smith joined Susie
and Alastair in British Columbia and the party set off – together with a
cloud of witnesses, including a sparrowhawk called Tertullian – for the
second leg of this extraordinary tour. They were following a similar path
to that taken by the eighteenth-century explorer, Alexander Mackenzie,
to an area of remote wilderness that had been established as a reserve in
March 1936 and named Tweedsmuir Park.* Some 5,400 square miles of
land, 300 miles north of Vancouver, and the other side of the Rockies
from the Northwest Territories, its attractions for the Tweedsmuirs
were the astonishing beauty and unspoilt wildness, the rich possibilities
for camping, riding, fishing and watching wildlife, as well as meeting
First Nations people, pack riders and 'old-timers', who remembered the
Caribou gold rush of the 1860s. JB was made a full Chief of the Babine
branch of Carrier Indians, and named 'Chief of the Big Mountain', and
later the Nuxalk (Bella Coola) people made him a Chief with the title
'The Man from Above Who has Come to Help Us'.

They camped on a headland in Ootsa Lake, which was named Point
Susan after Susie. They fished in lakes that had never seen an artificial
fly, and caught rainbow trout, which were then cooked on campfires.
They saw woodland caribou, moose, lynx and beavers, not to mention

*Now known as Tweedsmuir Provincial Park.

tiny rufous hummingbirds, which could be held in the hand, as well as masses of alpine wildflowers. To explore the southern part of the Park, they flew in a small aeroplane, Susie's pronounced vertigo ensuring it was a complete penance for her. She spent the flight with her scarf against the window, trying to read a book. 'We had to do a good deal of rather difficult flying, and Susie is thoroughly acclimatised now,' JB told his mother controversially.[69] Once at Bella Coola, they drove forty miles eastwards to Stuie Lodge, where they were met by the Prime Minister of British Columbia and, for some unexplained reason, the Federal Minister of Defence. From here – grizzly bear country – they followed Mackenzie's route up the valley, in the shadow of the Rainbow Mountains, so called because of the extraordinary range of colours that minerals and lava have given to the volcanic rocks. They reached Dean Channel on the Pacific coast and saw the memorial commemorating Mackenzie's arrival there in July 1793.

The only drawback to this extended trip was that JB's health took a turn for the worse afterwards, and would not substantially improve until his visit to a clinic in the summer of the following year. He later wrote to Alice: 'I am always well on tour, but when I am settled anywhere I get upsets, which looks as if psychology had something to do with it.'[70] Elsewhere he told her, 'I am an orthodox Christian who believes in the resurrection of the body, but I am hanged if my tummy will be resurrected!'[71] Alice also suffered from digestive troubles and he told her with feeling: 'Cherish the brute [her digestion] as if your salvation depended on it, for if it becomes malevolent it can poison life.'[72]

On their return east, JB made his third and most important incursion into politics. His speech to the Canadian Institute of International Affairs in Montreal on 12 October (for which he first gained approval from Mackenzie King) offered a good resumé of how he felt about Canada's present position in the world:

> [Canada] is a sovereign nation and cannot take her attitude to the world docilely from Britain, or from the United States, or from anybody else. A Canadian's first loyalty is not to the British Commonwealth of Nations, but to Canada and to Canada's King, and those who deny this are doing, to my mind, a great disservice to the Commonwealth. If the Commonwealth, in a crisis, is to speak

with one voice, it will be only because the component parts have thought out for themselves their own special problems, and made their contribution to the discussion, so that a true common factor of policy can be reached.[73]

This affronted some imperialists and constitutionalists but went down very well with the French Canadians.

A week earlier, Franklin Roosevelt had delivered his famous 'Quarantine' speech in Chicago, the fact of which may have emboldened JB. Seemingly out of the blue, whilst opening a bridge, FDR spoke of the need to take steps against the world 'gangster states' and, in effect, directly challenged the isolationists in his own party and beyond. He went on to say that if a disease begins to spread, 'the community approves and joins in a quarantine of the patients in order to protect … against the spread of the disease'.[74] Although Roosevelt was simply issuing a warning, this was still a great moment for JB since, as he told Gilbert Murray (enjoining him to keep it secret), this speech 'was the culmination of a long conspiracy between us'.[75]

Hard on the heels of this, Cordell Hull, the Secretary of State, came to Ottawa to talk to Mackenzie King about the possibility of a Nine-Power Treaty conference on Japan, whose invasion of China in July 1937 was causing huge disquiet in North America. He impressed on Mackenzie King, and almost certainly on JB since he stayed at Government House, how dangerous things had become. After Hull left, JB wrote to Neville Chamberlain about Hull's visit and American attitudes. Chamberlain replied that he had made a point of speaking in public to encourage those elements in America that favoured the Chicago speech, but that there were difficulties still to be overcome by the President before it could be said he had the people with him. The difficulties included the improving of trade relations when there was the question of war debt still to be resolved. He issued a stern warning to JB that a 'policy of silence' was best at that moment, something backed up by the Chancellor, Sir John Simon, when he wrote to JB the following week.

What JB did not know was that Chamberlain and his advisers had been told that Mackenzie King was looking askance at JB's intrusions into politics,[76] and that was the reason why they were keen to warn him off. As a result of Chamberlain's and Simon's cool responses to his letters, JB shut up.

*

About this time, *Augustus*, his most substantial work of Roman history, was published by Hodder and Stoughton, and dedicated 'To my friend William Lyon Mackenzie King, four times Prime Minister of Canada'. King chose to take this dedication as an *amende honorable* for the hurt he felt he had suffered from JB's determination to keep him at arm's length.[77] It was obviously no such thing.

JB did not see Augustus as a genius, like his great-uncle Julius Caesar, but as a practical statesman, a builder not concerned with fancies, a 'Scotsman *in excelsis*', brilliant at carrying out the ideas of others, and someone he thought had saved his world from disintegration. The book gave him a chance to reflect on the nature of dictatorship. On the last page, in particular, he drew some stern comparisons with the present:

> He [Augustus] would marvel … at the current talk of racial purity, the exaltation of one breed of men as the chosen favourites of the gods. That would seem to him a defiance not only of the new Christian creed, but of the Stoicism which he had sincerely professed. [Moreover] he would be perplexed by the modern passion for the regimentation and the assumed contradiction between law and liberty … And when this expert in mechanism observed the craving of great peoples to enslave themselves and to exult hysterically in their bonds, bewilderment would harden to disdain in his masterful eyes.[78]

No one at the time would have missed what JB was driving at: the similarities and differences between Augustus and the European dictators of the 1930s, especially Mussolini, who had the arrogance to arrive at an ambassadors' reception in 1936 in an Augustan toga. JB told Baldwin that he wished to goodness Augustus' mantle had descended upon 'the present ridiculous Dictator of Italy'.[79] Indeed, some of JB's comparisons between Augustus and the Fascist dictators – unfavourable to the latter – were excised from the Italian translation of the book, and were not reinstated until a revised edition was issued in 1961.

When JB sent a copy of the book to Roosevelt, he said that he hoped it would interest him, as many of Augustus' problems were his own, but he can hardly have been delighted when the pre-publication advertising in America ran: 'The Governor-General of Canada tells the story of

how a Republic became a Dictatorship. Americans, has this no lesson for you?'⁸⁰ Roosevelt, however, took no offence.

As in *Sir Walter Scott* and *Cromwell*, JB treated the general reader at the beginning to a *tour d'horizon* – in this case of the Roman Empire – which is flattering because so easily comprehensible, yet educative in the best way:

> A little fortified town, the centre of a community of yeomen, had within four centuries of her foundation made herself the mistress of all Italy. Two centuries later she controlled the shores of the Mediterranean and a large part of the empire of Alexander; her inconsiderable hills had become as famous as the Acropolis or the Pyramids; the mountain torrent which washed her walls was a name as familiar to men as the River of Egypt; and her commercial expansion had kept pace with her conquests...⁸¹

One of the delights of the book is a description of the poet Horace, whom JB had so much admired at Oxford:

> He was a plump little man with hair prematurely grizzled, and he had always been something of a valetudinarian ... Horace was a court poet, but no courtier; he was not afraid to laugh gently at Augustus's paternalism and his belief in making people virtuous by statute, and he cherished and gave constant expression to a kind of literary republicanism. There was never a more independent poet-laureate.⁸²

To JB's relief, the book went down well with Professor Tenney Frank, the great authority on Roman history, who told him he was going to make it a textbook for his classes at Johns Hopkins University. 'If I have the approval of scholars that is all I care for,'⁸³ JB wrote to Mrs Buchan, but as it happened, the critics liked it as well.

In December two articles appeared, in successive weeks, in *The Sunday Times*⁸⁴ about JB's time Down North, sent to the newspaper by an anonymous Canadian friend of the Governor-General, and based on the memorandum he wrote, and the radio broadcast he delivered, on his return to Ottawa. Needless to say this managed to irritate Buckingham Palace, since it seemed to King George VI (or his officials anyway) a way of promoting Canada at the expense

of the other Dominions, about which they were ultra-sensitive. Sir Alexander Hardinge wrote to JB: 'The "Sunday Times" episode did cause us a certain amount of anxiety but, thanks to your giving us a free hand with the Editor, we were able, without putting him to the embarrassment of cancelling the promised article, to arrange for its reproduction in such a way that the greatest objections were overcome. On the other hand it would be idle to pretend that even by this means criticism over here was entirely avoided.' Arguably, it was a just rebuke, but Hardinge continued, with stupendous pomposity, that the King didn't like 'His Majesty's personal representative ... being a Publicity Agent for boosting a particular Dominion'.[85] Hardinge also took this opportunity to caution JB severely against saying anything the least controversial in his public utterances. It is clear that the Palace not only wanted but expected him to be what T. E. Lawrence called 'a figure', a role for which JB discovered in Canada he was constitutionally unsuited, and against which he sometimes rebelled.

That autumn, his mother was very breathless and tired, which made her bothered and worried. In August JB had written to wish her a happy eightieth birthday. 'I don't think anyone has ever [had] a better spent life, for you have warmed the atmosphere for half Scotland. You have been a wonderful mother to your children. You inspired them with your own eager and courageous interest in life, and you made a centre of attachment for us all. You choose to pretend that you are nervous and timorous, but you really fear nothing except the Almighty. And your kindness is as wide as the mercy of God.' He finished by calling her 'the linch-pin of the whole coach'.[86]

She died quietly and without pain on 18 December at Bank House in Peebles. There were lengthy tributes in Scottish newspapers and she even earned an obituary in *The Times*. JB, to his surprise, received messages of condolence from, among others, the King, the American President, several Prime Ministers, Cardinal Villeneuve and Archbishop Cosmo Lang.

Susie told Johnnie: 'He [JB] was so good and took it so bravely but I can see that he feels that something big and interesting has gone out of life and I expect that's what we all feel ... Gran, for such a tiny person, filled up a big space and I can't imagine life without her.'[87]

It has been said on occasion that JB was afraid of his mother, but there is no clear evidence for that. He took his duty to his parents seriously, and had the enduring pleasure of bright childhood memories, but he stood up to her stoutly on many occasions. He was certainly irritated, even angered by her at times, but he loved her and could see her many sterling qualities, especially her selfless generosity and care for the people around her, her energy and drive, wit and sharp intelligence, what one correspondent called 'charm indescribable' and her steadfast belief in him. Her faults, in particular her worldly vanity, he understood, since he had something of that himself. She made life troublesome for him at times, she would not let him off family hooks even when he was 'hustled' with work and problems during the Great War, and she criticised his children. But there never was anything approaching a rift between them. For JB (and for Susie) such a thing would have been unthinkably disloyal and damaging. In 1937, he will have reflected with gratitude that, instead of dying twenty-five years before, which could well have happened, she had been 'spared' to see her children do her very proud.

Canada, 1938–1940

Mrs Buchan died the day on which the announcement was made that her son had won the election to be Chancellor of Edinburgh University. In late 1937 he had accepted an invitation from the university, since he thought his was the sole nomination, only to find, to his consternation, that the Marquess of Lothian had also entered the lists, so that there would have to be a contest. However, it was too late to back out and, in the event, he won easily. Predictably, it brought down, once more, a rebuke on his head from Buckingham Palace.

The new year opened with rumours in the newspapers that he would be given the American ambassadorship – one of the few diplomatic posts that did not necessarily go to a career diplomat – when Sir Ronald Lindsay finished his time in Washington; certainly Lindsay thought JB would do the job very well. JB claimed to Tommy Lascelles that the rumours were 'idiotic', but that 'there has been this much in them that the President and Cordell Hull keep on saying they want me. But only his Majesty and the Canadian Government can move me, and the Canadian Government certainly won't agree. I am determined not to desert Mr. Micawber, for my work here is only beginning.'[1] It must have caused him a considerable pang, for Washington was the job he really wanted, and Canada could feel rather out of the way. He told Stanley Baldwin that he sometimes felt like a late eighteenth-century Highland laird, cultivating his estates in Sutherland, while Fox, Pitt and Burke were sparring in the House of Commons, and France was in revolutionary turmoil.

Early in January, Neville Chamberlain coldly rebuffed Roosevelt's suggestion of an international conference to discuss economic and other worldwide difficulties. Roosevelt had talked at length about this with JB in April 1937 and thereafter, and he wanted British support in advance of any initiative. Chamberlain, who thought he knew better how to deal with the European dictators, turned down FDR precipitately and against the strong advice of Lindsay, and without consulting his Foreign Secretary, Anthony Eden, who was unfortunately away on holiday. As a result of Chamberlain's reaction, Roosevelt retreated and, when Eden found out, his relations with Chamberlain markedly deteriorated and he resigned the following month. The leader of the opposition, Clement Attlee, was never told of this initiative and maintained later that, if he had been in Downing Street, he would have accepted Roosevelt's invitation, saying: 'If Hitler had realised that there was also America, and America was going to stand in, he would have thought twice about it, or his generals would.'[2] Eden and Churchill were of the opinion that such a good opportunity to avert war as Roosevelt seemed to offer never came again.[3]

In the spring, JB toured the Prairies again to see how the drought-prevention measures were working. Amongst the communities he visited was the small, mainly French-speaking, frontier settlement of Val Marie, close to the American border in Saskatchewan. George Spence, Director of the Prairie Farm Rehabilitation Agency, wrote a vivid account[4] of the preparations that the town made for such a momentous occasion: the shooing of cows from Main Street; the painting of the fronts of the buildings; the removal of outdoor latrines; the bulldozing of rubbish into the river; the search for bagpipes and a kilt for the (Norwegian) piper; the prodigious lunch laid on in a tent; the vain efforts on the day to prevent His Excellency from joining the line of men to wash his hands; the cheering of schoolchildren, when the party arrived at the platform in the town park. JB spoke both in English and French, and declared another day's holiday for the children, which he said he had the constitutional right to do. After the formalities were over, he was told of an elderly Scots couple, originally from the Borders, who had travelled overnight more than 100 miles in an old car 'juist to get a guid look at John Buchan!' He asked to be introduced, and talked to them in Lowlands Scots, while the tears rolled down their cheeks.

In late June, he went south to the United States as a private citizen (for which he had had to ask permission from the King) to receive honorary degrees from both Yale and Harvard. These were the only two of many invitations he succeeded in accepting. The President at Yale University said of him that he was as versatile as Richard Hannay and as reliable as Mr Standfast and, in his reply, JB said he wouldn't talk the usual platitudes about what good friends the United States and the British Empire should be. 'I believe most profoundly in that friendship, but don't let's get self-conscious about it ... I think the best way for Americans and Britons to understand each other is not by analysing their feelings, but by doing things together.'⁵ At Harvard, he received a bigger cheer even than Walt Disney, and gave the Commencement Address, on the subject of Henry Adams' description of himself 'as a conservative Christian anarchist', declaring that it was a description that fitted himself. The 'anarchist' meant that he was resolute about clearing away rubbish, whether new or old. He wanted his audience to cultivate the three qualities necessary for the times: humility, humanity and humour. 'Humour is the best weapon with which to fight pedantry and vainglory and false rhetoric ... Laughter is the chief gift of civilization.'⁶

Shortly afterwards, he left for England for the first time since 1935, Susie having gone ahead some weeks earlier. He intended to be there for no more than a month or so, just long enough to see his doctor (Bertrand [now Lord] Dawson); be installed as Chancellor of Edinburgh University; meet Chamberlain, Baldwin and the Earl of Halifax in London; and see family and friends.

The idea for a Royal visit to Canada had been mooted as early as November 1936, but plans had scarcely got underway before the Abdication Crisis erupted. However, JB never lost sight of the immense value of a Royal tour, not only for Canada but also the United States, and persuaded Mackenzie King, who mentioned it when he was in London for the Coronation in May 1937. The year proposed was 1939.

The reaction of Buckingham Palace was favourable but, with the European news so unsettling, Chamberlain and the Foreign Secretary, Lord Halifax, were at first dubious, until persuaded by JB of the value at such a time of exposing the barely known Royals to the patriotic public gaze of Canadians and to harder-to-please Americans. Roosevelt

wrote directly to the King inviting him to the United States, on the grounds that it would be an excellent thing for Anglo-American relations.

JB was installed as Chancellor of Edinburgh University on 20 July. His address was entitled 'The Interpreter's House', a title drawn, of course, from *The Pilgrim's Progress*, 'where we receive our *viaticum*' for the road', and a compliment to the university as a place of both teaching and the advancement of learning. He played on one of his favourite themes, that of the undoubted quality of youth but its particular contemporary challenges. His son, Johnnie, listened to his speech on a ship's wireless close to Lake Harbour on the shore of the Hudson Strait, having gone to work for a year at a Hudson's Bay trading post on Baffin Land. In 1980 he could still recall his father's words: '... there are spiritual frontiers, the horizons of the mind. We are still frontiersmen in a true sense, for we are domiciled on the edge of mystery, and have to face novelties more startling than any which confronted the old pioneers.'[7]

Friends and family gathered en masse for the occasion, but the luncheon party, garden party with speeches, dinner party and evening reception made it a very long day, and old friends such as Sandy Gillon, Johnnie Jameson and Violet Markham, who had not seen him for three years, muttered anxiously to each other. (The Earl of Crawford and Balcarres told his brother, after he had seen JB in London that July, that he looked 'thin, meagre, almost shrunken in appearance'.)[8]

The next day, JB motored with Anna and Walter to Peebles, via the Empire Exhibition in Glasgow. Anna recalled:

> Partly because it was one of his 'well' days, and partly, I expect, because of the relief of getting a big job over, John that day seemed to throw from him every care ... He sang songs and told us ridiculous stories. We knew him well in this mood. All his life, after long concentration, writing for hours, he would suddenly take what Mother called 'a daft turn' and pour forth a stream of nonsense, which reduced us all to helpless laughter. And hearing him, Walter and I realized how much we had missed those fits of nonsense...[9]

*Supplies for the journey.

At his doctor's insistence, he spent time at Ruthin Castle in north Wales, a private sanatorium for those with digestive problems,* run by a physician called Sir Edmund Ivens Spriggs. In the end he was 'binned' for six weeks, from early August to mid-September. 'I console myself with reflecting how many good men have had to endure a spell in jug,'[10] he told his wife.

Although his time at Ruthin Castle initially entailed some very painful and wearisome examinations, the treatment undoubtedly improved matters, both by helping him to gain a stone in weight (he was no longer El Greco but Rubens, he told Violet Markham) and also by giving him a rest cure, far away even from international anxieties.

Susie stayed on in England so that she could visit JB at Ruthin, travelling up from Elsfield several times to see him and lodging nearby. They would walk together in the gardens or drive out into the hills. In one of the last letters he wrote to her, for they were never apart again, he said: 'I am going to miss you dreadfully, and shall wander about in the Italian Gardens, which I specially associate with you.'[11] By this time they had been married for more than thirty years.

The rest of the time he spent resting, reading ('Henry James' later style gives me the impression of swimming in spinach!'),[12] and writing his reminiscences. This engendered a period of acute retrospection and a rare mood of sentimentality. 'My love to every member of the best staff in the world,'[13] he wrote to his wife, when she was leaving once more for Canada.

Anna and Walter came from Scotland to keep JB company when they could, and William arrived at the end of the month and, not being well himself, was duly 'binned' in a room next to his father. JB reported that he was a 'great support and joy to me'.[14] Other visitors included Moritz Bonn, who was hag-ridden by fears that Chamberlain was going quite the wrong way about dealing with Hitler. JB was still convinced that Chamberlain had no alternative to his course of action, since nothing could be worse than another war, especially with Britain not yet prepared. It was not until the following spring that he told his daughter that 'now the time has come for a definite stand along with the other Democracies. I am coming to believe that things will not get

*The most expensive rooms, with treatment thrown in, cost 30 guineas a week in 1925.

right without a smash, but I hope that by the time Germany's outbreak comes, we will be strong enough to squash it at the start.'[15]

Susie's task in Canada, when she arrived back in Quebec in late August, was to hold the fort (almost literally) in the Governor-General's absence. Like countless others, she was beset with anxieties about what was happening in Europe, especially since she had three sons of military age. 'The papers here are <u>awful</u>, full of the most sinister rumours and conjectures. I must say I wish I was in England and with you, it is awful being so far away and not knowing and dreading things all the time. You could perhaps calm my fears.'[16] But JB was almost as much in the dark as she was, since the Foreign Office papers were not sent to him at Ruthin. Although she could get little out of him to settle her nerves, Susie was cheered by his reports of how well his treatment was going, and the fact that William was 'binned' with him. She ended with 'If war is declared please come back on an American boat and don't put me to the torture of thinking you might be torpedoed.'[17]

Feeling very fit, JB went from Ruthin to Elsfield for a few days, writing to Susie on 25 September that he hoped it would be the last letter he would write before he clasped her to his 'meagre bosom'. 'The situation is now a melancholy diplomatic tangle, when honest men are arguing with rogues – a wretched business, but I still think war is improbable.' He prowled around his old haunts, dropped in on his farming friends, the Wattses, and attended Harvest Festival in the church, 'which was charmingly decorated, principally from our garden'.[18]

The next day he had an audience with the King at Buckingham Palace, to talk over the proposed tour the following May. JB wrote to Susie: 'I was enormously affected by our talk – he looked so small and lonely and anxious. He seized both [my] hands when we said good-bye. The Palace thinks the odds slightly on war, I think them slightly against, but no one can forecast Hitler's mind.'[19]

On arrival in Canada on 8 October, he reported to Mackenzie King the gist of his meeting with the King, and the public announcement of a Royal Tour, to last a month, was made that day. Roosevelt told JB in early November that he had been corresponding directly with the King, and had asked the Royal couple to stay at Hyde Park, his house on the Hudson River, so that the formal functions 'could be supplemented by a peaceful and simple visit to a peaceful and simple American country

home'.²⁰ The American leg, although hugely important to JB, was the part that worried him, since it was by no means certain that the American people would take the new British King and Queen to their hearts.

The arrangements for Canada turned out to be time-consuming and difficult, in particular for Shuldham Redfern. He was the Governor-General's representative on the Royal Visit committee, which mainly comprised rather dilatory officials from the Department of External Affairs, and where he found himself the driving force. The hardest part was agreeing a timetable, for the provincial politicians could not see beyond their own boundaries and the committee had to balance the desire of the entire nation to catch a unique glimpse of serving Royalty – something never before experienced in any Dominion – with the very real anxiety about Their Majesties' staying power. Redfern and his committee had to ensure that one province did not see more of them than another. In such a vast country, with four different time zones, this was no small difficulty.

However, the man who should have been a source of impartial wisdom raised the most serious problems. It soon became clear to JB and Redfern, if they had not known it before, that Mackenzie King's *amour propre* was a matter of supreme importance to him. Although a Liberal, and a quasi-Republican, who refused to recommend the names of Canadians to the Sovereign for honours and was critical of the formality of Government House, he was very keen to be in the forefront of this regal jamboree.

The first dispute that came to a head was over who should meet the King and Queen when they arrived at Quebec. The obvious answer, as far as Government House and Buckingham Palace were concerned, was the Governor-General, since he would be symbolically handing over the country he was representing on behalf of his master, when that master arrived. Mackenzie King was unsuitable on the grounds that he was a partisan political figure. JB would then disappear into the shadows until just before the King went home, when the latter would confer on him the honour of representing him once more. But the Prime Minister was having none of it. He would meet them at Quebec and that was that. Neither the British High Commissioner nor Tommy Lascelles, the King's Assistant Private Secretary, who came out to help plan the visit in February, could move him. Buckingham Palace

continued to believe that Mackenzie King was wrong, since he only represented the majority, at best, of the people of Canada. In the end JB decided to swallow the constitutional irregularity, and advise the Palace that he was happy to meet the King and Queen at Ottawa, once Mackenzie King had greeted them in Quebec.

Worse was to come. On the evening of 11 March, Mackenzie King arrived at Rideau Hall for a conversation with the Governor-General. Their discussions began calmly enough but, at some point, Mackenzie King began a tirade about all his grievances, real and imagined, stumping up and down the room and working himself into a towering passion. The Governor-General had to endure an hour of this and, as Redfern indignantly remarked, exercise all his restraint to avoid taking substantial exception to some of the Prime Minister's observations.

What was the cause of this unseemly outburst? Mackenzie King had convinced himself that there was a conspiracy by Buckingham Palace courtiers and members of the British government to prevent him, in his role as head of the Department of External Affairs, from accompanying Their Majesties to Washington. There is, extant, the pencil draft of a letter to Tommy Lascelles, dated 13 March, written by Redfern and with some small emendations by his boss. The letter said that they believed that, in some respects, they were having to deal with 'a mental case'. Redfern told Lascelles that the man was 'bordering on insanity', but these words were amended by the emollient and circumspect JB to 'in an abnormal and unaccountable mood'.

Mackenzie King's comments were breathtakingly unfair, since JB had consistently made it clear to the British government and Buckingham Palace that it would look better if Mackenzie King accompanied the King and Queen to Washington, rather than the Foreign Secretary, Lord Halifax. Halifax's presence risked spooking the isolationists in Roosevelt's party. Mackenzie King traded on the fact that JB never sought a fight, and usually tried to deflect unpleasantness. Since he had no such qualms, he was at a definite advantage. Reading between the lines of the Prime Minister's self-serving account of this meeting in his *Diaries*, it is plain that he had been a bully.

JB added a P.S. to Redfern's letter: 'Please burn this.'[21] He could trust Lascelles, of all people, to be discreet and to do what he asked. It is hard to imagine the repercussions if it had ever become public that the Governor-General of Canada thought that his Prime Minister was mad.

Colonel Willis-O'Connor, a kindly man, thought that this encounter had made JB look very unwell. He told his boss not to distress himself, to which he replied, 'Nothing will come of it. There will be no constitutional crisis. I will let him have his own way, and stand on my head if that's what he wants of me.'[22]

Their Majesties therefore had the prospect of four weeks in the constant company of the Canadian Prime Minister, the sole politician in attendance all the time, something rather less congenial to them, one supposes, than the society of the Tweedsmuirs. This was probably the worst example of Mackenzie King's volatility during JB's time as Governor-General, and it required the latter to exert all the patience at his command to see it through without the kind of row that had erupted publicly between Mackenzie King and Lord Byng.

The year 1939 had opened with see-sawing temperatures and JB's see-sawing health. When well, he took what exercise he could, snow-shoeing with Susie or skating, but he was now spending at least one day a week in bed. He submitted to frequent massage sessions to help ease the pain. He weighed just over 9 stone. He took morphine. Well or not, he walked every day in the grounds and, when the weather was sunny, he would sit in a chair on the verandah, enveloped in a buffalo hide coat. He had begun to write *Sick Heart River*, his tale of illness, endurance and self-sacrifice in the Northwest Territories. It was much influenced by discussions with his son Johnnie, who had spent part of a winter near Prince Albert in northern Saskatchewan. Meanwhile, JB had to open Parliament, host luncheons, a state dinner and a 'drawing-room', as he had done in earlier years.

As a result of the Royal visit, plans were laid to redecorate both Rideau Hall and The Citadel. JB told Walter: 'Susie is just back from Toronto, where she has been pilfering things from the Museum to decorate this house for Their Majesties ... When you come you will find Rideau a miniature palace!'[23] But, amid this domestic busyness, there were gnawing anxieties about the European situation. On 26 January, JB received a very grave 'most secret telegram about Germany's intentions'.[24] These telegrams, together with despairing letters from British correspondents, continued to arrive through February. Chamberlain's gamble of the previous September had failed. JB wrote to his brother Walter in late January: 'The [Foreign Office] despatches recently, especially the secret ones dealing with the internal conditions

of Germany, are horrible reading. The treatment of the Jews has been beyond belief brutal.'²⁵

Once the Royal itinerary had finally been agreed, JB's main task was to write speeches for the King and Queen to give, while other members of the household wrote them for all the mayors whom they would meet, as well as the written replies from the King. All the paperwork was then sent to Buckingham Palace for approval.

The Tweedsmuirs set off for another trip to the Canadian west. 'We shall find an English spring in Vancouver, and the winter will be shortened for Susie,' JB told Violet Markham.²⁶ There was the usual round of Canadian Club speeches, inspections of new works, experimental farms and so on, with some fishing thrown in, but they also had the chance to go to the Hudson's Bay headquarters in Winnipeg and send a message to Johnnie, at Lake Harbour, way beyond the Arctic Circle. He was thriving in his northern solitude and finally putting on weight.

The King and Queen embarked on the journey across the Atlantic in early May on the *Empress of Australia*, and about the same time an article appeared in *The Sunday Times* entitled 'Canada and the Royal Visit'. The byline was Alice Buchan and, in this upbeat article, she set out some of the background to the visit, something of Canada's history, and explained accurately and neatly the constitutional position: 'He [the King] comes to Ottawa as to his own capital city, and to Rideau as to his own palace.'²⁷ (That cadence is unequivocally Buchanesque.) She also gave British readers a foretaste of what the Royal couple would experience, in particular staying in Rideau Hall, 'this pleasant rambling house', as well as the multifarious people they would meet on their travels. A map of Canada, showing the Royal route, accompanied the piece.

JB did not write this article, but he will have instigated it, knowing that he could trust Alice to produce a suitable and readable article if he gave her the background. Experienced publicist that he was, he could not pass up an opportunity to hammer home to the British public the importance of this visit, and to keep the record straight about his constitutional position.

It was inconvenient that he should be thinner than ever at this point, weighing on 7 May a mere 8 stone 4 lbs, his lowest as an adult. He had lost all the gains of the September before. And the imminent arrival of the Royal party did not help matters.

Susie took much of the strain of overseeing arrangements, and anyone who has ever had a dream about preparing for the Queen to come to tea will have sympathy for her. She chose new chintzes and curtains for both Rideau Hall and The Citadel, finally expelling the purple that was Lady Willingdon's favourite colour, and inspected the open landau carriage as well as the Royal train, which shone in its new blue and silver livery, with the Royal coat of arms now attached to the front of the engine. The train was made up of twelve carriages, and would have to accommodate ladies-in-waiting, equerries, maids, dressers, private secretaries, stewards, a chef, policemen, telephone officers, the Prime Minister and his staff, as well as members of the government in their own provinces. There was also a 'pilot train', to go ahead, just in case there was an 'obstruction' (by which, presumably, was meant either a cow or a bomb) on the line, and to carry RCMP (Royal Canadian Mounted Police) officers, members of the press, broadcasters – this was the first Royal visit to be transmitted on the radio – photographers, postal officials and a barber. This train had its own dark room and post office with a 'Royal Train' postmark stamp.

The *Empress of Australia*, bearing the King and Queen, docked on 17 May at Wolfe's Cove, two nerve-racking days behind schedule because of fog and the unseasonal presence of icebergs. Mackenzie King greeted the Royal party in his Gilbertian, gold-braided Windsor court uniform. With breathtaking disingenuousness he remarked that he felt particularly sorry for the Tweedsmuirs because, as a result of the delay, they would not have the opportunity of seeing much of Their Majesties.[28]

The next day, the King and Queen boarded the train to Montreal. The cheering crowds that met them everywhere in Quebec were a great source of satisfaction to Anglophone politicians such as Mackenzie King, although JB never doubted that the French Canadians would take the couple to their hearts. The conquest was made easier by the fact that they thought the Queen wonderfully glamorous, and were charmed by her smile and seemingly indefatigable stamina. The King also pleased the Québécois by speaking in French.

The Tweedsmuirs went to the Union Station in Ottawa to greet the couple, after which the King and Queen climbed into the open landau and were drawn through the streets to Rideau Hall. After the diplomatic corps had had the opportunity to catch a sight of them, there was a private luncheon, then the Royal party went to Parliament in evening dress, where

the King signed two treaties with the United States, one of which was the trade treaty. (JB, tactfully, stayed at Rideau Hall, reading in the garden.) Afterwards, the press corps came to Rideau Hall for a sherry party to meet the Royal couple, a shrewd piece of public relations by JB, which ensured glowing testimonials in all the newspapers. He encouraged Roosevelt to invite the press to the White House for the same reason.

In the evening, there was a State dinner of considerable magnificence. According to Susie, 'Joan [Pape] had surpassed herself. She had bagged silver bowls from everybody in Ottawa, and she had filled them with red tulips. The table was a horseshoe, and she had made a bank of tulips in the centre of it ... The Queen had on marvellous jewels, including a necklace that Prince Albert had given Queen Victoria on their marriage.'[29] Mackenzie King, who sat on one side of the Queen, told her of his meeting with Hitler in 1937 and of how the Führer didn't want war. After dinner, the King and JB stayed up talking until 1 a.m.

The next day, the Royal party witnessed, from the East Block of the Parliament buildings, the Trooping of the Colour by the Brigade of Canadian Guards, with the King taking the salute. After that, the Queen laid a cornerstone of the nearly completed Supreme Court building using a gold trowel. The couple were Mackenzie King's guests for lunch at Laurier House. He showed them his mother's 'shrine' and all his *lares et penates*, and surely only long training and good nature prevented the couple from betraying their amusement when presented by Mackenzie King with a framed photograph – of his mother.

That afternoon an enormous garden party of 5,000 guests assembled in the garden of Rideau Hall. At one point the Catholic Archbishop of Ottawa got carried away and shouted 'Vive La Reine!' This was followed by a formal dinner held at the Château Laurier hotel, after which the King and Queen went out onto the balcony to wave to the dense crowd who had been waiting patiently all evening to catch a glimpse of them. 'When the King and Queen appeared,' JB wrote to Anna, 'such a shout went up to heaven as I have never heard before. It was one of the great experiences of my life.'[30] Back at Rideau Hall, the King again talked with JB late into the night.

The next morning, the King unveiled the War Memorial in Confederation Square, close to Parliament Hill.* Watching the

*This fine monument, by Vernon March, consists of a granite arch with twenty-two bronze figures of servicemen and women from the First World War.

ceremony were several thousand veterans. The Queen told JB that she would like to go down amongst them. 'I said it was worth risking it, and sure enough the King and Queen and Susie and I disappeared in that vast mob! – simply swallowed up. The police could not get near us. I was quite happy about it because the veterans kept admirable order. It was really extraordinarily touching; old Scotsmen weeping and talking about Angus [where the Queen came from]. One old fellow said to me, "Ay, man, if Hitler could see this!" '[31] *Pathé News* reported on 'five riotous minutes of handshaking and surging enthusiasm'. American radio informed its listeners that no President would have dared to have done what the King and Queen did, with scarcely any guard at all.[32]

Before they left Ottawa, the King and Queen presented JB with a silver inkstand,* a copy of the Queen Anne one at No. 10 Downing Street, bearing JB's arms and an inscription in the King's handwriting. Susie remembered that, 'with a twinkle in his eyes, His Majesty handed me a most lovely gold cigarette case with a [Royal] monogram in diamonds'.[33]

From Ottawa, the Royal tour travelled to Toronto, then continued west to Winnipeg, stopping variously on the way, and on to Regina, then Medicine Hat, Calgary, and through the Rockies to Vancouver. As they sailed out of Vancouver Harbour on the way to Victoria, 25,000 voices sang 'Will ye no' come back again?' which was charming, if unhistorical, considering the King's Hanoverian ancestry.

At places, the countryside around emptied, as people came to town to see the couple. Melville, a town of 4,000, swelled for the day to 60,000; at Edmonton, 90,000 grew to more than 200,000. At night-time, groups of people would stand on the side of the railway to watch the train go by, remaining silent so as not to disturb Their Majesties' sleep. It is hard to overstate the impact such an extraordinary entourage had on the disparate communities that encountered it during the tour across Canada. The daylight had not yet been let in on the magic.

Three weeks after they arrived on Canadian soil, the King and Queen travelled to the United States, where King George VI made a deep impression on the President and vice versa. The King considered that the twenty-four hours he spent at Roosevelt's country home, Hyde

*Now in the John Buchan Story Museum in Peebles.

Park, was the apogee of the entire tour.* George VI told Mackenzie King that he felt exactly as though a father had been giving him his most careful and wise advice.[34] The mutual regard and trust between King and President were to prove very beneficial during the war years.

The King and Queen arrived back in Canada after their five-day visit to the United States and visited New Brunswick, Newfoundland and Prince Edward Island. One way and another they had seen parts of most of Canada, except for the far north. After a few days fishing on the Cascapedia River, the Tweedsmuirs travelled, with their staff, by ship from Quebec to Halifax, Nova Scotia, to say goodbye to the Royal party.

At a station at Truro, sixty miles north of Halifax, the Tweedsmuirs boarded the train, where JB was invested with the GCVO (Knight Grand Cross of the Royal Victorian Order), awarded for distinguished personal service to the sovereign, and in his gift. Shuldham Redfern was knighted. The party received a rapturous reception when they returned to Halifax, and then there were the 'affecting farewells' onboard ship. JB described the scene in a letter to Charlie Dick: 'a golden sunset, something like a hundred thousand people, and a forest of shipping, and the great liner, led by [Canadian] destroyers and followed by [British] cruisers, disappearing in the haze'.[35]

The rip-roaring success of the month-long tour was not a surprise to its architects, but the way the French Canadians reacted was, nevertheless, a profound relief and a cause for pride. And much of that was due to the personality of the Queen, her smile, unaffected grace and very fashionable clothes. Canadians thought her more beautiful in the flesh than in pictures. The King conducted himself with sincerity, courtesy and friendliness, and the bitter taste left in Canadian mouths by the Abdication was finally washed away. In an age when only newsreels and newspapers had pictures, and those were monochrome, the colourful, warm and distinguished presence of the head of the Commonwealth and his consort had an enormous and enduring impact on Canadians.

As JB wrote to a friend:

> When I induced Their Majesties to come out here last autumn I did
> not realize I was pulling the string of such a shower-bath!...

*The film *Hyde Park on Hudson* (2012) includes a fictionalised depiction of the Royal visit to Hyde Park.

Our Monarchs are most remarkable young people. I have always been deeply attached to the King, and I realize now more than ever what a wonderful mixture he is of shrewdness, kindliness and humour. As for the Queen, she has a perfect genius for the right kind of publicity...[36]

The King wrote in his own hand a personal letter to JB averring that the tour had done him 'untold good', and in a letter to Susie the Queen wrote, 'We feel strengthened and encouraged by our trip, and filled with love and pride in Canada and her grand people.' In the same letter she asked for a Karsh photograph of JB in 'an Indian headdress' for, it is said, she wanted to show the princesses what a North American 'Indian' looked like. The King told Burgon Bickersteth, a senior Canadian academic, who happened to be in England in the summer of 1939: 'Well Bickersteth, they [the Tweedsmuirs] are an extremely difficult couple to follow.'[37]

Violet Markham, on whom no fly ever settled, teased JB about the real reason for the tour, namely the Royal trip to Washington and New York. She praised him for arranging it. She knew he couldn't openly agree with her but hoped that he would send her 'a transatlantic wink at the same time. To have engineered that visit to the President was a real stroke of genius on your part and may have incalculable consequences for the world.'[38]

The tour had also had a substantial impact in the United Kingdom, thanks to the newsreels and the broadcasts of speeches. The nation was so gripped that, when the King and Queen travelled to Buckingham Palace from Waterloo Station in an open carriage, huge crowds turned out to welcome them back. This prompted them to come out onto the balcony, accompanied by Princess Elizabeth and Princess Margaret Rose, to acknowledge the enthusiasm. *Pathé News* reported that it was like the Coronation all over again.

At the Royal Luncheon given by the Lord Mayor at the Guildhall in the City of London the following day, at which Queen Mary was also present, George VI delivered the last of the speeches that JB had written for him:

[In Canada,] I saw everywhere not only the mere symbol of the British Crown; I saw also, flourishing as strongly as they do here, the institutions which have developed, century after century, beneath the

aegis of that Crown; institutions, British in origin, British in their slow and almost casual growth, which, because they are grounded root and branch on British faith in liberty and justice, mean more to us even than the splendour of our history or the glories of our English tongue ... For it was not alone the actual presence of their King and Queen that made them [Canadians] open their hearts to us; their welcome, it seemed to me, was also an expression of their thankfulness for those rights of free citizenship which are the heritage of every member of our great Commonwealth of Nations.[39]

According to George VI's biographer, John Wheeler-Bennett:

... even to this congeries of connoisseurs both the delivery and the content of the King's speech were a revelation, and the effect of its import was not lost on the world outside. In Europe it was hailed as a declaration of beliefs and an indication that Britain was prepared to defend her democratic institutions; in America it struck a chord of response, warm and immediate; while from Canada Mr. Mackenzie King telegraphed to Sir Alan Lascelles: 'I am sure that no Sovereign has ever uttered words fraught with greater good for mankind.'[40]

Tommy Lascelles told Mackenzie King that he had never heard George VI speak so effectively or so movingly. As both King and Queen were to say on more than one occasion about the North American tour, 'This has made us.'[41] Wheeler-Bennett believed that it was a pivotal episode in the King's life, giving him self-confidence and assurance, and marking the end of his kingly apprenticeship.

In late July, Violet Markham visited the Tweedsmuirs at Rideau Hall. She found JB in good spirits, full of jokes and stories as in the old days. He told her that he had decided to kill off Edward Leithen in his latest novel. On being told it was the worst literary murder since Trollope killed off Mrs Proudie, he replied, 'Leithen and the others have been on hand too long and I am getting bored with them and so must other people. It's time they disappeared.'[42]

Despite the succession of bleak news stories from Europe, which had served as a counterpoint to the upbeat broadcasts from Canada, Anna

and Walter decided to go ahead with their biennial visit and arrived in July, together with Alastair who had achieved a good Second in his 'Schools' (Johnnie had managed a Fourth), and wanted to spend the summer in Canada before enrolling at the University of Virginia.[43] The family party travelled to the remote port and railhead of Churchill in Manitoba, on the western shore of Hudson Bay, in a train now returned to its usual chocolate-brown livery, to pick up Johnnie who was on his way back in the SS *Nascopie* from Baffin Island.

Johnnie disembarked, not 'a wild man of the snows, but a most elegant and civilised young man',[44] as JB told Violet Markham. And one who had not even heard of the Munich Agreement. He was completely cured of his illness. The party then travelled to Jasper so that Anna and Walter could see the Rockies, and further to the fertile Peace River district. JB called it 'a sort of land beyond the North Wind, which the Elizabethan voyagers dreamed of'. At Tupper Creek they met some of the 500 anti-Nazi Sudeten Germans – amongst them a former member of the Reichstag – who had found refuge there, and who touchingly sang the National Anthem.

The news when they arrived back in Ottawa was heart-stopping, Germany having that day signed the Non-Aggression Pact with the Soviet Union. This piece of treachery on the part of Joseph Stalin sank everyone's spirits and prompted Anna and Walter to leave earlier than originally planned. It was as well, for they arrived home in Peebles only the day before war was declared. On 1 September the Germans marched into Poland. The British ADCs and footmen prepared to leave Rideau Hall for home. 'Eheu! "Now is the whole Round Table broken up"', reads JB's diary for that day.[45]

Johnnie and Alastair immediately joined the Canadian Army, Johnnie receiving a commission in the Governor-General's Life Guards while Alastair, the better horseman, joined the Princess Louise Dragoon Guards. This decision points not just to their father's commitment to Canada, but also their own. They were based in Ottawa initially, which was some comfort to Susie who was, not unnaturally, anxious about the rest of the family on the other side of the Atlantic. Early in September they received a letter from William saying that he was going to marry Nesta Crozier, the daughter of the bursar of Radley College who lived near Oxford. Although not even Susie had met her, William's indifferent health and unsettled ways inclined his parents to think that it would be

good for him to be married, with someone to look after him. The couple married at Elsfield in October, Anna and Walter making the journey from Scotland to attend the ceremony. JB told Sandy Gillon: 'By all accounts William's spouse is a most charming girl and well-fitted to be a poor man's wife.'[46]

On 3 September, Britain declared war on Germany, but Canada remained neutral for another week, ensuring that a certain amount of war materiel, aeroplanes and munitions in particular, could be moved across the border from the United States, without violating the latter's Neutrality Act. (The arms embargo was effectively ended in early November, when a new Neutrality Act was passed that allowed a 'cash-and-carry' arrangement with Britain.) Mackenzie King played the political game acutely, jollying along his colleagues, while not frightening the French-Canadian constituency. JB later told the King that the credit for bringing Canada into the war with almost complete unanimity belonged to the Prime Minister, 'by not asking for premature commitments he prevented people going off on the wrong lines and then being ashamed to retrace their steps'.[47]

Just after midnight on Sunday, 10 September, JB was wakened and asked to sign the proclamation of war for Canada, which was then relayed to London to be approved by George VI. Instead of the King asking Canada to declare war for him, Canada asked him to declare war on behalf of Canada. According to the British High Commissioner, this was 'the outcome of a deliberate decision of a free people by their own representatives in a free parliament'.[48] Alastair later recalled that only twice in Canada had he seen the light go out of his father's eyes – once when endorsing a death warrant and the day he signed Canada's declaration of war. He was sick at heart. To Anna he wrote, 'I hate this war as I never hated the last. Then we were fighting with a barbarous and dangerous enemy, but at any rate he was adult. Now I feel that we are contending with diseased and vicious children.'[49]

'The only duties left to me which matter will be vis-à-vis the United States and consultations with Ministers,' he told Walter, 'otherwise any stuffed shirt could be Governor-General. I do not feel too happy at the prospect, but of course I won't budge unless I am definitely recalled. It is rather a miserable time, because the weather is exquisite and sharpens the contrast between the beauty of nature and the folly of man ... In

1914 the Germany we fought had dignity and history behind it; the present régime seems to be a mere oozing of filth from the gutters.'⁵⁰

He entertained Americans – bankers, industrialists, journalists and the like – at Rideau Hall, giving influential people space and time to make fruitful connections. He also met with a number of patriotic organisations, since he was honorary President of most of them. On 13 September he prorogued Parliament, with Alastair acting as ADC. 'It makes me want to howl to see him in khaki,' JB told Walter, 'for he is the living image of our Alastair, only about half a foot taller.'⁵¹

Walter was JB's most trusted confidant, for he could depend on the Scots lawyer to be completely discreet. Even so, he sometimes wrote cryptically. For example, when severely condemning the anti-Semitic comments of the Peebleshire MP, Captain Archibald Maule Ramsay (imprisoned under the Defence of the Realm regulations in wartime), he referred to him not by name but, ironically, as 'our friend'.

JB nicknamed his brother the 'Peebles Fuehrer' since, as town clerk, his brother acquired a number of immediate wartime duties, such as organising the arrival and placement of children evacuated from Scottish cities, as well as the turning of the Peebles Hydro into a hospital. For her part, Anna, as a substantial literary celebrity in Scotland, devoted considerable time to speaking in public in aid of war charities.

JB thought much about propaganda to the USA, telling George VI, 'I am certain that really authentic information of every kind sent by way of news to be the best, indeed the only, kind of propaganda.'⁵² He exchanged a number of letters with his old colleague, Lord (Hugh) Macmillan, who had been appointed Minister of Information as soon as war broke out. He offered him friendly guidance over the British or American personnel in the States that might be helpful, taking into account that the Ministry would have to tread very warily. 'I have an excellent conning-tower in my position here, for I am not only in constant touch with American friends through correspondence, but we entertain a very large number of them.'⁵³ He warned Macmillan of the mistakes made in the years before the United States entered the war in 1917: 'Facts are the only argument that matter, and she [America] has a very shrewd eye for facts. She must be allowed to do her own persuasion, and there are many forces across the border working to that end.'

He also warned of battles with the War Office and the Admiralty. 'As you know well, the minor military and naval mind has a passion for babyish secrecy. Ninety per cent in the last war of what was censored in the first three years could have been published with impunity.' In the event, Macmillan lasted just four months in office for he was no administrator; moreover, he was dogged, unfairly, by the enormous size of his Ministry, built up in expectation of war in the late 1930s, which immediately attracted a great deal of criticism in Parliament and the country. At the end of 1939 he was replaced by Lord Reith, who famously reintegrated censorship into the Ministry, something that JB deprecated. 'The idea of mixing up propaganda and censorship in one department is insane,' he wrote to Walter, 'for the essence of propaganda is that you have to fight censorship!'[54]

One person who JB encouraged to become, in effect, an agent of influence in the United States was Professor Moritz Bonn. He had worked on German propaganda sent to the United States during the Great War but was keen, for obvious reasons, to do the same for the British this time round. And he was particularly useful to them because he had experience of developing propaganda against them. Bonn crossed to the United States in October 1939 for a few months, staying at Rideau Hall in November. In the end he remained in America for the duration of the war: 'Thanks to the Rockefeller Foundation and to the Institute of International Education, a number of visiting professorships were offered to me. I accepted them on the advice of Lord Tweedsmuir and Lord Lothian; both were of the opinion that such qualifications as I possessed were more useful in the Western Hemisphere than in England.'[55] He was doing just the kind of propaganda work for the Allies that Gilbert Murray and others had done during the Great War, but his status as a German Jewish refugee was a recommendation to his listeners that Murray could not command.

The best, but by no means the only, example of how JB worked round the fringes of diplomacy was the decisive part he played in closing the negotiations over the British Commonwealth Air Training Plan (BCATP). This has been called, by a Canadian historian, 'a highly irregular, somewhat surreptitious, but enormously effective intervention in something of great import to the Empire-Commonwealth'.[56]

Just after war broke out, the Canadian and Australian High Commissioners in London, Vincent Massey and Stanley Bruce, had – on their own initiative – met informally with Air Ministry officials to try to work out some kind of plan for training pilots in the Empire to serve in the RAF, since British aerodromes would be vulnerable to German bombers in time of war. They believed Canada was the best-placed country for training aircrew from all over the Commonwealth. They were pushing at an open door, since the British government had also been thinking along these lines; but the government knew how sensitive Mackenzie King was, so Massey himself helped to draft the air-training proposal.

Mackenzie King was attracted by the idea, since such a plan had the advantage of conferring prestige on Canada, without her having to commit large numbers of troops overseas. This would prove impossible anyway without conscription, which he had promised not to introduce. So a British delegation, known as a 'mission', led by Lord Riverdale and including a former Governor of Kenya, Air Chief Marshal Sir Robert Brooke-Popham, who was acting as the chief negotiator for the RAF, arrived in late October; Australian and New Zealand delegations followed soon after.

It soon became apparent that the British mission had very little idea of how Canada (and indeed Australia and New Zealand) had changed and developed since the Statute of Westminster was enacted, both with regard to its image of itself and in its attitude to the outside world. The inclination of British officials to throw their weight about irritated the Canadian politicians, who felt patronised.

Mackenzie King, very much on his dignity, insisted both that Canadians trained under this scheme would serve in the country's own service, the Royal Canadian Air Force, rather than the British RAF, and that Canada would not have to foot the bill for the BCATP. JB saw his task as smoothing his Prime Minister's feathers, while simultaneously keeping Neville Chamberlain apprised of Canadian sensitivities. He found himself cast as interpreter and even conciliator with the missions, roles that Mackenzie King seemed happy, just this once, for him to play, since it was in Canada's interest to do so.

One important sticking point, however, turned out to be the insistence by the British mission that British ground crews at the training establishments should not be commanded by Canadian

officers. Time wore on and Mackenzie King became very anxious about this issue. He wrote to JB on 12 December: 'The delay in reaching a final understanding with the Air Ministry of the UK on the important question of identity and command of Canadian units and formations in the field, which we believed had been settled weeks ago, has been unfortunate as respects the time of the announcement.'[57]

The crunch came late on Saturday evening, 16 December. The Prime Minister wanted to announce the deal in his weekly broadcast the next day, which was also his birthday, a fact he thought highly propitious. More importantly, the Australians had just announced their own agreement, so he could not afford to be behindhand. Moreover, the first Canadian troops (including Johnnie Buchan) would be landing in Scotland that day, and he wanted to announce the plan before, rather than after, their presence in Britain became known. That evening, Mackenzie King decided to go to visit JB, to put the whole situation before him 'as the representative of the King, and as one who could give Chamberlain the true story. I felt too that he might be able to assist in bringing the others together.'[58] He arrived at Government House about 10 p.m., where he discovered the Governor-General in bed, having been there all day, and looking 'pretty frail'. He asked him to intervene, saying it was the most important matter he had ever had occasion to discuss with him, and impressing on him the urgency.

Thus was Brooke-Popham summoned from an ice-hockey match to attend the Governor-General in his bedroom. When he came out, having received a courteous but firm lecture from the small, fragile man in pyjamas, propped up on his pillows, he had conceded the point. For Brooke-Popham, who had not been on hand to watch the development of the Governor-General's love for, and commitment to, Canada, his attitude must have come as quite a surprise. JB's diary entry for that day reads: 'Sent for Brooke-Popham and had long difficult talk with him. I thought his arguments far-fetched.'[59]

Brooke-Popham proceeded to the Prime Minister's office where the agreement was signed, a few minutes after midnight. Mackenzie King, triumphant, said he had never seen a man more deflated than Brooke-Popham; he looked as if he had been 'spanked'. 'His face was very red and his manner very crushed.'[60] Sir Gerald Campbell, British High Commissioner in Ottawa, said that he 'looked a broken man and

bewailed the fact that, in yielding to the Governor-General's pressure, he had been false to the traditions of his service'.[61]

Mackenzie King later mused that he did not believe any more significant agreement had ever been signed by the government of Canada. The reason for this, as he said in his broadcast the next evening, was that the 'United Kingdom government has informed us that ... the air training scheme would provide far more effective assistance towards ultimate victory than any other form of military co-operation which Canada can give'.[62]

It seems that the part JB played in the genesis of this plan, which during the Second World War trained 130,000 pilots and aircrew, was absolutely crucial. And he succeeded because he understood, as did the Prime Minister, if intermittently, how useful informal, non-diplomatic channels of communication and operation could be, when exploited in the right way.

At the same time, he was facilitating contacts between the 'British Supply Board in Canada and the United States', under its highly effective head, Colonel Greenly, of the engineering firm Babcock and Wilcox. JB's personal diary indicates that he entertained Greenly many times in those weeks, since the man was plainly very open to suggestions from the Governor-General, with his very wide acquaintance and lofty status among Canadian businessmen. JB's contacts were second to none and he could open doors otherwise firmly shut.

It seems that JB's personal connections with at least three British Prime Ministers, as well as Lord Halifax, the Foreign Secretary, meant that, in the words of one modern Canadian historian, 'his ideas about policy were considered at the highest political levels and that the information he sent reached these men unfiltered by departments'.[63] His influence didn't end there, for he was on such good personal terms with Franklin Roosevelt and Cordell Hull, as well as with successive British ambassadors in Washington – Sir Ronald Lindsay and the Marquess of Lothian – and bankers, politicians, soldiers, journalists and businessmen, that his views became common currency amongst senior opinion-formers in the United States as well.

We shall never know the precise extent of his influence over American, Canadian and British foreign policy, but Professor Neilson has maintained: 'By dint of personal prestige, widespread connections

and an unwavering view of the importance of and functioning of empire, Tweedsmuir provided a framework for cooperation among these three states that proved its worth in the Second World War.'[64] Neilson goes on to write, intriguingly if unverifiably, that the creation of the post-war condominium centring on the North Atlantic world owed much to JB's work. What is incontrovertible is that he played a significant role in the development of Canada as a self-governing (and self-respecting) dominion – perhaps the pre-eminent one – in the post-war Commonwealth of Nations. That is not bad for someone who Lawrence of Arabia feared would be just 'a figure'.

The only extant private diary of JB's is that for 1939, and it is instructive. In it he noted weather and temperature, who came to see him and at what times, the principal guests at luncheon or dinner, how he felt about his health, the bare details of his travels, occasionally news on the impending war, and its progress once begun, and regularly his weight in stones and pounds. Careful reading of this diary shows just how ill he was at times in 1939; it is easy to see how he had to steel himself to perform his duties. There is just one entry when he admits to feeling sorry for himself.

In October 1939 he gained Royal permission to make a private visit to New York, in order to consult a well-known physician at the Rockefeller Medical Center, Dr Miller. At the weekend he travelled to Tom Lamont's country house in New York State, where his fellow guest was the Marquess of Lothian, the newly arrived British ambassador. On Monday he lunched with the Morgan partners and a host of businessmen in New York, on Tuesday with journalists from the *New York Times*, leaving for Canada once more that evening.

JB had an ulterior motive for seeking a second opinion from an American doctor. Much as they would have liked to meet, both he and Roosevelt knew that the time was not opportune, since the isolationist wing of the Democratic Party would kick up an unholy fuss and might jeopardise the President's efforts to encourage Congress to rescind the Neutrality Act. Roosevelt told him that the 'bill [had] a good chance of going through' but that he was 'almost literally walking on eggs … saying nothing, seeing nothing and hearing nothing'.[65] However, Lothian, as the British ambassador, was a conduit to Roosevelt. In his turn, Lothian wanted advice from JB about the first public speech he was to make, a very important one to the Pilgrims of the United States

at the Plaza Hotel in New York, and in fact the speech he gave has JB's fingerprints all over it.[66]

JB received the same diagnosis and much the same advice – one day a week in bed – from Dr Miller in New York as he had had from his Canadian doctors. It cannot have come as any great surprise. However, he went again in early November to New York for treatment (he was told his gastritis was 'serious but not dangerous') and took further opportunities to listen and talk to opinion-formers, lunching again with *New York Times* journalists and spending an evening this time with John D. Rockefeller. These occasions made their way in fictional form into *Sick Heart River*.

His extraordinary stoicism did not go unremarked. The novelist David Walker recalled about his time as one of JB's ADCs in 1938: 'There are so many things of praise to say about him. It was almost the last year of his life, spent in constant discomfort with an ulcer and other ailments. His diet was entirely bland, things like scrambled egg or slops, and after meals he would have to prop himself lopsidedly along the sofa. He said to strangers, "The doctor makes me stretch out like this", but beyond that necessary explanation he never mentioned his health, or he never did to me, not once in our many walks and other times together.'[67]

Sleep no longer refreshed him, his blood pressure was too low, he suffered from headaches, and his eyesight was failing, particularly the left eye below the bump on his forehead from the childhood carriage accident. But the only time that Susie's lady-in-waiting, Joan Pape, ever heard him raise his voice was when luncheon was delayed during the Royal visit in May 1939, when tensions must have been running very high.[68] Lilian Killick remembered that 'the older he got, the kinder he got'.[69] The wonder is how he could so often be good company in social situations, when he was, perforce, the centre of attention, while he felt so awful. And it must have often hurt to be pushing a piece of steamed fish around his plate, and sipping a glass of water, while his guests enjoyed a multi-course banquet.

Meanwhile, he continued to write *Sick Heart River*, as well as his book of 'reminiscences', *Memory Hold-the-Door*, and what he called 'a Canadian *Puck of Pook's Hill*' children's story (published as *The Long Traverse* in 1941), to try to acquaint children with their history, since he thought the school textbooks were so dull. He also wrote two chapters of a book on fishing, which were appended to *Memory Hold-the-Door*

and entitled 'Pilgrim's Rest'. The writing is lyrical and precise, as he relived his youthful fishing expeditions in Tweeddale. (The last page of all is a digression, strangely, on 'the prose of mortality' and it ends with Lockwood's famous and comforting reflection over the graves of Catherine, Heathcliff and Edgar in *Wuthering Heights*.) George Trevelyan reckoned that the first chapter, 'The Springs', was the best thing JB ever wrote.[70] The flame was still bright. Meanwhile, Susie had never been busier in Canada, going off on her own to complete engagements with women's groups in particular, and organising a Red Cross work party, making 'comforts' (socks, gloves, blankets and so on) for Poles at Rideau Hall.

JB had gone to Canada on the understanding that his tenure would be for five years. His time was therefore up in the autumn of 1940 and, after war broke out, he began to consider how best to refuse a second term of office. The Canadian government requested him to stay on for another five years and, when he refused, Mackenzie King asked whether he might remain for the duration of the war, or even just for one further year. But their entreaties were unavailing.

'Roosevelt has unwittingly done me an unfriendly act,' JB wrote to Walter, 'and told the press that he would regard my refusal to accept a second term of office as a disaster both for the U.S.A. and for Canada! I can only reply in the words of my favourite quotation – "Not Ferdinand"!'* He was 'dragging his wing' and only a good long time at Ruthin Castle, he believed, would restore him to better health. Moreover, he did not feel he could subject Susie to another Canadian winter, and the war had made it worse: she had two sons in uniform, one of whom was already on the other side of the Atlantic in the Canadian Expeditionary Force, as well as one trying to get into the RAF,** and an elderly mother who had taken refuge at Elsfield.

He wrote to Walter in late November with all the reasons why he wanted to go home: 'But my case is not very strong. The case I put to the King, and with which he agreed – that I had had a very individual kind of term of office, and that I did not want my own idiosyncrasies

* The film, 'Ferdinand the Bull', came out in 1938. JB to Walter Buchan, 5 October 1929, NLS, Acc. 11627/84.

** William Buchan was accepted by the RAF to train as a pilot in early 1940. His father did not live to hear of it.

to be hardened into precedents and embarrass my successor – is unanswerable. But the argument falls to pieces in war, for the work I am now doing is that which anyone could do. I will plead my health and Susie's sanity for all they are worth, but I am always liable to be met with the argument that everyone has to sacrifice a good deal in war, and that we are not being asked to sacrifice more than other people. I also have no notion what the King may say. He is my master, and he may simply tell me to get on with it.'[71]

One thing JB achieved that autumn was to persuade the Queen to broadcast encouraging remarks to Canadian women, which could of course be heard in the United States as well. This was his initiative and he wrote the words she spoke. He told Walter: 'I am very glad I have got the Queen to broadcast on November 11th. She is a legendary figure on this side of the water. The ordinary French-Canadian says, "Well, if She wants us we're ready!" '[72] He spent much of his time reviewing troops, wearing the uniform of Commander-in-Chief as King George VI did in Britain. The last entry for 1939 in his diary reads: 'What a year! God send that 1940 gives victory and sees our family safe!'[73] It was rare indeed that he invoked the Almighty.

The first official event of 1940 was his last New Year's 'levée' at Government House. 'There is always something melancholy about doing something for the last time, even when you are glad. Susie keeps on saying, "Never again" about things, and then feeling regretful.'[74] He said that leaving Canada was like pulling up mandrakes. 'The appeals I get from humble folk, Prairie farmers, habitants, etc are really rather heart-breaking. They all say they feel so "safe" with me here – whatever they mean by that!'[75]

By the beginning of 1940 he had finished *Memory Hold-the-Door* and invited Yousuf Karsh to help him sort photographs for it. He wrote to Sir Alexander Hardinge, asking whether the King would mind if the book were published in serial form before he left Canada, George V having said he could publish, provided that the subject was not current politics. He read John Morley's *Gladstone* and told Sandy Gillon that he had become, late in life, a Gladstonian Liberal: 'I was in revolt in my early political days against Gladstonianism, for it seemed to preach only platitudes which had become generally accepted. But now it is just these platitudes which are at issue, and they have become living things for us.'[76] He was feeling surprisingly well, a source of particular satisfaction to his wife.

Memory Hold-the-Door (the title, with its curious hyphenation, is a quotation from Stevenson) was published in the summer of 1940 in Britain and as *Pilgrim's Way* in North America. Hodder and Stoughton called it an autobiography but Houghton Mifflin, under the influence of Ferris Greenslet of course, subtitled it 'An Essay in Recollection', which is what it is. JB wrote about it: 'This book is a journal of certain experiences, not written in the experiencing moment, but rebuilt out of memory.' He went on to say that experiences in youth are overlaid but not lost. 'Time hurries it [an experience] from us, but also keeps it in store, and it can later be recaptured and amplified by memory, so that at leisure we can interpret its meaning and enjoy its savour.' He wrote that at first he had thought the chapters were so brazenly egotistical he should have them privately printed. 'But I reflected that a diary of a pilgrimage, a record of the effect upon one mind of the mutations of life, might interest others who travel a like road.'[77] There were certainly many fellow travellers, for after its very lucrative serialisation in *The Sunday Times*, the hardcover book had a print run of 46,000, which almost immediately sold out. In wartime, between August 1940 and the end of 1945, despite paper shortages, there were twenty-eight reprintings.

The chapters take the conventional linear course of an autobiography: childhood, youth, Oxford, London, South Africa, London again, the Great War, Elsfield, Parliament. But only up to 1935; there is almost nothing about Canada in it, for obvious reasons. He wrote about his father, his mother, his dead brothers, but scarcely a thing about his living siblings, his wife or children. Along the way there are portraits of dead friends, such as Lord Milner and Raymond Asquith, some of the passages plucked straight from the privately printed *These for Remembrance*. There is a chapter on 'My America' and then a final passage in which he looks at civilisation and the challenges of the future. The book is an unusual mixture of preoccupations, only really comprehensible if understood as the musings in late middle life of a highly intelligent, reflective, private and discreet man, hampered by the confining circumstances in which he finds himself.

In his early life, he had been concerned with the promotion of civilisation, and the part-terror/part-attraction he felt for the primeval

and savage. By 1940, in a passage that may give the modern reader pause for thought, he voiced his fears of what he called 'de-civilisation'. Although he categorically did not reject increased mechanisation and scientific discovery, he did worry about what would happen once science had gained its major victories and all the globe was explored and exploited. In a nightmare scenario:

> Broad highways crowded with automobiles threaded the remotest lands, and overhead great air-liners carried week-end tourists to the wilds of Africa and Asia ... What once were the savage tribes of Equatoria and Polynesia were now in reserves as an attraction to trippers, who bought from them curios and holiday mementoes. The globe, too, was full of pleasure-cities where people could escape the rigour of their own climate and enjoy perpetual holiday.
>
> In such a world everyone would have leisure. But everyone would be restless, for there would be no spiritual discipline in life. Some kind of mechanical philosophy of politics would have triumphed, and everybody would have his neat little part in the state machine. Everybody would be comfortable, but since there could be no great demand for intellectual exertion everybody would be also slightly idiotic. Their shallow minds would be easily bored, and therefore unstable. Their life would be largely a quest for amusement...
>
> It would be a feverish, bustling world, self-satisfied and yet malcontent, and under the mask of a riotous life there would be death at the heart ... Men would go everywhere and live nowhere; know everything and understand nothing. In the perpetual hurry of life there would be no chance of quiet for the soul...

This passage was written just after the Second World War had broken out, and he continued:

> But something has happened. A civilisation bemused by an opulent materialism has been met by a rude challenge. The free peoples have been challenged by the serfs. The gutters have exuded a poison which bids fair to infect the world...

And the result? The free nations now valued freedom, as they had ceased to value it in the comfort of peacetime:

> We have been shaken out of our smugness and warned of a great peril, and in that warning lies our salvation. The dictators have done us a marvellous service in reminding us of the true values of life.[78]

This quirky book of reminiscences had a substantial impact, not only with the 'ordinary' reader, but with policy-makers and statesmen as well. None more so than John F. Kennedy, who numbered *Montrose* and *Pilgrim's Way* among his twelve favourite books. He quoted the latter in a number of speeches. According to his widow, Jacqueline, JB's views on democracy and the profession of politics profoundly shaped her husband's thinking. Three years after JB died, the King broadcast to the nation on Christmas Day in wartime. The last sentence, before the National Anthem sounded, was this: 'In the words of a Scottish writer of our day, "No experience can be too strange and no task too formidable if a man can link it up with what he knows and loves." ' This is a quotation from *Memory Hold-the-Door*.[79] Perhaps the King did not give the Scottish writer a name for fear he might stumble over the 'B' of 'Buchan'. But plenty of people will have known that these are the words that follow one of JB's favourite true stories, of a Scottish soldier in Mesopotamia who, when asked where he got his wound, replied that it was two miles on the Rothiemurchus side of Baghdad.

JB professed himself happy for the United States to stay out of the war for the time being, for American industrialists were proving extremely helpful, fulfilling Allied orders for materiel on favourable terms. 'The situation,' he told Walter, 'in [the States] is curious. America is confirmed in her isolationism, which is all to the good, for we could make no use of her infantry at present; while all the big industrialists are being extraordinarily helpful in our munition work, and the aeroplane people are quite excellent.'[80] His anxiety was over whether Britain could finance these purchases, since the Johnson Debt Default Act forbade any loans from America to the Allies. He wanted to talk to Roosevelt about this but thought it too dangerous at the time to suggest it.

To JB's relief, the King agreed to him leaving Canada in September 1940. He was aware that he had put his Sovereign on the spot, for it

might be difficult to find a successor in wartime. In the event, Queen Mary's brother, the Earl of Athlone, agreed to cross the Atlantic in wartime to replace him; Athlone had already been Governor-General in South Africa, so he knew the ropes. He and his wife, Princess Alice, would turn out to be very popular and hard-working in Canada, although it must be said that Redfern wrote Athlone's speeches for him.

JB opened Parliament in the last week of January 1940, and proclaimed an immediate dissolution at the request of Mackenzie King, since the time for an election was drawing near, and the Prime Minister had no wish for the life of the Parliament to be extended. He wanted a new mandate, and he felt this was an opportune moment to try to get it. Moreover, if Parliament were dissolved, there was less danger of the government being subjected to criticism, which they couldn't answer, since much of their work was now confidential. The Germans tried to make capital out of it, as JB noted in a letter to Walter at the beginning of February: 'I see that Goebbels on the radio, speaking about the Canadian election, said that I had ordered it in order to divert the deep fear and unrest, which is rampant in Canada, by a minor excitement! He is a blithe spirit!'[81]

JB was very proud of Canada: his Red Cross appeal had netted almost twice what he had asked for, and he sensed the country's unity and keenness to help in the war effort (there were long waiting lists to enlist, even in French Canadian regiments). It was a quiet time for him and he busied himself with trying to interest Colonel Sam McLaughlin, the millionaire head of General Motors of Canada,* in partly financing a British Columbian version of Hollywood – a scheme promoted by three prominent film actors, Charles Laughton, Ronald Colman and Sir Cedric Hardwicke. JB was enthusiastic because he thought film-making might become very difficult in Britain during wartime. In the end, for many reasons, one of them being the war, the idea came to nothing, but in light of the development of 'Hollywood North' in British Columbia and Ontario – now a billion-dollar business – his actions can be seen as visionary.[82] On the personal side, he was working hard on the story for an adventure film set in Canada, which Alexander Korda had wanted to make since 1938, and the production of which could begin once JB had left Canada that summer.

*He was to buy JB's library as a gift for Queen's University, Kingston, Ontario, in 1955.

On 25 January, JB travelled to Montreal to visit the Catholic Université de Montréal and spend the morning with the Sulpician Brotherhood. 'I never saw more beautiful faces than those of the brothers.'[83] Susie went with him and was mobbed by people in suburban Montreal, shouting 'You mustn't go away.' They brought back their old friend Father Martin D'Arcy, the Catholic philosopher and Master of Campion Hall, the Jesuit college in Oxford, to stay the night. JB told Walter: 'On Saturday [3 February] I am dining in high ecclesiastical circles, with the Cardinal, the new Archbishop and the Apostolic Delegate – fine company for a Presbyterian Elder!'[84] He also told Anna that he had finished his novel and reminiscences and was almost at the end of his children's book. 'This will leave me with a clear field for farewells this summer.' He ended his letter to Anna on Monday, 5 February, with 'Take great care of yourself, and make Walter do the same.'[85]

The next morning, he suffered a slight stroke while shaving in his bathroom, fell backwards against the bath, hitting the back of his head badly and causing it to bleed. He was concussed and rendered unconscious. An hour later, James Cast found him. The bulletin issued that evening from Government House and signed by Dr Wilder Penfield, the world-famous neurosurgeon, and Dr Jonathan Meakins, having rushed from Montreal in a snowstorm to see him, said that he had steadily improved and was now conscious. He was able to recognise and talk to Susie and Alastair, and his aides. However, during the next day, pressure began to build up in his brain, and he became restless and fatigued. By lunchtime on Thursday, he was unconscious and his condition was causing grave anxiety 'on account of increasing weakness'. The following morning his condition was so critical that Dr Penfield and his colleague, Dr William Cone, performed an emergency trepanning operation, to relieve the increased intra-cranial pressure.

The decision was then made to remove him to the Montreal Neurological Institute, and he was taken by ambulance to the station and put in the Governor-General's carriage. An ordinary carriage was coupled to the engine in front to deaden any shocks and the tracks were cleared of other rail traffic to let the train pass unhindered.

That day, Penfield and Cone carried out two subtemporal decompression operations, which resulted in a slight but definite improvement, but his condition was still considered critical. On Sunday morning he suffered a relapse, and a further emergency cranial

operation was carried out. The doctors thought then that they had seen him 'entering a safe harbour'. However, early on Sunday evening, 11 February, an embolus entered his lung from his leg, and it was all over.[86] The telegram to Bank House read: 'John died in perfect peace at 7.13 this evening.'[87] The doctors had not slept for three days and Susie told Alice that, when Dr Penfield came to tell her the news, he looked 'an old, broken man'.[88]

That evening, Mackenzie King broadcast to the nation, referring to JB as 'a great and good man'.[89] Three days of national mourning were announced and JB's body was brought back from Montreal by train the next morning, 12 February. At Union Station the coffin and party were met by a crowd of officials, including Mackenzie King, his Cabinet and the Mayor. The coffin was placed in the Chamber of the Senate, where JB had opened Parliament four times. Here he lay in state, guarded by four soldiers of the Governor-General's Foot Guards and the 4th Princess Louise Dragoon Guards, with Alastair taking three turns on guard. Some 15,000 people filed by in the two days before the funeral.

Ferris Greenslet, who came north for the funeral, recalled: 'When I went to Ottawa … porters, conductors, small shopkeepers, men in the street, spoke of him with broken voices. Even the French press of separatist Quebec, which had greeted his arrival with epithets of *agent provocateur* and *espion*, spoke of him with remorseful eloquence.'[90]

On the day of the funeral, 14 February, flags flew at half-mast, schools closed, and provincial legislatures opened only for memorial meetings. Early in the afternoon, the coffin was put back into a hearse and, flanked by JB's aides, was driven at walking pace down Wellington Street to the 'old' St Andrew's Church at the corner of Wellington and Kent, where the Tweedsmuirs had worshipped most Sundays when in Ottawa. The snow was swept from the streets and, behind a double row of troops, people stood many ranks deep, bare-headed (the CBC commentator described 'dense crowds of hushed, sorrowing people'), in an intense cold that measured zero degrees Fahrenheit (–18°C). In front of the hearse marched the band of the Governor-General's Foot Guards, playing Chopin's 'Funeral March'. Immediately behind was the Insignia bearer, carrying JB's decorations on a black cushion.

The service, which was broadcast live by the Canadian Broadcasting Corporation and heard across the Commonwealth and the United

States, was conducted by the Reverend Alexander Ferguson, the
Scotsman from Falkirk whose sermons JB had liked (although not his
affected parsonical delivery) and whom he used to invite to Sunday
lunch at Rideau Hall.

Ferguson's address began:

> When, just over four years ago, Lord Tweedsmuir stepped ashore at
> Quebec he was to us an official … Today all Canada mourns him as
> a friend. There is not a home among us that is not saddened by his
> passing, not a heart that does not sorrow with his gracious wife and
> family because so rare a spirit has fled. From coast to coast, from the
> Arctic Circle to the Great Lakes, our Governor was loved by us all,
> known to us all as one on whose eager interest we might count, as
> one who cared for Canada and made her life his own. With dignity
> and patience and humour and self-forgetfulness, this great heart put
> all his shining gifts of mind and character unreservedly at the service
> of the Dominion…
>
> Deep-rooted in our Governor's life was religion … His was no
> feeble sentimental faith but something robust, pure, unshakeable,
> that accepted in deepest humility the great gift of Divine atonement
> for his sins.

The minister quoted JB's own words:

> There is still for every man the choice of two paths and conversion in
> its plain evangelical sense is still the greatest fact in any life.

And he ended with the description of the death of Mr Valiant-for-
Truth in *The Pilgrim's Progress*, which Richard Hannay read over Peter
Pienaar's grave in *Mr Standfast*:

> So he passed over and all the trumpets sounded for him on the
> other side.[91]

At the end of the service, the eight pall-bearers from the three branches
of the Canadian forces, as well as the Mounties, strapped the coffin
onto a gun carriage and covered it with a Union flag, while the band
played 'God Save the King' and 'Abide with Me', and there was a

nineteen-gun salute. The gun carriage was pulled by naval ratings back along Wellington Street and past the Parliament buildings to Union Station.

Susie did not attend the funeral. It is most likely that, after long vigils by her husband's bedside and the shock of his death, she could not trust her composure when the eyes of the world were upon her. Instead she waited in the train, probably in the company of Joan Pape, listening to the broadcast. The coffin was loaded once more onto the train and, together with Alastair and her husband's close aides, she left for Montreal once more. There, in the Mount Royal Crematorium, close to the Neurological Institute where he had died, JB's body was cremated after a short, bleak service.

At the Neurological Institute, the doctors who had worked so hard to try to save JB's life met to honour him. Dr Meakins spoke of his 'beloved patient. Among all adjectives this is one which could not possibly be omitted by anyone who knew Lord Tweedsmuir ... I have often heard it said that he was frail – yes, perhaps, frail as a rapier is, compared to a battleaxe. There was that fineness of quality of Toledo steel in things physical, mental and spiritual.'[92]

In the words of the historian J. P. Parry:

> His send-off can be seen as the ultimate establishment accolade bestowed on Lord Tweedsmuir, the king's representative in the greatest dominion of the greatest empire in the world. But it can also be seen as the last tribute of a plain, unfashionable, God-fearing, democratic people to plain John Buchan, who represented and propagated their values more accurately and genuinely than any other official Briton of his day.[93]

The newspapers speculated that his ashes might be sent for burial to Scotland, but in fact they were sent home to Elsfield, secretly, on the light cruiser HMS *Orion*, which was leaving Halifax for England with men of the Royal Canadian Air Force on board. Johnnie, William and Vincent Massey* travelled to Plymouth to collect the ashes and took them to Elsfield to stand in the chancel of the church, until Susie's return.

*Governor-General of Canada himself between 1952 and 1959, the first Canadian to fill the role.

A memorial service was held in Elsfield church the Saturday after JB's death, for family, staff, neighbours and Oxford friends. We can easily picture the scene: the small medieval church packed with people, hunched in thick dark overcoats against the chilling cold in that first freezing winter in wartime. The service was devised by JB's children. The congregation sang Psalm 23 (no doubt to the Crimond setting) as well as the lesser-known Psalm 15: 'Lord, who shall dwell in thy tabernacle: or who shall rest upon thy holy hill? Even he that leadeth an uncorrupt life: and doeth the thing which is right, and speaketh the truth from his heart.'

William read the description of the death of Mr Valiant-for-Truth from his father's battered copy of *The Pilgrim's Progress*. The lesson was from *The Wisdom of Solomon*: 'But the souls of the righteous are in the hand of God, and there shall no torment touch them. In the sight of the unwise they seemed to die, and their departure is taken for misery, and their going from us to be utter destruction: but they are in peace.'*

The hymns would have been well known to the congregation: John Bunyan's 'Who would true valour see' and the so-called Old Hundredth (psalm), 'All people that on earth do dwell'. Professor Gilbert Murray, sombrely colourful in his scarlet and grey doctoral gown, gave an affectionate eulogy. Later that month, memorial services on a much grander scale were held at St Giles' Cathedral in Edinburgh, and in Westminster Abbey, London, where amongst the mourners were Neville Chamberlain, Earl Baldwin and Lord Halifax.

Sir Shuldham Redfern wrote to Sir Alexander Hardinge to describe the struggles to save JB's life, then he went on:

I saw him about an hour after he died. The lines had gone from his face** and he looked a young man, like those who 'carry back bright to the Coiner the mintage of man'. And now I miss the welcoming smile he used to give me whenever I went into his room, his boyish enthusiasm, his instantaneous understanding of the one point in a subject that mattered, his kindly and scholarly wit, his simple dignity, his tacit but firm reproof of all the vulgarities, his restraint and tolerance and that inestimable gift of never interfering in anyone

* *The Wisdom of Solomon*, chapter 3.
** Mackenzie King noted this, too.

else's job; and he never wore 'the sepulchral integuments of an English peerage' ... I cannot finish this letter without saying something of Lady Tweedsmuir and her youngest son Alastair ... I saw her very soon after the Governor General died. She spoke almost entirely of all the doctors and nurses had done, their skill and unselfishness ... She has never faltered and those of us who have been near her throughout this heartrending epic, have been amazed and immensely fortified by her dignity and courage. The same may be said of Alastair who has been a tower of strength and in all the matters we have had to consult him about, many of them of a morbid nature, he has never failed to give us immediate decisions in the crisp manner so characteristic of his father. All this has made our task immeasurably easier.[94]

On 18 March, Susie, with Alastair (who had been appointed to General Crerar's staff in England) and some of the English staff, slipped away unobtrusively in a warship from the harbour at St John, wartime conditions decreeing that her going should not be known until she was safely across the Atlantic. Her book scheme ended abruptly on her departure from Canada.

After she arrived home, JB's ashes were buried in Elsfield churchyard in a private ceremony. Sir Herbert Baker, the architect, whom JB had first met in South Africa decades before, designed the gravestone. He suggested a circular stone, laid flat, with a cross in relief on the top encircled by the Greek words ΧΡΙΣΤΟC ΝΙΚΗΣΕΙ, which translate as 'Christ will prevail'. Dougie Malcolm, the friend who had beaten JB to an All Souls Fellowship, devised a Latin couplet to go round the stone's edge:

QUI MUSAS COLUIT, PATRIAE SERVIVIT AMICIS
DILECTUM INNUMERIS HIC SUA TERRA TENET.
'His own earth here holds a man, who cultivated the muses, served his country and was loved by countless friends.'

Amos Webb, the chauffeur, who was in hospital in Ottawa at the time of JB's death, died a month or so after his return from Canada and was laid to rest close by. His upright gravestone was also designed by Baker and the inscription includes the words: 'Friend to Lord Tweedsmuir

for twenty years'. In March 1977, Susie's ashes were buried with her husband's.

After JB's death, the editor of *The Times* told A. L. Rowse that the newspaper had never received so many tributes to a public figure. Rowse was clear that JB paid a price in energy and concentration of achievement for his readiness and willingness to help others:

> What he gained in stature was unmistakable; what others gained from him immeasurable. He gave himself away, right and left, with no thought for his own strength, with an inner generosity of spirit that was more than generosity...[95] How he contrived to get through all the reading and writing he did, let alone everything else he accomplished, beats me; though I do not forget the ceaseless watchfulness and care, the aid and help, direct and indirect of his wife: a rare comradeship in life, in work and public service.[96]

George Trevelyan wrote: 'I don't think I remember any one who has died during my lifetime whose death evoked a more enviable outburst of sorrow and love and admiration, public and private ... <u>What</u> a friend! I feel he was [the] best human being I have known, and he gave himself so generously to so many friends':[97]

> Whenever I saw John Buchan ... I always felt ashamed in his presence that I was not more active, that I did not make more of the wonderful and variegated world of nature and of man, of past and of present, that was our common heritage. One's own little fire was feeble beside his sunlike warmth, but it was part of the world which meant so much to him, and his interest in one seemed to add to one's value. How many men and women of all sorts and conditions have come away from seeing John Buchan feeling just like that, going back the stronger to meet the world and wave of men.[98]

Douglas Fairbanks Jnr, the Hollywood actor who had stayed at Rideau Hall, thought him 'one of the greatest men of our day' and 'a hero to me'.

All these were friends, pole-axed by sudden grief, but as telling was something that the republican-minded J. W. Dafoe wrote, not to Susie,

but to a Canadian-born politician, Viscount Greenwood. Dafoe was a very influential Canadian journalist and editor of the *Manitoba Free Press*, member of the Rowell Commission, and a Liberal who held no brief for Governor-Generals:

> The mourning for Lord Tweedsmuir in Canada was very general and most sincere. Ordinarily a certain proportion of grief for the death of eminent people is, so to speak, official, but I think there was a universal sense of bereavement at the death of Tweedsmuir. He made himself most acceptable to the people of Canada.

Of all the Governor-Generals he had known in fifty years, JB was 'the pick of the lot'.[99]

He had made an impression in the United States as well. The *New York Tribune* opined that:

> History will have a tough time grading this extraordinary man's many different contributions to the life of his generation in the order of their importance and excellence ... Perhaps the whole effort at classification will be given up in favour of the lasting legend of his versatility and prodigious industry and the indelible impression of him as a person whose warmth of human feeling and adaptability matched his great gifts.[100]

After Franklin Roosevelt's death in April 1945, Arthur Murray, the diplomat, wrote to George Trevelyan:

> My thoughts have turned from the President to John Tweedsmuir, who was one of his greatest friends. He had warm feelings of friendship for John, and held him, in the public sense, in the highest regard...[101]

If he had lived until that autumn, JB planned to go back to Ruthin Castle to get his health right. He might perhaps have achieved the American ambassadorship, since the Marquess of Lothian unexpectedly died in December; this was the job he wanted and for which he was now very well qualified. On the other hand, his wary relations with

Winston Churchill, by then Prime Minister, might not have helped his cause.

What is certain is that, if he had survived, he would have continued to write daily while his health held up, fiction for relaxation and solid history for his legacy. At the time of his death he was contracted to write five books, including biographies of William the Conqueror and St Paul, and a novel entitled *The Island Called Lone*. His powers were not failing. *Sick Heart River* is for many people, even today, his best novel.

Sick Heart River (*Mountain Meadow* in the United States) was partly written in the winter of 1938–9, then left alone until after war broke out the following autumn, and revised in December after JB had read Johnnie's Baffin Island diary.

This novel indicates how much the country and its diverse people had got into his bones. Lilian Killick, who typed it, told Susie that 'His Excellency is writing a very odd book, so unlike him, so introspective.'[102] Mrs Killick, who knew him as well as anybody outside his family, was puzzled, but she need not have been. What she was clacking out on a typewriter was a spiritual testament, wrapped around by a gripping story of survival and self-sacrifice in the far north of Canada.

The book bears no dedication, but there are quotations at the beginning of each of the three parts. The first is from the *Proverbs of Alfred*: 'Thus said Alfred: If thou has a woe, tell it not to the weakling, Tell it to thy saddle-bow, and ride singing forth.' The second is from Psalm 46: 'There is a river, the streams whereof shall make glad the city of God.' The third is a translation from Plato's *Phaedo* 58: 'I had a singular feeling at being in his company. For I could hardly believe that I was present at the death of a friend, and therefore I did not pity him.' Anyone who reads *Sick Heart River* will see how apposite are those quotations, the kind that JB had been able to summon at will all his adult life.

The time is the present and the hero is the rich and successful but ultimately lonely Sir Edward Leithen. Just as Europe is plunging headlong into dreaded conflict, and after a diagnosis of terminal tuberculosis, he decides he must find a way of usefully employing what time is left to him. He is determined to die standing, as Vespasian said that an emperor should. So he takes up an invitation by John

S. Blenkiron, to go looking for a missing New York banker, a French Canadian émigré, who is somewhere in the remoteness of Canada's far north. He does it with the help of as motley a crew of comrades as are to be found in *Huntingtower*, including Scottish–Indian 'half-breeds' (métis), First Nations tribesmen and Catholic missionaries.

JB was not dying in 1939 and did not know that *Sick Heart River* would be his last novel, but it would be strange if he never thought about death. Now that his mother was 'away', his thoughts turned more and more to the past. He was the same age as his father had been when he died, he knew that his strength and powers of endurance were on the wane, the pain was almost constant, and he just could not put on weight. Like his pious Scots forebears, he was concerned with his 'latter end'. As the critic M. R. Ridley puts it: 'When he wrote it [*Sick Heart River*] he was, I think, keenly, but tranquilly, aware of the shadow of the wings of Azrael ... There are ... few books so clearly written *sub specie aeternitatis.*'[103] But it would not be true to say that the epiphany that Leithen, the lapsed Calvinist, experiences concerning the mercy of God was JB's. JB was never a lapsed Christian and Leithen was not Buchan.

Writing his reminiscences in 1939 triggered so many memories that it would be odd if some of these did not haunt him. And he put several into *Sick Heart River*. At one point Leithen recalls three especially delectable times in his youth: a long day's tramp in the Border hills as a boy with a fishing rod in hand; supper in his college hall in Oxford, after a day spent in the open air in the surrounding countryside; sitting in a young man's club in London, looking at fly-books with a friend before setting off for a fishing trip on Exmoor.

It is difficult to get all the marrow out of this novel without an understanding of the sore physical trial that JB's life had become in his final year, together with his belief, ultimately, in the illusory nature of worldly success, and his long-held and ongoing determination to 'make his soul'. If death came, it would not find him unprepared. As it turned out, death crept upon him unawares – mercifully, we would say – but he was ready for it. Like Leithen, he made his soul and died standing.

Many years earlier, as a very young man, he had written about dying:

He whose aim is high, whose mark is in the clouds, who presses
hot-foot on the race, will make light of the sudden darkness which
obscures his aim for the moment, the sudden ditch into which he
stumbles ere he can climb up the other side. He has no thought
of death. He cares not a jot for negatives when he has the burning
positive of fiery energy within him; and confident of immortality, he
lays aside the mortal and passes beneath the archway.[104]

Afterword

Susie settled back at Elsfield with her mother and Lilian Killick in 1940, accepting evacuees, organising classes for schoolgirls, worrying about her sons (all of whom came through the war), distributing the many 'comforts' sent over by church members in Ottawa, and giving hospitality to Canadian troops stationed nearby. Her mother died that August, aged eighty-two, and her death was much regretted, for she had been a solid rock. Susie remained close to Anna and Walter Buchan, visiting them regularly until their deaths, respectively, in 1948 and 1954.

However, without JB writing books and selling film rights, the house became too expensive to run and, in 1954, she retired to small-town life in Burford. She sold JB's library of 4,500 volumes to Queen's University in Kingston, Ontario. His speeches, scrapbooks, book manuscripts* and much of his correspondence also went to Queen's, while most of the rest of the material was deposited later in the National Library of Scotland in Edinburgh.

Susie kept herself occupied by writing pleasant, perceptive fiction as well as sprightly memoirs of her early life, now much mined for telling detail by social historians. She also worked hard to keep her husband's memory green, putting together *The Clearing House,*** an anthology of his writings, and *John Buchan by his Wife and Friends.* She invited Janet

*The only book manuscript that is missing is *The Thirty-Nine Steps*; no one knows what happened to that.

**With the assistance of Catherine Carswell, the Scottish novelist and biographer, whose family had been helped by JB.

Adam Smith, one of those clever undergraduates who came to tea at Elsfield in the 1920s, to write what turned out to be a masterly and highly readable biography. She received JB's fans kindly, and concerned herself – mostly at a distance, since she never learned to drive a car – with her fifteen grandchildren. But the house on the hill in Burford was cold and stiff and terribly empty of life. How much she must have missed the quick step in the hall.

While working on this book, I have been haunted by my grandmother's predicament in her long widowhood. I have also had moments of unease about setting her properly in the story, since she so plainly did not want to be there. Her habitual discretion, so obvious in the letters and such a virtue in the wife of a public man, was the reason why she is such an indistinct figure even, or perhaps especially, in the biographies (despite Janet Adam Smith having had many conversations with her), and only glimpsed intermittently in her children's memoirs. It suited her for all the attention to be on JB, but I knew that the story could not be told once more without ushering her gently into the light. As Alec Maitland wrote to her when JB died: 'without your love and sympathy and understanding he could never have done what he did or indeed have been what he was'.[1]

I came to know her best once I was old enough to drive the thirty miles to Burford. Mourning the untimely death of my mother, I was in sore need of a cheerleader – a role, I now realise, she was born to play. I have a sheaf of encouraging letters from her, including one wishing me luck in my Oxford and Cambridge entrance examinations; she told me she had long been sorry not to have gone to university, from which she would have undoubtedly benefited. Her tenacious desire to write and be published is testimony to that.

She would sit, straight-backed and stately, in a winged chair by the fire in the sitting room, puffing delicately on a cigarette, which she held by the tips of two of her long fingers. The cigarettes were the Canadian du Maurier brand, in a distinctive red and silver square cardboard box. Sadly, I never saw the gold cigarette case, with the Royal crest picked out in diamonds, that the King gave her in 1939; no doubt it was locked away in a safe. Her eyes were rosemary-blue, her golden-grey hair as fine as floss silk, her hands blue-veined and slender, and her cheek, when I kissed her goodbye, as soft and yielding as velvet. She had an unusually sweet smile. Her voice was smoke-deep but musical and she

spoke as she must have done when she was a 'young gairl', calling me 'dawling' and referring to Canada as 'Cenedaa'.

I can still conjure the prickle of embarrassment I felt nearly half a century ago when, after lunch one day, she asked me to go upstairs to her bedroom to help her undress, as she wanted an afternoon rest. For a buttoned-up teenager this was a trial, even though it consisted of no more than helping her take off her dress, necklace and shoes. It occurs to me only now that, for a woman who had the services of a lady's maid for much of her life, being helped to undress by a young woman must have seemed perfectly natural.

She became progressively deafer as she aged, and I was sometimes faced with an alarming ear trumpet, into which I alternately bellowed and whispered. Despite that, she was a very good listener, asking me what I had been doing, what I was reading, where my studies were taking me, what flowers I liked. She sent me books of German poetry and encouraged me to learn some of Heine's poems 'because they are so elegant'. She gave me H. G. Wells' *The New Machiavelli*, and told me that the house on fire during the dinner party in the book had belonged to a cousin of hers. Even here she was reticent: I had to consult Wells' autobiography to discover that the cousin was Harry Cust. (It is possible that she didn't want to proclaim that particular connection.) She also gave me her books of memoirs to read, in lieu of telling me about her earlier life. When she was very old and rather frail, I would go out into the garden, pick anything that was flowering and bring it in to talk to her about it. As far as she was concerned, these visits were about me, not her; listening to other people was, after all, how she had spent much of her life.

In 1976, the year before she died, I was working in Holland, and came across an English-language copy of *Montrose* in the local library. I gratefully abandoned my grim Dutch-language studies and read it through like a novel. I wrote to tell her how fascinated, thrilled and, frankly, appalled I had been by it, and she replied that she had always been careful (far too careful in my view) not to force JB's books on his grandchildren, but was very happy that I had found his non-fiction for myself.

I sometimes wonder why my grandmother talked so little about my grandfather to me. Surely it was not because I wasn't listening, since my dealings with her were profoundly respectful. (No one at my school had

a Granny remotely like her and she was the family matriarch.) Now, having spent so much time in her company over the last four years, I see that it was an unassuageable grief that struck her dumb. I perfectly understand, although I am very sorry for it. When she spoke, it was so often with a dying fall. JB's death had, in that inelegant phrase, knocked the stuffing out of her. She needed his energy to shine brightly. In any event, she probably thought that he revealed himself so completely in his works, that the answers to my timidly unspoken questions simply required me to read them with care and an open mind. And, since she could see what kind of person I was, she must have thought that, one day, I would feel impelled to go looking for him.

Notes

1 CHILDHOOD AND YOUTH, 1875–1895

1 O. Douglas, *Ann and Her Mother*, Hodder and Stoughton, London, 1922, p. 26.
2 Reproduced in the Free Church Newsletter 1973, Fife Cultural Trust (Kirkcaldy Local Studies).
3 Douglas, *Ann and Her Mother*, p. 77.
4 Anna Buchan, *W. H. B.*, privately printed, October 1913, p. 15.
5 John Buchan, *Memory Hold-the-Door*, Hodder and Stoughton, London, 1940, pp. 17–18.
6 *Fife Free Press*, November 1888, Fife Cultural Trust (Kirkcaldy Local Studies).
7 Anna Buchan, *Unforgettable, Unforgotten*, Hodder and Stoughton, London, 1945, p. 31.
8 John Buchan, *Sir Walter Scott*, Cassell, London, 1932, p. 23.
9 A fellow minister, quoted by Janet Adam Smith, *John Buchan: A Biography*, Rupert Hart-Davis, London, 1965, p. 21.
10 Recalled by JB in an early essay, 'Urban Greenery', in *Scholar Gipsies*, The Bodley Head, London, 1896, pp. 99–103.
11 Notes sent by John Hutchison, Rector of Hutchesons' Grammar School, to Janet Adam Smith, 1958. National Library of Scotland (NLS), Acc. 11164/11.
12 Buchan, *Memory Hold-the-Door*, p. 32.
13 Reprinted from *The Hutchesonian* in *The John Buchan Journal*, no. 20, spring 1999, p. 2.
14 Anna Buchan, *John Buchan 1847–1911*, privately printed, Peebles, 1912, pp. 13–14.
15 Ibid., p. 318.
16 Ibid., p. 321.

17 Buchan, *Memory Hold-the-Door*, p. 16.
18 Ibid., p. 17.
19 Buchan, *Unforgettable, Unforgotten*, p. 22.
20 *Fife Free Press*, November 1888, Fife Cultural Trust (Kirkcaldy Local Studies).
21 Buchan, *John Buchan 1847–1911*.
22 Ibid., p. 143.
23 Ibid., pp. 232–3.
24 Ibid., p. 114–5.
25 John Buchan and George Adam Smith, *The Kirk in Scotland, 1560–1929*, Hodder and Stoughton, London, 1930.
26 Buchan, *Memory Hold-the-Door*, p. 35.
27 Rev. James C. Greig, 'In journeyings often…', *The John Buchan Journal*, no. 11, spring 1992, p. 15.
28 Buchan, *Scholar Gipsies*, p. 46.
29 Interview with Janet Adam Smith, 16 May 1958. NLS, Acc. 11164/4.
30 Buchan, *Memory Hold-the-Door*, p. 33.
31 Lady Tweedsmuir, ed., *The Clearing House: A Survey of One Man's Mind*, Hodder and Stoughton, London, 1946, Preface by Gilbert Murray, O.M., p. vii.
32 JB to Charles Dick, letter, 11 April 1893, Queen's University Archives (QUA), John Buchan fonds, locator 2110, box 13.
33 Rev. John Buchan, *A Violet Wreath*, privately published, 1893, p. 5.
34 Ibid., p. 8–9.
35 Ibid., p. 12.
36 JB to Charles Dick, letter, 5 July 1893, QUA, 2110, box 13.
37 JB to Charles Dick, letter, 6 September 1893, QUA, 2110, box 13.
38 JB to Charles Dick, 13 January 1902, QUA, 2110, box 13.
39 Extract from Alexander MacCallum Scott's 'Reminiscences', NLS, Acc. 11164/4.
40 John Buchan, ed., *Essays and Apothegms of Francis Lord Bacon*, Walter Scott, London, 1894, p. vii.
41 JB, unpublished material, QUA 2110, box 20 (b).
42 JB to Charles Dick, 13 June 1893, QUA, 2110, box 13.
43 Buchan, *Memory Hold-the-Door*, pp. 23–4.
44 In the same Commonplace Book he quoted a piece of advice from Captain Cuttle in *Dombey and Son* which he took to heart: *When found, make a note of.* QUA, 2110, box 21.
45 Charles Dick to JB, 16 August 1893, QUA, 2110, box 13.
46 Lord Tweedsmuir, *Always a Countryman*, Robert Hale, London, 1968, p. 64.

47 It is in the W. D. Jordan Rare Books and Special Collections at Queen's University, Kingston, Ontario.

48 JB to Charles Dick, 30 December 1894, QUA, 2110, box 13.

49 JB to Charles Dick, October 1893, QUA, 2110, box 13.

50 Buchan, *Memory Hold-the-Door*, pp. 42–3.

51 Ibid.

52 Roger Clarke, *The Journalistic Writings of John Buchan: Selected Essays, Reviews, and Opinion Pieces*, Edwin Mellen Press, Lewiston, NY, 2018, pp. 162–3.

53 Buchan, *Memory Hold-the-Door*, p. 34.

54 Ibid., p. 37.

55 Ibid., p. 39.

56 John Buchan, 'The Novel and the Fairy Tale', The English Association, pamphlet 79, July 1931.

57 Buchan, *Memory Hold-the-Door*, p. 249.

58 Ibid., p. 47.

59 JB to Gilbert Murray, 8 October 1895, QUA, 2110, box 1.

60 JB to Gilbert Murray, 14 October 1895, QUA, 2110, box 1.

61 John Buchan, 'Sir Quixote', in *Good Reading about Many Books*, T. Fisher Unwin, London, 1895.

62 John Buchan, *Sir Quixote of the Moors*, T. Fisher Unwin, London, 1896, p.13.

2 OXFORD, 1895–1899

1 *The Glasgow Herald*, 2 November 1895.

2 Ibid.

3 Ibid.

4 John Buchan, *Memory Hold-the-Door*, Hodder and Stoughton, London, 1940, p. 77.

5 Brasenose College Archives, JB to C. B. Heberden, 25 January 1910.

6 Published by Henry Holt in America and T. Fisher Unwin in Great Britain.

7 JB's dealings with Lane are described by David Crackanthorpe in 'Buchan to Lane', *The John Buchan Journal*, no. 43, spring 2011, pp. 3–15.

8 Quoted in David Crackanthorpe, ibid., p. 9. Jepson, a prolifically published novelist, was the grandfather of the novelist Fay Weldon.

9 JB to Charles Dick, 29 February 1896, QUA, 2110, box 13.

10 JB to Charles Dick, 18 May 1896, QUA, 2110, box 13.

11 JB to Helen Buchan, 22 May 1896, QUA, 2110, box 1.

12 JB to Anna Buchan, 12 June 1896, QUA, 2110, box 1.

13 Reginald Pound, *Arnold Bennett: A Biography*, Heinemann, London, 1952, p. 103.

14 JB to Taffy Boulter, 16 July 1896, QUA, 2110, box 1.

15 JB to Charles Dick, 28 August 1896, QUA, 2110, box 13.

16 JB to Charles Dick, 26 September 1896, QUA, 2110, box 13.

17 John Buchan, *Scholar Gipsies*, The Bodley Head, London, 1896, Prefatory.

18 Ibid., p. 54.

19 JB to Charles Dick, 19 October 1896, QUA, 2110, box 13.

20 JB to Charles Dick, 30 December 1896, QUA, 2110, box 13.

21 *The Oxford Magazine*, 8 December 1897.

22 JB to Charles Dick, 9 August 1897, QUA, 2110, box 13.

23 JB to Charles Dick, 1 November 1897, QUA, 2110, box 13.

24 JB to Gilbert Murray, 29 January 1898, QUA, 2110, box 1.

25 JB to Charles Dick, 10 February 1898, QUA, 2110, box 13.

26 *The Spectator*, 18 March 1899, p. 23.

27 JB to Taffy Boulter, 3 April 1898, QUA, 2110, box 1.

28 According to John Betjeman in *Summoned by Bells*, John Murray, London, 1960, p. 104.

29 JB, *Memory Hold-the-Door*, pp. 56–7.

30 John Buchan, *These for Remembrance*, privately published, 1919, p. 65.

31 Buchan, *Memory Hold-the-Door*, p. 59.

32 Buchan, *These for Remembrance*, pp. 65–6.

33 Now in the Blackwell Collection in Merton College, Oxford.

34 *The Times*, 26 April 1901.

35 Susan Tweedsmuir, ed., *John Buchan by his Wife and Friends*, Hodder and Stoughton, London, 1947, p. 154.

36 *Who's Who*, A. & C. Black, London, 1898.

37 Quoted in Janet Adam Smith, *John Buchan: A Biography*, Rupert Hart-Davis, London, 1965, p. 61.

38 JB to Charles Dick, 10 February 1898, QUA, 2110, box 13.

39 Roger Merriman in Tweedsmuir, ed. *John Buchan by his Wife and Friends*, pp. 111–12.

40 *The Oxford Magazine*, 8 December 1897.

41 Ibid.

42 Quoted in Adam Smith, *John Buchan*, p. 64.

43 Ibid.

44 Quoted in Andrew Lownie and William Milne, eds, *John Buchan's Collected Poems*, Scottish Cultural Press, Aberdeen, 1996, p. 1.

45 Quoting Buchan, *Memory Hold-the-Door*, p. 35.

46 *The Interpreter's House* by David Daniell, Nelson, London, 1975, p. 9.

47 *The Times*, 6 September 1898.

48 NLS, Acc. 6975/22.

49 JB to Charles Dick, 18 July 1898, QUA, 2110, box 13.

50 Adam Smith, *John Buchan*, p. 70.

51 Ibid., pp. 72–3.

52 *The Isis*, 28 January 1899.

53 Adam Smith, *John Buchan*, p. 58.

54 Buchan, *Memory Hold-the-Door*, p. 41.

55 JB to Gilbert Murray, 13 October 1900, QUA, 2110, box 1.

56 JB to Dr. A. G. Butler, 5 November 1899, QUA, 2110, box 1.

57 JB to Helen Buchan, 3 November 1899, QUA, 2110, box 1.

58 JB to Rev. John Buchan, 10 November 1899, QUA, 2110, box 1.

59 John Buchan, *Sir Walter Scott*, Cassell, London, 1932, p. 42.

60 Buchan, *Memory Hold-the-Door*, p. 87.

3 THE BAR, JOURNALISM AND SOUTH AFRICA, 1900–1903

1 Calligraphically, the inscription seems compatible with JB's handwriting in early adult life, according to James C. G. Greig, 'The Writing on the Pane', *The John Buchan Journal*, no. 3, p. 23.

2 John Buchan, *Memory Hold-the-Door*, Hodder and Stoughton, London, 1940, p. 92.

3 Communication from Andy Haswell of GRM Law to the author, 31 August 2016.

4 JB to Anna Buchan, 14 January 1900, private collection.

5 JB to Charles Dick, 27 January 1900, QUA, 2110, box 13.

6 John Buchan, *The Spectator*, 3 November 1928, pp. 20–1.

7 Ibid.

8 Charles Graves, *The Brain of the Nation and Other Verses*, Smith, London, 1912, pp. 32–3.

9 JB to Anna, 20 January 1901, QUA, 2110, box 1.

10 Buchan, *Memory Hold-the-Door*, p. 94.

11 Buchan, *Memory Hold-the-Door*, p. 89.

12 See Anthony Lentin, *The Last Political Law Lord: Lord Sumner (1859–1934)*, Cambridge Scholars Publishing, Newcastle, 2008.

13 Buchan, *Memory Hold-the-Door*, p. 90.

14 JB to Willie Buchan, 17 November 1900, QUA, 2110, box 1.

15 Buchan, *Memory Hold-the-Door*, p. 89.

16 JB to Helen Buchan, 23 April 1901, QUA, 2110, box 1.

17 JB to Helen Buchan, 3 July 1901, QUA, 2110, box 1.

18 JB to Anna Buchan, 7 July 1901, QUA, 2110, box 1.

19 JB to Charles Dick, 9 June 1901, QUA, 2110, box 13.

20 Leo Amery, *My Political Life*, vol. 1, Hutchinson, London, 1953, p. 150.
21 Quoted in Michael Redley, 'John Buchan and the South African War', in *Reassessing John Buchan: Beyond the Thirty-Nine Steps*, ed. Kate Macdonald, Routledge, London, 2009, p. 66.
22 Lord Milner to JB, 12 August 1901, NLS, Acc. 6975/13.
23 R. D. Denman, *Political Sketches*, Thurnam, Carlisle, 1948, p. 115.
24 Quoted in A. M. Gollin, *Proconsul in Politics*, Blond, London, 1964, p. 41.
25 JB to Angela Malcolm, 17 October 1901, QUA, 2110, box 1.
26 Denman, *Political Sketches*, p. 115.
27 JB to Helen Buchan, 9 August 1901, QUA, 2110, box 1.
28 JB to Lady Mary Murray, 25 August 1901, QUA, 2110, box 1.
29 JB to Helen Buchan, 13 September 1901, QUA, 2110, box 1.
30 Buchan, *Memory Hold-the-Door*, pp. 96–7.
31 JB to Anna, 22 September 1901, QUA, 2110, box 1.
32 Buchan, *Memory Hold-the-Door*, p. 125.
33 JB to Anna Buchan, 7 October 1901, QUA, 2110, box 1.
34 Ibid.
35 JB to Charles Dick, 8 October 1901, QUA, 2110, box 13.
36 JB to Anna Buchan, 7 October 1901, QUA, 2110, box 1.
37 John Buchan, *These for Remembrance*, privately published, 1919, p. 41.
38 JB to Stair Gillon, 15 October 1901, NLS, Acc. 11164/17.
39 JB to Anna Buchan, 7 October 1901, QUA, 2110, box 1.
40 NLS, Acc. 11627/39.
41 JB to Angela Malcolm, 17 October 1901, QUA, 2110, box 1.
42 Ibid.
43 JB to Anna Buchan, 28 April 1902, QUA, 2110, box 1.
44 John Buchan, *The Spectator*, 22 June 1901, p. 905.
45 Quoted in Denman, *Political Sketches*, p. 118.
46 JB to Charles Dick, 13 January 1902, QUA, 2110, box 13.
47 JB to Lady Mary Murray, 16 January 1902, QUA, 2110, box 1.
48 Buchan, *Memory Hold-the*-Door, p. 109.
49 See Michael Redley, 'John Buchan and the South African War', in *Reassessing John Buchan*, ed. Kate Macdonald, pp. 68–71.
50 Ibid., p. 74.
51 JB to William Buchan, 27 February 1902, QUA, 2110, box 1.
52 Buchan, *Memory Hold-the-Door*, p. 110.
53 Ibid., p. 115.
54 John Buchan, *The African Colony: Studies in the Reconstruction*, William Blackwood, Edinburgh, 1903, p. 67.
55 Peter Henshaw, 'John Buchan and the British Imperial Origins of Canadian Multiculturalism', in *Canadas of the Mind: The Making and Unmaking of*

Canadian Nationalisms in the Twentieth Century, ed. N. Hillmer and A. Chapnick, McGill-Queen's University Press, Montreal, 2007, p. 197.

56 JB to Walter Buchan, 12 May 1902, QUA, 2110, box 1.

57 Edmund Ironside (with Andrew Bamford), *Ironside: The Authorised Biography of Field Marshal Lord Ironside*, The History Press, Stroud, 2018, p. 37.

58 See Bill Nasson in 'John Buchan's South African visions', in *The John Buchan Journal*, no. 26, p. 30.

59 JB to Helen Buchan, 23 August 1902, QUA, 2110, box 1.

60 JB to Helen Buchan, 7 December 1902, QUA, 2110, box 1.

61 *The Times*, 5 January 1903, p. 8.

62 Redley, 'John Buchan and the South African War', p. 71.

63 John Buchan, *A Book of Escapes and Hurried Journeys*, Thomas Nelson, Edinburgh, 1922, p. 122.

64 Buchan, *Memory Hold-the-Door*, p. 121.

65 JB to Anna Buchan, 21 December 1902, QUA, 2110, box 1.

66 Ibid.

67 Ibid.

68 Buchan, *Memory Hold-the-Door*, pp. 119–20.

69 JB to Anna Buchan, 4 January 1903, QUA, 2110, box 1.

70 Buchan, *The African Colony*, p. 390.

71 JB to Gilbert Murray, 30 January 1902, QUA, 2110, box 1.

72 Buchan, *The African Colony*, Introductory, p. 2.

73 JB to Helen Buchan, 22 February 1903, QUA, 2110, box 1.

74 JB to Anna Buchan, 15 February 1903, QUA, 2110, box 1.

75 JB to Helen Buchan, 11 January 1903, QUA, 2110, box 1.

76 JB to Helen Buchan, 9 May 1903, QUA, 2110, box 1.

77 JB to Anna Buchan, 29 May 1903, QUA, 2110, box 1.

78 JB to Helen Buchan, 29 July 1903, QUA, 2110, box 1.

79 Buchan, *Memory Hold-the-Door*, pp. 124–5.

80 Ibid., p.112.

4 LONDON, COURTSHIP AND MARRIAGE, 1903–1907

1 JB to Anna Buchan, 26 June 1903, QUA, 2110, box 1.

2 JB to Helen Buchan, QUA, 2110, box 1.

3 John Buchan, *Memory Hold-the-Door*, Hodder and Stoughton, London, 1940, pp. 127–8.

4 Willie Buchan to JB, March 1906, private collection.

5 JB to Helen Buchan, 28 November 1903, QUA, 2110, box 1.

6 JB to Helen Buchan, 11 November 1903, QUA, 2110, box 1.

7 JB to Sandy Gillon, 8 December 1903, NLS, Acc. 11164/18.

8 *The Scottish Mountaineering Club Journal*, vol. 22, 1942.

9 John Buchan, *The Law Relating to the Taxation of Foreign Income*, Stevens and Sons, London, October 1905.

10 Isobel and Michael Haslett, 'Buchan and the Classics, part 3: The Law Relating to the Taxation of Foreign Income (1905)', *The John Buchan Journal*, no. 26, p. 9.

11 JB to Anna Buchan, 14 April 1905, QUA, 2110, box 1.

12 JB to Helen Buchan, 23 June 1905, QUA, 2110, box 1.

13 Anna Buchan, *Unforgettable, Unforgotten*, Hodder and Stoughton, London, 1945, p. 102.

14 JB to Anna Buchan, 18 July 1905, QUA, 2110, box 1.

15 Susan Tweedsmuir, ed., *John Buchan by his Wife and Friends*, Hodder and Stoughton, London, 1947, p. 34.

16 According to Willard Connely, 'Willard Connely and the Buchans', *The John Buchan Journal*, no. 37, autumn 2007, p. 15.

17 Susan Tweedsmuir, *The Lilac and the Rose*, Duckworth, London, 1952, p. 16.

18 Tweedsmuir, *The Lilac and the Rose*, p. 92.

19 JB to Helen Buchan, 21 July 1905, QUA, 2110, box 1.

20 JB to Anna, 9 August 1905, NLS, Acc. 11164/18.

21 Undated letter from Susan Grosvenor to Hilda Lyttelton, Queen Mary University of London Archives (QMUL), Lyttelton Collection, PP5/26/1.

22 Willie Buchan to JB, 6 September 1905, QUA, 2110, box 2.

23 Tweedsmuir, ed., *John Buchan by his Wife and Friends*, pp. 35–6.

24 JB to Helen Buchan, 15 September 1905, QUA, 2110, box 1.

25 JB to Susie Grosvenor, 21 October 1905, NLS, Acc. 11627/1.

26 JB to Susie Grosvenor, 25 October 1906, NLS, Acc. 11627/5.

27 JB to Charles Dick, 17 November 1905, QUA, 2110, box 13.

28 JB to Charles Dick, 21 February 1906, QUA, 2110, box 2.

29 JB to Susie Grosvenor, 10 April 1906, NLS, Acc. 11627/1.

30 Susie Grosvenor to JB, 14 April 1906, NLS, Acc. 1627/5.

31 JB to Susie Grosvenor, 14 April 1906, NLS, Acc. 11627/5.

32 JB to Susie Grosvenor, 18 April 1906, NLS, Acc. 11627/1.

33 Katharine Lyttelton to 'Poo', 13 April 1906, QMUL KL/Fam/3426.

34 JB to Susie Grosvenor, 6 June 1906, NLS, Acc. 11627/1.

35 JB to Susie Grosvenor, 4 September 1906, NLS, Acc. 11627/1.

36 Susie Grosvenor to JB, 6 September 1906, NLS, Acc. 11627/5.

37 JB to Susie Grosvenor, 12 September 1906, NLS, Acc. 11627/1.

38 JB to Susie Grosvenor, 25 September 1906, NLS, Acc. 11627/1.

39 John Buchan, *A Lodge in the Wilderness*, William Blackwood, Edinburgh, 1906, p. 127.

40 JB to Helen Buchan, 14 November 1906, private collection.
41 JB to Anna Buchan, 5 November 1906, QUA, 2110, box 2.
42 JB to Helen Buchan, 12 November 1906, private collection.
43 JB to Susie Grosvenor, 14 November 1906, NLS, Acc. 11164/19.
44 Anna Buchan to Susie Grosvenor, 21 November 1906, NLS, Acc. 111627/69.
45 Helen Buchan to Susie Grosvenor, 17 November 1906, NLS, Acc. 11627/69.
46 Willie Buchan to Helen Buchan, 13 December 1906, private collection.
47 Willie Buchan to Helen Buchan, 25 December 1906, private collection.
48 Buchan, *A Lodge in the Wilderness*, p. 44.
49 Ibid., pp. 340–1.
50 *Dictionary of National Biography* entry for John Buchan by Professor H. C. G. Matthew, Oxford University Press, Oxford, 2004–9.
51 Quoted in Janet Adam Smith, *John Buchan: A Biography*, Rupert Hart-Davis, London, 1965, p. 162.
52 Ibid., p. 163.
53 Virginia Woolf to Violet Trefusis, 20 December 1906, Nigel Nicolson, ed., *The Flight of the Mind: The Letters of Virginia Woolf*, vol. I, *1882–1912*, The Hogarth Press, London, 1975.
54 John Buchan, *Midwinter*, Chapter XI, Hodder and Stoughton, London, 1923.
55 Buchan, *Unforgettable, Unforgotten*, p. 104.
56 Willie Buchan to Helen Buchan, 27 February 1907, private collection.
57 Willie Buchan to Anna Buchan, 20 February 1907, private collection.
58 St Loe Strachey to JB, 5 February 1907, QUA, 2110, box 2.
59 See Allan Ramsay, 'New Blood', in *The John Buchan Journal*, no. 4, autumn 1984, pp. 10–14.
60 JB to George Brown, 20 February 1920, University of Edinburgh Special Collections, Thomas Nelson Collection, Gen 1728/B/9/23.
61 Ramsay, 'New Blood'.
62 JB to Susie Grosvenor, 5 February 1907, NLS, Acc. 11627/2.
63 W. Forbes Gray, ed., *Comments and Characters*, Thomas Nelson, London and Edinburgh, 1940, pp. xiv–xv.
64 Ibid., p. xxiv.
65 Ibid., p. xxxii.
66 JB to Susie Grosvenor, n.d. 1907, NLS, Acc. 11627/2.
67 Willie Buchan to Helen Buchan, 9 April 1907, private collection.
68 O. Douglas, *Ann and her Mother*, Hodder and Stoughton, London, 1922, p. 240.
69 Buchan, *Unforgettable, Unforgotten*, p. 103.
70 Susie Grosvenor to Caroline Grosvenor, 11 May 1907, NLS, Acc. 11627/8.
71 Susie Grosvenor to Caroline Grosvenor, 15 May 1907, NLS, Acc. 11627/8.

72 Tweedsmuir, ed. *John Buchan by his Wife and Friends*, pp. 36–7.

73 Susie Grosvenor to Caroline Grosvenor, 16 May 1907, NLS, Acc. 11627/8.

74 Anna Buchan, *Farewell to Priorsford*, Hodder and Stoughton, London, 1950, p. 45.

75 Susie Grosvenor to Caroline Grosvenor, 14 May 1907, NLS, Acc. 11627/8.

76 Janet Adam Smith interview with Lilian Killick (Mrs Hawley), 9 October 1958, NLS, Acc. 11164/4.

77 Tweedsmuir, ed., *John Buchan by his Wife and Friends*, p. 280.

78 JB to Susie Grosvenor, 20 June 1907, NLS, Acc. 11627/2.

79 JB to Susie Grosvenor, 2 July 1907, NLS, Acc. 11627/2.

80 Undated letter from JB to Susie Grosvenor, annotated 'Just before our marriage' by Susan Tweedsmuir, NLS, Acc. 11627/2.

81 Tweedsmuir, *The Lilac and the Rose*, p. 144.

82 Buchan, *Unforgettable, Unforgotten*, p. 105.

83 JB to Caroline Grosvenor, 28 July 1907, NLS, Acc. 11627/8.

84 The eleventh edition was published in 1907.

85 Susie Buchan to Caroline Grosvenor, 13 August 1907, NLS, Acc. 11627/8.

86 Ibid.

87 John Buchan to Caroline Grosvenor, 11 August 1907, NLS, Acc. 11627/8.

88 JB to Janet Adam Smith, 5 May 1937, QUA, 2110, box 13.

89 Susie Buchan to Caroline Grosvenor, 18 August 1907, NLS, Acc. 11627/8.

90 Buchan, *Memory Hold-the-Door*, p. 137.

5 LONDON AND EDINBURGH, 1907–1914

1 Willie Buchan to Helen Buchan, 17 July 1907, private collection.

2 Willie Buchan to JB, 29 March 1908, QUA, 2110, box 2.

3 JB to Lucy Lyttelton, 24 February 1908, QUA, 2110, box 2.

4 John Buchan, *Memory Hold-the-Door*, Hodder and Stoughton, London, 1940, pp. 151–2.

5 Willie Buchan to JB, n.d. September 1909, QUA, 2110, box 2.

6 JB to Gilbert Murray, 22 April 1910, QUA, 2110, box 2. This was an early sign of what was to come, the 'ethnic cleansing' of Armenians by Turks during the First World War.

7 JB to Charles Dick, 30 April 1910, QUA, 2110, box 2.

8 Ibid.

9 Published in *Blackwood's Magazine*, April 1914.

10 JB to Susie, 15 October 1910, NLS, Acc. 11627/4.

11 JB to Susie, 25 February 1911, NLS, Acc. 11627/4.

12 Buchan, *Memory Hold-the-Door*, pp. 135–6.

13 Caroline Grosvenor to Katharine Lyttelton, 23 August 1911, QMUL, Lyttelton Collection, PP5/24/14.

14 Buchan, *Memory Hold-the-Door*, p. 146.

15 John Buchan, *The Thirty-Nine Steps*, William Blackwood, Edinburgh, 1915, chapter IV.

16 William Blackwood to Willie Buchan, 26 March 1912, quoted in Anna Buchan, *W. H. B.*, privately published, 1913, p. 63.

17 Willie Buchan to JB, 17 April 1911, QUA, 2110, box 2.

18 Willie Buchan to JB, 22 November 1911, QUA, 2110, box 2.

19 JB to Susie, 21 November 1911, QUA, 2110, box 2.

20 JB to Katharine Lyttelton, 28 November 1911, QMUL, Lyttelton Collection, PP5/24/20.

21 Sir Arthur Quiller-Couch to JB, 11 January 1912, QUA, 2110, box 2.

22 Sir Arthur Conan Doyle to JB, n.d., QUA, 2110, box 2.

23 *The Bookman*, December 1912, p. 140.

24 Stuyvesant Fish to JB, 30 November 1910, QUA, 2110, box 2.

25 John Buchan, *Women's Suffrage: A Logical Outcome of the Conservative Faith*, Conservative and Unionist Women's Franchise Association, October 1913, p. 1.

26 Ibid., p. 3.

27 Susan Tweedsmuir, *A Winter Bouquet*, Duckworth, London, 1954, p. 90.

28 Anna Buchan, *Unforgettable, Unforgotten*, Hodder and Stoughton, London, 1945, p. 176.

29 JB to Helen Buchan, 21 October 1912, NLS, Acc. 11627/4.

30 JB to Susan Buchan, 12 November 1912, QUA, 2110, box 2.

31 Lord Carmichael to JB, 5 December 1912, NLS, Acc. 11627/37.

32 John Buchan, 'Fratri Dilectissimo' (poem), the dedication to *The Marquis of Montrose*, Thomas Nelson, Edinburgh, 1913.

33 JB to Hugh Walpole, 30 March 1913, QUA, 2110, box 2.

34 Quoted in Janet Adam Smith, *John Buchan: A Biography*, Rupert Hart-Davis, London, 1965, p. 233.

35 John Buchan, 'The Muse of History' in *Homilies and Recreations*, Thomas Nelson, Edinburgh, 1926, p. 95.

36 Ibid., p. 101.

37 Quoted in Anna Buchan, *A. E. B.*, privately published, 1917, p. 14.

38 JB to Helen Buchan, 30 December 1913, NLS, Acc. 11627/4.

39 John Buchan, *Francis and Riversdale Grenfell, A Memoir*, Thomas Nelson, Edinburgh, 1920. Arthur Grenfell, although over forty when war broke out, joined the 9th Lancers, in which his twin brothers also served, was badly wounded, and won the DSO.

40 Ibid., pp. 182–3.
41 Ibid., p. 183.
42 Ibid., pp. 184–5.
43 The history has been meticulously analysed by John Gilpin in his PhD thesis, 'The Canadian Agency and British Investment in Western Canadian Land, 1905–1915', University of Leicester, 1992, in which there is extensive reference to contemporary records, including correspondence and the Official Receiver's Report on the Canadian Agency, issued on 13 February 1915.
44 Gilpin, 'The Canadian Agency', pp. 137–9 and 164–7.
45 Arthur Grenfell to the Earl Grey, 26 August 1906, quoted in Gilpin, 'The Canadian Agency', p. 159.
46 Guy St Aubyn to the Earl Grey, 11 July 1908, quoted in Gilpin, 'The Canadian Agency', p. 166.
47 Interview between the Earl Grey and Herbert Smith, June 1914, quoted in Gilpin, 'The Canadian Agency', p. 316.
48 Herbert Smith to Lady Wantage, 4 June 1914, quoted in Gilpin, 'The Canadian Agency', p. 318.
49 JB to Susie, 26 June 1914, NLS, Acc. 11627/4.
50 Susan Tweedsmuir, ed., *John Buchan by his Wife and Friends*, Hodder and Stoughton, London, 1947, p. 73.
51 Author's conversation with Sir Edmund Fairfax-Lucy, Alice's son, January 2018.
52 JB to George Brown, 4 August 1914, University of Edinburgh Special Collections, Thomas Nelson Collection, Gen 1728/B/5/68.
53 JB to George Brown, 6 August 1914, UESC, Thomas Nelson Collection, Gen 1728/B/5/69.
54 JB to Lord Rosebery, 9 October 1914, NLS, Acc. 11164/21.
55 In the Thomas Nelson Collection, UESC.
56 JB to George Brown, 3 December 1914, UESC, Thomas Nelson Collection, Gen 1728/B/5/160.
57 John Buchan, *Greenmantle*, Hodder and Stoughton, 1916, chapter II.

6 THE GREAT WAR, 1914–1918

1 *The Spectator*, 27 February 1915, p. 16.
2 Hew Strachan in the Introduction to John Buchan, *Mr Standfast*, Polygon, Edinburgh, 2010.
3 John Buchan, *A History of the Great War*, vol. III, Thomas Nelson, Edinburgh, 1922, p. 436.

4 David Lloyd George, *War Memoirs*, vol. III, Ivor Nicholson and Watson, London, 1933, p. 1,492.

5 B. H. Liddell Hart, *The Liddell Hart Memoirs*, vol. I, Cassell, London, 1965, p. 886.

6 Peter Buitenhuis, *The Great War of Words*, University of British Columbia Press, Vancouver, 1987, pp. 94 and 132.

7 For example, Niall Ferguson, *The Pity of War*, Allen Lane, Penguin Press, London, 1998, p. xxix.

8 See, for example, Alan Clark's *The Donkeys* (1961), Benjamin Britten's *War Requiem* (1962), a new edition of *The Collected Poems of Wilfred Owen* (1963), the play and film *Oh! What a Lovely War* (respectively, 1963 and 1969), and the television series *The Monocled Mutineer* (1986) and *Blackadder Goes Forth* (1989).

9 Ivor Gurney, *Severn & Somme*, Sidgwick & Jackson, London, 1917.

10 Dan Todman, *The Great War: Myth and Memory*, Continuum, Hambledon, 2005, p. 162.

11 For example, Todman, *The Great War*.

12 William Philpott, *Bloody Victory: The Sacrifice on the Somme*, Abacus, London, 2010, p. 292.

13 Keith Grieves, 'A History of the Great War: the re-emergence of Buchan's grand narrative on the Great War in 1921–2', *The John Buchan Journal*, no. 13, p. 8.

14 John Buchan, *Nelson's History of the War*, vol. XIV, Thomas Nelson, Edinburgh, 1915–19, p. 160.

15 Ibid., vol. XVI, p. 40.

16 Ibid., p. 36.

17 Ibid., vol. XXIV, pp. 123–4.

18 Lecture, 22 March 1915, QUA, 2110, box 14.

19 *The Times*, 17 May 1915, p. 9.

20 *The Times*, 22 May 1915, p. 9.

21 *The Times*, 29 May 1915, p. 6.

22 JB to Gilbert Murray, 19 July 1915, QUA, 2110, box 2.

23 JB to Susie, 28 September 1915, NLS, Acc. 11627/4.

24 Buchan, *Nelson's History of the War*, vol. X, p. 200.

25 The first two volumes came out in 1921 and the second two in 1922.

26 Buchan, *A History of the Great War*, vol. II, Thomas Nelson, Edinburgh, 1921–2, p. 321.

27 Quoted in the *Daily Telegraph*, 10 October 2015.

28 Sandy Gillon to JB, 6 and 9 December 1915, QUA, 2110, box 2.

29 JB to Gilbert Murray, 30 December 1915, QUA, 2110, box 2.

30 *The Spectator*, 6 November 1915, p. 630.

31 Janet Adam Smith, *John Buchan: A Biography*, Rupert Hart-Davis, London, 1965, p. 197.

32 John Buchan, *The Thirty-Nine Steps*, William Blackwood, Edinburgh, 1915, chapter V.

33 LeRoy L. Panek, *The Special Branch: The British Spy Novel, 1890–1980*, Bowling Green University Popular Press, Bowling Green, OH, 1981, p. 66.

34 Ibid., p. 39.

35 John G. Cawelti and Bruce A. Rosenberg, *The Spy Story*, University of Chicago Press, Chicago, IL, 1987, p. 100.

36 Leslie Stephen, in *Hours in a Library*, Smith, Elder, London, 1874, quoted in John Buchan, *Sir Walter Scott*, Cassell, London, 1932.

37 Byron Rogers, *The Man who Went into the West: The Life of R. S. Thomas*, Aurum, London, 2007, p. 194.

38 '39 steps to a better life', *Country Life*, 11 May 2011.

39 The Scottish novelist Robert J. Harris has recently written a sequel to *The Thirty-Nine Steps*, entitled *The Thirty-One Kings*, Polygon, Edinburgh, 2017.

40 'Fountainblue' in *Blackwood's Magazine*, part II, 1901.

41 Howard Spring, *In the Meantime: Reminiscences*, Constable, London, 1942, p. 111.

42 JB to Susie, 23 May 1915, QUA, 2110, box 2. Repington also caused an uproar by disclosing in *The Times* that General French had told him that shortage of munitions had caused the failure of the Battle of Neuve Chapelle. This at least partly led to the founding of the Ministry of Munitions, under David Lloyd George.

43 Quoted by Hew Strachan in 'John Buchan and the First World War', in Kate Macdonald, ed., *Reassessing John Buchan: Beyond the Thirty-Nine Steps*, Routledge, London, 2009, p. 79.

44 Brigadier-General John Charteris, *At G. H. Q.*, Cassell, London, 1931, pp. 146–7.

45 Ibid., p. 149.

46 General Charteris to Lord Newton, 15 July 1916, The National Archives (TNA), FO 395/51.

47 JB to George Brown, 22 July 1916, University of Edinburgh Special Collections, Thomas Nelson Collection, Gen 1728/B/6/152.

48 Alfred Noyes, *Two Worlds for Memory*, Sheed and Ward, London, 1953, p. 118.

49 JB to Susie, 5 October 1916, QUA, 2110, box 2.

50 *The Battle of the Somme, First Phase* and *The Battle of the Somme, Second Phase*, published by Thomas Nelson in 1916 and 1917 respectively.

51 JB to George Brown, 5 October 1916, University of Edinburgh Special Collections, Thomas Nelson Collection, Gen 1728/B/6/222.

52 JB to Captain Basil Liddell Hart, 2 December 1916, QUA, 2110, box 13.

53 Dedication in John Buchan, *Greenmantle*, Hodder and Stoughton, London, 1916.

54 Lord Tweedsmuir, *Always a Countryman*, Robert Hale, London, 1953, p. 292.

55 Buchan, *Greenmantle*, chapter II.

56 Ibid.

57 Quoted by James Buchan in *The John Buchan Journal*, no. 12, autumn 1992, p. 3.

58 Buchan, *Nelson's History of the War*, vol. XIII, pp. 82–98.

59 JB to Charles Dick, 30 April 1910, QUA, 2110, box 13.

60 Arthur Balfour to JB, 30 October 1916, QUA, 2110, box 2.

61 According to General Sir Douglas Haig in a letter to *The Times*, 28 November 1916.

62 David S. Katz, *The Shaping of Turkey in the British Imagination, 1776–1923*, Palgrave Macmillan, London, 2016, pp. 220–1.

63 Ibid., p. 210.

64 Ibid., p. 204.

65 JB to Helen Buchan, 27 October 1917, QUA, 2110, box 3.

66 JB to Susie, 14 October 1916, QUA, 2110, box 2.

67 JB to Susie, 17 October 1916, QUA, 2110, box 2.

68 John Buchan, *These for Remembrance*, privately published, 1919, p. 36.

69 John Buchan, *Memory Hold-the-Door*, pp. 164–5.

70 JB to Susie, 19 October 1916, QUA, 2110, box 2.

71 JB to Susie, 20 October 1916, QUA, 2110, box 2.

72 Anna Buchan, *A. E. B.*, privately published, 1917, p. 24.

73 Cabinet minute, 31 August 1914, TNA, CAB 41/35/38.

74 Gary S. Messinger, *British Propaganda and the State in the First World War*, Manchester University Press, Manchester, 1992, p. 38.

75 Cabinet minute, 24 January 1917, TNA, CAB 21/37 24.

76 'Propaganda Arrangements', Robert Donald's report to David Lloyd George, 9 January 1917, TNA, INF 4/9.

77 Lord Milner to David Lloyd George, 17 January 1917, Parliamentary Archives, LG/F/38/2/2.

78 'Propaganda – A Department of Information', memorandum by John Buchan, 3 February 1917, TNA, CAB 24/3/33.

79 Michael Redley, 'What did John Buchan do in the Great War?', *The John Buchan Journal*, no. 47, p. 20.

80 Susan Tweedsmuir, ed., *John Buchan by his Wife and Friends*, Hodder and Stoughton, London, 1947, p. 81.

81 Reginald Farrer, *The Void of War: Letters from Three Fronts*, Houghton Mifflin, Boston, 1918.

82 Tweedsmuir, ed., *John Buchan by his Wife and Friends*, p. 83.

83 Paul Nash, *Outline: An Autobiography and Other Writings*, Faber and Faber, London, 1949, p. 207.

84 Buchan, *A. E. B.*, p. 22.

85 Ibid., pp. 31–2.

86 Anna Buchan, *Unforgettable, Unforgotten*, Hodder and Stoughton, London, 1945, p. 150.

87 Buchan, *A. E. B.*, pp. 37–8.

88 JB to Anna Buchan, 18 April 1917, NLS, Acc. 11627/37.

89 JB to Helen Buchan, 19 July 1917, QUA, 2110, box 3.

90 JB to Anna Buchan, 20 July 1917, NLS, Acc. 6975/14.

91 JB to Helen Buchan, 23 July 1917, NLS, Acc. 6975/14.

92 Lord Burnham to Robert Donald, 31 July 1917, TNA, INF 4/7.

93 Buchan, *A History of the Great War*, vol. II, p. 65.

94 John Buchan, *Poems Scots and English*, T. C. and E. C. Jack, Edinburgh, 1917, p. 7.

95 *The Times*, 7 August 1917, p. 7.

96 JB to Helen Buchan, 7 August 1917, QUA, 2110, box 3.

97 JB to Susie, 10 September 1917, QUA, 2110, box 3.

98 Collection of reports and memoranda by John Buchan and others, Department and Ministry of Information, March 1917–December 1919, QUA, W. D. Jordan Library, John Buchan Collection, no. 130.

99 Pembroke Wicks to Sir Edward Carson, 20 October 1917, TNA, CAB 21/37 20.

100 Hubert Montgomery to JB, 24 October 1917, TNA, CAB 21/37.

101 Entry for 20 August 1917, Leo Amery, *The Leo Amery Diaries, vol. I, 1896–1929*, Hutchinson, London, 1980.

102 Tweedsmuir, ed., *John Buchan by his Wife and Friends*, pp. 82–4.

103 JB to Helen Buchan, 17 May 1918, QUA, 2110, box 3.

104 Quoted in Cate Haste, *Keep the Home Fires Burning*, Allen Lane, London, 1977, p. 47.

105 Tweedsmuir, ed., *John Buchan by his Wife and Friends*, p.82 footnote.

106 Buchan, *Memory Hold-the-Door*, p. 38.

107 Tweedsmuir, ed., *John Buchan by his Wife and Friends*, p. 134.

108 William Buchan, *John Buchan: A Memoir*, Buchan and Enright, London, 1982, p. 160.

109 Pilgrim Trust Ninth Annual Report, 1939, Cambridge University Press, Cambridge, 1939.

110 JB to Helen Buchan, 5 August 1918, NLS, Acc. 11627/4.

111 JB to Helen Buchan, 10 August 1918, QUA, 2110, box 3.

112 Lord Beaverbrook's memorandum to the House of Commons, September 1918, p. 3, QUA, W. D. Jordan Library, John Buchan Collection, no. 130.

113 JB to Helen Buchan, 11 September 1918, NLS, Acc. 11627/4 11.

114 John Buchan, *The King's Grace 1910–1935*, Hodder and Stoughton, London, 1935, pp. 234–5.

115 Buchan, *The King's Grace 1910–1935*, pp. 247–9.

116 John Buchan, *The Three Hostages*, Hodder and Stoughton, London, 1924, chapter IV.

117 Adolf Hitler, *My Battle*, Houghton Mifflin, Boston, MA, 1933, pp. 76–7. See also Haste, *Keep the Home Fires Burning*, p. 200.

118 James Duane Squires, *British Propaganda at Home and in the United States from 1914 to 1918*, Harvard University Press, Cambridge, MA, 1935, p. 283.

119 Buchan, *Memory Hold-the-Door*, p. 166.

7 ELSFIELD, 1919–1927

1 Memorandum, 1 January 1919, Parliamentary Archives, LG/F/95/1/1.

2 John Buchan, *Memory Hold-the-Door*, Hodder and Stoughton, London, 1940, p. 181.

3 Ibid., pp. 182–3.

4 Ibid., p. 184.

5 Susan Tweedsmuir, ed., *John Buchan by his Wife and Friends*, Hodder and Stoughton, London, 1947, pp. 289–90.

6 Toby Buchan, 'John Buchan and the Great War', in *The John Buchan Journal*, no. 7, winter 1987, p. 6.

7 John Buchan, *These for Remembrance*, privately published, 1919, Preface.

8 JB to Helen Buchan, 19 June 1919, NLS, Acc. 6975/14.

9 Cadmus and Harmonia (John and Susan Buchan), *The Island of Sheep*, Hodder and Stoughton, London, 1919, p. 68.

10 J. P. Parry, 'From the Thirty-Nine Articles to the Thirty-Nine Steps: reflections on the thought of John Buchan', in *Public and Private Doctrine: Essays in British History presented to Maurice Cowling*, Cambridge University Press, Cambridge, 1993, p. 217.

11 Arthur Balfour to Lord Beaverbrook, 13 December 1918, NLS, Acc. 7006.

12 JB to Lord Beaverbrook, 22 February 1922, NLS, Acc. 7006.

13 JB to Lord Beaverbrook, 11 May 1922, NLS, Acc. 7006.

14 Lord Beaverbrook to Winston Churchill, 2 June 1922, Parliamentary Archives, BBK/G/15/2.

15 University of Glasgow to JB, 1 May 1919, QUA, 2110, box 3.

16 John Buchan, *Mr Standfast*, Hodder and Stoughton, London, 1919, chapter 1.

17 JB to Helen Buchan, 9 May 1919, QUA, 2110, box 3.

18 JB to Helen Buchan, 16 June 1919, QUA, 2110, box 3.

19 JB to Helen Buchan, 5 June 1919, QUA, 2110, box 3.

20 Buchan, *Memory Hold-the-Door*, p. 187.

21 Ibid., p. 188–9.

22 Ibid., p. 188.

23 Robert Stanley, 'Mr. John Buchan at Home', in *Homes and Gardens*, November 1932, pp. 251–4.

24 William Buchan, *The Rags of Time*, Ashford, Buchan and Enright, Southampton, 1990, p. 21.

25 JB to Helen Buchan, 15 December 1919, NLS, Acc. 6975/14.

26 Susan Tweedsmuir, *A Winter Bouquet*, Gerald Duckworth, London, 1954, p. 48. There is no longer a Women's Institute in Elsfield.

27 Quoted in Ursula Buchan, 'An Instinct to Please: The writings of Susan Buchan', *The John Buchan Journal*, no. 14, spring 1995, p. 6.

28 Hilda Grenfell to JB, 8 August 1926, QUA, 2110, box 4.

29 From George Herbert's poem 'Prayer 1.'

30 According to Susie in BBC's *Times Remembered*, broadcast 11 November 1972.

31 G. M. Trevelyan to JB, 30 June 1926, QUA, 2110, box 4.

32 He died in October 1940. As much as is known about Tom Buchan is to be found in 'Thomas Henderson Buchan: the last bushranger?' by Rev. Edwin R. Lee, in *The John Buchan Journal*, no. 21, autumn 1999, pp. 2–13.

33 Letter from Nigel Napier, published in *The John Buchan Journal*, no. 11, spring 1992, p. 23.

34 Quoted in John Buchan, *Sir Walter Scott*, Cassell, London, 1932, p. 90.

35 George Graham to George Brown, 4 August 1920, University of Edinburgh Special Collections, Thomas Nelson Collection, Coll-25, box 125.

36 Buchan, *Sir Walter Scott*, p. 239.

37 Quoted in Margaret Newbolt, ed., *Later Life and Letters of Sir Henry Newbolt*, Faber and Faber, London, 1942, p. 285.

38 Ibid., p. 340.

39 John Buchan, *A Book of Escapes and Hurried Journeys*, Thomas Nelson, Edinburgh, 1925, p. v.

40 JB to Ian Nelson, 6 January 1923, UESC, Thomas Nelson Collection, Gen. 1728/B/11/2.

41 Ian Nelson to JB, 8 January 1923, UESC, Nelson Collection, Gen. 1728/B/11/4x.

42 JB to Ian Nelson, 9 January, 1923, UESC, Nelson Collection, Gen. 1728/B/11/5x.

43 JB to Ian Nelson, 24 January 1923, UESC, Nelson Collection, Gen. 1728/B/11/15x.

44 Ian Nelson to JB, 30 January 1923, UESC, Nelson Collection, Gen. 1728/B/11/17x.

45 JB to Ian Nelson, 1 February 1923, UESC, Nelson Collection, Gen. 1728/B/11/18x.

46 Ian Nelson to JB, 4 July 1923, UESC, Nelson Collection, Gen. 1728/B/11/141c.

47 JB to Ian Nelson, 16 July 1923, UESC Nelson Collection, Gen. 1728/B/11/145x.

48 JB to the Earl of Rosebery, 2 November 1920, QUA, 2110, box 13.

49 JB to the Earl of Rosebery, 13 January 1922, QUA, 2110, box 13.

50 G. M. Trevelyan to JB, 27 February 1921, QUA, 2110, box 3.

51 'I had poor luck at Glen Etive – got up to a stag after a long stalk and found the cartridges didn't fit the rifle!' JB to George Brown, 24 August 1920, UESC, Thomas Nelson Collection, Gen. 1728/ B/9/105.

52 John Buchan, 'Montrose and Leadership' in *Men and Deeds*, Peter Davies, London, 1935, p. 278.

53 John Buchan, *Huntingtower*, Hodder and Stoughton, London, 1922, chapter XVI.

54 John Buchan, ed., *The Northern Muse*, Thomas Nelson, Edinburgh, 1924, p. xix.

55 Ibid., pp. xxix–xxx.

56 Ibid., p. 452.

57 Ian Brown and Alan Riach, eds, in *The Edinburgh Companion to Twentieth-Century Scottish Literature*, Edinburgh University Press, Edinburgh, 2009, p. 57.

58 Quoted in Hugh Macmillan, *A Man of Law's Tale*, Macmillan, London, 1952, p. 242.

59 Thomas Hardy to JB, 21 November 1921, John Buchan Museum collection.

60 JB to Thomas Hardy, 2 June 1922, John Buchan Museum collection.

61 Buchan, *Memory Hold-the-Door*, p. 197.

62 John Buchan, 'The most difficult form of fiction', *The Listener*, 16 January 1929.

63 Buchan, *Sir Walter Scott*, pp. 130–1.

64 Quoted in 'A Mis-Rated Author?', in M. R. Ridley, *Second Thoughts*, Dent, London, 1965, p. 15.

65 JB to Alice Fairfax-Lucy, 27 March 1939, private collection.

66 Arthur Balfour to JB, 16 May 1912, QUA, 2110, box 2.

67 J. R. B. Hart to Hodder and Stoughton, 1 December 1919, QUA, 2110, box 3.

68 John Buchan, *The Three Hostages*, Hodder and Stoughton, London, 1924, Dedication.

69 Ibid., chapter 1.

70 Catherine Carswell in Tweedsmuir, ed., *John Buchan by his Wife and Friends*, Hodder and Stoughton, London, 1947, p. 160.

71 Violet Markham, *Friendship's Harvest*, Reinhardt, London, 1956, pp. 125–6.

72 Sir Brian Fairfax-Lucy, undated, h/w memoir of JB, private collection.

73 Quoted in Adam Smith, *John Buchan*, p. 244.

74 Diaries of William Lyon Mackenzie King (MKD), 28 May 1919, Bibliothèque et Archives / Library and Archives Canada (BAC/LAC), MG26-J13, 6994.

75 MKD, 13 September 1924, BAC/LAC, MG26-J13, 8919.

76 C. Gray, *Mrs King: The Life and Times of Isabel Mackenzie King*, Viking, London, 1997, p. 287, quoted by Victoria Wilcox in 'John Buchan's Canadian Prime Minister', *The John Buchan Journal*, no. 49, 2016, p. 27.

77 MKD, 14 September 1924, BAC/LAC, MG26-J13, 8921.

78 Ferris Greenslet, *Under the Bridge*, Houghton Mifflin, Boston, MA, 1943, p. 158.

79 JB to Walter Buchan, 18 September 1924, NLS, Acc. 1162/79.

80 Greenslet, *Under the Bridge*, pp. 202–3.

81 Ibid., p. 203.

82 Greenslet, *Under the Bridge*, p. 202.

83 Milton Graduates Bulletin, 1922.

84 John Buchan, *Homilies and Recreations*, Thomas Nelson, Edinburgh, 1926, pp. 152–3.

85 Ibid., p. 158.

86 Greenslet, *Under the Bridge*, p. 205.

87 Quoted in Jeffery Williams, *Byng of Vimy: General and Governor General*, Leo Cooper, 1983, p. 277.

88 John Buchan, *The King's Grace*, Hodder and Stoughton, London, 1935, p. 289.

89 Reproduced in *The John Buchan Journal*, no. 34, spring 2006, p. 5.

90 John Buchan, *John Macnab*, Hodder and Stoughton, London, 1925, chapter VIII.

91 Lord Tweedsmuir, *Always a Countryman*, Robert Hale, London, 1953, pp. 104–5.

92 Buchan, *Memory Hold-The-Door*, pp. 196–7.

93 T. E. Lawrence to JB, 21 December 1928, NLS, Acc. 11627/51.

8 ELSFIELD AND LONDON, 1927–1935

1 Quoted in 'John Buchan and Parliament' by Lord Stewartby, *The John Buchan Journal*, no. 31, autumn 2004, p. 12.

2 Hansard House of Commons (HC) Debate, 6 July 1927, vol. 208, col. 1316.

3 Ibid., col. 1315.

4 JB to Helen Buchan, 7 July 1927, QUA, 2110, box 4.

5 Ibid.

6 JB to Henry Newbolt, 8 July 1927, Brown University Archive, John Buchan, Manuscripts & Correspondence.

7 James Johnston, *Westminster Voices*, Hodder and Stoughton, London, 1928, pp. 250–1.

8 *The Spectator*, 15 July 1927, p. 8.

9 Hansard HC Debate, 15 December 1927, vol. 211, cc 2615–19.

10 Hansard HC Debate, 24 November 1932, vol. 272, cc 259–67.

11 Hansard HC Debate, 27 May 1932, vol. 266, col. 741.

12 Hansard HC Debate, 22 February 1933, vol. 274, cc 1848–51.

13 John Buchan, 'Conservatism and Progress', *The Spectator*, 23 November 1929.

14 John Buchan, *The Morning Post*, 31 December 1929.

15 John Buchan, *The Runagates Club*, Hodder and Stoughton, London, 1928, Preface.

16 Preface addressed to the President of the United States, F. D. Roosevelt, by Alexander Woollcott in 'Proofs of Holy Writ' by Rudyard Kipling, Doubleday, Doran and Co., NY, 1942.

17 Alice Buchan, *A Scrap Screen*, Hamish Hamilton, London, 1979, p. 147.

18 JB to Alice Fairfax-Lucy, n.d. 1938, private collection. Although he was never to make a living as a writer, as his father did, William Buchan (1916–2008) published half a dozen novels, as well as an elegant memoir of his father, and a 'fragment of autobiography', *The Rags of Time*, in which he described the enchantment of his childhood and the discontent of his youth. See Bibliography.

19 William Buchan, *The Rags of Time*, Ashford, Buchan and Enright, Southampton, 1990, p. 127.

20 Janet Adam Smith, *John Buchan: A Biography*, Rupert Hart-Davis, London, 1965, p. 225.

21 John Buchan, *Memory Hold-the-Door*, Hodder and Stoughton, London, 1940, p. 221.

22 Susan Tweedsmuir, ed., *John Buchan by his Wife and Friends*, Hodder and Stoughton, London, 1947, p. 175.

23 Buchan, *Memory Hold-the-Door*, p. 213.

24 Ibid., pp. 214–15.

25 Ibid., pp. 212–13.

26 Ibid., p. 216.

27 T. E. Lawrence to JB, 19 May 1925, QUA, 2110, box 4.

28 T. E. Lawrence to JB, 5 July 1925, QUA, 2110, box 4.

29 T. E. Lawrence to JB, 21 December 1928, NLS, Acc. 11627/51.

30 T. E. Lawrence to JB, 22 August 1931, NLS, Acc. 11627/51.

31 John Buchan, *The Blanket of the Dark*, Hodder and Stoughton, London, 1931, chapter I.

32 Quoted in Andrew Lownie, *The Presbyterian Cavalier*, Constable, London, 1995, p. 226.

33 Stewartby, 'John Buchan and Parliament', *The John Buchan Journal*, no. 31, p. 15.

34 Pilgrim Trust, Ninth Annual Report, Cambridge University Press, Cambridge, 1939, p. 13.

35 The *Sunday News*, n.d., quoted by Juanita Kruse in *John Buchan and the Idea of Empire: Popular Literature and Political Ideology*, Edwin Mellen Press, Lewiston, NY, 1989, p. 139.

36 Conversation between Janet Adam Smith and Lord Davidson, 5 March 1963, NLS, Acc. 11164/4.

37 John Buchan, *The Graphic*, 26 February 1927 pp. 294–5.

38 Quoted in Thomas Jones, *A Diary with Letters 1931–1950*, Oxford University Press, Oxford, 1954, pp. 42–3.

39 Ibid.

40 JB to Stanley Baldwin, 4 October 1932, QUA, 2110, box 6.

41 JB to Leo Amery, 16 May 1936, Leopold Amery Papers, Churchill Archives Centre, AMEL 2/1/26.

42 Buchan, *Memory Hold-the-Door*, pp. 238–9.

43 JB to Lord Beaverbrook, 5 January 1932, NLS, Acc. 7006.

44 Hansard HC Debate, 24 November 1932, vol. 272, cc 261–6.

45 John Buchan, *The Three Hostages*, Hodder and Stoughton, London, 1924, chapter IV.

46 John Buchan, *Sir Walter Scott*, Cassell, London, 1932, p. 111.

47 Ibid., pp. 16–17.

48 Ibid., p. 170.

49 Ibid., p. 43.

50 Tweedsmuir, ed., *John Buchan by his Wife and Friends*, p. 16.

51 JB to Susie, 26 October 1932, NLS, Acc. 6975/15.

52 JB to Susie, 31 May 1932, NLS, Acc. 6975/15.

53 See Harry Defries, *Conservative Party Attitudes to Jews 1900–1950*, Routledge, London, 2001.
54 Allan Massie, 'In the Shadow of Empire', in *The John Buchan Journal*, no. 42, p. 22.
55 Owen Dudley Edwards, 'John Buchan: Novelist, Publisher and Politician', in A. Reid and B. D. Osbourne, eds, *Discovering Scottish Writers*, Scottish Library Association and Scottish Cultural Press, Edinburgh, 1997, p. 16.
56 JB to Susie, 16 March 1932, QUA, 2110, box 5.
57 *The Jewish Chronicle*, 4 May 1934, p. 28.
58 Christopher Harvie, *The Centre of Things: Political Fiction in Britain from Disraeli to the Present*, Unwin Hyman, London, 1991, p. 170, footnote.
59 Robert Louis Stevenson, *Edinburgh: Picturesque Notes*, Seeley, Jackson and Halliday, London, 1879, chapter 1.
60 *The Times*, 24 May 1933, p. 11.
61 Quoted by Adam Smith, *John Buchan*, p. 364.
62 Violet Markham, *Friendship's Harvest*, Reinhardt, London, 1956, p. 123.
63 JB to Sir Alexander Grant, 3 July 1933, private collection.
64 *The Times*, 23 May 1934, p. 7.
65 Buchan, *Memory Hold-the-Door*, p. 197.
66 John Buchan, *Oliver Cromwell*, Hodder and Stoughton, London, 1934, book I, chapter IV.
67 Ibid., book I, chapter I.
68 Ibid., book IV, chapter V.
69 Quoted in Adam Smith, *John Buchan*, p. 331.
70 Ibid., p. 367.
71 JB to Johnnie Buchan, 22 January 1935, NLS, Acc. 11627/10.
72 François Truffaut, *Hitchcock by Truffaut*, Simon and Schuster, London, 1967, p. 102.
73 JB to Johnnie Buchan, 12 February 1935, NLS, Acc. 11627/10.
74 John Buchan, *The King's Grace 1910–1935*, Hodder and Stoughton, London, 1935, pp. 227–8.
75 JB to Johnnie Buchan, 19 March 1935, NLS, Acc. 11627/10.
76 JB to Susie Buchan, 3 July 1934, QUA, 2110, box 6.
77 John Buchan, *The Spectator*, 6 July 1901.
78 Quoted in Adam Smith, *John Buchan*, p. 368.
79 Tweedsmuir, ed., *John Buchan by his Wife and Friends*, p. 146.
80 JB to Susie, 19 March 1935, NLS, Acc. 6975/15.
81 JB to Johnnie Buchan, 26 February 1935, NLS, Acc. 11627/10.
82 JB to Johnnie Buchan, 19 February 1935, NLS, Acc. 11627/10.

83 John Buchan, *Greenmantle*, Hodder and Stoughton, London, 1916, chapter I.

84 Helen Buchan to JB, 24 March 1935, NLS, Acc. 11164/20.

85 Quoted in Professor Keith Neilson, 'An excellent conning-tower: John Buchan on the fringes of diplomacy', in *On the Fringes of Diplomacy: Influences on British Foreign Policy, 1800–1945*, ed. John Fisher and Antony Best, Ashgate, Farnham, 2011, p. 249.

86 JB to Johnnie Buchan, 26 March 1935, NLS, Acc. 11627/10.

87 Adam Smith, *John Buchan*, p. 370.

88 JB to Susie, 28 March 1935, NLS, Acc. 6542/14.

89 Quoted in Adam Smith, *John Buchan*, p. 372.

90 T. E. Lawrence to JB, 1 April 1935, NLS, Acc. 11627/51.

91 JB to Johnnie Buchan, 6 May 1935, NLS, Acc. 11627/10.

92 'Beverley Baxter's London Letter', 15 March 1940, *Maclean's Magazine*, Toronto.

93 Alan Lascelles to JB, 27 May 1935, QUA, 2110, box 7.

94 Alan Lascelles to JB, 20 April 1935, QUA, 2110, box 7.

95 Alan Lascelles to JB, 9 May 1935, QUA, 2110, box 7.

96 JB to Johnnie Buchan, 5 March 1935, NLS, 11627/10.

97 Buchan, *The Rags of Time*, Ashford, Buchan and Enright, Southampton, 1990, pp. 174–6.

98 Helen Buchan to JB, 10 July 1935, NLS, Acc. 11164/20.

99 JB to Johnnie Buchan, 11 June 1935, NLS, Acc. 11627/10.

100 Nigel Nicolson, ed. *The Sickle Side of the Moon: Letters of Virginia Woolf 1932–1935*, Hogarth Press, London, 1979, pp. 410–11.

101 Helen Buchan to JB, 5 August 1935, NLS, Acc. 11164/20.

102 Helen Buchan to JB, 8 August 1935, NLS, Acc. 11164/20.

103 Helen Buchan to JB, 27 August 1935, NLS, Acc. 11164/20.

104 JB to Helen Buchan, 18 October 1935, NLS, Acc. 6975/15.

9 CANADA, 1935–1937

1 JB to Helen Buchan, 5 November 1935, NLS, Acc. 11627/9.

2 Yousuf Karsh, *Faces of Destiny*, Ziff-Davis, Chicago, IL, 1946, pp. 146–7.

3 Quoted in Duff Hart-Davis, ed., *In Royal Service: Letters and Diaries of Sir Alan Lascelles 1920–1936, Vol. II*, Hamish Hamilton, London, 1989, p. 128.

4 Quoted in *The John Buchan Journal*, no. 9, winter 1989, p. 3.

5 JB to Walter Buchan, 27 December 1935, NLS, Acc. 11627/79.

6 John Buchan, *Memory Hold-the-Door*, Hodder and Stoughton, London, 1940, pp. 240–1.

7 JB to Charles Dick, 3 February 1936, QUA, 2110, box 13.

8 Susie to Walter Buchan, 18 December, 1939, NLS, Acc. 11627/90.

9 JB to Walter Buchan, 9 March 1936, NLS, Acc. 11627/79.

10 Shuldham Redfern to Sir Clive Wigram, 13 March 1936, private collection.

11 William Deacon to Ellen Elliott, 8 May 1940, quoted by Professor Andrew David Irvine in *The John Buchan Journal*, no. 49, p. 29.

12 John Buchan, *Canadian Occasions*, Musson, Toronto, 1940, p. 241.

13 Joanne Larocque-Poirier, contribution to a round-table discussion, hosted by Queen's University Archives and held on 21 October 2004 at Queen's University, Kingston, Ontario.

14 Anna Desmarais, 'Lord Tweedsmuir and the Search for Identity', *Ottawa Citizen*, 20 March 2017.

15 JB to Sir Henry Newbolt, 31 March 1936, Brown University Archives, John Buchan, Manuscripts & Correspondence.

16 *The Scotsman*, 13 February 1940.

17 Beatrice Spencer-Smith to Penelope Butler, 28 June 1936, ZKZ/05/02/11/02/06, Archive of the Graham family of Norton Conyers, North Yorkshire County Record Office.

18 Beatrice Spencer-Smith to Penelope Butler, 18 July 1936, ZKZ/05/02/11/02/07, Graham Papers, North Yorkshire County Record Office.

19 JB to King Edward VIII, 5 August 1936, Royal Archives, PS/PSO/GVI/C/048/017.

20 *Rod and Gun*, December 1936.

21 Toronto *Globe*, 27 August 1936.

22 Quoted in Janet Adam Smith, *John Buchan: A Biography*, Rupert Hart-Davis, London, 1965, p. 396.

23 Diaries of William Lyon Mackenzie King (MKD), 4 September 1936, Bibliothèque et Archives / Library and Archives, Canada. MG26-J13, 17172.

24 JB to Helen Buchan, 4 September 1936, NLS, Acc. 11627/9.

25 Susan Tweedsmuir, ed., *John Buchan by his Wife and Friends*, Hodder and Stoughton, London, 1947, pp. 227–8.

26 JB to Helen Buchan, 13 September 1936, NLS, Acc. 11627/9.

27 Mrs Marion W. DeBoice, *The John Buchan Journal*, no. 6, autumn 1986, p. 32.

28 JB to Helen Buchan, 10 September 1936, NLS, Acc. 11627/9.

29 Ibid.

30 Quoted in Peter Henshaw, 'John Buchan and the British Imperial Origins of Canadian Multiculturalism', in *Canadas of the Mind: The Making and*

Unmaking of Canadian Nationalisms in the Twentieth Century, eds. N. Hillmer and A. Chapnick, McGill-Queen's University Press, Montreal and Kingston, 2007, p. 191.

31 Adam Smith, *John Buchan*, pp. 391–2.

32 John Buchan, *Canadian Occasions*, p. 29.

33 JB to Mackenzie King, 29 September 1936, QUA, 2110, box 8.

34 Captain John Boyle to Lady Trenchard, 5 October 1936, private collection.

35 JB to Mackenzie King, 29 September 1936, QUA, 2110, box 8.

36 The Earl of Crawford and Balcarres to JB, 3 November 1936, QUA, 2110, box 8.

37 Ramsay MacDonald to JB, 7 December 1936, QUA, 2110, box 8.

38 JB to Walter Buchan, 17 December 1936, NLS, Acc. 11627/79.

39 Susie to JB, 30 October 1936, NLS, Acc. 11627/6.

40 JB to Sir Alexander Hardinge, 27 October 1936, QUA, 2110, box 7.

41 JB to Stanley Baldwin, 9 November 1936, QUA, 2110, box 7.

42 Susie to JB, 16 November 1936, NLS, Acc. 11627/6.

43 Sir Alexander Hardinge to JB, 16 November 1936, QUA, 2110, box 7.

44 Susie to JB, 4 December 1936, NLS, Acc. 11627/6.

45 JB to Susie, 1 December 1936, NLS, Acc. 6975/15.

46 JB to Helen Buchan, 7 December 1936, NLS, Acc. 11627/9.

47 JB to Susie, 10 December 1936, QUA, 2110, box 8.

48 JB to Helen Buchan, 17 December 1936, NLS, Acc. 11627/9.

49 JB to Stanley Baldwin, 3 February 1937, Cambridge University Library MS Baldwin, 122/181–3.

50 Undated cartoon by Shuldham Redfern, QUA, 2110, box 28.

51 JB, 'Private notes on Washington visit', 8 April 1937, QUA, 2110, box 12.

52 Quoted in J. William Galbraith, *John Buchan: Model Governor-General*, Dundurn, Toronto, 2013, p. 172.

53 JB, 'Private notes on Washington Visit', 8 April 1937, QUA, 2110, box 12.

54 Quoted in Buchan, *Canadian Occasions*, pp. 61–2.

55 Harry S. Truman to Bess Truman, 1 April 1937, Harry S. Truman Library and Museum, Independence. MO, Family, Business and Personal Affairs Papers, Truman Papers.

56 JB to Walter Buchan, 5 April 1937, NLS, Acc. 11627/79.

57 JB, private memorandum, 'Note for the President', NLS, Acc. 11627/79.

58 JB to Stanley Baldwin, 8 April 1937, QUA, 2110, box 8.

59 Ibid.

60 See Professor Kevin Hutchings, 'John Buchan and the First Nations of Canada', in *The John Buchan Journal*, no. 50, 2017, pp. 55–61.

61 Buchan, *Memory Hold-the-Door*, p. 220.

62 Hutchings, *The John Buchan Journal*, no. 50, p. 59.

63 Margaret Bourke-White, *Portrait of Myself*, Collins, London, 1964, p. 156.
64 Shuldham Redfern's personal diary entry for 28 July 1937, private collection.
65 Susie to JB, 2 August 1937, NLS, Acc. 11627/6.
66 *The Sunday Times*, 12 December 1937, p. 18.
67 Archibald Fleming, *Archibald The Arctic*, Appleton Century Crofts, New York, 1956, p. 336.
68 Quoted in Beverley Baxter's 'London Letter' in *Maclean's Magazine*, 15 March 1940, Toronto.
69 JB to Helen Buchan, 28 August 1937, NLS, Acc. 11627/9.
70 JB to Alice Fairfax-Lucy, 10 June 1938, private collection.
71 JB to Alice Fairfax-Lucy, 2 February 1938, private collection.
72 JB to Alice Fairfax-Lucy, 19 April 1938, private collection.
73 Quoted in Buchan, *Canadian Occasions*, pp. 82–3.
74 Delivered in Chicago, 5 October 1937.
75 JB to Gilbert Murray, 8 October 1937, QUA, 2110, box 8.
76 See TNA, PREM 1/229.
77 MKD, diary entries for 9 and 20 October 1937, BAC/LAC, MG26-J13, 18397 and 18428.
78 John Buchan, *Augustus*, Hodder and Stoughton, London, 1937, pp. 346–7.
79 Quoted in Adam Smith, *John Buchan*, p. 432.
80 JB to Helen Buchan, 18 October 1937, NLS, Acc. 11627/9.
81 Buchan, *Augustus*, pp. 25–6.
82 Ibid., p. 191.
83 JB to Helen Buchan, 3 November 1937, NLS, Acc. 11627/9.
84 On 5 and 12 December 1937.
85 Sir Alexander Hardinge to JB, 20 December 1937, Royal Archives, PS/PSO/GVI/C/048/055.
86 JB to Helen Buchan, 19 July 1937, NLS, Acc. 11627/9.
87 Quoted in Andrew Lownie, *The Presbyterian Cavalier*, Constable, London, 1995, pp. 267–8.

10 CANADA, 1938–1940

1 JB to Alan Lascelles, 1 January 1938, QUA, 2110, box 9.
2 Quoted in Francis Williams, *A Prime Minister Remembers: The War and Post-War Memoirs of the Rt. Hon. Earl Attlee*, Heinemann, London, 1961, p. 17.
3 See Winston Churchill, *The Gathering Storm*, Cassell, London, 1948, p. 199.
4 George Spence, 'When the Governor-General came to Val Marie', 11 May 1938, QUA, 2110, box 25.

5 Quoted in Janet Adam Smith, *John Buchan: A Biography*, Rupert Hart-Davis, London, 1965, p. 449.

6 'Harvard Commencement Address', *The John Buchan Journal*, no. 19, autumn 1998, pp. 3–4.

7 Lord Tweedsmuir, *The John Buchan Journal*, no. 1, spring 1980, p. 3.

8 Quoted by Professor Keith Neilson, 'An Excellent Conning-Tower: John Buchan on the fringes of diplomacy', in *On the Fringes of Diplomacy: Influences on British Foreign Policy 1800–1945*, ed. John Fisher and Antony Best, Ashgate, Farnham, 2011, p. 262.

9 Anna Buchan, *Unforgettable, Unforgotten*, Hodder and Stoughton, London, 1945, pp. 213–14.

10 JB to Susie, 17 August 1938, NLS, Acc. 6975/15.

11 JB to Susie, 14 August 1938, NLS, Acc. 6975/15.

12 JB to Susie, 29 August 1938, NLS, Acc. 6975/15.

13 Ibid.

14 JB to Susie, 15 September 1938, NLS, Acc. 6975/15.

15 JB to Alice Fairfax-Lucy, 6 April 1939, private collection.

16 Susie to JB, 9 September 1938, NLS, Acc. 11627/6.

17 Susie to JB, 15 September 1938, NLS, Acc. 11627/6.

18 JB to Susie, 24/25 September 1938, NLS, Acc. 6975/15.

19 Ibid.

20 Franklin D. Roosevelt to JB, 3 November 1938, QUA, 2110, box 10.

21 Shuldham Redfern to Alan Lascelles, 13 March 1939, private collection.

22 Col. H. Willis-O'Connor and M. Macbeth, *Inside Government House*, Ryerson, Toronto, 1954, p. 82.

23 JB to Walter Buchan, 26 January 1939, NLS, Acc. 11627/83.

24 JB's personal diary for 1939, NLS, Acc. 6975/11.

25 JB to Walter Buchan, 26 January 1939, NLS, Acc. 11627/83.

26 JB to Violet Markham, 3 February 1939, QUA, 2110, box 10.

27 Alice Fairfax-Lucy, 'Canada and the Royal Visit', *The Sunday Times*, early May 1939 (date from internal evidence).

28 Diaries of William Lyon Mackenzie King (MKD), 17 May 1939, BAC/LAC, MG26-J13, 20278.

29 Susan Tweedsmuir, 'Memories of Royal Visit', dated 22 May 1939, unpublished, NLS, Acc. 11627/65.

30 Quoted in Buchan, *Unforgettable, Unforgotten*, p. 218.

31 Quoted in Adam Smith, *John Buchan*, p. 456.

32 Susan Tweedsmuir, 'Memories of the Royal Visit', NLS, Acc. 11627/65.

33 Ibid.

34 John Wheeler-Bennett, *King George VI: His Life and Reign*, Macmillan, London, 1958, p. 390.

35 JB to Charles Dick, 20 June 1939, QUA, 2110, box 13.

36 Quoted in Wheeler-Bennett, *King George VI*, p. 380.

37 Burgon Bickersteth to Susie, 24 July 1939, NLS, Acc. 6975/22.

38 Violet Markham to JB, 17 January 1939, QUA, 2110, box 10.

39 Quoted in Wheeler-Bennett, *King George VI*, p. 393.

40 Ibid., p. 394.

41 Ibid., p. 392.

42 Violet Markham, *Friendship's Harvest*, Reinhardt, London, 1956, p. 129.

43 Alastair never got to the University of Virginia, because war intervened, but he inherited his father's interest in the United States, serving as the Washington correspondent of *The Observer* for some years after the Second World War. Later, he became the first head of the International Institute for Strategic Studies, then the head of the Royal College of Defence Studies, and his counsel on the politics of the Cold War was widely sought by Western statesmen. In 1973 he delivered the Reith Lectures ('Change without War') and ended his career as Professor of International Relations at Oxford University. He had as incisive a mind as his father, as well as his capacity for hard work. He died in 1976, the year before his mother.

44 JB to Violet Carruthers [Markham], 5 September 1939, QUA, 2110, box 11.

45 JB, diary entry for 2 September 1939, NLS, Acc. 6975/11.

46 JB to Sandy Gillon, 1 December 1939, QUA, 2110, box 11.

47 JB to King George VI, 19 September 1939, Royal Archives, PS/PSO/ GVI/C/048/095.

48 Sir Gerald Campbell, *Of True Experience*, Hutchinson, London, 1949, p. 86.

49 JB to Anna Buchan, 13 November 1939, NLS, Acc. 11627/25.

50 JB to Walter Buchan, 14 September 1939, NLS, Acc. 11627/84.

51 Ibid.

52 JB to King George VI, 19 September 1939, Royal Archives, PS/PSO/ GVI/C/048/95.

53 JB to Lord (Hugh) Macmillan, 11 September 1939, QUA, 2110, box 11.

54 JB to Walter Buchan, 19 October 1939, NLS, Acc. 11627/84.

55 Moritz J. Bonn, *Wandering Scholar*, Cohen and West, London, 1949, p. 369.

56 Peter Henshaw, 'John Buchan and the British Commonwealth Air Training Plan: The Under-Rated Role of the "Man on the Spot"', *Defence Studies*, vol. 1, no. 2, Summer 2001, p. 130.

57 Mackenzie King to JB, 12 December 1939, QUA, 2110, box 11.

58 MKD, 16 December 1939, BAC/LAC, MG26-J13, 21052.

59 JB, diary entry, 16 December 1939, NLS, Acc. 6975/11.

60 MKD, 16 December 1939, BAC/LAC, MG26-J13, 21059.

61 Quoted by Henshaw, 'John Buchan and the British Commonwealth Air Training Plan', p. 133.

62 *Ottawa Citizen*, 18 December 1939.

63 Neilson, 'An Excellent Conning-Tower', p. 267.

64 Ibid., p. 269.

65 Franklin D. Roosevelt to JB, 5 October 1939, Franklin D. Roosevelt Library, President's Personal File, PPF 3396.

66 See J. William Galbraith, *John Buchan: Model Governor General*, Dundurn, Toronto, 2013, chapter 10.

67 David Walker, *Lean, Wind, Lean*, Collins, London, 1984, p. 99.

68 Joan Pape, diary of the Royal Visit, unpublished, John Buchan Museum, Peebles.

69 Quoted in Adam Smith, *John Buchan*, p. 461.

70 Tweedsmuir, ed., *John Buchan by his Wife and Friends*, p. 13.

71 JB to Walter Buchan, 23 November 1939, NLS, Acc. 11627/84.

72 JB to Walter Buchan, 2 November 1939, NLS, Acc. 11627/84.

73 JB's diary entry for 31 December 1939, NLS, Acc. 6975/11.

74 JB to Anna Buchan, 1 January 1940, NLS, Acc. 11164/25.

75 JB to Anna Buchan, 15 January 1940, NLS, Acc. 11164/25.

76 JB to Sandy Gillon, 19 January 1940, QUA, 2110, box 11.

77 John Buchan, *Memory Hold-the-Door*, Hodder and Stoughton, London, 1940, p. 7.

78 Ibid., pp. 284–7.

79 Ibid., p. 169.

80 JB to Walter Buchan, 25 January 1940, NLS, Acc. 11627/84.

81 JB to Walter Buchan, 1 February 1940, NLS, Acc. 11627/84.

82 See Galbraith, *Model Governor General*, chapter 17.

83 JB to Anna Buchan, 5 February 1940, NLS, Acc. 6542/14.

84 JB to Walter Buchan, 1 February 1940, NLS, Acc. 11627/84.

85 JB to Anna Buchan, 5 February 1940, NLS, Acc. 6542/14.

86 Reported in the *Daily Mail*, 15 February 1940.

87 Telegram from Susie to Anna and Walter Buchan, 11 February 1940, NLS, Acc. 11164/25.

88 Susie to Alice Fairfax-Lucy, 12 February 1940, private collection.

89 Memorial booklet, Royal Archives, PS/PSO/GVI/PS/DOM/04518/52.

90 Ferris Greenslet, *Under the Bridge*, Houghton Mifflin, Boston, MA, 1943, pp. 207–8.

91 The Reverend Alexander Ferguson, 14 February 1940, CBC Broadcast.

92 Memorial Meeting for the Governor-General, Montreal Neurological Institute, 14 February 1940, QUA, 2110, box 12.

93 J. P. Parry, 'Reflections on the thought of John Buchan', in Michael Bentley, ed., *Public and Private Doctrine: Essays in British History Presented to Maurice Cowling*, Cambridge University Press, Cambridge, 1993, p. 235.

94 Sir Shuldham Redfern to Sir Alexander Hardinge, 16 February 1940, private collection.

95 A. L. Rowse, *The English Past*, Macmillan, London, 1957, p. 184.

96 Ibid., p. 194.

97 George M. Trevelyan to Susie, 19 February 1940, QUA, 2110, box 23.

98 Tweedsmuir, ed., *John Buchan by his Wife and Friends*, p. 12.

99 J. W. Dafoe to Viscount Greenwood, 29 March 1940, NLS, Acc. 11164/10.

100 *The New York Tribune*, 12 February 1940.

101 Arthur Murray, *At Close Quarters*, John Murray, London, 1946, pp. 97–8.

102 Quoted in Adam Smith, *John Buchan*, p. 463.

103 M. R. Ridley, *Second Thoughts: More Studies in Literature*, J. M. Dent, London, 1965, pp. 25–6.

104 John Buchan, *Scholar Gipsies*, The Bodley Head, London, 1896, pp. 205–6.

AFTERWORD

1 Alec Maitland to Susie, 12 February 1940, QUA, 2110, box 23.

Select Bibliography

ARCHIVES

Bibliothèque et Archives / Library and Archives Canada, Ottawa, Canada (BAC/LAC).
Bodleian Library, Oxford.
Brasenose College Records, Brasenose College, Oxford.
British Institute, Florence.
John Buchan Story, Peebles.
John J. Burns Library, Boston College, Boston, MA.
Cambridge University Library, Cambridge.
Ede and Ravenscroft Archives, Waterbeach, Cambridge.
Edinburgh University Special Collections, Edinburgh (UESC).
Fife Cultural Trust (Kirkcaldy Local Studies) on behalf of Fife Council.
Hay Library, Brown University, Providence, RI.
Hutchesons' Grammar School Archives.
Yousuf Karsh Archive.
John F. Kennedy Presidential Library and Museum, Boston, MA.
Middle Temple Archive, Middle Temple, London.
National Archives, Kew (TNA).
National Library of Scotland, Edinburgh (NLS).
North Yorkshire County Record Office, Northallerton.
Oxfordshire History Centre, Oxford.
Parliamentary Archives, Houses of Parliament, London.
Queen's University Archives and Library, Kingston, ON (QUA).
Queen Mary University of London (QMUL).
Rauner Special Collections Library, Dartmouth College, Hanover, NH.
Franklin D. Roosevelt Presidential Library and Museum, Hyde Park, NY.
Royal Archives, Windsor.
Harry S. Truman Presidential Library and Museum, Independence, MO.
I have also been able to consult several private and unpublished collections of papers and
 correspondence: those of Lady (Alice) Fairfax-Lucy,
 W. H. Buchan, Captain John Boyle, Sir Alexander Grant and Sir Shuldham Redfern.

BOOKS AND BOOKLETS

Adam Smith, Janet, *John Buchan: A Biography*, Rupert Hart-Davis, London, 1965.
— *John Buchan and his World*, Thames and Hudson, London, 1979.
Adams, David K. and Vaudagna, Maurizio, eds, *Transatlantic Encounters: Public Uses and Misuses of History in Europe and the United States*, VU University Press, Amsterdam, 2000.
Amery, Leo, *My Political Life*, vols I, II and III, Hutchinson, London, 1953–5.
Arnold, Bruce, *Orpen: Mirror to an Age*, Cape, London, 1981.
Baker, Herbert, *Architects and Personalities*, Country Life, London, 1944.
Barnes, John and Nicholson, David, eds, *Leo Amery Diaries, vol. I (1896–1929)*, Hutchinson, London, 1980.
Beaverbrook, Max, *Men and Power, 1917 and 1918*, Hutchinson, London, 1956.
Bennett, Alan, *Forty Years On*, Faber and Faber, London, 1969.
Bentley, Michael, ed., *Public and Private Doctrine: Essays in British History Presented to Maurice Cowling*, Cambridge University Press, Cambridge, 1993.
Best, A. and Fisher, J., eds, *On the Fringes of Diplomacy: Influences on British Foreign Policy 1800–1945*, ed. J. Fisher, Ashgate, Farnham, 2011.
Best, Brian, *Reporting from the Front: War Reporters during the Great War*, Pen and Sword Military, Barnsley, 2014.
Blanchard, Robert, *The First Editions of John Buchan: A Collector's Bibliography*, Archon, Hamden, CT, 1981.
Bonn, Moritz J., *Wandering Scholar*, Cohen and West, London, 1949.
Bothwell, Robert, Drummond, Ian and English, John, *Canada 1900–1945*, University of Toronto Press, Toronto, 1987.
Bourke-White, Margaret, *Portrait of Myself*, Collins, London, 1964.
Brinckman, John, *Down North: John Buchan and Margaret Bourke-White on the Mackenzie*, John Brinckman, Toronto, 2007 (e-book).
Brown, Ian and Riach, Alan, eds, *The Edinburgh Companion to Twentieth-Century Scottish Literature*, Edinburgh University Press, Edinburgh, 2009.
Buchan, Anna, *John Buchan, 1847–1911*, privately published, 1912.
— *W. H. B.*, privately published, 1913.
— *Alastair Buchan, 1894–1917*, privately published, 1917.
— *Unforgettable, Unforgotten*, Hodder and Stoughton, London, 1945.
— *Farewell to Priorsford*, Hodder and Stoughton, London, 1950.
Buchan, Anna (as Douglas, O.)
— *Olivia in India*, Hodder and Stoughton, London, 1913.
— *The Setons*, Hodder and Stoughton, London, 1917.
— *Ann and her Mother*, Hodder and Stoughton, London, 1922.
— *Pink Sugar*, Hodder and Stoughton, London, 1924.
— *Eliza for Common*, Hodder and Stoughton, London, 1928.
Buchan, Rev. John, *Tweedside Echoes and Moorland Musings*, Maclaren, Edinburgh, 1881.
Buchan, John, ed., *Essays and Apothegms of Francis, Lord Bacon*, Walter Scott, London, 1894.
— *Sir Quixote of the Moors*, T. Fisher Unwin, London, 1895.
— *Scholar Gipsies*, John Lane, The Bodley Head, London, 1896.
— *Musa Piscatrix*, John Lane, The Bodley Head, London, 1896.
— *Sir Walter Ralegh* (Stanhope Prize essay), Simpkin, Marshall, Hamilton and Kent, London, 1897.
— *The Pilgrim Fathers* (Newdigate Prize poem), Simpkin, Marshall, Hamilton and Kent, London, 1898.

— *John Burnet of Barns*, John Lane, The Bodley Head, London, 1898.
— *A History of Brasenose College*, F. E. Robinson, London, 1898.
— *Grey Weather: Moorland Tales of My Own People*, John Lane, The Bodley Head, London, 1899.
— *A Lost Lady of Old Years*, John Lane, The Bodley Head, London, 1899.
— *The Half-Hearted*, Isbister, London, 1900.
— ed., *The Compleat Angler* by Izaak Walton, Methuen, London, 1901.
— *The Watcher by the Threshold and other Tales*, William Blackwood, Edinburgh, 1902.
— *The African Colony: Studies in the Reconstruction*, William Blackwood, Edinburgh 1903.
— *The Law Relating to the Taxation of Foreign Income*, Stevens, London, 1905.
— *A Lodge in the Wilderness*, William Blackwood, Edinburgh, 1906.
— *Some Eighteenth Century Byways and Other Essays*, William Blackwood, Edinburgh, 1908.
— contrib., *Nine Brasenose Worthies*, Clarendon Press, Oxford, 1909.
— *Prester John*, Thomas Nelson, Edinburgh, 1910; *The Great Diamond Pipe*, Dodd, Mead, New York, 1910.
— *Sir Walter Raleigh*, Thomas Nelson, Edinburgh, 1911.
— *The Moon Endureth: Tales and Fancies*, William Blackwood, Edinburgh, 1912.
— *The Marquis of Montrose*, Thomas Nelson, Edinburgh, 1913.
— *Andrew Jameson, Lord Ardwall*, William Blackwood, Edinburgh, 1913.
— *Nelson's History of the War* (24 vols), Thomas Nelson, Edinburgh, 1915–19.
— *Britain's War by Land*, Oxford Pamphlets, Oxford University Press, Oxford, 1915.
— *Ordeal by Marriage: An Eclogue*, privately published, 1915; SMS Books, East Leake, 2016.
— *Salute to Adventurers*, Thomas Nelson, Edinburgh, 1915.
— *The Achievement of France*, reprinted from *The Times*, Methuen, London, 1915.
— *The Thirty-Nine Steps*, William Blackwood, Edinburgh, 1915.
— *The Future of the War*, address to Booksellers' Provident Institution, Boyle, Sons and Watchurst, London, 1916.
— *The Power-House*, William Blackwood, Edinburgh, 1916.
— *The Purpose of War*, address for Fight for Right Movement, J. M. Dent, London, 1916.
— *The Battle of Jutland*, Thomas Nelson, Edinburgh, 1916.
— *Greenmantle*, Hodder and Stoughton, London, 1916.
— *The Battle of the Somme, First Phase*, Thomas Nelson, Edinburgh, 1916.
— *The Battle of the Somme, Second Phase*, Thomas Nelson, Edinburgh, 1917.
— *Poems Scots and English*, T. C. and E. C. Jack, Edinburgh, 1917.
— *The Battle-Honours of Scotland 1914–1918*, George Outram, *The Glasgow Herald*, Glasgow, 1919.
— *Mr Standfast*, Hodder and Stoughton, London, 1919.
— *These for Remembrance*, privately published, 1919.
— and Susan Buchan (as Cadmus and Harmonia), *The Island of Sheep*, Hodder and Stoughton, London, 1919.
— *The History of the South African Forces in France*, Thomas Nelson, Edinburgh, 1920.
— *Francis and Riversdale Grenfell: A Memoir*, Thomas Nelson, Edinburgh, 1920.
— *The Path of the King*, Hodder and Stoughton, Edinburgh, 1921.
— *A History of the Great War*, 4 vols, Thomas Nelson, Edinburgh, 1921–2.
— *Huntingtower*, Hodder and Stoughton, London, 1922.
— *A Book of Escapes and Hurried Journeys*, Thomas Nelson, Edinburgh, 1922.
— and Henry Newbolt, *Days to Remember: The British Empire in the Great War*, Thomas Nelson, Edinburgh, 1923.
— *Midwinter: Certain Travellers in Old England*, Hodder and Stoughton, Edinburgh, 1923.
— *The Last Secrets: The Final Mysteries of Exploration*, Thomas Nelson, Edinburgh, 1923.

— *Some Notes on Sir Walter Scott*, Pamphlet no. 58, The English Association, 1924.

— *The Three Hostages*, Hodder and Stoughton, London, 1924.

— *Lord Minto: A Memoir*, Thomas Nelson, Edinburgh, 1924.

— ed., *The Northern Muse: An Anthology of Scots Vernacular Poetry*, Thomas Nelson, Edinburgh, 1924.

— *Two Ordeals of Democracy*, Houghton Mifflin, Boston, 1925.

— *The Man and the Book: Sir Walter Scott*, Thomas Nelson, Edinburgh, 1925.

— *John Macnab*, Hodder and Stoughton, London, 1925.

— *The History of the Royal Scots Fusiliers (1678–1918)*, Thomas Nelson, Edinburgh, 1925.

— with Stewart DSO, Lieutenant Colonel J., *The Fifteenth (Scottish) Division 1914–1919*, William Blackwood, Edinburgh, 1926.

— *The Dancing Floor*, Hodder and Stoughton, London, 1926.

— *Homilies and Recreations*, Thomas Nelson, Edinburgh, 1926.

— *Witch Wood*, Hodder and Stoughton, 1927.

— *The Runagates Club*, Hodder and Stoughton, 1928.

— *Montrose*, Thomas Nelson, Edinburgh, 1928.

— *What the Union of the Churches Means to Scotland*, address to General Assembly, Macniven and Wallace, Edinburgh, 1929.

— *The Courts of the Morning*, Hodder and Stoughton, London, 1929.

— *The Causal and the Casual in History*, Rede Lecture, Cambridge University Press, Cambridge, 1929.

— *Montrose and Leadership*, Walker Trust Lecture on Leadership, Humphrey Milford, London, 1930.

— with George Adam Smith, *The Kirk in Scotland 1560–1929*, Hodder and Stoughton, London, 1930.

— *Castle Gay*, Hodder and Stoughton, London, 1930.

— *The Blanket of the Dark*, Hodder and Stoughton, London, 1931.

— *The Novel and the Fairy Tale*, Pamphlet no. 79, The English Association, 1931.

— *Sir Walter Scott*, Cassell, London, 1932.

— *Julius Caesar*, Peter Davies, London, 1932.

— *The Gap in the Curtain*, Hodder and Stoughton, London, 1932.

— *The Magic Walking Stick*, Hodder and Stoughton, London, 1932.

— *Andrew Lang and the Border*, Humphrey Milford, London, 1933.

— *The Massacre of Glencoe*, Peter Davies, London, 1933.

— *A Prince of the Captivity*, Hodder and Stoughton, London, 1933.

— *Principles of Social Service*, address, City of Glasgow Society of Social Service, Glasgow, 1933.

— *The Margins of Life*, address, Birkbeck College, J. W. Ruddock, London, 1933.

— *The Scottish Church and the Empire*, address, Church of Scotland, Edinburgh, 1934.

— *The Free Fishers*, Hodder and Stoughton, London, 1934.

— *Gordon at Khartoum*, Peter Davies, London, 1934.

— *Oliver Cromwell*, Hodder and Stoughton, London, 1934.

— *The King's Grace 1910–1935*, Hodder and Stoughton, London, 1935.

— *The House of the Four Winds*, Hodder and Stoughton, London, 1935.

— *Men and Deeds*, Peter Davies, London, 1935.

— *The Island of Sheep*, Hodder and Stoughton, London, 1936; *The Man from the Norlands*, Houghton Mifflin, Boston, 1936.

— *Episodes of the Great War*, Thomas Nelson, Edinburgh, 1936.

— *Augustus*, Hodder and Stoughton, London, 1937.

— *Presbyterianism Yesterday, Today and Tomorrow*, address, The Church of Scotland, Edinburgh, 1938.
— *Naval Episodes of the Great War*, Thomas Nelson, Edinburgh, 1938.
— *The Interpreter's House: The Chancellor's Installation Address delivered before the University of Edinburgh, July 20th 1938*, Hodder and Stoughton, London, 1938.
— *Memory Hold-the-Door*, Hodder and Stoughton, London, 1940; *Pilgrim's Way*, Houghton Mifflin, Boston, 1940.
— *Canadian Occasions*, Musson, Toronto, 1940.
— *Comments and Characters*, ed. W. Forbes Gray, Thomas Nelson, Edinburgh, 1940.
— *Sick Heart River*, Hodder and Stoughton, London, 1941; *Mountain Meadow*, Houghton Mifflin, Boston, 1941.
— *The Long Traverse*, Hodder and Stoughton, London, 1941; *Lake of Gold*, Houghton Mifflin, Boston, 1941.
Buchan, Susan, *The Sword of State*, Hodder and Stoughton, London, 1928.
— *Lady Louisa Stuart*, Hodder and Stoughton, London, 1932.
— *Funeral March of a Marionette*, Hogarth Press, London, 1935.
— *The Scent of Water*, Hodder and Stoughton, London, 1937.
Buchan, Susan (as Susan Tweedsmuir)
— *Carnets Canadiens*, Les Editions du Zodiaques, Montreal, 1938.
— *Canada*, Collins, London, 1941.
— ed., *The Clearing House: A Survey of One Man's Mind: A Selection from the Writings of John Buchan*, Hodder and Stoughton, London, 1946.
— ed., *Life's Adventure: Extracts from the Works of John Buchan*, St Hugh's Press, London, 1947.
— *John Buchan by his Wife and Friends*, Hodder and Stoughton, London, 1947.
— *The Lilac and the Rose*, Duckworth, London, 1952.
— *A Winter Bouquet*, Duckworth, London, 1954.
— *The Edwardian Lady*, Duckworth, London, 1966.
Buchan, J. Walter, *The Duke of Wellington*, Thomas Nelson, Edinburgh, 1914.
— ed., *A History of Peeblesshire in 3 vols*, Jackson, Wylie and Co, Glasgow, 1925–7.
Buchan, William, *John Buchan: A Memoir*, Buchan and Enright, London, 1982.
— *The Rags of Time: A Fragment of Autobiography*, Ashford, Buchan and Enright, Southampton, 1990.
Buitenhuis, Peter, *The Great War of Words: Literature as Propaganda, 1914–1918 and After*, B. T. Batsford, London, 1989.
Burnett, John and Mackay, Kate, *John Buchan and the Thirty-Nine Steps: An Exploration*, National Museums of Scotland, Edinburgh, 2014.
Cadell, Patrick and Mathieson, Ann, eds, *For the Encouragement of Learning: Scotland's National Library, 1689–1989*, HMSO, Edinburgh, 1989.
Cain, Peter and Hopkins, Tony, *British Imperialism, 1688–2000*, Longman, Harlow, 2001.
Campbell, Gerald, *Of True Experience*, Hutchinson, London, 1948.
Campbell-Preston, Frances, *The Rich Spoils of Time*, Dovecote Press, Stanbridge, Dorset, 2006.
Cannadine, David, *G. M. Trevelyan: A Life in History*, HarperCollins, London, 1992.
— *George V: The Unexpected King*, Allen Lane, London, 2014.
Cawelti, John G. and Rosenberg, Bruce A., *The Spy Story*, University of Chicago Press, Chicago, 1987.
Charteris, Brigadier-General John, *At G.H.Q.*, Cassell, London, 1931.
Cheyette, Bryan, *Constructions of 'the Jew' in English Literature and Society: Racial Representations, 1875–1945*, Cambridge University Press, Cambridge, 1993.
Chitty, Susan, *Playing the Game: A Biography of Sir Henry Newbolt*, Quartet, London, 1998.

Clarke, Roger, *The Journalistic Career of John Buchan (1875–1940): A Critical Assessment of its Context and Significance*, Edwin Mellen Press, Lewiston, NY, 2018.

— *The Journalistic Writings of John Buchan: Selected Essays, Reviews, and Opinion Pieces*, Edwin Mellen Press, Lewiston, NY, 2018.

— *John Buchan: A Bibliographic Catalogue of His Uncollected Journalism*, Edwin Mellen Press, Lewiston, NY, 2018.

Cowan, John, *Canada's Governors-General, Lord Howick to General Vanier*, York Publishing, Toronto, 1952.

Dallek, Robert, *Franklin D. Roosevelt and American Foreign Policy, 1932–1945*, Oxford University Press, NY, 1979.

Daniell, David, *The Interpreter's House: A Critical Assessment of the Work of John Buchan*, Nelson, London, 1975.

Daniell, David, ed., *The Best Short Stories of John Buchan, vol. I*, Michael Joseph, London, 1980, *vol. II*, Michael Joseph, London, 1982.

Davidson, J. C. C., *Memoirs of a Conservative: J. C. C. Davidson's Memoirs and Papers, 1910–1937*, ed. Robert Rhodes James, Weidenfeld and Nicolson, London, 1969.

Defries, Harry, *Conservative Party Attitudes to Jews 1900–1950*, Frank Cass, London, 2001.

Denman, R. D., *Political Sketches*, Thurnam, Carlisle, 1948.

Denning, Michael, *Cover Stories: Narrative and Ideology in the British Spy Thriller*, Routledge and Kegan Paul, London, 1987.

Dick, Rev. Charles H., *Highways and Byways in Galloway and Carrick*, Macmillan, London, 1916.

Douglas-Hamilton, James, *Roof of the World: Man's First Flight over Everest*, Mainstream, Edinburgh, 1983.

Downing, Taylor, *Secret Warriors: Key Scientists, Code-Breakers and Propagandists of the Great War*, Little, Brown, London, 2014.

Drescher, Horst and Volkel, Herman, eds, *Nationalism in Literature: Literature, Language and National Identity*, Peter Lang, Frankfurt-am-Main, 1989.

Dutton, David, *Anthony Eden: A Life and Reputation*, Arnold, London, 1997.

Eden, Anthony, *The Eden Memoirs, vol. I: Facing the Dictators*, Cassell, London, 1962.

Elliot, Walter, *Long Distance*, Constable, London, 1943.

Elliot, W. G., *In My Anecdotage*, Allan, London, 1925.

Fairfax-Lucy, Alice, *A Scrap Screen*, Hamish Hamilton, London, 1979.

Feiling, Keith, *The Life of Neville Chamberlain*, Macmillan, London, 1946.

Fitzherbert, Margaret, *The Man who was Greenmantle*, John Murray, London, 1983.

Fleming, Archibald, *Archibald the Arctic*, Appleton Century Crofts, NY, 1956.

Forrester, Wendy, *Anna Buchan and O. Douglas*, Maitland, London, 1995.

Fuchser, Larry William, *Neville Chamberlain and Appeasement: A Study in the Politics of History*, Norton, London, 1983.

Galbraith, J. William, *John Buchan: Model Governor-General*, Dundurn, Toronto, 2013.

Garnett, David, ed., *Letters of T. E. Lawrence*, Cape, London, 1938.

Gilmour, David, *The Long Recessional: The Imperial Life of Rudyard Kipling*, John Murray, London, 2002.

Gollin, Alfred, *Proconsul in Politics: A study of Lord Milner in Opposition and in Power*, Anthony Blond, London, 1964.

Gorman, Daniel, *Imperial Citizenship: Empire and the Question of Belonging*, Manchester University Press, Manchester, 2006.

Granatstein, J. L., *Mackenzie King: His Life and World*, McGraw-Hill Ryerson, Toronto, 1977.

Graves, Charles, *The Brain of the Nation and Other Verses*, Smith, London, 1912.

Graves, Robert, *T. E. Lawrence to his Biographers, Robert Graves and Liddell Hart*, Cassell, London, 1963.

Green, Martin, *A Biography of John Buchan and His Sister Anna: The Personal Background of Their Literary Work*, Edwin Mellen Press, Lewiston, NY; Lampeter, Wales, 1990.

Greenslet, Ferris, *Under the Bridge: An Autobiography*, Houghton Mifflin, Boston, 1943.

Grenville, Anthony, ed., *Refugees from the Third Reich in Britain*, Rodopi, Amsterdam, 2002.

Grieve, C. M., *Contemporary Scottish Studies: First Series*, Leonard Parsons, London, 1926.

— *Annals of the Five Senses: The First Collected Work by Hugh MacDiarmid*, Polygon, Edinburgh, 1983.

Grosvenor, Caroline, *The Bands of Orion*, Heinemann, London, 1906.

— *The Thornton Device*, Constable, London, 1907.

— *Laura*, Heinemann, London, 1911.

— and Lord Stuart of Wortley, *The First Lady Wharncliffe and her Family (1779–1856)*, Heinemann, London, 1927.

Gurney, Ivor, *Severn & Somme*, Sidgwick & Jackson, London, 1917.

Halperin, Vladimir, *Lord Milner and the Empire: The Evolution of British Imperialism*, Odhams, London, 1952.

Hammond, Michael and Williams, Michael, *British Silent Cinema and the Great War*, Palgrave Macmillan, Basingstoke, 2011.

Hart-Davis, Duff, ed., *End of an Era: Letters and Journals of Sir Alan Lascelles 1887–1920*, Hamish Hamilton, London, 1986.

— ed., *In Royal Service: Letters and Diaries of Sir Alan Lascelles 1920–1936*, Hamish Hamilton, London, 1989.

— ed., *King's Counsellor: Abdication and War: The Diaries of Sir Alan Lascelles*, Weidenfeld and Nicolson, London, 2006.

Harvie, Christopher, *The Centre of Things: Political Fiction in Britain from Disraeli to the Present*, Unwin Hyman, London, 1991.

— *A Floating Commonwealth: Politics, Culture and Technology on Britain's Atlantic Coast, 1860–1930*, Oxford University Press, Oxford, 2008.

Haste, Cate, *Keep the Home Fires Burning: Propaganda in the First World War*, Allen Lane, London, 1977.

Herbert, Aubrey, *Mons, Anzac and Kut*, Edward Arnold, London, 1919.

Hillier, Kenneth, and Ross, Michael, *The First Editions of John Buchan: A Collector's Illustrated Bibliography*, Avonworld, Bristol, 2008.

Hillier, Kenneth, *The First Editions of Susan Buchan (Susan Tweedsmuir): A Collector's Illustrated Bibliography*, The Greenmantle Press, Melbourne, Derbyshire, 2014.

Hillmer, N. and Chapnick, A., eds, *Canadas of the Mind: The Making and Unmaking of Canadian Nationalisms in the Twentieth Century*, McGill-Queen's University Press, Montreal, 2007.

Himmelfarb, Gertrude, *Victorian Minds*, Weidenfeld and Nicolson, London, 1968.

Holmes, Heather and Finkelstein, David, eds, *Thomas Nelson and Sons: Memories of an Edinburgh Publishing House*, Tuckwell Press, East Linton, 2001.

Hubbard, R. H., *Rideau Hall: An Illustrated History of Government House, Ottawa from Victorian Times to the Present Day*, McGill-Queen's University Press, Montreal, 1977.

Jackson, D. Michael and Lagassé, Philippe, eds, *Canada and the Crown: Essays in Constitutional Monarchy*, McGill-Queen's University Press, Montreal, 2013.

Jeremy, David J., ed., *Dictionary of Business Biography: A Biographical Dictionary of Business Leaders Active in Britain in the Period 1860–1980, vol. 3*, Butterworths, London, 1984–6.

Johnston, James, *Westminster Voices: Studies in Parliamentary Speech*, Hodder and Stoughton, London, 1928.

Jolliffe, John, ed., *Raymond Asquith: Life and Letters*, Collins, London, 1980.

Jones, Sir Roderick, *A Life in Reuters*, Hodder and Stoughton, London, 1951.

Jones, Thomas, *Welsh Broth*, Griffiths, London, 1951.

— *A Diary with Letters, 1931–1950*, Oxford University Press, Oxford, 1954.

Karsh, Yousuf, *Faces of Destiny*, Ziff-Davis, Chicago, IL, 1946.

Katz, David S., *The Shaping of Turkey in the British Imagination, 1776–1923*, Palgrave Macmillan, London, 2016.

Kaufman, Beatrice and Hennessey, Joseph, eds, *Letters of Alexander Woollcott*, Cassell, London, 1946.

Kimball, Roger, *The Fortunes of Permanence: Culture and Anarchy in an Age of Amnesia*, St Augustine's Press, South Bend, IN, 2012.

King, Robert D. and Kilson, Robin W., eds, *The Statecraft of British Imperialism: Essays in Honour of Wm. Roger Louis*, Frank Cass, London, 1999.

Kipling, Rudyard, *Proofs of Holy Writ*, preface by Alexander Woollcott, Doubleday, Doran, Garden City, NY, 1942.

Kruse, Juanita, *John Buchan (1875–1940) and the Idea of Empire: Popular Literature and Political Ideology*, Edwin Mellen Press, Lewiston, NY; Lampeter, Wales, 1989.

Kynaston, David, *The City of London, vol. II, Golden Years 1890–1914*, Chatto and Windus, London, 1995.

Lascelles, A. F., *Government House, Ottawa* (the 'Green Book'), privately published, 1934.

Lentin, Anthony, *The Last Political Law Lord: Lord Sumner (1859–1934)*, Cambridge Scholars Publishing, Newcastle, 2008.

Liddell Hart, Basil, *T. E. Lawrence: In Arabia and After*, Cape, London, 1934.

— *The Memoirs of Captain Liddell Hart*, Cassell, London, 1965.

Lloyd George, David, *War Memoirs of David Lloyd George, vols I and II*, Nicholson and Watson, London, 1933.

Lockhart, John Gilbert ('Janitor') and Lyttelton, Mary, *The Feet of the Young Men: Some Candid Comments on the Rising Generation*, Duckworth, London, 1929.

Lownie, Andrew, *John Buchan: The Presbyterian Cavalier*, Constable, London, 1995.

— and Milne, William, eds, *John Buchan's Collected Poems*, Scottish Cultural Press, Aberdeen, 1996.

MacDonagh, Michael, *In London during the Great War: The Diary of a Journalist*, Eyre and Spottiswoode, London, 1935.

Macdonald, Kate, *John Buchan: A Companion to the Mystery Fiction*, McFarland, Jefferson, NC, 2009.

— ed., *Reassessing John Buchan: Beyond The Thirty-Nine Steps*, Pickering and Chatto, London, 2009.

— *Novelists against Social Change: Conservative Popular Fiction, 1920–1960*, Palgrave Macmillan, Basingstoke, 2015.

— and Waddell, Nathan, eds, *John Buchan and the Idea of Modernity*, Pickering and Chatto, London, 2013.

Macleod, Roderick and Kelly, Denis, eds, *The Ironside Diaries, 1937–1940*, Constable, London, 1962.

Macmillan, Lord, *A Man of Law's Tale: The Reminiscences of the Rt. Hon. Lord Macmillan*, Macmillan, London, 1952.

Maiden, John, *National Religion and the Prayer Book Controversy 1927–1928*, Boydell and Brewer, Suffolk, 2009.

Malvern, Sue, *Modern Art, Britain and the Great War: Witnessing, Testimony and Remembrance*, Yale University Press, London, 2004.

Markham, Violet, *Return Passage*, Oxford University Press, Oxford, 1953.

— *Friendship's Harvest*, Reinhardt, London, 1956.

Marsh, Edward, *A Number of People: A Book of Reminiscences*, Heinemann, London, 1939.

Marshall-Cornwall, James, *Wars and Rumours of Wars: A Memoir*, Leo Cooper, Secker & Warburg, London, 1984.

Masheder, Mildred, *Carrier's Cart to Oxford: Growing up in the 1920s in the Oxfordshire Village of Elsfield*, Wychwood Press, Chipping Norton, 2007.

Massey, Vincent, *What's Past is Prologue*, Macmillan, Toronto, 1963.

Massie, Allan, *101 Great Scots*, Chambers, Edinburgh, 1987.

Masterman, Lucy, *C. F. G. Masterman: A Biography*, Nicholson and Watson, London, 1939.

Matthew, H. C. G. and Harrison, Brian, *Oxford Dictionary of National Biography*, Oxford University Press, Oxford, 2004.

Messinger, Gary S., *British Propaganda and the State in the First World War*, Manchester University Press, Manchester, 1992.

— *The Battle for the Mind: War and Peace in the Era of Mass Communication*, University of Massachusetts Press, Amherst, MA, 2011.

Middlemas, Keith and Barnes, John, *Baldwin: A Biography*, Weidenfeld and Nicolson, London, 1969.

Millman, Brock, *Pessimism and British War Policy, 1916–1918*, Frank Cass, London, 2001.

Moorman, Mary, *George Macaulay Trevelyan: A Memoir*, Hamish Hamilton, London, 1980.

Murray, Arthur, *Master and Brother: Murrays of Elibank*, John Murray, London, 1945.

— *At Close Quarters: A Sidelight on Anglo-American Diplomatic Relations*, John Murray, London, 1946.

Murray, Gilbert, *Gilbert Murray: An Unfinished Autobiography*, Allen and Unwin, London, 1960.

Nash, Paul, *Outline: An Autobiography and Other Writings*, Faber and Faber, London, 1949.

Newbolt, Margaret, ed., *The Later Life and Letters of Sir Henry Newbolt*, Faber and Faber, London, 1942.

Nicolson, Nigel, ed., *The Flight of the Mind: The Letters of Virginia Woolf*, Hogarth Press, London, 1976.

— *The Sickle Side of the Moon: The Letters of Virginia Woolf, vol. V, 1932–1935*, Hogarth Press, London, 1979.

Nimocks, Walter, *Milner's Young Men: The 'Kindergarten' in Edwardian Imperial Affairs*, Duke University Press, Durham, NC, 1968.

Noyes, Alfred, *Two Worlds for Memory*, Sheed and Ward, London, 1953.

O'Brien, Terence H., *Milner: Viscount Milner of St James's and Cape Town, 1854–1925*, Constable, London, 1979.

Oliver, F. S., *The Endless Adventure*, vols I, II and III, Macmillan, London, 1930–5.

Paddock, Troy, ed., *World War I and Propaganda*, Brill, Leiden, 2014.

Pakenham, Thomas, *The Boer War*, Weidenfeld and Nicolson, London, 1979.

Panek, Leroy L., *The Special Branch: The British Spy Novel 1890–1980*, Bowling Green University Press, Bowling Green, OH, 1981.

Parrinder, P. and Gasiorek, A., *The Reinvention of the British and Irish Novel, 1880–1940*, Oxford University Press, Oxford, 2011.

Peterson, H. C., *Propaganda for War: The Campaign against American Neutrality, 1914–1917*, University of Oklahoma Press, Norman, OK, 1939.

Philpott, William, *Bloody Victory: The Sacrifice on the Somme*, Abacus, London, 2010.

Pickersgill, J. W., *The Mackenzie King Record, vol. 1, 1939–1944*, University of Toronto Press, Toronto, 1960.

Pound, Reginald, *Arnold Bennett: A Biography*, Heinemann, London, 1952.

Rankin, Nicholas, *Churchill's Wizards: The British Genius for Deception 1914–1945*, Faber and Faber, London, 2008.

Read, Donald, *The Power of News: The History of Reuters, 1849–1989*, Oxford University Press, Oxford, 1992.

Reeves, Nicholas, *Official British Film Propaganda during the First World War*, Croom Helm, London, 1986.

Reid, A. and Osborne, B. D., eds, *Discovering Scottish Writers*, Scottish Library Association and Scottish Cultural Press, Edinburgh, 1997.

Ridley, M. R., *Second Thoughts: More Studies in Literature*, J. M. Dent, London, 1965.

Ritchie, Charles, *The Siren Years: Undiplomatic Diaries, 1937–1945*, Macmillan, London, 1974.

Robertson, Heather, ed., *A Gentleman Adventurer: The Arctic Diaries of Richard Bonnycastle*, Lester and Orpen Dennys, Toronto, 1984.

Rogers, Byron, *The Man Who Went Into the West: The Life of R. S. Thomas*, Aurum, London, 2007.

Rowse, A. L., *The English Past*, Macmillan, London, 1951.

Russell, Leonard, ed., *Parody Party*, Hutchinson, London, 1936.

Sanders, M. L. and Taylor, Philip, *British Propaganda During the First World War 1914–18*, Macmillan, London, 1982.

Scott, Sheila, *J. Walter Buchan*, privately published, 1983.

— *O. Douglas*, privately published, 1993.

Sheffield, Gary and Bourne, John, eds, *Douglas Haig: War Diaries and Letters, 1914–1918*, Weidenfeld and Nicolson, London, 2005.

— *The Chief: Douglas Haig and the British Army*, Aurum, London, 2011.

Smith, David E., *The Invisible Crown: The First Principle of Canadian Government*, University of Toronto Press, Toronto, 1995.

Sommer, Dudley, *Haldane of Cloan: His Life and Times 1856–1928*, Allen and Unwin, London, 1960.

Spoto, Donald, *The Dark Side of Genius: The Life of Alfred Hitchcock*, Collins, London, 1983.

Spring, Howard, *In the Meantime*, Constable, London, 1942.

Squires, James Duane, *British Propaganda at Home and in the United States from 1914 to 1917*, Harvard University Press, Cambridge, MA, 1935.

Strachan, Hew, *The First World War: Vol. I, To Arms*, Oxford University Press, Oxford, 2001.

— *The First World War*, Simon & Schuster, London, 2014.

Stuart, Sir Campbell, *Secrets of Crewe House: The Story of a Famous Campaign*, Hodder and Stoughton, London, 1920.

Terraine, John, *The Western Front 1914–1918*, Hutchinson, London, 1964.

Thompson, Andrew S., *Imperial Britain: The Empire in British Politics c. 1880–1932*, Longman, Harlow, 2000.

Todman, Dan, *The Great War: Myth and Memory*, Continuum, Hambledon, 2005.

Trevelyan, G. M., *An Autobiography and Other Essays*, Longmans, Green, London, 1949.

Trotter, David, *The English Novel in History 1895–1920*, Routledge, London, 1993.

Truffaut, François, *Hitchcock*, Secker and Warburg, London, 1968.

Turner, Arthur C., *Mr. Buchan, Writer: A Life of the First Lord Tweedsmuir*, SCM, London, 1949.

Tweedsmuir, Lord, *Always a Countryman*, Robert Hale, London, 1953.

— *Hudson's Bay Trader*, Clerke and Cockeran, London, 1951.

Usborne, Richard, *Clubland Heroes: A Nostalgic Study of Some Recurrent Characters in the Romantic Fiction of Dornford Yates, John Buchan and Sapper*, Constable, London, 1953.

Vincent, John, ed., *The Crawford Papers: The Journals of David Lindsay, Twenty-Seventh Earl of Crawford and Tenth Earl of Balcarres 1871–1940: During the Years 1892–1940*, Manchester University Press, Manchester, 1984.

Walker, David, *Lean, Wind, Lean: A Few Times Remembered*, Collins, London, 1984.

Watt, D. C., *Personalities and Policies: Studies in the Formulation of British Foreign Policy in the Twentieth Century*, Longmans, London, 1965.

Webb, Paul, *A Buchan Companion: A Guide to the Novels and Short Stories*, Alan Sutton, Far Thrupp, 1994.

Weekes, David, *ΧΡΙΣΤΟΣ ΝΙΚΗΣΕΙ: on John Buchan's Grave*, Lavender Inprint, London, 2010.

Welch, David, ed., *Propaganda, Power and Persuasion: from World War I to Wikileaks*, I.B. Tauris, London, 2015.

Welles, Sumner, *The Time for Decision*, Hamish Hamilton, London, 1944.

Wells, H. G., *Experiment in Autobiography: Discoveries and Conclusions of a Very Ordinary Brain (since 1866)*, Victor Gollancz, London, 1934.

West, Francis, *Gilbert Murray, a Life*, Croom Helm, London, 1984.

Wheeler-Bennett, John, *George VI: His Life and Reign*, Macmillan, London, 1958.

White, William Allen, *Autobiography of William Allen White*, Macmillan, New York, 1946.

Williams, Francis, *A Prime Minister Remembers: The War and Post-War Memoirs of the Rt. Hon. Earl Attlee*, Heinemann, London, 1961.

Williams, Jeffery, *Byng of Vimy: General and Governor General*, Leo Cooper, London, 1983.

Willis-O'Connor, H. and Macbeth, M., *Inside Government House*, Ryerson Press, Toronto, 1954.

Wilson, A. N., *Hilaire Belloc*, Hamish Hamilton, London, 1984.

Wilson, Duncan, *Gilbert Murray O.M.: 1866–1957*, Clarendon Press, Oxford, 1987.

Wilson, Trevor, ed., *The Political Diaries of C. P. Scott, 1911–28*, Collins, London, 1970.

— *The Myriad Faces of War: Britain and the Great War 1914–1918*, Polity Press, Cambridge, 1986.

Winter, Denis, *Haig's Command: A Reassessment*, Viking, London, 1991.

Wolffe, John, *God and Greater Britain: Religion and National Life in Britain and Ireland 1843–1945*, Routledge, London, 1994.

JOURNALS, NEWSPAPERS, THESES, UNPUBLISHED MATERIAL, ONLINE RESOURCES AND BROADCASTS

This is by no means an exhaustive list, especially as far as JB's output is concerned. I refer readers to the invaluable *The First Editions of John Buchan: A Collector's Bibliography* by Robert G. Blanchard, Archon, Hamden, CT, 1981.

Most important of the journals is the one published by the John Buchan Society, at least once a year since its foundation in 1979. In the last forty years, both professional academics and amateur enthusiasts have contributed to *The John Buchan Journal*, in the process

substantially widening and deepening our knowledge of JB and his work. Material
from these journals is quoted or cited throughout the book: see endnotes for individual
references.

I have also had much recourse to the speeches in the Houses of Parliament, in the *Hansard*
archive, 1803–2005, now available online. Also online are the *Diaries of William Lyon
Mackenzie King* (MKD).

OTHER SOURCES

Allison, R. S., 'Ruthin Castle: a private hospital for the investigation and treatment of obscure
medical diseases (1923–1950)', *Ulster Medical Journal*, vol. 46, no. 1, 1977, pp. 22–31.
Buchan, John, *Battle diary of the Somme* (unpublished), QUA, Special Collections.
— 'G.H.Q. intelligence summaries', QUA, Special Collections.
— 'Reports and memoranda, Department and Ministry of Information, March 1917–
December 1919', QUA, Special Collections.
— *The Mountain* (unfinished novel), QUA, Special Collections.
— 'The Revision of Dogmas', *The Ashridge Journal*, no. 3 (August 1930), pp. 7–19.
— *The Scott Pageant*, 1932, QUA, Special Collections.
— 'The University, the Library and the Common Weal', *Columbia University Quarterly*,
December 1934, vol. XXVI, no. 4, pp. 301–12.
— *What the Home Rule Bill Means*, privately published, 1912.
— contrib., *Oxford Prologizes*, Oxford Preservation Trust, 1930.
Cannadine, D., 'John Buchan: A life at the margins', *The American Scholar*, vol. 67, no. 3,
summer 1998, pp. 85–93.
Clavin, Patricia, ' "A Wandering Scholar" in Britain and the USA, 1933–45: the life and work
of Moritz Bonn', *Yearbook of the Research Centre for German and Austrian Exile Studies*, vol.
4, 2002, pp. 27–42.
Desmarais, Anna, 'Lord Tweedsmuir and the search for identity', *Ottawa Citizen*, 20 March
2017, p. A7.
Gilpin, John F., 'The Canadian Agency and British Investment in Western Canadian Land,
1905–1915', PhD thesis, University of Leicester, 1992.
Grieves, Keith, '*Nelson's History of the War*: John Buchan as a contemporary military historian,
1915–22', *Journal of Contemporary History*, vol. 28, no. 3,
July 1993, pp. 533–51.
Henshaw, Peter, 'John Buchan and the British Commonwealth Air Training Plan: the under-
rated role of the "Man on the Spot" ', *Defence Studies*, vol. 1, no. 2, Summer 2001, pp.
129–36.
— 'John Buchan from the "Borders" to the "Berg": nature, empire and white South African
identity, 1901–1910', *African Studies*, vol. 62, no. 1, 2003, pp. 2–32.
Idle, Jeremy, 'The pilgrim's plane-crash: Buchan, Bunyan and canonicity', *Literature and
Theology*, vol. 13, no. 3, September 1999, pp. 249–58.
Kirke-Greene, Anthony H. M., 'The Governors-General of Canada, 1867–1952: a collective
profile', *Journal of Canadian Studies, Revue d'études canadiennes*, vol. 12, no. 4, Summer
1977, pp. 35–57.
Lee, Edwin R., 'Presbyterian ethos and environment in the novels of John Buchan: a religious
and historical study', MA thesis, Deakin University, Australia, 1996.
Little, Geoffrey, ' "The people must have plenty of good books": The Lady Tweedsmuir Prairie
Library Scheme, 1936–40', *Library and Information History*, vol. 28, no. 2, June 2012, pp. 103–16.

Macdonald, Kate, 'The diversification of Thomas Nelson and Sons: John Buchan and the Nelson Archive, 1909–1911', *Publishing History*, vol. 65, 2009, pp. 72–96.
— 'John Buchan's breakthrough: the conjunction of experience, markets and forms that made *The Thirty-Nine Steps*', *Publishing History*, vol. 68, 2010, pp. 25–106.
Pape, Joan, 'Account of Royal Visit to Canada, 1939' (unpublished).
Pilgrim Trust, Ninth Annual Report, Cambridge University Press, Cambridge, 1939.
Rajamäe, Pilvi, 'John Buchan's heroes and the chivalric ideal: gentlemen born', PhD thesis, University of Tartu, Estonia, 2007.
Strachan, Hew, 'John Buchan and the First World War: fact into fiction', *War in History*, vol. 16, no. 3, July 2009, pp. 298–324.
Weekes, David, 'John Buchan (1875–1940): A reassessment of his Christian faith and practice', PhD thesis, University of St Andrews, 2017.

JOURNALS AND NEWSPAPERS

Atlantic Monthly
Blackwood's Magazine
Country Life
Glasgow Herald
Glasgow University Magazine
Illustrated London News
Isis
Maclean's Magazine
Newsweek
Oxford JCR
Punch
The Alpine Journal
The Bookman
The Bookseller
The Boston Globe
The Brazen Nose
The British Weekly
The Daily Express
The Daily News
The Daily Sketch
The Daily Telegraph
The Edinburgh Review
The Globe (Toronto) (later *Globe & Mail*)
The Graphic
The Jewish Chronicle
The Listener
The Morning Post
The New Edinburgh Review
The New Statesman
The New York Times
The New Yorker
The Observer
The Ottawa Citizen

The Oxford Mail
The Oxford Times
The Scotsman
The Scottish Mountaineering Club Journal
The Sketch
The Spectator
The Sunday Times
The Times
The Times Literary Supplement
Time

TELEVISION AND RADIO BROADCASTS

Canadian Broadcasting Corporation, 14 February 1940, 1.45–3.45 p.m. EST, broadcast of State Funeral Service for Lord Tweedsmuir.

Times Remembered, BBC broadcast of interview between Susan, Lady Tweedsmuir, and Joan Bakewell, 1 November 1972.

The Thirty-Nine Steps, *The Three Hostages* and *Huntingtower* have been adapted for television, and *The Island of Sheep*, *Witch Wood*, *The Power-House*, *Greenmantle*, *The Three Hostages*, *Huntingtower*, *The Thirty-Nine Steps* and *The Courts of the Morning* for the radio.

FILM

Huntingtower (1927, George Pearson)
The 39 Steps (1935, Alfred Hitchcock)
The 39 Steps (1959, Ralph Thomas)
The Thirty-Nine Steps (1979, Don Sharp)

STAGE

The 39 Steps, written by Patrick Barlow, played for ten years in London (2005–2015) and continues to be staged all over the world.

Acknowledgements

This book could not have been written without the assistance of many people, whose efforts on my behalf I gratefully acknowledge here.

First and foremost, my husband, Charlie Wide, did all he could to encourage me, including submitting with impressively good grace to JB-related conversations almost daily over four years. He read the manuscript more than once and I could never have cut it down to a manageable length without being able to rely on his good sense and ability to see the big picture.

My brothers and sisters – Deborah Stewartby, Toby Tweedsmuir, Edward Buchan, Laura Crackanthorpe and James Buchan – saw the point of what became known as 'the Project' from the start and assisted me in many crucial ways. The children of the Reverend John Buchan could not have exhibited more warm-hearted family cooperation than I received. JB's works are out of copyright and can be freely reproduced, but I thank Toby for giving me permission to quote from Susie's writings.

My son, Tommy Wide, read the manuscript, making helpful suggestions, and also rendered into elegant English the Greek and Latin quotations that occur all too frequently in JB's non-fiction. My daughter, Emily Thomas, and her husband, Will, showed keen understanding and interest, while Henry, Alexander and Hector Thomas provided welcome and recuperative diversion.

Other members of the family played a significant part: Sauré Tweedsmuir, William's widow, lent me many of the images that appear in the book and gave me treasured books; the late Ian Stewartby provided insights into JB's political life and Susie's widowhood; David Crackanthorpe made me aware of the importance of both John Lane and F.S. Oliver; Perdita Buchan Connolly sent me an illuminating essay she had written about Susie; Emma Lambe made available Willie Buchan's invaluable letters; Edmund Fairfax-Lucy showed me private papers belonging to his parents, Alice and Brian; Susie Selkirk and Harry Douglas-Hamilton did the same for Susie's father and Harry's grandfather, Johnnie; and David and Benjamin Buchan answered questions about their father, Alastair. Andrew Elder read that part of the manuscript referring to JB's brain operations. I had fruitful conversations with Lisa Buchan, Elizabeth Buchan and Laura Warrender, and I benefited enormously from the opportunity to talk with Dame Frances Campbell-Preston and Peggy Peyton-Jones, both of whom knew JB.

James Redfern generously lent me all his grandfather's papers, while David and Sir Simon Boyle made available to me the letters their father, Captain John Boyle, sent home from Canada. Lord Ironside invited me to look through diaries belonging to his father, and Mark Laing enabled me to see private correspondence between JB and Sir Alexander Grant.

I owe an enormous debt to those scholars with an interest in JB. They are a most collegiate group of people, and could not have encouraged me more: in particular, Dr Michael Redley and William Galbraith, for many conversations and for reading parts of the manuscript; Dr Kate Macdonald and Dr Peter Henshaw for sending me academic papers they had written; Dr Roger Clarke for conversations concerning JB's journalism; the Reverend Dr David Weekes for his work on JB's religion; and Andrew Lownie and Dr Eileen Stewart for helpful advice. Professor Andrew D. Roberts, the son of Janet Adam Smith, lent me some papers belonging to his mother and alerted me to the rest now deposited in the National Library of Scotland, while Professor David S. Katz pointed me to work he has done on pre-Great War Turkey and *Greenmantle*.

A book of this nature would be quite impossible without the professional help of archivists and librarians. I should like to thank in particular Olive Geddes and her staff, especially Robbie Mitchell, at the National Library of Scotland; Paul Banfield, Heather Home and Jeremy Heil at the Archives at Queen's University, Kingston, Ontario; Dr Alvan Bregman and Jillian Sparks at the W.D. Jordan Library, also at Queen's; Frank Bowles, Superintendent of the Manuscripts Reading Room, and his staff at Cambridge University Library; Julie Crocker at the Royal Archives; Jill Delaney at Library and Archives, Canada; and Jerry Fielder and Julie Grahame at the Yousuf Karsh Archive.

Also very helpful were the archivists of the Bodleian Library, Oxford; Brasenose College, Oxford; the British Institute, Florence; the John J. Burns Library, Boston College, Boston, Massachusetts; the Centre of Research Collections at the University of Edinburgh; the Ede and Ravenscroft Archives, Waterbeach; the Fife Cultural Trust (Kirkcaldy Local Studies); the John Hay Library, Brown University, Providence, Rhode Island; Hutchesons' Grammar School, Glasgow; the John F. Kennedy Presidential Library, Boston, Massachusetts; the Middle Temple Archives, London; the National Archives, Kew; Oxfordshire History Centre, Oxford; the Parliamentary Archives, London; Queen Mary University of London Archives; the Rauner Library, Dartmouth College, Hanover, New Hampshire; the Franklin D. Roosevelt Presidential Library, Hyde Park, New York and the Harry S. Truman Presidential Library, Independence, Missouri.

I read many of the secondary sources in Cambridge University Library, and would like to express my thanks to the Librarian, Dr Jessica Gardner, and her colleagues.

I acknowledge, with gratitude, the permission to reproduce material from their collections from Her Majesty Queen Elizabeth II, the Syndics of Cambridge University Library, and the Yousuf Karsh Archive.

I am indebted to the members of the John Buchan Society, which has kept the flame burning brightly since 1979; in particular the Chairman, Kenneth Hillier, Drs William and Andrena Telford, and Peter Thackeray. The Society has given me a

platform for airing some of my research in the last few years, which has been of great assistance to me. I thank the Chairman and Council of the Society for permission to quote from several articles in *The John Buchan Journal*.

The memory of John Buchan is also cherished and promoted at the John Buchan Story Museum in the Chambers Institution in Peebles, and I am grateful to the Trustees and to the Management Committee, especially Ian Buckingham and Dr Peter Worthington. I acknowledge with thanks permission to reproduce a number of the images deposited at the Museum.

Kate and Richard Love, Julia Elcock and Richard Buxton, Amanda Buchan and Rosalind Wild gave me much-needed hospitality on my travels; my researches would have been far less agreeable without their open-hearted generosity and enduring interest in my sometimes rather arcane preoccupations.

There are many other people who have helped me in one way or another – answering specific queries, sending me information, lending books, making domestic life run smoothly, or simply encouraging me to talk about JB. I should like to thank Baroness Bakewell, John Ballantyne, Adam Begley, Liz Boxall, David Brearly, Jane Brown, Isabel Buchanan, Nancy Champion, Dr Jim Cox, Peter and Ray Cox, Alan Crombie, the Reverend Dr Karen Dimock, Taylor Downing, Carl Folker, Sir James Graham, Andy Haswell, Richard and Cressida Inglewood, Charles and Kate Ironside, Louis Jebb, Igor Judge, Lori Knoll, Alex Leith, Alexander McCall Smith, Dr Daniel Maccannell, Dr Christopher McCreery, Christine MacIntyre, Sir William Macpherson of Cluny, Sandy McCracken, Andrew Martin, Simon Milne, Peter Morrell, Cynthia Ogilvie, Reg Paintin, Anna Pavord, Philip Potterton, Alexander Reford, Jean Ann Scott Miller, Anne Simpson, Sandra Smith, Jan Usher and Bob Watson.

I should like to thank my literary agent, Felicity Bryan, as well as Michael Fishwick and his colleagues at Bloomsbury, in particular Sarah Ruddick, Lilidh Kendrick, Holly Ovenden, Francesca Sturiale, Richard Mason and Douglas Matthews. The collaboration has been a very happy one.

Finally, I was enormously helped by a grant from the Society of Authors' Foundation, which enabled me to undertake research abroad. It would have been difficult to complete the task without it.

Index

A Note on the Type

The text of this book is set Adobe Garamond. It is one of several versions of Garamond based on the designs of Claude Garamond. It is thought that Garamond based his font on Bembo, cut in 1495 by Francesco Griffo in collaboration with the Italian printer Aldus Manutius. Garamond types were first used in books printed in Paris around 1532. Many of the present-day versions of this type are based on the Typi Academiae of Jean Jannon cut in Sedan in 1615.

Claude Garamond was born in Paris in 1480. He learned how to cut type from his father and by the age of fifteen he was able to fashion steel punches the size of a pica with great precision. At the age of sixty he was commissioned by King Francis I to design a Greek alphabet, and for this he was given the honourable title of royal type founder. He died in 1561.